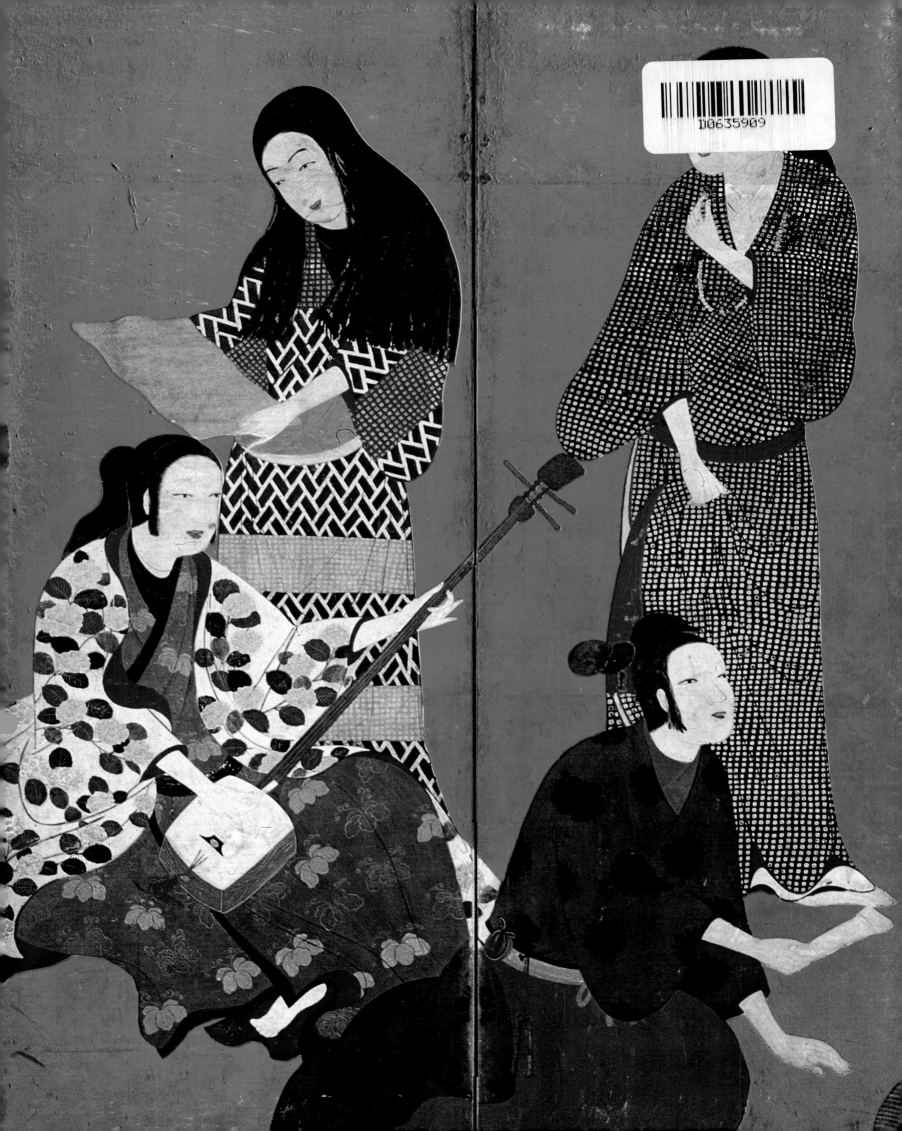

The Luckie Agee Waller

Collection in

Far Eastern History

Stanford University Libraries

ART OF JAPAN

DANIELLE AND VADIME ELISSEEFF

ART OF JAPAN

TRANSLATED FROM THE FRENCH BY
I. MARK PARIS

HARRY N. ABRAMS, INC., PUBLISHERS, NEW YORK

ILLUSTRATION CREDITS

The illustrations in this volume have been supervised by JEAN MAZENOD, who is also the photographer for figures 5, 9, 11, 22–25, 53, 58–60, 70, 71, 97, 101, 103, 112, 113, 121, 141, 154–56, 174.

Color photographs: Yamato Bunkakan, Nara: 1, 3, 21, 100, 104, 126, 128; Taizo Nagano: 2, 62; Sakamoto: 4, 39, 41, 43, 46, 51, 96, 114, 145–49, 165; Asahi: 6, 63, 73, 85; Shogakukan-Tuttle-Mori: 7, 87; John Hymas: 8, 28–30, 33, 35, 37, 40, 48, 49, 54, 55, 82, 123; Zauho-Press: 10, 18, 19, 26, 27, 57, 90, 105, 106, 110, 111, 124, 131, 133, 134, 140, 142–44, 158, 159, 161, 167, 168, 173; Freer Gallery of Art, Washington, D.C.: 12, 64, 66, 67, 69, 77, 91–94, 98, 102, 116, 150, 163, 164; Gakken: 13, 74, 115, 129; Lauros-Giraudon: 14; Fujimoto Shihachi: 15–17; Benrido: 31, 72, 83, 86, 95, 118; K. Ogawa-Ziolo: 32, 34, 42, 44; Dusan Ogrin: 36; Jean-Paul Nacivet: 38; Shueisha: 45, 50, 52, 78, 84; Zenrinji, Kyoto: 47; Silvio Fiore: 56; Iwanami Shoten: 61; Kodansha: 65, 76, 89, 109; Bulloz: 79; Mireille Vautier-Decool: 80; K. Ogawa-Asuka-En: 81; Fujita Art Museum, Osaka: 88, 127, 166, 169–71, 176; Rheinisches Picture Archive, Cologne: 99; Museum of Nezu, Tokyo: 107, 117; Hōfu Mōri Hōkōkai, Hōfu: 108; Atami Art Museum, Atami: 119, 120, 175; Shibundo; 122; Gotō Art Museum, Tokyo: 125; Chōgosonshiji, Nara: 130; Okura Cultural Foundation, Tokyo: 132; Kitano Temmangū, Kyoto: 135; Namban Bunkakan, Osaka: 136, 138, 139, 154, 157, 160; Sasabe-Shibata: 137; Giraudon: 151; Musée Cernuschi, Paris: 152, 153; Jacqueline Hyde: 162; Idemitsu Art Gallery, Tokyo: 172

This work was published with the assistance of the Centre National des Lettres, Paris

Editor: Patricia Egan

Library of Congress Cataloging in Publication Data

Elisseeff, Danielle.
 Art of Japan.

 Translation of: L'art de l'ancien Japon.
 Bibliography: p.
 Includes index.
 1. Art, Japanese—To 1868. I. Elisseeff, Vadime.
II. Title.
N7353.E4313 1985 709'.52 84-14627
ISBN 0-8109-0642-2

Colorplates and black-and-white illustrations printed in France.
Text printed in West Germany. Bound in West Germany

FOREWORD TO THE FRENCH EDITION

WHEN *my wife and I began the publication of the "Art and Great Civilizations" series, it was not our aim to follow a strict chronological sequence. In this age tremendous strides toward a more diversified knowledge of world history have been made, and people are now eager to explore the stupendous legacy of non-Western cultures. To satisfy this understandable desire we thought it best to embody our inquiries into art throughout the world in a group of books presenting certain key periods of creativity that each approached differently the timeless question of art.*

We now know that, underlying differences notwithstanding, all innovative styles—whether they happened to arise in the Near East, Egypt, Greece, Rome, the Far East, the Islamic countries, or Western Christendom—have emerged and flourished out of reciprocal influences and exchange. The better informed we are, the easier it is to discard the one-sided concept of beauty that we inherited from classical civilizations and to broaden our spectrum of aesthetic guidelines: there is no one true yardstick for evaluating works of art. Without adhering to strict chronology in our first group of books, we nonetheless tried to evaluate, when possible, those trends that could be judged by a common set of aesthetic criteria, even if the civilizations in question were fundamentally different or even poles apart. And the arts which took shape in India, China, and Japan were spawned by one and the same force: a new religion, Buddhism. In each region, Buddhism gave rise to a mode of expression peculiar to the people inhabiting it. But in this case there was no escaping the necessity of a chronological order for our three successive books on Far Eastern art.

Buddhism developed in India several centuries before the birth of Christ. The new faith did not make its way across Upper Asia and into China until the second century A.D. Only in the middle of the sixth century—nine centuries after it had appeared in India, and four centuries after it had penetrated China—did monks from Korea and China bring Buddhism to Japan.

Sixth-century Japan was then emerging from a protohistoric stage of development; two centuries later, Islamic invasions would signal the demise of Buddhism in India. Chinese artists had meanwhile forged a distinctive form of religious art based on Buddhist doctrine and iconography, notably a splendid school of sculpture in which the Indian Buddha's spiritual message quickly took on an unmistakably Chinese cast.

In Japan, the first appearance of true sculpture coincided with the advent of Buddhism in the sixth century, and it is not surprising that their earliest effigies of the newly arrived deity were

heavily indebted to Chinese tradition; for religious and artistic influences had made their usual course from China to Korea and then to the Japanese archipelago. Now China was exporting what she herself had imported before from India—a complete iconographic repertory of Buddha and his disciples, all of whose positions, gestures, and attributes had become fixed and codified over the centuries.

Faced with such formidable constraints, Japanese artists might have found small opportunity to develop their own feelings and imagination. Yet, over the centuries Japanese sculptors blazed their own trails, emphasizing and even glorifying the idiosyncratic and the particular, while their Chinese counterparts, steeped in mysticism, maintained their depersonalized style. During the Kamakura period, Japanese sculptors were to create their own world of deities, intimidating guardian kings, and Buddhist disciples. Some of these combine sculptural vitality with an expressionistic, almost Baroque realism that occurs nowhere else in the Far East. Their pursuit of realism also resulted in sculptured portraits—of emperors, founders of sects, clergy, and laymen—an extraordinary period in Japanese art, though it was over by the fourteenth century.

Painting underwent a comparable development. Even though China cast a long shadow over the archipelago for many years, the Japanese painters' astounding gift for adaptation assimilated all Chinese styles, refining, improving, and reshaping them in their own image.

There can be no understanding of ancient Japanese art without a knowledge of the arts on continental Asia before and after the advent of Buddhism. Whoever hopes to draw an overview of Japanese art finds awesome obstacles: its extreme complexity; its many stylistic paths, from representational and expressionistic to quasi-abstract; the baffling virtuosity of its creators; and, in the early stages, its close ties with Chinese art. Only authors with wide experience in Far Eastern art, especially Chinese art, could master so hazardous a subject.

DANIELLE and Vadime Elisseeff willingly accepted our invitation to write this book and to join in making it a worthy addition to this series. They have worked together for many years, and their scholarly publications, as well as their efforts to foster an understanding of the many facets of Chinese and Japanese civilization, place them in the vanguard of specialists in Oriental art. They have traveled throughout the Far East and have flawless command of the Japanese and Chinese languages. Vadime Elisseeff is chief curator of the art and history museums of Paris, and of the Eastern collections of the Musée Cernuschi. As cultural attaché with the French Embassy in China, director of the Franco-Japanese houses in Tokyo and Kyoto, professor at the Ecole du Louvre and the Institut Nationale des Langues Orientales Vivantes, and director of studies at the Ecole des Hautes Etudes en Sciences Sociales, he has supervised art and archaeological exhibitions and presided over numerous cultural associations; his honors include Japan's Order of the Rising Sun.

Danielle Elisseeff, his wife, is a research assistant at the Ecole des Hautes Etudes "Civilisations d'Extrême-Orient" and teaches the history of Chinese art at both the Institut National des Langues Orientales Vivantes and the Institut d'Art et d'Archéologie. She has published numerous scholarly works. Together, the Elisseeffs have published Civilisation japonaise (Arthaud, 1974) and Civilisation chinoise classique (Arthaud, 1979), both volumes awarded prizes by the French Academy.

In their preface the authors explain that they wished to avoid the tediousness of strict chronological sequence, and to present Japanese art at its most typical and genuinely personal level. In one

chapter we follow the Japanese artist as he interprets literary subjects, an inexhaustible source that gave wide latitude to his gift for storytelling; in another, the approach of successive generations of painters to the theme of nature. A wide-ranging discussion of religion and religious art precedes the chapter on portraiture and the quest for realism. The authors investigate Japan's relations with the West, especially the encounter between the Japanese and Christianity that inspired the gorgeous, Westernized screen paintings depicting the arrival of the Portuguese and the Dutch.

After a historical chapter, the book opens with architecture, so integral a part of the Japanese landscape, and the chapters close with the Japanese love of life's pleasures, a love they have clung to in even their darkest times.

THE authors' course simplified our task of arranging the colorplates, for we could group the portraits and landscapes to facilitate the reader in tracing the Japanese artists' development. Wonderful portraits of emperors and high-ranking officials—those curious combinations of delicate features and severe, almost abstract clustered folds of fabric—could be juxtaposed with equally fascinating sketches of figures, in which minutely detailed faces, hands, and feet blend with fanciful swirls of drapery. We have included a section of monochromatic drawings, to illustrate that distinctive technique of Japanese draftsmanship.

The same guidelines determined our approach to landscapes, a type of painting that prompted Japanese artists toward a wide range of styles, from narrative landscapes with a full cast of characters to enthralling views of mountains or waves in fanciful arabesques. In the sumptuous screens painted on gold ground, "realistic" flowers, birds, and blossoming branches mingle with "contrived," sweeping patterns, while gold—the ultimate in abstract color—is used to convey a special ambience for everything the Japanese saw and depicted. Here we introduce another section of line drawings whose peerless draftsmanship attests to the rich store of techniques tapped by Japanese artists.

The influence of Chinese art is patent in panoramic landscapes or in the treatment of certain trees or rocks, but the Japanese genius shines through in the impressionistic interpretation of a tree in a screen painting, or in a painting of stunning modernity. A massive maple bough may flash across the full width of a multifold screen, while the even, spare, meticulously drawn lines of a clump of reeds demonstrate that no style or technique was beyond the mastery of the artists.

When possible, we have illustrated entire screens or substantial fragments of handscrolls, for the full flow of forms and subjects is crucial here: a portion does not convey the sense of space—or rather, of emptiness—that characterizes certain types of Japanese composition. In the section of documentary illustrations, a number of screens and long handscrolls are reproduced in their entirety. Japanese artists indulged their penchant for narration in these works, recounting the lives of individuals in successive scenes. We were given permission to reproduce—for the first time in a non-Japanese publication, so far as we know—the full version of Sesshū's celebrated handscroll, The Four Seasons (figs. 374–76).

Gold, so prominent in Japanese painting, is also an integral part of sculpture and an adjunct of wood and lacquer in interior design. To convey the gorgeousness of this art, we were committed to giving an important place to illustrations with gold, notwithstanding the technical difficulties of using this color in conjunction with offset printing. In addition to eight dazzling colorplates of sculpture having gold highlights, we have included entire paintings and details whose omnipresent gold

"grounds" appear as superb arabesques that envelop the space with surprising fullness and depth, while allowing the viewer to linger over the soft delicacy of a bird, flower, branch, or leaf as it emerges from the surrounding gold.

To introduce the reader immediately to the sumptuousness of Japanese art, the front end-papers of the book present a portion of a famous screen of Japanese ladies against a gold background—in our estimation a lovely beginning for a book on the art of the Empire of the Rising Sun.

A major problem has been to obtain or to take our own photographs of the works of art. Jean Mazenod has led his team of photographers through many countries to take as many in situ pictures as possible, and into the museums and private collections to which they had access. In Art of Dynastic China we mentioned our difficulties in photographing works of art in situ, but our initial fears were allayed by finding that the many statues and paintings—often the most beautiful and most typical pieces—were in the major museums and a few well-known private collections. It was not even necessary to travel to China to photograph a great many of her consummate works of art. Most of Japan's artistic heritage, however, remains on the archipelago, carefully guarded in museums and temple treasuries. Although a number of pieces are in foreign collections, especially in the United States, we soon realized that only Japan's museums and countless temples would yield a true picture of her artistic heritage. In addition, the Japanese are constantly in hopes of reclaiming for their homeland the few superb pieces that now and again appear in major auctions; one can only imagine the difficulties which this "conservatism" presents to a non-Japanese publisher hoping to bring out a sizable book on Japanese art. We found it well-nigh impossible—and then only after endless negotiations over regulations designed to discourage infringement of copyrights—for a foreign photographer to take pictures in Japan with professional equipment. No work of art may be photographed without the express permission of the "owner" and of any photographer who already possesses a negative. This daunting line of consent reflects a mentality alien to Westerners, so accustomed to disseminating information—in this case, an artistic heritage—through publishing. A foreign publisher has no alternative but to use pictures taken by Japanese photographers, and these are by and large of high quality. But it was not easy to gather material this way. Jean Mazenod, charged with the search for illustrations, realized that he had to travel to Japan and obtain the requisite permissions before he could even locate the negatives that might meet our standards. Most of the feelers we sent out from Paris were unanswered, and not because they failed to reach their destination. With a new patience more in the Eastern style, we spelled out again the nature of our project in new letters written in Japanese. In addition to the support of His Excellency, the Ambassador of France to Japan, who recommended our undertaking to many of the individuals and government agencies we had to see, Jean Mazenod had also the unstinting support of the authorities at the French Cultural Service in Tokyo, who freely advised him and made invaluable efforts on his behalf.

Special mention must be made of the friendliness and cooperative spirit of the leading Japanese publishing firms during these negotiations. Far from defending their artistic "rights," they were more instrumental than anyone else in helping us locate material. We wish to express our appreciation for their extraordinary accessibility. In large measure it was they who enabled Jean Mazenod to bring together this exceptional group of photographs, to be found in no other Western book on Japanese art.

ANY *book furthering knowledge about the arts will face the twofold dilemma of object and method: the illustrations address the senses immediately, and the text must satisfy their appetite for as broad a range of information as possible. With these objectives as our guiding principle, we have attempted to meet and to give special attention to the quality of the colorplates and to thorough "documentation," particularly in the section on Archaeological Sites.*

This is the only part of the book which allows the reader to "travel" through a country, to look closely at renowned sites and re-create a world that is no more, and here the emphasis is placed squarely on architecture. With the authors as their guide, readers are free to make countless "stops" as they view the photographs of monuments, and the sweeping general plans of sites, skillful reconstructions, and axonometric diagrams that were drawn expressly for us by Pierre and Lilian Giroux.

LUCIEN MAZENOD

ACKNOWLEDGMENTS

THIS *book was several years in the making, and as early as 1978, many of the same people who helped us put together the illustrations for* Art of Dynastic China *assisted in the same capacity for this book,* Art of Japan. *We now find that we cannot always give credit to everyone who, directly or indirectly, had a hand in its publication.*

In the foreword and acknowledgments of Art of Dynastic China, *we expressed our appreciation to museums in both America and Europe for their cooperation. We want all those mentioned there to know our gratitude for their help in this new undertaking; if we do not thank them once again, it is for lack of space.*

We express our special thanks to: His Excellency, Xavier Daufresne de la Chevalerie, French Ambassador to Japan; Mr. Loïc Hennekine, Consul; and all those at the French Cultural Service in Tokyo, particularly Mr. Ono, who monitored the progress of our negotiations, as did the Cultural Attaché, Mr. Christian Morieux, and the Educational Adviser at the Cultural Service, Mr. Pierre Groll.

We also extend our gratitude to Mr. Robert Sanson, French Minister for Trade and Economic Affairs, for his support and helpful suggestions.

We express our appreciation to His Excellency, Katsuichi Ikawa, Japanese Ambassador to France; Mr. Hiraoka, Assistant Director of the Department of Cultural Affairs at Gaimusho; Mr. Yoshikazu Hasegawa and Mr. Kyotaro Nishikawa of Bunka-cho.

For their invaluable advice at the Japan Foundation, we thank: Mr. Toru Sawada, Executive Director; Mr. Masaaki Iseki, Director of the Exhibition Department; Mr. Otsuka and Mr. Tsuyoshi Chida.

A special word of thanks to Mr. Teikichi Tarusawa, Managing Director of Kodansha, and to the following: Messrs. Toru Midorikawa and Yoshikatsu Nakajima, President and Director of Iwanami Shoten; Messrs. Ichiro Narahara and Yoshimasa Naito of Shueisha; Messrs. Shunichiro Aikawa and Shinnisuke Yamaji of Gakken Publishers.

Our thanks also to: Mr. Fumio Hatano and Mr. Nadaya of Kodansha, as well as to Mr. Shirai Tetsu; Mr. Junichi Yuge of Shueisha; Messrs. Shigeru Takakusa and Takao Hori of Iwanami Shoten; Messrs. Noboru Haraguchi, Katsunobu Yoshida, and Ikuo Maki of Benrido; Mr. Minoru Mutakami and Miss Togashi of Zauho-Press; and Messrs. Ena and Akira Nakano and

Mrs. Takahashi of the Cultural Project Department of Asahi Shimbun, for their assistance in our arrangements at a number of prominent temples; and to Mr. Tanaka in Kyoto.

Our thanks to the many officials, museums, temples, and private collections in Japan that made so much splendid material available to us: Akamajingu (Shimonoseki); Atami Art Museum; Byōdōin (Uji); Chūgūji (Nara); Daitokuji (Kyoto); Dōjōji (Wakayama); Eiheiji (Fukui Prefecture); Gōto Art Museum (Tokyo); Hatakeyama Kinenkan (Tokyo); Hofu Temmangū (Hofu); Honnōji (Kyoto); Hokkeji (Nara); Honpa Hongwanji (Kyoto); Hōrinji (Nara); Idemitsu Museum (Tokyo); Ishiyamadera (Shiga Prefecture); Jingōji (Kyoto); Jōdo-in (Kyoto); Kitano Temmangū (Kyoto); Kōfukuji (Nara); Kyoogokuji, or Toji (Kyoto); Kyūshū Historical Museum; Murōji (Nara); Fujita Art Museum (Ōsaka); Tokyo and Nara National Museums; Museum of the City of Kyoto; Nezu Museum (Tokyo); Myoshinji (Kyoto); Ninnaji (Kyoto); Okura Cultural Foundation (Tokyo); Shitennōji (Ōsaka); Shiritsu Namban Bijutsukan (Kobe); Shōsōin (Nara); Suntory Bijutsukan (Tokyo); Tokugawa Reimeikai Foundation (Tokyo); Tōshōdaiji (Nara); Umezawa Kinenkan (Tokyo); Yamato Bunkakan (Nara); Yokokuraji (Gifu); Zenrinji (Kyoto); and in particular to Mr. Mototaka Mohri, President of Hofu Mohri Hokokai, Mr. Sasabe of the City Museum of Kobe, and Mr. Kitamura of Namban Bunkakan (Ōsaka).

Our heartfelt appreciation to the officials of the two renowned temples at Tōdaiji, for their help and receptiveness to our project, and at Hōryūji, for permitting us to publish photographs of the extraordinary masterpieces that grace this great temple's Treasury.

We also extend our thanks to John Hymas for his gracious assistance. Miss Mami Takahashi, whose patience was tested in bringing together the last material, deserves our heartfelt thanks.

Invaluable help was offered to us by the Museum of the City of Cologne, the Museum of Ancient Art in Lisbon, and by Mr. Thomas Lawton and his associates at the Freer Gallery of Art, Smithsonian Institution, in Washington, D.C.

A number of people in the United States began to help us in 1978, including Mrs. Julia Meech Pekarik of the Metropolitan Museum of Art, New York, and the curators of Japanese collections at the Museum of Fine Arts, Boston, and the Asian Art Museum, San Francisco, where René-Yvon Lefebvre d'Argencé, Director of the Avery Brundage Collection, again placed himself at our disposal with his usual friendliness. To him we extend our warmest thanks.

We wish to thank for their support: Mrs. Jeanine Auboyer and her associates at the Musée Guimet; Marie-Françoise Bobot of the Musée Cernuschi; Mr. and Mrs. Shibata in Paris; and François Descoueyte in Tokyo.

LUCIEN MAZENOD
JEAN MAZENOD

ART OF JAPAN

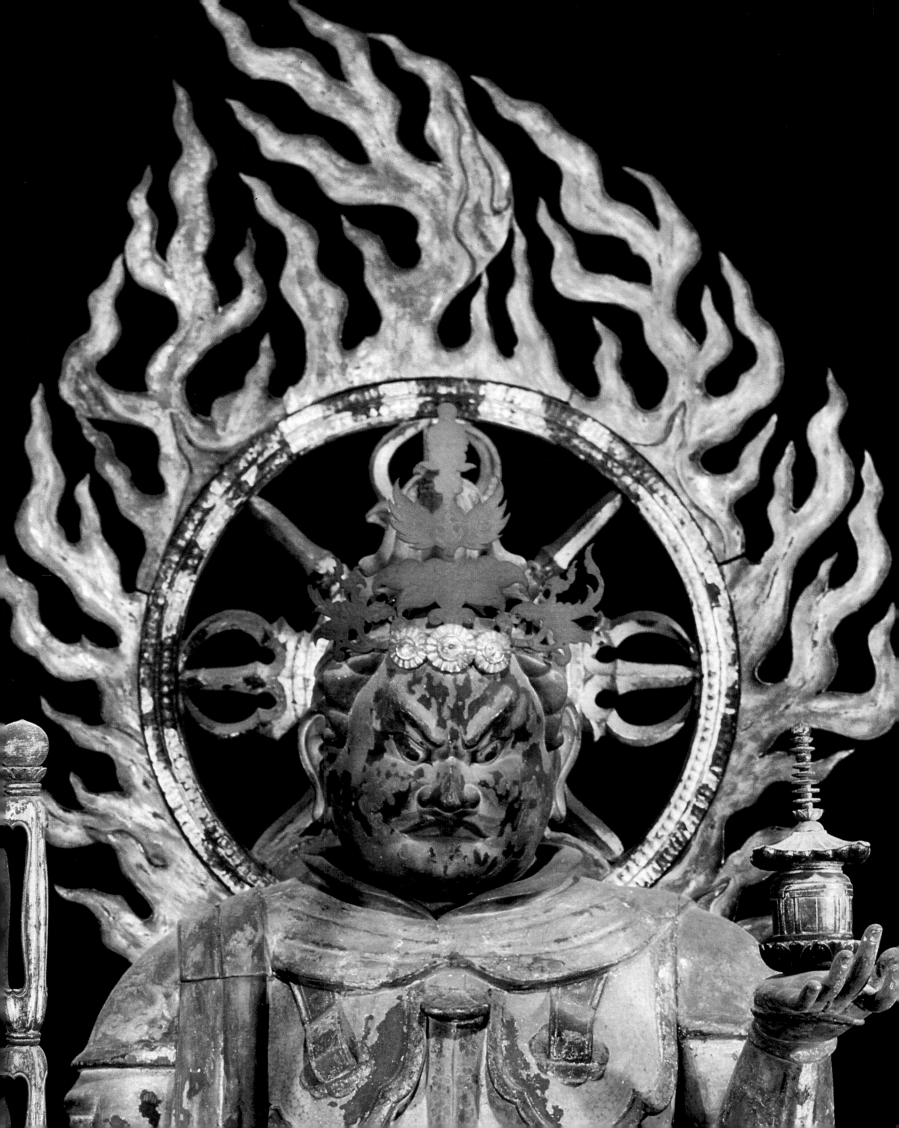

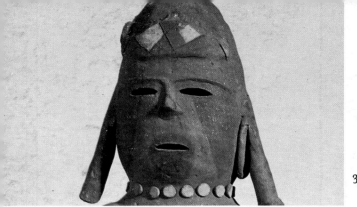

3

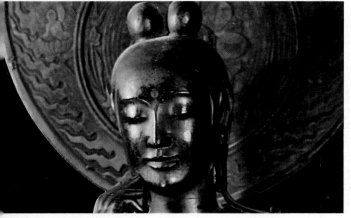

4

5

6

7

CONTENTS

1 (Front endpaper) MATSUURA BYŌBU (SCREENS WITH WOMEN OF FASHION AT LEISURE).
 FORMERLY MATSUURA COLLECTION. Four panels of six-fold screen, one of a pair (see
 fig. 482). Color on gold paper, each screen 1.8 × 3.7 m. Early Edo Period, first half of
 17th century. Yamato Bunkakan, Nara

2 TAMONTEN (VAIŚRAVANA). Painted and gilded wood. Heian Period, 9th–11th century.
 Jōruriji, Kyoto

3 HEAD OF STANDING FIGURE. Terracotta (see fig. 21). Kofun Period, 6th century. Yamato
 Bunkakan, Nara

4 HEAD OF MIROKU BOSATSU. Wood (see fig. 41). Asuka Period, 7th century. Chūgūji,
 Nara

5 KŌNIN SHŌNIN EDEN. Detail of handscroll. Kamakura Period, 14th century. Nelson
 Gallery-Atkins Museum, Kansas City

6 HEAD OF JIZŌ BOSATSU. By Kaikei (active c. 1185–1220). Wood (see fig. 63). Kamakura
 Period, 1203–1208, Tōdaiji, Nara

7 PORTRAIT OF MINAMOTO-NO-YORITOMO. By Fujiwara-no-Takanobu (1142–1205).
 Detail of painting (see fig. 87). Color on silk. Kamakura Period. Jingoji, Kyoto

8 NAGOYA CASTLE. 17th century (1959 reconstruction; see figs. 556, 557)

9 KUMANO MANDALA. Detail of painting (see fig. 154). Color on silk. Kamakura Period,
 c. 1300. Cleveland Museum of Art

10 ŌEYAMA EMAKI (TALE OF ŌEYAMA). Detail of handscroll (see fig. 161). Color on paper.
 Momoyama Period, late 16th–early 17th century. Tokyo National Museum

11 DETAIL OF PLATE, KO-KUTANI OLD KUTANI WARE. White porcelain (see fig. 174).
 Early Edo Period, 17th century. Asian Art Museum, San Francisco

12 WINTERTIME PARTY. By Toyoharu (1735–1813). Detail of painting (see fig. 164). Ink,
 color, and gold on silk. Edo Period. Freer Gallery of Art, Washington, D.C.

13 PORTRAIT OF MUSŌ KOKUSHI (posthumous name: Soseki, 1271–1346). Detail of statue.
 Painted wood, height 1.1 m. Kamakura Period. Zuisenji, Kamakura

8

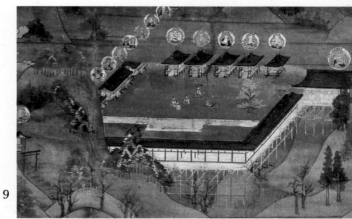

9

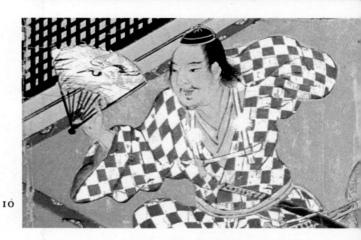

10

11

12

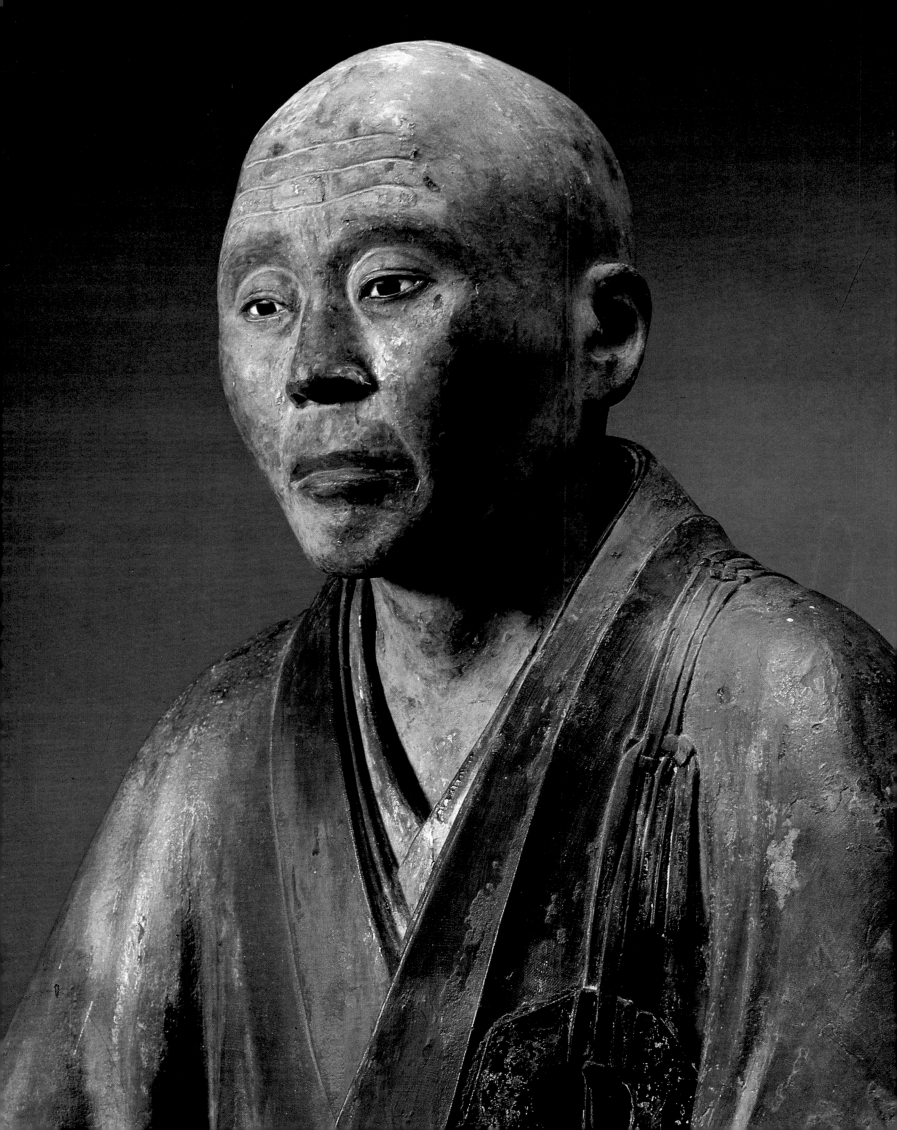

AUTHORS' PREFACE

AUTHORS' PREFACE

MORE *now than in the past, it seems a risky undertaking to write about the art of Japan from a purely historical point of view. The champions of "total history," however innovative, have shattered a time-honored, ill-defined, and fundamentally prescriptive approach, but have not yet worked out a fully satisfactory method for modern needs. Thus we will spell out our objectives here before we take up our subject.*

Such definitions of art as "works through which man expresses an aesthetic ideal" and "a particular way of expressing beauty," which have appeared in certain large dictionaries, apply to the use of the word only since the 18th century (1752, to be precise, says the lexicographer). But a historical study of the earlier meaning of the word will show us that art must first be thought of as knowledge, then as method. It is a form of "know-how" designed to achieve specific aims within a suitable framework. Its successive modes appear to us as stylistic changes, and these, in turn, reflect the manner or path that is chosen by an individual or group to achieve an objective.

The purpose of this book is not to theorize, nor to serve as a manual, nor even to catalogue an impressive artistic heritage. We think of it as a step along the long, arduous road toward our greater appreciation of the intangible riches we all share.

We wanted to do more than turn a few felicitous phrases about Japanese art.

Our aim was to bring clashing theoretical questions into sharper focus, and to bring out side issues of perhaps seeming unimportance, which illuminate the many ways people have viewed the extraordinary legacy of Japan. Another primary goal in this book is to examine and describe the techniques of art.

WE *found that our original plan led to shedding much of the chronological sequence, yet we did not want to dismiss wholesale this altogether natural and familiar approach. An introductory journey "down the centuries" seemed necessary, for the measured flow of time is inescapable here on earth.*

Nor could we put off an early chapter on architecture, so important as a component of the Japanese landscape. Then came the gods, a pantheon not to be shortchanged to save space, for iconography is rooted in the deepest yearnings of the human spirit. Our decision was to stress the artists' methods in making religious images. Many of their stylistic choices probably reflect the exigencies

of their craft, and before assessing any spiritual significance it is essential to investigate the challenges that the medium posed to an artist's imagination.

After the representation of divine countenances come those of flesh-and-blood models: our aim here was to clarify how individuals saw themselves, and how artists captured that most ephemeral of phenomena, the human face.

Then comes the world of nature, seen and re-created through the eyes of the Japanese artist. A painter's use of ink or colors will determine the technique he adopts, whether the treatment of his subject be "real" (landscape) or fictitious (literature). To this we have added a discussion of the Japanese preoccupation with life's pleasures, which has always spurred this people to rebuild their culture even when brought near to annihilation by terrible upheavals.

Our chapters end with the individual objets d'art which, in the traditional Japanese scheme of things, deserve our attention no less than the mightiest monuments. Tea masters looked upon ceramic pieces as the epitome of aesthetic fulfillment, and our discussion of these is a closing chapter that is not a conclusion, for there can be no last word about an outlook that is still much in the making.

MANY names, deeds, works of art, and important sites have been omitted from our survey, for we have touched only lightly on the overly familiar and have concentrated instead on less famous or hitherto unknown pieces. Names that are not to be found in the "Sites and Monuments" or "Concise Biographies" crop up throughout the main text: witness Koyasan, a once-devastated site of no great archaeological importance, that is a beacon for esoteric Buddhism and boasts priceless works of painting and sculpture.

May we add in conclusion that, just as a haiku conveys a profound message in only seventeen syllables, the meaning of this book will lie in what it suggests as much as in what it says.

DANIELLE AND VADIME ELISSEEFF

PART ONE:
PATHS TO JAPANESE ART

1. ACROSS THE CENTURIES

1. ACROSS THE CENTURIES

JAPANESE civilization began its research into decoration, actually its concern for beauty, during the Neolithic period with Jōmon or "cord-pattern" pottery. A rich, diverse group of objects gained in complexity between the middle of the second millennium B.C. and the 3rd century B.C; Jōmon pottery is our most reliable guidepost in understanding the evolution and interaction of the numerous little hunting and fishing societies then inhabiting the archipelago (figs. 14, 27, 177–84).

Depending on the time and place, makers of Jōmon pottery utilized various decorative techniques, from impressions with cords or braids and rocker-stamping to incising with sticks and combs; rolls or pieces of clay were applied, which could be incised, carved, scraped, or smoothed. This ware in coiled technique was left unpainted; later, under the influence of lacquered basketwork and woods from China, the only known painted specimens appear in Tōhoku (northeastern Honshū). By that time, however, the advent of writing had swept western Japan into the mainstream of history, and its peoples had mastered a gamut of highly sophisticated techniques.

The forms of Jōmon pottery over the centuries were derived from the uses to which these objects were put as well as from the potters' skill. Proto-Jōmon ware, produced throughout Japan, is characterized by pointed bottoms that could be set in the ground; flat, circular undersides typify the subsequent Early Jōmon phase, which first appeared in southern Hokkaidō and northern Tōhoku. Vessels of the Middle Jōmon period have high, uneven rims, the necks and handles swelling into voluminous protuberances that are elegant but no longer in any way functional. Late and Recent Jōmon include a wide range of forms that answered a number of specific domestic and ritual needs; these objects show an appreciable influence of Chinese bronzes from the Shang (15th–12th centuries B.C.) and Chou periods (12th–7th centuries B.C.). As time passed, the uneven development of agriculture left in its wake a number of increasingly diverse regional variants, but by the 4th and 3rd centuries B.C. these, too, had begun to disappear. The metalworking, rice-growing Bronze Age influx known as the Yayoi civilization gradually drove Jōmon pottery types further north.

Although Japanese art lovers rightly stress the formal and decorative originality

of Jōmon pottery, this corded, combed, and stamped pottery has been found elsewhere, in China, in Siberia, and indeed throughout northern Eurasia. At the same time, the antiquity of materials discovered at a number of sites—for example, Natsushima (Chiba Prefecture) and Fukui (Nagasaki Prefecture)—support the hypothesis that Japan might have been a center of creativity. The issue of originality is not limited to Jōmon pottery, nor even to the archipelago as a whole, but involves the entire history of ancient ceramic art in Eurasia.

The argument in favor of Japanese creativity is also supported by the astonishing male and, more commonly, female statuettes known as *dogū*, whose rounded contours and bulging, single-slit eyes suggest a link with civilizations of the Arctic. They are striking above all for their expressive character: already Japan was striving to give faces to its deities, who otherwise remain mysterious (figs. 27, 182–84).

THE second great development in the course of "prehistoric" Japanese art was the so-called Yayoi culture, named for the section of Tokyo where evidence of its existence was first discovered. Traditionally, this period extends from the 3rd century B.C. to the 4th century A.D., subdivided into Early, Middle, and Late periods of approximately two centuries each. Here again, the evolution of pottery provides the most complete chronological data. The invention of the potter's wheel enabled Yayoi artisans to create a new type of large, thin-walled vessel, usually left unpainted (fig. 185). The forms became simple again, and decoration was geometrical and incised only. The ceramic output provided archaeologists with entire sets of pottery types, but Yayoi civilization also affected Japan through two momentous technological changes: the use of bronze, and the introduction of advanced agricultural practices, in particular the cultivation of rice in irrigated fields, a technique probably originating in central and southern China before those regions became linked politically and culturally to the kingdoms of the Central Plain. Japan's geographical remoteness from the mainland accounts for one curious phenomenon: even while—in some cases, well before—Japan was "importing" from China and Korea the basic techniques of bronzeworking, it was already receiving the rudiments of Iron Age culture, as attested by tools found in tombs in the Kansai region (see p. 515).

Apparently, quantities of these bronze imports, especially spears and mirrors, had begun to arrive from the mainland, but the major importation came in the 3rd century B.C. (end of the Warring States period in China), which marked the starting point for Japan's skillful metalworking tradition. One can appreciate the sheer volume of this influx from China by noting that, to compensate for the absence of mineral ores they did not yet know how to mine from the earth, the Japanese artisans first melted down the imported objects and fashioned them into new ones. These were imitations, to be sure, but there were also a number of original pieces, the most innovative of which were paddle-shaped spears (*dōken, dōboko*) and clapperless bells (*dōtaku*) (fig. 20). We do not know the use of these objects, and, for lack of a better explanation, we ascribe to them moral, social, ritualistic, or magical significance.

34

From the archaeologist's point of view, the most intriguing thing about these bronze objects is that, with some exceptions, they occur almost entirely within two well-defined zones. The paddle-shaped spears have been found on Kyūshū, especially in the northern reaches of the island, while the bells come only from the central region of Honshū known as Kinki. Chronologically speaking, it has not been possible to establish any consistent connection between the two zones, and it seems reasonable to conclude that both Kyūshū and Kinki had by this time emerged as powerful hubs of civilizing influence. Chinese dynastic histories (the *Wei-shu*) tell of a great Japanese shaman-queen named Pimiho, who lived around the middle of the 3rd century A.D., perhaps on Kyūshū. But Kinki was doubtless the more prosperous of the two regions, and toward the end of the century it achieved a certain preeminence as the pace of borrowing from Korea and urban China steadily increased.

The Iron Age witnessed the emergence of powerful warrior clans in the farming communities of Japan, clans that materialize before our eyes in the rusted remains of weapons and armor in the great burial mounds from the early 4th century to the mid-7th century, a span of almost 400 years. But by the second half of the 6th century—fully a hundred years before the Iron Age ended—the tenets of Chinese Buddhism were starting to overspread the archipelago, and with them the old tribal system of Japan took on the legalistic veneer of Chinese-style centralized administration. In all probability, this did not come about by accident: at this time the Chinese empire—dismembered since the fall of the Han dynasty in 220 A.D., beset by barbarian incursions, and deeply shaken by internal unrest—re-emerged under the unified Sui dynasty (581–618), followed by that of the Tang (618–907).

THAT China was an important cultural source for Japan was nothing new. But Buddhism, more than any other factor, introduced a new era in Japan's artistic activity. Materials and techniques would change, but this time within the framework of a particular vision of space that expressed a complex philosophy hitherto unknown to human history. How was this new concept received? Variously, it would seem, according to the vagaries of the bellicose but lasting relationship then existing between the fledgling court of the Yamato basin and the Three Kingdoms of the Korean peninsula: Koguryō, Paekche, and Silla. The reunification of China substantially affected its immediate neighbors, bringing them closer into the shadow of the home continent of the monks and teachers of the Buddhist Law. Japan, for its part, reciprocated by sending over a succession of missions, beginning in the reign of Empress Suiko (r. 592–628) and continuing despite the frequency of shipwrecks in the Japan and East China seas.

As we shall see, the sculpture of the Asuka period bears witness to the astounding number of paths along which Chinese culture was relayed to Japan at this moment in history. Styles from northern and southern China as well as northern and southern Korea inundated the Japanese archipelago with a vast amount of knowledge about techniques and artistic approaches, all related, but differing slightly in significant ways. Unprecedented in the history of Japanese civilization, however, was the fact that foreign

artists now accompanied their works to the shores of Japan. We know that in 577, for example, a certain architect from Paekche used his skill to build temples and monastery complexes, and that shortly the celebrated Tori family of China placed their talent as "masters of Buddhist images" (*busshi*) at the disposal of Empress Suiko. These were the people the Japanese called *kikajin*, usually translated today as "immigrants" or "naturalized," words that evoke the difficulties experienced by uprooted persons on foreign soil, such as being rejected by the very groups they are trying to join. Actually, if we go back to the original sense of the characters used to describe them, we find there a quite different symbolical meaning: "those who brought civilization."

To these émigrés the gifted artisan families of Japan traced their beginnings. Little is known about these families, except that Japanese emperors ennobled them and that, as they worked in their nameless studios and workshops, they perpetuated more than once certain skills and techniques that might have died out and vanished forever in China; these found in Japan a fertile ground for new and often dazzling achievements.

The enormous effort to assimilate knowledge from the mainland was supported by the government for hundreds of years, from the Taika reform of 645–46, which made the legal and institutional framework of China an integral part of Japanese life, to the end of the 9th century. The Nara period (8th century) stands out as the most balanced phase of a Sino-Japanese culture that was steeped in religious thought. What is perhaps most startling about the Nara phenomenon is that it came into being with no struggle save that for a better society, a more advanced way of looking at the world. Neither China nor Korea actually invaded Japan, but they had no need to do so; their influence proved so irresistible that the archipelago ended by openly welcoming the new culture they exemplified. Urban planning, legal codes, land distribution, the concept of property, the idea of sovereignty itself and of political or administrative authority—all these were copied from China. The roots of this transplanted political system were to sink deep into Japanese soil and to affect incalculably the nation's future. The intense movement toward centralization not only brought to a halt the fragmentation wreaked by Iron Age warrior clans, but later concentrated the wealth—that is, the means of production—into the hands of those who wielded authority: the court, as the official wellspring of all political and administrative power, and the major temples, which safeguarded the purity of a doctrine that the local population did not yet fully understand.

This concentration of moral and material resources also spelled unity, and beginning with the 8th century, one can speak in terms of truly "Japanese" art, even if it was indebted to China as the French school of Fontainebleau was indebted to Renaissance Italy. Artistic currents within Japan took on more than one form in response to various social or religious climates, but gone was now the heavy layer of regionalism that, despite cultural bypaths and interaction, had marked all the products and, in a wider sense, the civilizations of the previous centuries.

Faced with this broad picture, a number of art historians tend to adopt a somewhat accusatory attitude toward Japanese art, seeing throughout its evolution a persistent tendency to imitation. There was certainly no single technique from the mainland

that Japanese artisans did not immediately seize upon, quickly master, and exploit in order to fashion their own bronze, lacquered, and especially clay objects: witness the softly colored pottery reminiscent of various Yue ceramics in China, or the "three-color" glazed funerary urns (*sansai*) which art lovers today consider the crowning glory of Tang craftsmanship. Close examination of Chinese and Japanese pieces will reveal, however, that in many cases the island "pupils" outstripped their mainland teachers or, starting with a similar technique, devised their own way of using it. This will become increasingly apparent in the pages to come.

In 896, the winds of change seemed to sweep everywhere over Japan. A certain minister, later almost deified, named Sugawara-no-Michizane (845–903), instituted in what looked like personal intransigence, but was deep wisdom, a so-called closed-door policy; it proved to be a judicious decision, apparently aimed primarily at husbanding domestic resources. For two hundred years the Japanese had been dispatching large official missions and small ships toward mighty China; pilgrims and monks had also rushed forth in search of practical knowledge and spiritual enlightenment that might breathe new vigor into the life of their homeland. But one out of every two of their rudimentary vessels, by some accounts, foundered in the ocean swells, and their reception by the emperor of China, whether they were princes or men of faith, was as simpletons or tribute-bearing barbarians. Michizane's policy, in addition to reflecting a sudden rise of national consciousness, showed justifiable concern about the irrational enthusiasm that was sacrificing the cream of Japan's human and material resources to the sea gods. The Japanese, despite their peripheral location, may also have sensed the irreversible decline into which the stupendous Tang empire was drifting in the late 9th century, though the trend was unnoticed by contemporary travelers such as the monk Ennin, who spent nine years visiting the renowned Buddhist temples in China. But the extreme poverty of the Chinese people would not easily have been seen from abroad, and a number of decisions being made in China at the time must have seemed incomprehensible to the Japanese, caught up as they were in the zeal of their newly acquired faith: how could they account for, much less accept, the series of harsh decrees within China (845), aimed at suppressing "alien" religions and institutions? To be sure, the secular power of monasteries had, as far back as the 8th century, also created thorny problems for the Japanese, and it was to break their stranglehold that the emperor had quitted his radiant capital of Nara and, after a few years of uncertainty, settled in 794 at the site of Heian-Kyo, now Kyoto. In Japan, however, the stakes of such disputes always concerned material, political, or ritualistic issues; matters of doctrine were not part of the picture, of pure faith even less so. We may assume that henceforth a two-fold sentiment prevailed: on the one hand, the Japanese rulers felt duty-bound to preserve the heritage that seemed to be vanishing on the mainland, and on the other, the Japanese nation was undoubtedly taking stock of its own strength. The stage was set for the emergence of the magnificent Heian culture (9th–11th centuries), named after the new capital.

Theoretically, at least, the political structure did not change except that power-

ful religious groups were now excluded from political activity. At the outset, the emperor's decision to transfer his residence and the seat of administration seemed to spell a return to balance within the body politic, a balance that had been disturbed by the attempt of the monk Dōkyō (d. 772) to usurp the throne. But in point of fact the Heian era may rather be characterized as the era that witnessed the irrevocable collapse of the Chinese political model in Japan. Paradoxically, this occurred just when Chinese culture and literature were flourishing at court as never before, thanks in part to the founding of prestigious schools at this time to educate royal children (the Kangaku-in for the Fujiwara family, the Gakkan-in for the Tachibana family, and the Shōgaku-in for the Ariwara clan).

But circumstances decreed that this wealth of foreign learning be restricted to a relatively small group of individuals who had mastered the arts of the brush. Within this cultivated circle one influential current, fostered primarily by women of the aristocratic class, struck out on its own path of literary self-expression. Their favorite themes were lyrical, their vehicle a transcription of pure spoken Japanese. The same attitude toward mainland "imports" was taking shape among painters, too: in time they ventured upon new compositions that reflected more of the natural configurations of the Japanese landscape.

At the same time the effects of religion on the people, and no longer only on the aristocracy, triggered another social upheaval, one that would long nourish a new strain of artistic expression. Soon after the imperial court settled in Kyoto two monks, Saichō (767–822) and Kūkai (774–835), returned from their respective sojourns in China, each bringing a religious doctrine that was enjoying tremendous popularity on the mainland but was not yet known among the intellectual Buddhists of Nara.

These two schools of thought, both introduced in 806, were known as *T'ien-t'ai* (*Tendai* in Japanese) and *Chen-yen* (*Shingon* in Japanese). The seminal text of T'ien-t'ai— a complex synthesis of the mysticism espoused by the philosophical schools of southern China and the harsh discipline practiced by the monastic orders of northern China— was the *Saddharma Pundarika Sutra* (*Hokke-kyō* in Japanese), or *Lotus Sutra*, which, according to tradition, was the last to be preached by the Buddha. Chen-yen or Shingon stressed the power of the cosmic forces that surround us and the need for the worshiper to master the "correct formulas" in communicating with these forces, to release selectively the most beneficent among them. Through Shingon, Japan was first exposed to what people generally refer to as "esoteric Buddhism," but Japanese historians today assign to this term a much broader meaning that encompasses Tendai as well, thereby underscoring the common characteristics of the two new arrivals: a strong undercurrent of mysticism, even magic, resulting in symbols that were often perplexing and alien to the uninitiated; the importance accorded to the word and to the intervention of all the faithful, even the lowliest among them, whose thoughts must be aroused and nourished by simple, touching images; a marked tendency to assimilate local Shinto ideas and treat them as a first stage of revelation; and a taste for withdraw al far from the tumult of the cities, which brought about a new emphasis on the individual and on the conversion of the rural population.

For Japanese society, this phenomenon spelled out a broader indoctrination of the masses just when a growing number of communities were being incorporated into the empire. In 801, General Sakanoue-no-Tamuramaro (758–811) extended government control once and for all over northeastern Japan, a region where the so-called Ezo peoples of Hokkaidō, still locked in a neolithic pattern of hunting and fishing, periodically attempted forays into state-dominated areas.

Thus the 9th century was of paramount importance in Japan's social and intellectual history, for it witnessed profound changes in religion and government. Now we see all too clearly that the court was paving the way for the erosion of its power by bringing more territory under its sway. An elaborate Chinese-style administrative structure could not be thrust upon regions unprepared for it, and the tendency was to resort to a new kind of land tenure that was already enjoyed by certain communities or the descendants of important families. This system of lands, called *shōen*, consisted of tax-exempt rice fields granted by the emperor on a selective basis to persons of rank or to temples, a separate practice from the traditional Chinese land-distribution system.

In China, the practice was to allocate to each individual two parcels of land, one of these to be hereditary, the other to revert to public use when old age or death prevented the owner from farming it. Periodically parcels of tenured land were reassigned, to permit everyone to enjoy a fertile share of the earth at least once during his lifetime, and thereby compensate for any inequities of the original allotment. On paper, such was the even-handed system that Chinese men of letters had dreamt of for centuries, and the Chinese government tried more than once to turn it into a reality, notably during the Tang dynasty (618–907). But these efforts invariably ended in the monopolizing of lands, *de facto* if not *de jure*, by those in possession of capital.

In Japan, the system led to the same results, though along simpler avenues. All those obtaining tax-exempt land-grants—sons of noble descent compelled to leave the family home, selected generals or civil servants in compensation for services rendered, leaders of religious communities, ordinary farmers willing to clear unexplored land— not only did not pay taxes, but they and their descendants simply converted the improved tracts into their permanent holdings. The fact that these lands belonged to the government was quickly dismissed as a purely theoretical consideration; within less than a century, private property had become a *de facto* institution. Given the weakness of an emperor whose authority was more spiritual than political, Japan seemed ready to forge the mechanism that would bring about much physical suffering, but that also proved an undeniable source of moral and intellectual vigor: feudal society.

The process was slow, and Japan was not to feel its full impact until the end of the 12th century. In the intervening four hundred years, a handful of families of ancient imperial origin took hold of the actual reins of power, whether allowed by law to do so or not. First came the mighty Fujiwara, whose daughters married emperors and thereby cemented the bond between their clan and the imperial bloodline, followed by the Taira and the Minamoto, less cultivated aristocrats who had gained prominence in the provinces. The imperial incumbents, on their part, devised a subtle game: an emperor, by effacing himself through official abdication, could tighten his grip on the

political world and manipulate it more easily from behind the scenes. Thus was born *insei*, or "government of the cloistered emperors," a practice which, for a century, from its inception in 1086 to the end of the Heian period in 1185, helped to curb the fierce antagonisms that threatened to mire families and provincial factions ever more deeply in fratricidal war.

Such were the political ramifications of "withdrawal," a practice that was to play a crucial role in the history of Japanese civilization. At its roots lay a Taoist concept handed down from ancient China: it is in the void of Heaven that the creative union of male and female forces takes place, and thus withdrawal, absence, and emptiness were not seen as negative elements. In the plastic arts, empty space would always represent not only the indispensable counterpart of physical presence, but the open door to endless possibilities of the unformed, far from the decisive, partly destructive choice that brings specific form into being.

By the end of the 12th century, Japan found herself divided into a western region (Kansai) devastated by warring clans and an eastern region (Kantō) which enjoyed relative calm and prosperity along with deep social instability. The aristocratic civil servants attached to the court lived in one world, while the younger sons and other blood relatives of the court formed a rival faction within the capital itself. Consumed with ambition and served by "clients" born too humbly to hope for any kind of promotion, these malcontents despaired of upward movement through an administrative hierarchy held for centuries by senior branches, and they swelled the ranks of troops maintained by more affluent "outsiders." Residents of 11th- and 12th-century Kyoto learned the bitter meaning of the power struggle that ensued as they saw their houses burned to ashes by the murderous onslaughts of contending groups.

During that time other warrior clans were also flexing their muscles far to the east of the capital and on more stable social and economic bases. The prizes coveted and fought over by the Kyoto warriors were a mere appointment, sinecure, advantageous marriage, or the chance to gain influence. But the paladins of the outlying regions were cultivating new rice fields and tapping wealth from the mines and the sea, and their vassal troops, whom they knew personally, were kept in hand through an almost monastic discipline.

The final victory of the Minamoto over the Taira clan at the dramatic naval battle of Dan-no-ura (1185) assured their accession to power and ushered in the Kamakura regime (late 12th–14th centuries). Their mission, as they saw it, was to restore social and economic order; moral and religious direction was to be left to the revered person of the emperor. They styled themselves *shōgun*, or "general-in-chief," borrowing a title created in 801 for Sakanoue-no-Tamuramaro.

A pause at Kamakura, despite time's toll upon the site, will give us some sense of the Minamoto shōguns' vitality. Here, where Minamoto-no-Yoritomo (1147–1199) had been exiled as a boy and where his famous ancestor Yoriyoshi (995–1082) had lived, Yoritomo established in 1190 the center of what he referred to as his "barracks

government" (*bakufu*), a term he hoped would dispel any doubts about his military efficiency and his resolve to govern in an assertive, straightforward manner. His aim was to underscore his break with his aristocratic predecessors, whose language bristled with archaic allusions that muddled affairs of state into inaction.

Geographically, Kamakura is an intriguing site: a fertile rim of land thrust upward along the sea in a series of wavy, mountainous crests that are honeycombed with connecting caves; something about its appearance suggests a molehill. In addition to the "Young Palace" (*Wakamiya*), Kamakura boasted a large Shinto shrine (fig. 55) dedicated to the war god Hachiman, tutelary deity of the Minamoto family.

Craftsmen flourished in Kamakura, and the city soon became home to seven different corporative families (*za*) grouped by districts. Prestigious guilds of talented carpenters and silkmakers helped to create the city's reputation as a second capital of Japan, but rice merchants, dried-fish manufacturers, and other tradesmen also played their part. The carpenters and joiners seemed to be the real masters of Kamakura, for a bustling port nearby provided anchorage for ships arriving from or bound for China. When times were good, the docks may have teemed with some seven hundred craft, many bearing the breathtaking Song celadon ware that made up the vast bulk of Chinese trade at the time.

Economic activity was not the only field in which Kamakura tried to rival the cities of Kansai. Through her efforts, all of eastern Japan strived to demonstrate the value of its culture, a movement so vigorous that it could even withstand disputes over shogunal succession. Upon the death of Yoritomo in 1199, a strange turn of events made the shōguns themselves subject to the *insei*, or "secluded master" system: the real power now devolved to the regent or *shikken*, a position sometimes filled by descendants of the Fujiwara clan, but more often by the Hōjō family, who were related to the Taira. Kyoto cast its spell over these new overlords, and they decided to settle there, in the heart of ancient Japan, but Kamakura continued to enjoy, if not a supremacy believed dangerous to their designs, at least a degree of moral authority rooted in ancient, almost magical beginnings. Had not Kamakura been the home since time immemorial of the *tsuru*, the graceful cranes that symbolize good fortune throughout the Far East? Temples mushroomed at the end of Sagami Bay, centers of learning devoted to the study of what the Chinese called Ch'an, the Japanese, Zen. Five of these sanctuaries reached such intellectual heights that, in the second half of the 14th century, they were proclaimed the five finest in Kantō, a reflection of the widespread admiration in the capital for the "Five Mountains" (*Gōsan*) of the budding Zen school of thought. This rational, but activist and non-literary, philosophy was well suited to the life and tastes of the multi-talented warriors destined to construct modern Japan.

Lest Kamakura's immense wealth during these decades be doubted, one need only point to the great bronze statue of Buddha (1252), which still towers eleven meters high over the site, undaunted by and seemingly immune to every catastrophe visited upon it (fig. 56). No effigy on this scale had been attempted since the Nara period, doubtless for religious reasons, but mainly for reduced material circumstances. It is intriguing that in far-off Kantō should be found the necessary conditions to create an im-

posing statue in the "old style"; this meant that mining had been resumed on a large scale, and that a marked tendency had developed to emulate the vitality of the founders of Nara (see fig. 49).

Today, this strange image is a tourist attraction for a curious and indifferent public; but the Great Buddha of Kamakura, though hardly a masterpiece of delicacy, is nevertheless a marvelous demonstration of the provincial forces during the so-called Kamakura period, yearning for bulk and solidity, for a return to the golden age of Nara and its Sinophile culture, and for the rejection, in favor of realism, of the somewhat frivolous refinement of Heian art.

THIS stable period of direct feudal command was, however, short-lived. The descendants of Yoritomo soon found themselves replaced by the Hōjō clan, which favored a permanent return to Kyoto. Provincial clans considered themselves abandoned once again or, even more dangerous, left to their own devices; their successes seemed meaningless, despite the exhortations of Nichiren (1222–1282), who moved to Kamakura in 1253 and placed his life in jeopardy by preaching the rearmament of ancient Japan.

A threat to the archipelago from beyond its shores—an unprecedented event—served to galvanize for a time the nation's energies: invasions by the Mongols in 1274 and 1281. These failed despite the Mongols' more sophisticated weaponry, including a small, grenade-like flying bomb that the Chinese had experimented with during the Song dynasty (10th–13th centuries). The only Japanese defense, apart from a low cyclopean wall along the coast of northern Kyūshū, was their warriors' impressive panoply, lightweight when used as cavalry gear, but cumbersome in action against the foot soldiers landing from the Mongol ships. Probably the mounted warriors of Japan realized at this moment how obsolete was their weaponry and how antiquated the impressive, but needlessly suicidal behavior of their generals, who by tradition moved onto the battlefield in full armor, mounted on heavily armored steeds. With oriflammes flapping in the wind and helmets glistening with their *mon*, or family crest, the officers filed slowly by, reciting the genealogies of the gallant ancestors whose blood coursed through their veins. The code of knighthood prescribed that with terrible cries they would challenge the enemy generals to take up a similar position so that they might engage in hand-to-hand combat, but a crossbow or exploding cannonball would cut down the Japanese warrior abruptly, before he had a chance to fight. The well-equipped aggressors would probably have gained a foothold on Japanese soil had the Mongol armada not been decimated in 1281 by a "divine wind" (*kamikaze*).

From this strange victory the Japanese drew a number of lessons that would loom large in the future of their nation. They found it necessary to reevaluate completely not only their weaponry, but their concepts of a war leader and his role in battle, and of the military profession itself, which is the warrior's life. But they also marveled at how, at the last moment, heaven had saved Japan from an invasion which by all odds should have vanquished them. From then on, the "gods of Japan" were accredited with the power to shield the archipelago from the entire world. As for the troops who

had won with hardly a fight but had nothing to show for their victory—no land, no booty, no gain—an unspoken, festering resentment was now added to their haughty self-confidence and yearning for change. In this resentment lay the seeds of the catastrophic events that would steep Japan in blood for three centuries and doubtless affected its history more than the tumultuous developments within the government: the attempt in 1330 of Emperor Go-Daigo to regain political power; the triumph of the Ashikaga family over the Hōjō "regents" and its accession to the shogunate in 1338; the schism within the imperial dynasty that remained unsettled until 1392, so that Japan was ruled for half a century by a "Northern Dynasty" and a "Southern Dynasty."

The Ashikaga, who resided in the Muromachi district of Kyoto, were unable to control their vassals as the Minamoto did. Their feudal organism was shattered into numerous cells; beset by difficulties that disrupted the chain of command, the Ashikaga system fell into perpetual instability, resulting in widespread confusion and the ruthless triumph of "might makes right." Those holding the official reins of power took refuge in diminutive, but no less genuine paradises of their own; in these fairytale estates they tried to forget the battles raging in the heart of Kyoto and the uprisings of poverty-stricken peasants. This age of mingled refinement and barbarity brought Japan to the verge of economic and social collapse, but within monasteries and palace compounds it also witnessed a surge of intense religious and intellectual activity, an age obsessed with a literary-inspired aestheticism. There was the Kitayama culture of the late 14th century, centered around the Golden Pavilion (1394; figs. 717–18) of Ashikaga Yoshimitsu (1358–1408); the "Five Mountains" (Gosan) literary movement, which had as its hub Nanzenji, the great Zen temple in southeastern Kyoto (figs. 706–7); and the Higashimaya culture that flourished in the late 15th century at the Silver Pavilion (1479; figs. 687–90) of Ashikaga Yoshimasa (1435–1490). Around the middle of this century the Nō theater, that noble exchange of poetic discourse between the living, the dead, and the divine, also reached its zenith.

But an endless succession of revolts brought an end to this miraculous efflorescence of culture. For whatever cause—even allowing for an occasional justified or defensive war—the revolts invariably spelled devastation that spawned further devastation in a diabolical cycle of feuds. Only adventurers and profiteers emerged from this situation better off than before, and those members of the decaying country nobility who seized the opportunity to drive out any and all representatives of authority. The people, for their part, remarked bitterly that "those on top are being overturned by those below" (gekokujō).

This frenzied mechanism perhaps came to a halt of its own accord, but mention should be made of an apparently inconsequential event: the arrival of the Portuguese at Tanegashima in southern Kyūshū in 1543, followed six years later by a ship bearing Jesuit priests, including the future St. Francis Xavier. This complex encounter concerned art as well as civilization, and we shall return to that in a later chapter. But one fact is certain: amid a conflict both gruesome and tragic, which seemed to be becoming interminable and even routine, the appearance of the foreigners—a small, comical contingent, but full of initiative and equipped with wondrous ships—must have

had a greater impact than is generally thought. The Europeans brought with them new devices such as the fuse musket that were sometimes devastating in their effects, but useful to those who understood their operation. At the same time they offered what people everywhere yearn for, an explanation of the world, and especially of death, always so close at hand; in their words this became the hope for eternal life. But it was in the long run that the foreigners had their most important effect, for these men from the other side of the globe—peaceable now though no less aggressive in commercial and intellectual matters—sparked in Japan a nationwide reaction. In this sense the adventurers, merchants, and missionaries from abroad may have simplified the task of the three dictators who, despite an abortive invasion of Korea, turned Japan into a powerful, centralized state in the short space of fifty years: Oda Nobunaga (1534–1582), Toyotomi Hideyoshi (1536–1598), and Tokugawa Ieyasu (1542–1616).

It was late in the 16th century, at a time known to the world of arts and letters as the Momoyama, or "Peach Hill" civilization (from the site of the castle that Oda Nobunaga built at Azuchi), that Japan rose again from the ashes. Its people agreed to lay down their arms and accept the authoritarian establishment of social classes according to birth; the warrior-monks who had long held Kyoto and the surrounding region in deadly fear were now sent off to pray. The government chartered ships for the express purpose of conducting peaceful foreign trade, renouncing its connection with international pirates that had abraded the relations between Ming China and Kyoto. When Tokugawa Ieyasu, the last of the great dictators, triumphed over the supporters and descendants of his predecessors at the battle of Sekigahara on October 21, 1600, he founded a new line of shōguns that was to last almost three centuries. Their iron-fisted regime was marked by blind, excessive xenophobia and flagrant miscarriages of justice, but from their headquarters in the castle at Edo (modern Tokyo), they transformed the whole of Japan into the richest economic power in the Far East, especially from the 18th century on.

The Tokugawa family held China in high esteem and the mainland again exerted its cultural presence, but not through monks and artisans; this time it was imposed from above in as cerebral and bureaucratic a form as during the Asuka period long before. Throughout Japan every type of society—guilds and markets, rural communities and military "households," Buddhist temples and Shinto shrines—bowed to sweeping regulations enforced by the feudal lords, now promoted to civil servants. Beginning in 1615, a series of directives known as the *bukeshohatto* forced the old military nobility to comply with strict rules of discipline, on pain of death, banishment, or confiscation of property. This mandatory submission to the state—in effect, an authoritarian code of personal conduct—was designed to forestall those earlier bursts of excessive energy and ambition. To families such as the Hayashi was entrusted the office of censor, a measure thought necessary to the nation's moral and political stability.

What paths were open to art, given such a climate? Probably a greater number than those art lovers who care only for older Japanese art are willing to admit. For

peace enriched the cities despite, or at the expense of, the impoverishment of rural areas. The flourishing of urban society, the overall growth in production, the development of a money-based economy, the fledgling industrial groups formed in the late 17th century, the requirement that all *daimyō* maintain a residence in Edo and that all *samurai* observe a strict code of conduct—all of these conditions fostered the growth of crafts. Makers of weapons and armor, building contractors, gilders, lacquerers, toolers, weavers, dyers, to name only the most numerous, were kept busy as never before. Raw materials were actively sought throughout the archipelago, and with such discoveries of mineral ores as the copper lodes at Besshi, in Ehime Prefecture, mining proceeded rapidly.

Sources of inspiration renewed themselves to a certain extent. In the late 16th and early 17th centuries, before misunderstanding and mutual contempt soured relations between the Japanese and the Europeans, what Japanese art lovers there were waxed enthusiastic over foreign styles. Chinese and European fabrics were much desired for kimonos, and embroiderers made copies in gold and silver thread of the tracery and floral designs adorning the vestments of European priests. The Portuguese, in return for copper and silver ingots, imported Chinese goods of all kinds which they brought in relatively large quantities together with their own goods: books, paintings, porcelains, fine silks, pharmaceuticals, even gold.

At this cultural crossroads we sometimes catch sight of certain individuals who would go unnoticed except for objects that give us insight into their lives. To take the example of Ryūtatsu (1527–1611), a pharmacist at the port of Sakai in the 1560s (the pharmacists' guild, always hoping to learn new prescriptions and remedies, welcomed foreigners): who would have believed that this simple apothecary, by singing his favorite songs to the accompaniment of a *samisen*, the three-stringed mandolin he had brought with him from the Ryūkyū Islands, would revolutionize the life of the pleasure districts all over Japan?

But for those on the lowest rungs of society, especially the peasants, times were hard, for the government, beginning with the Tokugawa shogunate, siphoned off sixty to ninety-eight percent of their harvests. Confucian to the core, Tokugawa Ieyasu (1542–1616) regarded the peasants as mere production units forming the economic bedrock of the state. "Peasants must not have a moment's rest," he declared. "They must clear land in the morning, work the fields during the day, braid ropes and weave straw baskets at night. They may drink neither *sake* nor tea. They must not eat too much rice; millet instead. Women must weave late into the night, and those who refuse to do so should be driven from their homes. They must all refrain from smoking."

Much more might be said about the social history of Tokugawa Japan, for it is against this background that we must examine and assess the astounding crafts created during the so-called Edo period. Colors, for example, now enlivened the clothing of the well-to-do with such abandon that sumptuary laws were required to control them. People paid little heed to these regulations, by and large, and the workers who gathered and processed dye plants continued their long and grimy labors. It is characteristic of the new

attitude toward civilian enterprise that the *daimyō* now turned their attention to dye-stuffs, seeing in them both a profit and the source for an essential element of their finery. The cultivation of indigo, in particular, which furnished blue dye for the clothing of pageboy and farm laborer alike, formed the basis of a full-blown chain of production, especially in the Osaka region. By the end of the 19th century, some 50,000 hectares of Japanese soil (about 123,750 acres) were being used for the cultivation of the indigo plant (*Polygonum tinctorium*).

Indigo dye is an example of an apparently simple product that requires many tedious processes to obtain it. In early spring, young indigo shoots were transplanted from seedbed to field, where they matured in summer. The harvested leaves were soaked for hours in wooden vats of hot water and then beaten at length with wooden paddles to release a dark color through oxidation. The cloth was slowly immersed in the dye bath several times and left to rest for some hours, then rinsed in clean running water—like paper makers, dyers preferred to work near the valley streams among Japan's lower mountains. In the last step the dyed fabric was spread out to dry in the open air.

In theory, this sums up the operation, though there were as many secrets for obtaining a specially vivid or permanent color as there were workshops and masters. One might, for instance, heighten the productivity of the indigo leaves by adding crushed or ground indigo seeds and by using powdered wood, especially oak, as a mordant. Or the thread or fabric could be treated to alter the absorption of the dye. There were countless techniques for distributing the indigo decorations on the fabric, including gathering or pleating the material before or during the dyeing, and applying wax-resist patterns of all sorts.

This is only one illustration of the technical refinement that characterized the Edo period. The growing expertise came as much from local experimentation as from the Chinese example, and Japan itself had now developed into a sizable market. To this was added a factor rarely mentioned: the scientific and technical knowledge from Europe that was relayed to the archipelago by the Dutch, the only foreigners authorized to reside on Japanese territory after 1639 and restricted to the island of De-jima, or Deshima, in Nagasaki harbor, save for an annual visit of tribute to Edo. The Japanese authorities greeted with implacable mistrust any idea that might disrupt the internal stability of the nation—an attitude made official by the 1639 closing of Japan (*sakoku*)—but excuses were always found for being near the Europeans. They observed the foreigners' behavior and, insofar as this was possible, their thoughts; knowledge acquired thus was called *Rangaku*, or "Dutch culture." Despite the climate of official suspicion, *Rangaku* proved an enduring and powerful catalyst of change, and it explains to some extent the extraordinary rapidity of Japan's technological growth after 1868, when the emperor regained power with the Meiji Restoration (*Meiji isshin*).

With the reopening of its doors to the West in 1854, Japan sought in earnest to achieve economic vitality. The archipelago found itself suddenly swept far away from its 18th- and 19th-century world where the most "foreign" art was that of the Chinese-inspired "poet-painters" movement (*bunjinga*), a style of intense idealism and sometimes tedious refinement.

A change of such magnitude could not fail to create a degree of havoc, and Japan has endured this for a full century. A most painful episode was the Meiji government's peremptory suppression of the *samurai,* who, for better or worse, had so long been a part of Japanese society. This measure precipitated tragedies and catastrophes at every level: many artisans, for example, deprived of their clientele, found themselves unemployed, thereby presenting the government with serious moral and social problems. The decree of 1876 prohibiting individuals from carrying swords was disastrous for ironmongers, lacquerers, toolmakers, metal-chasers—for anyone whose work touched the making of the combat and dress swords in which the Edo *samurai* had taken such pride. The artisans who produced regalia for state occasions, also much restricted under the shogunate, were similarly affected.

In a recent article, Hasegawa Sakae examines the calamities provoked by those difficult times, and the ways of survival found by a few ingenious souls. Consider the case of Kanō Natsuo (1828–1898) from Kyoto, talented in the craft of forging sword guards (*tsuba*): with an energetic group of artisan colleagues, he devised a manner of adapting their technical knowledge of metal-chasing to the engraving of medals, and, in a spectacular turnabout of fortune, secured government commissions, first to strike coins, then to set up the entire Japanese monetary system in conjunction with the entry of the Empire into the community of nations. Aside from his own success, Kanō Natsuo obtained the support of foreign-born Japanophiles, notably Gottfried Wagner, for a number of measures and technical improvements that saved many Japanese crafts from oblivion and introduced them into Western markets. The first European view of Japanese products was in London in 1862, followed by Paris in 1867 and 1889, Vienna in 1873, Philadelphia in 1876 and Chicago in 1893, and in all subsequent expositions. Companies for exporting crafts were formed, and for importing Japanese objects, especially through the shops of Samual Bing in Paris and New York. Japanese craftsmen were employed by such Western firms as Tiffany and Company in the 1870s and '80s.

Many workshops that had been disbanded slowly reentered the mainstream of artistic life, and in 1877 a crafts fair was held in Japan. Purists—who perhaps were simply envious—criticized this movement as an effort to curry Western favor, or to concoct an artificial "exposition style." Craftsmen must always face this problem when they find themselves cut off from the purposes that first created the demand for their work.

All Japanese artisans were not as talented or resourceful as Kanō Natsuo, and a number of them swelled the ranks of Japan's budding proletariat. As for the *samurai,* many earned their living as schoolteachers but harbored a desolate feeling of bitterness, seeing themselves as unjustly stripped of their role as moral standard-bearers of the nation.

Thus, Meiji Japan's substantial efforts at self-modernization strangled two classes which, on their respective levels, had always provided the most dynamic elements of Japanese society: the artisans and the warriors. Did the breakup of this thousand-year-old partnership lie behind the frenzied race for arms and military conquest that turned Asia into a bloodbath throughout the first half of the twentieth century?

14 POT WITH CORD-PATTERN DECORATION
Terracotta, height about 50 cm.
Jōmon Period, 2nd millennium B.C.
Musée Guimet, Paris

15 SLABS WITH PAINTED ABSTRACT MOTIFS
Chibusan tomb.
Kofun Period, 3rd–4th century A.D.

16 MEN AND BIRD ON A BOAT
Painting on stone, Mezurashizuka tomb (Fukuoka).
Kofun Period, 3rd–6th century A.D.

17 MAN AND HORSE ON A BOAT
Painting on stone, Takehara tomb (Fukuoka).
Kofun Period, 3rd–4th century A.D.

18 MIRROR WITH CIRCLE SEGMENTS AND STYLIZED
FLORAL MOTIFS
Bronze, diameter 24.8 cm.
4th–9th century A.D.
Munakata Taisha, Okinoshima

19 MIRROR WITH HUNTING SCENES
Bronze, Takasaki (Gumma), diameter 18.2 cm.
Kofun Period, 3rd–6th century A.D.
Tokyo National Museum

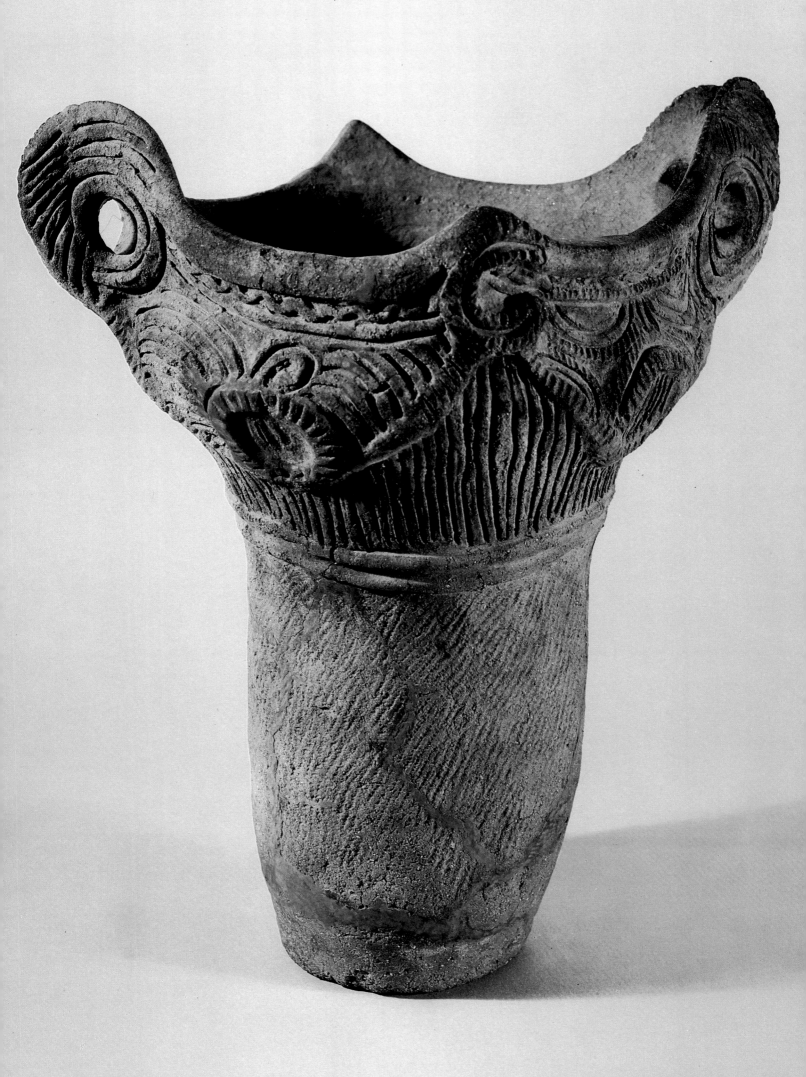

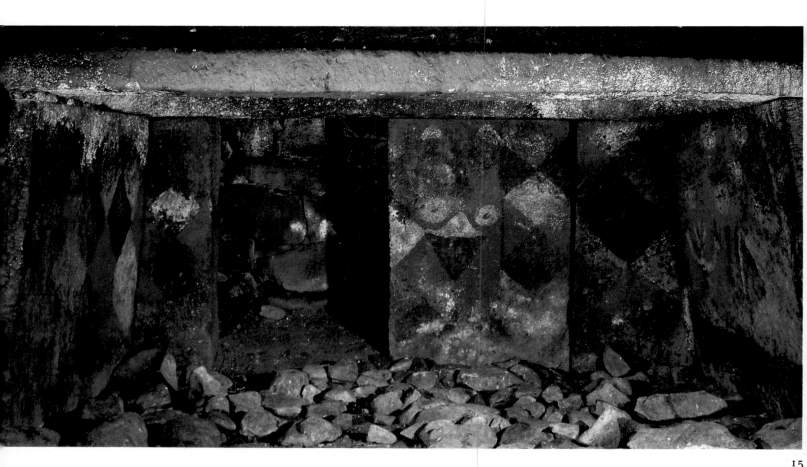

15

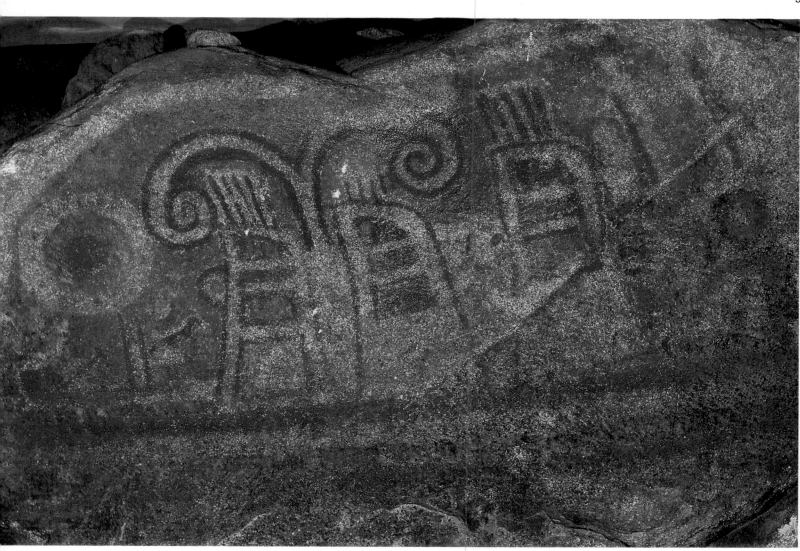

16

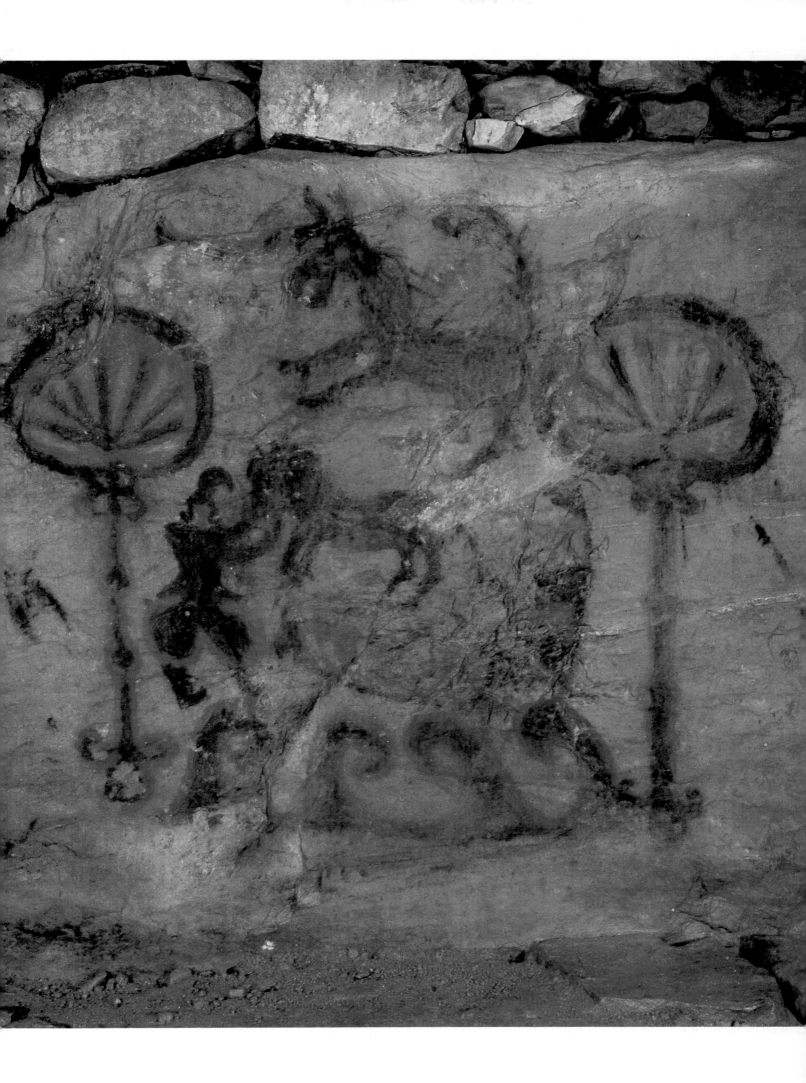

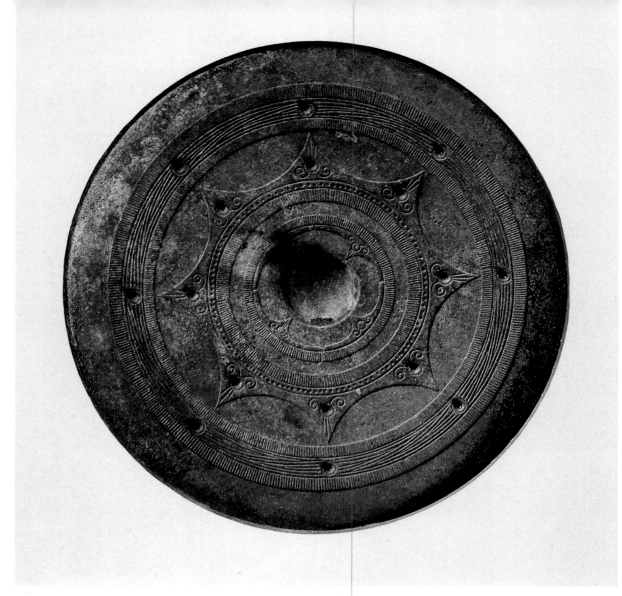

18

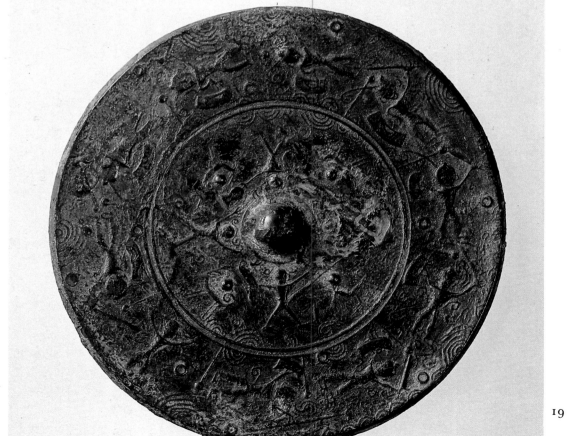

19

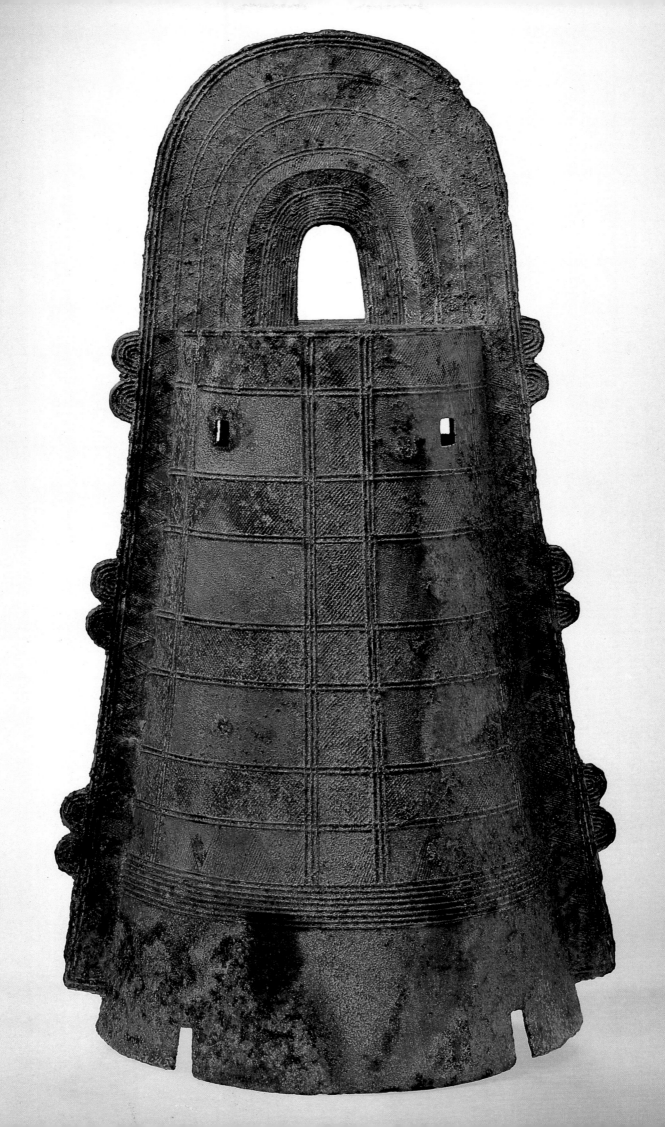

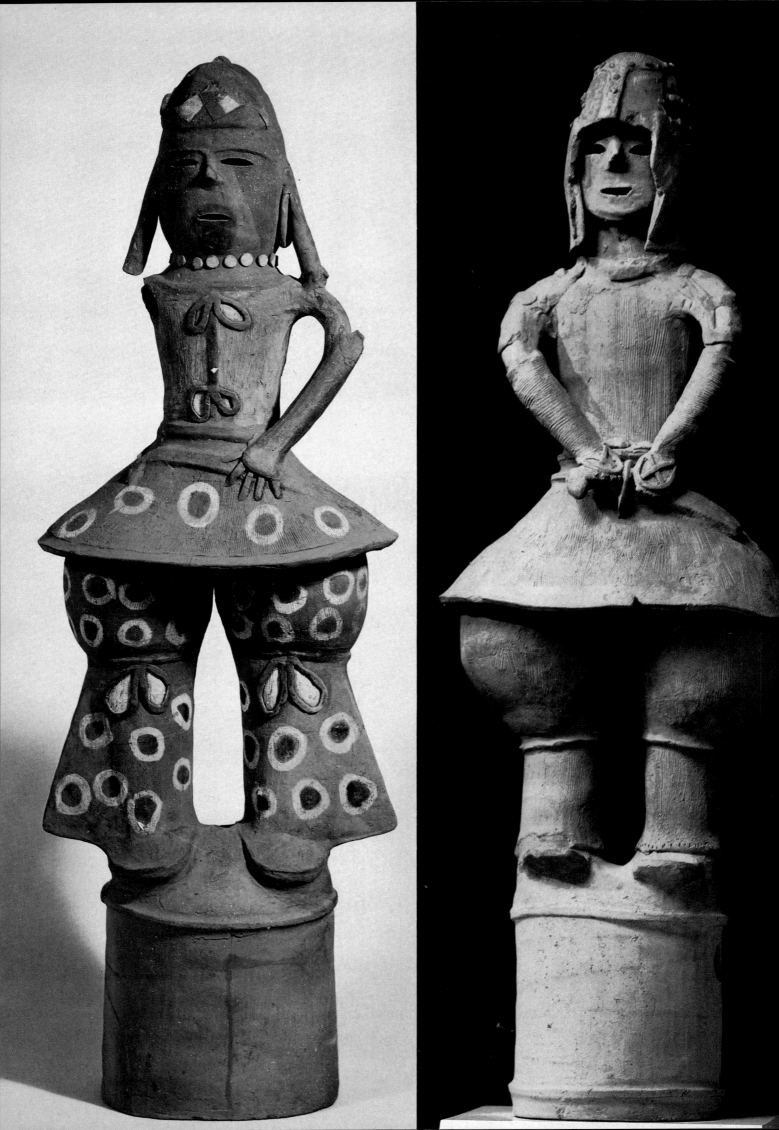

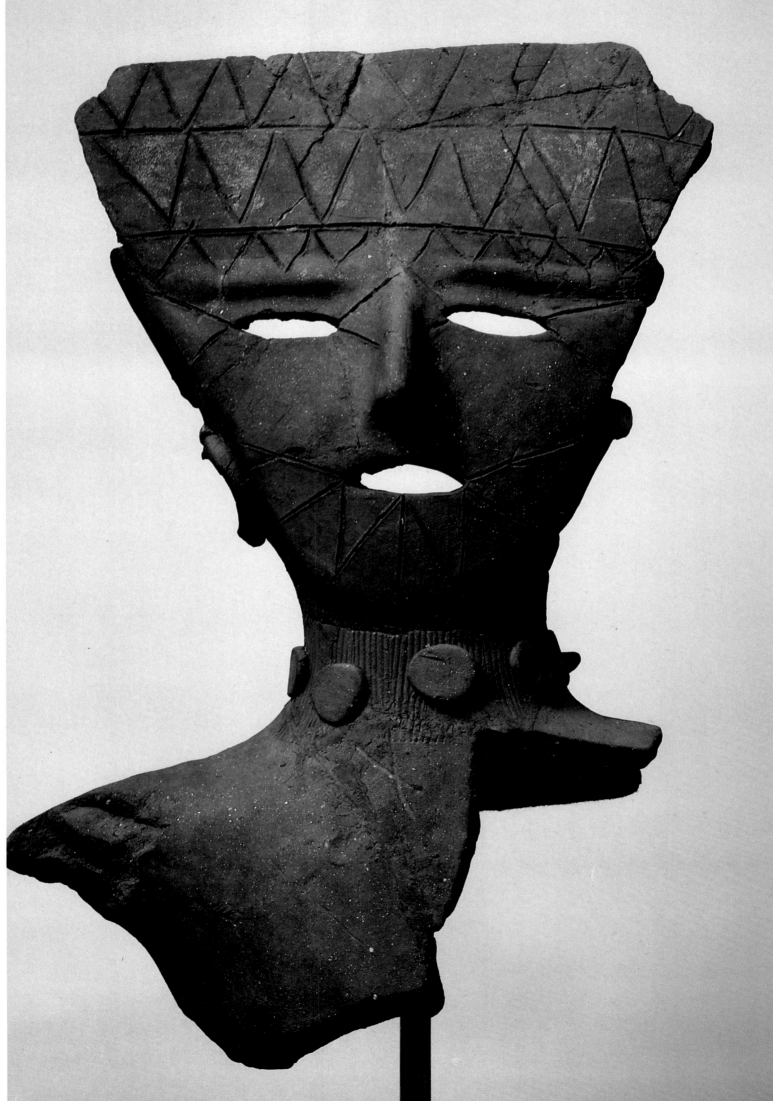

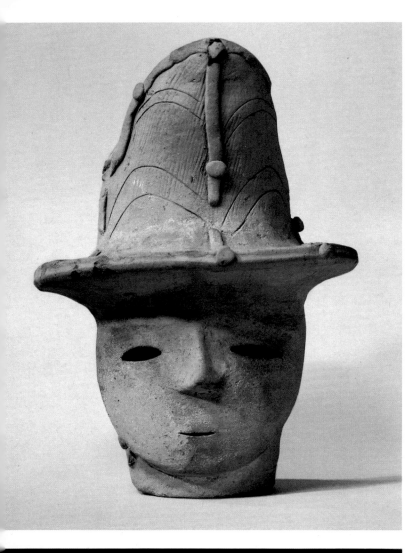 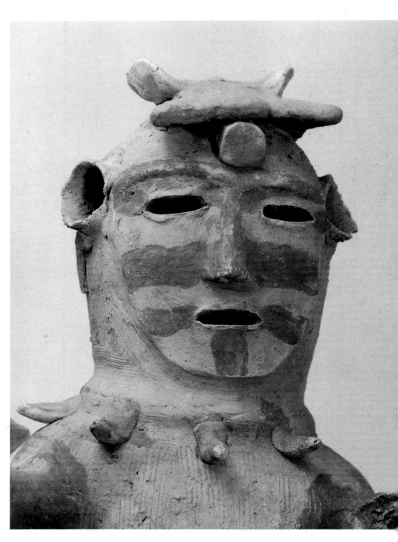

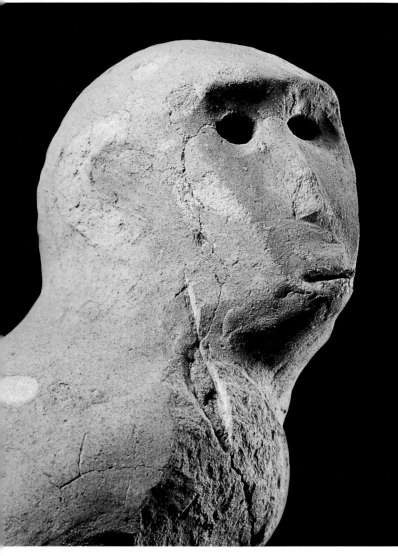 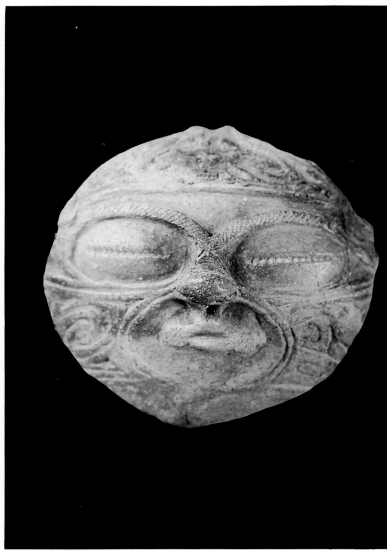

20 DŌTAKU (BELL)
Bronze, height 63.8 cm.
Yayoi Period, 2nd–3rd century A.D.
Asian Art Museum, San Francisco

21 STANDING FIGURE
Terracotta, Ibaragi Prefecture, height 1.2 m.
Kofun Period, 6th century A.D.
Yamato Bunkakan, Nara

22 HANIWA WARRIOR
Terracotta, height 1.2 m.
Kofun Period, 5th–6th century A.D.
Asian Art Museum, San Francisco

23 HANIWA HEAD
Clay, Ibaragi Prefecture, height 32.7 cm.
Kofun Period, 4th–6th century A.D.
Metropolitan Museum of Art, New York

24 HANIWA HEAD
Terracotta, height 27.9 cm.
Kofun Period, 3rd–4th century A.D.
Cleveland Museum of Art

25 HEAD OF A HANIWA WOMAN
Terracotta, height of entire figurine 62 cm.
Late Kofun Period, 6th century A.D.
Asian Art Museum, San Francisco

26 HEAD OF A HANIWA MONKEY
Terracotta, Ibaragi Prefecture, height of entire figurine 27.3 cm.
Kofun Period, 3rd–6th century A.D.
Private collection, Tokyo

27 DOMEN: HUMAN MASK
Terracotta, Kamegaoka (Aomori), height 10.6 cm.
Late Jomon Period, 7th–4th century B.C.
Tokyo National Museum

2. ARCHITECTURE

2. ARCHITECTURE

At all times, in all places, men have felt dependent upon their surroundings to a greater or lesser degree, and their civilizations have borne correspondingly the stamp of the environments that shaped them. Some civilizations chose to exalt man, to free him from the hold of nature. This was one of the principles underlying such philosophies as Hellenism in the Mediterranean region and Christianity in western Europe. Others chose to exalt nature, in order that man might be integrated with it. So true is this of the Far Eastern civilizations that developed in the shadow of China that one cannot grasp the qualities peculiar to ancient or contemporary Japanese art—and especially its architecture—without a profound appreciation for the essence of its natural surroundings.

Our aim, however, is not to dwell on the picturesque landscapes so dear to the hearts of adventure-seeking travelers, but to probe the religious feeling that underlies the Japanese attitude toward nature. There was a time when foreign observers hastily subsumed that feeling under the ambiguous rubric of "animism." Today, instead of rushing into premature debates over ideology or terminology, people tend to stop and examine in detail the many aspects of a feeling whose existence is unmistakable, but whose sources are not so easily discerned.

The Japanese call this world view *shintō*, literally, "way of the gods"; it is a word that calls for further clarification. For *shintō* embraces a whole complex of religious beliefs. In contemporary philosophy, it connotes a reverent admiration—motivated by fear or gratitude—for the unknown forces that surround us with bursts of boundless growth in a system of multiple hierarchies. These forces, it is believed, breathe life into the extraordinary world of nature and of man, who is only one of its manifestations.

It all begins with a sudden awareness of what is literally above us (*kami*), such as the sun, moon, and stars, as well as things that are "beyond" us: wind, thunder, rainbows, volcanos, hot springs, earthquakes. Man also continues to ask himself about those whose fate he does not know: the dead. Whatever transcends human understanding can develop into one or a multitude of deities (*yao yorozu no kami*), but collectively they express the single, ubiquitous, immutable truth of divinity, of sacredness. Japan is a land

of contrasting landscapes, deep, mysterious mountains, meandering river banks, wind-buffeted seas, and well-defined seasons, and nature is always in a state of flux. Like human beings, she is unpredictable in the short run, but cyclical over longer periods of time, now receptive, now inaccessible. In Shintoism, nature is fundamentally good, for everything can be purified and forgiven. The creative bond (*musubi*) uniting worshiper and deity is strengthened during special ritual feasts (*matsuri*) that provide man with an opportunity to reaffirm his relationship with the *kami*.

We do not intend to recount here the full story of *shintō* or to discuss how, early in Japan's historical era, it blended ancient totem worship and Chinese Taoism with the rational, socially oriented precepts of Confucianism. But the existence of Shintō, its maze of rituals and texts subsequently modified by its union with Buddhism as much as by the shocks of political events, invests all of Japanese art with special meaning. This is particularly true of the art form which, by definition, forms an integral part of the landscape: architecture.

Moreover the Japanese, not content with contemplating from outside the silent, impassive splendors of a natural world that transcends them, have read a host of symbols into nature and singled out countless individual features for special significance. A simple wooden gateway (*torii*; fig. 31) or a crude hemp rope (*shimenawa*; fig. 551) draws the attention of passers-by to the importance of a spot, which acquires human meaning through these human markers. Without such signposts, the ordinary traveler might regard the place as one that existed before man and was therefore alien to him.

Perhaps we will better grasp the role that landscape plays in Japan—not as an abstraction or a vehicle for meditation, but as an integral part of life and, consequently, of art—if we remember how it intrigued Hayashi Razan (1583–1657), official "master thinker" of Japan during the Tokugawa period. Thoroughly steeped in *li-hsueh*, the Chinese neo-Confucianist doctrine that dominated Japanese life from the 17th to the 19th century, this stern philosopher and director of censorship did not think his time idly wasted when he described his choice of the "Scenic Trio of Japan" (*Nihon sankei*): Itsukushima (Hiroshima Prefecture) and its sea-girt shrine on the Inland Sea (figs. 31, 594, 595); Ama-no-hashidate (Tottori Prefecture), a long spit of pine forest thrust into the sea near Kyoto (fig. 109) that was immortalized by the painter Sesshū (1420–1506); and the Matsushima (Miyagi Prefecture), off the eastern coast of Japan, an archipelago of pine-clad islands raked by Pacific winds.

Deeply rooted in nature and at peace with her surroundings, Japan owes much of her civilization to her forests. It was plants and trees that supplied the logs and thatch for the Bronze Age dwellings of the Yayoi period (3rd century B.C.–3rd century A.D.). The great influence of China, whose origins can also be traced in part to Siberia, was destined to change the way these building materials were combined, but it did not affect their fundamental character. Japanese architecture started out as an architecture of for-

esters and remained so, emerging from the inexhaustible depths of vegetation, and reconstituted by each generation in its principles, though beset by typhoons and earthquakes.

This brings us to a first given fact: since these building materials are doomed to disintegrate in the space of a lifetime, the style, authenticity, and elegance of Japanese architecture always evolved within the framework of a particular form, scheme, or design. Over the centuries, all of Japan's "historic" monuments have undergone one or many reconstructions, yet, aside from deliberate alterations in answer to specific needs, they retain to this day their original arrangement, some dating back more than a thousand years. This deference to the past extends almost to the knots and veins of the wood itself in a meticulous reconstruction that would be an affront to a stonecutter's spirit of creativity.

Respected in theory throughout the archipelago, the custom of periodic reconstruction takes on special meaning in the case of Ise Jingū, Japan's most sacred shrine (figs. 586–88). The rebuilding of this structure is the occasion for a solemn ritual observed every twenty years, except in times of national calamity. Even allowing for the perishable nature of the materials used, twenty years seems an unusually short period of time. The unpainted wooden buildings at Ise must have fallen into a state of disrepair sooner or later, which doubtless had something to do with the need to rebuild the shrine but would not account for the twenty-year span between reconstructions. A human factor must be introduced to explain this periodicity, namely, the average length of an emperor's reign. Here we shall pause to discuss the possible link between Japanese and Chinese emperors, specifically their symbolic role as agents of rebirth.

In China's *Shujing*, or "Book of History," we find references to a tradition that the living should make room for the dead, and that sovereigns should build their residences elsewhere than on the sites chosen by their predecessors. If the site was itself holy, as in the case of Ise, and the location could not be changed, the appropriate solution would be to rebuild the structure periodically. Thus, through an association consistent with the Chinese mentality, a "resurrection" of this kind would not only evoke the birth-death-rebirth cycle of nature, but reaffirm the mandate that transcends individual rulers: "The king is dead—long live the king."

Some believe that the alliance of architecture and imperial symbolism came about in a definite manner at a specific moment in history, namely, in the late 7th century, during the reign of Emperor Temmu (673–686). This hypothesis, widely accepted from the Edo period on, was strongly opposed in certain quarters immediately after World War II. The controversy still goes on, and many scholars have shifted their support from the old "Emperor Temmu" argument to a theory that places the origin of the phenomenon later, during the reign of Emperor Kammu (781–806), whose reign was innovative in many respects, even revolutionary. Although Kammu attached great importance to religion, it was he who removed the court far from Nara, the imposing capital where Buddhist temples weighed heavily—perhaps too heavily—on affairs of state. Given this context, it is tempting to think that a revival then occurred of the native religion, unbeholden to foreign ideologies though patterned more or less after Con-

fucianism. Moreover, only the far-reaching statutes of the Nara period (8th century) appear to have defined the emperor's role in detail, making it more probable that a complex imperial symbolism was formulated at the end of the 8th century rather than at the beginning. Advocates of the "Emperor Kammu" hypothesis, such as Sakamoko Tarō, who brings psychological arguments into play, also point out that the new capital of Heiankyō—modern Kyoto—was built within twenty-four years, and that twenty years might well have been reckoned a sufficient time for a "political generation" to bring about a "revolution."

Perhaps we shall come closer to the truth if we strike a balance between the two proposals. The process might have been set in motion with Emperor Temmu, during whose reign the Taika reform of 645–46 paved the way for Chinese-style bureaucracy, and the symbolism more fully developed under Kammu. In any event, suffice it to say that the practice of periodicity existed and that it suggests a correspondence between the permanence of structures and human biological rhythms, especially in those days of brief lifespans.

The second essential principle arises from the cellular, "vegetal" character of Japanese architecture: its early tendency to standardization. As a building "module," the treetrunk offers little in the way of variety, its usable part even less. In China, this "module" played so crucial a role that complex forms of architecture (notably during the Song dynasty of the 11th–13th centuries) did not appear until deforestation made unavoidable the use of the whole tree, not just the majestic trunk but its branches and fallen limbs. The Japanese, however, were always careful to respect nature and restore it to its original state; moreover the scarcity of flatland (not counting the plain of Kantō) discouraged excessive deforestation. Consequently, the archipelago probably never suffered the dearth of materials that plagued China. But the designs that the "trunk shortage" forced upon Chinese architects found their way into the rich repertory of Japanese architectural forms, despite the ample supply of local varieties of trees: hinoki (cypress; Chamaecyparis obtusa), sawara (cypress; Chamaecyparis pisifera), tsuga (hemlock; Tsuga sieboldii), sugi (cedar; Cryptomeria japonica), matsu (pine; pinus), and keyaki ("Japanese elm"; Zelkova serrata).

Over half a century ago, Claudel pointed out, in a particularly appropriate description, that, except for farmhouses of brick, a dwelling in the Far East is primarily a space defined, or sanctified, by a roof borne on wooden supports. There are virtually no walls, only simple wind- and cold-resistant partitions made of slats and pounded earth, because the building's essential structure is already in place. By contrast, the roofs that punctuate the landscape of the Far East clearly reveal man's diverse ways of settlement: from the rustic but proud thatched roofs of peasant houses and the hinoki-bark shingles (*hiwada*) of Shinto shrines to the metallic blue-gray tiles crowning Buddhist temples and elegant traditional city residences, and the gilded crests of the castles and palaces.

The invariably massive roofs of Japan are reinforced with strong architectonic elements, such as the heavy ridge beams of country houses, that are designed to withstand summer downpours and the fierce blasts of hurricanes. In this manner, the space

below is sheltered from the rigors of winter as well as the sweltering heat of summer. The walls between columns, which often took the form of sliding—thus, removable—doors, provide a protective screen in winter and allow air to circulate freely when the weather is sultry, at least that was the original idea of their creators; in practice, embittered observers point out that these flimsy partitions afford little protection against ice and snow, even when sheathed with solid shutters. In a sense, the Japanese house (with a few exceptions in the Tōhoku region) is a summer dwelling more akin to the straw hut of the Pacific islands than to the Siberian isba.

Yet, for all its beauty and undeniable effectiveness as a protective shield, this ample roof had the disadvantage of considerably shading the space below. This is especially noticeable in such temples as Tōdaiji at Nara, where people must strain to see the faces of sacred images (fig. 212). Japanese architects, like their counterparts on the mainland, addressed this situation by devising an intricate system of roof supports made of interlocking square blocks (masu) and corbels (hijiki): each resulting bracket was then surmounted crosswise by another, and so on, to form bracket clusters (masugumi). Aside from its highly decorative effect, bracketing pushed the roof up and away from the load-bearing outer beams and columns, thereby making it possible to lessen the pitch and even to add such finishing touches as upturned tips or "beaks"—an old technique used by the Chinese architect Li Ju (fl. c. 1100) during the Northern Song dynasty and soon widely copied in Japan. Thus arose a distinction between the "straight-roof" style (kirizuma-zukuri) and the "curved-roof" style (shichū-zukuri). We note in passing that the pronounced curve achieved by a carefully calculated balance of diagonal corner girders must not be confused with the gently sloping roofs seen in the Dunhuang frescoes of 7th- and 8th-century China. The latter involved nothing more than positioning brackets in a certain way and then accentuating the effect with antefixes and ridge tiles; the antefixes are of interest to archaeologists, however, for buildings may be dated by the evolution of these decorative elements.

In discussing Far Eastern architecture, it is customary to point out the absence of clear-cut distinctions between secular and religious buildings—the most that foreign observers will concede is that a particular style of military architecture appeared after the importation of firearms. Actually, their contention is supported by the many palaces and private residences that became, upon the master's death, the centers of monasteries, some destined to grow into great establishments. It was also common practice to locate places of worship and sacred images within the heart of what looked like manor houses of the most frivolous sort. Yet the chapels of European castles were invariably within the main building, too, though it would be hard to dispute the traditional division of Western architecture into civil and religious structures. Once we allow that the use of a single building material, wood, led to a degree of technical uniformity, we may well recall some of the distinctions drawn by early 20th-century Japanese historians between Shinto, Buddhist, palace, domestic, and "tea" architecture, the latter being peculiar to Japan.

GENERALLY speaking, the most remarkable feature of Shinto architecture is its retaining, in part or entirety, of ancient schemes developed during the Bronze Age, or more precisely, during the "Great Tomb" period (*Kofun jidai*, 4th–6th centuries). Some of the little clay figures (*haniwa*) that both decorated and shored up the earth of burial mounds took the form of houses, and these little models give us an idea of prehistoric architecture (fig. 191). Dwellings at that time were constructed on piles and covered with heavy protective roofs further reinforced by massive ridge beams. This type of building, at least in its basic components, recurs time and again throughout Japanese civilization, distant echoes of a society which still heeds a spiritual message nourished on shamanism. In such buildings people honor woodland deities, the souls of the dead, in short, matters strictly Japanese that cannot be fitted into the otherwise all-embracing Chinese model.

In the wake of the government's sweeping reorganization of Shintoism during the Edo period (17th–19th centuries) and the Meiji era (1868–1912), Shinto buildings were classified into a number of categories: four original types from ancient Japanese times, and five later "composite" types that transmit in a blending of styles the influence of Buddhist and administrative architecture from China. Let us remember that the mixing of styles was in no way regarded as a betrayal. As far back as the 9th century, Japanese thinkers already looked upon Shintoism and Buddhism as two aspects—one particular, the other general—of the same universal truth. This was how *ryōbu* (two-part) *shintō* came into being.

The shores of the Sea of Japan provide the setting for the most ancient of all Shinto styles, at Izumo (Shimane Prefecture) in northwestern Honshū (figs. 601–5). In plan it is a spacious square house (two bays across, two bays deep) surrounded by a gallery, the whole atop tall piles and reached by a long stairway. The entrance, on the front side, was evidently shifted to the right to achieve an asymmetrical effect. The thatch roof is protected against storms by heavy billets (*katsuogi*) placed along the ridge; these, in turn, are secured by prominent scissors-shaped timbers called *chigi*.

Except for the entrances, which are at the center of the short side, the same layout occurs in both a simple version, two bays by three, at Ōtorijinja (Osaka), and a deeper counterpart, four bays by four, at Sumiyoshijinja (Osaka). The latter, though twice as long as it is wide, retains the entrance on the short side.

The shrines at Ise (Mie Prefecture), however, have a different rectangular plan (three bays long by two bays wide), the entrance positioned at the center of one of the long sides (fig. 587).

There were, to be sure, departures from the extremely simple quadrilateral plan shared by all of these ancient structures; but they were few. Curved lines, difficult to obtain in wooden architecture, were totally excluded from the design, and the materials were left "raw," with no colored protective covering.

The impressive structures that rose after the arrival of Buddhism and the emergence of Nara as the capital in the 8th century blended this native tradition with Buddhist and administrative styles from the mainland. Thus evolved the types exemplified by Kasugajinja (Nara; figs. 737–40), Shimogamojinja (Kyoto), Usajingū (Oita

Prefecture), and Hieijinja at Mt. Hiei, near Kyoto. But even the oldest buildings that stand today at these sites date back no farther than the late 16th century, or the Momoyama period.

The first two possess sets of curving roofs whose overhanging eaves (*kōhai*) act as a protective covering above the main stairway. Prominent in both Usajingū at Usa (Oita Prefecture, Kyūshū) and Kitano temmangū (Kyoto) is the *ai-no-ma*, or "intermediate hall," a covered chamber connecting the front and rear sections that constitute the two main buildings of the sanctuary that otherwise are similar in plan to those at Ise. The tripartite complex makes up what was referred to in the 16th century as the *gongen* style of Shinto architecture (*gongen-zukuri*). The Hieijinja shrine located at the foot of Mt. Hiei, northeast of Kyoto—which, together with its Buddhist counterparts high on the mountain, helped to protect the city from the baleful forces believed to come from the northeast—is especially famous for its unusually shaped roof. A deftly constructed framework dating from the late 16th century makes the roof look as though it has been tossed like a piece of cloth over all of the main or secondary structures beneath its protective cover. It is a triumph of master carpenters who, using small, intricate *masugumi*, exploited to the full the velvety, organic smoothness of hinoki-bark shingles (*hiwada*).

Remarkable for their complex, ingenious layouts, all of these relatively late shrines unite, to varying degrees, the rustic simplicity of native prototypes with luxurious elements borrowed from Chinese architecture: columns whose coating of red lacquer contrasts sharply with whitewashed earthen walls; series of pavilions connected by covered verandas (in imitation of aristocratic palaces); tiled roofs; even painted and carved decoration. We are a long way from the simplicity that characterized the original architecture of ancient Japan.

THE implantation of Buddhism in the middle of the 6th century had serious consequences in Japan, for the new faith brought with it the formidable social, political, and intellectual apparatus of the Chinese empire. Likewise, the design of the buildings to house China's monastic communities had a new and decisive effect on Japanese architecture.

We have already mentioned a number of Chinese elements—lacquered columns, covered galleries, tiled roofs—that were gradually assimilated into Shinto shrines over the centuries. But less conspicuous components, more subtle or at least more abstract in quality, were also fraught with meaning. In the first place, there was the Chinese notion of an enclosure that would simulate a microscopic image of the macrocosm around us; Japanese monasteries would tend to suggest such limits through symbolic markers rather than physical barriers.

Traditionally a monastic community was bounded by a surrounding wall, within which lay a complex of several buildings: a gateway, its elegance already hinting at the stature of the institution; the sanctifying presence of a relic-tower (pagoda), built in accordance with a local style (*gojūnotō*) or later in an Indian style (*tahōtō*); the sanc-

tuary proper, home of the principal sacred images; and a hall set aside for reading sacred texts and preaching, for teaching was as much a part of monastic life as meditation.

But Japanese monks very early built their dormitories, refectories, storerooms for books or treasures—in short, all the buildings that fulfilled material needs—outside of the enclosing wall. Instead of setting limits on the monastery as a whole, the wall surrounded only the sanctuary reserved for ceremonies and meetings of a purely religious nature—what we would call the church. The architects at first made no allowance for public worship indoors, even though the devout included aristocrats and other persons of rank. Everyone gathered together to pray outdoors in the courtyard that was bounded by the cloister (*kairō*). The amenity of shelter was reserved solely for the sacred images.

People could identify the buildings that housed these images not so much by their size as by their elegant exterior decoration. The vermilion of lacquered columns contrasted forcefully with the soft blue-gray of the tiled roofs. The only apertures were doors, which were flung open during ceremonies to permit pilgrims to worship the statues of the deities. Inside everything was shadowed, but no human beings ever dwelled there; these 7th-century *kondō* apparently served as great open-air altars. This concept has endured over the centuries in the small portable temples found in Japanese homes.

Whithin the enclosing wall the sanctuaries and pagodas, whether single or doubled, tended to become arranged in a star-shaped plan around a central pagoda. An example of the Korean prototype that inspired the kind of star layout at, for instance, the Asukadera at Asuka (fig. 576) turned up during the 1938 excavations in the Korean region once known as Koguryo. Sometimes the buildings were aligned along a single axis, and the plan of Shitennōji in Osaka (figs. 625–27) is a direct offshoot of these Chinese models. However, the Japanese were intrigued by other geometrical figures as well as by seemingly irregular configurations. Both Kawaradera (Asuka), with two sanctuaries and one pagoda, and Yakushiji (Nara), with two pagodas and one sanctuary, are based on triangular plans (figs. 761–63); while the architectural volumes of Hōryūji are arranged in such a way that the massive *kondō* counterbalances the slender, soaring pagoda it faces in perfect symmetry with the central gateway (fig. 734).

Little by little, the plans of these building-clusters evolved as the crowds grew larger. Over the years, and especially in 8th-century Nara, it became customary to keep the courtyard clear so that the area would hold more worshipers. The pavilion (*kondō*) housing the main image or images (*honzon*) was pushed farther and farther back until it formed a part of the rear enclosing wall. Such was the original plan of Tōshōdaiji at Nara, although the now-vanished cloister makes it difficult to imagine how the complex looked at the time. The visitor is immediately struck by the almost living presence of the *kondō* (whose roof was lower before the 18th-century reconstruction): the bays increase in width toward the center, where the main image is placed (fig. 49), thereby giving the façade an unexpected effect of convexity (figs. 755–58).

The often harsh climate of Japan, however, with its extremes of cold, heat, and precipitation, soon prompted attempts to erect a structure, either opposite or adjacent

to the main building, for the express purpose of sheltering the worshipers during the ceremonies. An example is the Hokkedō (or Sangatsudō) south of Tōdaiji at Nara (mid-8th century), where two structures are juxtaposed so as to form a single unit (fig. 752). A look at the method of assembly—the original framework can be deduced from the unobstructed ceiling of the 13th-century addition—reveals the simplicity of the scheme and the imperfection of its execution. Each of the two structures has its own framework, but they share a common roof above; the connecting beams seem inelegant and contrived, as if knowledge of the use of wood was not particularly advanced at the time. The simplest, and perhaps most usual, solution was to extend the roof outward, especially along the façade and sides. Something of this sort may have been attempted at the Daibutsuden (Hall of the Great Buddha) of Tōdaiji (fig. 750), although the 17th-century restoration thoroughly disarranged the original plan. Doubtless there was little reason to shelter the worshipers except during the few ceremonies attended by persons of rank. The Tōdaiji and its auxiliary buildings—the crowning "state temple" or *kokubunji* created by Emperor Shōmu's decree in 741—did indeed provide the setting more than once for particularly solemn ceremonies witnessed by the entire court, but this was not true of other institutions. The development of Japanese architecture in this respect was sluggish until Saichō (767–822) and Kūkai (774–835) introduced the Tendai (T'ien-tai) and Shingon (Chen Yen) sects from China in 804.

One of the pivotal ceremonies of Tendai was the circumambulation of images by monks and worshipers alike, and after its introduction temples could no longer be considered large open-air altars for the faithful to admire as though spectators in a theater. The worshipers became a vital part of the ritual, their presence giving meaning to the images they venerated; certainly they could no longer be left exposed to the elements. Architects were now faced with a still more vexing problem, for it seemed right that worship offered by the public should be clearly distinguished from worship offered by monks. In the case of a more ancient form of worship, as at the Hokkedō (or Sangatsudō) of Tōdaiji, segregation was accomplished without difficulty: the monks could take their places near to the images, and ordinary worshipers stayed on the periphery. But the act of circumambulation required that space be allowed for a double path around the main image, and gradually the altar, together with the statues associated with the most sacred area of the sanctuary, was brought forward to the center of the room. Here the roof rose to its highest point, sufficient to house even the loftiest effigy; low galleries surrounding the statues sheltered the ordinary worshipers.

The *jōgyōdō*, or building with the holy of holies placed at the center, evolved from the solutions attempted, for example, at the Yakushidō (reconstructed 1121) of Daigoji (Kyoto) and the Amidadō of Jōruriji (first half of 12th century), also at Kyoto. When the increased central elevation threatened to make the exterior seem disproportionately high with respect to the area of its base, architects resorted to a double-shell construction of the roof, already used to graceful effect in the *kondō* of Hōryuji at Nara (fig. 733). To the central roof they added a lower skirting roof (*mokoshi*) similar to those that lend such elegance to the tiers of pagodas (fig. 735).

The most accomplished specimen of the *jōgyōdō*, the "functionalist" building of

both the Tendai and Shingon sects, is the Mandaladō of Taimadera, between Osaka and Nara. Two areas, each with its own framework, run alongside each other in the old style, but beneath a single, immense roof whose gentle, symmetrical pitch allows for a soaring central space. As a model of simple, elegant, functional design, this building left nothing to be desired. Nevertheless, architects continued to devise inventive solutions to problems posed by specific religious needs, terrain, or more refined forms of worship, and thus were developed buildings roofed with an asymmetrical pitch. But this inexhaustible creativity, exploiting materials of all kinds and every possible combination of brackets (*masugumi*) and columns, was never to stray from the basic guidelines set forth at the beginning of the Kamakura period (late 12th century).

THE preceding summary should make it clear that the development of Japanese architecture was little affected by chance or passing fashions. However, we must add that decisive, subtle, and sometimes elusive ingredient called "spirit." The spirit of so-called esoteric Buddhism, whether Tendai or Shingon, always connoted the idea of withdrawal into "the wilderness," far from cities and the compromises of court life. Remains from the period that saw Heian (modern Kyoto) rise as the capital of Japan are exceedingly rare, but they all convey a sense of dreaminess and tranquility set within a rugged natural landscape that inevitably required accommodation. Witness the temple and miniature pagoda of Murōji (figs. 745–47), not far from Nara, a remainder of the Kōnin era (810–823) when the government dispatched "envoys" to seek out Chinese civilization at its source; the Konjikidō of Chūsonji at Hiraizumi (Iwate Prefecture) and the Amidadō of Hōkaiji (Kyoto), both exemples of the Fujiwara culture (898–1185), when a temporary period of self-imposed isolation enabled Japan to develop one of the most original aspects of her civilization.

It was the evolution of religious thought that paved the way for new forms of architecture. The compassionate Buddhism of the True Sect of the Pure Land (*Jōdo Shinshū*) would require twice as much room for human worshipers as for divine images. Zen (Ch'an) Buddhism, a philosophy steeped in Chinese intellectualism and disciplined austerity, encouraged the development of buildings whose compact and unpretentious façades belied a sturdy and often highly sophisticated design constructed in accordance with one of two styles: *karayō*, the "Chinese" manner, or *tenjikuyō*, the "Indian" manner; Zen's elevated moral principles were soon translated into a style of greater delicacy, the more slender columns and increased roof volumes reflecting a taste for verticality. Apart from the *shariden* of Engakuji at Kamakura (figs. 547–48) and a few other "miraculously" rescued buildings, all of these early specimens of Zen art succumbed to the cataclysmic events of Japan's troubled political history. Nevertheless, the dynamic architecture of modern Japan still derives much of its vitality from the spirit of Zen.

The Heian period (9th–12th centuries) is always hailed as the era that best embodies the originality of ancient Japanese culture at the peak of its development. Actually, little remains of this culture, except for a few pavilions that managed to escape the ravages of fire and war. One such survivor is the Byōdōin, a marvelous complex

located at Uji, a short distance from Kyoto (figs. 31, 671–73). This building is known the world over for its Phoenix Hall (Hōōdō), which consists of a main hall (*shinden*) flanked by veranda corridors that link it to two auxiliary structures (*tainoya*). The layout of the Hōōdō resembles a bird in flight—people have been saying this for a thousand years, since its creation in 1053—and served as the prototype for *shinden-zukuri*, the *shinden* style of upper-class residential architecture that crystallized during the Heian period. The hallmark of this approach is a horseshoe-shaped plan that allows space at the heart of the complex for a garden, complete with pond and miniature island—a microcosm of the outside world. However, since the Byōdōin houses a splendid statue of Amida in gilded wood, a work that marked an important stage in the history of Japanese sculpture, people often dwell on its role as a temple. Paradoxically, by classifying the Byōdōin as a religious building, they run the risk of unjustly minimizing the impact religion had on everyday life and thus of wrongly underestimating its importance.

These palaces, as appealing now as they were then, were designed to evoke the Western Paradise in which Amida awaits the souls of the pure. To confirm this symbolism, one need only examine the way this theme was expressed in the 7th and 8th centuries on the walls of the sacred caves at Dunhuang, in western China. There we find the same type of buildings along with wondrous, lush, clearly drawn gardens enlivened by the presence of water: gushing water, the wellspring of life, as well as quiet pools as deep and enigmatic as the mystery of existence itself. Among the edifices can be seen the radiant figures of various Buddhas and celestial creatures. Finally, the island at the center of the pool cannot but recall the famous "Island of the Immortals," one of the recurrent themes of Chinese iconography since the dawn of the empire: witness, to cite but one example, the countless bronze or ceramic incense burners (*boshanlu*) discovered in Han tombs (3rd century B.C.–3rd century A.D.). Thus, by the Heian period in Japan, the Far East had already been haunted with ideas of paradise and eternal life, in one form or another, for a thousand years. In this respect, the Byōdōin may indeed be considered the embodiment of a religious or philosophical yearning, provided that we acknowledge how fully this yearning permeated every aspect of life, at least the life of the privileged class. Let us concede that the Byōdōin might have been conceived as a prayer in architectural form; let us also add that this palace was, in fact, converted into a temple upon the death of its builder, Fujiwara-no-Yorimichi (992–1074). But never was it intended to be one of the great rallying points of worship and theological inquiry, like those that had been drawing crowds to Nara for the preceding three hundred years.

THE ambivalence toward monuments—palaces that were turned into monasteries upon the death of their builders—would remain a constant feature of Japanese architecture, at least if we limit ourselves to the most prestigious structures: in Kyoto, the Golden Pavilion (1397) of Ashikaga Yoshimitsu (1358–1408) and the Silver Pavilion (1489) of Ashikaga Yoshimasa (1435–1490). Combining the uncluttered, functional design of dwellings of the warrior class (*buke-zukuri*) with the symbol-laden aesthetic of

Zen buildings, these two monuments determined the future course of traditional architecture in modern Japan.

This style, known as *shoin-zukuri*, blended a number of very specific elements which, regardless of how they might be combined, were henceforth always to be found in important residences. These elements included: a quadrangular alcove or niche (*toko-no-ma*) opening out of a wall of the main room, in which one or more decorative objects might be temporarily displayed, the only place of that kind in the entire house; a relatively spacious window (*shoin*) to provide as much light as possible for the desk or work table below; shelves (*tana*) on an adjacent wall, positioned as much for aesthetic appeal as for practicality; a formal entranceway with a vestibule (*genkan*) to indicate the rank of the master of the house. In addition, as early as the late 15th century, the floor began to be covered with straw mats (*tatami*) instead of being left a bare parqueted surface. The venerable *tatami*, formerly used as a throne (when thick, richly embroidered with silk braid, and covering a raised surface) or a bed (whence its "modular" dimensions of about 1.8 by 0.9 meters, or 6 by 3 feet), now evolved into a refined floor covering that was soft to the touch and cool during hot summer weather.

The comfort and fragility of *tatami* eventually led to the floor-oriented life of Japanese houses, in which one always feels close to the earth and to nature. As floors became more comfortable, the rooms became more intimate, an atmosphere heightened by a seemingly minor change in structure: architects often now replaced, at certain points, the all-purpose round column with square columns. These, in turn, permitted the installation of sliding screens (*fusuma*) built to the owner's specifications. In addition to providing more effective protection against drafts and prying eyes than the older folding screens, they offered to painters large, flat surfaces suitable for decoration. The sides of the house that provided light were fitted with sliding wall panels (*shōji*) consisting of a wooden frame and translucent paper which, if need be, could be covered with solid shutters (*shitomido*). These *shōji* replaced the type of blind depicted in *The Tale of Genji*, a narrative handscroll of the 13th century (fig. 125). The Hiunkaku of Nishihonganji, the Sambō-in of Daigoji, and the Ni-no-maru of Nijō Palace (all in Kyoto) are usually cited as characteristic specimens of 15th- and 16th-century architecture (fig. 708), a style befitting the monks and warriors that made up the dynamic elite of the nation at the time. It was they who gave to the "human landscape" of Japan the aspect we still see today, wherever industrial materials have not changed its face.

The vast countryside that stretches from end to end of the Japanese archipelago (not counting the north and south "extremes" of Hokkaidō and the Ryukyū Islands) has an astonishing unity that can become a picturesque monotony. Plains alternate with wooded mountains and deep, narrow valleys, and everywhere the terraced rice fields—reminders of man's ceaseless activity—both accentuate and compensate for the uneven terrain.

Yet Japan's climate changes imperceptibly as one travels north, from the almost tropical conditions of Kagoshima Prefecture to the chilly, temperate weather of Akita Prefecture, and it is further modified by unpredictable factors—the changeable severity of the monsoon, or the Siberian winds that begin sweeping down over Kyūshū in De-

cember, transforming the mild, almost Mediterranean breeze of mid-November into an icy, biting north wind. The architecture of a region is directly affected by its proximity to the sea, and by the lay of its valleys with respect to prevailing winds; add to these climatic variations the imaginativeness of individual architects, and the result is the astounding multiple synthesis of Japan's residential structures. Within their originality, however, local architects have taken their cue from the capital and worked within the two approaches between which traditional Japanese architecture always oscillated: the Chinese house, with its characteristic wooden supports and tiled roof, and the isba of Siberia.

The finest of these *minka*, or "popular dwellings," had more in common with *samurai* manor houses (*yashiki*) than with the huts of impoverished farmers. Since it is precisely these residences that reveal specific regional traits, we should like to replace the term *minka* with that of "country house." In every country house elements of the centralized *shinden-zukuri* were blended with those of the Zen-based *shoin-zukuri* according to the needs of a location where the primary activity was growing crops, not making war. This difference in function is precisely what distinguished the typical country house from the *yashiki* of warriors, who were constantly tempted, or compelled, to follow the model prescribed by the ruling class. By imitating the elite, the *samurai* tried to become part of it. The differences between these two architectural strains—the *samurai* "manor house" on the one hand and the opulent residences of well-to-do farmers on the other—first began to appear in the Kamakura period. For example, the handscroll narrating the attempted Mongol invasions, *Mokoshūrai Ekotoba* (figs. 133, 134), depicts *samurai* dwellings in much the same manner as those of aristocrats; the *samurai*, it seems, had already repudiated their humble rural origins. By the Muromachi period (14th–16th centuries), however, the *shinden* style had given way to *shoin-zukuri*. With the *shōgun* as the arbiter of taste, wealthy farmers—though lagging somewhat behind the capital—became as "fashionable" as their purses and pursuits allowed. Meanwhile, the opposite was taking place among the gentry, many of whom (like their European counterparts) preferred homes with a decidedly rustic flavor.

The buildings depicted in the 14th-century handscroll recounting the life of the monk Hōnen (*Hōnen Shōnin Eden*) illustrate the differences between ordinary farmhouses and *samurai* dwellings (fig. 131). The home of the holy man's father in Mimasaka Province (modern Okayama Prefecture) looks at first glance like an everyday rural house, with wooden planks and a thatch roof, but closer inspection reveals its distinguishing features: a veranda skirts the perimeter of the house, which is amply supplied with shutters (*shitomido*); an elegant wing juts out into the garden and leads toward the main entrance of the estate; bare floors (*doma*), a hallmark of farmhouses, are nowhere seen; and the kitchens are located in a small building detached from the main residence. Access to the garden, which is partially enclosed by a pleasant "fence" of braided straw mats, is through a sturdy wooden gate roofed with thatch, a countrified version of the portal leading to aristocratic dwellings.

These signs of rank had often disappeared—when, for example, the *samurai*, largely responsible for the fighting that scarred the end of the Muromachi period, found

73

themselves anything but affluent—even before they were redefined by the dictators of the late 16th century. With the advent of rigid social stratification by class (1582–1598), the *shoin* style, as embodied by the newly built castle at Osaka, set the standard for upper-class domestic architecture.

It should be noted that the *tatami*, used by this time to cover entire rooms, do not provide a reliable criterion for determining the purpose and quality of Japanese buildings. One must not be misled by the apparently humble character of straw mats; in this forest-clad country plant life has always been held in high esteem. True, unusual stones always intrigued people in the Far East, but this was in the spirit of enthusiastic collectors looking for curios rather than for the sumptuous colors and textures that fascinate Europeans. Rarely, in Japan, were stones placed far from the earth. Whether incorporated into rubble foundations or set in a garden to convey symbolic or philosophical meaning, they remained a vital part of the earth and of plant life, never to be used as decorative elements in residential architecture (figs. 28, 29, 35).

The Ōbai-in (1588), a temple-pagoda of Daitokuji in Kyoto, is the oldest surviving structure whose floors are entirely covered with *tatami* and, more important, were designed specifically with these straw floor mats in mind. Its domestic counterpart, the house of the Kuriyama family at Gojō (Nara Prefecture), rose soon after, in 1607, but doubts persist as to the original arrangement of the interior. The *tatami* in the house of the Imanishi family (1650), also in Nara Prefecture (at Imaimachi), are laid out in sections of about 1.9 by 0.94 meters (6 feet 3 inches by 3 feet 1 inch), which was to become the accepted size throughout the region. Thus began in and around the former imperial capital of Japan that phenomenon associated with the rise of cities, and a hallmark of the Edo period, the standardization of the *tatami*.

From this point on, the various paths in the development of Japanese dwellings can be traced with some accuracy. The first salient fact is the differentiation of domestic architecture into zones located on either side of the "Japanese Alps," the natural boundary that has traditionally divided the archipelago into two geographical and cultural regions: western Japan (Kansai) and eastern Japan (Kantō). Since the country gravitated toward Kyoto—the capital and the source, or at least the heart, of authority—the point of equilibrium between the two areas was there, though Kyoto lay well within Kansai. The essential differences of modern domestic architecture in Kansai and Kantō were in their respective choice of a basic architectonic unit or "module." Stated simply, the architects of Kansai planned houses in relation to *tatami* size; their counterparts in Kantō based their calculations upon the mean length of the horizontal beams that connected two columns and established the intercolumniation (in Japanese, *ma*).

In addition to the two major "spheres of influence" defined by the norms of Kyoto and Nara on the one hand and Edo on the other, there were a number of regions with composite or wholly original characteristics. The area of Nagano Prefecture, for example, developed in the cultural shadow of Nagoya to the south, and in that of the northern prefectures of Yamagata, Niigata, and Akita, linked by major routes to Kyoto and

Osaka. These regions occasionally borrowed from Kansai the practice of basing residential design solely on *tatami* size, but this proved to be the exception; the influence of Kantō clearly won out, for most houses in these regions used the "Edo" module (the average length of an intercolumnar beam) as their basic architectural unit. These rural dwellings are the finest of the Tokugawa period. But the Kōchi region on the island of Shikoku, though it lies geographically within the orbit of Kansai, is located along the Inland Sea including the eastern entrance, and thus at a crossroads; here the houses based on *tatami* and on intercolumniation are almost equal in number.

Tatami size varied within Kansai itself, depending on the locality or even—as is generally the case in feudal societies—the particular fief. The celebrated *tatami* of Kyoto, about 1.9 by 0.94 meters (6 feet 2 inches by 3 feet 1 inch), was favored in and around the capital, but *tatami* in what is now Hiroshima Prefecture were usually 1.83 by 0.92 meters (6 by 3 feet); this module was called the *ankidatami*. People in Okayama Prefecture used both modules, which led to variations in the intercolumniations. In modern Saga Prefecture (Kyūshū), the preferred mat was known as the *Hizen tatami*, which measured about 1.86 by 0.93 meters (6 feet $\frac{1}{2}$ inch by 3 feet $\frac{1}{2}$ inch). Generally speaking, the Kyoto *tatami* tended to become shorter the further its use from the capital, the "average" size occurring in the vicinity of Shiga and Hikone. In Gifu, Fukuyama, and Ishikawa a noticeably smaller mat was used, about 1.74 by 0.87 meters (5 feet $8\frac{1}{2}$ inches by 2 feet $10\frac{1}{2}$ inches), called the *inakama tatami* or "country *tatami*."

The intercolumniation (*ma*) in building plans based on columns and crossbeams showed similar degrees of variation, depending on period and locality. The *Edo ma*, or "Edo intercolumniation," measured 6 feet (1.83 meters) and was used over a wide area that included the prefectures of Niigata, Nagano, Yamanashi, and Shizuoka. The further from Edo, the more the length of the *ma* tended to vary, only approximating the intercolumniation favored in the shogunal capital. By the end of Japan's military dictatorship (*bakufu*), the *ma* had held steady at 6 feet in Fukushima Prefecture, while in Aomori Prefecture it had expanded to 6 feet 3 inches (1.9 meters). With the Meiji Restoration of 1868 came an important change: the Kansai *tatami* "module" was adopted more widely, spreading to northeastern Japan (Tōhoku).

Japanese writers were intrigued by these regional differences, and described in close detail the architectural curiosities they found off the path of their travels. Furukawa Koshōkan (1726–1806) mentions in his travel diary that bamboo was used to cover and enclose the houses of southern Kyūshū: its leaves for the roof, its trunks for the walls. In volcanic regions where clay was not available, a plaster coating based on volcanic ash was used instead. The ingenious solutions of local builders were endless, but it is the structural distinctions between houses adopting the *ma* of Kantō and those built on the *tatami* of Kansai that best allow us to trace the diffusion of influences from one village to another.

TRADITIONAL Japanese architecture, even when graced with urbane culture and comforts, is always united by one element, the quality of rustic simplicity, which sometimes verges on austerity. This cannot be fully understood without mentioning the tea ceremony, an aesthetic ritual that combined extreme reserve with refinement. It developed from Japan's appreciation for green tea, the beverage used by monks to prevent drowsiness and by warriors as a non-intoxicating stimulant.

In the late 16th century, Sen-no-Rikyū (1520–1591) designed and built a structure for the preparation and drinking of tea. What made this idea so original was that he treated like a separate structure what had been until then only a room, sometimes merely a space (*kakoi*) screened off from a room. Still today tea-rooms within houses are referred to as *kakoi*, originally designating the place where guests assembled, protected by screens that served the same purpose as tapestries in medieval European castles.

In addition to providing for the reception of guests in the room in which tea is served, the traditional Japanese teahouse (*sukiya* or *chashitsu* or *chatei*) includes a small side room (*mizuya*, literally, "place for water") where serving utensils are readied, cleaned, and stored, as well as a covered anteroom or porch either inside or outside (*machi-ai*) the teahouse, where guests await their host. The rustic pathway (*roji*) leading from the garden entrance to the teahouse door, or from the "waiting pavilion" to the teahouse proper, is made of irregular stones set amid a subtle arrangement of sand, gravel, mosses, and trees whose appearance, and meaning, change with the seasons.

Every aspect of these teahouses—unobtrusive meeting-places set aside for aesthetic and intellectual fulfillment—is regulated by a well-defined symbolism. The approach pathway (*roji*) is conceived as a path of initiation: step by step, it leads the individual toward an oasis of tranquility and thus enables him to sever all ties to the outside world. It is his path to the state of beatitude that is one of the ultimate aims of the tea ceremony. Various spots along a particular *roji* are designed to touch the guest's mind or senses. Sen-no-Rikyū, for his part, stressed the importance of solitude—the solitude of a man within nature as his life draws to a close, the solitude of a man among men. A somewhat later tea master, Kobori Enshū (1579–1647), adopted a different tone, seeming to arouse the soul to the truth, the hidden significance of life, and the anticipation of freedom in a future life.

Early in the 20th century, Kakuzo Okakura described tea architecture in a manner that still seems apt today: ". . . Thus prepared the guest will silently approach the sanctuary, and, if a samurai, will leave his sword on the rack beneath the eaves, the tea-room being preeminently the house of peace. Then he will bend low and creep into the room through a small door not more than three feet in height. This proceeding was on all guests,—high and low alike,—and was intended to inculcate humility. The order of precedence having been mutually agreed upon while resting in the machiai, the guests one by one will enter noiselessly and take their seats, first making obeisance to the picture or flower arrangement on the tokonoma. The host will not enter the room until all the guests have seated themselves and quiet reigns with nothing to break the silence save the note of the boiling water in the iron kettle. The kettle sings well, for pieces of iron are so arranged in the bottom as to produce a peculiar melody in which

one may hear the echoes of a cataract muffled by clouds, of a distant sea breaking among the rocks, a rainstorm sweeping through a bamboo forest, or of the soughing of pines on some faraway hill.

"Even in the daytime the light in the room is subdued, for the low eaves of the slanting roof admit but few of the sun's rays. Everything is sober in tint from the ceiling to the floor; the guests themselves have carefully chosen garments of unobtrusive colours. The mellowness of age is over all, everything suggestive of recent acquirement being tabooed save only the one note of contrast furnished by the bamboo dipper and the linen napkin, both immaculately white and new. However faded the tea-room and the tea-equipage may seem, everything is absolutely clean. Not a particle of dust will be found in the darkest corner, for if any exists the host is not a tea-master. One of the first requisites of a tea-master is the knowledge of how to sweep, clean, and wash, for there is an art in cleaning and dusting. A piece of antique metalwork must not be attacked with the unscrupulous zeal of the Dutch housewife. Dripping water from a flower vase need not be wiped away, for it may be suggestive of dew and coolness . . ."

Okakura continues: "The tea-room (the Sukiya) does not pretend to be other than a mere cottage—a straw hut, as we call it. The original ideographs for Sukiya mean the Abode of Fancy. Latterly the various tea-masters substituted various Chinese characters according to their conception of the tea-room, and the term Sukiya may signify the Abode of Vacancy or the Abode of the Unsymmetrical. It is an Abode of Fancy inasmuch as it is an ephemeral structure built to house a poetic impulse. It is an Abode of Vacancy inasmuch as it is devoid of ornamentation except for what may be placed in it to satisfy some aesthetic need of the moment. It is an Abode of the Unsymmetrical inasmuch as it is consecrated to the worship of the Imperfect, purposely leaving some thing unfinished for the play of the imagination to complete. . . . True beauty could be discovered only by one who mentally completed the incomplete. The virility of life and art lies in its possibilities for growth. In the tea-room it is left for each guest in imagination to complete the total effect in relation to himself. . . . In the tea-room the fear of repetition is a constant presence. The various objects for the decoration of a room should be so selected that no colour or design shall be repeated. . . . There and there alone can one consecrate himself to undisturbed adoration of the beautiful. In the sixteenth century the tea-room afforded a welcome respite from labour to the fierce warriors and statesmen engaged in the unification and reconstruction of Japan. In the seventeenth century, after the strict formalism of the Tokugawa had been developed, it offered the only opportunity possible for the free communion of artistic spirits. Before a great work of art there was no distinction between daimyo, samurai, and commoner. Nowadays industrialism is making true refinement more and more difficult all the world over. Do we not need the tea-room more than ever?" (*The Book of Tea*, 1906)

So pervasive was the effect of the tea ceremony on upper-class architecture that even buildings as majestic as the Katsura Palace (first half of the 17th century) and the Shūgakuin, both in Kyoto, were classified under the rubric of *sukiya zukuri* or "teahouse

architecture" (figs. 691–93). The aim of the *sukiya* style was to expand the rules for a teahouse to an entire residence. Consequently, these austere, yet sophisticated houses typically combine a seemingly spare use of materials with a deep yearning to harmonize with nature. A traditional Japanese dwelling could hardly exist without its environment of plants, however diminutive, and however obvious is the part man has played in its "natural" appearance.

The preceding statement may sound like a heresy to those who see Japanese gardens—and rightly so—as hymns to nature. They point out that the garden makes use of all plant species, even the humblest, arranged with seeming abhorrence of any suggestion of symmetry, affectation, or forced effects. The aim is to make the garden appear as if man had had no part in its design; and such may well have been the effect their creators—Soseki (posthumous name: Musō-kokushi, 1271–1346; fig. 13) and Sen-no-Rikyū, to name only two among many—had in mind. But to achieve this aim, they had to select, exclude, prune, trim, in short, to bend nature totally to their will. Their real goal was to create neither a landscape nor a Shinto-style site to which evidence of man gives a social existence, but a work of art, or, in the case of Zen gardens, a work of faith designed to foster meditation. Everything—the presence or absence of natural forms, the greenness or dryness of condition—conveys symbolic, often hidden meanings. The master could pass these on to a favorite disciple, or he might prefer to let each individual embark on his own endless quest for the meanings contained within the re-created landscape.

In a land where vegetation was the building material of choice and where, save for pagodas, horizontals prevailed and even floors were covered with mats made from plants, the advent of military architecture—exemplified by the proud silhouette of Himeji castle (fig. 40)—marked a startling shift in architectural design. Japanese values seemed to have changed abruptly.

All Japanese architecture, whether civil, administrative, or religious, is rooted in the unwritten principle that buildings are ephemeral, even transferable, and to this day, the master of a luxurious house will say that he owns his house, but not the garden on which it stands. Major complications can ensue if a landowner wishes to reclaim his rented property, thereby forcing the "tenant" to dismantle his house and rebuild it elsewhere. This phenomenon is as old as Japanese civilization itself, as revealed in the history of the archipelago's principal temples: most temples changed location at one time or another, or an emperor or lord might donate a building from an older structure, which would then have to be carefully reassembled at the new site. Consequently, the evolution of Japanese architecture included two forms of impermanence: the impermanence of materials that were continually replaced without the slightest concern for disturbing the original, "authentic" state of a building; and the impermanence of geography, since, paradoxically, Japanese property is anything but "immovable." The mighty castles of later times, built on massive earthen fortifications reinforced with cyclopean masonry, seem an exception, even an aberration, for their builders rejected

"lighter" designs that might minimize damage and injury during earthquakes or changes of location; one may wonder why the castles appeared at this moment in history.

These citadels were, relatively speaking, latecomers in Japanese architecture. For a thousand years only a few fortresses had been built in all of Japan: for example, Dazaifu, built in 665, an offshoot of a Sino-Korean prototype whose key element was a rampart of rammed earth (figs. 633–34). Most of these early structures were located on Kyūshū because it was closest to the Korean peninsula, considered a likely source of enemy attack. In Central Japan a regular imperial army had been created when the Taika Reform of 645–46 attempted to fit Japan into the Chinese administrative mold, but the "new order" soon fell into abeyance: Emperor Temmu (r. 673–686) had arsenals built, but to no avail, and by the next century the official government army was no more. Feudal nobles filled this military vacuum in the provinces, and the ensuing rivalries of clan against clan eventually gave rise to the *samurai* code and fortified defense works. Curiously enough, these fortresses remained quite primitive, for the warriors of medieval Japan showed a decided preference for chase and confrontation, hand-to-hand combat, and ambush, in short, for making war "on the move." The defenses they built, like other forms of Japanese architecture, were essentially short-lived structures, often no more than hastily built stockades to defend a temporary camp or to meet the assault of a more numerous or better-equipped enemy. It was the mountains, with their steep slopes and unmapped valleys, that long remained the preferred haven of Japan's warriors during their wars of defense and attrition.

The construction of full-sized fortresses did not begin in earnest until the locus of fighting shifted to level ground. At such times, the Japanese resorted to a palisade-and-moat arrangement not unlike the *vallum* used by the Roman army. This was the strategy adopted in 1184 at the battle of Ichinotami (Hyōgo Prefecture), which marked the decisive victory of the Minamoto over the Taira. Another expedient widely used for waging war on level ground was to entrench the forces within temple compounds. Usually shielded by a sturdy enceinte and built on sloping embankments that were sometimes faced with bonded masonry, temple compounds were all the more desirable as headquarters for the private armies of mercenaries or soldier-monks (*sōhei*) that the temples often maintained.

Thus the sudden appearance of Japanese castles during the second half of the 16th century is usually ascribed to an external factor: the advent of the Portuguese, who dropped anchor at Tanegashima in 1543. They brought with them not only a world view that seemed strange indeed to Japanese eyes, but such weapons as the fuse musket and the harquebus. For all their novelty, these firearms did not revolutionize the Japanese conduct of war until Oda Nobunaga (1534–1582) assembled little by little whole brigades armed with harquebuses, beginning in the 1560s. This new strategy proved the key to his success as military dictator, and later to that of his ex-lieutenant, Toyotomi Hideyoshi: harquebus volleys enabled soldiers to begin a battle at longer range, and thereby to provide cover for successive waves of archers, halberdiers, and sword-bearing *samurai*.

The splendid castles of Japan—or what remained of them after the shōguns issued rules governing their number and size—were direct offshoots of this momentous change in tactics. The first (and by tradition, the most beautiful) was built by Oda Nobunaga at Azuchi (fig. 577), on the eastern shore of Lake Biwa (1576), which fell victim to the turmoil that ushered in the Tokugawa shogunate (1600), but was copied throughout Japan. Close examination of these citadels reveals that the design remained simple and did not vary significantly from what soldiers had found in the major temples: again wooden buildings set on embankments, but much taller and surrounded by a deep moat to hold off assailants. The main edifice was structurally independent from the ramparts below and remained relatively fragile, although its wooden frame reinforced with plaster walls was less susceptible to fire than rammed earth. From these elements—a massive, sturdy foundation and a lighter superstructure that served as both shelter and observation post—there evolved a network of posterns, chambers, and underground passageways designed to channel the aggressor's advance once the fortress was penetrated, then to help in beating him back before an assault on the donjon could be mounted.

But these strongholds also served as residences and thus stood for the rank of the lord who dwelled within. Their lavish decoration indicates that they were intended to be, not only citadels, but awe-inspiring seats of personal power. Probably this factor accounts even more than utilitarian needs for the numerous castles that mushroomed across Japan during the dynamic Momoyama period (late 16th–early 17th centuries). However, it was Hideyoshi, and the Tokugawa that succeeded him, who disarmed the people and categorized them according to class in order to forestall the disastrous spread of a false, self-styled nobility of unruly, half-starved swashbucklers. As soon as the dictators' grip on Japan was secure, they forbade and, thanks to their superior armies, succeeded in curtailing private wars once and for all. In 1650, Japan entered an iron-fisted but peaceful era that was to last for more than two hundred years. How, given this climate of strict government control, do we explain the remarkable growth of the castles that later developed into the major urban centers of Japan? It is because they were not so much fortresses as the seats of regional government and, above all, unmistakable proof of the prestige enjoyed by the *daimyo* that lived within them. For it often seems that Japanese architecture does not fulfill a particular need or objective until it has first satisfied an aspiration or state of mind (figs. 36, 39, 40).

28 GARDEN AT DAZAIFU, NEAR FUKUOKA

29 GARDEN, SAMBŌIN, NEAR THE DAIGOJI, KYOTO
Momoyama Period, early 17th century

30 SACRED BRIDGE (MIHASHI) OVER DAIYA RIVER,
NIKKŌ.
Wood, painted red.
Originally built 1648, rebuilt 1907 after 1902 flood
(see fig. 563)

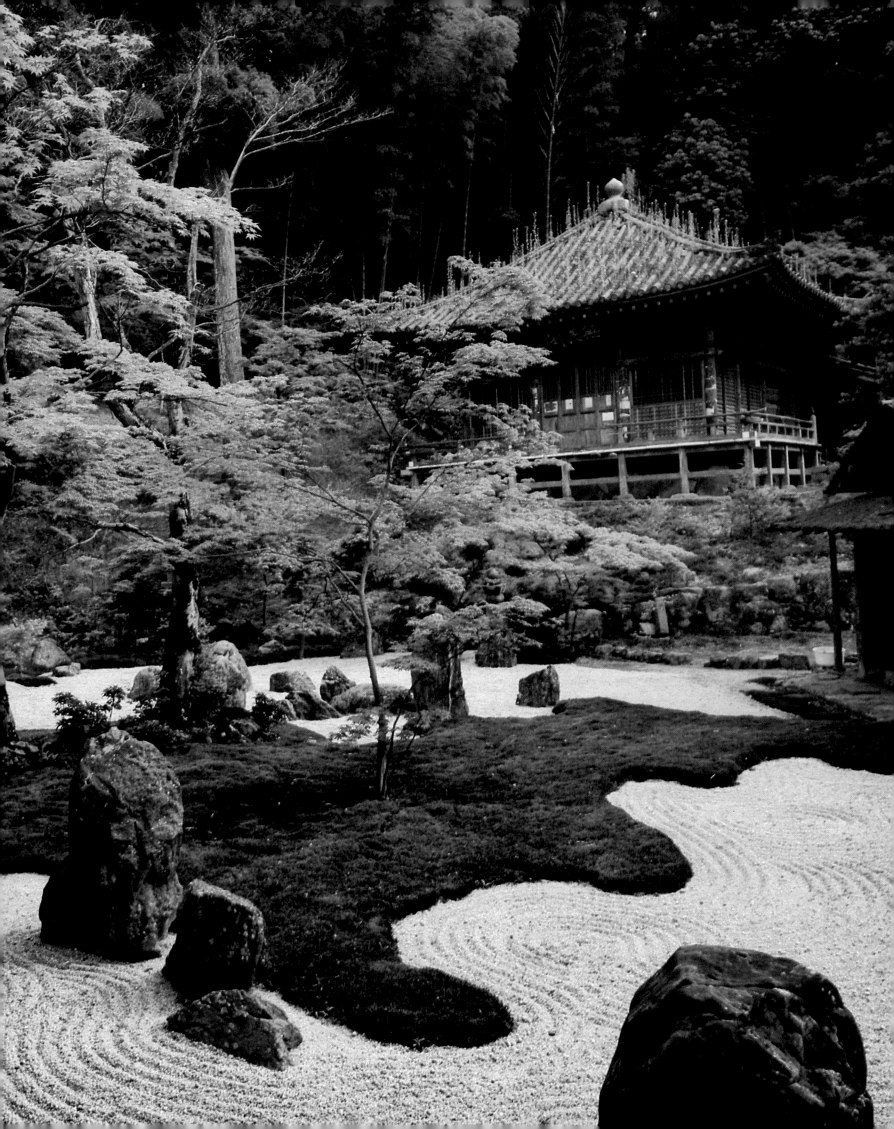

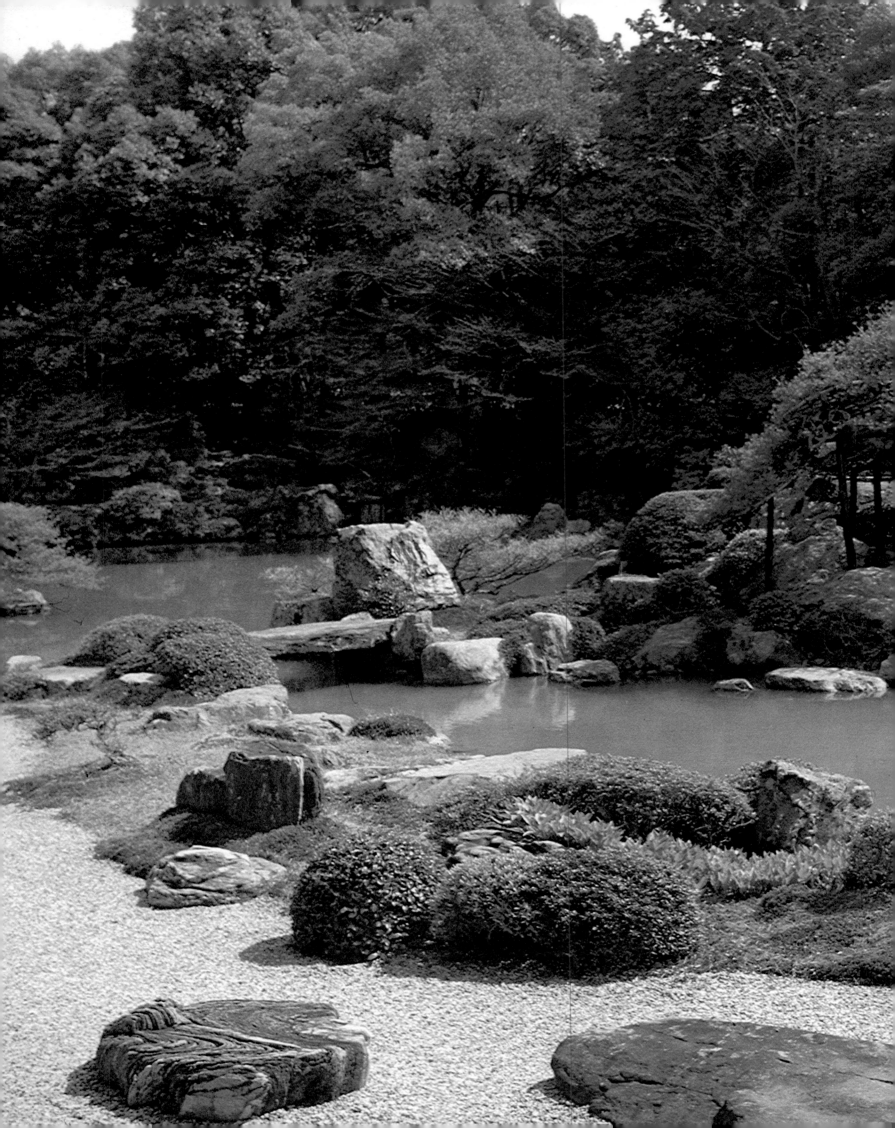

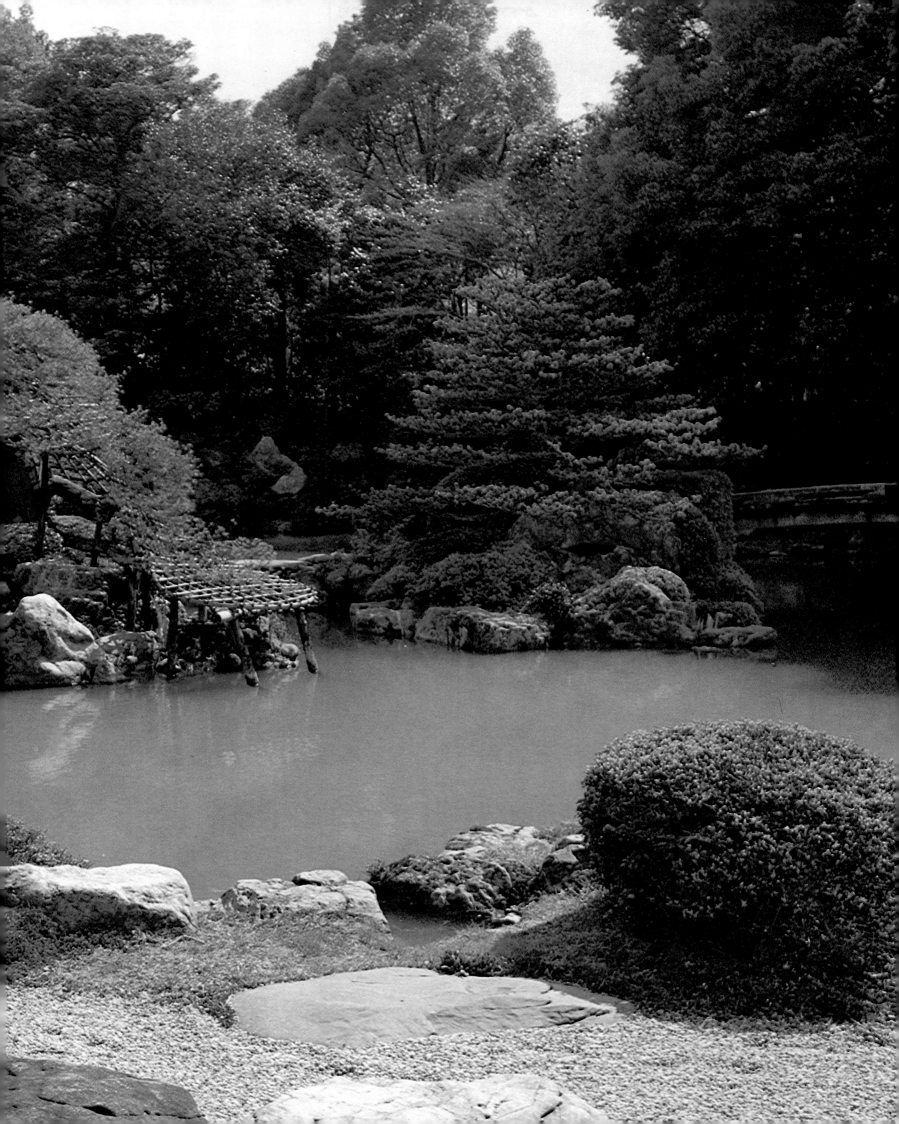

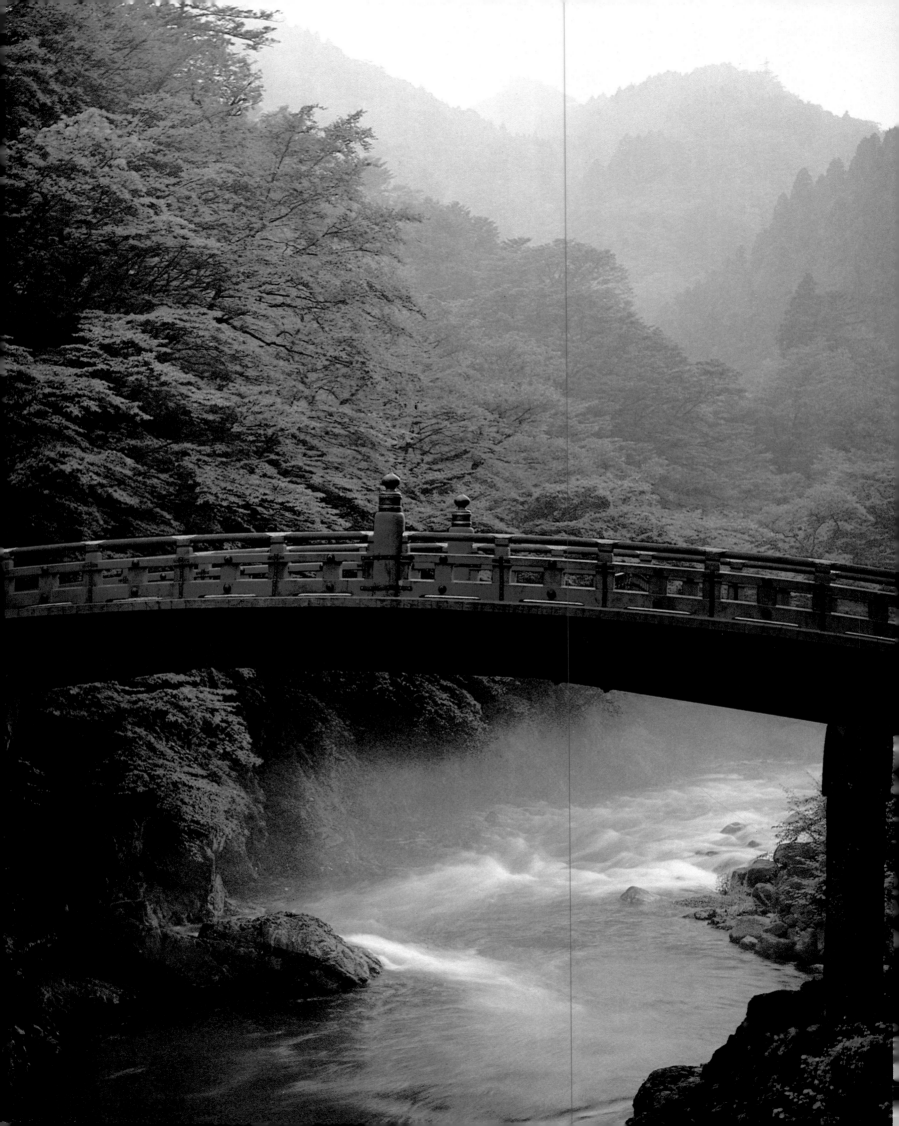

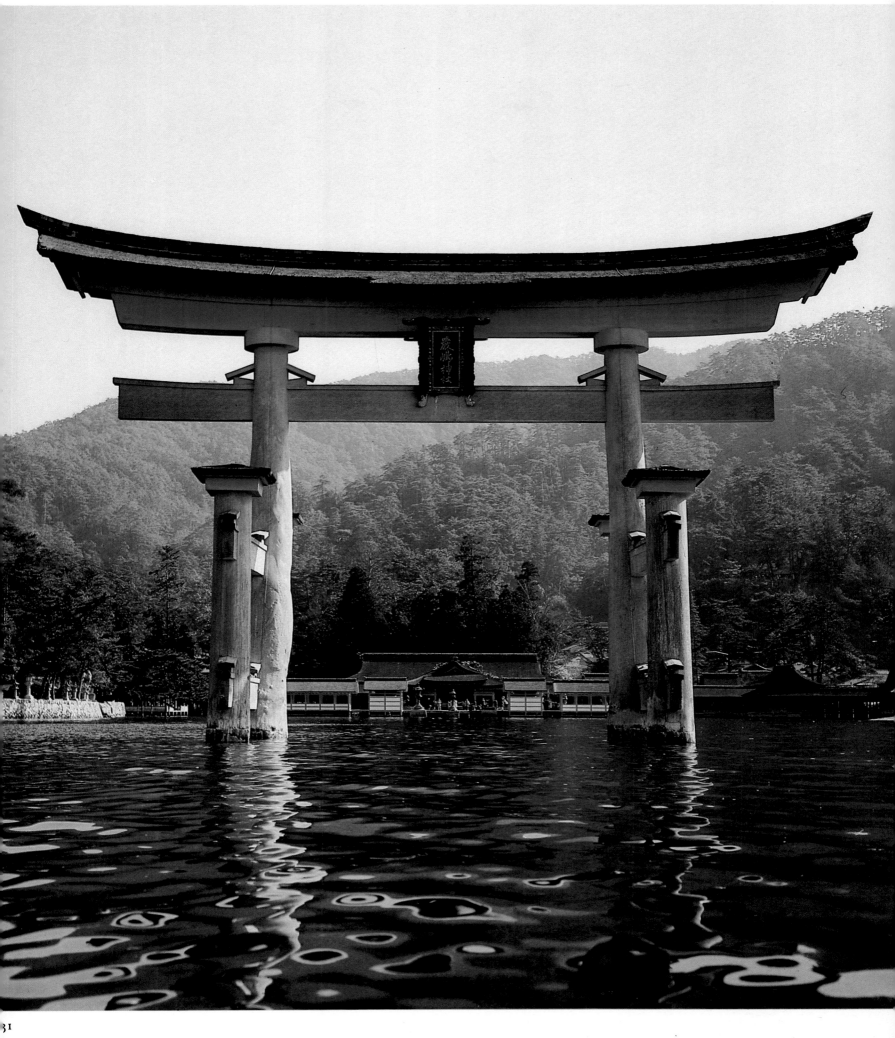

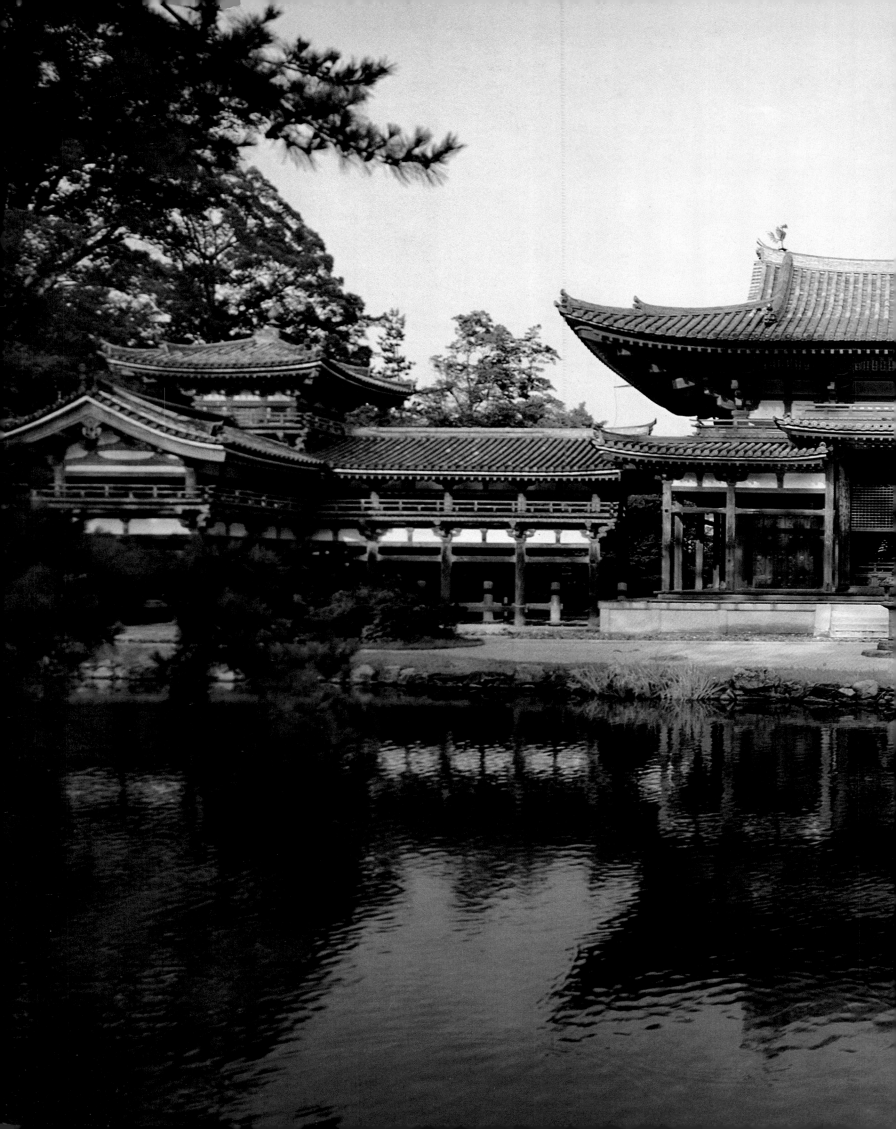

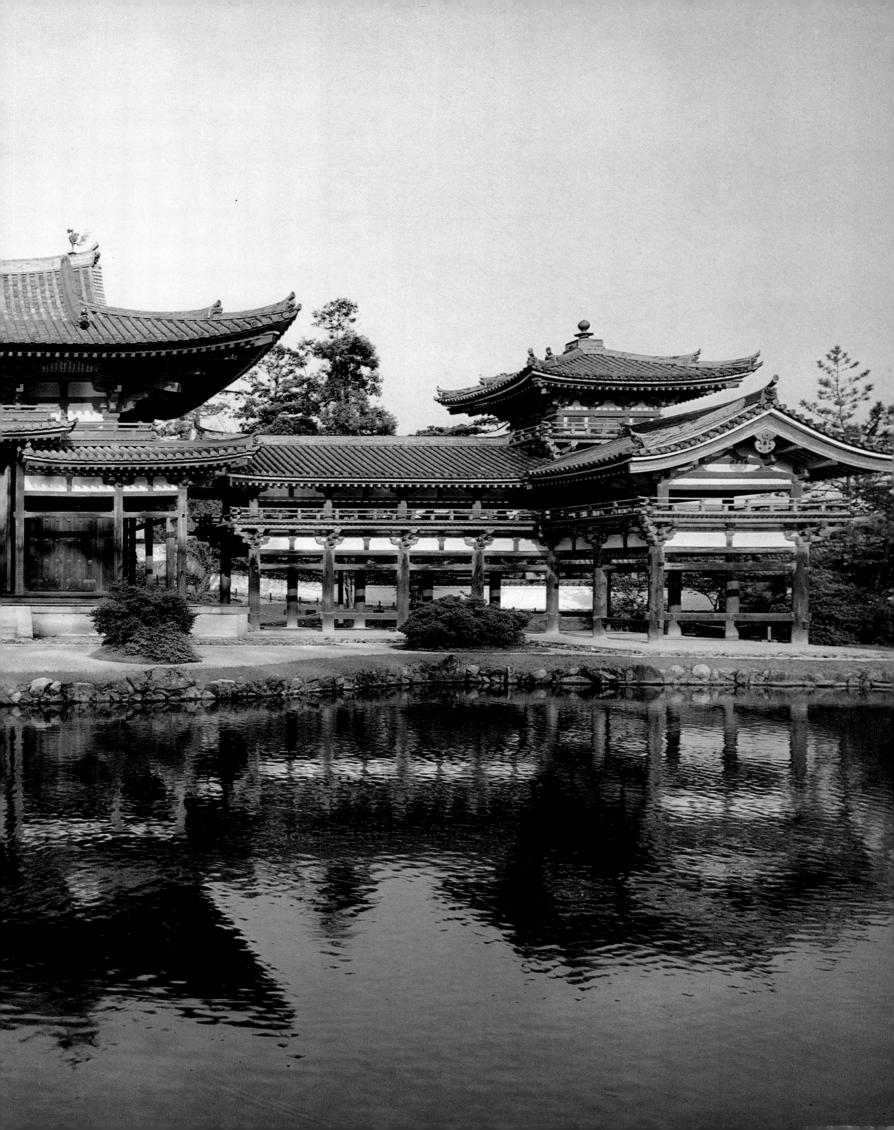

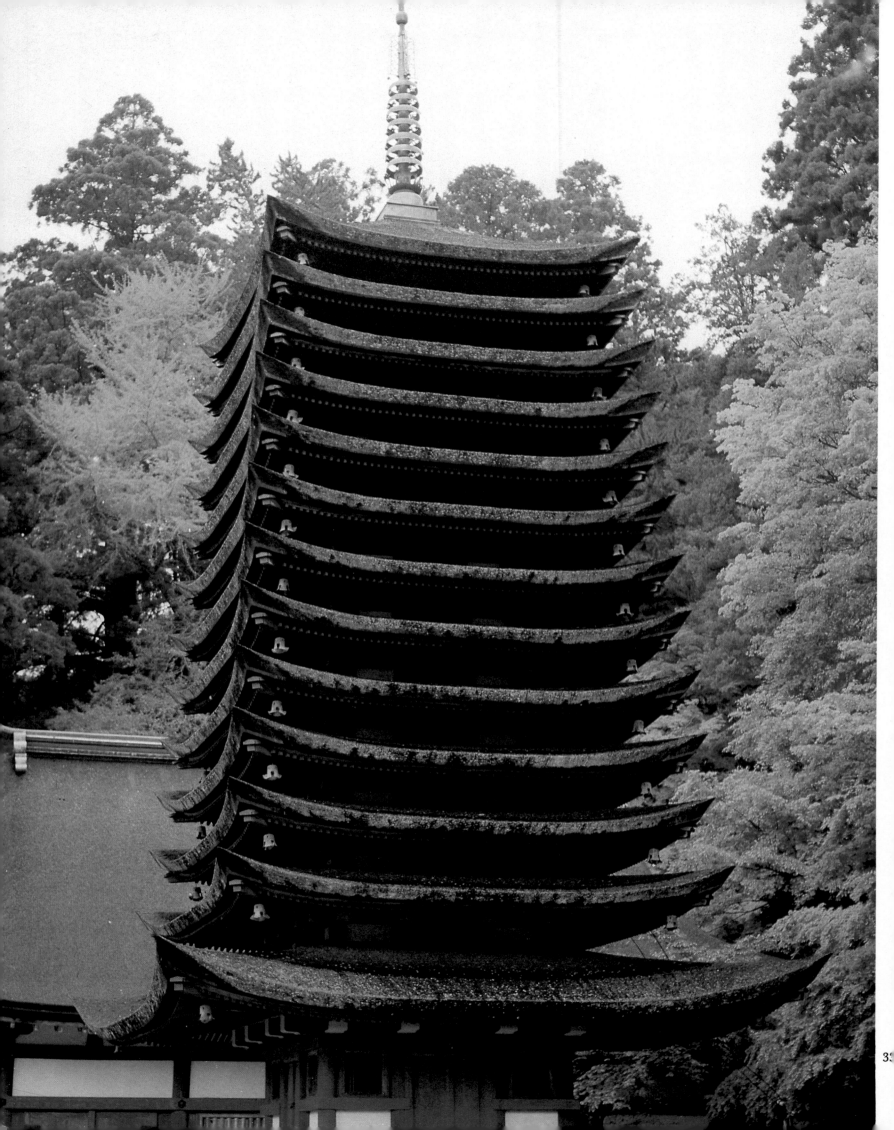

31 TORII, ITSUKUSHIMAJINJA, MIYAJIMA, HIROSHIMA BAY, INLAND SEA
Wood.
Originally built 811 A.D.; rebuilt numerous times

32 HŌŌDŌ (PHOENIX HALL), BYŌDŌIN, UJI
1053

33 THIRTEEN-STORY PAGODA, DANZANJINJA, NEAR NARA
Cypress wood, height 13 m.
Muromachi Period, 1532

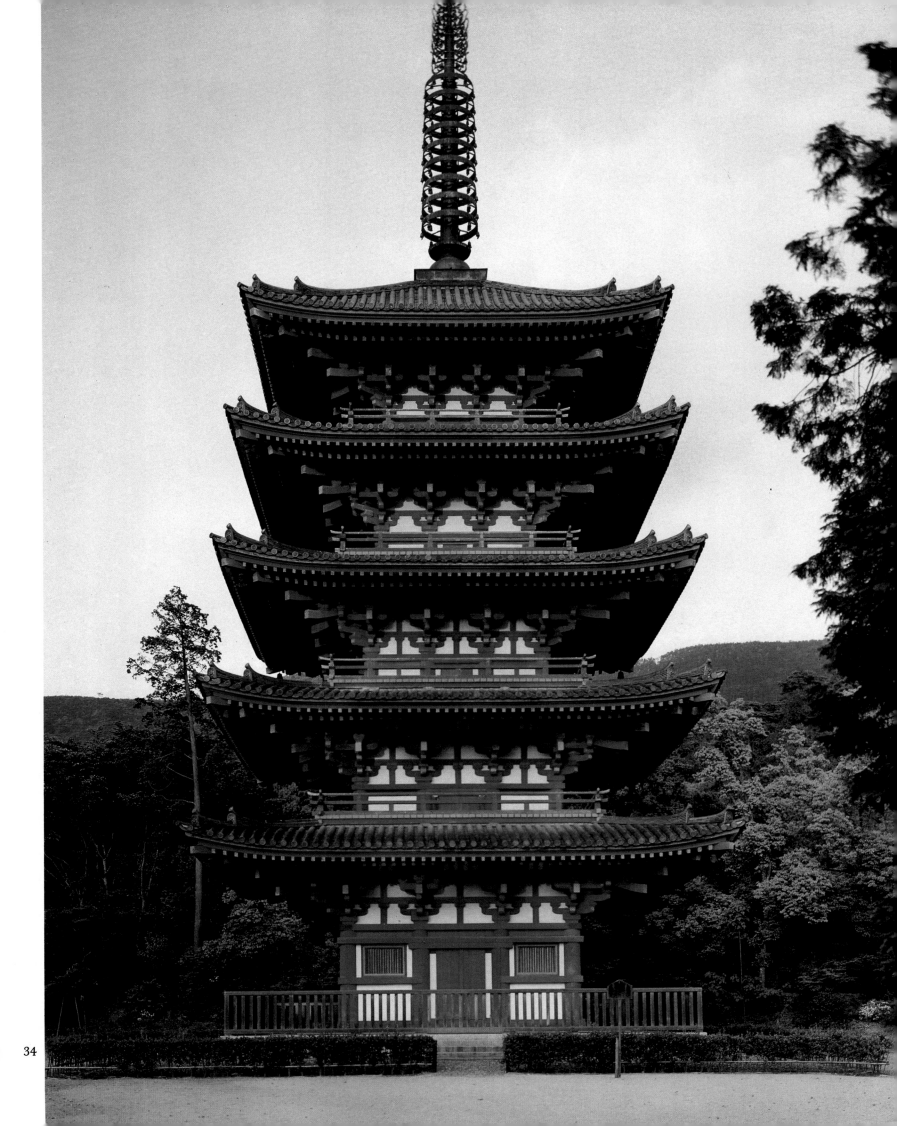

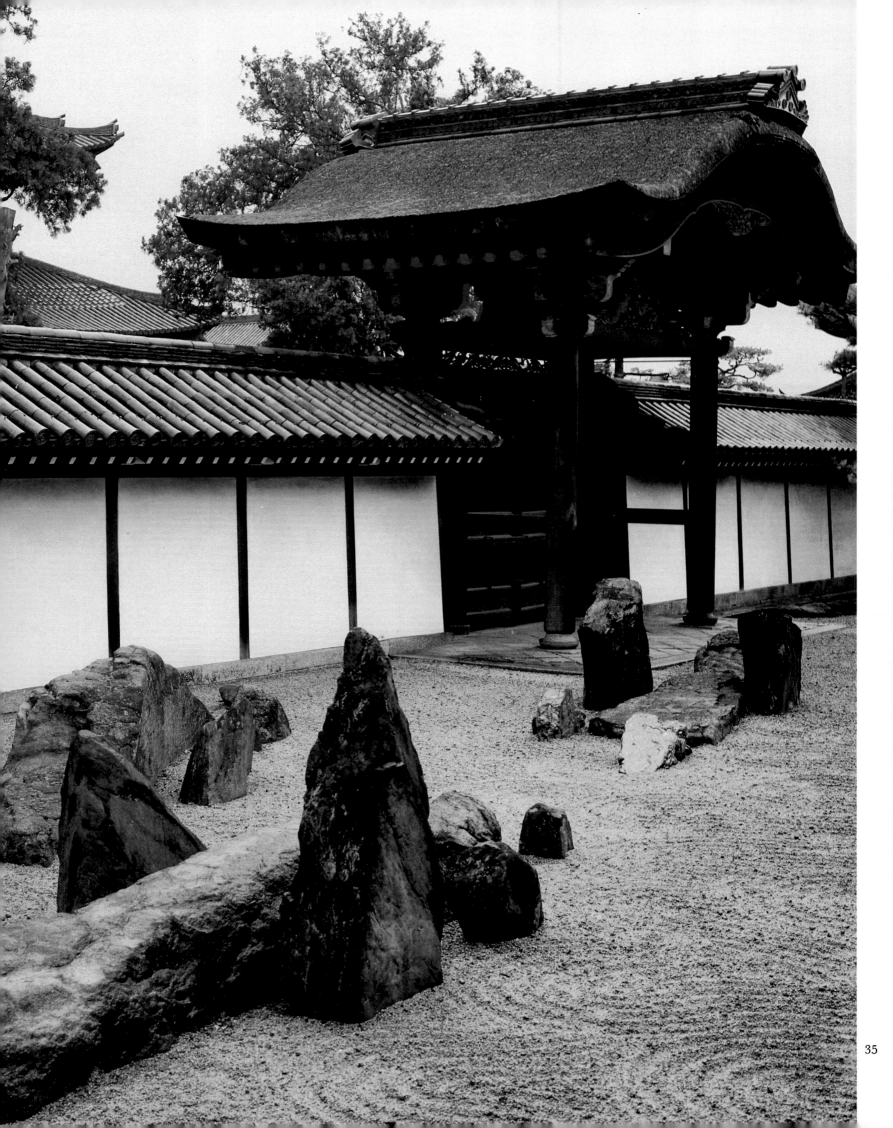

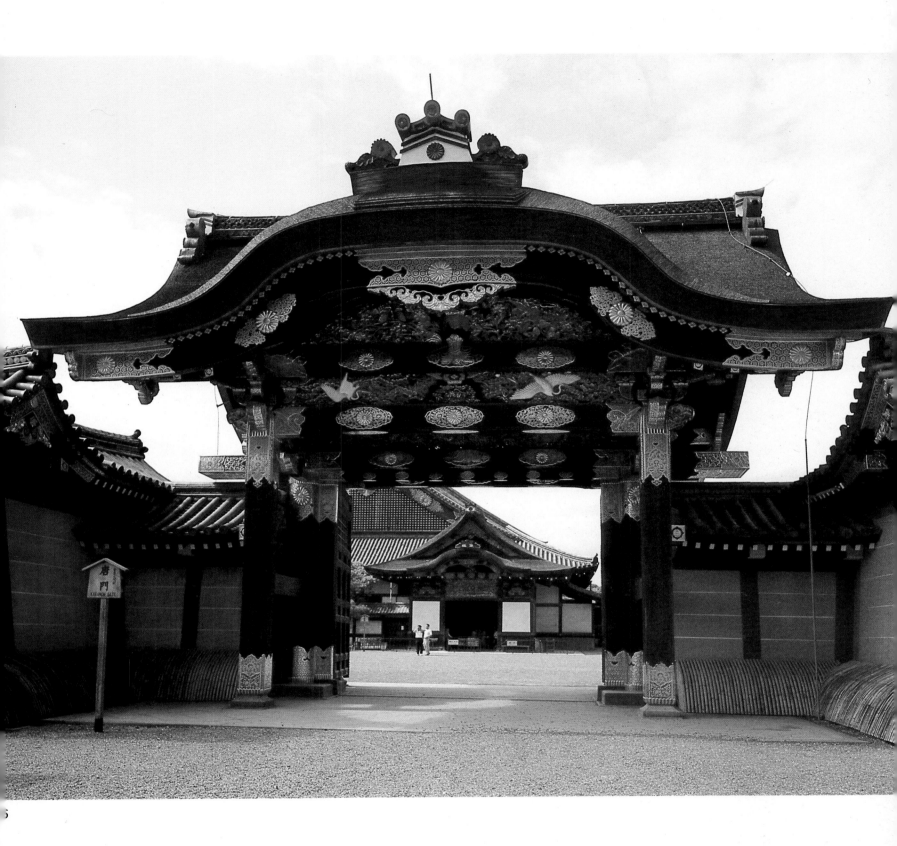

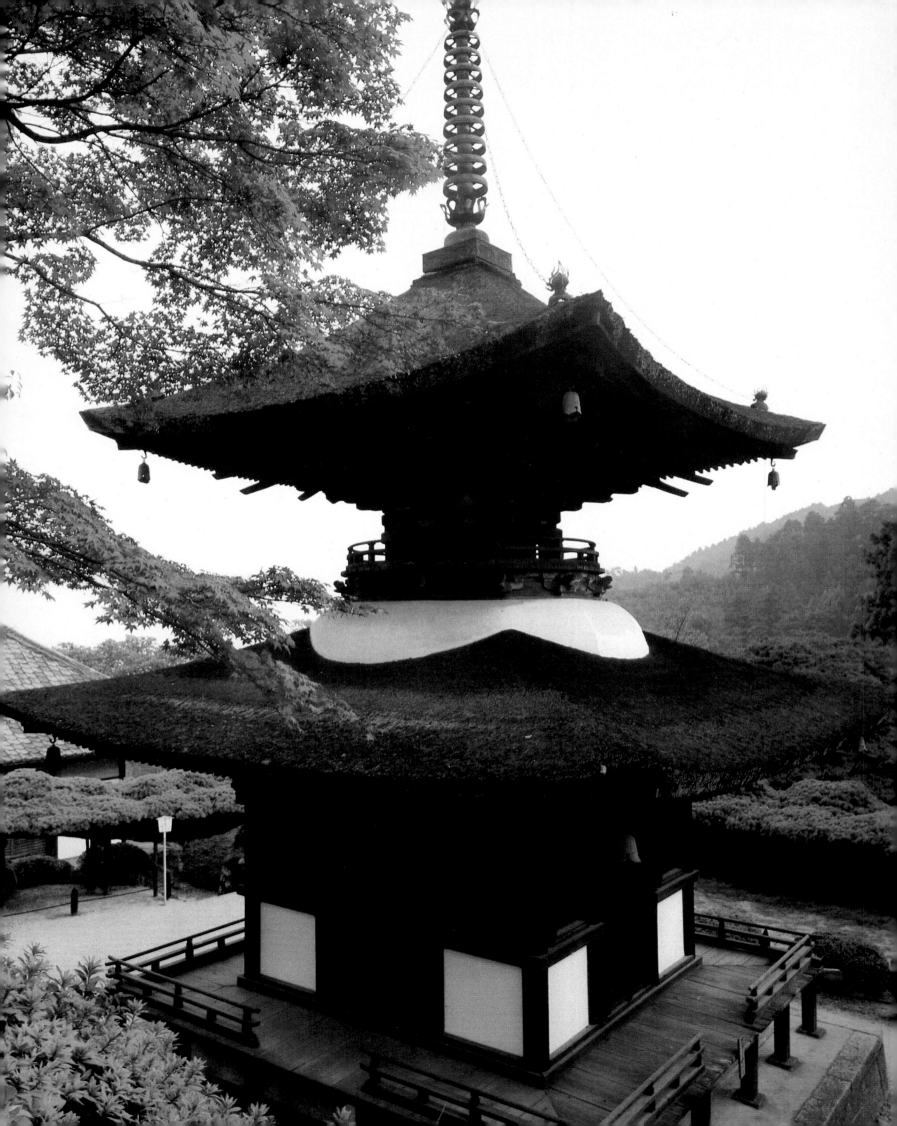

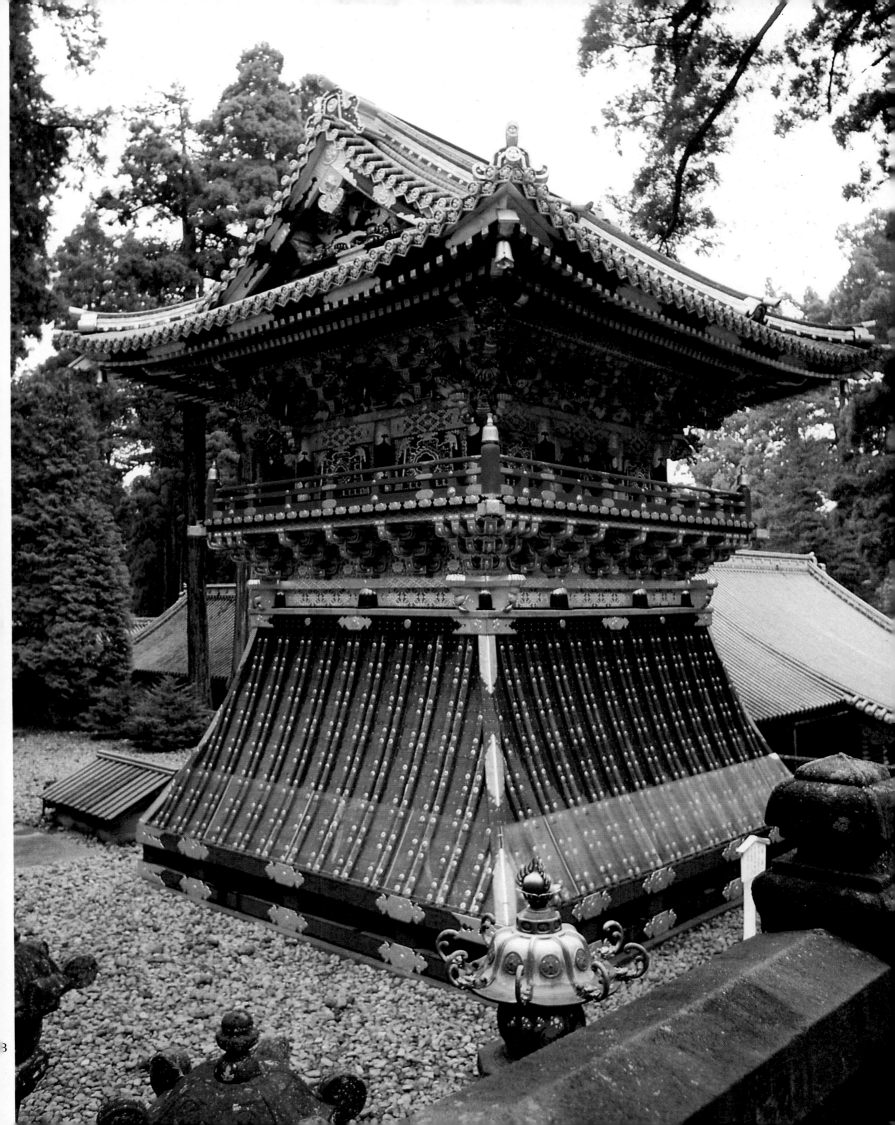

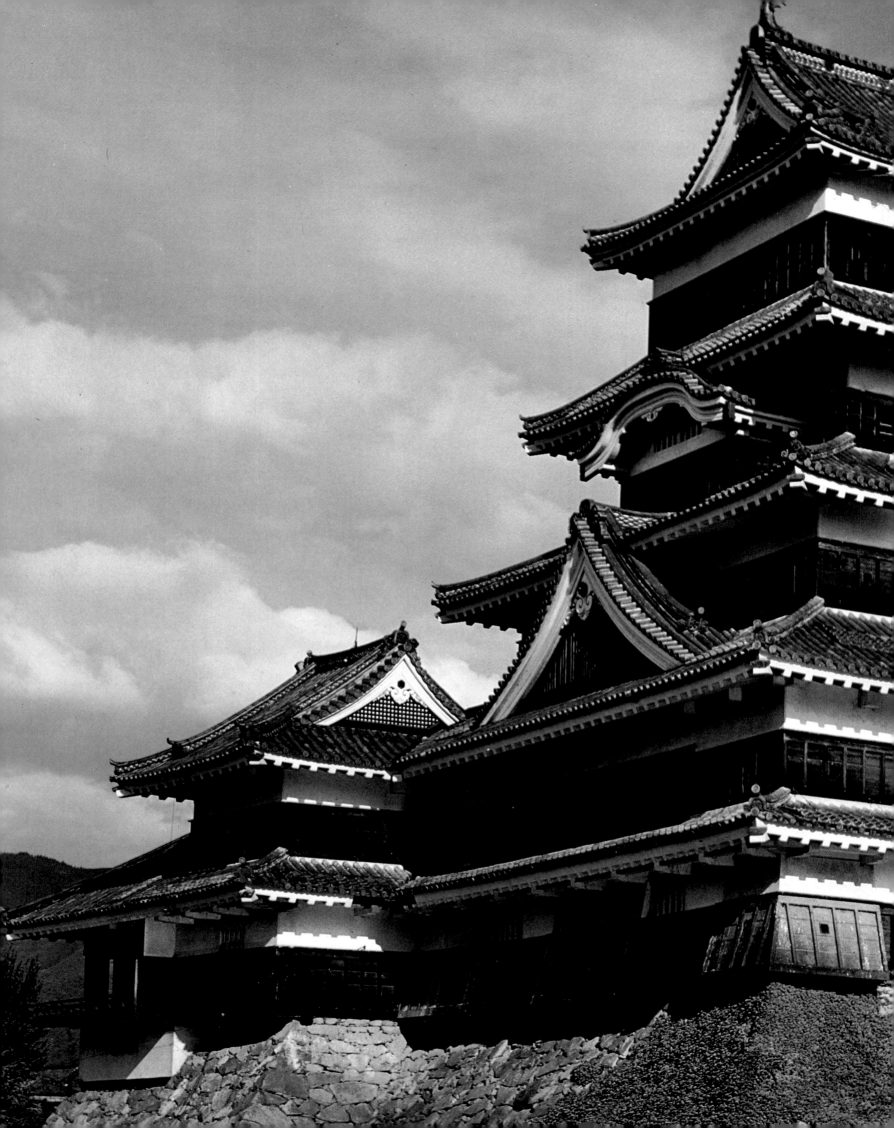

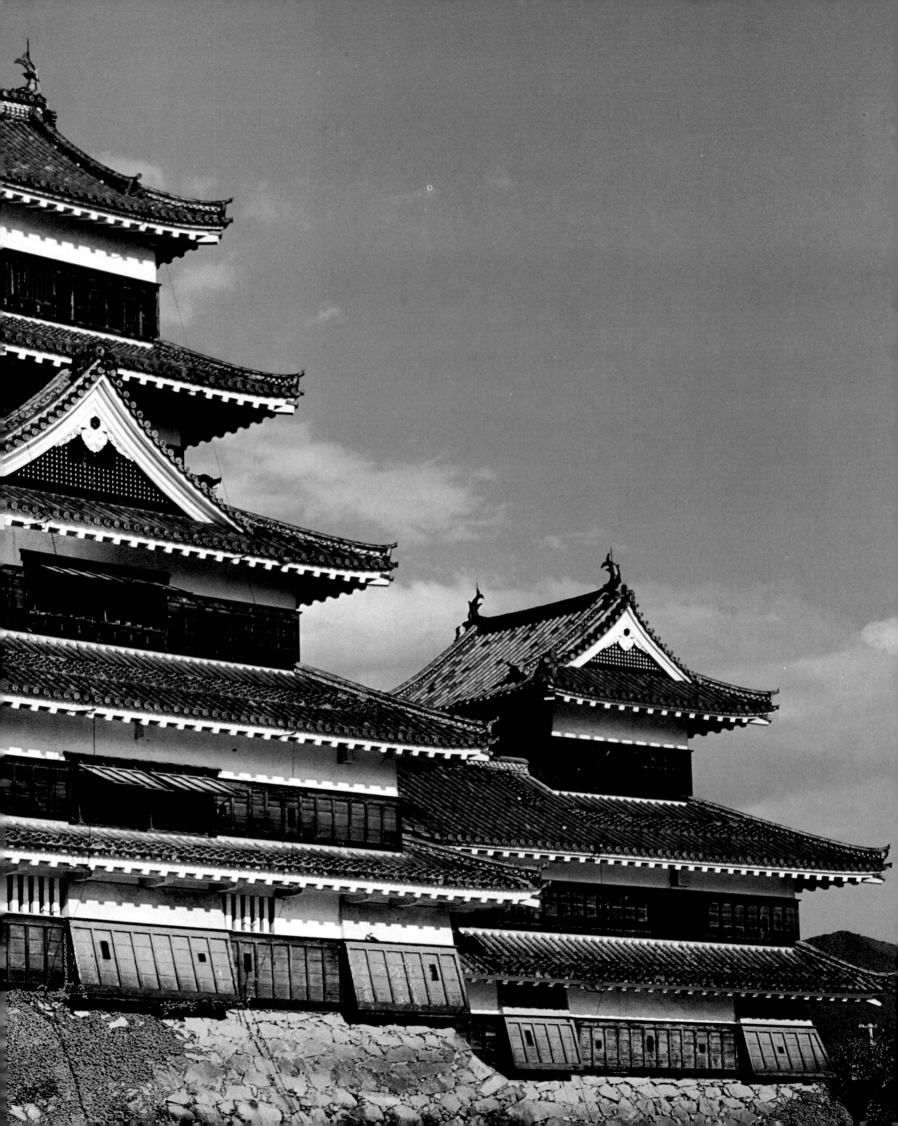

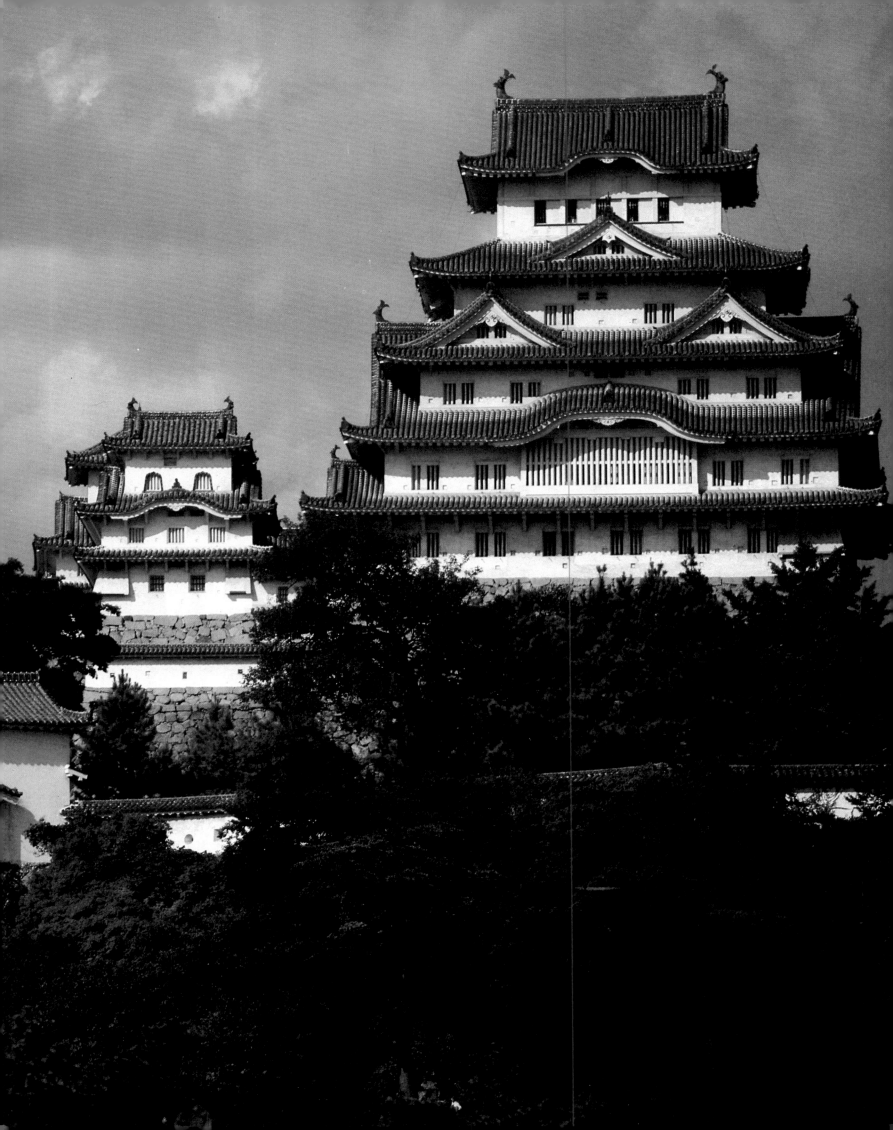

3. THE GODS

3. THE GODS

From Thought to Object

LIKE all peoples who trace their roots to an ancient culture, the Japanese seek in their gods and myths a spark of truth that might shed light on their origins. Our problem is to know the degree to which the Japanese still harbor some hope of finding their identity in this manner, and whether this mythology, like that of Greece or Rome, has proved a source of artistic inspiration.

Today acknowledged as a body of myth in its own right, the legends of Japan are inextricably linked to a single group in society, the imperial family and its related branches, which wielded tremendous moral authority but whose political power was limited by its relatively small size. Critics point out that the great seminal texts of Japanese mythology, the *Kojiki* and the *Nihon Shoki*, were in part modified for political reasons as recently as the Edo period, and that the Japanese, except when deluded by the nationalistic dreams of the war years, have found little of their true heritage in these legends. In any case, artists living prior to the Edo period had no recourse to them.

The removal of the once-sacrosanct *Kojiki* and *Nihon Shoki* from their pedestals does not mean that we must look askance at Japanese mythology in its entirety. If anything, the archipelago appears to have been fertile in breeding such narratives; even when not pieced together and arranged into a continuous literary form, they still constitute a coherent cycle of myths richer than those of China or Korea. Literary historians also stress how many of these tales were carefully recorded in books, although the literary texts do not do justice to the wealth of other ancient narrative cycles still linked to provincial families, and often surviving in traditional local dances.

In this respect, Japan differs markedly from the mainland. What caused the dearth of an "official" mythology in China? Beginning with the Han dynasty, Chinese society was controlled by Confucian or Legist political systems that tended to stifle whatever did not fit into the imperial mold, including the myths and shamanistic beliefs indigenous to lands beyond the Central Plain. The most advanced of these outlying peoples—and the ones to suffer most from the government's authoritarian policies— seem to have been located in the Wu and Yue regions, the very ones which, from earliest times, were to play a decisive role in shaping Japanese civilization.

ALTHOUGH many of the texts that recount Japan's principal legends were compiled at a fairly late date, they passed on a number of ancient concepts that have much in common with myths in Micronesia, Melanesia, Polynesia, and even Europe and North America. This alone gives some idea of the richness and universality of their subjects.

The first of these is an account of the creation of the world as an island people might well imagine it. The earth floated like a cork on the primeval ocean, so the legend goes, until the demiurges steadied it with stones and made it habitable by planting trees that protected it from winds blowing off the sea.

The second myth deals with the origin of the human race. It is the story of an incestuous couple—in this case, siblings—whose procreation is the only possible explanation when an entire people or family must trace their roots to one and the same stock. Such accounts are still found today among peoples of Southeast Asia and Indonesia, where, for example, the story describes a flood that wiped out all of humanity except for a man and his sister; the aura of taboo that later surrounded incest is not present in these myths of the first couple. Most versions mention that the brother and sister lived in innocence and accidentally "learned" how to re-create the human race by watching animals. It should be noted that the Flood theme, so prevalent everywhere else, is not plainly evident in Japanese mythology.

The third myth attempts to ascribe the imperfection of their issue to the incestuous bond of the brother-sister parents. A more elaborate version of this theme developed throughout maritime areas of the Far East. The brother and sister did not succeed in bringing a real human being into the world until they had begotten a strange, fishlike creature that looked more like a child of the sea than of the earth.

IN addition to the various tales that recount the appearance or creation of the world, there are legends explaining how man gradually mastered the techniques that enabled him to survive. The birth of Japanese agriculture inspired two different cycles. According to the more straightforward version—and this is the solar myth *par excellence*—rice cultivation was revealed to humankind by Ninigi grandson of the sun goddess Amaterasu, who thus gave the archipelago its first rice and became its first sovereign. But the legend has a negative counterpart, according to which Japan's first crops sprouted from a victim's corpse: silkworms from the head, rice from the eyes, millet from the ears, red beans from the nose, wheat from the genitals, and soybeans from the buttocks. The corpse is that of Ohogetsu-hime, slain by Susanoō, the sacrilegious and troublesome hero whose "tricky" ways had already forced his sister, Amaterasu, to withdraw to the cave of Awano-iwaya. The version given in the *Nihon Shoki*, though not identical, is structurally the same: an unruly hero, feeling that he has been offended, murders a kind of benevolent goddess from whose corpse sprout all the domesticated plants needed to ensure the survival of humanity. The theme of plants growing from a corpse is also found throughout southern China, as far west as Sichuan Province.

The dualistic nature of the myths dealing with Japan's origins—witness the Amaterasu-Susanoō couple—is significant in that the same idea of opposing but com-

plementary forces (male and female, light and darkness, etc.) appears in Iranian mythology, which also involves a two-fold creation and an ensuing struggle for dominion over the world. Other versions of this theme are still told by peoples of Siberia and Central Asia (the Tungus, for example) as well as by the shamans of Korea. The Chinese concept of *yin* and *yang*, albeit related, differs in that it places greater emphasis on complementary alternation than on conflict.

In what degree did these myths inspire images? The question is in no way easy to answer, for the early Shinto religion which kept them alive for so long was traditionally satisfied with abstract representation, such as the celebrated mirror of Amaterasu. Then Buddhism arrived, and covered the uncomplicated cycle of native legends with its rich veneer of countless icons. Consequently, literature has provided most of what we know about Japanese myths; a few mysterious stone gods are our only tangible link with the deities of ancient times.

Before China had completed her cultural conquest of the archipelago, the Japanese for a time venerated stone gods—human or animal figures that were to be eclipsed by the refined effigies of Buddhism for nearly a thousand years. These curious sandstone sculptures abound in the Asuka region, the very heart of ancient Japan; the subjects range from men, monkeys, and tortoises to entwined, two-faced figures that remind one of a kind of conciliatory Janus. Once the warriors of the Iron Age (*Kofunjidai*) were gone, no one was left—at least, no one in educated society—who could still fathom their message. It was not until 1797 that they appeared in a catalogue of antiquities compiled by Fujiwara Sadamoto, who based his information on the observations that Motoori Norinaga (1730–1801) had recorded twenty-five years earlier in his "Journal of a Straw Hat" (*Kanryū Nikki*).

At least two of these stone gods—discovered in 1903—stand 1.7 meters high and served as fountains, benevolent male and female spirits who presided over woodland springs as they spat a flow of natural water through their mouths. Apart from huge noses, their aspect is rather European, and only a flap of pleated clothing, now much eroded, distinguishes one sex from the other. The male figure apparently once sported an imposing beard (since broken off), and above his upper lip can still be made out what looks like a mustache.

The sacred area around the tomb of Kibi-hime yielded four highly exaggerated figures of men or animals.

Still other stones, like the Suminoyamaishi fountain (height 2.3 m.), are decidedly more abstract. This particular object consists of two truncated, hollow cones covered by a hollowed hemisphere, and recalls the Jōmon phallic monuments of Tōhoku. It is intriguing that this pagan fertility deity, albeit indigenous to Japan, bears decorations of the flowing water and pyramidal mountains that are found on Chinese mirrors from the Han and the Six Dynasties periods—motifs evoking both Mount Sumeru of Buddhism and the Taoist Island of the Immortals. Here, in 7th-century Japan, the beliefs of three active religions have merged in a symbolic treatment of fertility. But

Japanese sculptors were to find their primary source of inspiration for this theme in Buddhism.

According to the doctrines of Māhāyana Buddhism, the worshiper may choose between two different types of "contact" with the divine. He can summon forth the Buddha by reciting his name: this is the celebrated *nien-Fo* (pronounced *nembutsu* in Sino-Japanese) introduced to China by the monk Huei Yuan (334–417). Or the supplicant may "gaze upon the Buddha" (*kambutsu* in Sino-Japanese); it is here that religion entered the domain of art.

Sculptors and painters alike quickly found two avenues beyond merely representing the *lakshana*, or physical attributes of the Buddha: the romanticized portrayal of celestial or profoundly human subjects, and the often terrifying but always spellbinding symbolism of esoteric Buddhism. But at what point do master sculptors take us out of the realm of true meditation and into that of ordinary dreaming? The austerity and utterly spiritual nature of meditation—that fundamental confrontation between the human and the divine—did not seem compatible with all forms of material representation, even when expressed with consummate skill. Chan (Zen) masters, for example, turned their back on the uses of iconography, and not without good reason. Thus, Buddhist art did not lead directly to the "sentimental" style, although it was always bound by a few specific rules that eventually developed in the Sino-Japanese world.

In looking at a Buddhist image, whether painted or carved, the observer must always bear in mind that the hand gesture, in a sense, has more importance than the face. The latter, a reflection of the subject's essential nature must be unchanging; the gesture expresses the particular state in which the deity is captured at a given moment. It is a signal to those who contemplate it, a step on the long path to wisdom. Thus, everything about an effigy must conspire both to underscore the hand gesture (*mudrā*) and not to betray its meaning. Clothing and drapery must be designed in a way that not only emphasizes the gesture, but makes it virtually "of the essence." The Chinese, for instance, took this tendency toward coherence and turned it into one of the major driving forces behind their art. But they also bent backward in their concern for symmetry, even at the expense of meaning: thus they occasionally replaced the *abhaya mudrā* of blessing with the *dhyana mudrā* of meditation for the simple reason, it seems, that the latter lent itself more readily to frontal symmetry.

Although the Japanese *busshi* (sculptors of Buddhist images) were open to any and all styles, they tended to favor the approach adopted by Indian sculptors, who were more concerned with achieving balance than symmetry. Indeed, the prototypes of Japanese art—at least, the ones that the artists of the Asuka period selected—are less often found in northern China than in the more remote regions of western China (Gansu and Sichuan provinces, Maijishan), where sculpture had managed to remain original and open to foreign influences ever since the Han dynasty. Its hallmarks were a heightened feeling for line, movement, and simplification, as well as for combining elongated forms having various volumes.

The path that brought this art to Japan is not as mysterious as might first appear. In all likelihood, it followed the same inland waterways (notably the Yangtze River) that carried commerce to Nanjing and on to the port of Hangzhou, thence to northern and eastern China as well as Korea and Japan. During the turbulent Six Dynasties period and right up to the reunification of China under the Sui dynasty (581), southern China became a veritable repository of the arts and of the outlook that had undergone significant changes in the barbarian-controlled North and had produced artistic blends that were sometimes startling, as under the Wei. The Northern Wei (386–535), great admirers of the Chinese tradition, were unable to maintain the balance they had worked so hard to achieve, and the dynasty split into the Eastern Wei and the Western Wei. Meanwhile, in the South, the Liang dynasty (502–556) was installing over the traditional ideologies the absolute intellectual and religious supremacy of Buddhism, and from this came a vigorous strain of artistic expression. But in 556 the Southern dynasty was defeated by the Northern Wei, who proceeded to deport to northern China the very painters and sculptors who had been influenced by Maijishan. The circle was now closed: northern Chinese art became influenced by that of western China, and a new symbiosis took place. What the Japanese failed to receive through the southern sea routes, they obtained by way of northern China and Korea. One must not lose sight of this long cultural chain if one is to understand Japanese art: the distant archipelago did, indeed, benefit from the experience of Central Asia at a very early date, but the lessons were often modified according to their passage along two routes, down the Yangtze River or across the northern regions. Both routes originated, in a sense, at China's greatest early Buddhist temples: Yungang and Maijishan.

THE northern route—and, paradoxically, sometimes the southern one, too—passed through Korea, where it branched again into two major directions. One led west through the kingdom of Paekche, which, it seems, transmitted art directly from Sichuan and western China; the other was through the eastern kingdom of Silla, which conveyed the Sui dynasty style (581–618) that prepared for the artistic zenith to be achieved by the Tang (618–907). According to Diana Pyle Rowan (*Artibus Asiae*, XXXI, 4, p. 275), these two routes brought about a historic choice in Japan: the Soga clan opened and fostered trade with Paekche, while Prince Shōtoku attempted to consolidate governmental authority by maintaining relations with Silla. As the two sides jockeyed for power and economic supremacy, an unexpected jewel was forged: the astounding, multifaceted synthesis we call Japanese sculpture.

THE development of Japanese sculpture rests first on the mastery of a certain number of complicated techniques, a fact that must be fully understood by anyone wishing to appreciate the particular character of the works. Long relegated to secondary importance, these procedures have now become the subject of intense scientific research in the world of art, abetted by laboratory analysis.

The first significant point is that specialization, as we understand it, did not exist during the early centuries of Japanese art. Guilds were distinguished from one another by the materials worked in them, not by the ultimate destination of the finished product. Those that erected walls of pounded earth also molded the clay cores that would become costly statues of lacquer or bronze. The completion of a work of art was a complex affair that required the participation of many guilds, and thereby the anonymity of the finished object was guaranteed. Creative individualism evolved only after techniques had become simplified, generally during the Heian period (9th–12th centuries).

This chronology differs from the usual timetable for societal evolution, from a narrow to a broader range of knowledge. But Buddhist Japan, as the spiritual offspring of China, began by enthusiastically learning all of China's artistic methods, then gradually discarding those it did not find inherently useful. When compared with the restrained manner that set in with the Kamakura period (13th–14th centuries), the technical diversity within the fledgling Japanese empire (Asuka, Hakuhō, Tempyō) seems prodigious indeed. Guided by Chinese and Korean artisans brought to the shores of the archipelago by personal tribulation or love of adventure, the Japanese accepted immediately a wide range of new media: unfired clay, wood, dry lacquer, cast bronze, and gilded bronze.

In the 6th century, the most sacred Buddhist effigies (*honzon*, or principal images) were made of bronze, a process that not only called for large amounts of copper, tin, and lead in a country relatively poor in metal deposits, but also required a lengthy series of varied operations.

The first step in casting these large bronze statues by the lost-wax process is to fashion a clay mold of the work in two parts: the inner mold (or core), mounted on a crude wooden armature—usually only an ordinary post and pedestal—is covered with sculptured wax, then with one more layer of clay. Bonding (or separating, if you will) the two molds is a layer of wax, and the whole is put into a kiln. In the firing process the melted wax escapes through small blowholes bored in the mold, as molten bronze is poured in to fill the space left vacant by the wax. When the metal shell has solidified come the final and most delicate steps: the outer mold must be broken, and the clay core removed and replaced by a permanent wooden armature.

The making of a dry lacquer statue also starts with a core, but the subsequent processes differ. To this core is applied layer after layer of lacquered hemp. Areas in high relief are reinforced with delicate latticework or stiff cloths. As the artist approaches the desired surface, the texture of the lacquer layers becomes finer. This form, built up so slowly in successive layers, is then dried and polished equally laboriously, and the finished statue is dusted with perfumed powder.

These splendid images of dry lacquer (*kanshitsu*) or bronze were either left unadorned or, more often, covered with a layer of gold that befitted their liturgical importance. The method employed in gilding depended on whether the statue was of bronze,

wood, or dry lacquer. If of dry lacquer or wood, a relatively straightforward procedure used lacquer to bond gold leaf—either in sheets (*kimpaku*) or cut to form decorative friezes and openwork (*kirikane*)—directly to the surface. Craftsmen later developed a cheaper and less laborious method, brushing on gold powder that had been sized or mixed with lacquer, but the results were less durable and less spectacular.

Bronze sculpture required a different approach. During the Asuka, Hakuhō, and Nara periods, craftsmen made use of *tokin*, a delicate chemical process probably imported from Korea. When fixed with mercury (*suigin*), pure gold formed a butter-like amalgam (*keshi mekki*) that could easily be spread over an entire statue. But the difficult part came in disposing of the mercury, for when the coated surface was heated over a charcoal fire the mercury burned off, leaving a layer of gold on the statue. To reduce the mercury completely the process had to be repeated five or six times, always with care, over a low flame. The technique was long and tedious: to gild the Great Buddha of Tōdaiji (fig. 292) took five years, from March 752 to April 757. It was also extremely dangerous, for burning mercury oxidizes into highly toxic fumes. Nevertheless, artisans of the Asuka, Hakuhō, and Nara periods were anything but hesitant about employing *tokin*. The process explains the high copper content of their bronze, nine parts of copper to one part of tin, a proportion that allowed the gold to bond more permanently with the surface.

Another procedure of the time consisted of coating the statue with mercury, followed by a thick layer of gold leaf. As the object was heated, the chemical reaction took place immediately on the statue, but the gilding that resulted was scanty, and what gold remained on the surface tended to disintegrate easily.

In the late 8th century sculptors were confronted with what has been called a "materials crisis" and were forced to find new techniques, for central Japan had depleted its copper resources. It was necessary to shift from bronze sculpture, with its surface modeling (*nenzō*), to direct carving (*chōkoku*) in other materials. Thus the 9th century witnessed a major change in Japanese sculpture. During the Nara period, metal statues had served as models for the wood sculptures that were produced at Tōshōdaiji and elsewhere. The process was reversed during the Heian and Kamakura periods, when wood, Japan's inexhaustible and carefully maintained resource, became the preferred medium, and this led to a new artistic approach. Correspondingly, the few bronze statues cast during the latter periods show a turn to wood statues for their sculptural inspiration.

Simplification and economy seem to have been the watchwords of Heian sculptors. Even lacquerers reduced their work to essentials, now simply applying lacquer to statues already fully carved from ordinary wood (*urushi kokuso*). These fast, inexpensive techniques supplied the esoteric Buddhist sects with the countless deities they needed for their new temples. When making *honzon* (principal images), however, sculptors worked with single pieces of wood of high quality, turning its knots, veins, and textures to advantage with consummate skill.

The method of carving sculpture from a single block (*ichiboku zukuri*), that flourished during the early decades of the Heian period, was less costly than casting the majestic bronze statues of the past. But carved sculpture had its own guidelines and requirements. For the wood of a tall, straight tree is not the same throughout: the heartwood is often hardened and necrotic, for example, without the pliancy and resiliency essential to proper carving. Thus from one trunk, depending on its diameter, one or more cylinders could be cut, each having somewhat less than the tree's radius. This produced statues that were generally small, often elongated, and invariably slender. For bulkier figures, sculptors resorted to another technique known as *uchiguri zukuri*: the heartwood could be scooped out from a wide slit in the trunk, leaving a statue having the diameter of the original tree but hollow in the back. This cavity could be filled with relics and properly sealed, thus giving to the statue its religious importance.

A variation on the single-block technique was to split the trunk in two with wedges. The sculptor, after carefully examining the pieces, would be guided in his carving by the meandering lines and curves of the wood rather than by a preconceived design. This process was called *ichiboku wari hagi zukuri*, or "cut and bring into harmony."

These physical imperatives account for the appearance of single-block sculptures from the 10th and 11th centuries: they are either very slender, or wider but carved in very low relief to avoid cutting through to the hollow interior. Hinoki and kaya wood were especially valued for their extreme hardness; sculptors could carve highly detailed reliefs on their relatively thin surfaces, which led to the calligraphic appearance of "rolling wave" drapery (*hompashiki*). But Japanese artisans, fascinated by the beauty of precious woods, soon turned away from this technique, considering the effect too mannered.

The revolutionary "joined-wood" technique (*yōsegi zukuri*) intervened in the 11th century, making it possible to create large wooden effigies and to transport them relatively easily from the carving site to their permanent installation in the new temples. These sanctuaries were usually in remote locations, reflecting the new introspective, withdrawn lifestyle with its greater emphasis on meditation.

A statue carved in the *yōsegi* manner consisted of at least five pieces: one for the entire front, two for the back, and two for the arms. If the veining of the wood offered no aesthetic appeal, or an injudicious cut or unforeseen splintering had caused a fissure in a critical part (such as the face), the entire surface was lacquered to cover the joints as well as the defects in the wood. The joined-wood process, which allowed artisans to retouch at will and create a wide range of works, proved especially well suited to the needs of the sentimentalist sect of Amida Buddha that blossomed during the Heian period. An ever greater number of images could now be carved of intercessors, saints, and compassionate guides along the narrow path toward Illumination.

Sculptors using the more "flexible" *yōsegi* process had to accommodate a new set of objectives as the preoccupation with decorative effects gave way to a concern for physical structure: how to conceive the parts of a whole? How to fit them together and form a single, harmonious work? No longer were statues restricted to the domain of in-

spired craftsmanship, for the use of wood raised much the same theoretical issues as those confronting architects. A number of sculptors developed their own approaches to these problems, and a few individual artists began to emerge from the nameless "teams" of the past. Jōchō (d. 1057) was the first in a line of 11th-century "Nara sculptors" (Nara horimonoya), and one of his descendants, Unkei (1151–1223), founded a brilliant school of busshi, or sculptors of Buddhist images (Jōchō: figs. 51, 264; Unkei: figs. 76, 284, 285).

Even though the prolific output of Japanese sculpture has now and again been disfigured by time or unfairly dismissed as a meaningless voice from the past, it continues to fascinate us today, though we cannot always see these works in their original setting or understand the psychological climate at the time of their creation. Who now remembers, for example, that the remarkable Tōshōdaiji, along with its workshop of Chinese-inspired sculptors, was nothing more than a private temple in the 8th century, on the fringes of Japan's artistic hierarchy and the "official" sculptural schools of Tōdaiji and Saidaiji? Its impact on the evolution of art was nonetheless considerable throughout the archipelago, but in the 8th century it was neither Tōshōdaiji nor its founder, Ganjin, that set the fashion at Nara.

WHAT was the "Nara" style? Here we will put aside the technical minutiae and thorny questions of attribution and turn instead to the images and effigy-types that for centuries mirrored the faith of an entire people. Theories about archaism and its criteria may well find themselves turned upside down.

The oldest Japanese statue we know of today is the bronze Buddha in the Asukadera (the temple at Asuka), a small sanctuary at a distance from the metropolis of Nara, that once pulsed with a quiet vitality all its own (fig. 198). It competes for this priority with the bronze Buddha known as the Asuka Daibutsu (fig. 199), created as some scholars believe by the Tori family (Busshi kuratsukuri no Tori) in the fourteenth year of the reign of Empress Suiko, or 606 A.D., seventeen years earlier than the famous Shaka Triad of the Hōryūji in Nara (fig. 200). The mysterious origin of the Asukadera Buddha has led to animated disagreement; little remains today of the original, which has undergone a number of clumsy restorations, but in this mutilated image there still glimmers some of the light of the unquestioning faith of the Northern Wei that traveled from far-off western China to Korea, and then to Japan. This was the beginning of an extraordinary "explosion" of statues that are to be admired for their quality and their quantity. Even before Nara became the capital of Japan, the bronzesmiths of Asuka were already in the footsteps of their great predecessors on the mainland. First had come the influence of Paekche, which favored the meditative, introspective type of divinity we see in the Asukadera Buddha (fig. 198); then, influenced from Silla, came the smiling, idealized gods (650) and more serious, almost sullen effigies (c. 670–685), culminating in the rotund type of Buddha exemplified by the Yakushi Nyorai of Yakushiji (c. 700), a direct offshoot of Chinese prototypes.

Was the Yakushiji Triad—Yakushi flanked by two attendants (figs. 48, 210,

211)—created in 697, or perhaps some twenty years later, during the Yoro period (717–724)? The damage sustained by the Triad during the Yoshino earthquake of 1952 necessitated repairs that led to a thorough technical study of the work and equally interesting publications; although the answer is no more definite than when the debate began half a century ago, the investigation demonstrates that valuable information came from what sometimes seemed pure and sterile erudition. It was noted during the restoration that the pedestal consisted of four sections and that the central Yakushi figure had been cast in one piece except for the right arm, head, and drapery. This did not go contrary to what was already known about the casting of statues at the time; but certain details proved intriguing: the core (katemochi) consisted of an exceptionally thick copper plate (approximately $\frac{1}{2}$ in. or 1 cm.) studded with nails, a process otherwise known only with the massive head of Buddha at Kōfukuji, of 685, which was also cast from a core studded here and there with long iron nails still visible inside the statue. And a final observation, important for technique: the bronze of the Yakushi pedestal contains a great number of blowholes. This information has helped investigators to narrow the span from the *terminus a quo* to *ad quem* during which the statue was cast, but does not yet give an exact date.

This may seem of no great consequence, but behind it lies another problem. Did the early Tang style (with its strong influence of Gupta art from India), which the Yakushiji Triad illustrates so superbly, reach Japan before or during the Nara period? The answer is important, for it was this work that led to the "Tōdaiji" style in Japan, referring to the great Buddha that is its most awe-inspiring specimen (figs. 49, 212).

It would seem that the major Sino-Japanese art produced during the 8th century had actually begun to take shape long before, around the same time that the new influences were coming from China. Thus the Asuka period (7th century), usually seen as totally dominated by the bulky and energetic, but nevertheless stiff and archaic manner of the Tori Busshi, may also have known a style that stemmed directly from Northern Wei art of the Six Dynasties period (i.e. Tianlongshan, Gong Xian, Xiangtangshan). On the seated or standing figures from the Asuka period the drapery covers both the shoulders and falls in symmetrical folds, exactly as on Chinese figures at Yungang or at the Binyang cave of Longmen. Radiating a joyous liveliness, their graceful bodies and round, sweetly smiling faces convey something of the feminine charm peculiar to the monuments at Gong Xian (Henan Province).

Likewise, the appearance of the "Amida Triad" theme—Amida Buddha had become a subject in Japanese sculpture long before the Amidist-inspired doctrine of salvation overspread the archipelago—was not only important for the creation of the celebrated Shaka Triad of Hōryūji (fig. 200). This Shaka Triad is a pure example of the Tori style: systematic frontality and symmetry translated into lines and massive volumes; drapery in folds of close-set curves, parallel and precise; half-closed eyes; and smiling mouth finely chiseled and full, animating a flattish face that suggests a close link with the contemporary Three Kingdoms period of Buddhist art in Korea. And indeed it was Nara craftsmen who helped popularize this interpretation. Yet we must not forget that the same period produced another style that came directly from China, one

perhaps less intellectual than the Tori manner, but more accomplished in its modeling and free of Korean stylization.

THE technical mastery of the craftsmen of the Asuka period made it possible for their Nara counterparts to assimilate fully the realistic, expressive Tang style and to create works that rivaled those fashioned on the mainland. It would be incorrect, however, to conclude that the statues produced in the fledgling Japanese empire were in complete conformity with their Chinese prototypes. The pool of Sino-Korean knowledge about sculpture was vast, and Japanese sculptors, as well as foreign craftsmen working for Japanese institutions or wealthy patrons, had much to choose from. The most conspicuous decision—the one least prompted by personal caprice—concerned the poses. A bodhisattva, for example, so frequently represented at Yungang and Longmen as seated on a high seat with legs crossed in an X form, the tips of the toes touching the ground, almost never appears in that pose in Japanese sculpture in the round. On the other hand, the "meditating bodhisattva" pose seen at Longmen—right foot resting on left knee, left leg hanging down, right arm resting bent on right knee, and right hand supporting the chin, and the "waterfall" drapery typical of the Northern Wei style—underwent in Korea and Japan a modification toward restrained simplicity and mysticism that surpassed that of the continent. The most celebrated specimens of the latter pose are the Maitreyas (Buddhas of the Future) of Kōryūji at Kyoto and in the Chūgūji of Hōryūji at Nara (fig. 41).

As far as we know, the characteristic halos of Northern Qi stone statues (550–577), in which flying deities (apsaras) and treelike patterns are so skillfully blended, never had any direct counterparts in Japan, but the Japanese metalworkers were masters of openwork and devised countless variations on the flames and undulating banners favored by the Northern Wei (6th century).

When other iconographic types entered the repertory of Japanese forms, they were adopted only in part or by a single group of craftsmen. The pose of the Buddha on a high seat with each foot resting on a lotus blossom occurs frequently in Japanese art, but only on terracotta tiles and reliefs.

The story of these types, the rich threads of Chinese art becoming multiplied and entangled as they progressed along the way to Japan, is a most curious one. Characteristics of the Northern Wei manner are frontality, and smiles accentuated by strongly curved lips, especially as embodied by those figures at Longmen with long cascades of upturned drapery. But the light, airy drapery of the Guze Kannon (Yumedono of Hōryūji) does not echo the unyielding stone of Longmen so much as the sculptural approach seen at the cliff of Maijishan (Gansu Province). In the Kannon we see the same trompe-l'oeil effects as at Dunhuang, that vibrant world where painting and sculpture joined forces to create a fleeting glimmer of the invisible spirit world that surrounds us. The artistic signals that the "fringe" cultures of Korea and Japan were then responding to emanated less often from China proper—that is, the Yellow River basin—than from regions in central Asia, where cultural interaction fostered the growth

of many hybrid styles. Yet the statues created for official temple use did retain something of the austere grandeur typical of the Chinese "bureaucratic" approach.

The most awe-inspiring expression in Japan of that "political" style (as opposed to that expressing religious ardor) is the Great Buddha of Tōdaiji (fig. 212). The iconography of this renowned statue cannot be understood without alluding to the *Brahmajala-sūtra (Bommokyō)*, a Kegon text that had considerable impact on the growth of the Tendai sect and on art of the Tempyō era in general (725–794). Moreover, it demonstrates that neither the religious nor political implications of this type of statue can be fully appreciated from a purely stylistic or "structural" point of view.

In all likelihood, it was the Chinese monk Tao-Xuan (Dōsen in Japanese) who brought the *Bommokyō* to Japan; certainly he was instrumental in the prominence it gained in the archipelago. After his arrival in 736, he taught in Nara at the Daianji temple under the aegis of Emperor Shōmu, and within twenty years, public readings of the *Bommokyō* were being held in all of the major temples. Tao-Xuan's successor, Chien-Chen (Ganjin), came to Japan in 753 and, after being granted imperial protection, taught and deepened the tenets of Tendai; like his predecessor, Ganjin stressed the *ritsu* "laws"; and Tendai was first known as a doctrine of ritual and discipline before Saichō (Dengyō Daishi) established it more generally in 806.

Before it gained the iconographic importance that the Great Buddha of Tōdaiji illustrates, the *Bommokyō* had a decisive impact on the political thinking of Emperor Shōmu (r. 724–749). The hierarchy of Buddhas described in the sūtra provided him with an unambiguous picture of the function of the body politic and the emperor's role within it. Locana created a thousand greater Buddhas, the *Bommokyō* states, each of which in turn gave birth to thousands of lesser Buddhas who spread the "good word" throughout countless worlds. For Emperor Shōmu this was a heavenly model of the chain of command here on earth, with the emperor in the role of Locana and his civil servants as the greater and lesser Buddhas. These visions explain the powerful grip of Buddhism on the rulers of Japan; Buddhism supplied them with a political structure and its own spiritual legitimacy. The Great Buddha of Tōdaiji, perhaps the largest bronze statue in the world, seems like a pure embodiment of this ideology, blending philosophy, religion, and political thought.

The idea to have the Great Buddha cast in bronze came to Emperor Shōmu in a moment of "divine" inspiration: an effigy of Locana (Roshana) Buddha would protect the country from a thousand misfortunes, just as the Locana at Longmen was believed to watch over China. Casting of the statue began late in 744, and was only completed five years later, in 749. Many problems arose from its gigantic size—work had to be started afresh no fewer than five times—and gilding the Great Buddha raised a complication of a different kind. Emperor Shōmu, who attached symbolic importance to this final step, insisted that the gold be found within Japan, and the gods seemed to smile on his empire, for gold was discovered that very year (749) in the northern part of the archipelago. A few more years were required to complete the massive gilding process and to construct a hall large enough to accommodate the stupendous effigy. The celebrations and ceremonies that took place upon its completion were attended

by the abdicated emperor Shōmu, his wife, the empress Kōmyō, and the reigning empress Kōken (749–759); the extraordinary treasures sent to the Tōdaiji and preserved in the Shōsōin attest to the splendor of the occasion (see figs. 748–50, 753).

Like other monuments dating from this period, the majority of which are no longer extant, the Great Buddha was destined for hardship. In 855, about one hundred years after the dedication ceremony in 752, the statue was damaged by an earthquake. It was restored, only to fall victim to the civil wars that rocked Japan in 1180 and in 1567. The repairs made in 1691 left the statue in the state we see today: what remains of the original 8th-century work is a part of the torso, the legs, and a few lotus petals. The original face is long a memory: worshipers now see the soulless expression given it by uninspired craftsmen of the Edo period, a time of impoverishment and "bureaucratization" of the faith.

Nevertheless, the figure's pose remains intact, and the scenes incised on the surviving lotus petals also indicate that the Great Buddha scrupulously follows the description of Roshana as set forth in the *Bommokyō*:

"Children of Buddha, listen closely to me; weigh my words carefully and conduct yourselves accordingly. For countless *kalpas* I have practiced the attributes [of bodhisattvas] and the stages of perfection. I have made them my guide. I began by forsaking the world and I achieved *samyak-sambodhi*. My name is Locana. I sit on the lotus throne that contains the worlds and oceans. This throne is surrounded by a thousand petals. Since each petal is a world, there are a thousand worlds. I transform myself into a thousand *Sakyas* that correspond to those thousand worlds. Furthermore, upon each petal that is a world there are a hundred million [Mount] Sumerus, a hundred million suns and moons, a hundred million worlds in each of the four parts, a hundred million *Jambudvipa*. A hundred million Bodhisattva-Sakyas are seated beneath a hundred million bodhi [sacred fig] trees, each of whom exemplifies the attributes and path of a Bodhisattva that you invoke.

"Each of the thousand *Sakyas* produces thousands and hundreds of millions of *Sakyas*, who do likewise. The Buddhas on the thousand petals are transformations of myself; the thousands and hundreds of millions of *Sakyas* are transformations of those thousand *Sakyas*. I am their source and my name is Locana Buddha" (transl. S. Elisseeff, *Harvard Journal of Asiatic Studies*, I, 1936).

Amid the surge of tourists in the temple and the bustle of souvenir hawkers, and the occasional din of restoration activity, who still remembers today that the Great Buddha of Tōdaiji is the City of God as seen through Far Eastern eyes?

THE developments that Buddhist sculpture underwent as it passed from the Nara to the Heian phase—more precisely, from the Tempyō period (729–749) to the Jōgan period (859–879)—reflected radical changes in the religion and in the material conditions facing craftsmen at the time.

Whereas Nara artisans worked essentially with bronze and dry lacquer, the chosen medium of Heian artisans was wood. The only workshop in the Nara vicinity

that had regularly used wood was at Tōshōdaiji, where Chinese techniques were fostered. Its influence would be great, but not until later, at the beginning of the Jōgan period. In one sense wood sculpture left in a pure, uncovered state can be considered a less fine—or, to avoid pejorative overtones, a simplification—of the earlier lacquer-covered wood statues, themselves related to the superb works in dry lacquer.

We have already touched upon the principal techniques and on the traditional explanations by historians of the increasing complexity or simplicity of technique. Modern scientific methods, however, have revealed facts invisible to the naked eye that have shed new light on an evolutionary "timetable" that had become oversimplified. The scientist Kuno Takeshi made X-rays of some twenty lacquer-over-wood statues, in date as far back as Early Heian times, and discovered that these works were assembled from several pieces of wood. He concluded that the *yōsegi* or assembled technique, so often discussed solely from mature works of a particular phase, has been unjustly isolated from its true beginnings.

The earliest wood sculptures from the Jōgan period—the years just before the "closing" of Japan—are the statues of Yakushi Nyorai at the Jingoji in Kyoto, which dates from 824 (figs. 43, 250), and at the Shin-Yakushiji in Nara. Both works attest to the impact of the sculptors of Tōshōdaiji, whose influence apparently gained power some thirty years after the imperial court, fearful of the overbearing religious climate at Nara, had been relocated far from the capital.

Material considerations seem to have had as much to do with this change as the purely spiritual developments that occurred when *Kūkai* (774–835) brought the mysteries of esoteric Buddhism to Japan. The emperor's decision to move the capital from Nara was part of a carefully weighed plan to secularize the State, much as the Chinese had done. The major temples, stripped of government sponsorship, found their status reduced to that of private institutions. None had the financial means either to obtain the raw materials or to maintain the many artisans needed for the long, delicate process of making bronze and dry-lacquer statues. Thus, the disappearance of the key workshops coincided with the government's decision to withdraw the support it had once lavished on the temples. The only workshops to survive and flourish were small ateliers that made wood sculpture, for the abundance of that material and the relative ease of carving it made for a craft that was not only profitable, but better adapted to the new religious circumstances.

During this period many priests and monks had left the sprawling, almost bureaucratic religious communities of Nara to seek in the mountains a more secluded form of monastic life. These hermit-monks required for their worship only small, uncomplicated images, so long as the canons of Buddhist iconography prevailed, and these monks, like the individuals who set up private altars in their homes, found wooden effigies sufficient. The *busshi* (master of religious effigies), who had made the transition from artisan to civil servant, was now relegated to the ill-defined category of ordinary sculptor. No longer part of a team, he struck out on his own. Apparently, the resulting revolution in technique entered its first stages even before intellectual and political changes brought about this new style.

A careful examination of Japan's oldest and finest wood statues—such as the Miroku Bosatsu of Chūgūji (fig. 41)—reveals the true origins of the joined-wood or *yosegi* technique, of fitting together several pieces of wood to form a single work. Considering the difficulties involved in carving a relatively large statue from a single bole—the heartwood that usually tended to split slantwise, and therefore had to be hollowed out—it is quickly evident that the sculptors carving such seated figures with the left foot hanging down, right arm resting on the bent right knee and supporting the head, had no alternative but to make "joints," at least for the slender, delicately articulated arms and legs that were detached in whole or in part from the torso. Once sculptors understood the principle and acquired the technique, they saw no reason to reject a process that facilitated their work and allowed them to select pieces of wood having the most aesthetically pleasing grain.

A careful study of the Miroku Bosatsu led Sherwood F. Moran (see Bibliography) to conclude that the renowned statue, including the pedestal but excluding the halo, consisted of no fewer than twenty-four pieces. Thus the chronology of sculptural types must be modified, bearing in mind that the term *ichiboku* ("single-block") has in Japanese a broad meaning that for us is necessarily imprecise. A statue can be referred to as *ichiboku* if an important element—head or torso—is carved from a single block even if its appendages have been made separately.

The simplest and most popular approach for small or medium-sized works was to carve the head and body separately, but a number of statues required a different cutting to produce a front and rear, or right and left sides. The *yōsegi* sculptor found himself in much the same dilemma as the single-block sculptor: he had to use the bole at its greatest semicircumference and hollow out the heartwood. This rudimentary type of *yōsegi* technique was used for such works as the Fudōsanson of Myōōji at Osaka (1094) and the Dainichi Nyorai (1185) of Yosōji at Gifu. The most common solution was to make a front and back section and to position the head joint behind the ear; by the late Fujiwara period, Japanese sculptors had become past masters of the two-part *yōsegi* method.

Actually, *yōsegi* sculpture was not a full-blown revolution but the outgrowth of expedients long in use. The "front-back" technique can already be seen beneath the lacquer of the Yakushi Nyorai of Kōzanji, west of Kyoto; the late 8th-century Dainichi Nyorai of Tōshōdaiji also consists of several pieces of wood covered by a layer of lacquer (fig. 253).

It would be arbitrary to limit Chinese influence on late 9th-century Japanese culture to the sphere of politics. The interest in mainland techniques appears to have provided the impetus for the revival of *yōsegi* carving, which had once been popular among the master sculptors of Nara, only to be abandoned in the wake of the "nobler" *ichiboku zukuri*. Whatever the navigational hazards of the time—and even if no new Chinese pieces reached the archipelago until the 12th century—Japanese sculptors evidently continued to copy Chinese prototypes throughout the 10th century. Nor can it be doubted that the Japanese were exposed to Song sculpture at the beginning of the 12th century, but the joined-wood technique had already regained popularity in Japan a

hundred years earlier, during the first half of the 11th century: witness the huge Thousand-armed Kannon (1012) of Kōryūji. The front of the head and body was carved from a single piece of wood (although the face shows two sections joined across the bridge of the nose); the rear is made of two pieces, head and torso. The celebrated Amida Nyorai by Jōchō, in the Hōōdō of Byōdōin, is more complex but follows the same general pattern of assembly (figs. 51, 264), though the two statues are worlds apart in their treatment of the subject. Jōchō's masterpiece, with its densely packed volumes, remains an eminently spiritual work and thus stands outside the Chinese Buddhist mainstream, so often characterized by a tendency to picturesque effects and relaxed poses (such as the so-called posture of "royal ease"). The Japanese sculptors also exploited with uncanny skill every possible cut and grain of the wood, far surpassing their Chinese and Korean counterparts in putting the *yōsegi* theory into practice. Iconography played a pivotal role in the composition of a statue: a seated Buddha was usually assembled from only two or three pieces of wood, whereas standing and especially gesturing figures—heavenly kings, temple guardians, preaching apostles—required an altogether different approach.

In consideration of these factors, Kuno Takeshi spent several years studying *yōsegi* sculpture, and determined nine distinct compositional types that evolved during the 11th and 12th centuries, nine solutions that Kamakura sculptors turned into masterpieces of movement and expressionism.

The first type is the one Jōchō selected for the Amida Nyorai in the Hōōdō of Byōdōin. As mentioned above, the front of the head and torso is formed from a single piece of wood, to which are added pieces at right and left for the limbs. The back of the head and the back of the body are each in two sections, a total of four pieces for the back of the statue (right head, left head, right body, left body). This is the "right/left, front/back" method that is still practiced in Kyoto, where sculptors have remained true to the spirit of the great Jōchō.

The seated Dainichi Nyorai of Shoshanji in Wakayama, which dates from 1062, is an example of the second *yōsegi* statue type: body and head are separate, and each has a front and rear section, four parts in all. The third category includes the Eleven-headed Kannon (1069) of Kanseonji at Fukuoka, a splendid piece carved from *kusunoki* wood (fig. 266). The two parts of the head, joined along the vertical axis of the ears, and the two parts of the body, joined along the sides, create the illusion from front and back of a single piece of wood. The Yakushi Nyorai (1085) of Fugenji in Nara illustrates the fourth approach. Apparently this work started as a "rough" single-block torso to which were added the face (or an assemblage of facial features) as well as the limbs carved from a number of separate pieces.

The fifth type of joined-wood sculpture can be seen in the seated Amida Nyorai (1096; fig. 265) of Jōdōin (Kyoto). The body and head are separate, each consisting of two sections, but the head is divided into front and back pieces, the body into right and left components. The Tarōten (1130) of Chōanji (Oita Prefecture, Kyūshū) provides an example of the sixth type: in addition to the four main parts comprising the head and body, several additional pieces form the limbs. The figure is flanked by two

118

smaller single-block attendants, proof that artists at the time had not fully abandoned single-block carving and used the joined-wood technique only when the size of a statue made it virtually impossible to carve the entire figure from one piece of wood. The seventh category includes such works as the Yakushi Nyorai figures of Kyoto's Jōruriji (1140; fig. 267) and Kōmyōji. The head consists of two pieces, while the body is essentially a single section, though "supplemented" with other pieces.

The Shaka Nyorai (1151) of Hōrakuji (Kōchi) is a fine example of the eighth type: the head and body were carved from a single piece, to which the sculptor added secondary elements of his choosing. The ninth and final category is represented by the Amida Nyorai of Shōbodaiji in Kanagawa, whose body and head are separate and each divided into right and left halves. In this, as in the eighth type, the cavity hollowed from the back section is covered by a flat board.

The lesson to be drawn from this enumeration is that master sculptors in Japan were in full command of *yōsegi zukuri* as early as the late 11th century. In practice, however, this technique was used only for *honzon*, or large-scale effigies; single-block carving remained the usual method for smaller statues representing lesser deities. For lack of metals, *yōsegi* wood sculpture had replaced the once popular bronze statues.

History has left no significant records of the renowned Jōchō (d. 1057) or of his father Kōshō (fl. 998–1020), also a sculptor. A text from the early Kamakura period makes mention of "Jōchō, son of the 'Great Master of Buddhist images,' Kōshō [or Kōjō]." The family was referred to explicitly when nine statues created for the Amida-dō of Hōseiji were recorded in the temple archives for the year 1148: here is written evidence that Kōshō and Jōchō were indeed father and son. Lastly, there is recorded proof that the two worked together on the Dainichi Nyorai of Enjōji, near Nara. Kōshō was probably active from 998 to about 1020. In the absence of specific data, we must assume that Jōchō had lost his father at a relatively early age, and was already working on his own while still young. It also follows that Jōchō's majestic Amida Nyorai (1053) in the Hōōdō of Byōdōin dates from his maturity (fig. 51); his example was to inspire sculptors throughout the Kamakura period.

Technical considerations aside, what characterized Jōchō's style? Every Japanese, whether ordinary worshiper or serious scholar, looks upon the Amida in the Byōdōin as Fujiwara sculpture at its most sublime, a harmonious blend of power and delicacy. They admire both the lightness and serene earnestness of the round face, with its small, unobtrusive mouth and nose that are counterbalanced by sparkling eyes lowered in the direction of the supplicant (a *honzon* was always composed from this vantage point). In this dazzling, yet emotionally charged effigy, Jōchō struck a subtle balance between Nara art, heavily influenced by grandiose Tang statues, and the Kamakura school, whose Song prototypes were more mannered but also more directly humane.

However engrossing is the study of forms and their lines of evolution and aesthetic implications, it does not describe the whole nature of an image. A statue has its own life that suffuses its substance over the centuries as a soul fills a body. People approach a divine image by endowing it, as one does a child nearing adolescence, with all the qualities they deem indispensable to life in their own world.

A fine example of such an image is the statue of Sakyamuni (red and black lacquer over sandalwood: 985), doubtless a copy that Chōnen, a monk of Tōdaiji (d. 1016), brought back from China in 988 (fig. 257). Mystery surrounded the statue, for it was a *hibutsu*, a sacred image hidden behind the great altar of Todaiji and concealed by a curtain that was lifted only slightly on solemn occasions. Legend has it that the Sakyamuni was brought from India and made only a "visit" in China, but a look at its style leaves no doubt that China was where it was created. The image was moved in 1022, six years after Chōnen's death, to a temple that had once been the residence of Minamoto-no-Tōru (822–895) in Kyoto. Originally called the Seikaji, it was re-named Seiryōji in respect for Chōnen's vow to bequeath the Sakyamuni to Ching-Liang-Su (Seiryōji in Sino-Japanese), a temple that he had visited on Mount Wutai (Shanxi Province). This magical statue may seem less beautiful than intriguing: little crystal balls inserted into the ears—the space is slightly larger than needed—scatter the light and create the effect of an inward glow. Something of the frenzied reverence that Tang China accorded to its relics was transmitted to Japan through this copy of the statue of Sakyamuni—itself a copy of the near-magical image of the living Buddha executed on the order of King Udayama, which Xüan-Zang (602–664) supposedly brought back to China from India.

In 1954 the back cavity of the statue was opened, revealing objects and documents untouched since the back was sealed at the Northern Song capital of Kaifeng in 985, just before Chōnen left for Japan. In addition to the usual offerings of images, coins, and pieces of fabric, the cavity contained replicas of internal organs that nuns had fashioned: a digestive tract of white silk with spots of ink; a belly or stomach of brocade, decorated with lions and wild dogs; a bladder(?) of brocaded silk; a silken stomach, now yellowed; a red silk liver(?) stuffed with a silk floss; a red silk heart(?); a blue silk bag with relics inside; red silk lungs; and two brown silk kidneys. Most of these organs contained "jewels" that have not yet been positively identified, because the extremely fragile wrappings cannot be opened without risk of immediate disintegration.

Among the other documents that accompanied these offerings was a profession of faith written by Chōnen and his friend Gizo, in which the two monks promise to work together and build a monastery on Mount Atago, west of Kyoto. The document is authenticated by the imprint made on the paper by each man's hand from their pooled blood. To understand the Buddhist art of Japan, whether carved or painted, we must sometimes forget our modern concerns with pure aestheticism.

Visions of Paradise

T HE Pure Land sect of Buddhism, based on charity and on an aspiration toward the marvelous, originated in China but had its most widespread and enduring popularity in Japan. From the Early Heian period, it proved an inexhaustible source of inspiration for images of every kind and made felicitous use of painting techniques that were being perfected in imperial and monastic workshops. One of the essential traits linking religious and secular painting is, in the modern view, a stylistic homogeneity within a single group over a specific period of time, but form, style, and technique do not explain everything in religious painting: more so than in other areas of art, the intellectual keys to the artistic expression will often open the doors to our understanding.

The serene, often exquisite paintings of Japanese Buddhism rest, paradoxically, on the belief that life on earth consists only of misfortune, sickness, aging, death, and separation from loved ones. The Jōdo sect took this typically Buddhist outlook and enveloped it to a substantial degree in nonintellectual sentimentality. This did not lead to the absolute detachment that Buddhism had first sought, but to hope based on that most irrational of human dreams: a Pure Land or Paradise of "Eternal Joy" (*shōjō jōraku*) that awaits the reborn at the end of an earthly existence. But Paradise implies Hell as its logical counterpart, a place of retribution according to one's acts or to divine intervention—not unlike the conduct and choice common to the other world religions. Its anthropomorphic interpretation of the hereafter blossomed into a complex art designed to elucidate perplexing concepts and, in keeping with the teachings of the "Six Ways," to point out which paths to follow or avoid.

Consequently, the religous paintings of this period include: "explanatory paintings," diagrams of existing worlds (*mandalas*); "heavenly visions" conducive to Good, as well as "infernal" counterparts designed to turn the believer away from Evil; and countless sacred images of deities or saints who stand ready to help individuals along the Right Path (commonly symbolized by a narrow, precipitous line pummeled by raging waves on one side and threatened by a blazing river of fire on the other). The principal deities of the Pure Land sect were Amithābā (Amida) and Vairocana (also called Roshana and Dainichi Nyorai by the Jōdo and Shingon sects, respectively), two beings of light and hope who were the sources of Salvation.

Centuries of prayer and meditation altered this basic formulation in countless ways. Special attention was given, for example, to the events of the Buddha's earthly existence as well as to his previous lives. The most famous story—the young prince throwing himself down to become food for the starving tigress and her cubs—appears on the sides of the reliquary known as the Tamamushi, or "Beetle-Wing," shrine of Hōryūji, Nara (fig. 290). Although such scenes may be difficult to identify, the anecdotal stories they depict remain intriguing to this day.

Even more baffling, at least at first glance, are those densely packed compositions known as *mandalas* (in Japanese, *mandara*), the aim of which was to translate basic religious doctrine into readable symbols. Until recently, the tendency was to associate

mandalas almost exclusively with the Shingon sect that developed during the early part of the 9th century. However, current studies have broadened the definition of "esoteric thought" to include the "sentimental" (that is, nonintellectual) forms of Buddhism, such as Jōdo or Pure Land, that were praticed in Japan after the religion was first introduced in the 6th century—a plausible development, since all of these movements existed previously in China. A number of early examples can now be seen to belong to an unbroken chain. It is acknowledged today that Japanese mandalas and representations of the Pure Land originated in the wall painting (panel 6) in the Kondō of Hōryūji at Nara, now much destroyed, that was long thought to be simply an "Amida Triad."

Mandalas, though diverse in form, fall into three main groups: the Chikō, Taima, and Seikai varieties. The first type, which takes its name from the painting in Gangōji (Nara), dates from the mid-8th century and is, therefore, the oldest and most venerable form of mandala art, but the name "Chikō Mandara" was not linked to it until much later, in the 10th or even 11th century. It is believed that Chikō was a monk residing at Gangōji during the 8th century who was transported in a dream into Amida's presence and was either inspired there or given this representation. The Amida Triad appears in front of a Chinese-style palace surrounded by gardens and a lake, and thronged with heavenly beings. The markedly curving roofs, treatment of faces, and the partially inverted perspective that creates an effect of an octagonal setting all bring to mind similar representations at Dunhuang. Nevertheless, there is no mention of it in texts until much later, which casts doubt on its actual date. Although the Chikō Mandara is now associated with other mandalas and no longer considered an isolated specimen, its relatively uncluttered structure makes it unquestionably the oldest work of its kind in Japan.

The arrangement of the Taima Mandara based on the *Muryōjukyō*, or "Sutra of Endless Longevity," is a good deal more elaborate. It illustrates the lesson—already promulgated in China by T'an Luan (476–542)—that there are sixteen paths to illumination and supreme joy; deities watch over each path and stand ready to help. The origin of this mandala, called Taima because it is kept in the Taimadera near Nara, is legendary. Princess Chujō-hime wove it overnight in 763 of silk or lotus-thread, the legend goes, to depict her visions as a nun. Deeply revered by throngs of worshipers, the original is at least as early as the Early Heian period, and it was copied in 1217, 1502, and 1685 (see also figs. 129, 347, 362). Its present condition attests to the unremitting value accorded to these reproductions: the few surviving fragments have been pasted onto a painted copy, and it is very difficult to tell the restored sections from the original fabric. The subject it illustrates (figs. 68, 129)—copied in painted or printed form a hundred times in as many temples since the 13th century—is based entirely on Jōdo doctrine: the Paradise of Amida.

Again we see an Amida Triad, but the buildings and gardens, depicted in a kind of Renaissance perspective, are more elaborate than those in the Chikō Mandara. Each pavilion shelters a deity and surrounding attendants; boats drift across a lotus pond; celestial beings and *apsaras* sweep across the sky, focusing the observer's attention on the central image of Amida. Instead of the majestic, but static design worked out by

the painter of the Chikō Mandara, in which the Amida Buddha is framed by secondary figures and landscape elements, the painter of the Taima Mandara created a dynamic design in which important architectural lines and the paths described by the flying deities converge on an imaginary center occupied by Amida. This more advanced type of composition might have lacked vigor, had not a number of figures near the main components been skillfully designed to suggest movement by turning their backs to the main axes of the painting. The large central scene is surrounded by thirty-three insets and explanatory texts narrating the story of Lady Ida-ike, who was denied happiness on earth and prayed her entire life to be reborn in the Paradise of Amida.

The very quality of the Taima Mandara raised a number of questions. So intricate a textile, it was believed, could not have been realized that early in Japanese history, and many were convinced that it was an imported Chinese work. By now, that question has lost its importance; like the carefully preserved objects in the Shōsōin, the Taima Mandara exerted so much influence on this type of representation in Japan that it has been accepted as part of the archipelago's cultural inheritance.

The Seikai mandalas were also named for a monk who is thought to have painted a vision of Paradise (now kept in the National Museum at Nara) at some time during the 8th century. Scholars who have probed the style and technique of this work believe it to be less ancient than previously thought and now date it from the Middle Heian period (1017), the era of Fujiwara-no-Michinaga (966–1027) and the celebrated monk, painter, and sculptor, Eshin (942–1017). Its principal sources were two, the "heavenly vision" type of representation and the Ryōkai Mandara ("diagrams of the two worlds") of esoteric Buddhism, which illustrate the relationship between the "diamond world" (*Kongō-kai*; fig. 310) of spirit and wisdom and the "womb world" (*Taizō-kai*; figs. 308–9) of form and reason.

The Seikai Mandara is like a synthesis or mean between the archaic Chikō Mandara and the magnificent Taima Mandara. Much in its relatively uncomplicated design is reminiscent of the Chikō Mandara: the deities are arranged in the same way around a palatial setting (all rendered, however, according to a single perspective). But in its symbolism the Seikai Mandara is more elaborate than its earlier counterpart. Among the dancers in the foreground we see the *nitoshi*, the two childlike pages of Fudō Myōō— a reminder of the mysteries of Shingon and of the future coming of Vairocana, "he whose light shines everywhere," the inexhaustible source of life.

Countless variations on these three image-types portraying Amida in his Western Paradise combined visual inventiveness and symbolic subtlety (figs. 311–14). All are classified under the term *Amida Jōdo Mandara*, or "Mandala of Amida's Paradise," but some, such as the one in the Chion-in in Kyoto (fig. 114), are quite lyrical; others, like that in the Seizen-in of Koyasan, are more geometrical, more severe, with delicate background patterns comparable to those found in textiles. Still other mandalas depict, not the Amidist version of paradise, but that of Miroku (Maitreya): these so-called Tosotsuten mandaras are characterized by an elaborate and precisely delineated design.

THE other important Buddhist theme that appeared during the Late Nara period was that of *raigō*: the "descent" or welcome that Amida holds in store for the devout who have left behind them the world of form and suffering. The intention was not to depict, even symbolically, a supernatural world, but to evoke the deity in his boundless radiance, love, and concern for mankind. Late Nara artists first included the descent of Amida within larger scenes such as those depicted in mandalas, not as a subject in its own right. The Descent theme comes from the same *Muryōjukyō* sūtra that the Taima Mandara illustrates in nine of its insets.

The *raigō* had the stylistic effect of infusing the traditional, static Amida Triad— a kind of Amida "in majesty"—with greater vitality. Thus, art historians today believe that the asymmetrical Amida Triad of Hokkeji, in which the deity is portrayed with two attendants on the right and one on the left, may have been a rudimentary *raigō*, a first step toward a theme whose rich possibilities remained largely untapped during the Heian period. This is not to say that symmetrical *raigō* paintings could not also be dynamic: the whorling, trailing clouds on either side of deities act like a halo of golden light that carries the viewer's eye toward the top of the painting and beyond into infinity.

The main contribution of Kamakura painters was to add a long "train" to the elongated clouds so popular during the Heian era, as in the *raigō* of Kōfukuji (Nara), with its nineteen bodhisattvas. The deities seem to be crossing the sky along diagonal axes running from top to bottom and, for the main subjects, left to right. Although one may wish to conclude that symmetrical representations gave way to diagonally oriented *raigōs*, this does not mean that the former—much favored by Heian painters—merely vanished in the wake of a new and successful approach.

Yet the diagonally structured *raigōs* indeed possess a compelling presence that is lacking in the meditative images of the Heian period. The heightened sense of rapid movement is enhanced by long rays—made of gold leaf flakes (*kirigane*) in the more sumptuous works—that symbolize the gaze of Amida and his redemptive power. Artists worked this more energetic version of the *raigō* theme into countless variations. Instead of dividing the rectangular surface into two equal triangles (as in the Chion-in *raigō*, with its twenty-five bodhisattvas), a painter might represent Amida's gladdening retinue as an S-curve or a zigzag, or cause it to burst into several branches or, conversely, to swirl about the central deity in endless rounds. All of these solutions, it seems, were highly esteemed during the Kamakura period.

The combination of the Paradise and Descent themes ultimately inspired the extraordinary paintings entitled *Yamagoshi Amida*, or "Amida Behind the Mountains." Several Buddhist texts depict paradise in terms of a mountain, a belief shared by Hinduism and Chinese Taoism, but beginning with the Heian period, these paintings showed Amida with other benevolent deities as well (Kannon, Seishi), rising like the sun above a majestic landscape of gently rolling mountain crests reminiscent of those around Kyoto. The two most renowned examples of this type of representation, at the Kōmyōji in Kamakura and the Zenrinji in Kyoto (fig. 47), are rigorously symmetrical; yet both of them, at least in their present state, date from the Late Kamakura period. Might

they be "retouched" versions of older works? Kamakura artists knew well how to introduce asymmetry into depictions of this theme: witness the Kumano Yōgōzu, the painting of Amida at the Hōrinji, Nara. Perhaps in this lies one of the primary reasons for the astounding diversity of Japanese art: no style or approach was ever abandoned in the search for innovation. Invariably invention adds to its richness, but never destroys what has gone before.

41 MIROKU BOSATSU (NYŌIRIN KANNON BOSATSU)
Wood, height 1.3 m.
Asuka Period, mid-7th century A.D.
Chūgūji, Hōryūji, Nara

42 ASHURA, KING OF HUNGER AND WRATH
Dry lacquer, entire height 1.5 m.
Nara Period, Tempyō Era (729–748).
Kōfukuji, Nara

43 YAKUSHI NYORAI
Wood, height 1.7 m.
Early Heian Period, 824.
Jingōji, Kyoto

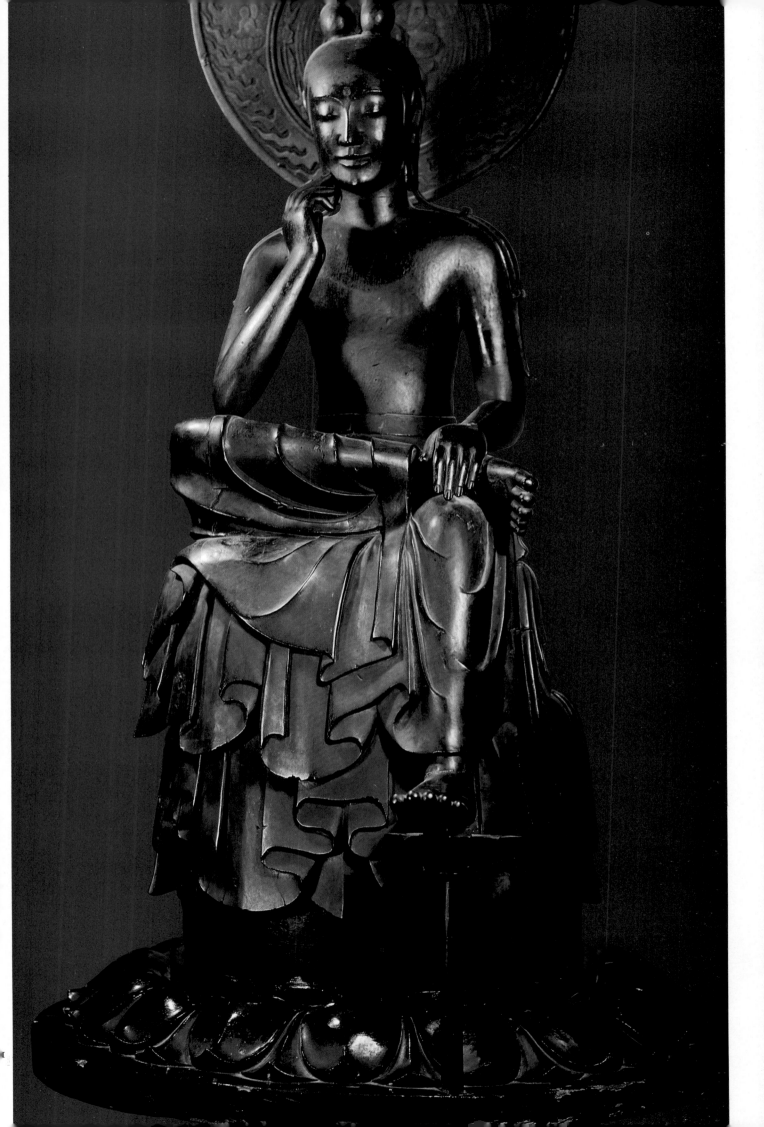

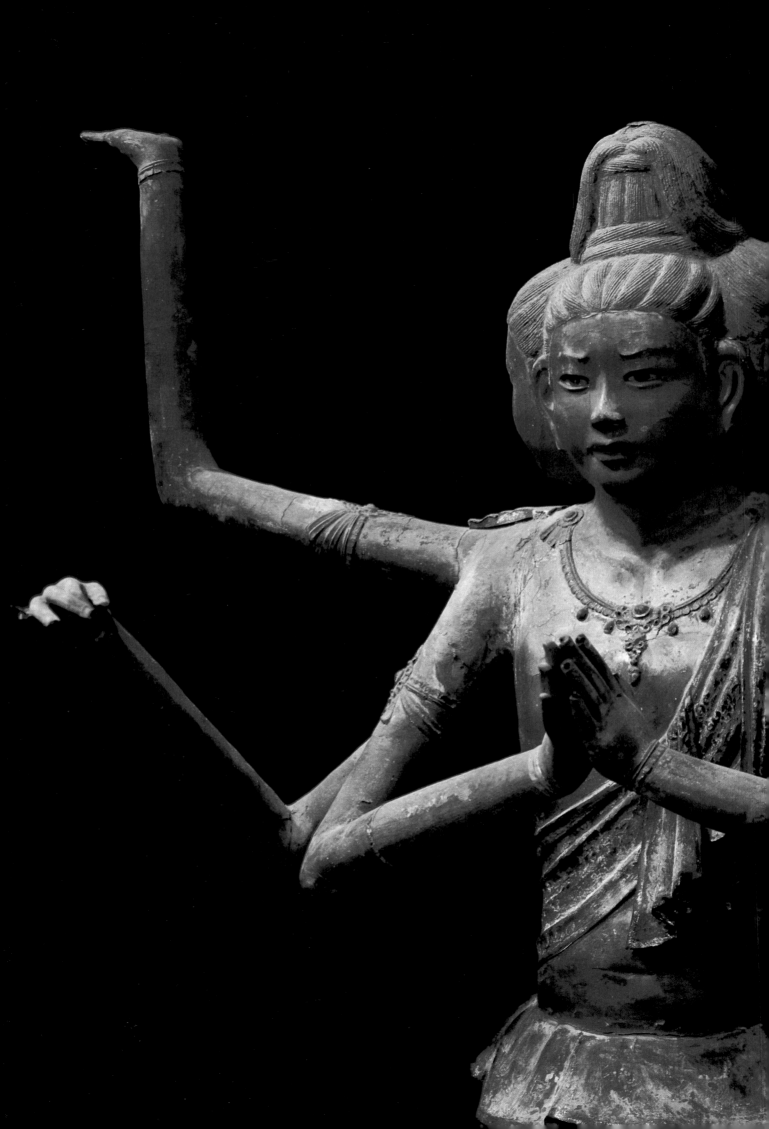

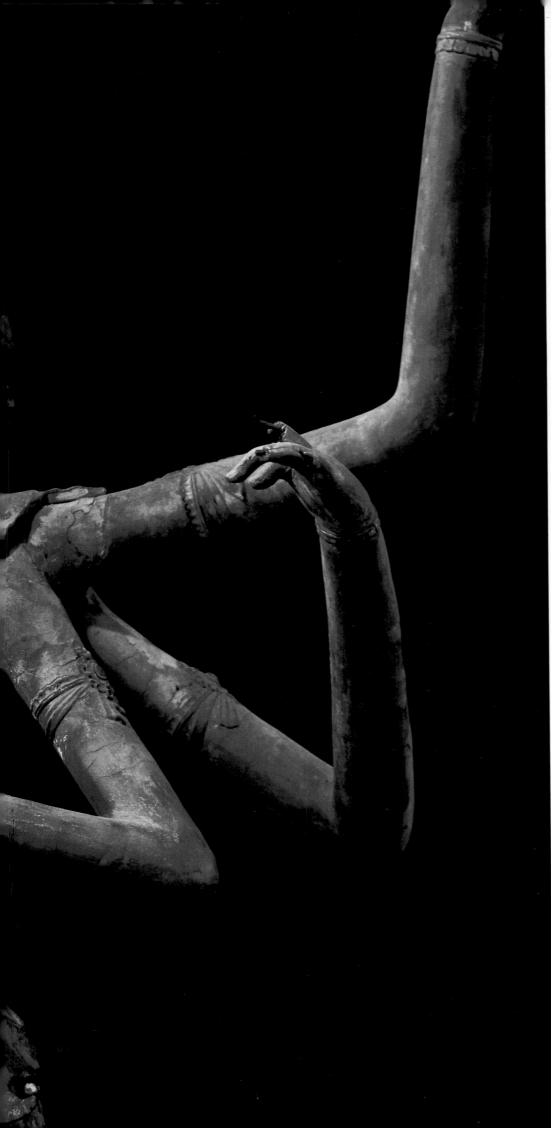

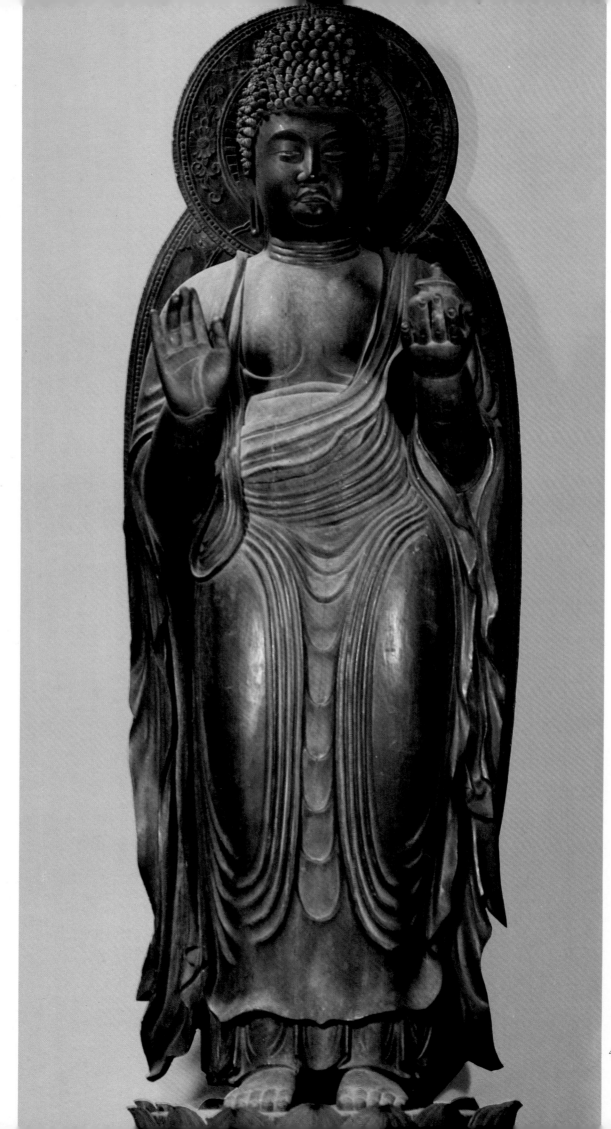

43

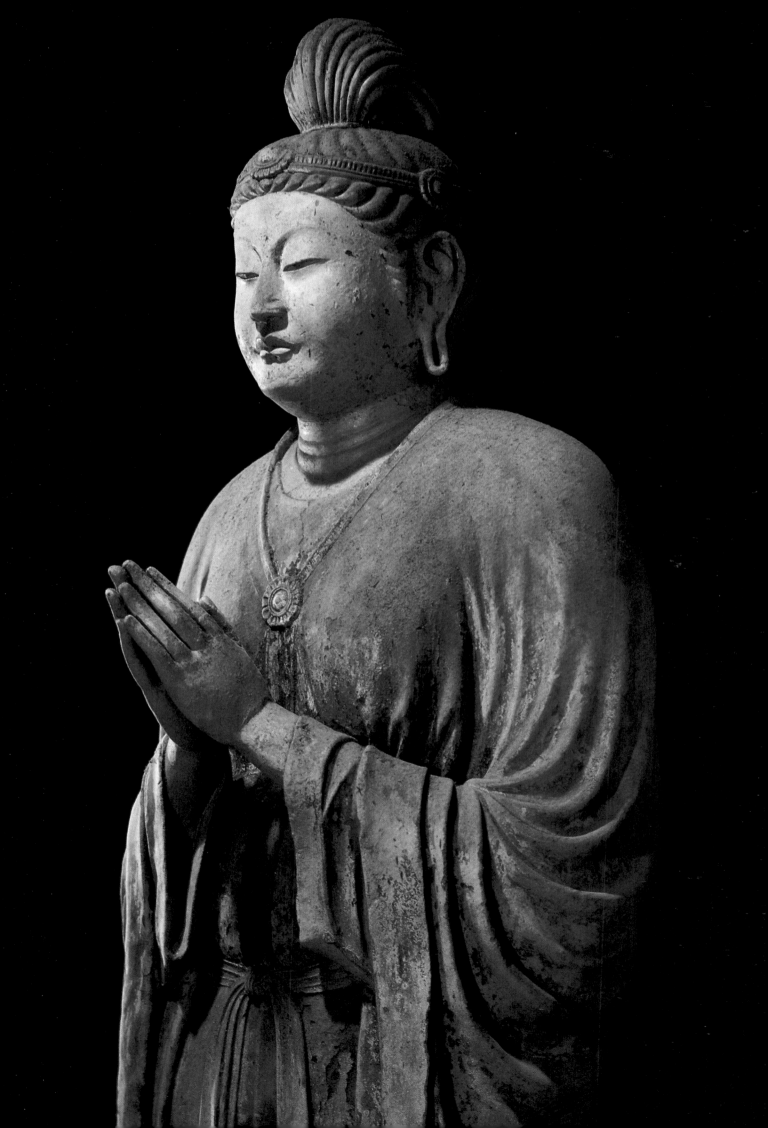

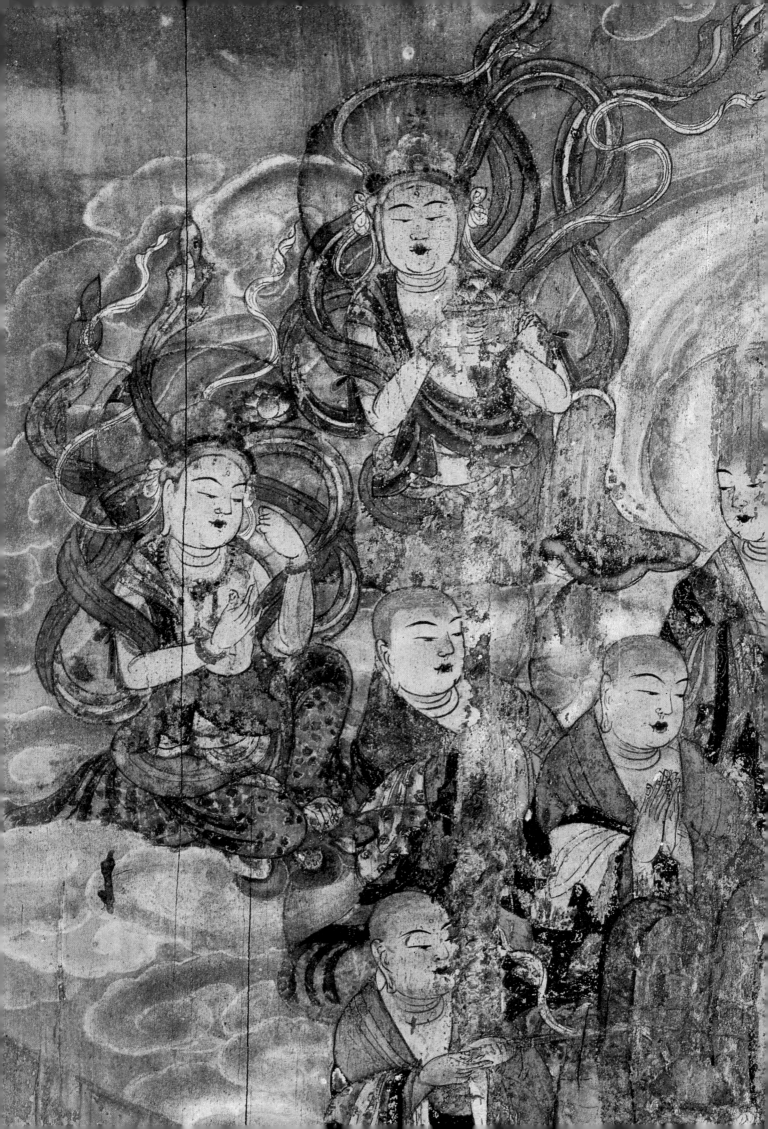

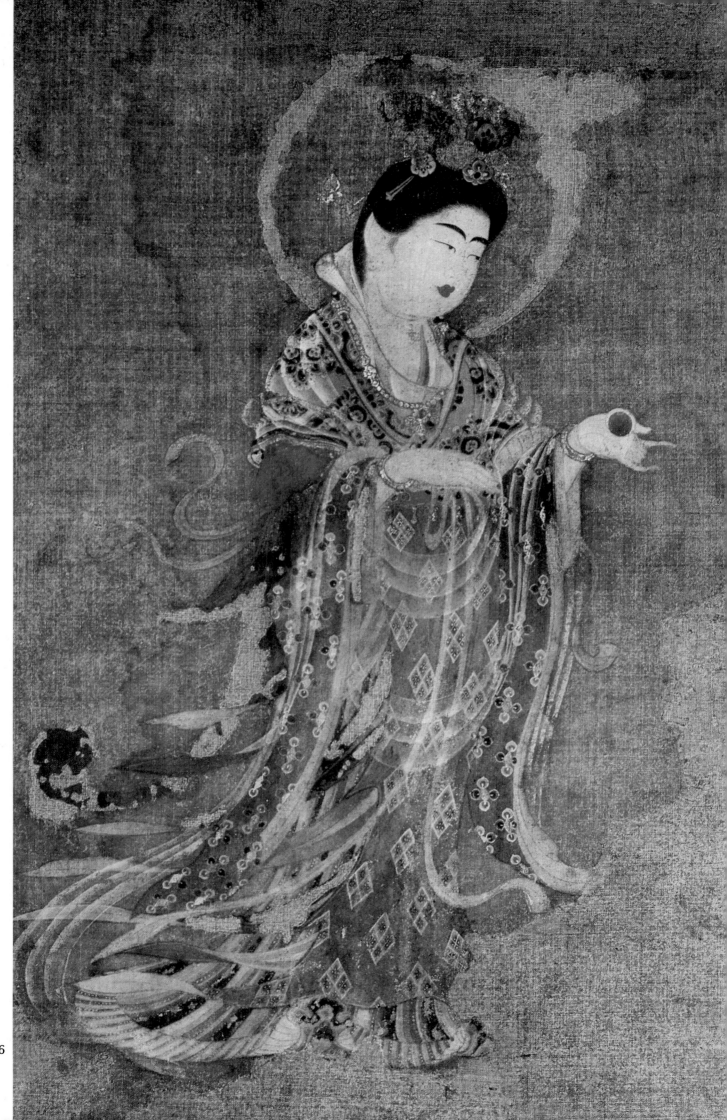

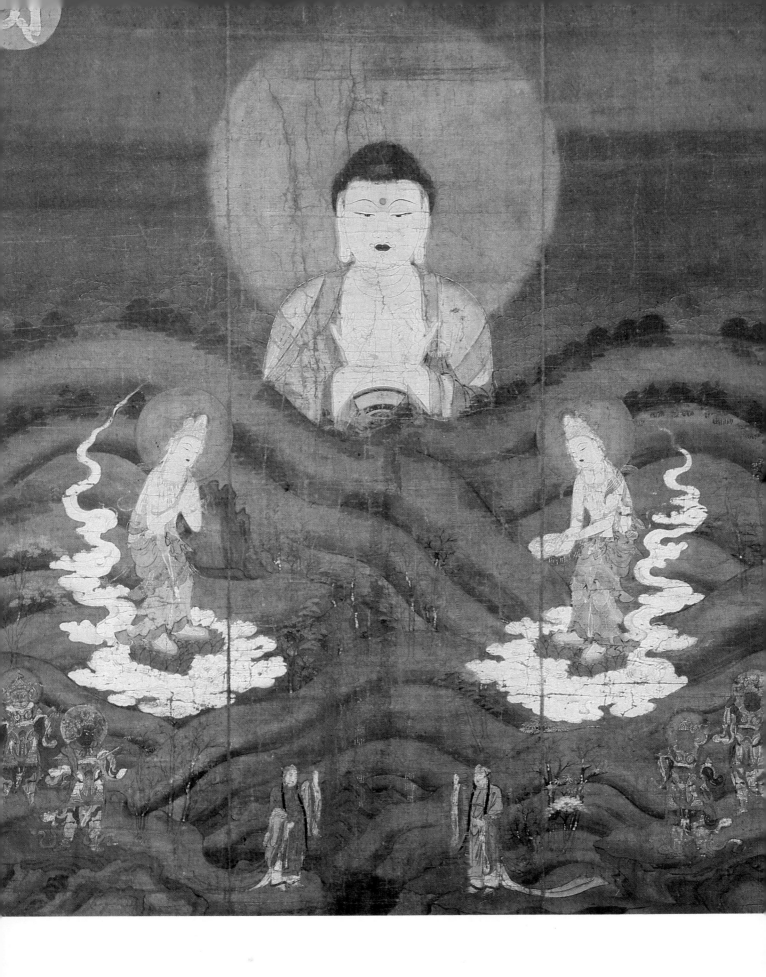

44 GAKKŌ BOSATSU (CANDRAPRABHA)
Solid clay with traces of color, entire height 2.1 m.
Nara Period, 8th century.
Sangatsudō, Tōdaiji, Nara

45 DIVINE PROCESSION
Detail of painting.
Color on wooden panel.
Heian Period, 1053.
Hōodō, Byōdōin, Uji

46 KICHIJŌTEN (MAHĀSHRI)
Color on hemp cloth, 53.4 × 31.3 cm.
Nara Period, 8th century.
Yakushiji, Nara

47 YAMAGOSHI AMIDA (AMIDA ACROSS THE MOUNTAINS)
Detail of hanging scroll.
Color on silk, 1.34 × 1.12 m.
Kamakura Period, 13th century.
Zenrinji, Kyoto

48 GAKKŌ BOSATSU (ATTENDANT AT RIGHT OF YAKUSHI
NYORAI; *see figs. 210, 211*).
Bronze and gilt bronze, entire height 3.12 m.
Early Nara Period, 718–728.
Yakushiji, Nara

49 ROSHANA BUTSU (VAIROCANA)
Dry lacquer with gold leaf, entire height 3.4 m.
Nara Period, 8th century.
Kondō, Tōshōdaiji, Nara

50 SENJŪ KANNON BOSATSU (SAHASRABHUJASAHASRANETRA)
(THOUSAND-ARMED KANNON)
Dry lacquer over wood, entire height 5.5 m.
Nara Period, 8th century.
Kondō, Tōshōdaiji, Nara

51 AMIDA NYORAI (AMITĀBHĀ)
By Jōchō (?–1057).
Gilded wood, height 3.3 m. (see fig. 264).
Heian Period, 1053.
Hōodō, Byōdōin, Uji

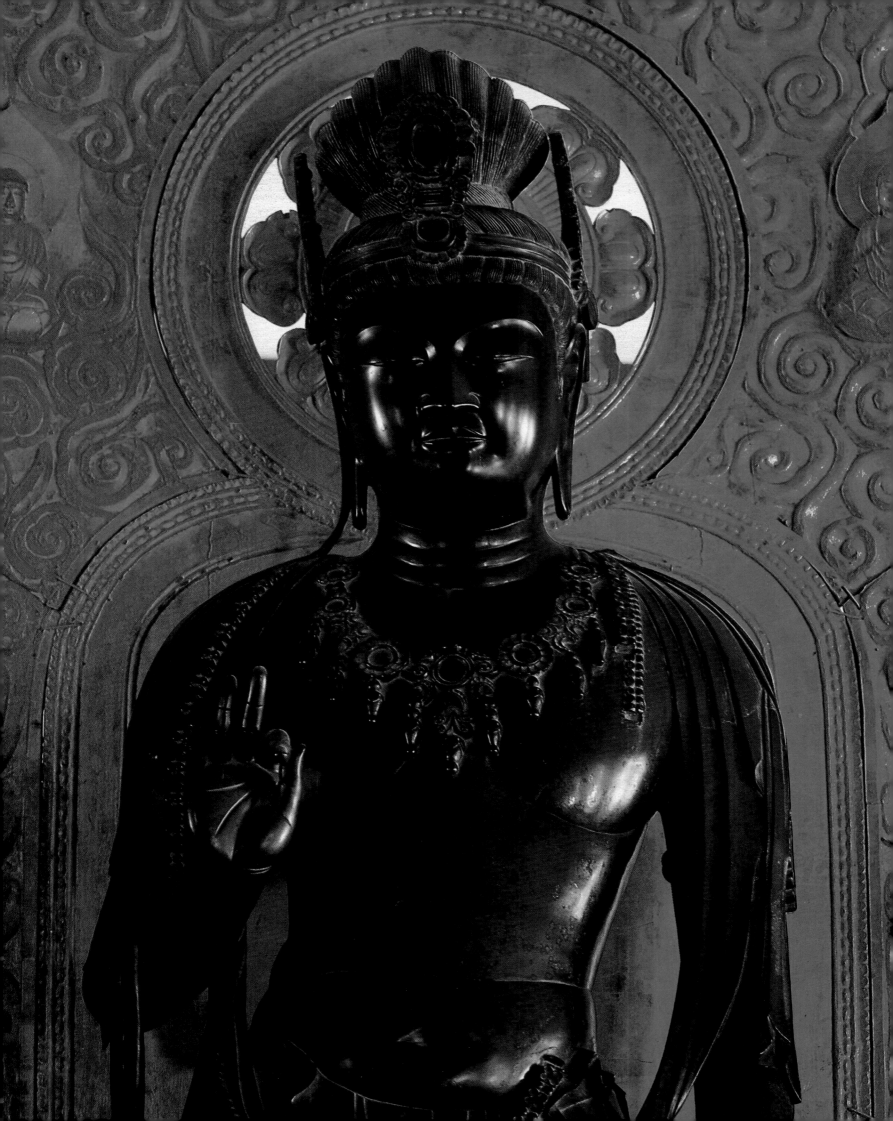

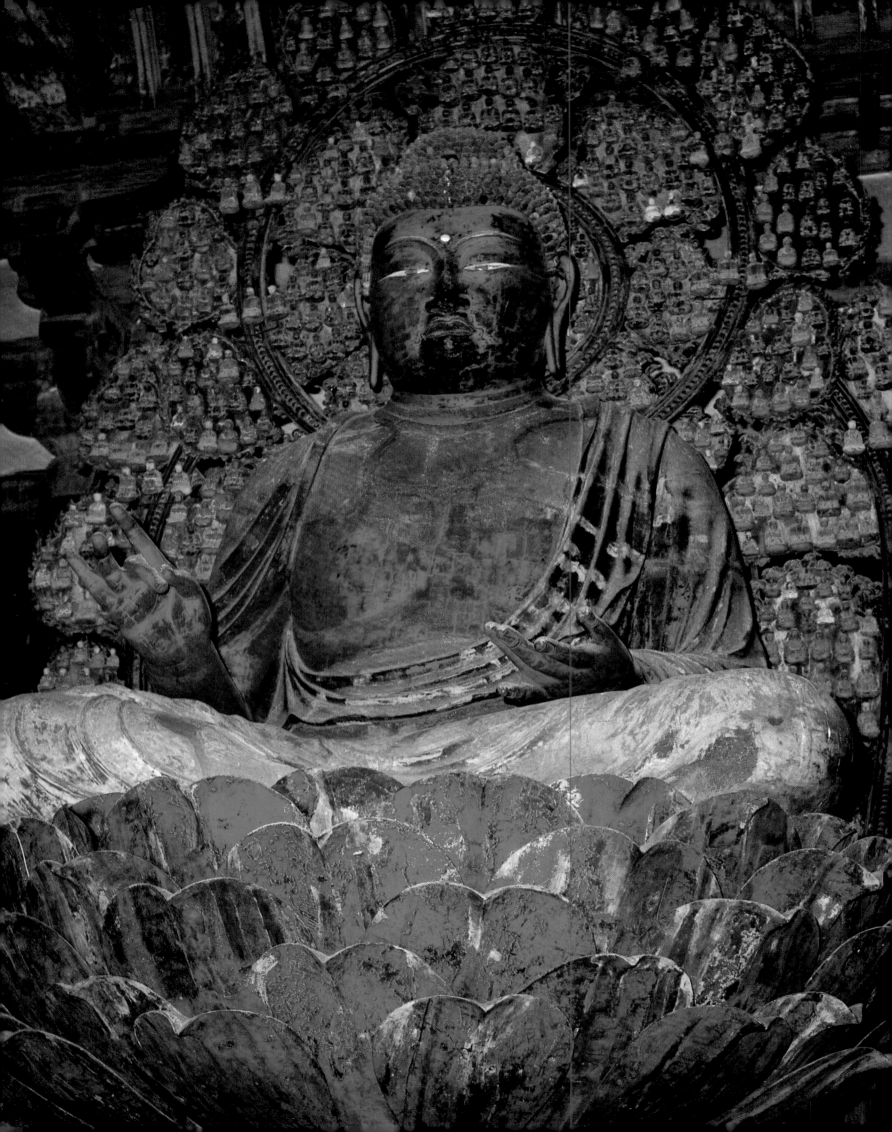

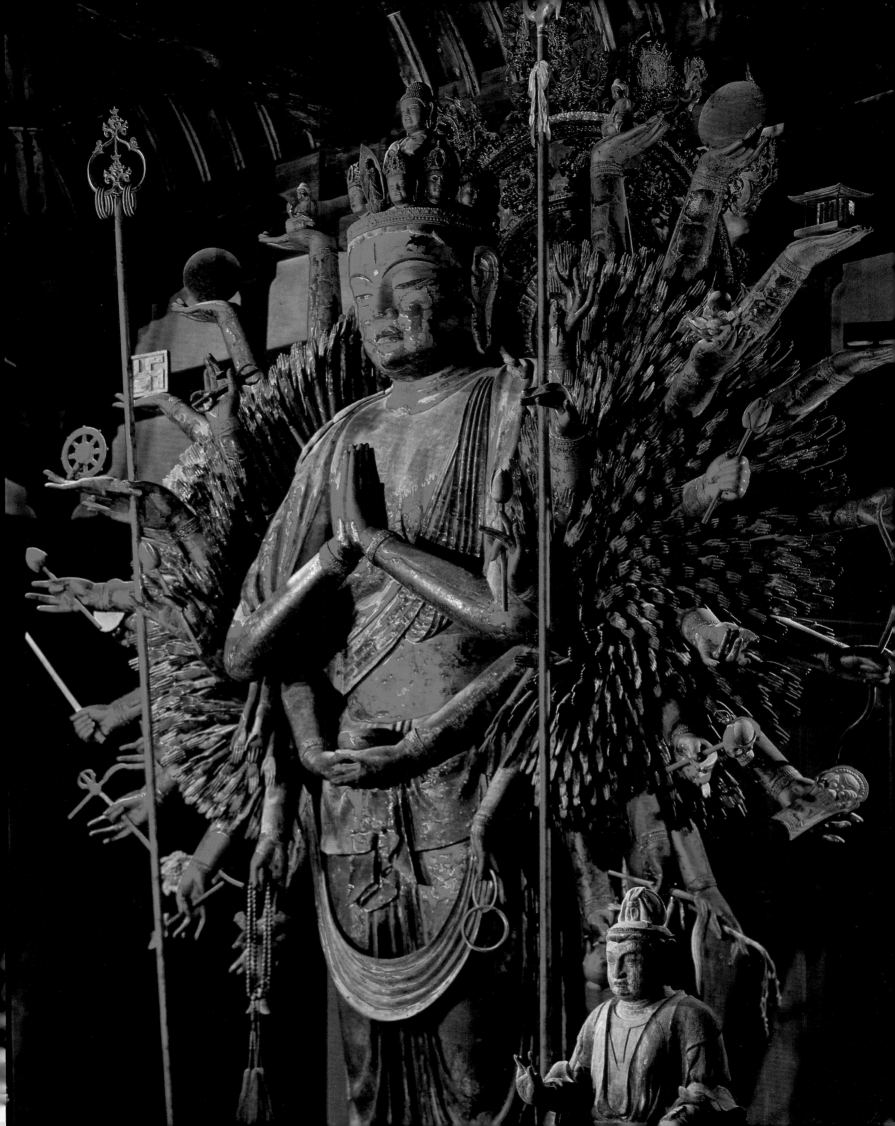

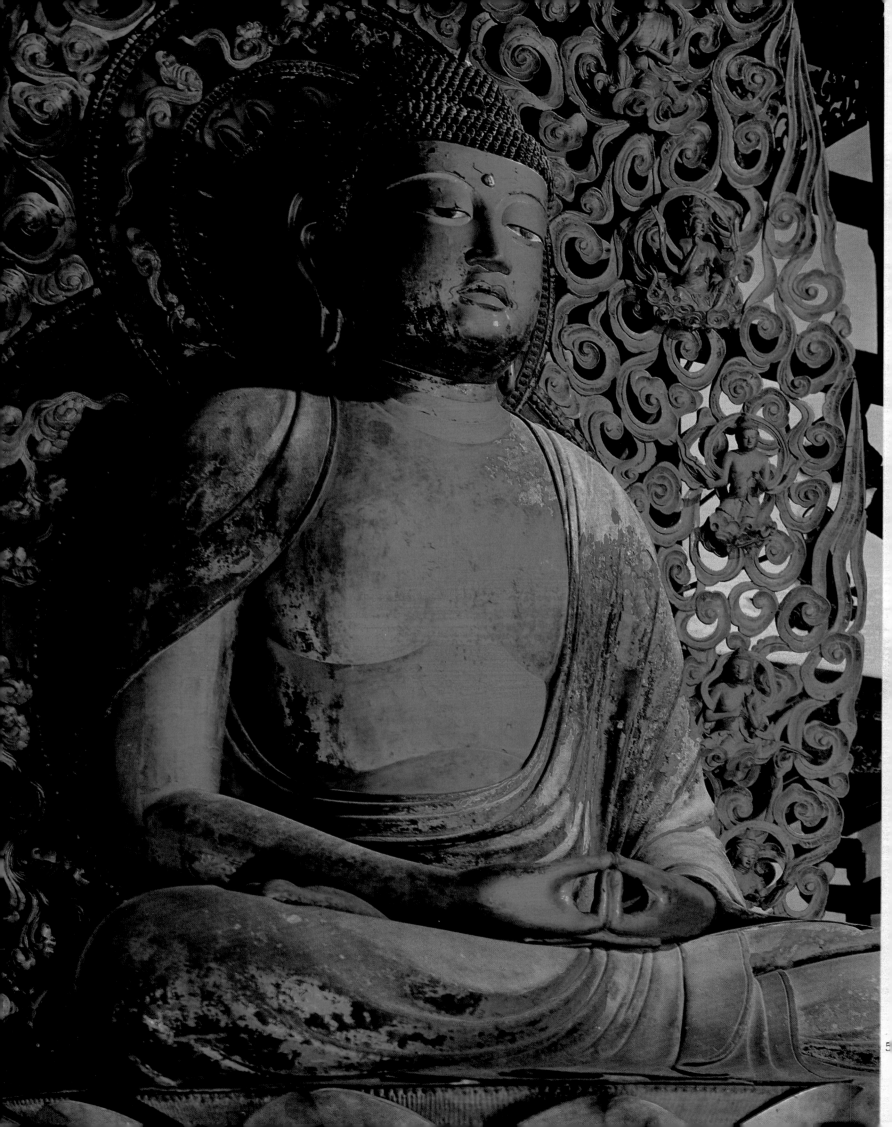

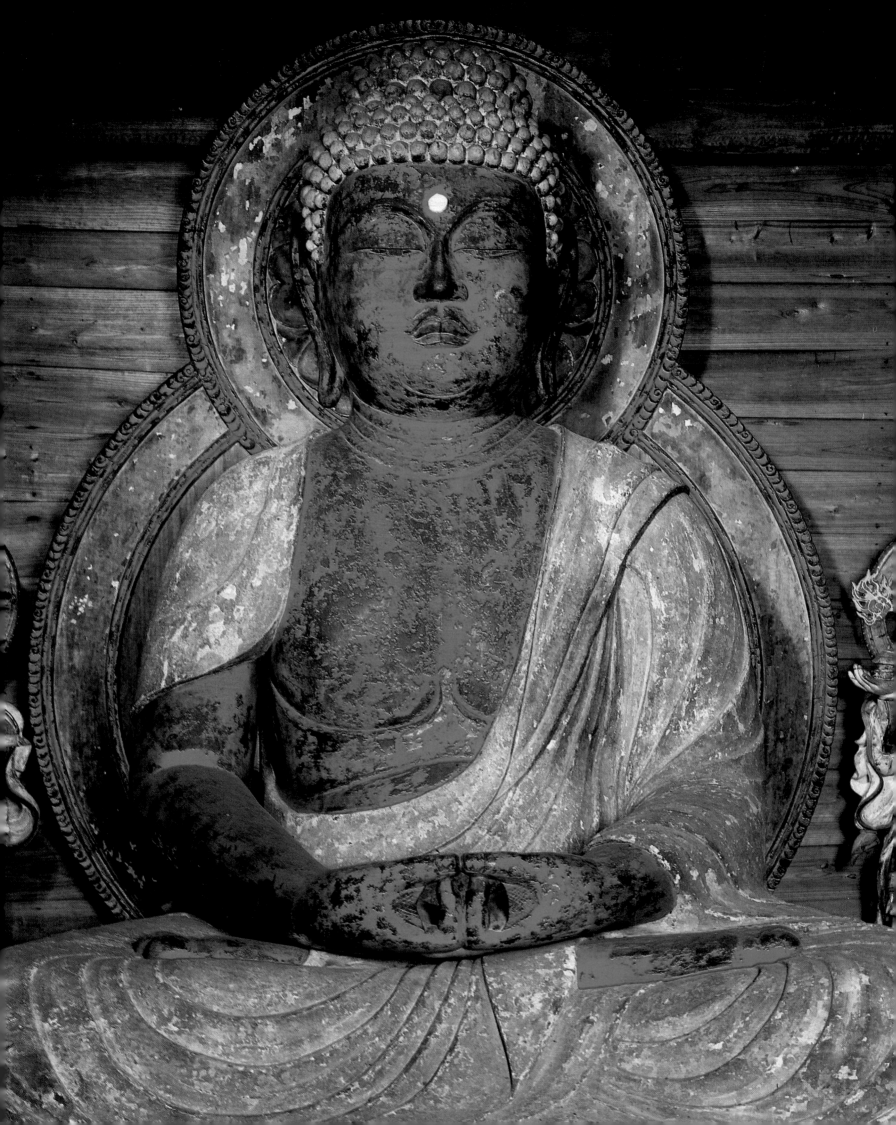

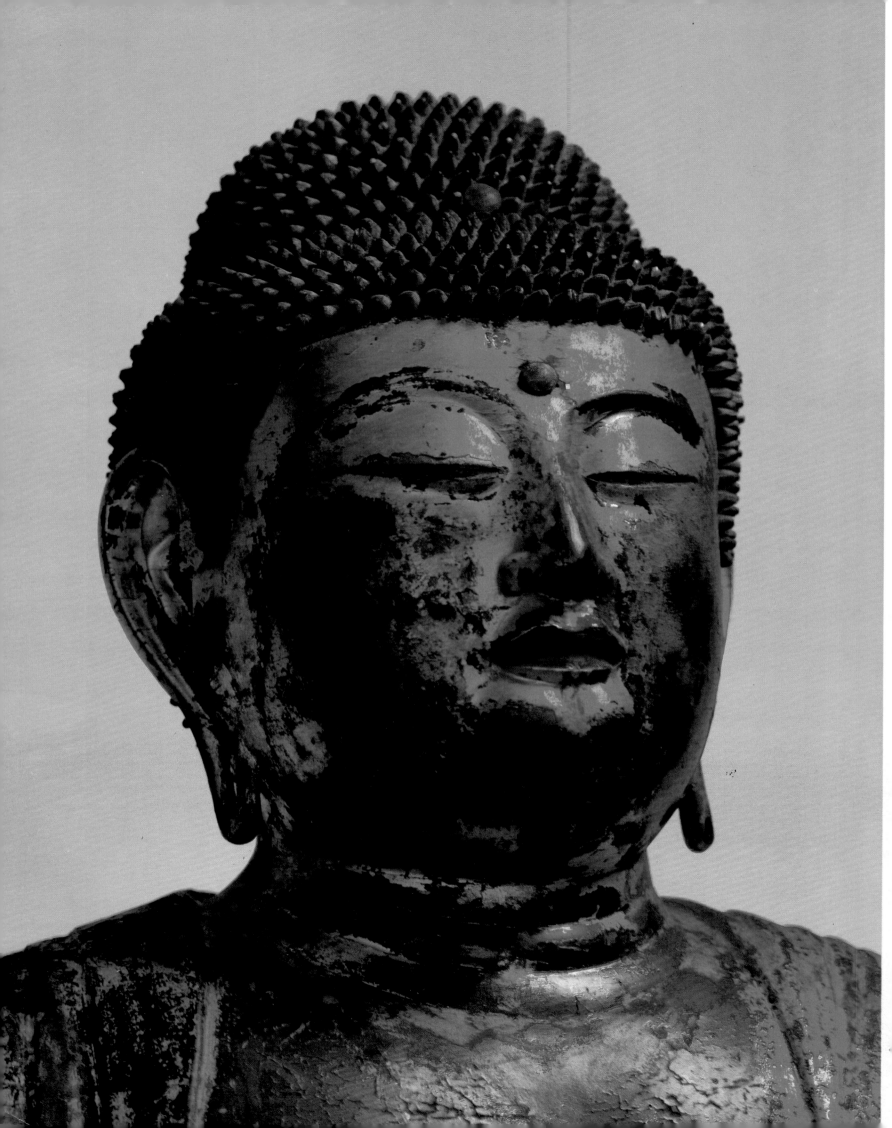

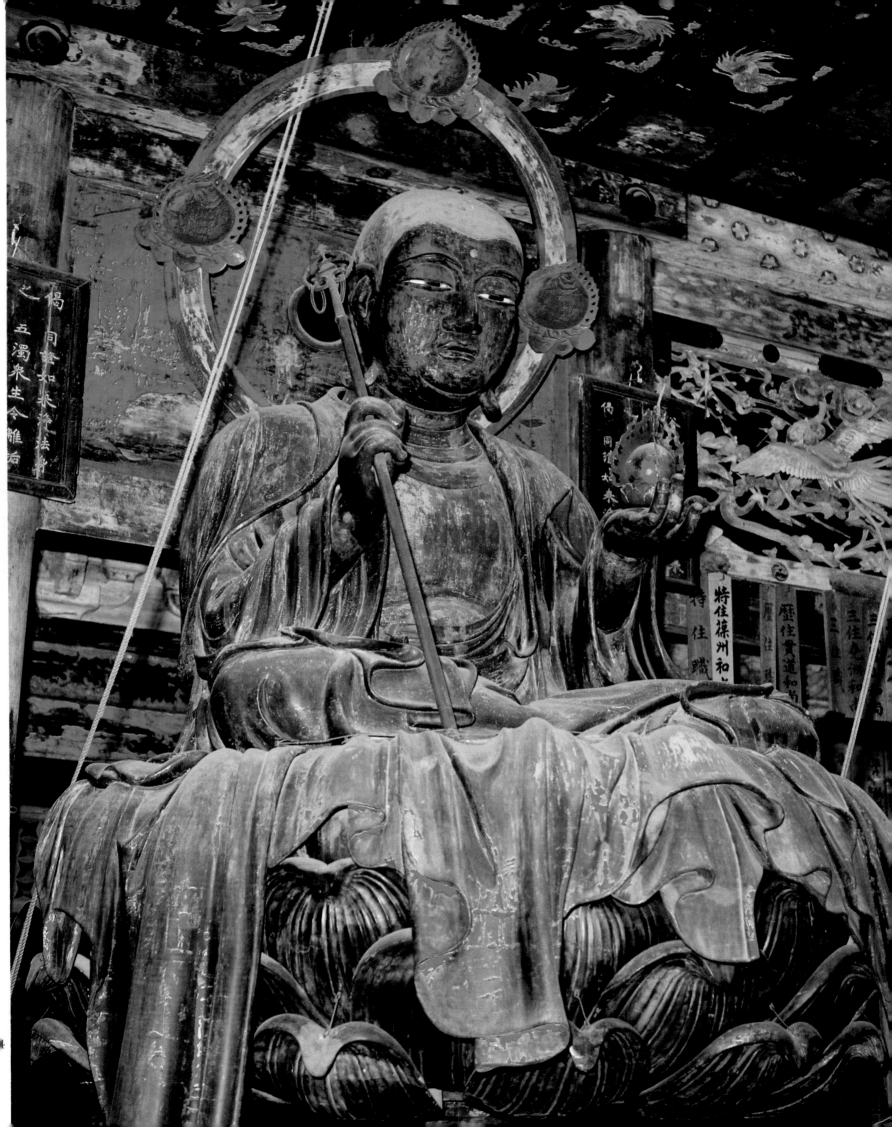

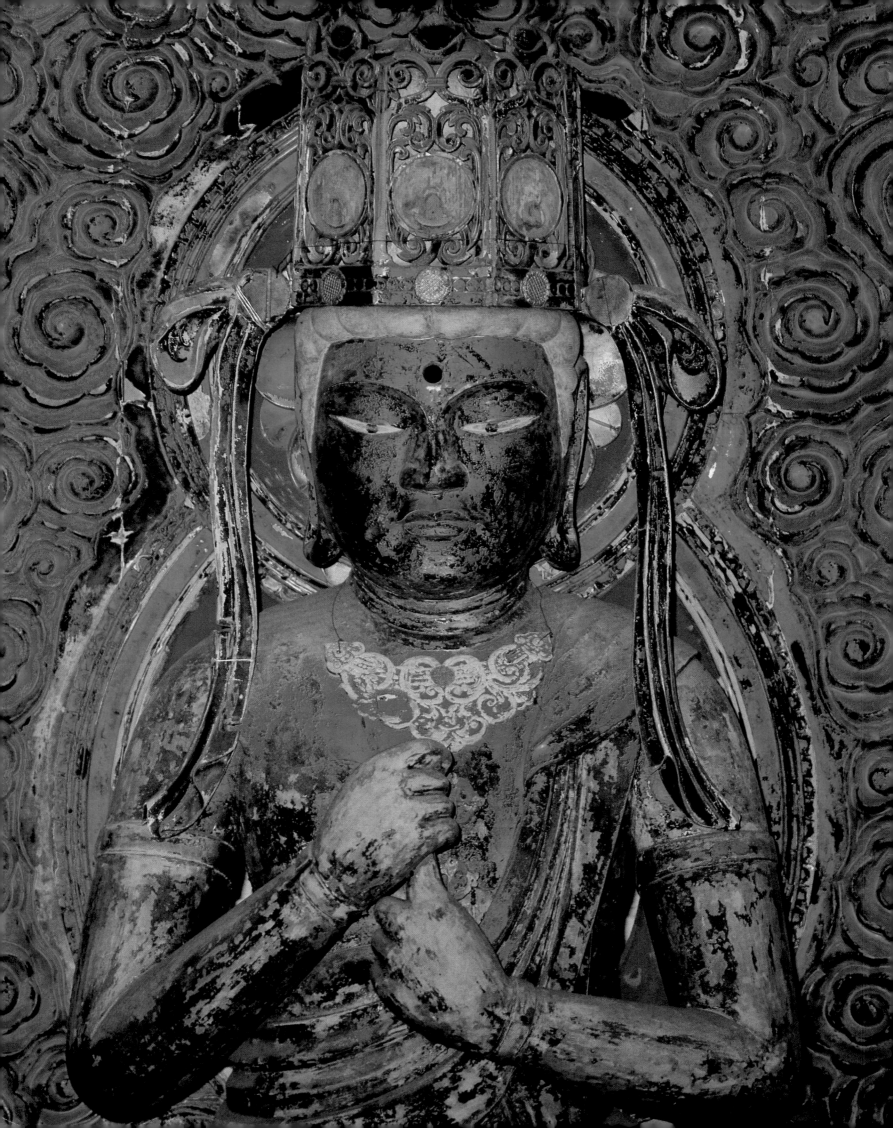

52 AMIDA NYORAI (AMITĀBHĀ)
Gilt bronze, height 2.8 m.
Heian Period, 9th–11th century.
Iwafunadera, Kyoto

53 AMIDA NYORAI (AMITĀBHĀ)
Detail of statue.
Gilded lacquer over wood, entire height 1.6 m.
Late Heian Period, 12th century.
Asian Art Museum, San Francisco

54 JIZŌ BOSATSU (KSITIGARBHA)
Wood, height 3.7 m.
Muromachi Period, 15th century.
Kenchōji, Kamakura

55 DAINICHI NYORAI (VAIROCANA)
Gilded and painted wood.
Late Heian Period, 12th century.
Murōji, Nara

56 DAIBUTSU (GREAT BUDDHA)
 Bronze, height 11.4 m.
 Kamakura Period, 1252.
 Kōtokuin, Kamakura

57 FUGEN BODHISATTVA (SAMANTABHADRA)
 Wood, height about 70 cm.
 Early Heian Period, 9th century.
 Fugenji, Mei Prefecture

58 NYŌIRIN KANNON (SINTAMANICAKRA,
 "KANNON WITH THE MYSTICAL WHEEL")
 Wood with traces of lacquer and color, height 1.2 m.
 Heian Period, 900–950.
 Asian Art Museum, San Francisco

59 SHŌ-KANNON (AVALOKITEŚVARA, "WISE KANNON")
 Wood with traces of lacquer and gold, height 1.9 m.
 Kyoto, Late Heian Period, 12th century.
 Asian Art Museum, San Francisco

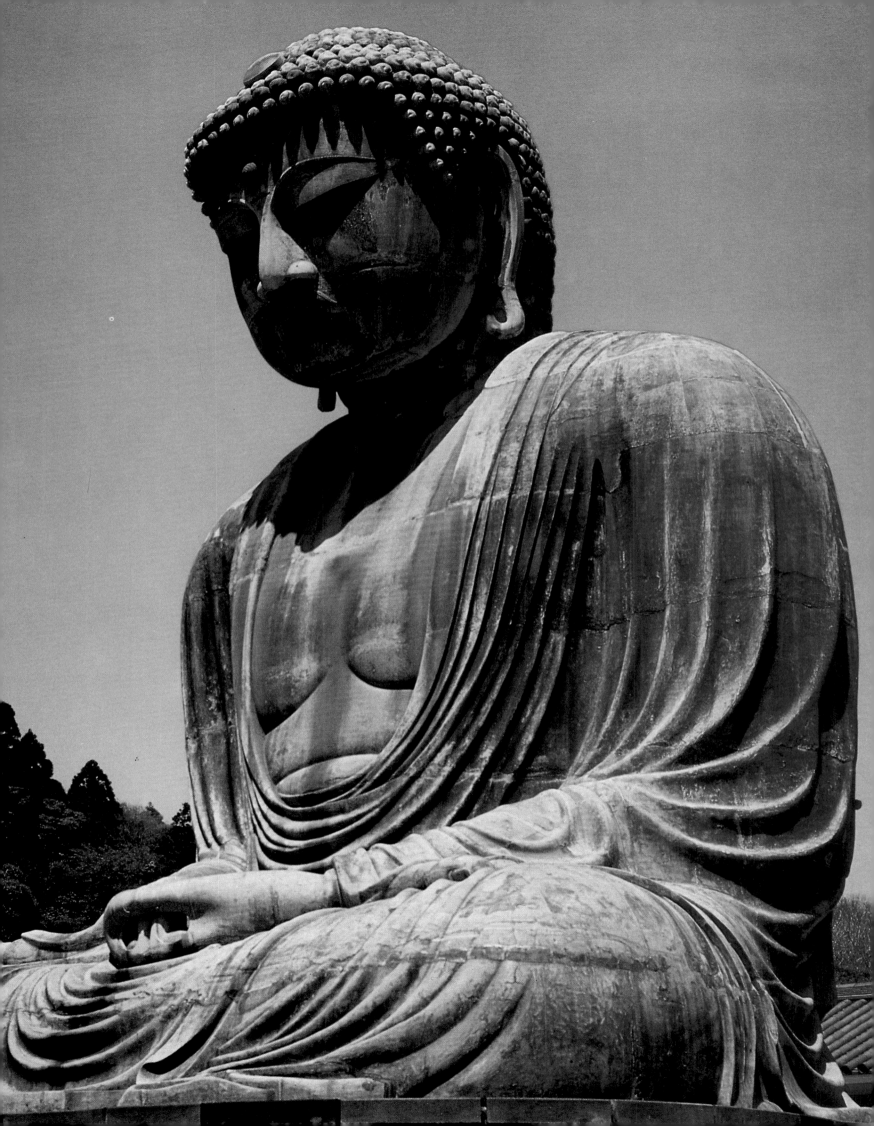

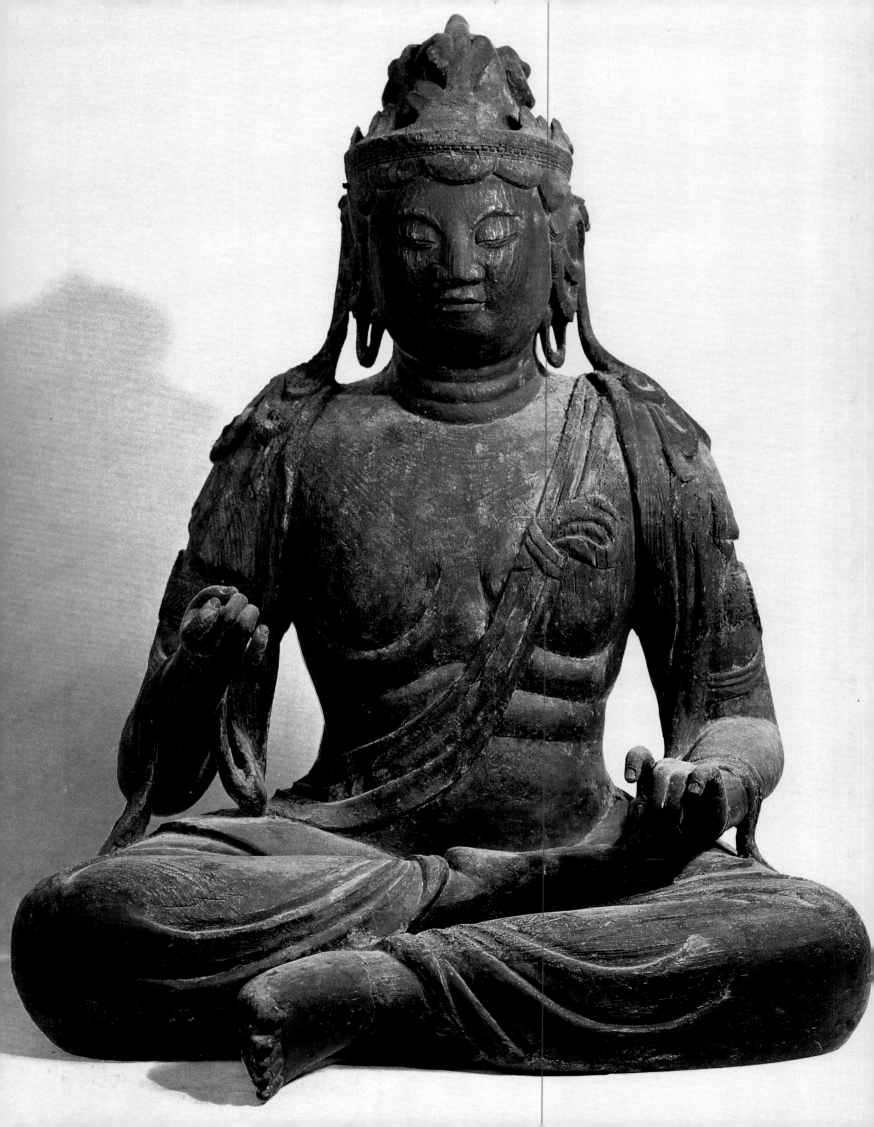

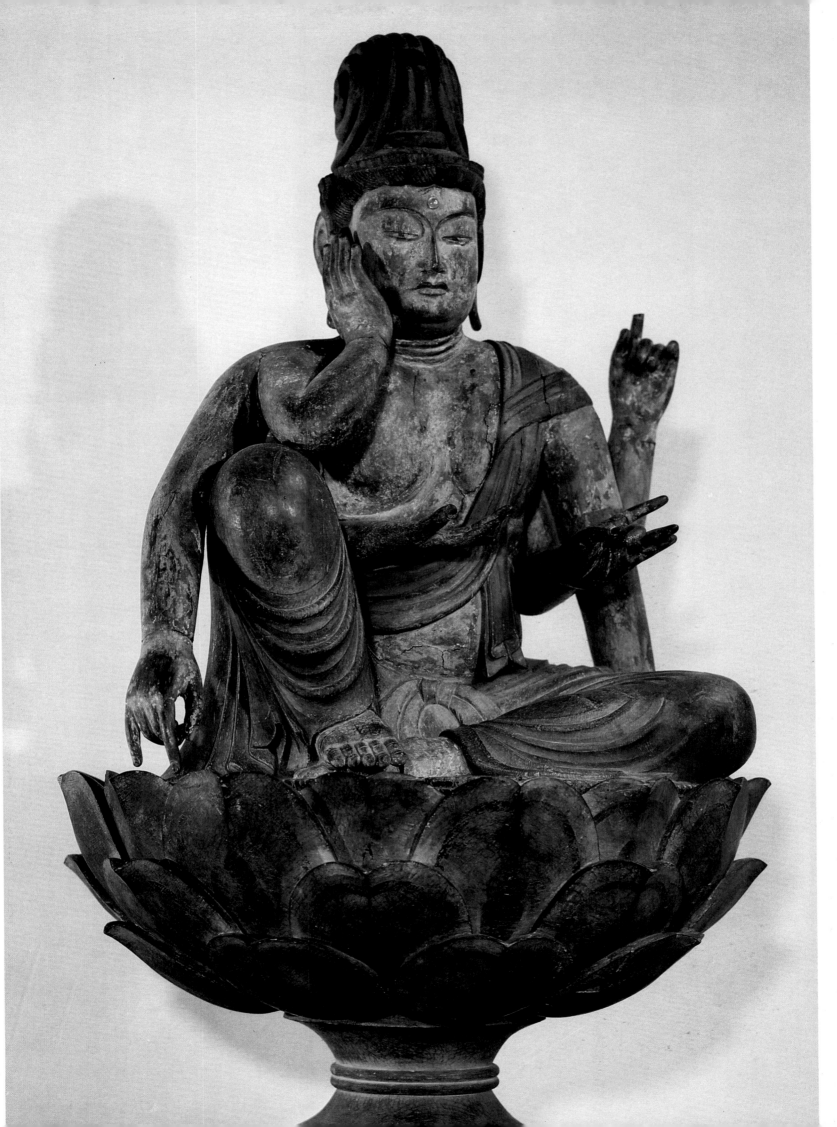

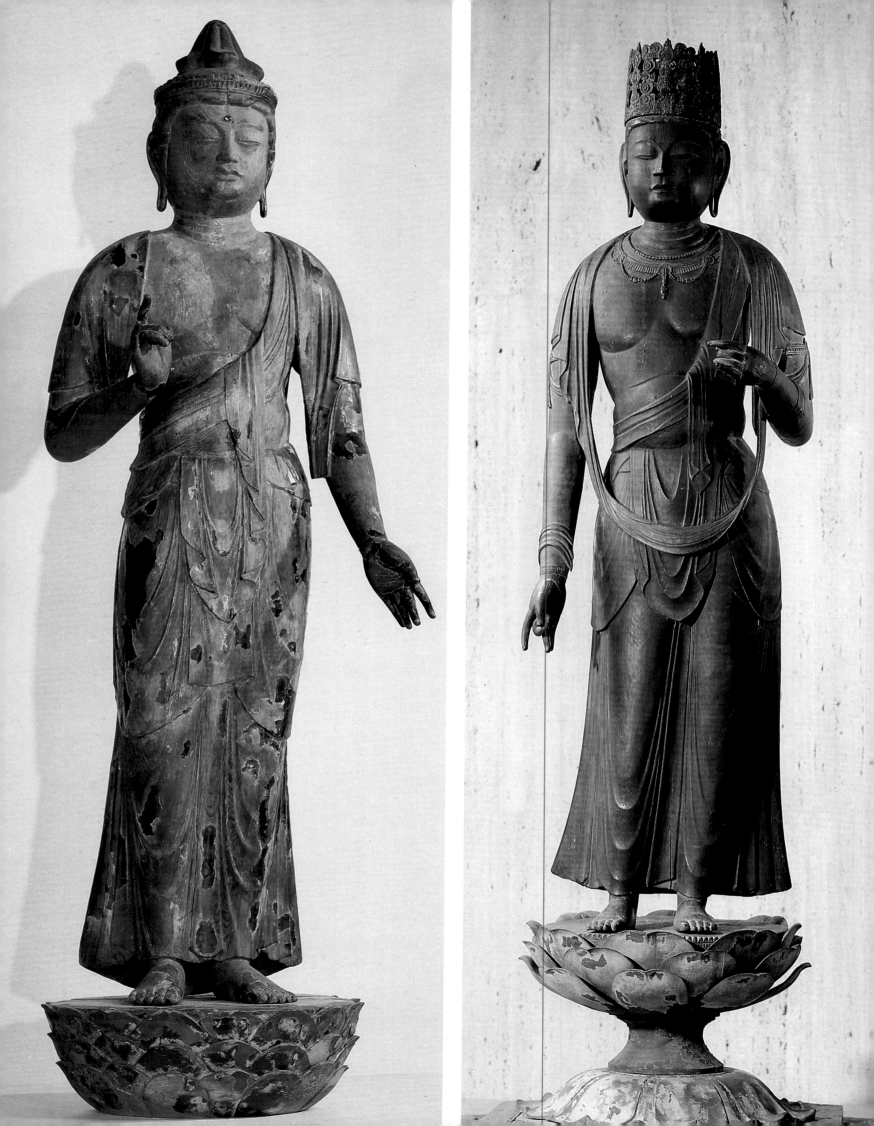

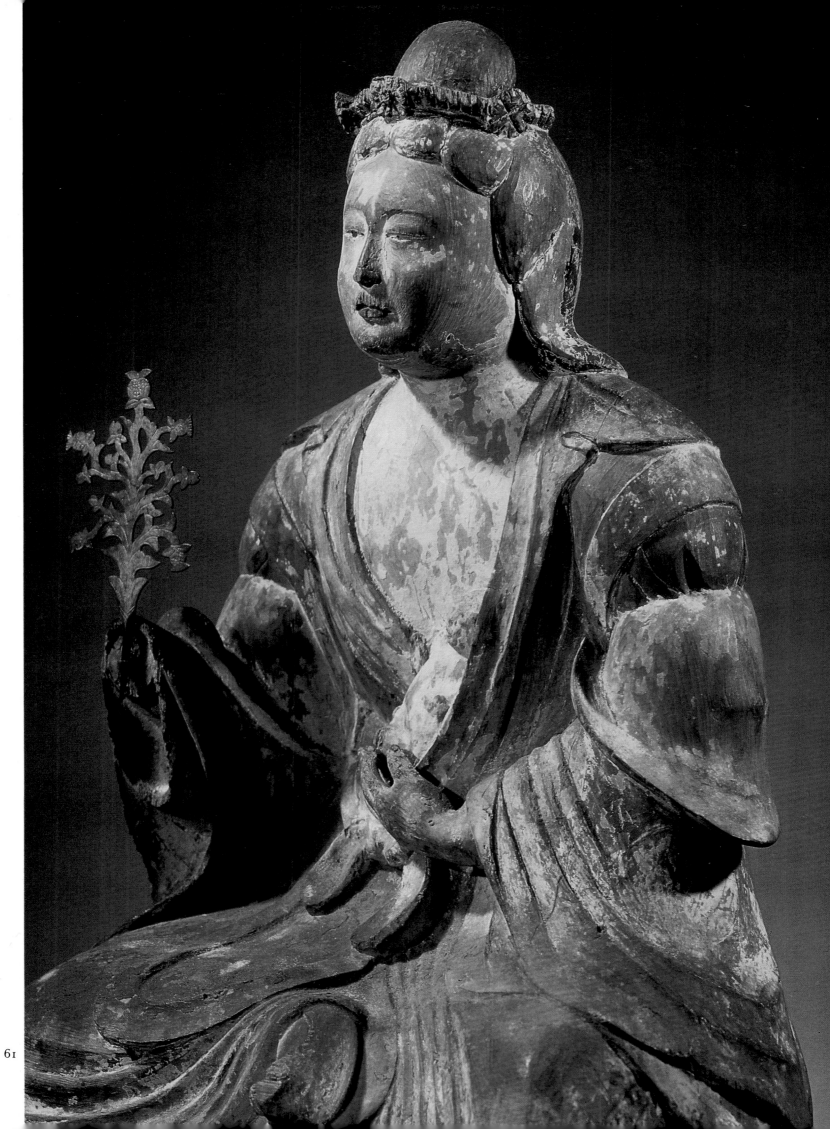

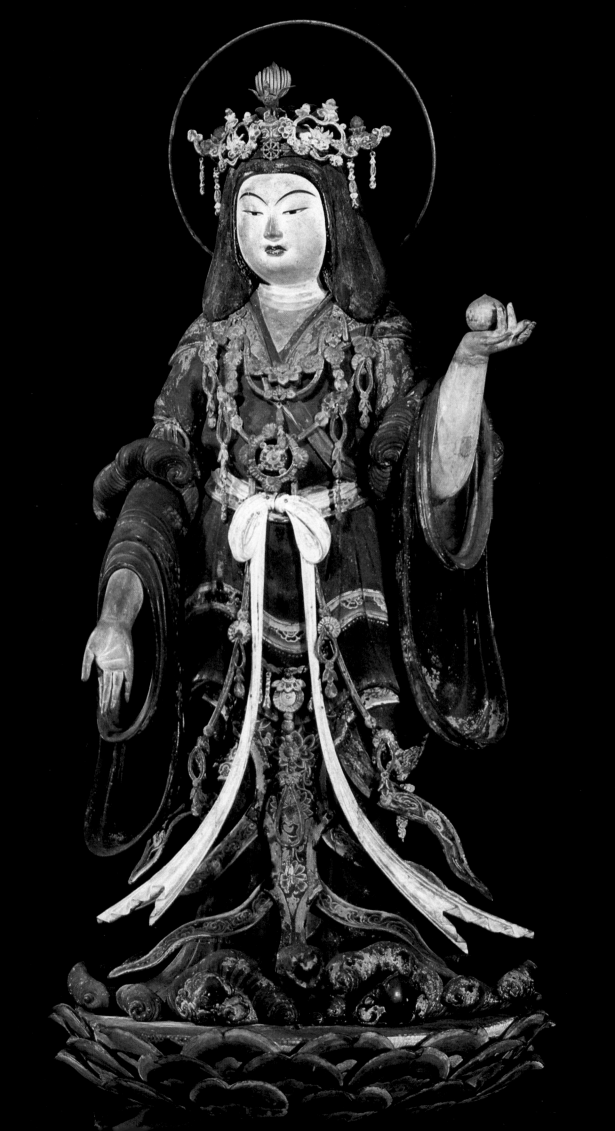

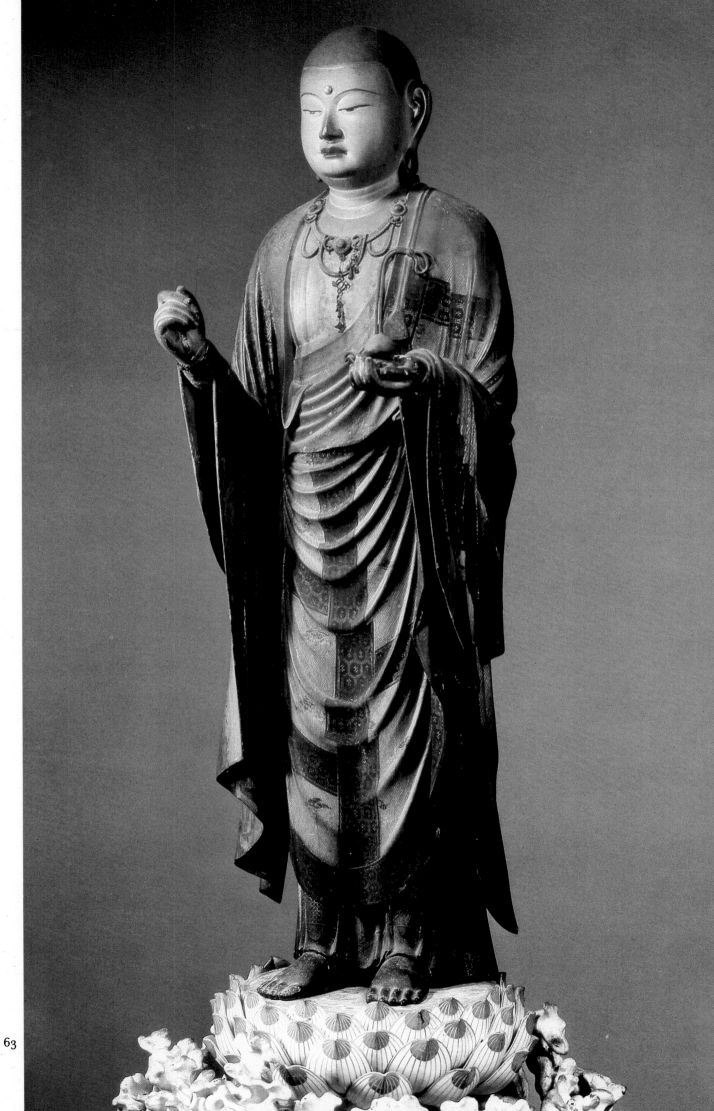

63

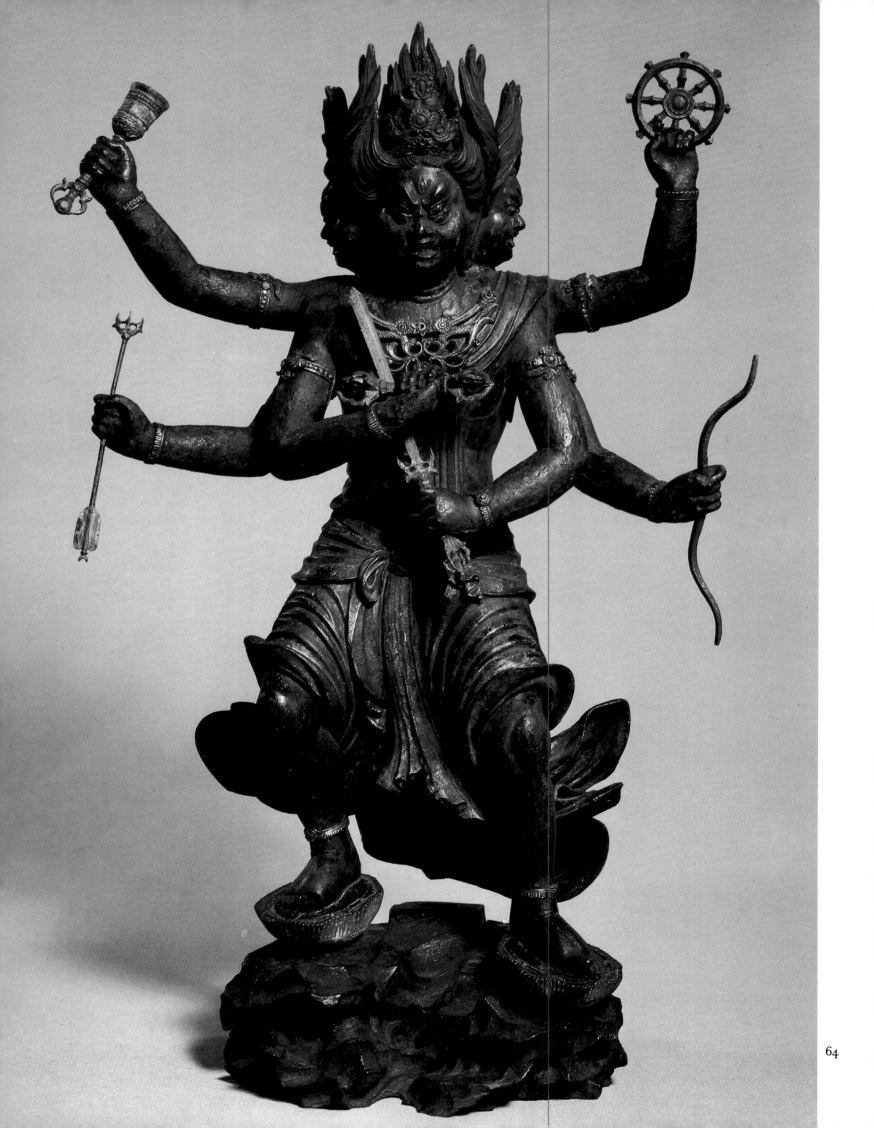

60 BODHISATTVA
 Wood, height 2.12 m.
 Heian Period, 9th–12th century.
 Los Angeles County Museum of Art

61 KARITEIMO (HĀRITI)
 Colored wood, height 42.2 cm.
 Heian Period, 12th century.
 Tōdaiji, Nara

62 KICHIJŌTEN (MAHĀSRI)
 Colored wood, height 90 cm.
 Heian Period, 1212.
 Jōruriji, Kyoto

63 JIZŌ BOSATSU (KSITIGARBHA)
 By Kaikei (fl. c. 1185–1220).
 Colored wood, height 89.8 cm.
 Kamakura Period, 1203–1208.
 Tōdaiji, Nara

64 KONGŌYASHA (VAJRAYAKSA)
 Wood with paint over gesso, height 42.9 cm.
 Kamakura Period, 13th century.
 Freer Gallery of Art, Washington, D.C.

65 FUDŌ MYŌŌ (ACALA) AND TWO ATTENDANTS
 ("BLUE FUDŌ")
 Color on silk, 2.1 × 1.5 m.
 Heian Period, 11th century.
 Shōren-in, Kyoto

66 HŌRŌKAKU MANDARA
 Color and gold on silk, 144.4 × 86.7 cm.
 Heian Period, 12th century.
 Freer Gallery of Art, Washington, D.C.

67 FUGEN BODHISATTVA (SAMANTABHADRA)
 Ink, color, gold, and silver on silk, 155.6 × 83.1 cm.
 Heian Period, 12th century.
 Freer Gallery of Art, Washington, D.C.

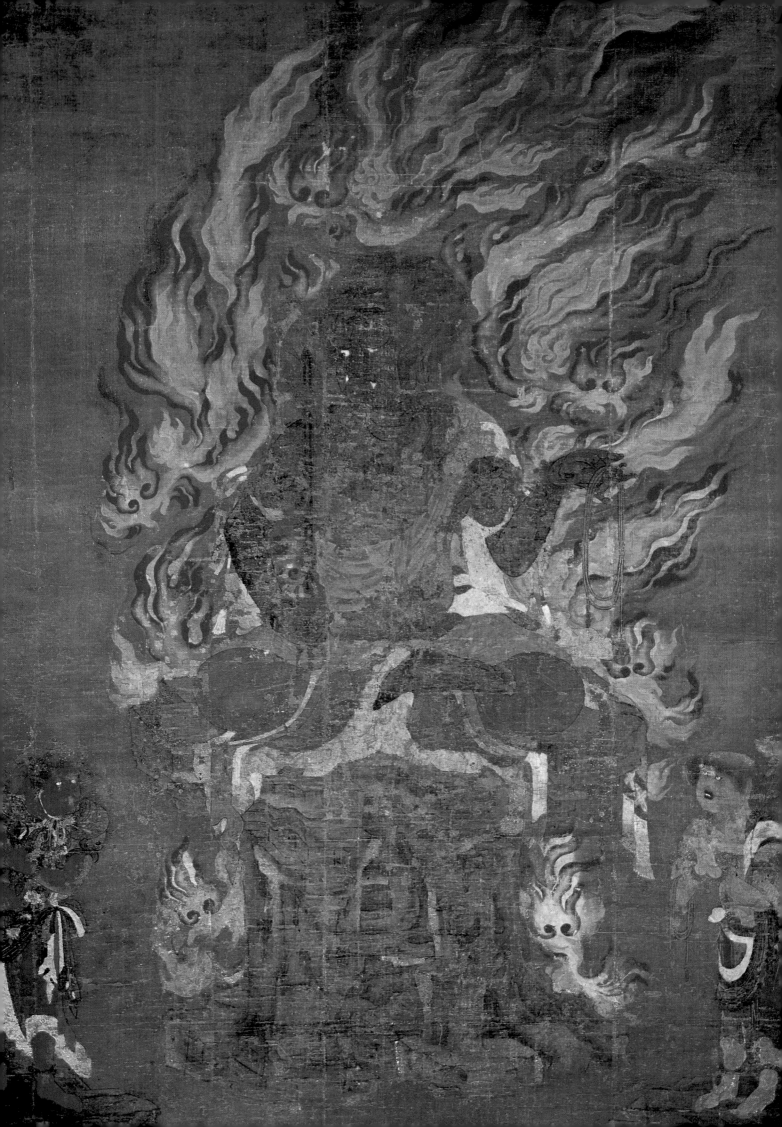

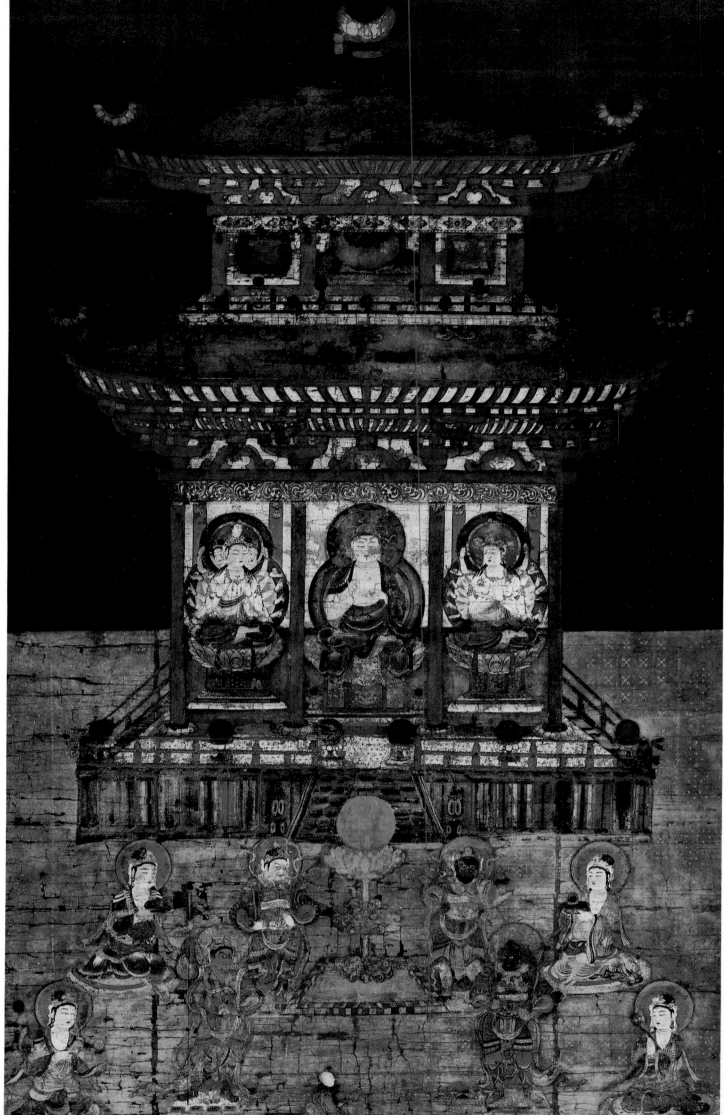

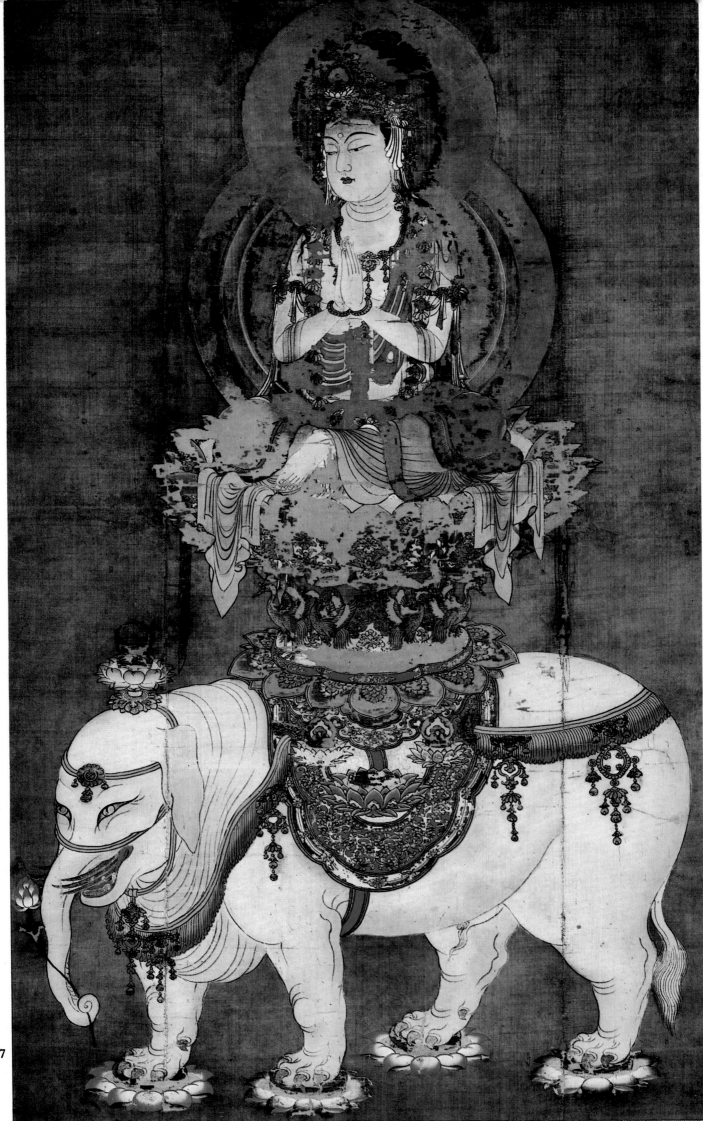

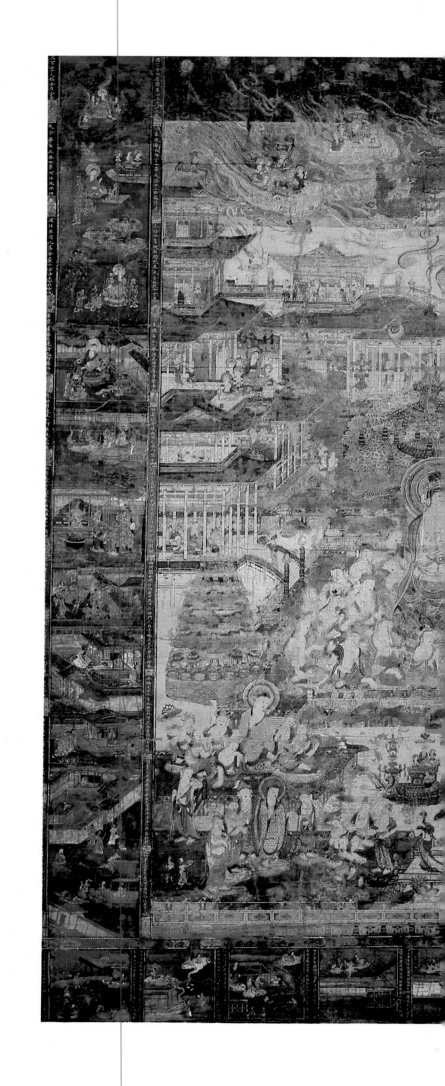

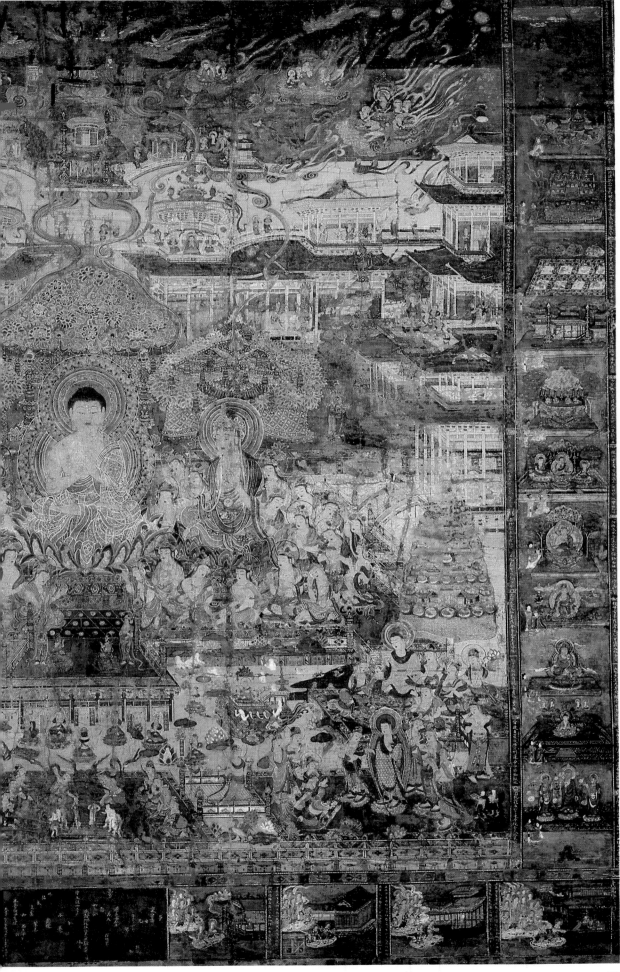

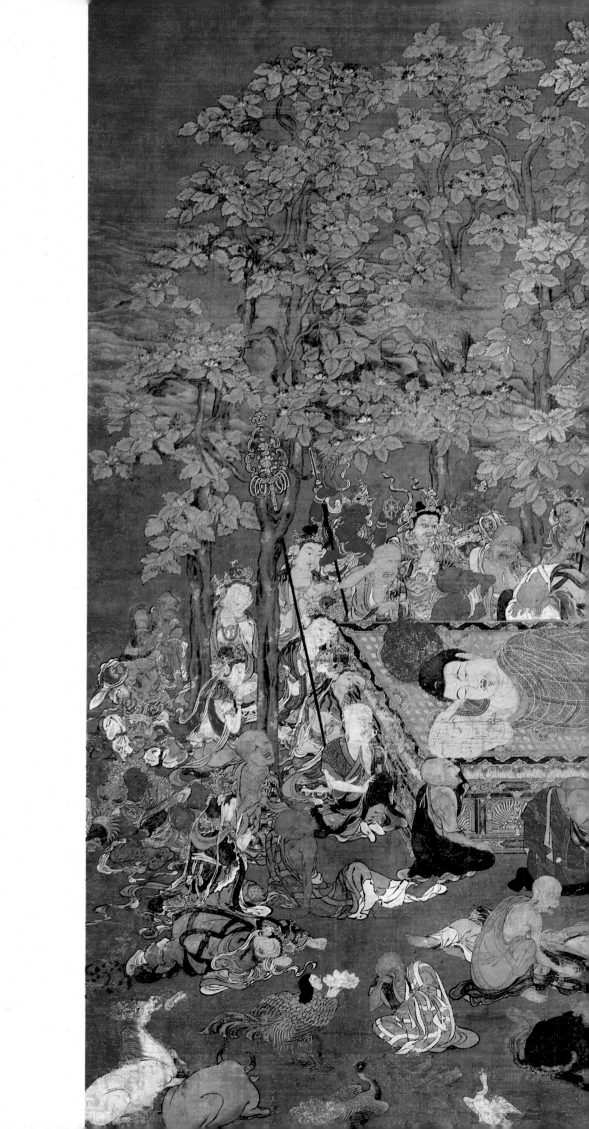

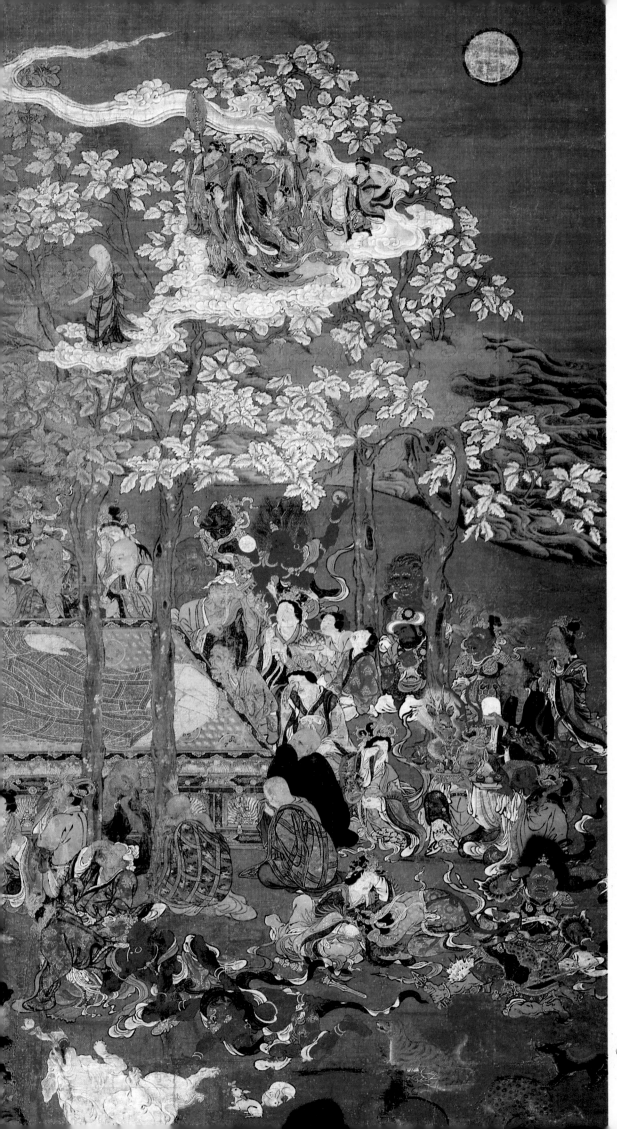

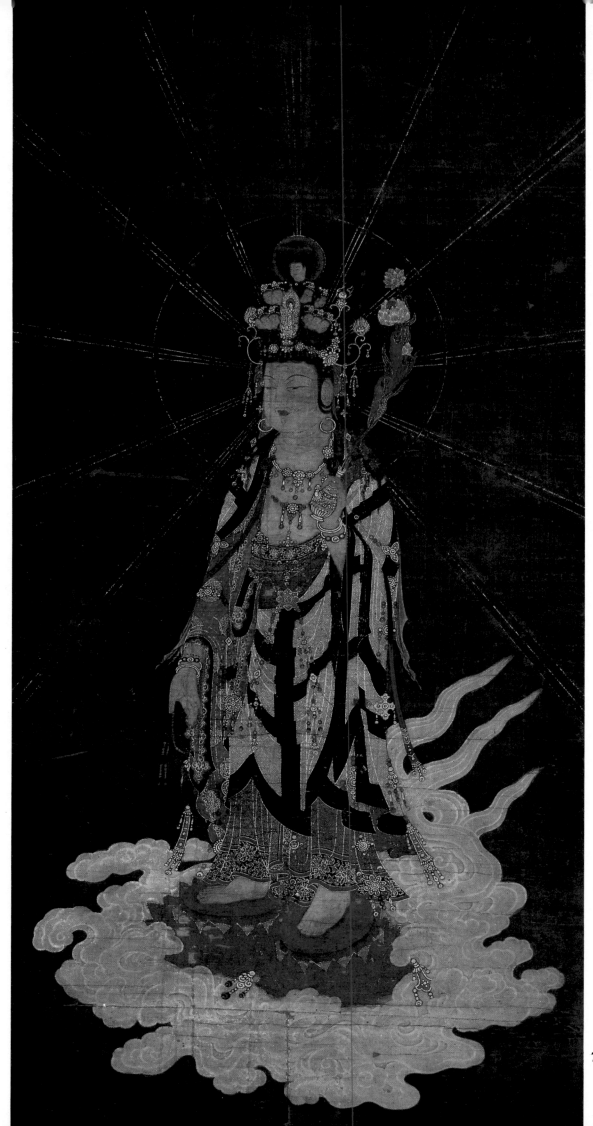

68 TAIMA MANDARA
Ink, color, and gold on silk, height 1.7 m.
Kamakura-Muromachi Period, 14th century.
Asian Art Museum, San Francisco

69 NIRVĀNA SCENE (NEHAN)
Ink, color, and gold on silk, 2 × 2 m.
Kamakura Period, mid-14th century.
Freer Gallery of Art, Washington, D.C.

70 ELEVEN-HEADED KANNON (JŪICHIMEN KANNON,
EKADAŚAMUKLA)
Color and kirikane *(gold leaf flakes) on silk,*
height 86.9 cm.
Kamakura Period, 13th–14th century.
Metropolitan Museum of Art, New York

71 FUDŌ MYŌŌ (ACALA)
Wood, entire height 70 cm.
Heian Period, 12th century.
Museum of Fine Arts, Boston

72 FUDŌ MYŌŌ (ACALA) SURROUNDED BY FLAMES
Colored wood, height 1.7 m.
Heian Period, 9th century.
Kōdō, Tōji, Kyoto

73 FUDŌ MYŌŌ (ACALA) SURROUNDED BY FLAMES
Colored wood, height 86 cm.
Late Kamakura Period, late 14th century.
Tōdaiji, Nara

74 KARURA (GARUDA), ONE OF THE EIGHT GUARDIANS
(HACHIBUSHŪ) OF SHAKA NYORAI *(see fig. 244).*
Dry lacquer, entire height 1.5 m.
Nara Period, 8th century.
Kōfukuji Treasure House, Nara

75 GUARDIAN
Wood with traces of color, entire height 95 cm.
Heian Period, 9th century.
Asian Art Museum, San Francisco

76 KONGŌRIKISHI (VAJRAPĀNI)
By Unkei (1151–1223) and Kaikei (fl. c. 1185–1220).
One of two wooden statues (figs. 284, 285),
entire height 8.4 m.
Kamakura Period, 1203.
Tōdaiji, Nara

77 GUARDIAN KING (NIŌ), KONGŌRIKISHI (VAJRAPĀNI)
Wood, entire height 2.3 m.
Kamakura Period, 13th century.
Freer Gallery of Art, Washington, D.C.

78 KŌMOKUTEN (VIRŪPĀKSA, ONE OF THE FOUR
GUARDIAN KINGS)
Unpainted wood, entire height 1.2 m.
Heian Period.
Shōjōji, Fukushima

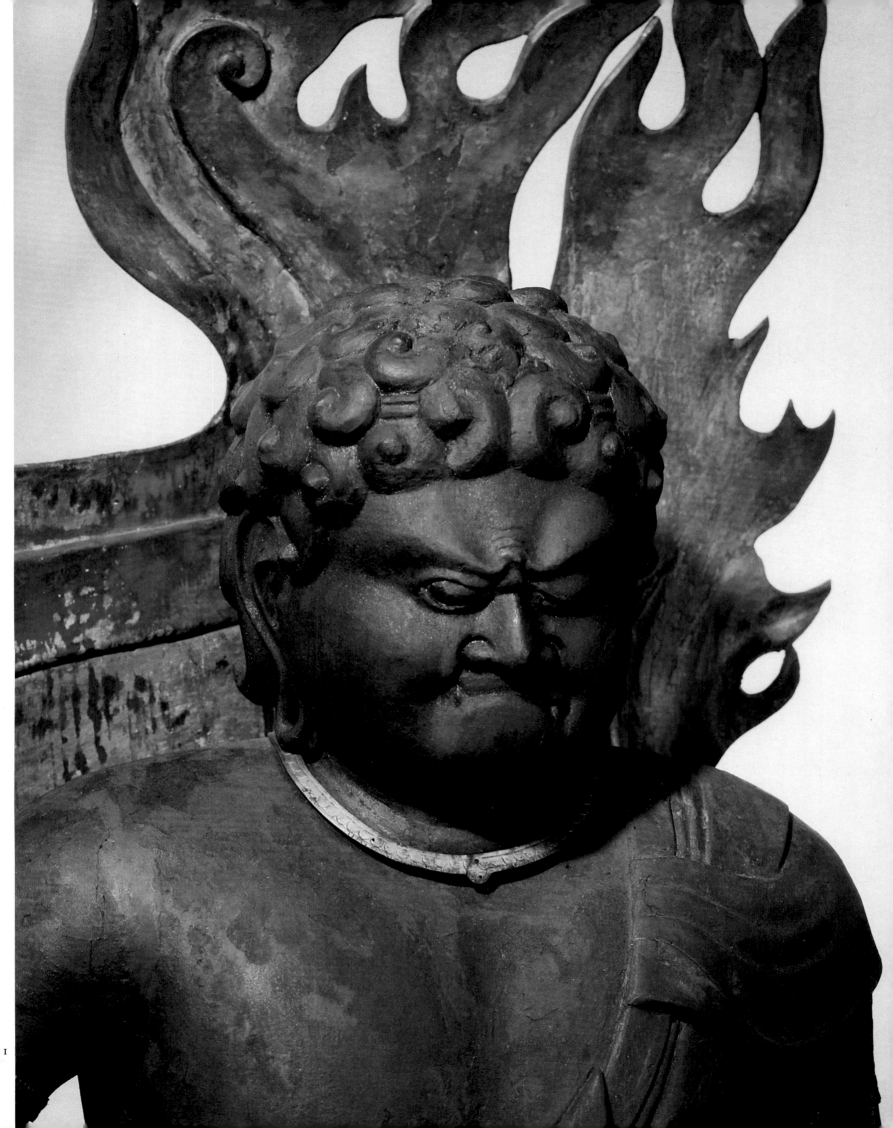

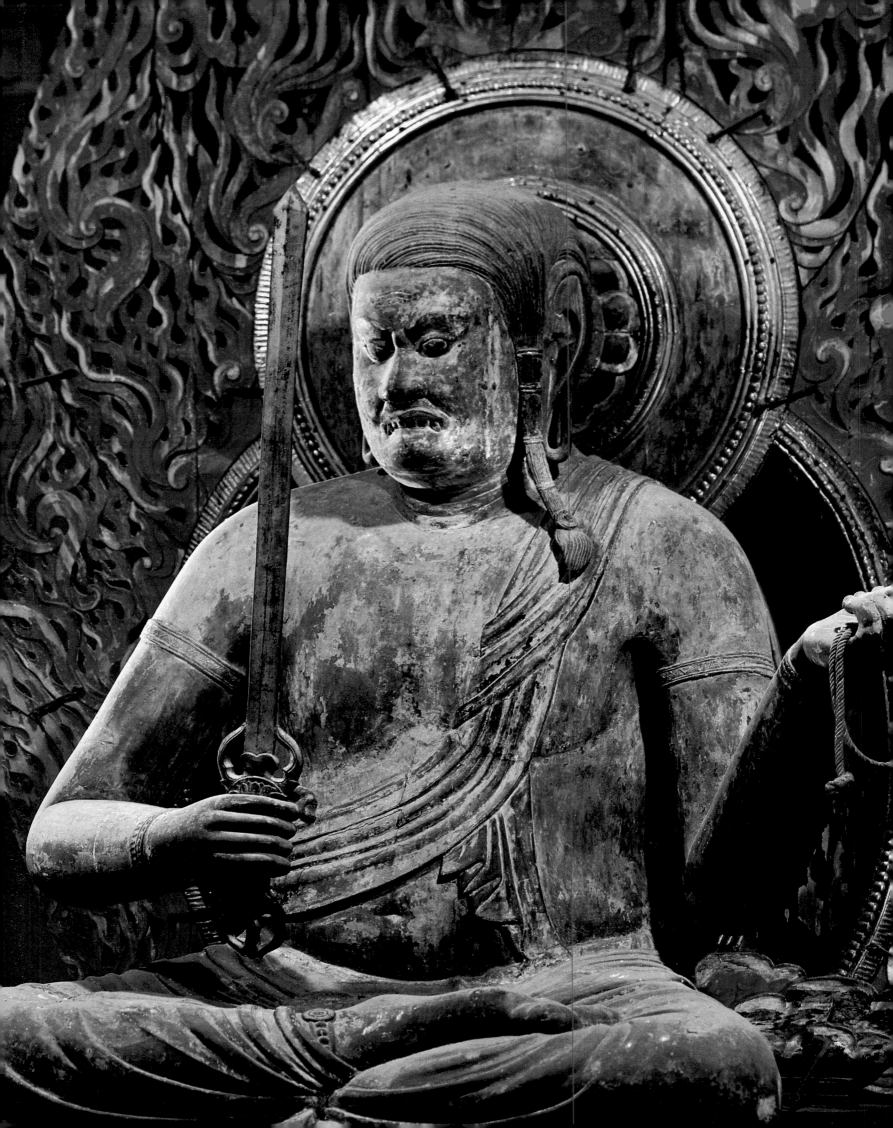

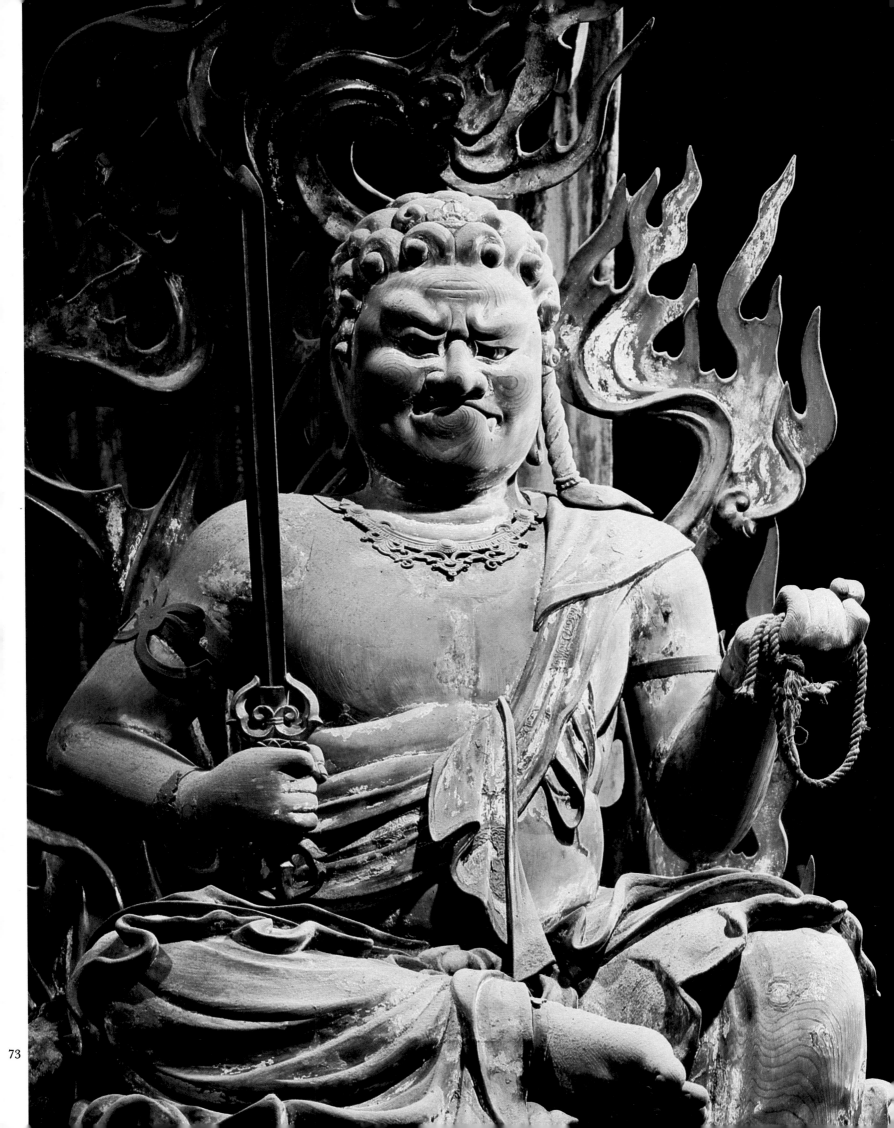

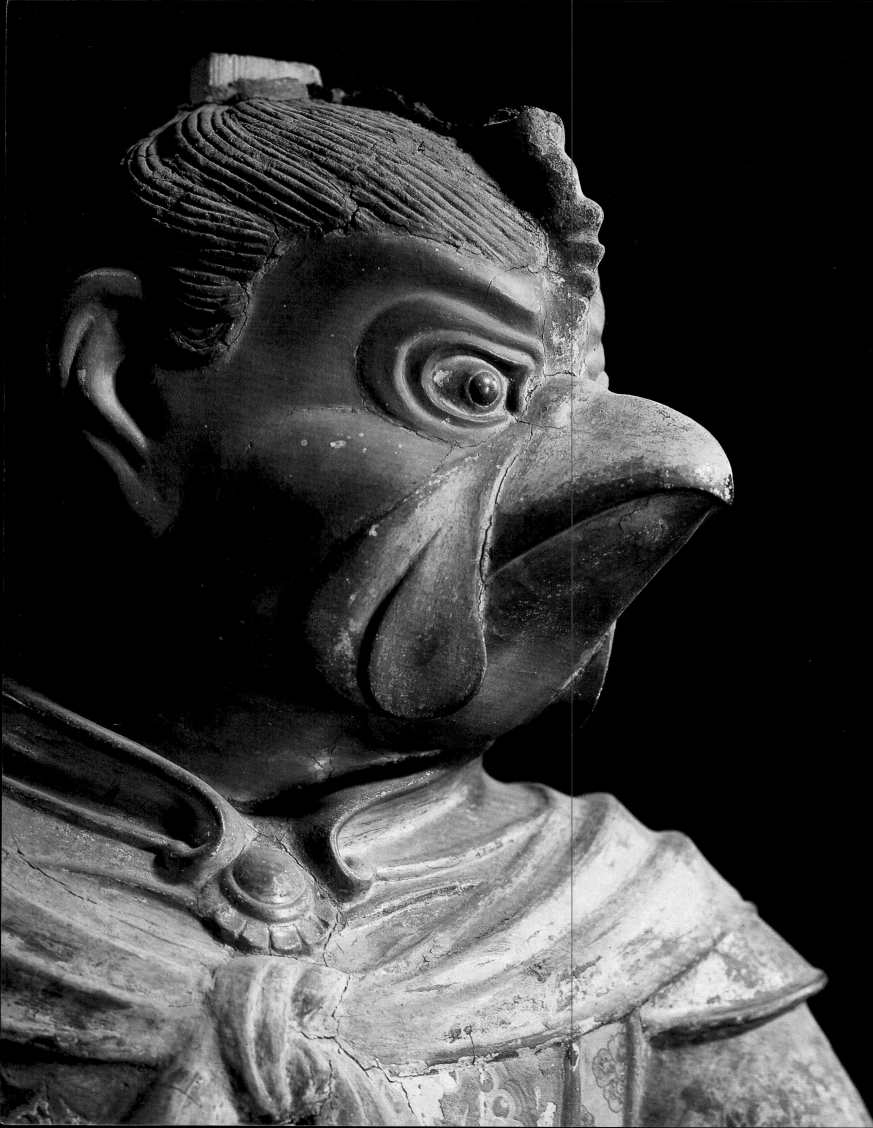

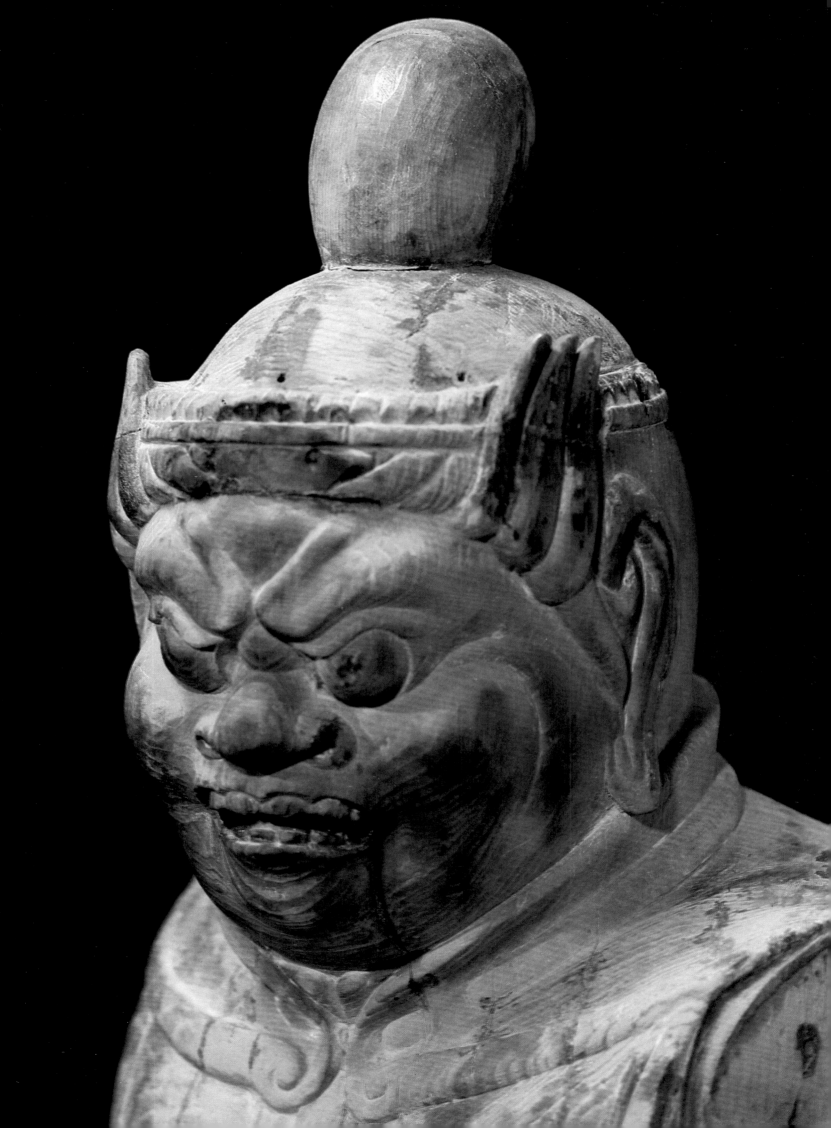

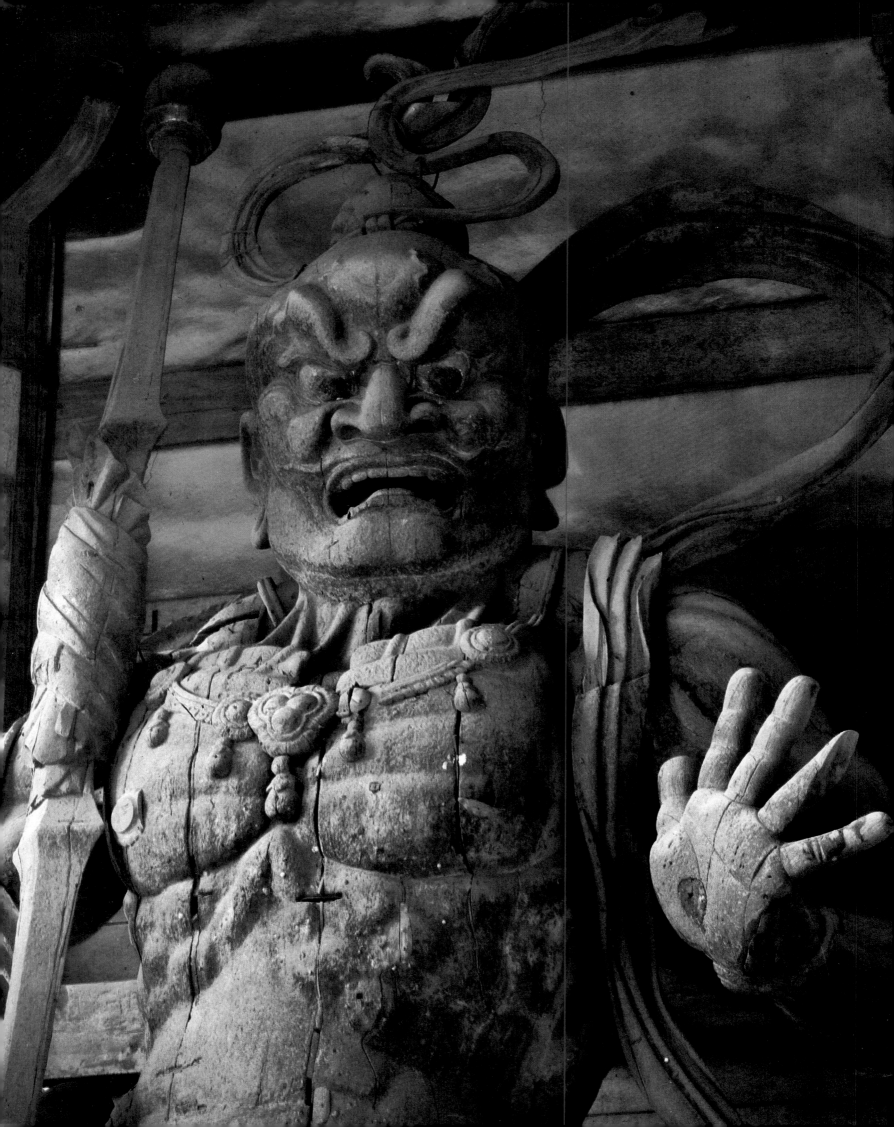

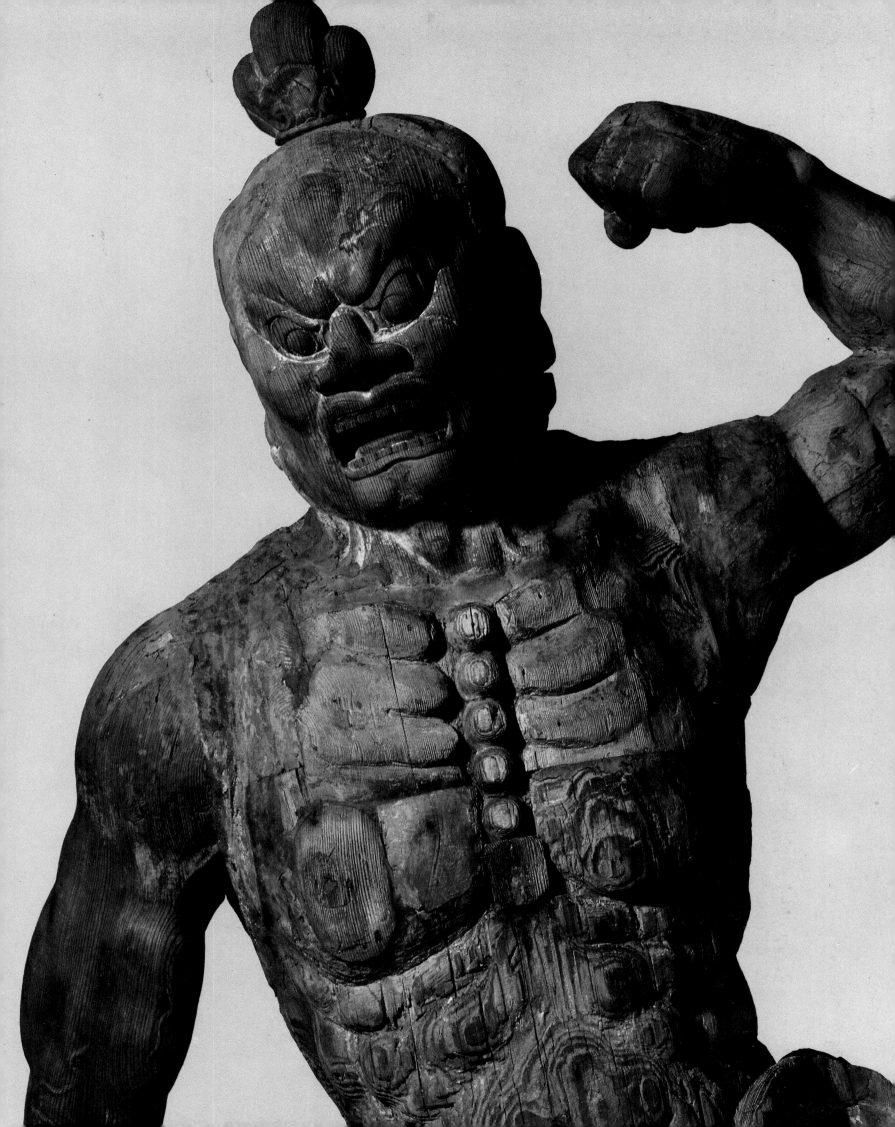

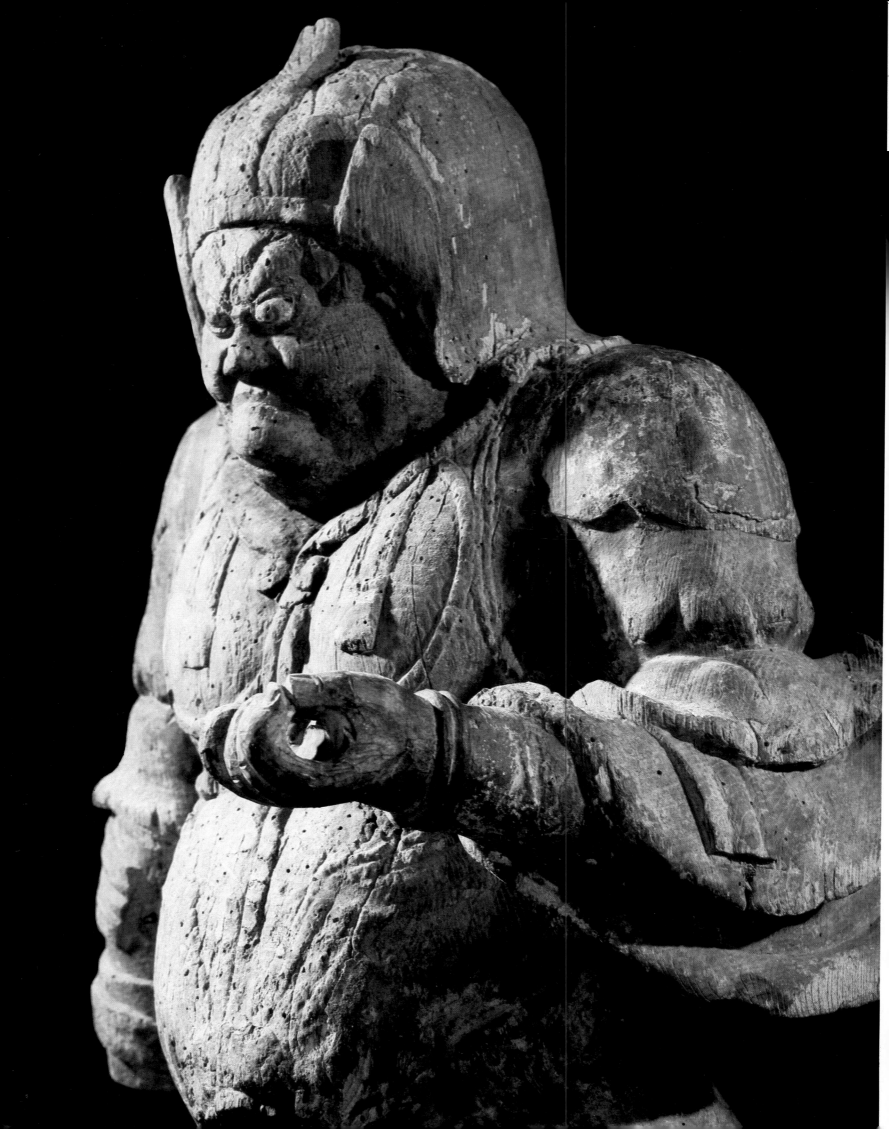

4. PORTRAITS

4. PORTRAITS

Persons and Their Images

FAR Eastern portraits both fascinate and baffle Westerners, who cannot respond instinctively, as they do in their own culture, to what is aroused by a portrait or simply by a painting of a person—for these are thematic paintings, and in the Far East they are often paintings that pose a particular thesis.

The concept of the image as an instrument of morality overshadowed all Chinese painting until the Ming dynasty. This attitude contributed so far toward cutting the tie uniting the portrait with its model that in the Far East, even in modern times, the portrait in the individual, "personal" sense virtually does not exist. But it is a bit severe to state, as did Donald Keene about a portrait of the Japanese monk Ikkyu (1394–1481) of the Rinzai sect, that "the art of portraiture, though practiced and developed in the Far East over the centuries, has seldom been esteemed as highly as landscape, religious, or other types of painting" (*Archives of the Chinese Art Society of America*, XX, 1966–67, p. 54). Indeed, what Chinese scholars had to say about art—consider the writings of Chang Yen-Yuan (9th century), to name only the most famous among them—indicates that for a long time, at least until the Song dynasty, the Chinese held portrait painting to be the highest achievement. But what did this preeminence imply? Was it the portraitist's aim to convey a man's personality? or his nature, enhanced by the philosophical value of an archetype? Who saw these paintings? People who grasped their spiritual meaning, or others who needed them simply to support the rituals performed in blind routine, only half understood? It was the latter tendency that marked the beginning of the decline of the portrait in Chinese art.

JAPANESE portraits—a subject that often conjures up for the foreigner picturesque images of *samurai*, *kabuki* actors, and comely geishas enlivening guests at elegant banquets—cannot be understood without reference to the Chinese portrait tradition. Unfortunately, although that tradition flourished for over a millennium, we see of it only the cold, tiresome "ancestor portraits" our forefathers brought back from an Asia full of sellers of "curiosities." At the most, people will acknowledge the value of the "Korean

177

portrait," which retained a liveliness into the 20th century that seemed to have vanished on the mainland.

It is the great merit of current historical research into Far Eastern portraiture that, if it cannot salvage the lost images themselves, it has aroused an awareness of the pivotal role that portraiture played in ancient China. And it is well known that Japan never remained long unaffected by what happened in China.

REGIONAL courts in China seem to have much esteemed the genre of portraiture, painted or carved, as early as the Warring States period (473–221 B.C.) and even long before, if we include the little carved human figures discovered in 1976 in Tomb 5 of Fu Hao at the Yin Ruins near Anyang (12th century B.C.). Despite the expanse of time and changes in government, this interest never waned. To celebrate the completion of a bridge over the Wei River, the First Emperor of Qin (r. 221–210 B.C.) had a caryatid-like statue built that also gave needed solidity to the bridge. In the Han dynasty, the deceased wife of Emperor Wu Di (r. 140–87 B.C.) appeared in his dreams, and the emperor, on advice from a counsellor, had her effigy made to appease her spirit, whether in sculpture or painting is not known. There were statues honoring Confucius; there were also propitiatory images to be thrown into flooding rivers.

Thus, the representation of the human figure seems to be as old as Chinese civilization itself, but it remained closely linked with propitiatory or magical activities: the cult of royalty, the honoring of leaders or heroes, harnessing the forces of nature, or appeasing a ghost. The simple admiration of the human body had no more to do with the origins of Chinese sculpture than did religious symbolism of an intellectual sort. Moreover, ancient Chinese philosophers had no conception before Buddhism of any infinity without form, contour, or absolute limit. The Chinese world view was always deeply rooted in material reality; nothingness was only a negative version of what is—a type of premonition of antimatter. The calamities that strike humanity were believed to result from still greater calamities befalling the formidable powers, an adverse fate that forced them out of their enveloping "shell" as a soul is forced out of its body. To reestablish peace and harmony, the living could only provide these forces with a "shell" to return to. This is why every statue and portrait has primarily a magical power rather than a symbolic meaning. The great Buddhist revolution, sparked by Indian and Greek thought, consisted precisely in viewing an image only as a tangible object of meditation, a fulcrum for the mind seeking to lift itself toward *nirvāna*. As the religion spread among the masses, the Buddhist image also became an educational tool. In both ways—as a support for meditation and as education—it joined the mainstream of religious art the world over. But one must never forget the old magical sources, however disguised by the development of rational Confucian thought, that would always infuse Far Eastern imagery with a life whose secret beat we can no longer always hear. This hidden vitality gives to their portraits an exceptionally impressive power that is all the more compelling if the subject is a priest or holy person privileged to intermediate between what man sees and what is beyond his understanding.

Every tendency, every strain of Japanese religion developed its preferred type of representation. Thus the portrait type of the "great master" appeared in connection with esoteric Buddhism during the Heian period (9th–12th centuries), then especially with Chan (Zen) Buddhism during the Kamakura period (12th–14th centuries). To be sure, all offshoots of the Greater Vehicle were rooted in a single fundamental belief: Enlightenment could be passed on by those who, having almost reached "Buddha-hood" or Buddha nature, chose to turn toward men in order to show them "the Way." Zen, however, went still further by dismissing textual studies as worthless and replacing them with living experience, the only kind which could lead each worshiper to salvation. The Zen sect extended immeasurably the prestige of the Master, the One who knows, the One who, like Socrates and his questions, could awaken unsuspected forces and capacities in the disciple.

The art of portraiture evolved within the broader current of Buddhist representation. To understand what transpired in Japan, we must again return to China. In very early times we find a preoccupation with preserving material containers that had already inspired Bronze Age civilizations to construct the remarkable tombs that are among the primary sources of our information about ancient China. But for now we go back to the heyday of the Tang culture (618–907) that the fledgling Japanese nation admired so intensely.

The history of the sculpture that deserves the name "portraiture" probably began in Japan with Chien Chen (Ganjin: 688–763), the celebrated founder of Tōshōdaiji at Nara. About 750 he was passing through the island of Hainan, off the coast of southern China, and he happened to see people worshiping the mummified and lacquered corpse of the venerable Hui Neng (638–713), Sixth Patriarch of Chan Buddhism. Made immediately after the death of the holy man in 713, this bizarre effigy—as much a relic or shriveled figure as a statue—seemed still to impart something of the Master's spiritual message. Shortly thereafter, Ganjin made the first of his difficult attempts to cross the sea to Japan. Then—should it be attributed to the many grueling shipwrecks, or to a higher power?—Ganjin's eyes, the eyes that had gazed on the statue of Hui Neng, went blind. Possibly Ganjin saw this as a sign. When he felt that the end was near, he confided to his faithful Su T'uo, a Chinese disciple who had followed him to Japan, that he wished to be mummified and, like Hui Neng, to become a statue. Dying, he tried to bring about a kind of natural mummification of his own body, to obtain through extreme self-discipline and self-denial a body "shell" whose form, though emaciated and withered, would retain a face having an expression forged by the soul's inner fire. Remarkable specimens of this practice can still be found throughout northeastern Japan (Tōhoku), where severe winters and relatively cool summers have preserved some of these self-mummified corpses over the centuries, but if similar practices existed in the rest of the archipelago, their chance of survival has long since vanished in the suffocat-

ing heat of the summer monsoon. Ganjin himself did not succeed in bringing his body to the condition he longed for: it had to be burned like an ordinary corpse, but his disciples immediately fashioned a lacquer version of the mummy that had been denied them (fig. 277).

In this way the archipelago discovered the statue-portrait, which, like its counterpart in ancient China, was supposed to be somehow "inhabited." In Japan, it was looked upon both as a simple likeness (*nise-e*) and as a reliquary filled with supernatural power, a miraculous object that conveyed the spirituality of the soul. Statues of the latter form became much more than vehicles of doctrine: such an effigy was the holy man himself, someone who had been able to die "in a seated position" and had achieved *nirvāna* by leaving his earthly shell behind, deep in some cave. (The practice had begun in India and spread to Khotan and the Pamir.) In China, this method of bringing about one's own death was rooted in the Taoist notion of "casting off the cicada shell": a wise man could directly enter the realm of the blessed and gain immortality by shedding his withered, useless shell on the spot, as cicadas do. In Chinese Buddhism, therefore, a holy man was someone able to bring about his mummification on his own. If need be, the mummy could be protected or even remodeled at less sturdy spots by applying hemp cloth and lacquer.

This phenomenon remained very uncommon, and this is why people resorted to a simpler way of turning images into relics. After cremation, the ashes of the deceased were mixed with clay and modeled into as accurate a likeness of the subject as possible. Since self-mummification called for exceptional willpower and circumstances, the ashes of a holy man could also be placed inside a wood statue to create a kind of "instant" reliquary. So long as Japan remained in close touch with China, this was the most widespread method of sanctifying images after the time of Ganjin's death (763) until the end of the 9th century.

DECEASED individuals were not the only subjects of portraits. The Japanese also developed the art of making portraits of a living man (*juzō*) to commemorate a milestone (such as a seventieth, seventy-fifth, or eightieth birthday) or to mark a solemn event, such as entering a monastic order. This favorite practice during the Kamakura period reflects the influence of Song China, where, despite the growing popularity of landscapes, portraiture remained the undisputed leader among types of art. These statues of living subjects were all in the realistic style then in fashion, and particularly well suited to representing the human figure. Upon the death of the model, these effigies became portrait-reliquaries that were either opened to receive the ashes of the deceased or placed upon his tomb.

It is always arbitrary to separate one component of a cultural phenomenon from another, and among the different genres that existed no absolute distinction can be drawn between religious and secular portraits, although the latter were aimed more directly at eliciting an amused or emotional response from the onlooker.

THERE were three types of nonreligious portraits: "portraits of men" (*otoko-e*), "likeness portraits" (*nise-e*), and "portraits of women" (*onna-e*).

The *onna-e*, or "portraits of women," were created in compliance with the canons of scroll painting as they appear in that consummate achievement, *The Tale of Genji* (fig. 125): the characters—their famous "hook-nose, dash-eye" faces—are endlessly repeated in the illustration of romantic stories and personal diaries, and they move in the same intimate atmosphere where feelings are expressed through color. For portraits of men (*otoko-e*), bold, energetic lines were the rule; the forceful brush stroke counted here, not areas of brilliant color. Ultimately the imperial court blended the two manners into the *nise-e*, or "likeness" style of portraiture.

Even religious art was not immune to the mixing of genres. Many portraits of priests rendered in the *nise-e* manner—a direct offshoot of court art—were discovered folded up inside statues portraying monks. In the absence of other relics, these images, it was believed, could impart something of the Master—his outward appearance or, in the case of an inspired portrait, the gleam in his eye, and even "lay" portraits could be used to sanctify statues. Does not all of Far Eastern painting retain something of the universal, magical power of the word-pictogram?

In this respect Far Eastern portraits represented not so much the actual appearance of the model as what the appearance had to be in order to serve as an example for posterity. Artists at the time were required to render only the essentials, disregarding all superfluous or incidental details, such as shadows. The painter's approach was not unlike that of the calligrapher, who always placed greater trust in smooth, vigorous strokes than in the virtues of shading. The only useful criterion for judging a work is that of 6th-century Xie He's *qi yun*, to convey the breath and spirit of life. This principle has been too often linked with the painting of landscape; it was formulated when portraiture was the prevailing genre. The distinction, now traditional in the Far East, between the term *qi yun*, as it applies to landscape, and the term *ch'uan chen*—"transmit the spirit"—which is often used for portraiture, should be reconsidered in discussing ancient painting. In fact all aesthetic judgment should be a function of the criterion *qi yun*, a literary term in which the cosmic and mystical ideas of "spirit" and "movement" are blended.

Indeed, movement is inherent in all Far Eastern painting. The same vitality radiating from the painted scrolls and landscapes, where numerous vanishing points take the observer on mental journeys in the realm of imagination, can also be sensed in the portraits. If one looks closely at a truly inspired portrait, each part of the face has its own life and itself transmits a pulse of the soul. This principle of the whole formed from a set of independent living parts is brilliantly illustrated in China in the painting of the great *literati* of the Yuan and Ming dynasties (13th–14th centuries and 14th–17th centuries, respectively). For portrait painters, this became a systematic "technique" based upon the widespread belief that, despite how easy it seems, it is difficult to perceive a face in its entirety and that we unconsciously focus on the eyes, the mouth, or the nose successively, depending on how significant or unremarkable they appear to us at a given moment. Versed since the Han dynasty (3rd century B.C.–3rd century A.D.) in the

science of physiognomy, Chinese characterologists anticipated the most recent theories concerning the "messages" we send out, not only by our speech, but by the "body language" we utter through our muscles and positions.

Consequently, the face in a Far Eastern portrait is an aggregate of independent elements, each of which is deliberately captured at a slightly different point in time. If we single out each component of the splendid portrait of Dōryū (1213–1278) in Kenchōji (Kamakura, Kanagawa Prefecture), we find ourselves isolating, then fusing such features as the following: the left eye, with its sagging corners and pupil slightly flattened beneath a line of black lashes, reflecting sadness or a meditative or careworn sternness while the nearly triangular right eye, accentuated by a curved line at the lower edge and a round pupil that seems to be staring out, evokes a smile; the wrinkles that crisscross the subject's forehead offset the suggestion of a smile hinted at in the beginning of a "character line" at the base of the model's long, straight nose, though the full, finely chiseled mouth remains horizontal. In a word, nothing about this portrait is clear-cut. Now serious, now mirthful, the face poses an enigma that the observer must unravel by comparing and piecing together its various components. An engrossing pastime for Confucian scholars and *literati*, yes; but something more crucial was at stake. From the Han to the Tang dynasties, civil servants were usually chosen according to their physiognomy, which was believed to indicate the person's *fen*, or lot in life, the place he was destined to occupy in the universal scheme. We do not know if this portrait of Dōryū (1272)—the monk who brought Chan Buddhism to the archipelago—was made in China or Japan, and this is our main reason for selecting it to represent Far Eastern portraiture. The work embodies an art that transcends nationalities and regional differences.

Hands act as the second focal point of a portrait. Whether wielding a symbol of authority (such as a ceremonial or pastoral staff), or frozen in a symbolic religious gesture (*mudrā*), hands express differences in social or intellectual status. And finally, the costume has more than simply a decorative role. In hierarchical or socially compartmented societies—whether political, religious, or feudal—costume indicates most precisely the official niche occupied by each member of that society.

The subject of the oldest known Japanese portraits is a legendary figure as popular in the archipelago as Charlemagne was in western Europe: Shōtoku-Taishi, the prince whose governmental reforms introduced the Chinese political system into Japan. The parallel drawn between Prince Shōtoku and Charlemagne is more traditional than factual, but it is legitimate to the extent that both figures inspired a rich iconography with heavy moral and didactic overtones. And the image often proved more consistent than the man it portrayed (figs. 279, 291).

When Ennin (794–864) returned from China in the middle of the 9th century, he described a ceremony that the residents of Changan had begun to perform in the time of Emperor Hsuan Tsung (712–756), praising the mighty deeds of a holy personage in front of his image. This practice helped to lift the souls of worshipers into a spiri-

tual communion through admiration and respect, but it was also designed to acquaint the masses with basic religious precepts. This *koshiki*, or recitation of deeds, was uttered before a painted or carved portrait of the saint or deity in whose honor the ceremony was being performed. Since both Hōryūji in Nara and Shitennōji in Osaka observed *koshiki*, these temples today possess portraits of Shōtoku-Taishi that were once used as part of the ritual. A certain time was needed before this practice was accepted after Ennin's return, but it had gained popularity by the following century. On many occasions, music preceded and followed the ritual proper, and by the 13th and 14th centuries *koshiki* had such wide acceptance that ceremonial portraits of Prince Shōtoku-Taishi could be found throughout Japan. This explains both the immediate standardization and the permanence of an art type that gratified the worshiper's sense of national awareness and served as a tool of political propaganda.

The "personalized" forms of religion that had developed brought in portraits as part of meditation and liturgy; they were displayed at certain times of the year in a building (*miedo*) set aside for this purpose. And as we have already seen, the votaries of Chan (Zen) looked upon portraits of Buddhist masters (*chinsō*) as integral to their lives. These ceremonies doubtless had much to do with the artist's choice of one type of composition over another. The three-quarter pose, for example, already valued as a way of capturing the "whole" subject, can also be traced back to the ritual display of portraits on either side of an image of Daruma, the First Patriarch of Zen, in much the same way that bodhisattvas are shown flanking Amida.

Court portraiture in its purest form—the celebrated examples are the portraits of Minamoto-no-Yorimoto (1147–1199; fig. 87) and Taira-no-Shigemori, both attributed to Fujiwara-no-Takanobu (1142–1205)—is quite different in spirit from portraiture of monks. Closely related to the colorful *yamato-e* style of painting, they do not seek the almost imperceptible but complex facial movements through which painters of religious works expressed the intensity of a subject's inner life. These courtly faces are motionless, their features, uniform: Yorimoto stubbornly looks toward the right, Shigemori stares toward the left. This unvarying rigidity was actually based on concrete reasons. Takanobu had been commissioned to paint four friends of the abdicated emperor Go-Shirakawa (r. 1156–1158, d. 1192) to decorate the inside of the Sendōin, a residence built for the "retired" emperor in 1188, and he had to consider architectural and interior features that were markedly different from those prevailing in the work of religious portraitists. Furthermore, respect for the social standing enjoyed by officials and a strong bond with the *yamato-e* style adopted by most court portraitists prompted Takanobu toward the canons of secular Chinese portraiture, depicting aristocrats as social creatures rather than individuals faced with vexing questions of Salvation.

These courtly faces have the oval shape and "hook" nose typical of figures in painted scrolls; the wide-open eyes have an inflexible, somewhat conventionalized look

(though it should be added that a more than cursory examination is needed to comprehend all the subtleties of technique). Our sole means of determining differences in personality is the artist's deft modulation of the facial oval: fuller and more pliant in the portrait of Shigemori, stiff and spare in that of Yorimoto. But Takanobu's real genius lay in his meticulous rendering of costumes, those superb mounds of dark silk from which emerge long, white-and-gold *hakama* (trousers) and the emblems of authority: a white *shaku* (ceremonial staff) and the hilt of the imposing ceremonial sword (*tachi*) once carried by noblemen of the imperial court.

TAKANOBU's son, Fujiwara-no-Nobuzane (fl. 1185–1265), is traditionally credited with the creation of portraiture in Japan (figs. 316, 317). Thanks to information in the Hirohashi family papers and elsewhere, more is known about Nobuzane's life than about his father's. He was, like all artists of his era, also a writer and a poet, underscoring once again the characteristic ties—with divergences, to be sure—between Japanese painting and literature. This close relationship must have been, if anything, even more patent in China, where, with the advent of ink painting during the late Tang dynasty, the use of identical materials and procedures forged a strong bond between the two forms of expression, painting and literature. The same relationship existed in Japan, but the sharper differences in technique often veil this from foreigners.

As the Heian master artists produced illustrated sutras to spread the message of Buddhism among the people, so too did they express literary forms and literary sensitivity through painting. The *yamato-e* style would never have come into being without the Japanese-language novel. But the Japanese portrait, with its overtones of sobriety, even austerity, brings to mind the dignified themes and mood of Japanese literature written in Chinese (*kanbun*). Nobuzane penned a fair amount of verse, as well as a novel that is mentioned in the archives of Ninnaji at Kyoto. In keeping with the climate of the times, his poetry has a deeply felt Amidist inspiration that is still more natural since his father, Takanobu, was a fervent disciple of the great monk Hōnen (1133–1212). Thus, Nobuzane's paintings included portraits of holy persons and illuminated sutras. It is believed that a number of these religious works, especially from his youth, are among the portraits of emperors or monks now preserved in national collections.

Self-portraits are rare in any type of portraiture in the Far East, but it would go too far to claim that they do not exist. We know of at least one disturbing example (fig. 100): the self-portrait of Sesson, whose intense admiration for the great Sesshū (1420–1506) is borne out by the similarity of their names (his name being made from the master's name). Sesson must have been well advanced in years when he painted himself with hoary features and a monk's robe, and seated in a fur-covered chair. In the background is a half-veiled moon and a steep, white cliff outlined in black and ending in a craggy summit; both elements underscore the absence of warmth. It is winter: Nature's cycle and the life of a man are both drawing to a close and with the appearance of death comes the moment when the artist shall know at last the sequel to death. Has he labored under a delusion his whole life long, or, on the contrary, shall he attain

the ultimate Enlightenment? The work is signed, and, prompted by similar feelings to those that inspired the poetry on Chinese paintings, bears the holographic inscription:

Mountain, river: one and the same color, white as cotton.
From the cottage rises a slanting wisp of smoke;
When one reaches the end, better to return to the stake.
The firewood is there by the door, the water drains off, and ahead is the
 shimmering moon.

 —Sesson, the old man

79 GIGAKU MASK
Wood, height about 30 cm.
Nara Period, 8th century.
Musée Guimet, Paris

80 SHINTO GODDESS
Painted wood, height 86 cm.
Heian Period, 9th century.
Kyoto National Museum

81 EMPRESS JINGŪ
Colored wood, entire height 35.8 cm.
Heian Period, 9th century.
Yakushiji, Nara

82 SHAKA NYORAI
Wood, originally painted; entire height 1.4 m.
Early Heian Period, mid-9th century.
Miroku Hall, Murōji, Nara

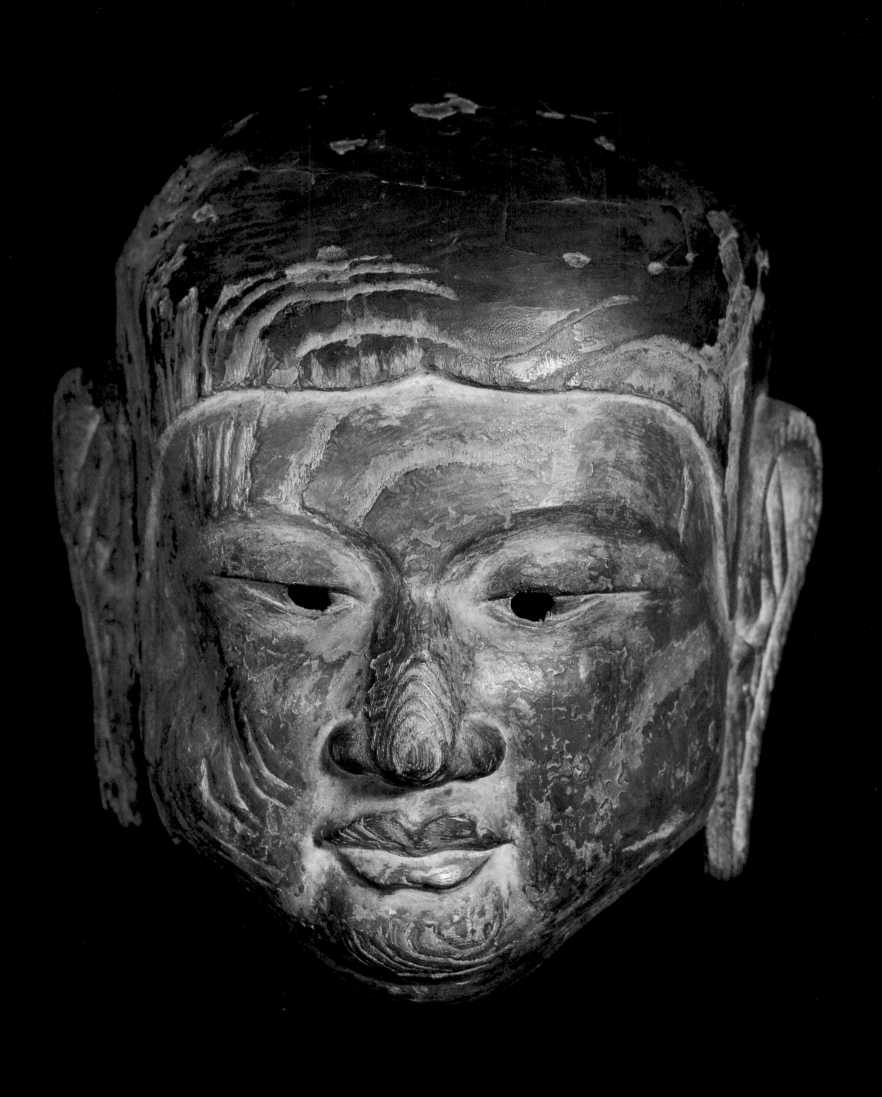

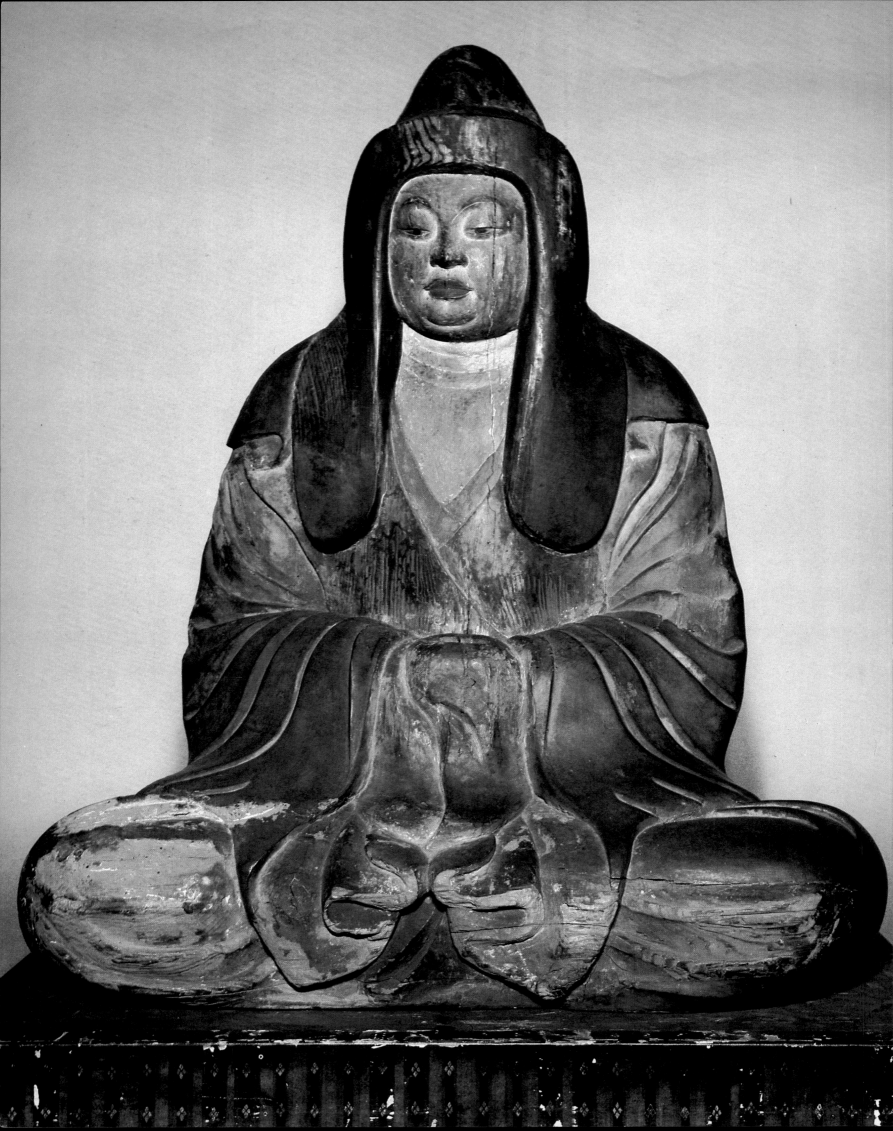

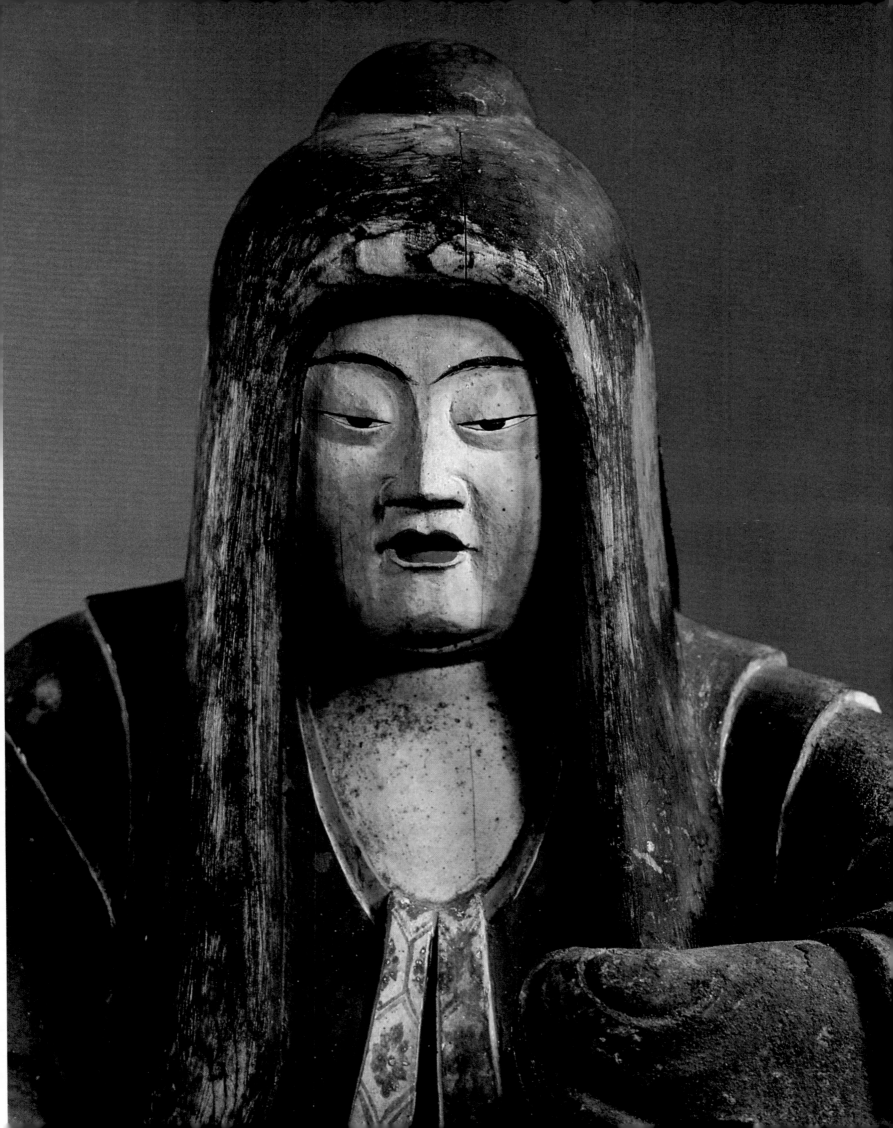

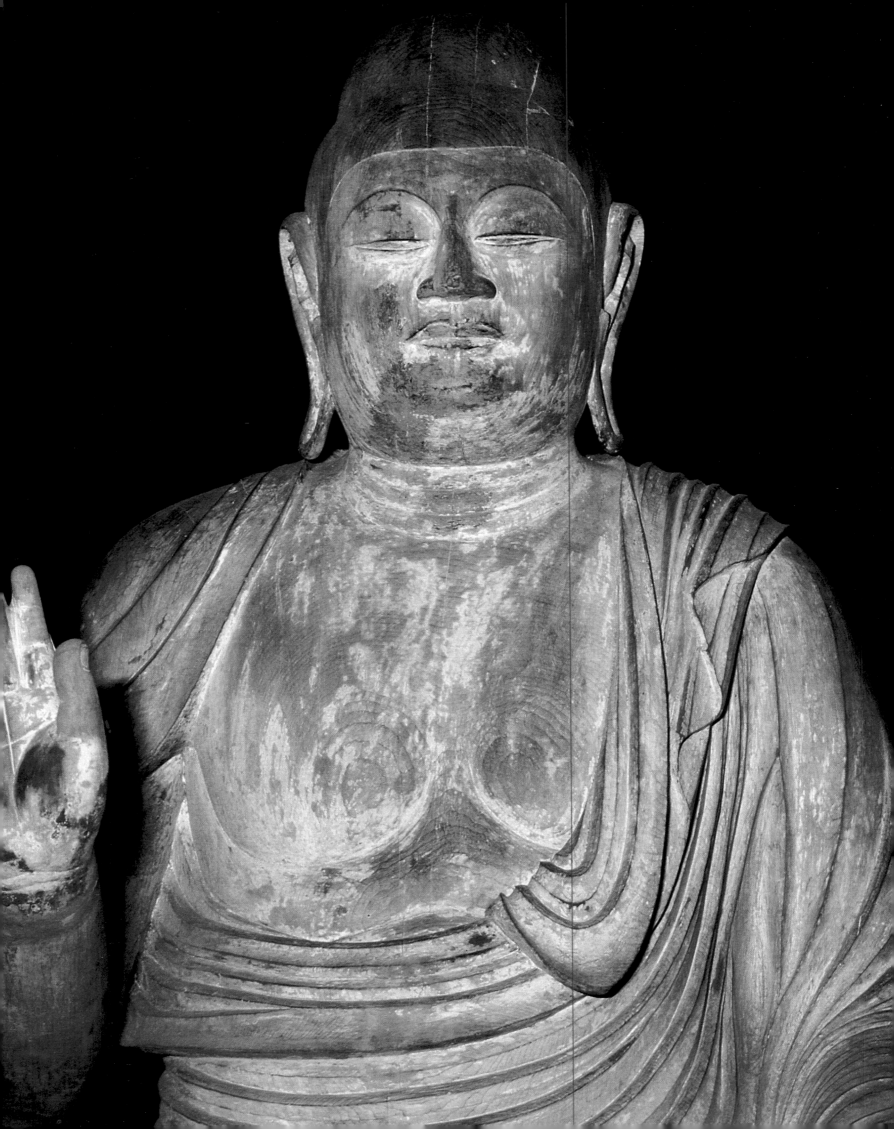

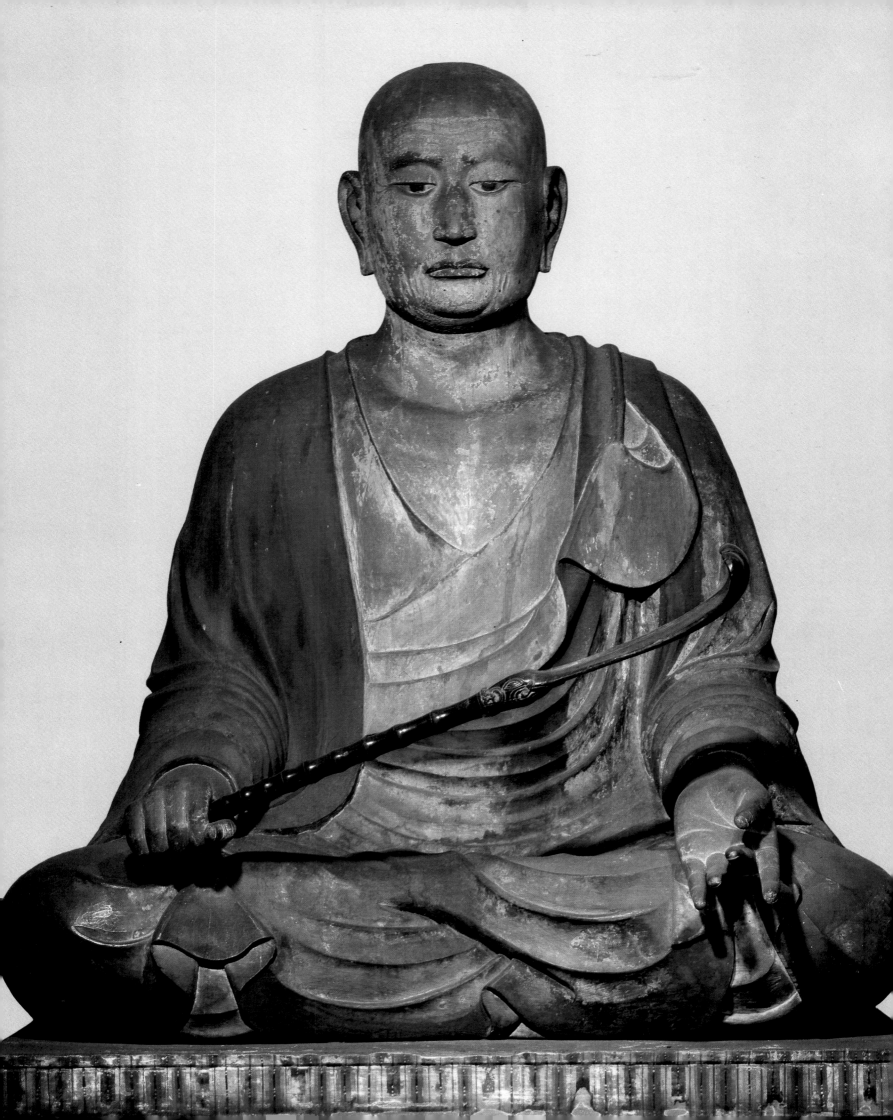

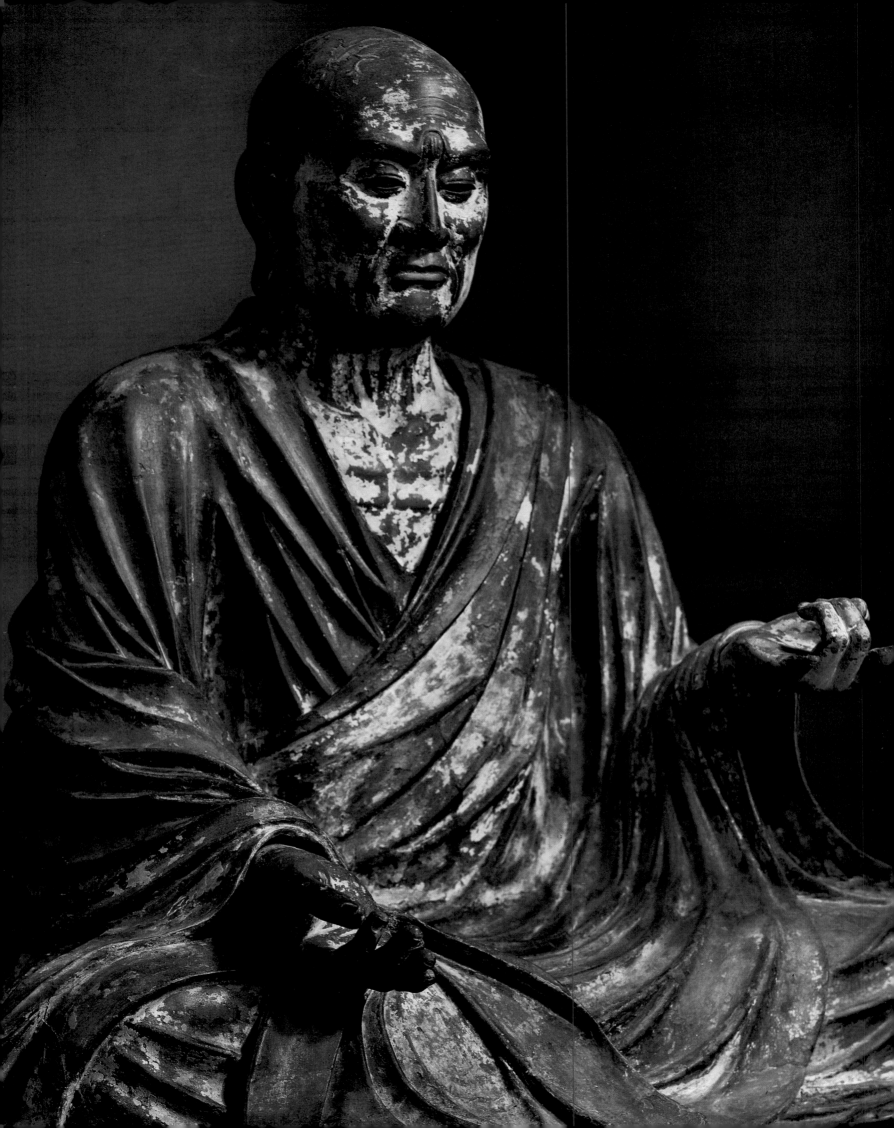

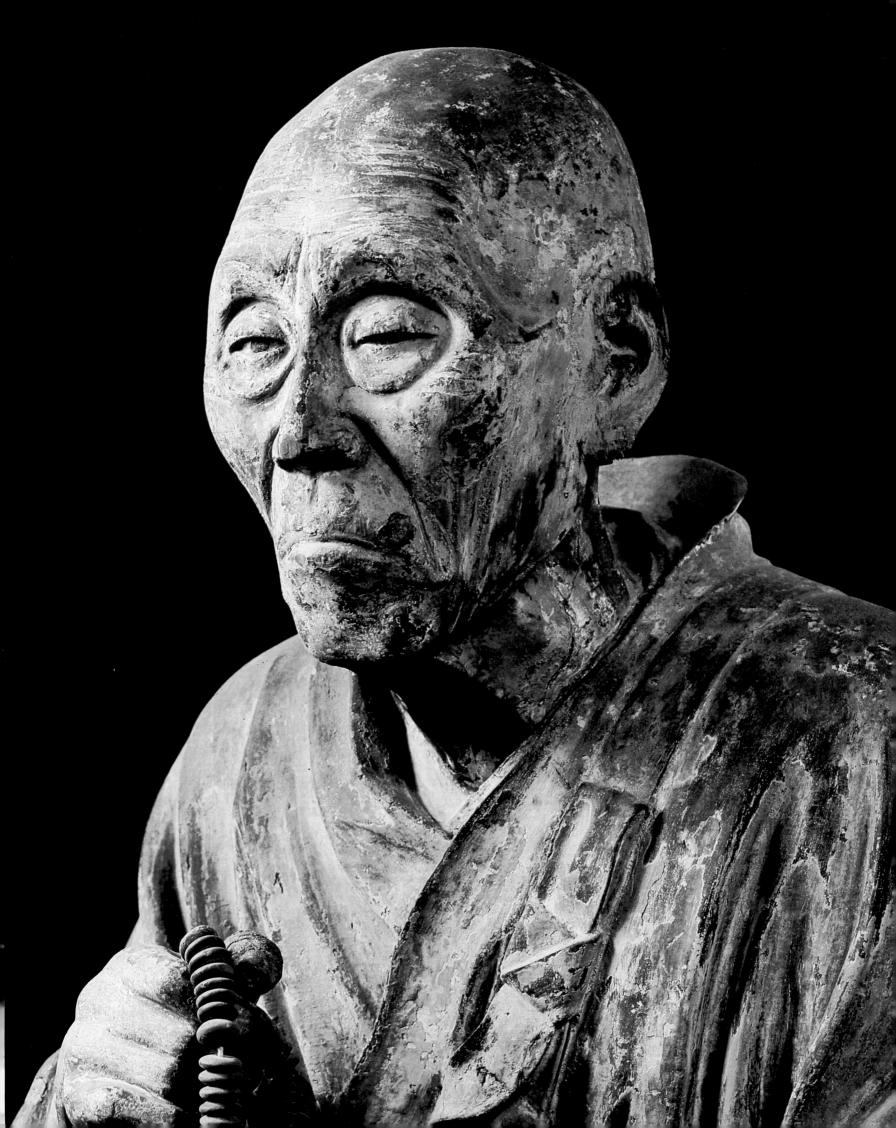

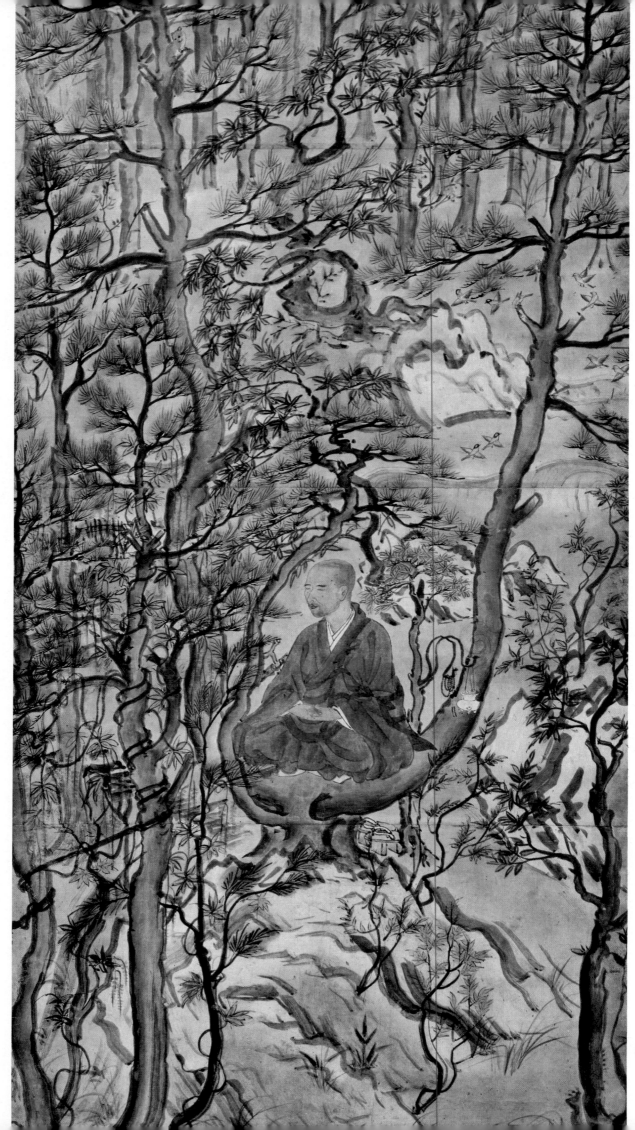

83 RŌBEN (NARA-ERA PRIEST, PATRIARCH OF THE
 KEGON SECT)
 Colored wood, height 92.4 cm.
 Heian Period, 1019.
 Tōdaiji, Nara

84 GYŌGI BOSATSU (670–749), PRIEST AND FOUNDER OF
 THE RYŌBU-SHINTO
 Emperor Shōmu (r. 724–748) bestowed on him the title
 of Bosatsu.
 Painted wood, height 1 m.
 Kamakura Period, 13th century.
 Tōshōdaiji, Nara

85 THE PRIEST SHUNJŌ
 Wood, entire height 82.2 cm.
 Kamakura Period, first half of 13th century.
 Tōdaiji, Nara

86 PORTRAIT OF THE PRIEST MYŌE SHŌNIN (1173–1232)
 Attributed to Jōnin (Seinin or Enichibō,
 fl. first half of 13th century).
 Hanging scroll.
 Ink and color on paper, 146 × 58.6 cm.
 Kamakura Period.
 Kōzanji, Kyoto

87 PORTRAIT OF MINAMOTO-NO-YORITOMO (1147–1199)
By Fujiwara-no-Takanobu (1142–1205).
Color on silk, 1.4 × 1.1 m.
Kamakura Period.
Jingoji, Kyoto

88 EMPEROR SAGA (r. 809–823) WITH THE SANSKRIT
CHARACTER "A" OVER HIS HEART
Detail of handscroll.
Color on paper with gold and silver, 26.1 × 685.7 cm.
Kamakura Period, 13th century.
Fujita Art Museum, Ōsaka

89 EMPEROR GO-TOBA (r. 1183–1198)
Color on paper, 40.3 × 30.6 cm.
Kamakura Period, 13th century.
Minase Jingū, Settsu (Ōsaka)

90 ARHAT
Color on silk, height about 1 m.
Late Heian Period, second half of 11th century.
Tokyo National Museum

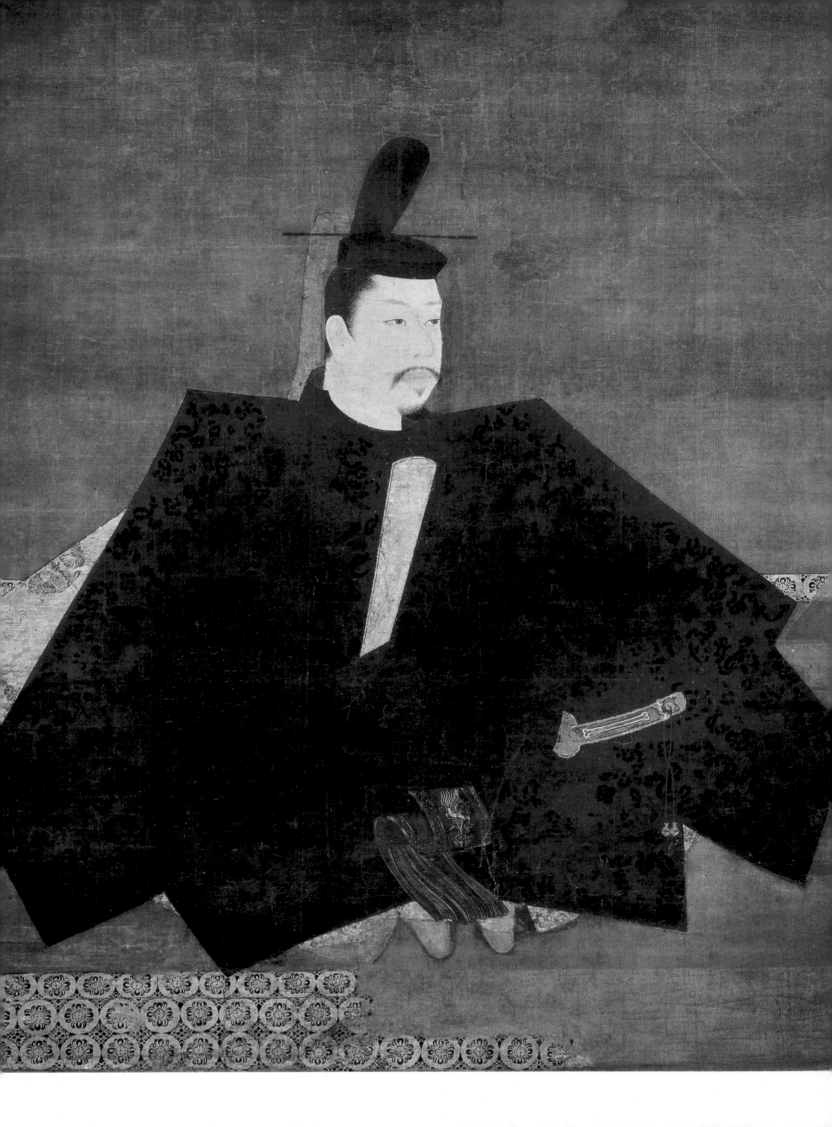

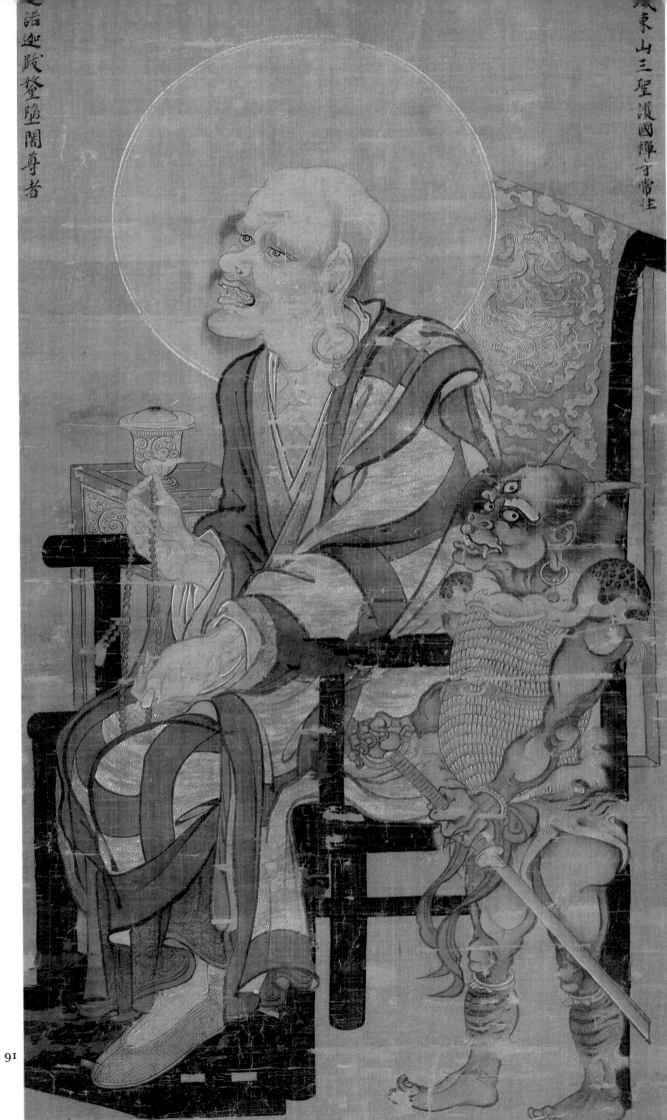

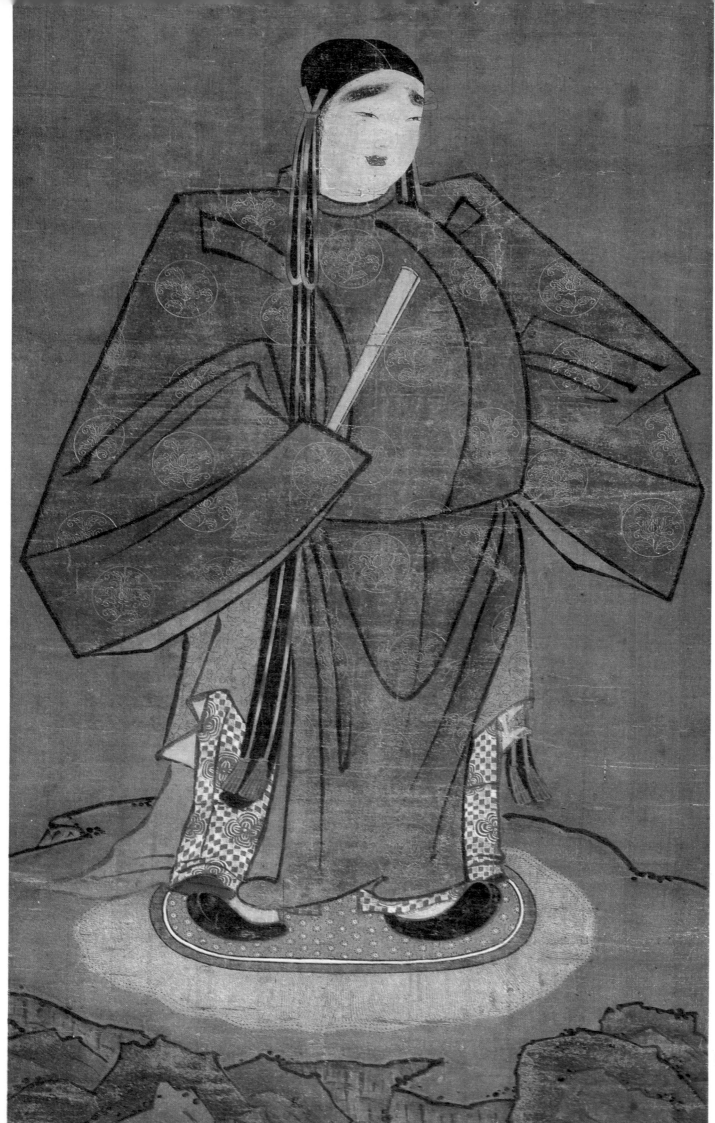

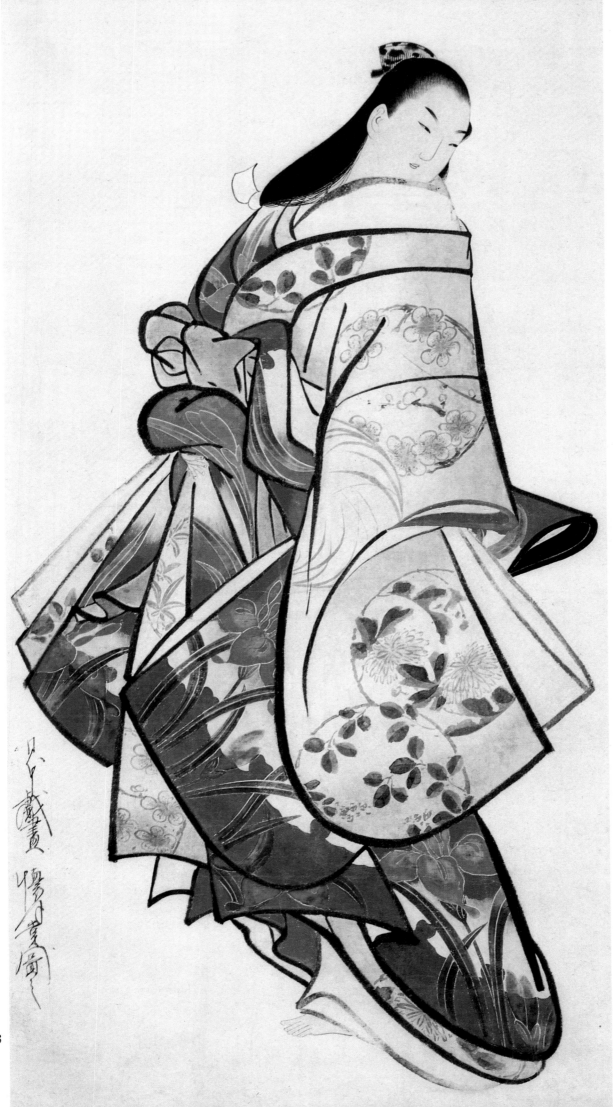

93

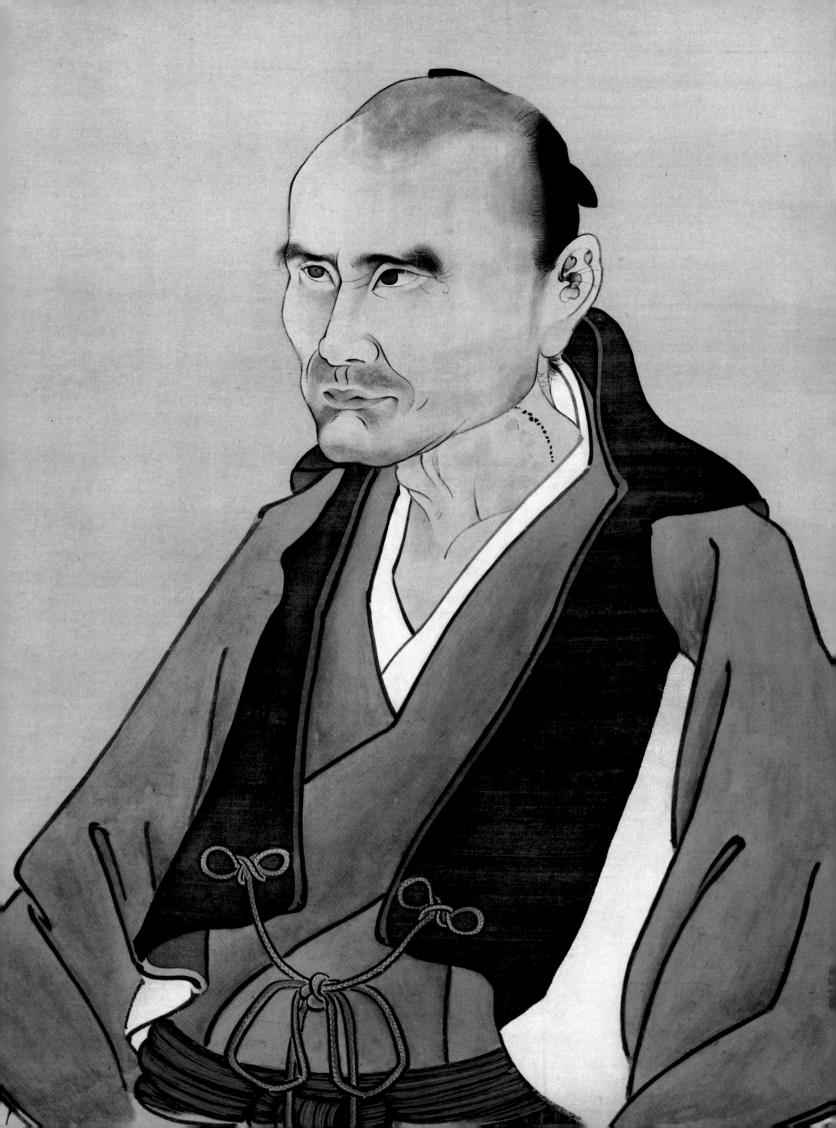

91 ARHAT
Attributed to Ryōzen (fl. 1348–1355).
Ink and color on silk, 113.1 × 58.8 cm.
Namboku-cho-Ashikaga Period.
Freer Gallery of Art, Washington, D.C.

92 KASUGA WAKAMIYA (DEITY OF KASUGA WAKAMIYA-
JINJA, SUB-TEMPLE OF KASUGAJINJA, NARA)
Ink, color, and gold on silk, entire dimensions
85.3 × 39.6 cm.
Yamato-e School, Namboku-cho-Ashikaga Period,
14th century.
Freer Gallery of Art, Washington, D.C.

93 COURTESAN
By Kaigetsudō Ando (Okazaki Genshichi).
Ink and color on paper, 98.1 × 45.1 cm.
Ukiyo-e School, Edo Period, 18th century.
Freer Gallery of Art, Washington, D.C.

94 PORTRAIT OF SATŌ ISSAI (1772–1859)
By Watanabe Kazan (Watanabe Sadayasu: 1793–1841).
Ink and color on silk, entire dimensions 113 × 51.5 cm.
Edo Period, 1824.
Freer Gallery of Art, Washington, D.C.

95 MASK
Hemp cloth, 34 × 38 cm.
Nara Period, 8th century.
Hōryūji Great Treasure House, Nara

96 EMPEROR HANAZONO (r. 1308–1313)
Color on paper, 31.2 × 97.2 cm.
Kamakura Period, 1338.
Chōfukuji, Kyoto

97 CHŌYO, PRIEST SEWING UNDER THE MORNING SUN
By Kaō (d. 1345).
Detail of hanging scroll. Ink on paper, entire dimensions
83.5 × 34.7 cm.
Namboku-cho Period, c. 1350.
Cleveland Museum of Art

98 KANZAN, A CHINESE MONK OF THE TANG DYNASTY
(SUBJECT FAVORED BY EARLY SUIBOKU PAINTERS)
By Kaō (d. 1345).
Ink wash on paper, 102.5 × 30.9 cm.
Muromachi-Suiboko School, Ashikaga Period.
Freer Gallery of Art, Washington, D.C.

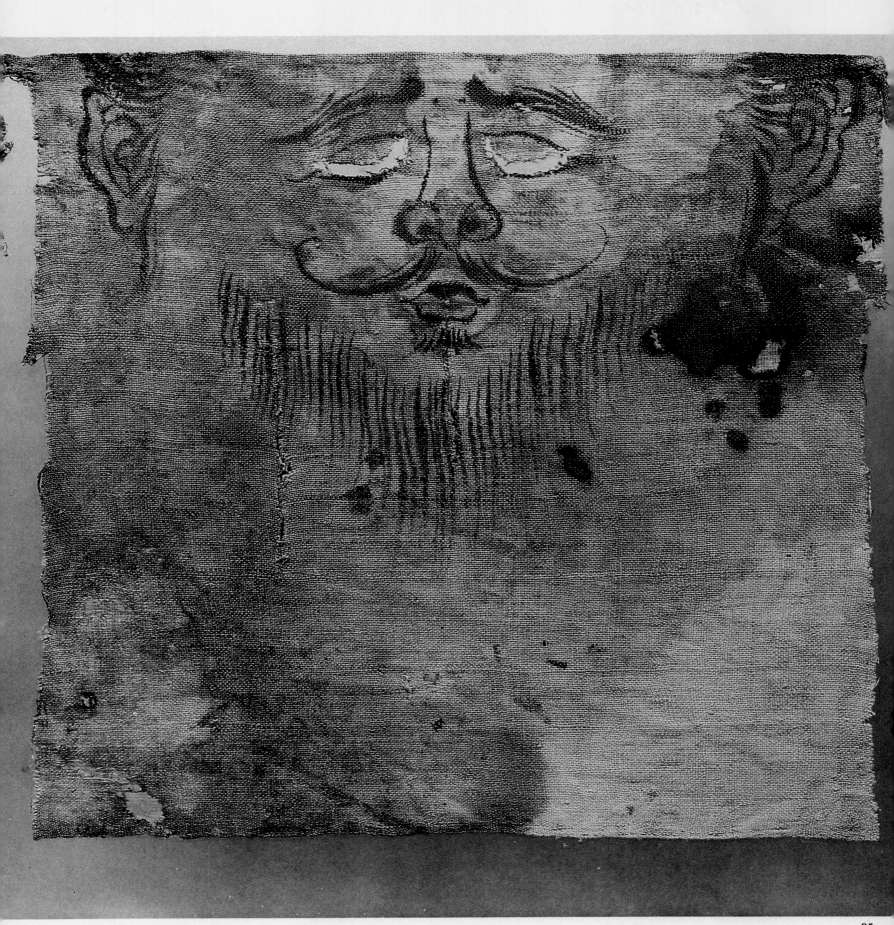

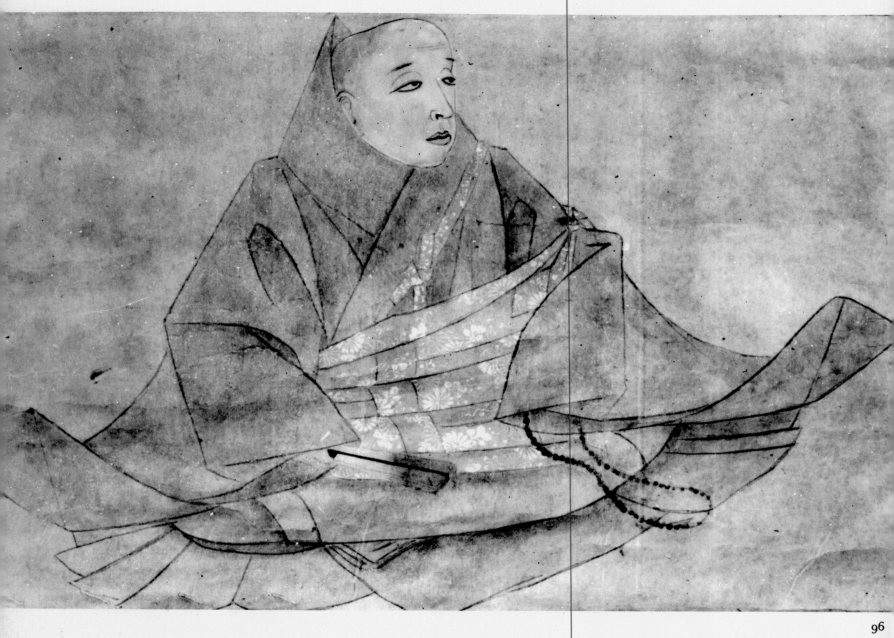

96

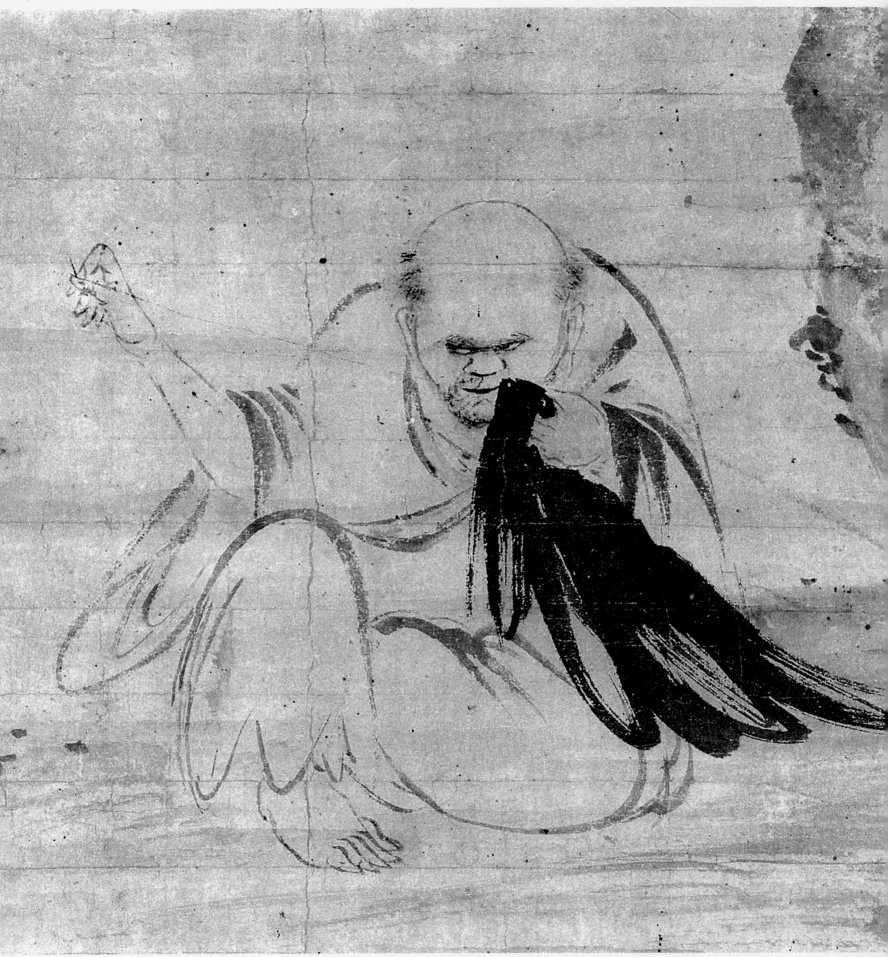

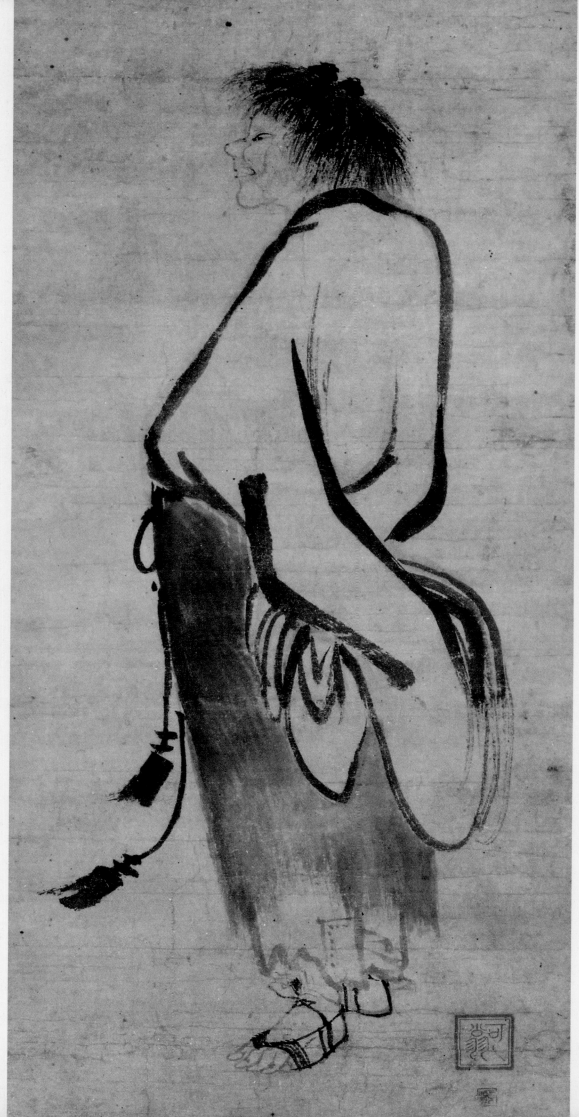

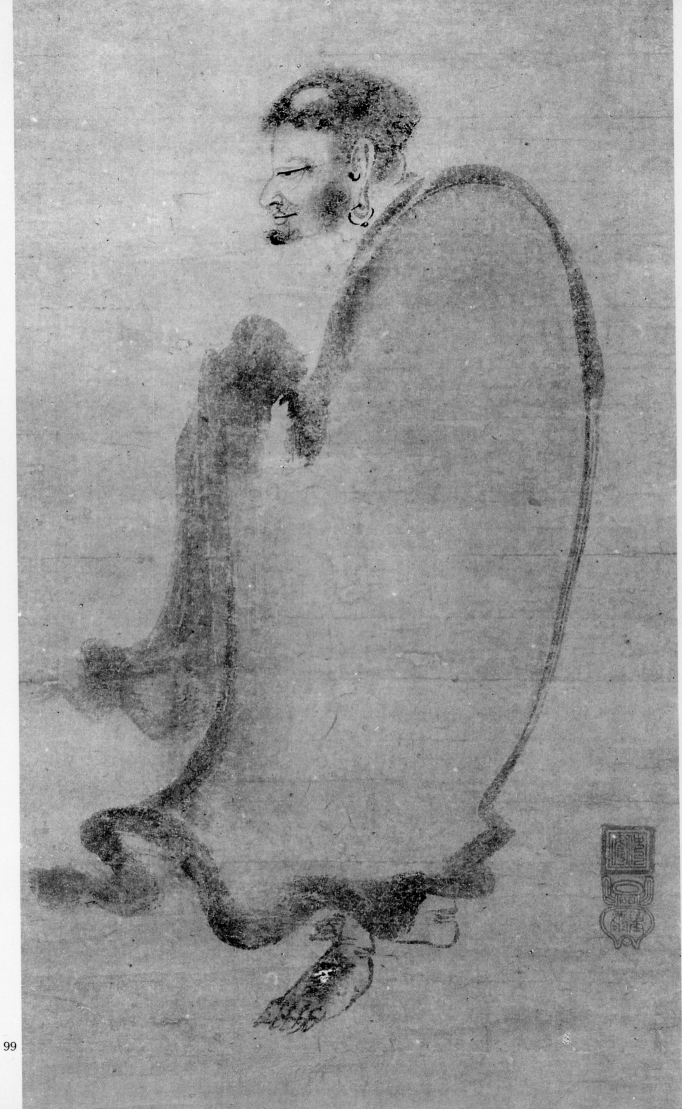

99

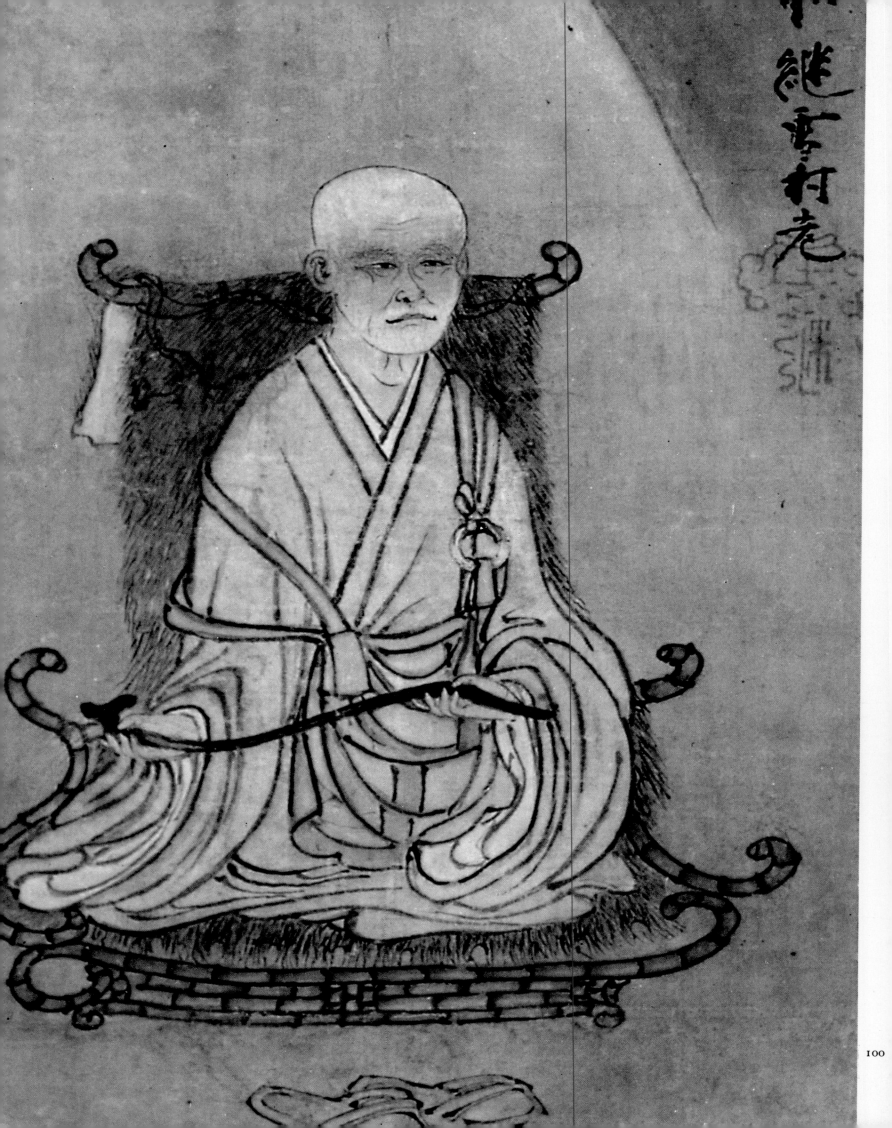

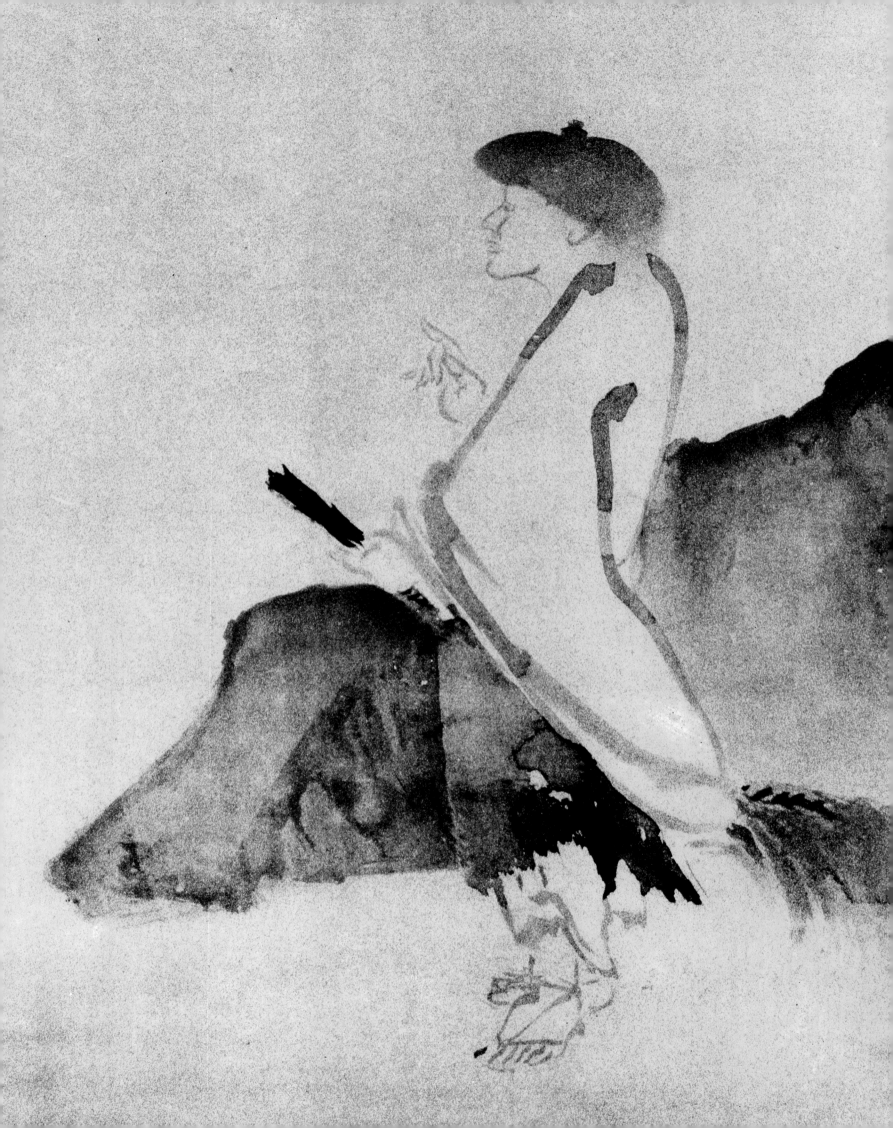

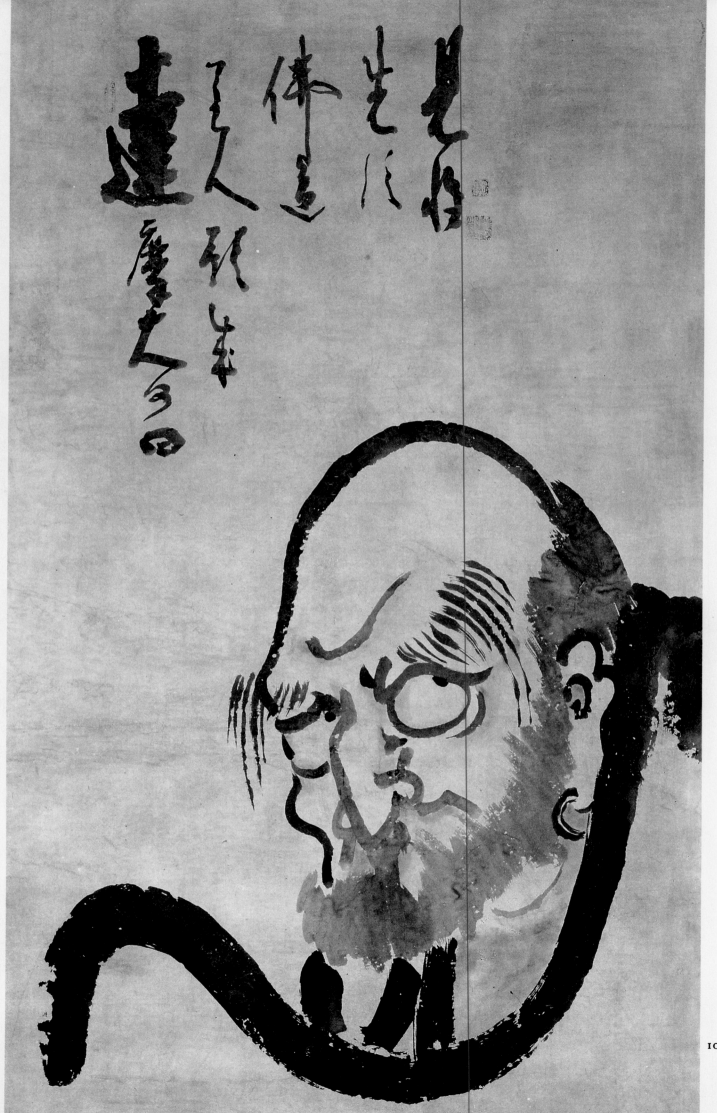

99 BUDDHA OF THE MOUNTAIN
By Chuān Shinkō (fl. 1444–1457).
Ink on paper, 77 × 27 cm.
Muromachi Period.
Museum für Ostasiatische Kunst, Cologne

100 SELF-PORTRAIT OF SESSON (c. 1504–1589)
TOWARD THE END OF HIS LIFE
Detail. Ink and soft highlights on paper, entire work
65.5 × 22.2 cm.
Muromachi Period.
Yamato Bunkakan, Nara (Museum photo)

101 JITTOKU
By Sōtatsu (Nonomura or Tawaraya Ietsu, 1575–
1643).
Ink on paper, height 95.3 cm.
Edo Period.
Nelson Gallery-Atkins Museum, Kansas City

102 DARUMA
By Hakuin (Nagasawa Ekaku, 1685–1768).
Ink on paper, 160 × 93 cm.
Zen painting, Edo Period.
Freer Gallery of Art, Washington, D.C.

5. NATURE INTO ART

5. NATURE INTO ART

OUR search for Japan's originality within the vast overflow of Chinese civilization is motivated by more than intellectual curiosity. It is a way to a deeper understanding of a delicate process, the process of cultural interaction that shattered the gamut of rules and formulas imported from the mainland.

In the matter of art, countless questions are raised and unexpected horizons are opened. It may readily be conceded that historical Japan originated in the aesthetic heritage of China, but the issue does not rest here. For example, how did Japanese artists interpret the famous canons for painting that Xie He prescribed about 500? How did they later perceive Western "realism" or European "subjectivity"?

No sooner are the questions posed than there arises the stumbling block of vocabulary, and of the concepts implied in words. The use of the suffix "-ism" is alien to traditional Japanese thought, which perceives things concretely, in terms of adjectives. A work will be somewhat realistic or somewhat subjective, and consequently the same work may bear several labels; Japanese artists could not be pigeonholed according to artistic theories until succumbing to the tide of Western civilization in the late 19th century. Groups of artists formed as they had in medieval Europe, along blood lines or according to levels in society. Family, profession, affiliation with a workshop—these were the determining factors. Compared with Chinese painting, which often conveyed a didactic or political, if not patently ideological message, Japanese painting seems uncomplicated, untroubled, unburdened by systems.

The result is an art that goes straight to the point while radiating a purely decorative glow. "Decorative" is a term with pejorative connotations for Westerners, but Japanese artists consider it a vital component of their style, of their very being. As they see it, a work of art is not robbed of forcefulness simply because it pleases the eye and is "undisturbing." Perhaps there is a connection between this attitude and the court aesthetic, for when *The Tale of Genji* appeared in the 11th century, works of art were being frowned upon that jarred the polished reserve of dignitaries. If a truth had to be confronted, it was important to keep it within proper bounds, a constraint reinforced by the Shintoist dread of profanation or defilement. One need only recall that when

the 16th-century Japanese first heard the Jesuits' graphic sermons on the Crucifixion, they reacted with uncontrollable revulsion.

Against this psychological backdrop, perhaps one can understand why Japanese painters showed little enthusiasm for techniques that might overdramatize a subject, such as the shadows seen in Tang art, or the modeling of surfaces in light and shade. Japanese paintings achieve their special glow by the juxtaposing of colors in isolated, independent "units" that do not interact and modify each other but resemble jewels sending out pure rays of light. Of course, this approach can be found elsewhere—in Egypt, in ancient Islamic art, and in China itself during the Han dynasty—but nowhere did it produce such happy results as in Japan.

THE same "unreality"—or, more precisely, the same, almost Impressionist concern with representing the real world in all its diversity—was a key factor in the development of Japanese perspective. In this respect, the archipelago was clearly indebted to the Chinese tradition, which had perfected views into depth from above or below, as well as the use of several vanishing points to differentiate scenes and suggest a path of contemplation. The Japanese innovation was their regular use of diagonal composition, a technique inherited from the Southern Song. And within the compositional area, line did not describe a theme removed from its immediate surroundings, as in the grand tradition of Chinese art, but conveyed a movement, or a living being seized in a fleeting instant. Capture the essential, yes, but with its ephemeral aspects as well.

ANOTHER characteristic of Japanese painting is its astounding continuity reinforced by strict compartmentalization, not so much of types or schools as of techniques and families. This continuing loyalty to social or aesthetic categories that gradually lost their viability cannot be understood without the concept of *giri*, still alive in modern Japan, that denotes a combination of respect and gratitude, a feeling that both enriches and constrains the individual. *Giri* binds together teacher and student, father and son. Because of *giri*, no disciple could reject a master's wealth of knowledge or leave his workshop without losing his sense of decency. This situation had the enormous advantage of perpetuating art forms that might otherwise have died out, and had also a drawback, for artists of the Edo period were unsympathetic to innovative forms of expression even though the older approaches had become exhausted. The *ukiyo-e* style of woodblock prints, for example, might not have come into being but for artists trained in disciplines outside of painting: the reputed founder of *ukiyo-e*, Hishikawa Moronobu (1618/38?–1695), was an embroiderer by profession.

Japanese painters who took nature as their theme availed themselves of three basic approaches: the first was in keeping with the "red and blue" or "blue and green" Tang styles; the second grew from personal expressions linked with the development of *yamato-e* processes; the third was inspired by "black-and-white" (that is, ink) paintings of the Song and Yuan dynasties, key periods in China that had almost simultaneous

repercussions in Japan, sparking varied reactions according to individual and social sensibilities.

It may be useful to consider the place of landscape art in the Chinese and Japanese cultures, respectively. For the Japanese, after having acquired the genre in its fully developed form, appear to have given it perhaps even greater importance than it enjoyed on the mainland.

Chinese landscape art can be traced back to two sources. The officials who issued *fangzhi*, or local reports sent to the central government, soon began to supplement their texts with explanatory sketches. Then came Buddhist stories in which all of creation played its part and nature was no longer subordinate to man. These compositions were painted on sheets or scrolls of silk or paper, on screens, and on the walls of religious institutions; in whatever medium, the idea of teaching or of conveying a message prevailed over all other considerations. Japanese landscapes, however, painted on folding screens as far back as the Heian period, had to fulfill two functions, both basically architectural: one was decorative, the other practical, or for ritual. Folding screens were used in houses to protect an area from wind and prying eyes; in temples, they circumscribed a sanctuary or stood as a kind of iconostasis, a tangible boundary between the material and ineffable worlds.

The screens that served as walls in Japanese houses also provided artists with low, elongated spaces suitable for decoration. But one must not confuse the proportions of a traditional Japanese screen (even with narrow leaves) with those of modern "Coromandel" screens. Furthermore, the Japanese artist worked while squatting on a mat and therefore painted his screens from below them, whereas his Chinese counterpart had regularly used a chair since the Song dynasty and was to that degree above his screens. It should be noted that screens made of paper or silk lent themselves also to writing, and specifically to calligraphic verse. Thus, in addition to decorating the household, a screen was like a "throb of the heart," a large beloved book that one could keep open nearby, and distinguished from ordinary horizontal painting by the stroke of the artist's brush across the surface. From the Nara period on, Chinese-inspired themes—the seasons, the months, celebrated landscapes—began to recur in Japanese landscapes almost to the point of monotony, but the best of these works have always some personal touch that attests to a particular era, custom, or style.

The oldest known Japanese landscapes date from the Asuka period, as early as the first half of the 7th century A.D. Temple archives mention that in the thirty-first year of the reign of Empress Suiko (that is, 623 A.D.), the platform supporting the Shaka Triad in the Kondō of Hōryūji (fig. 200) was decorated with paintings, but the surviving traces are difficult to evaluate.

A few mountainous landscapes can be seen on the sides of the Tamamushi Shrine (fig. 290). The trees here are as lofty as the hills—as they also are at

Dunhuang—while the rapidly sketched mountains, crowned with stylized "umbrella forests," echo a theme frequently sounded in Chinese Buddhist painting of the Northern Wei era (late 5th–early 6th century). Some see these as an unabashed imitation of mainland landscapes, such as the silted, copse-covered cliffs of northern China. All "naturalistic" interpretations of this sort are equally plausible; it is just as likely that these works depict islands or peninsulas along the coast of Japan (which might account for the recurrent use of this motif on the pedestals of the earliest bronze statues at Hōryūji). All we should say with any degree of certainty is that Japanese artists seem to have been attracted in the 7th century to the same kind of stylization that prevailed on the mainland during the first part of the 6th century.

ACTUALLY, the number of Japanese landscapes dating from early times appears to be rather small. A few were duly recorded in monastery or temple archives, notably at Tōdaiji, but with no mention of provenance. Probably many of these paintings, like the two famous little scenes that decorate *biwa* in the Shōsōin, were simply brought in from the continent. (The *biwa* scenes have been given a disproportionate place in the history of Japanese landscape art; they should be evaluated for what they are: the ornament on musical instruments, not large-scale compositions.) Tracing here the origins of a genre that exploited so many media and techniques must seem a futile exercise, but the Shōsōin contains other treasures that may well be the earliest landscapes of undeniably Japanese character: ink drawings on silk or hemp (figs. 289, 436, 534) that go back no further than the first half of the 8th century (Nara period).

Color and how to master it remained the major problem facing Japanese artists. Several pieces in the Shōsōin had already used color to enliven many familiar subjects, from birds on the wing to ordinary fishermen. The intellectualism of Chinese painting seems to vanish utterly, and with it religious symbols and allusions to Buddhist stories and parables. Perhaps the deep attachment to everyday life, already visible on the walls of certain decorated Iron Age tombs (figs. 16, 17), should be our first criterion for determining how a truly indigenous Japanese art came into being.

Nature has always modulated the lives and thoughts of the Japanese and aroused in them an inexhaustible passion for brilliant color. They first expressed this passion through formulas inherited from *kara-e* ("Chinese-manner") painting of the Tang imperial court, in particular the "blue and green," "blue and red," and "fine gold" styles that soon were to inspire *yamato-e*.

Chinese landscape artists applied color in broad areas of flat tints, like so many layers of lacquer. The natural setting was usually given in several shades of green; buildings were depicted in pale pink; human figures were boldly outlined and highlighted with pigments.

Each aspect of nature—*shan shui*, the Chinese equivalent of "landscape," literally "mountain and water"—called for a particular approach or treatment. Water was usually depicted with black strokes, now straight and parallel, now winding to suggest degrees of turbulence. Waterfalls almost invariably occur, imparting their special flavor

to the landscape; in vertical or broadly diagonal lines, they disappear amid whitish, irregular areas—a cloud of mist—only to reappear below as seething, effervescent currents that wend their tortuous way along rocks and ledges.

In most instances, mist—that indispensable element with which Chinese master painters as far back as the Five Dynasties period (10th century) had "finished off" a section of landscape, thus effecting smooth transitions from one level to the next—evokes autumn. This season was held in especially high esteem because the intricate play of fall tones afforded artists an endless variety of scenes and special effects. In the hands of *yamato-e* painters, the subtle mists of Chinese masters very quickly became the domain of decorative make-believe, a tendency more pronounced in Japan than on the mainland.

The more or less standard blue and green curves delineating hills and mountains are highlighted with brownish lines that act as shaded areas. The result is a rhythmic, abstract play of dark lines and bright surfaces.

Trees play an especially important part in landscape art. Not only do different species help us to identify geographical locations (a river bank, a craggy peak, etc.), but such incidental features as bare branches or snow-covered leaves indicate the season or even the month. The same holds true for flowers and wild grasses, which send out associative signals as unambiguous as they are abundant. In addition to their obviously decorative effect, they provide valuable criteria for our assessment of the technique of a master painter. Human figures become more clearly Japanized than animals do, which continue to echo the animal representations in Tang paintings.

Concrete evidence of the early approaches and formulas that sparked the creative alchemy of ancient Japan had, it was once thought, all but vanished; the paths followed by entire generations of Japanese artists seemed impossible to ascertain. However, recent research by Akiyama, Ienaga, and Soper finally sheds light on the early days of landscape art in Japan. These three art historians discovered that the *Keikoku-shū*, an anthology completed in 827, contained four poems commissioned by Emperor Saga (r. 810–825) which describe the wall paintings that once adorned the Seiryōden, his private pavilion in the Imperial Palace at Kyoto. Although poems dealing with the subject of painting were almost commonplace in China by the Six Dynasties period, these particular texts give us a clearer picture of the extent to which early Heian painting still patterned itself after mainland prototypes.

What do these poems tell us? The first describes a well-balanced composition that blends mountain ranges and clouds with areas of water both tranquil and turbulent—a suitably grandiose setting for a gathering of Immortals. Since the poet praises the artist's masterful handling of the "red and blue" style, the painting in question belongs to the classical tradition of Li Sixun (651–716), the great master landscapist of the Tang dynasty. But the closing verses underscore an original touch: to create a world bursting with gladness and vitality, the Japanese artists clustered several symbols of good fortune in a single work, breaking the strict Chinese tradition of classifying subjects according to the seasons.

This first poem prompted a response by Sugawara-no-Kiyogimi (770–842), a

high official who had been sent as an envoy to the court of Emperor Tang Dezong (r. 785–804). He, too, marvels at the "red and blue" manner of painting mountains, waterfalls, and Immortals, but he goes on to say that the landscape in question also offers us a glimpse into the workaday world of farmers and fishermen, more down-to-earth subjects too often associated solely with the Southern Song school. There follow the somewhat deceiving remarks of two dignitaries known in literary court circles at the time: Miyako Haraka and the legist Shigeno Sadanushi (785–852), a distinguished man of letters.

Alexander Soper's contribution of a comparative study of groups of Chinese and Japanese poems inspired by paintings (*Artibus Asiae*, XXIX, 4, 1977) concludes that all of these display a remarkable lack of originality, the same themes being sounded again and again: the passage of time, the melancholy of mist-shrouded water, the Taoist hope of Epicurean escape. The Japanese had dutifully echoed the clichés of Tang poetry, yet their poems and paintings have a different feeling, a different ring. The Yamato countryside, with its flatlands and undulating mountains—at times disorderly, but never overpowering—doubtless had something to do with this, but a social phenomenon must also be taken into account: even as feudalism was in full swing during the Heian period, Japanese society managed to escape the stultifying effects of Chinese-style bureaucracy. Individual desires had to conform to well-defined and exacting codes of conduct, yet personal relationships were marked by mutual friendship and respect; either the apparatus of government weighed less heavily upon them, or they were less aware of it. Such larger-than-life figures as the munificent revolutionary, or the outlaw idolized by the mob, did not occur in Japan, where everything was played out on a more modest, more human scale. Perhaps this explains why Chinese literary forms never took firm root in the archipelago. Just as Japanese literature began with the great novels written in *kana* that were then recast in spoken Japanese, so Japanese painting came into its own when artists dared to shift their attention from far-away, often mythical China, and paint instead the gentle countryside surrounding Kyoto. The serene art it inspired touches the heart more than the mind: it is the world of an artist rather than of a philosopher.

However, one may ask oneself whether *yamato-e*, which for us embodies Japanese painting at its most splendid and original, was fully appreciated by those who witnessed its heyday. Did they see in this art a mirror of themselves and of their special character, or was it simply their way of counteracting an "imported" foreign style? In all probability, the latter feeling did not surface until the Kamakura period, when *yamato-e* (literally, "Japanese painting") found itself challenged by the "black-and-white" manner of *kanga-e*, the "Chinese" or "Chinese-inspired" approach exemplified by Song and Yuan painting.

It comes as no surprise that a major current of ink painting flourished in Japan as well as in China. We must always remember that so-called literary painting was favored by a particular segment of society and reflected a particular frame of mind,

whereas ink painting was to the Far East what pencil drawings, engravings, and etchings were to the West. These "black-and-white" works could be considered "paintings" from the standpoint of technique, but notwithstanding the opinion of many Japanese art historians, they are often closer in spirit to pure drawing and they run the gamut of approaches, from the most uninhibited to the most rigorously controlled. It is characteristic of the Japanese mentality to seek out the unique or singular at all costs, and perhaps another constant factor is a disinclination to analyze or compare things too closely. In striving, and properly so, to achieve technical excellence, Japanese artists express their own yearning for self-sufficiency or uniqueness.

Thus, in addition to the Chinese prototypes (such as those in the Shōsōin), and the sketches that Nara and Heian master painters "flung" onto walls and then covered over with rich "blue and green" landscapes (figs. 145, 146), there was already a strain of narrative ink painting prior to those influenced by the arrival of Song and Yuan works in Japan. These "white paintings" were dubbed *hakuga*, *shira-e*, or *kaku byō* if a scroll was painted entirely in black and white, such as the celebrated *Chōju Giga*, or *Satirical Tales of Birds and Animals* (figs. 147–49). Others, like the "poets' scrolls" or those that depicted courtly life, de-emphasized this kind of spirited, caustic humor and concentrated on pure story-telling (figs. 336, 337).

BEDAZZLED by the Ami (see page 228), the 15th-century artists responsible for the genuinely Japanese art and theater that developed under the Ashikaga, we tend to forget that Song painting had already made itself felt in Japan, much earlier than is sometimes believed.

Sometime after 987, during Japan's period of self-imposed isolation, Chōnen, the renowned priest of Tōdaiji, brought back a number of Chinese paintings depicting the Sixteen Arhats; they were transferred to the Seirinji after his death. The significant use of ink in these works—a hallmark of the Song manner—had a considerable influence on Japanese artists. Other works that subsequently filtered in from the mainland had a like impact. Gradually the technique of drawing in "wire lines" to delineate the spaces and filling these with color gave way to the seemingly unplanned—but, in fact, carefully controlled—subtleties of *p'o-mo*: jagged strokes of ink, now thick, now thin, now bursting into deftly improvised blotches and blurs.

The painters of the Kōzanji workshop, under the supervision of the renowned priest Myōe Shōnin (1173–1232), were the first to adopt this severe, meticulous, and understated style so well suited to the precepts and spirit of esoteric Buddhism (fig. 86). In the compelling work of these innovative artists a single scene could combine the even strokes of the Tang decorative tradition with livelier strokes of the Song style. The Tarima group, unlike the more eclectic Kōzanji school—witness its *Legends of the Kegon Sect* (*Kegon Engi*)—faithfully adhered to only the Song prescriptions, but the workshops located in and around Kyoto showed a less unswerving loyalty to Song and Yuan painting than did those in the Kamakura vicinity. The decidedly "continental" flavor of works by Kantō artists was due not so much to a particular religious climate—after

all, the eastern part of Japan had spawned the Zen masters—as to the immediate impact of Chinese works. Not only did this region have fairly active trade with the mainland, but also no ancient traditions interfered with the artistic vision of the young painters who lived and worked there. They created from whole cloth, so to speak; and their creations followed the Chinese style.

Religion, it seems, loomed so large in the early years of ink washes that it is difficult to say if it was Chan Buddhism or ink painting that most fascinated these Japanese amateurs, whether monks or lords. And who were these amateur painters? Should they be assigned in this way to separate social classes?

Overlapping life-styles and world views complicate the already thorny problems of attribution. There are a number of well-known, unambiguous cases—a monk, a ranking civil servant, a high court official—but this still leaves a number of questions, for nothing is final in the course of a lifetime. A government minister might forswear the fashions of the world and convert his palace into a monastery; a man who had been ordained might decide to reenter secular life. It can be said that the monk and the warrior are exceptions to the rule, and that a substantial portion of Japanese society fell between these two extremes, but the only logical inference is that in an art whose techniques and meaning so strongly reflect the concept of austerity, the spiritual weight of the Buddhist monk would inevitably prove more decisive than that of the courtier. But along the path of Enlightenment, there proved to be little difference between the self-disciplines of the ascetic and of the man of action.

Thus we know little about the kind of people these painters were, even less about their status in society. Were they amateurs, professionals or ordinary civilians? Do they fall into the category of *e-busshi*, painters of Buddhist images?

The issue becomes even more difficult when placed in the context of religion or philosophy. Buddhist artists proved remarkably, even brilliantly, adept at ink painting, but this does not mean that the genre belonged to them alone. The late arrival of Buddhism in Japan shows that other religious forces were at work within the archipelago, and Shintoism, like Confucianism or Taoism in China, was the principal current in an age-old native culture that tempered the Buddhist tide. From their encounter emerged the vast, all-embracing synthesis of the ink wash technique (*suiboku*), which adopted all the features of Song and Yuan painting, including its ability to blend poetry, painting, and calligraphy into a complex vehicle of artistic expression (*shiga-jiku*).

Prolific and subtle, intimate and sometimes repetitious, this kind of Japanese painting—for all of the uncertain attributions that plague art historians—nevertheless produced a certain number of principal currents or schools. The first of these, from which all subsequent achievements developed, was the Amikai, or Ami group. Their very names—Nōami, Geiami, Sōami—evoke their particular talents: the theater, the fine arts, and the ability to reconcile all artistic sensibilities (*sō* meaning "entirely," "reciprocity"). Should we infer from the resemblance of these famous names that the three individuals were blood relatives, colleagues, or simply kindred spirits? For lack of tex-

tual evidence, current research has not provided a clear answer. When a text (such as the *Honchō Gashi* of Kanō Einori) mentions lines of descent that point to some interrelationship, the references are neither dated nor convincingly corroborated. At the most, it may be said that the Japanese of early Edo times—when Kanō Einori wrote his biographical history of Japanese art—were so struck by the spiritual affinity of the Ami that they accepted family ties as a foregone conclusion.

All three shared an admiration for Chinese art, a penchant they imparted to the ruling Ashikaga shōguns at the time, sometimes loosely labeled *bogata no samurai*, or "soldier-monks." The shōguns indeed possessed certain qualities of the feudal ideal embodied by Ippen Shōnin, the 13th-century founder of the Ji sect and the subject of a celebrated series of painted scrolls (figs. 159, 363). It was such men who swelled the ranks of the Ami "family."

Even the name "Ami" or "Se" (*Ze*) is closely associated with the cult of *Kanse* ("Kwannon who sees the world") that was especially popular among members of the Ji sect. During the Muromachi period, the names of a number of master painters included the particle "ami," and all of them had strong ties with that sect. One of the Ami's more prominent traits was their commitment to religion, as unshakable as their penchant for anything Chinese in matters of art. In addition to playing a key role in the history of painting techniques, these members of the Ami group were to inspire Hasegawa Tōhaku (1539–1610), the great master of Momoyama art.

This artistic current was to merge most fortunately with the "tea mentality" promulgated by itinerant preachers and abetted by the passion for Chinese ink painting that Nōami (1397–1471?), who endlessly copied Chinese masters, successfully communicated to Yoshimasa (1435–1490), the eighth Ashikaga shōgun. After Nōami, entire generations of "black-and-white" painters tried their hand at what became an almost obsessive theme in Japanese art; of these, the inspired Sesshū (1420–1506) remains in the minds of most people the landscapist *par excellence* (figs. 108–10, 374–76).

If the projects Nōami completed for the *Gosan* ("Five Mountain") monks in 1436 helped to fire his enthusiasm for Chinese ink painting, he must have been overwhelmed by his journey to China in 1468 as an envoy from the emperor of Japan to the Ming imperial court. During this time his new artistic vision blossomed. The sites may have been Chinese, but his interpretation of them was altogether his own, as in the *Eight Views of Xiaoxiang* he painted upon his return to Japan. He died three years later at the Hasedera temple, but the "eight views" theme, based on an original painting by the Southern Song master Mu-Qi (13th century), was often imitated by later artists.

Nōami found the Ashikaga to be appreciative and intelligent patrons of the arts, if conservative. Traditionally, members of this family had never claimed authority where art was concerned, leaving such matters to an "art adviser" (*dōboshū*). When this post fell to none other than Nōami, it was as *dōboshū* that he compiled a catalogue of the Ashikaga art collection, treasures the family had amassed from the time of Yoshimitsu (1358–1408), third Ashikaga shōgun and architect of Japan's ties with Ming China (Hong Wu period), to Yoshimasa (1435–1490), the eighth Ashikaga shōgun. (Posterity also remembers these two rulers for having built in Kyoto the Golden Pavilion, or Kin-

kakuji, and the Silver Pavilion, or Ginkakuji, in 1397 and 1489, respectively; figs. 687–90, 717–18).

The 291 Song and Yuan paintings listed in Nōami's catalogue—it was interrupted by his death in 1471(?)—are grouped in the traditional Chinese categories: 124 paintings of Buddhist figures; 94 paintings of flowers and birds; 73 landscapes. Only one of these works dates from early Ming times; all the others are older. Even if we allow for the fact that trade between China and Japan did not really flourish until the Ashikaga shogunate, this gross imbalance cannot be dismissed as mere coincidence; the preponderance of earlier paintings must reflect a conscious choice by the Japanese at that time. The intellectual and admittedly less sensitive approach of the Ming literary painters did not interest the Japanese art lovers, but they were overwhelmed by the romantic vision of the Southern Song school.

Indeed, the impact of Southern Song masters on the new, Chinese-inspired painting of the Muromachi period cannot be overstressed. Reports of the Japanese mania for this style soon reached China, and it seems that a number of Chinese paintings, before they were shipped to Japan, were arbitrarily signed "Ma Yuan," "Mu-Qi," or "Liang K'ai" to flatter the tastes of the prospective buyers. In other cases, Japanese enthusiasts attributed imported landscapes to these Chinese masters as soon as the works reached Kyūshū. But let us not be hasty in judging or condemning this practice. A "signature" of this kind was not a deliberate forgery so much as an indication that a painting belonged to a particular school or had been executed in the style of a particular master. East and West have different interpretations of the concept of "authenticity," and art historians and knowledgeable dealers today are trying to examine this matter in the light of the West's more rigorous criteria of "genuine" and "false."

Actually, what most intrigued Muromachi artists about Chinese painting was not its artistic history or chronology, but the wealth of themes, visual outlooks, and techniques that it provided for them. Carla M. Zainie's recent study of early ink paintings in the Cleveland Museum of Art (see Bibliography) shows that Japanese "students" of Chinese art assumed from the beginning their right to rearrange subjects and pictorial treatments as they deemed fit, to compose their paintings in ways that departed considerably from the canons espoused by their mainland teachers.

THE innovative style that took shape within the circle of the Ashikaga shōguns is broadly referred to as the "Ami school," a convenient label for a wide range of manners and sources of inspiration. Their common denominator is a "soft" approach to landscape art, that is, a relatively generous use of the blurred washes and mists favored by Southern Song masters. Landscape now became a genre of major importance, and one that would be dominated by the Kanō family.

With which group then active should Masanobu (1434–1530), the founder of the Kanō line, be linked—with the Tosa school, masters of traditional *yamato-e* painting? or with that energetic group of Chinese-inspired Zen painter-monks: Sesshū (1420–1506), Oguri Sōtan (1413–1481), the Ami, and the fictitious artist called Soga Dasoku,

to whom the work of the obscure monks was later attributed? In any event, the Kanō school crystallized into a unified, recognizable style only with the indefatigable Motonobu (1476–1559). The archives mention that his many and varied commissions (fig. 402) brought him to the workshops of institutions as important as the Ishiyama Honganji near Osaka. And his sons, over the years, were appointed painters to shōguns as well as to the leading temples, at that time the crossroads of Japan's intellectual and economic life.

Despite the misfortunes during this troubled era, the *shoin* style of architecture came into full maturity, providing large surfaces suitable for decoration, and leading the way toward what became a revolution in Japanese painting. While maintaining the limitations of their art, painters had now to adapt it to a more monumental format and a climate of grandeur fostered by these bold, yet complex architectural designs.

Eitoku (1543–1590) was Motonobu's grandson; he learned his craft from his grandfather and succeeded him upon his death in 1559. The archives state that the young painter completed his first important works in 1564 and 1566 at the Shukōin of Daitokuji, while he was still working with his father. Word of his talent gradually spread, and he became the unrivaled master of *fusuma* (sliding screen) painting (figs. 141, 422).

Defining Eitoku's style—difficult enough in a painter with such a range of talents—is made more difficult because almost every sliding or stationary partition painted during his lifetime is usually attributed to him as a work by his own hand, or supervised or simply inspired by him.

When the paintings signed by him or certified as being his work are set apart, they reveal that Eitoku distinguished himself above all in *suiboku*, ink washes of Chinese themes in the 13th-century tradition of Ma Lin. It is curious that Eitoku apparently did not "Japanize" his subjects as much as such painters as Sesshū did. Indeed, his works might be taken for Chinese, except that one can identify Eitoku's style by his consistent "horse's-tooth" rocks, a rather pleasing imitation of the angular effects favored by Li Tang in the 12th century.

Generally speaking, Eitoku's work is both fascinating and irritating: it has all the technical elements of Chinese ink painting, but the arrangement of things somehow sets it outside the realm of Chinese visual logic. One senses—and this is a new slant—an echo of Ming literary painting, but against a backdrop of Song landscape. It is as though the archaism, compartmentalization, and deliberate stiffness of the Yuan literary painters had never intervened. This is a good example of the celebrated "gap" that appeared as facets of Chinese civilization made their way to Japan, a gap that helped turn Japanese art into a truly original phenomenon.

IF the Kanō family enjoyed undisputed success among monks and warriors caught up in the Zen ethic, their star rose still higher with the advent of the Edo dictatorship. Suddenly official painting shifted away from the court style and its endlessly repeated *yamato-e* formulas.

The Tokugawa sought to establish and control a school of painters that would serve as models for young artists. The moral and political framework of his government was steeped in Confucianism, and Ieyasu could conceive of no art other than Chinese. This was fortunate for the Kanō school, whose members were the spiritual heirs of the Southern Song tradition. They proceeded to adapt their art to the moralizing tendency—a hallmark of Confucian painting—that emerged as one of the overriding concerns of the Tokugawa regime.

The shift toward Confucianism was nothing new for the Kanō. As far back as 1573, they regularly took as their model the *Di-jian tushuo* (*Teikan Gusetsu* in Japanese), a famous Chinese collection with didactic plates depicting good and evil deeds of the emperors of China. The work was reprinted in Japan in 1606 and provided an inexhaustible, though painfully repetitious source of inspiration for Tokugawa painters.

Eitoku's grandson, Kanō Sadanobu (1597–1623), was the first to be ordered by the shōgun to settle at Edo; he arrived with his cousins Morinobu (1602–1674), Naonobu (1607–1650), and Yasunobu (1613–1685), the latter of whom he named his immediate successor. Sadanobu died early, at twenty-six, but his cousins founded the three branches of the Kanō family, henceforth known by the districts in which they resided: Kajibashi, Kobikichō, and Nakabashi.

Morinobu was appointed painter to the shōgun in 1617, at the age of fifteen. Nineteen years later, he was ordered to "shave his head," that is, to enter the ecclesiastical hierarchy, the only path of upward movement in the unyielding society of Edo Japan. Morinobu became Tan-yū, the name by which posterity knows him. Shortly thereafter, he received the Buddhist title of *hōgen* and was then promoted to *hōin*, the equal of a courtier of the fourth rank (figs. 423, 426).

But, as always in such situations, this officially sanctioned art, the product of an immobile society, became mired in the soulless repetition of tedious, theatrical motifs. Had the Tokugawa painters lost sight of the natural world? No, but its wonders would now be sung by a different kind of artist.

THE person destined to breathe new life into the somewhat hackneyed manner of both the Tosa and Kanō schools was Ogata Kōrin, who was the son of a merchant, a typical sign of the times in modern pre-industrial societies. His great contribution was to reintroduce two elements indigenous to Japanese art: a soft elegance, and the gleaming, subtle colors that express feelings in tune with nature.

Born in 1658, Ogata Kōrin—he did not change his original name of Ichinojō to that of Kōrin until 1691 or 1692—was the second son of a wealthy and distinguished Kyoto cloth merchant, Ogata Sōken, master of the Kariganeya, or "Golden House of the Wild Goose." His brother Gompei, born in 1653, was also destined to achieve fame as a potter under the names of Shinsei and especially Kenzan (figs. 512, 513, 519–22).

It might be useful to trace the genealogy of these "shopkeepers" whose eminence and artistic sensitivity exemplified the two qualities on which the residents of Kyoto prided themselves, sophisticated taste and ancestral erudition. These qualities account

for the aura of refinement that surrounded the capital of old Japan, and also for the high standing that the upper middle-class artisans and tradespeople began to enjoy during the Genroku era (1688–1703).

Ogata Sōken was the son of Shinzaburo Sōhaku, also a cloth merchant, whose clients included former Empress Tōfukumon-in, wife of Emperor Go-mino-o (r. 1612–1629). Sōhaku's father, Shinzaburo Dōhaku, was a Shinto priest at the temple of Ogata, not far from Kitanojinja (Kyoto), and the scion of an illustrious family from Bungo Province (modern Oita Prefecture, Kyūshū). Shinzaburo Dōhaku's father (thus, Kōrin's great-great-grandfather), Ogata Shinzaburō Koreharu, had served Yoshiaki (1537–1597), the last Ashikaga shōgun, who granted him a yearly pension of five thousand *koku* of rice. When the victorious dictators forced Yoshiaki to abdicate, Koreharu likewise found himself ostracized from public life. Thus the family gradually withdrew into the world of religion, then found a reentry through what might be called a "craft." The process was slow, but helped along by advantageous marriages into the circle of artists and leading merchants.

Koreharu's son, Dōhaku, took as his wife Hōshū, elder sister of Hon-ami Kōetsu. Marrying into one of the most prominent merchant families in Kyoto not only brought wealth to the Ogata, but opened doors for them to the reigning powers of the time. Dōhaku began to design and produce kimonos for the three daughters of a great lord named Asai Nagamasa (1545–1573): it happened that these daughters married, respectively, Toyotomi Hideyoshi (1536–1598), Kyōgoku Takatsugu (1560–1609), and Tokugawa Hidetada (1579–1632).

With Sōhaku, the Karigane household reached its zenith. About that time, Sōhaku's uncle, Kōetsu, founded a village of artisans at Takagamine, near Kyoto. Devoted to the improvement of life through the magic of beauty and inspired by the tea ceremony, the members of this creative community worked together and considered the problems raised by their various artistic disciplines. Protected from economic hardship by a wealthy and attentive clientele, Takagamine craftsmen had the opportunity to develop the best within them.

Sōhaku had two sons: the elder and heir, Sōko, by a first marriage, and Sōken (Kōrin's father), by another. According to the rule for younger sons, Sōken was supposed to leave the family home and establish his own branch, or enter another family through adoption or marriage. However, the young man, thanks to his tenacious mother and his own talents, obtained the entire inheritance as head of the Karigane household in 1660 after Sōko's death. He owed much of his subsequent dazzling success to the patronage and clientele of Empress Tōfukumon-in, whose death in 1678 must have been a severe blow for the Kariganeya.

Yet Sōken became so prosperous that, like many artisans and important merchants, he began to lend money to *daimyō*. Shackled by the Tokugawa's code of formality, the great feudal lords of Japan had no choice but to lay out ever greater sums for ceremonies and regalia whose cost exceeded their income from the Edo government. The political and psychological tack adopted by the Tokugawa shōguns seems to match, point for point, the contemporary strategy of Louis XIV in France. In order

231

to calm a hopelessly quarrelsome and politically dangerous aristocracy, both the Sun King and the shōguns tied their courtiers down by playing on their vanity. The courtiers' ruin then brought about Sōken's undoing as a moneylender, for his account books attest to substantial sums that he could not recover in his lifetime, neither principal nor interest. A number of 17th-century Kyoto merchants were caught in the same way and found themselves near bankruptcy.

Sōken had three sons, each of whom—and this was exceptional for the time—was allotted an equal share of their father's handsome property when he died in 1687: Tōzaburō, the eldest, who succeeded Sōken as head of the family and the business; Kōrin; and Kenzan. Kōrin, for his part, squandered his fortune with the insouciance of a wealthy heir, blessed with a natural gift for the arts but lacking a definite profession. He sensed that the life-style of Kyoto's upper middle-class merchants and artisans—connoisseurs of art, enthusiastic patrons of the Nō theater, intimates of an aristocracy and sharing their tastes and follies—had seen its day; up-and-coming families like the Mitsui, less frivolous, and obsessed only with profit, were beginning to make inroads into Japanese society.

In 1697 Tōzaburō left the cloth business, moved to Edo, and entered the service of a leading feudal lord. The two younger sons became aware that they had to earn a living (figs. 510, 512–15, 519–22). Kōrin painted kimonos, while Kenzan applied the skill he had acquired during his leisure time from the master potter Nonomura Ninsei II (fl. 1695–1699). The style of Kōrin's first teacher, his father, was an elegant blend of the Kanō and Tosa traditions. Kōrin also made copies of painters like Sōtatsu (d. 1643?), and he was much indebted to Yamamoto Sōken (fl. 1683–1706), whose works were only a footnote to the history of Japanese painting until fairly recently—we now have a better picture of this artist's style, thanks to the discovery in the 1950s of a large screen (the *Tsukinami Byōbu*: a pair of large six-fold screens) at Enshōji, in Nara. This treatment of a frequent theme, the passing months and seasons, is a harmonious combination of Kanō ink painting and the colorful manner of the Tosa school.

Kōrin's lessons stood him in good stead. He made so great a name for himself that in 1701 the illustrious Nijō family—the family from which empresses were traditionally chosen—bestowed upon him the rank of *hokkyō*, an honorary title once reserved exclusively for monks, but now granted occasionally to artists. Nevertheless, Kōrin found himself completely bankrupt by 1704, and he went to Edo to try his luck. Three years later, he entered the service of the *daimyō* Sakai, a move that finally assured him of a steady source of income. But Kōrin found unbearable this inhibiting climate of cramped formality; he returned to Kyoto in 1709, and died there seven years later.

Kōrin was an artist at the crossroads of two worlds, and the essence of his style can be found in a work dating from his last years: the celebrated screens with white and red plum trees (figs. 119, 120). Despite the differences in spirit and technique, they are in the tradition of Sōtatsu's famous screens depicting the god of wind and the god of thunder (figs. 427, 428). Kōrin captured in this single work the feeling for space that typified the master who had so greatly influenced his art. Never before had anyone attempted his daring arrangement of branches along a diagonal axis that leads the eye

beyond the narrow confines of the screen. Moreover, Kōrin filled the area that Sōtatsu had left empty (save for the gleam of gold- and silver-leaf) with a phenomenal current of swirling waves. We feel as though we are gliding on the billows of a cosmic river dividing two worlds, separating light from darkness like Michelangelo's God.

What has happened to the gentle landscapes of the Kyoto countryside? After a thousand years of pictorial transposition, they sweep us now toward the stars (figs. 116–17, 119–20, 408, 409, 423–24, 427–30, 432–34).

103 KŌNIN SHŌNIN EDEN
Detail of painting.
Color on paper, height 33.7 cm.
Kamakura Period, early 14th century.
Asian Art Museum, San Francisco

104 NEZAME MONOGATARI EMAKI
Detail of handscroll.
Color on paper, entire height of scroll 24.9 cm.
Heian Period, 12th century.
Yamato Bunkakan, Nara

105 MAPLE VIEWING AT TAKAO, KYOTO
By Kanō Hideyori (Kanō Jōshin, d. 1557).
Six-fold screen.
Color on paper, 1.5 × 3.6 m.
Muromachi Period.
Tokyo National Museum

106 THE FOUR SEASONS
Attributed to Shūbun (Ekkei, fl. 1414–1463).
Detail of painting.
Ink on paper, 110 × 38 cm.
Muromachi Period.
Tokyo National Museum

107 NACHI WATERFALL
Color on silk, 159 × 57.9 cm.
Kamakura Period, 13th century.
Nezu Art Museum, Tokyo

108 THE FOUR SEASONS
By Sesshū (1420–1506).
Detail of handscroll.
Ink and slight color on paper (see fig. 375),
entire height, 39.7 cm.
Muromachi Period, c. 1486.
Mōri Museum, Hōfu

109 AMA-NO-HASHIDATE
By Sesshū (1420–1506).
Ink on paper, 89.4 × 168.5 cm.
Muromachi Period.
Kyoto National Museum

110 HABOKU LANDSCAPE
By Sesshū (1420–1506).
Detail of hanging scroll.
Ink on paper, "flung-ink" technique, width 32.6 cm.
Muromachi Period.
Tokyo National Museum

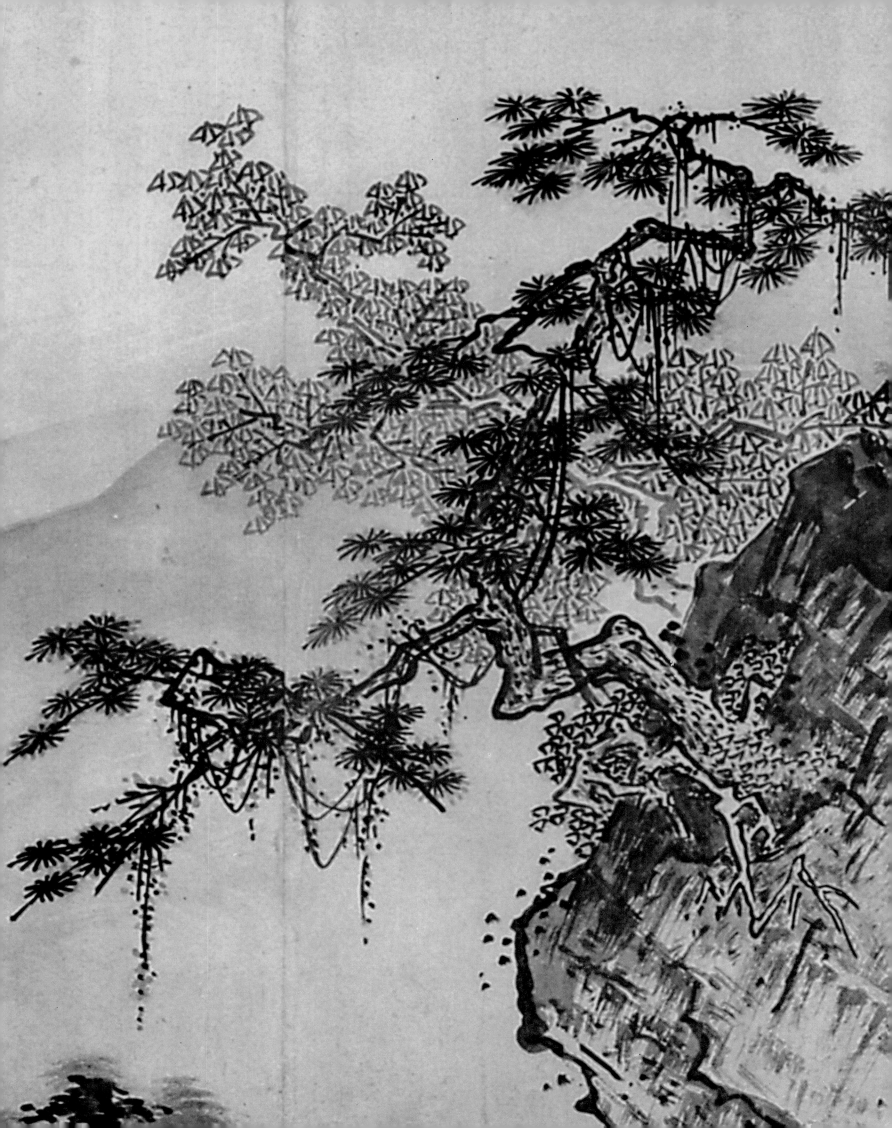

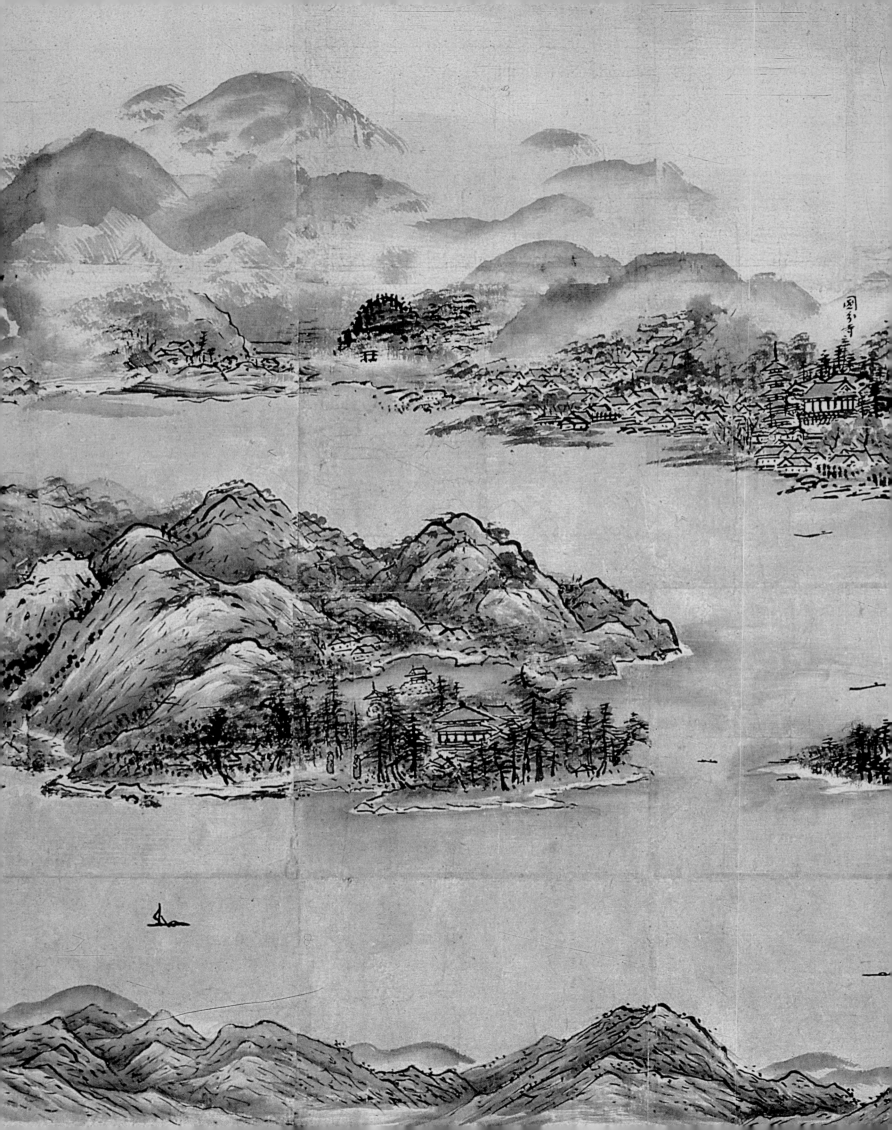

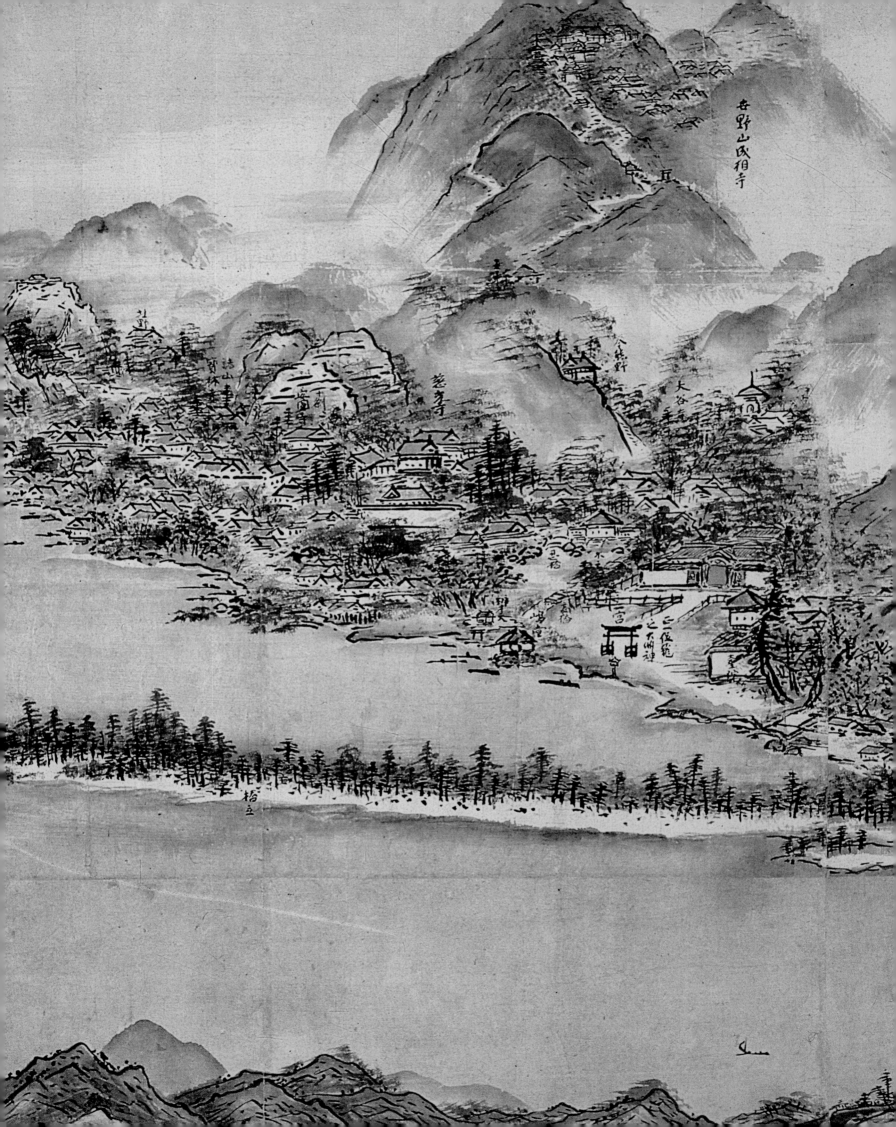

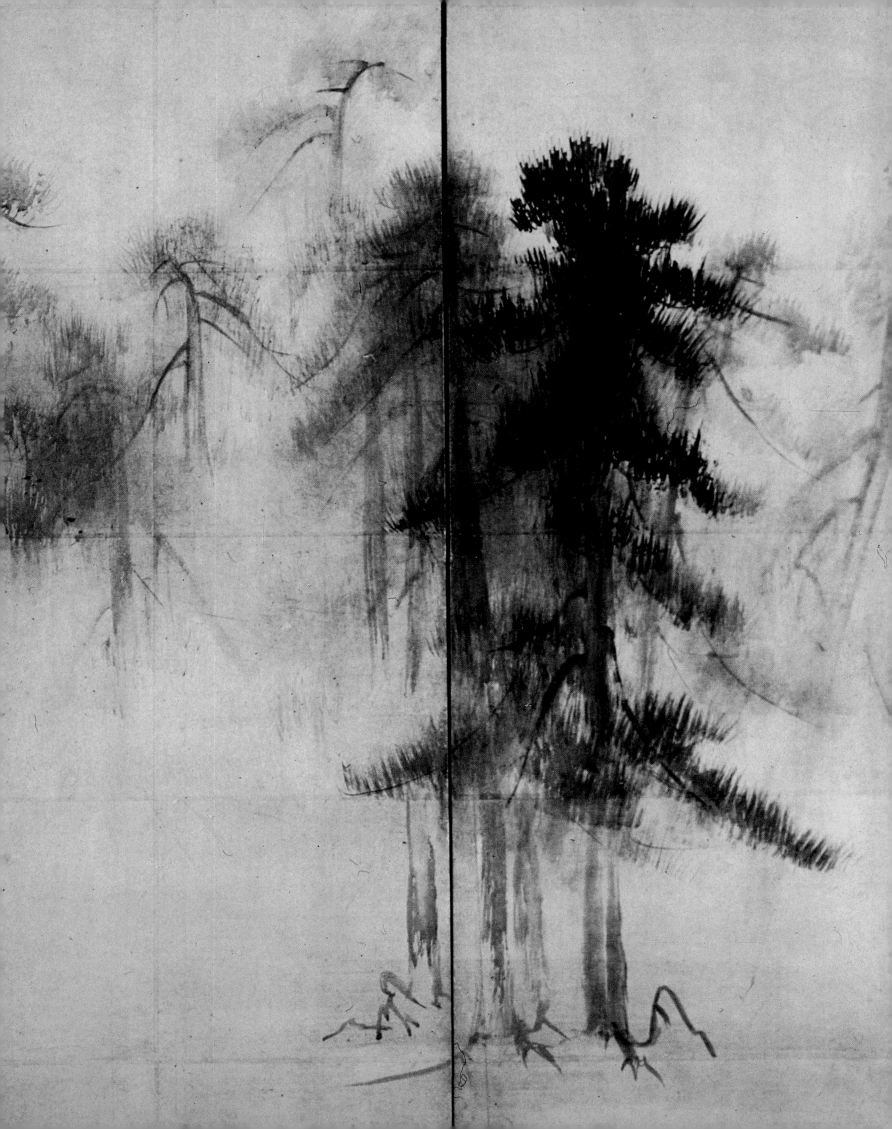

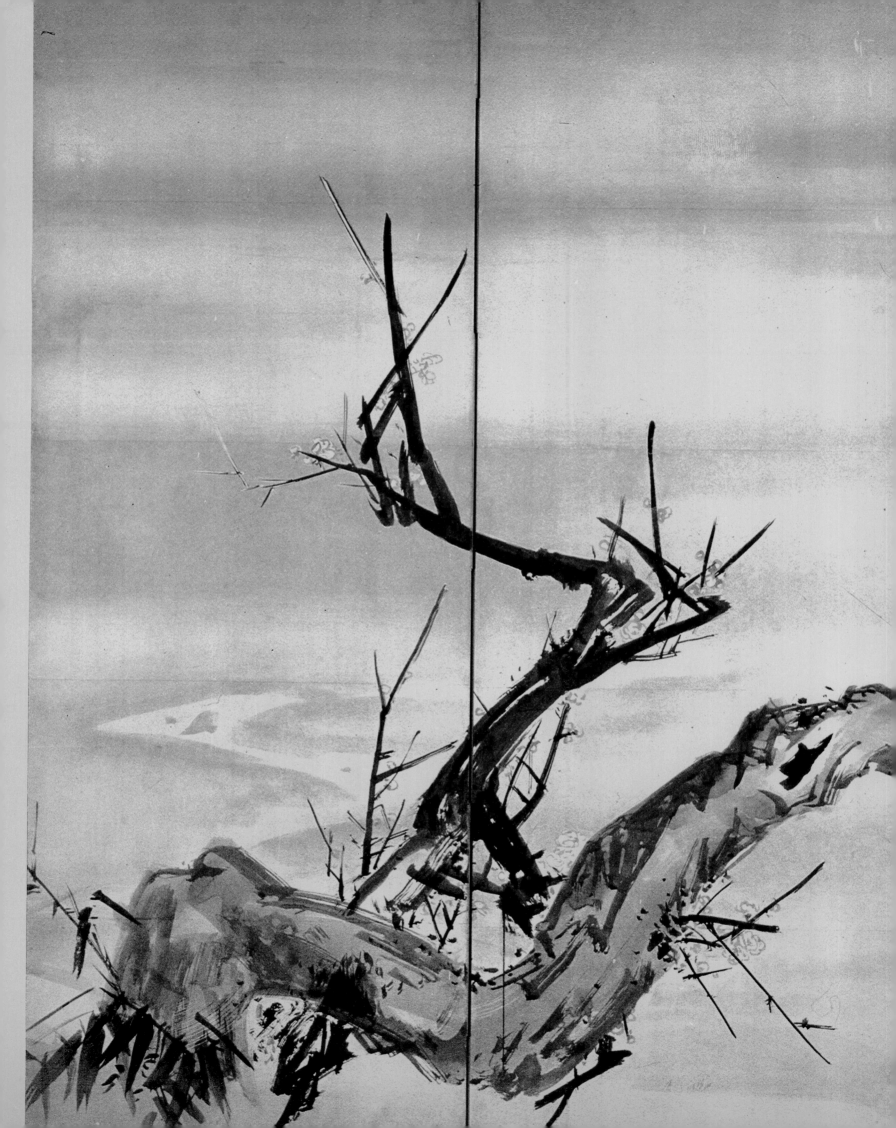

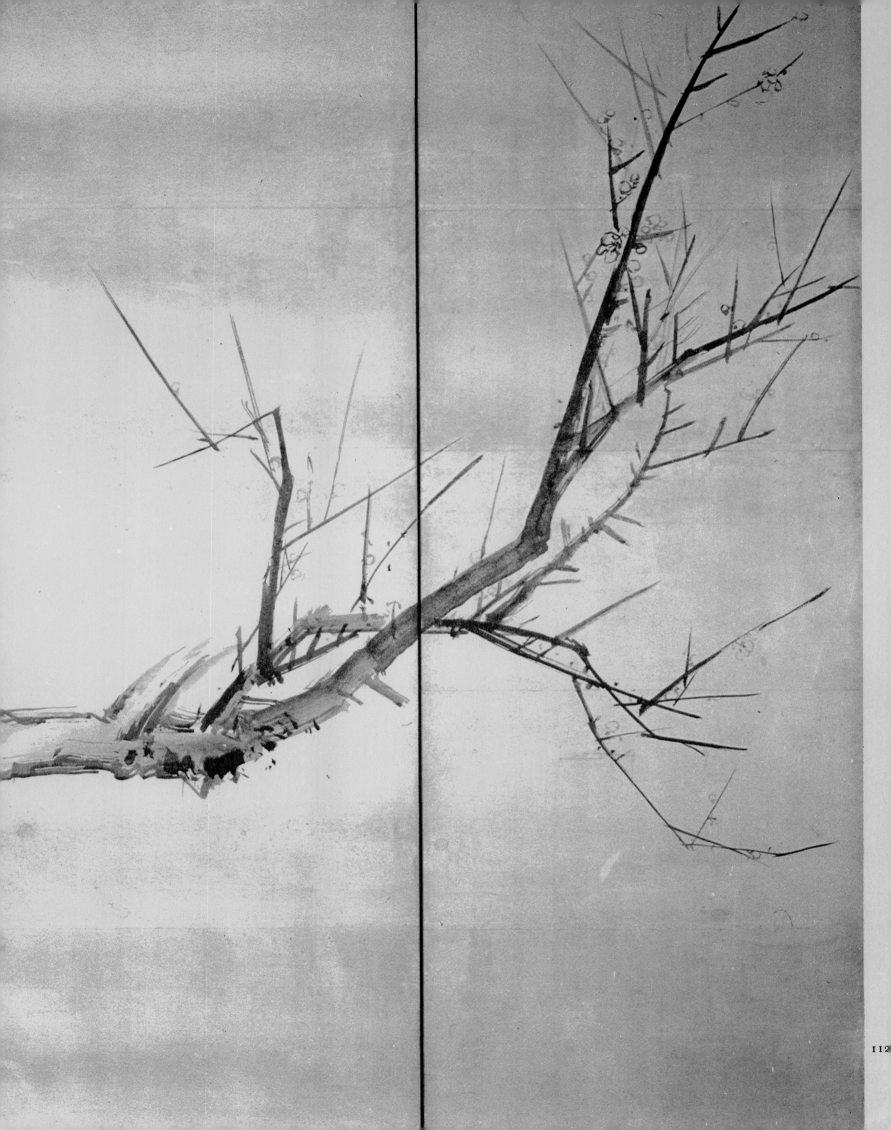

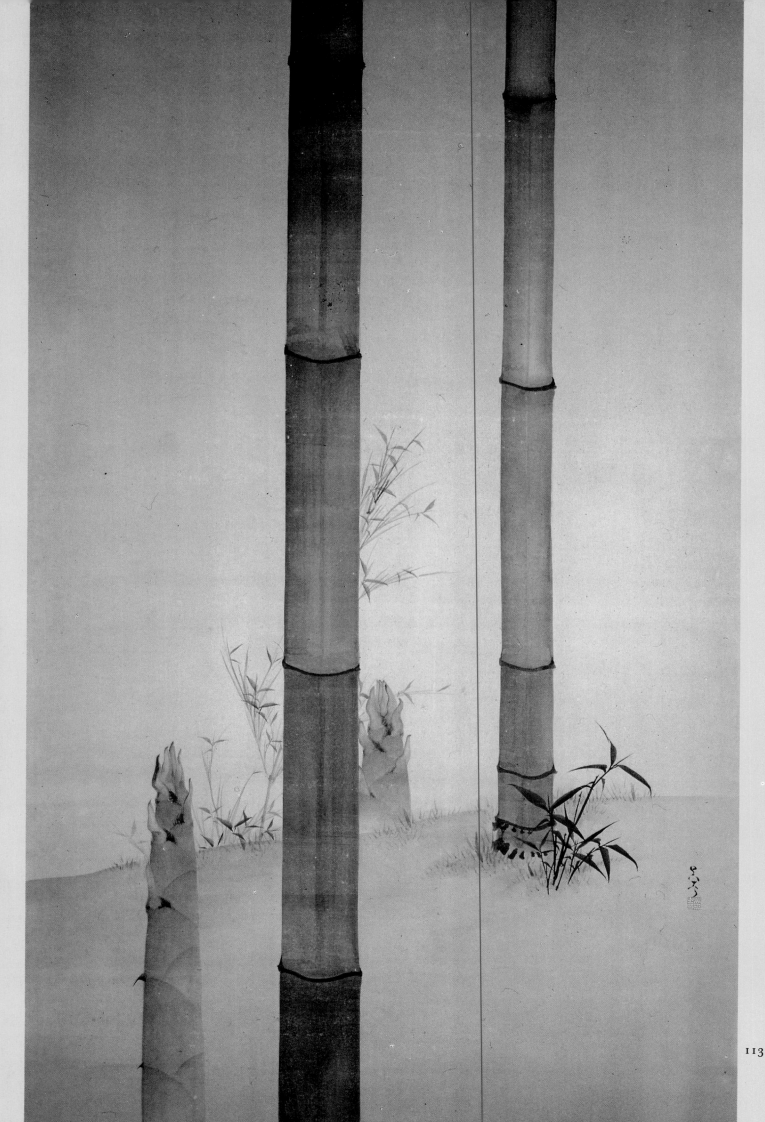

111 PINE TREES
By Tōhaku (Hasegawa Kyūroku, 1539–1610).
Detail of six-fold screen.
Ink on paper, 1.6 × 3.5 m.
Momoyama Period.
Tokyo National Museum

112 PINE TREE AND PLUM TREE
By Ōkyo (Maruyama Masataka, 1733–1795).
Detail of four-fold screen.
Ink and gold on paper, height 1.6 m.
Edo Period.
Asian Art Museum, San Francisco

113 BAMBOO
Goshun (Matsumura Toyoaki or Gekkei, 1752–1811).
Detail of hanging scroll.
Ink on paper, 146 × 90.5 cm.
Edo Period.
Los Angeles County Museum of Art

114 AMIDA RAIGŌ (DESCENT OF AMIDA)
Detail of painting.
Color on silk, entire painting 1.5 × 1.6 m.
Kamakura Period, 13th century.
Chion-in Treasure House, Kyoto

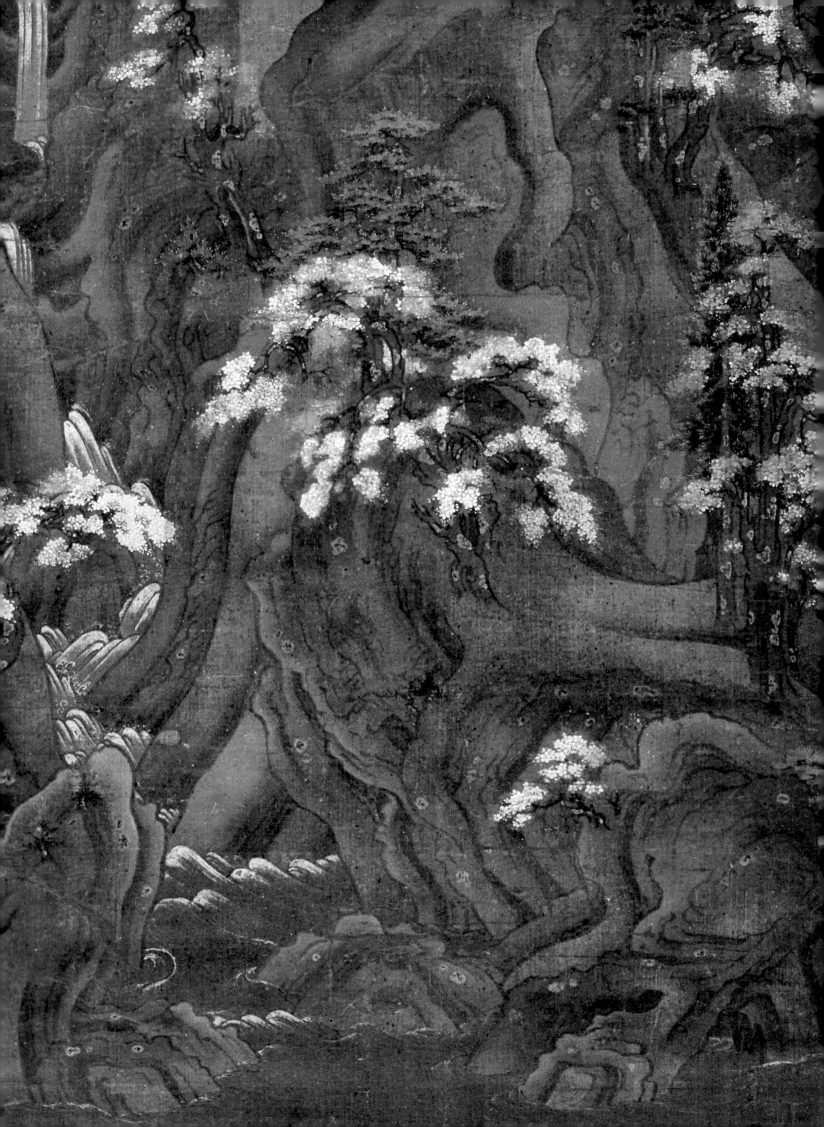

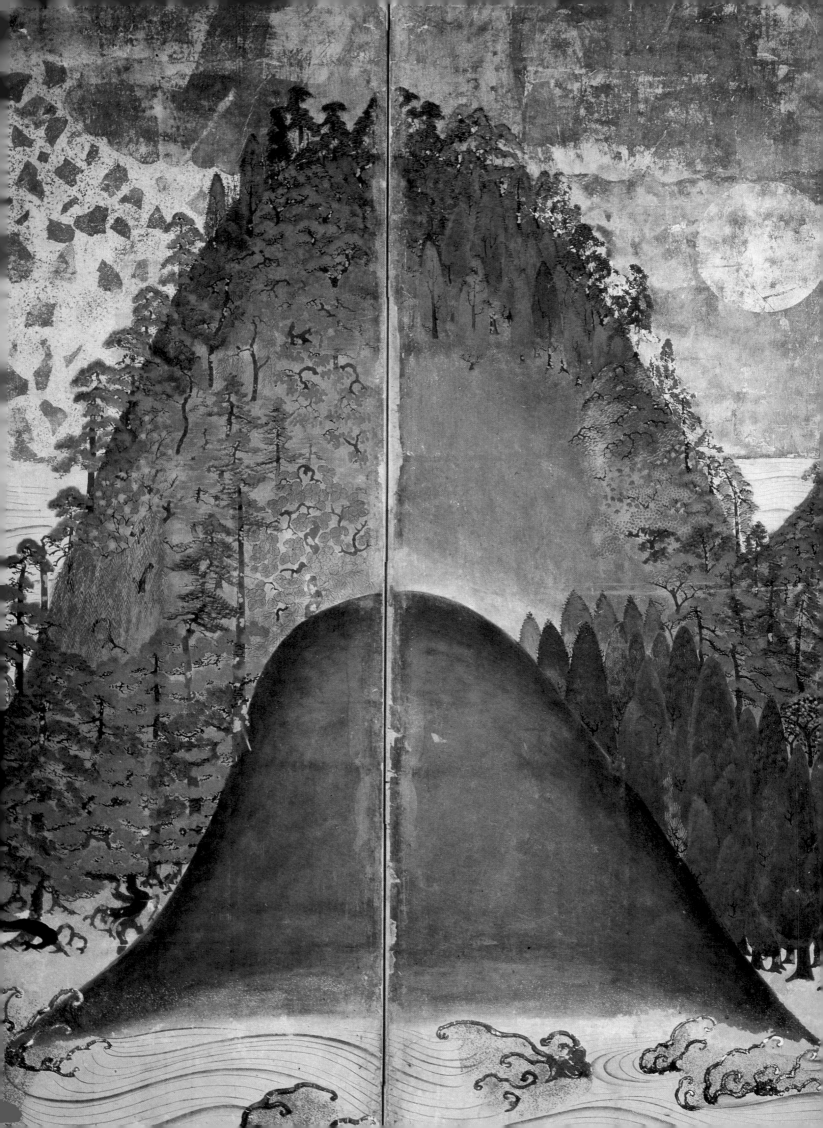

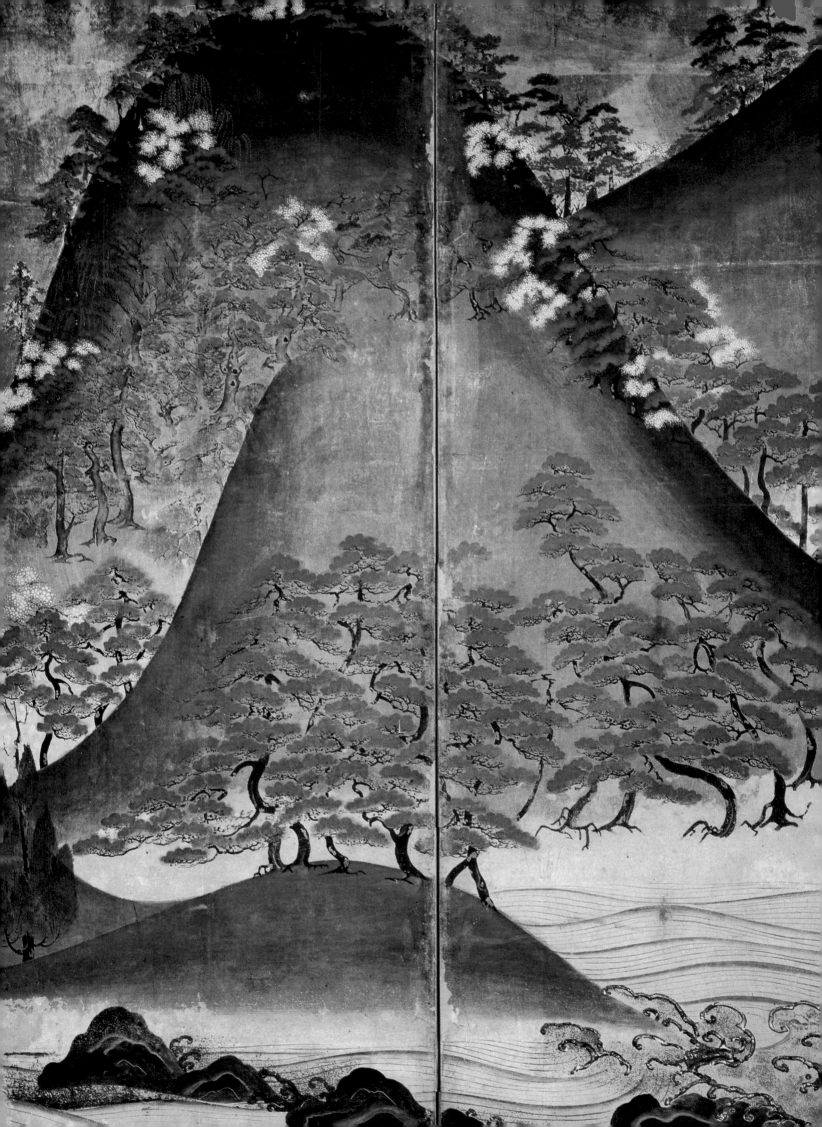

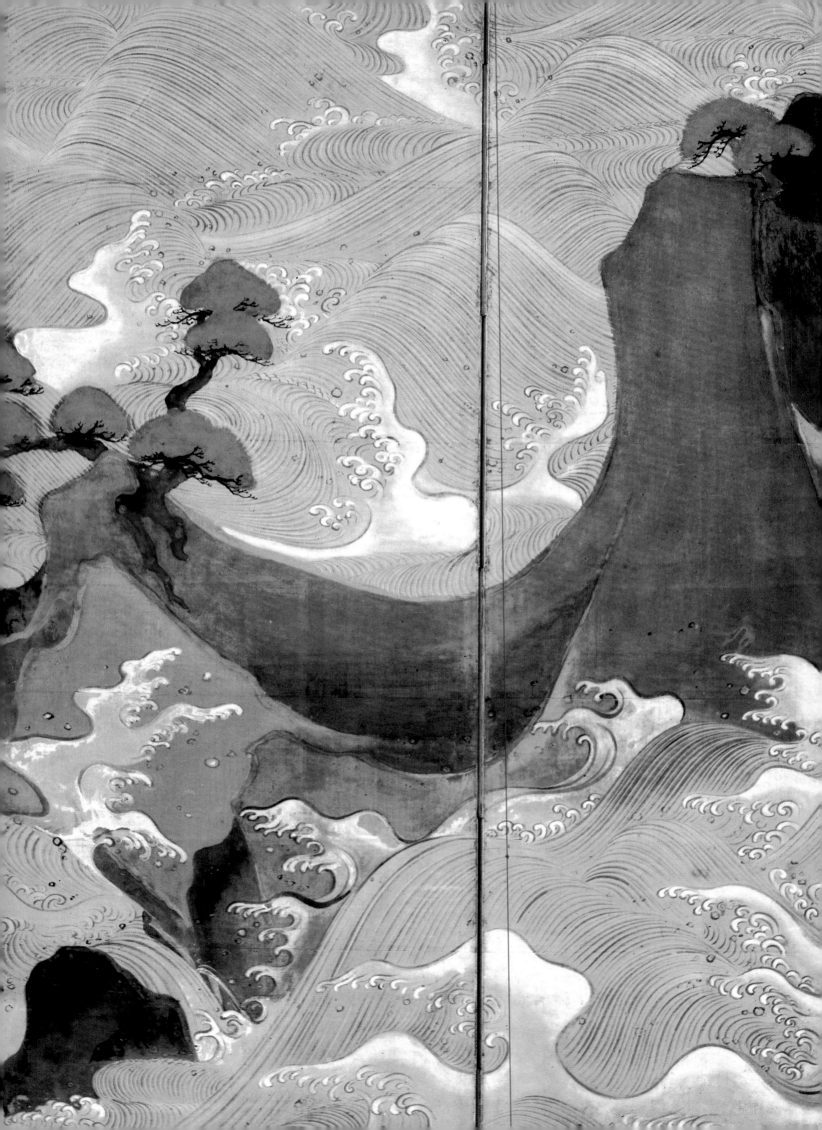

115 NICHI GETSU SANSUI BYŌBU (SUN AND MOON)
*"Spring Landscape by Sunlight," one of a pair of screens
(other pair entitled "Winter Landscape by Moonlight").
Color on paper, each panel 147.2 × 47.9 cm.
Momoyama Period, late 16th century.
Kongōji, Ōsaka*

116 WAVES AT MATSUSHIMA
*By Sōtatsu (Nonomura or Tawaraya Ietsu,
1575–1643).
Two panels. Detail of six-fold screen (one of a pair).
Ink, color, and gold on paper, entire screen 1.5 × 3.6 m.
Rimpa School, Edo Period, 17th century.
Freer Gallery of Art, Washington, D.C.*

117 IRISES
By Ōgata Kōrin (Ōgata Koretomi, 1658–1716).
Detail of six-fold screen (one of a pair).
Color and gold on paper, 1.5 × 3.6 m.
Edo Period, before 1704.
Nezu Art Museum, Tokyo

118 MAPLE TREE WITH AUTUMN PLANTS
By Tōhaku (Hasegawa Kyūroku, 1539–1610).
Detail of fusuma *painting at Shōunji.*
Color and gold on paper, entire panel 1.8 × 5.5 m.
Momoyama Period, 1592.
Chishakuin Storehouse, Kyoto

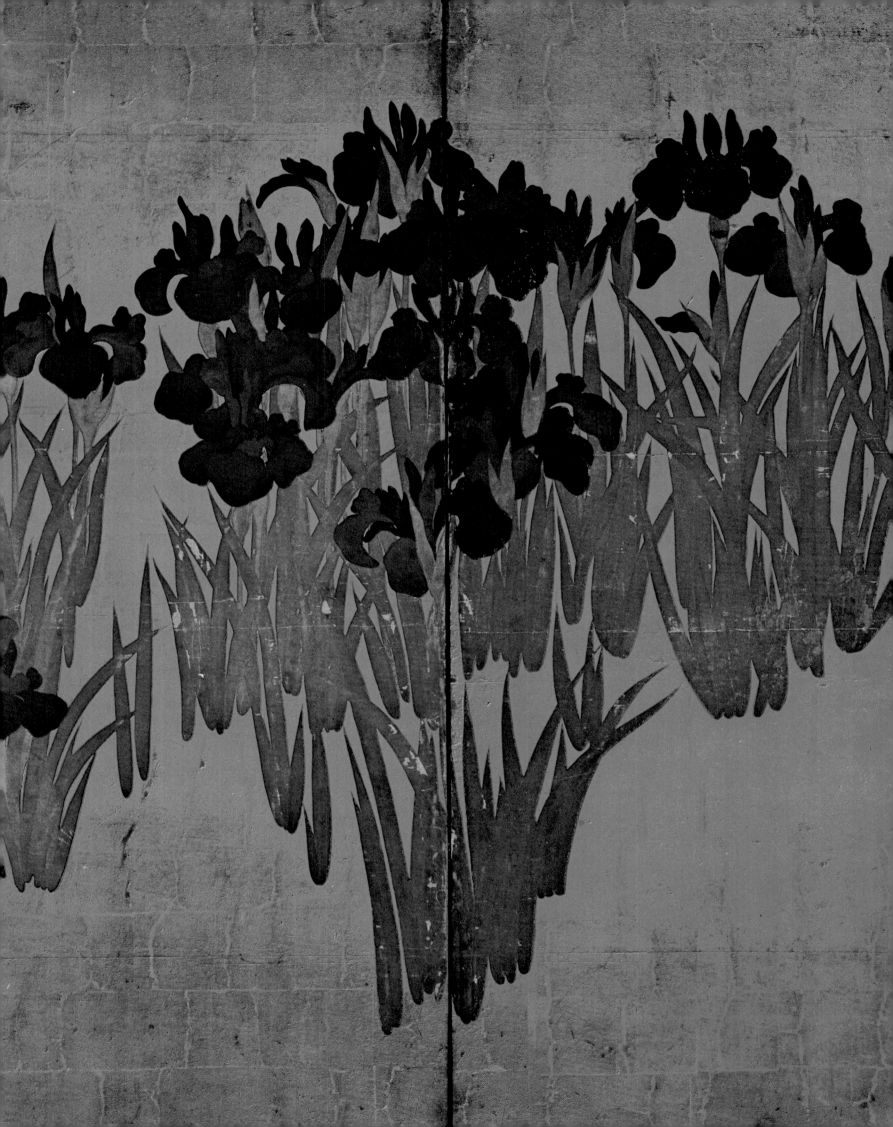

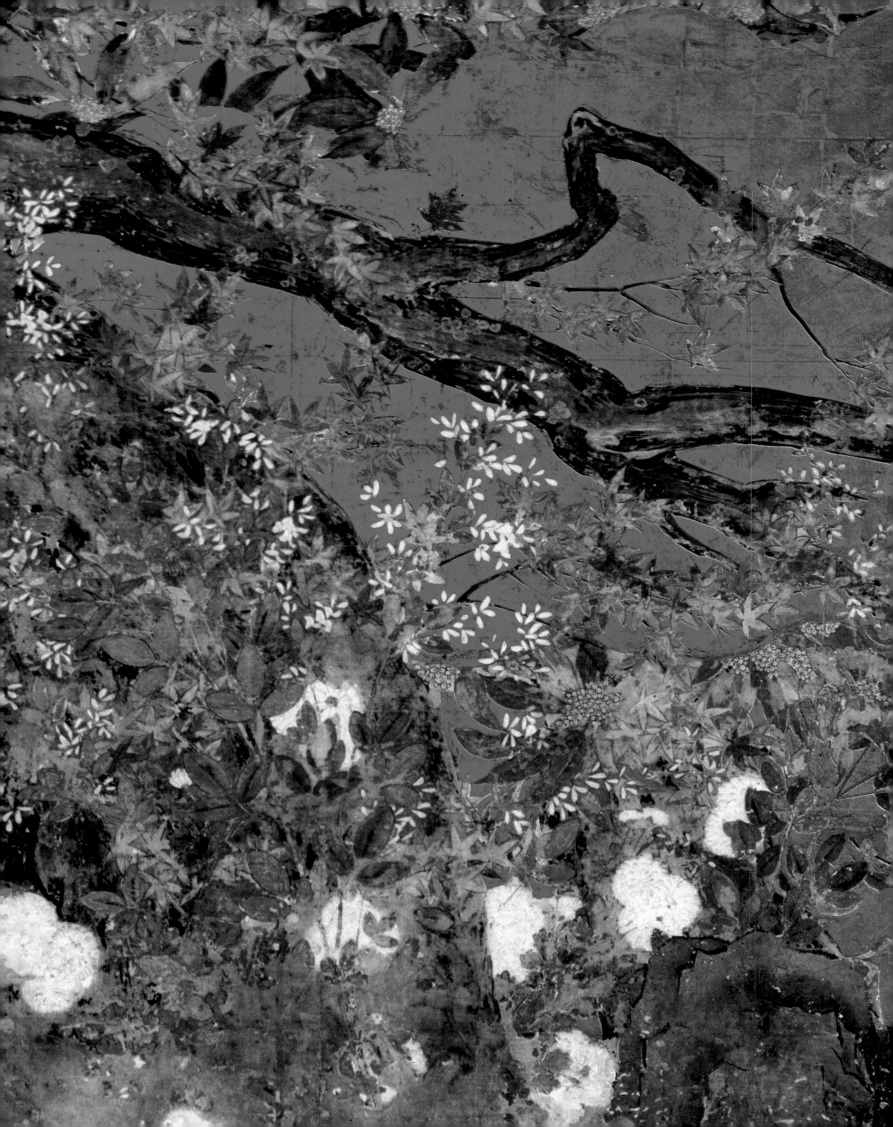

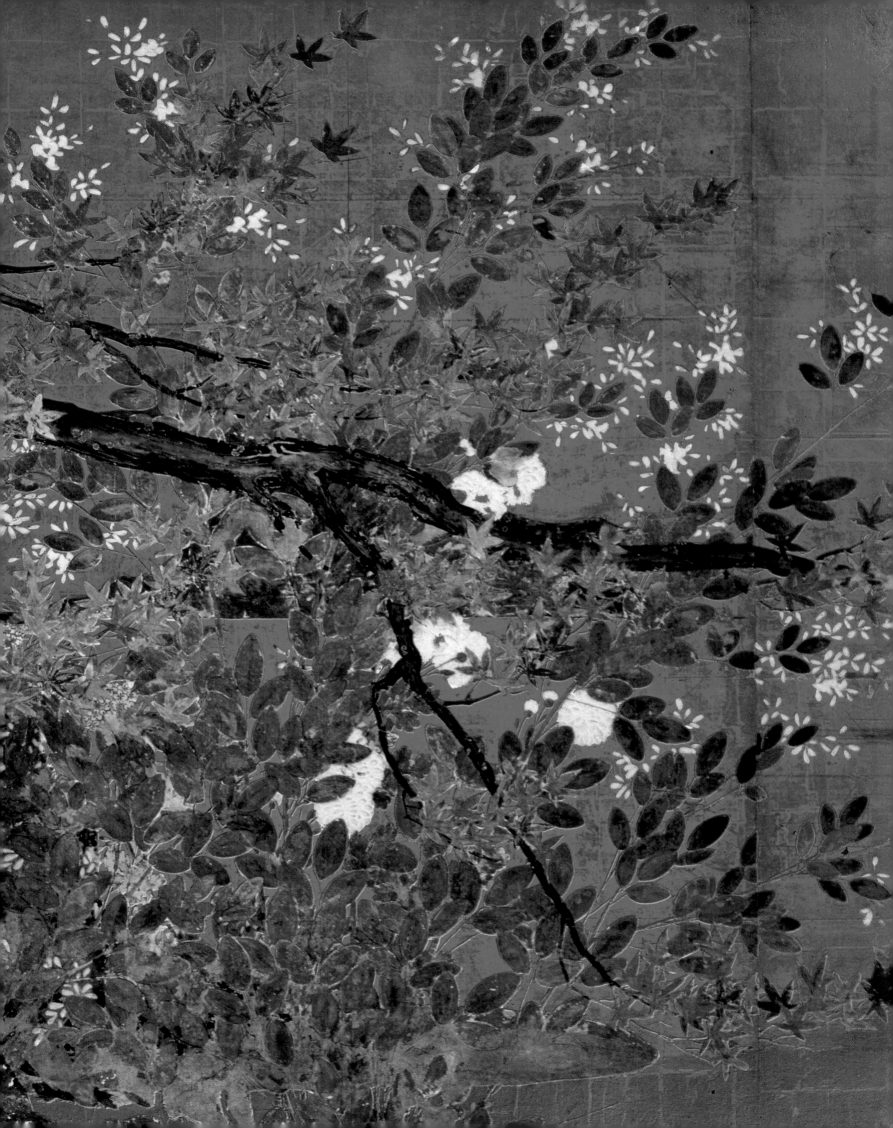

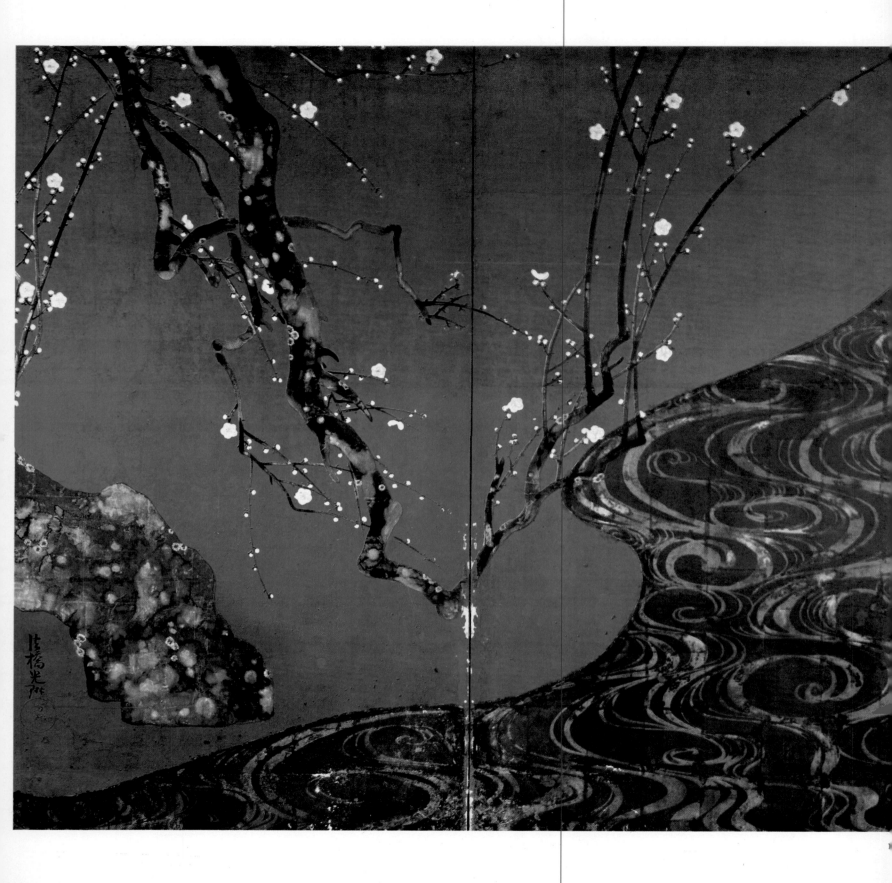

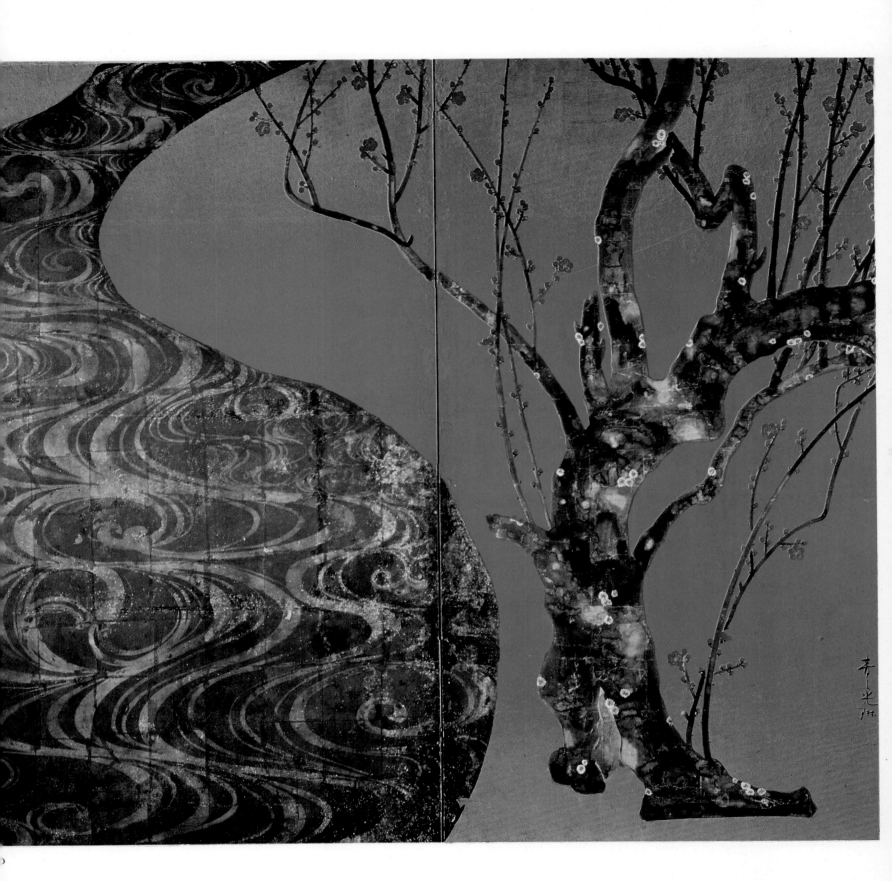

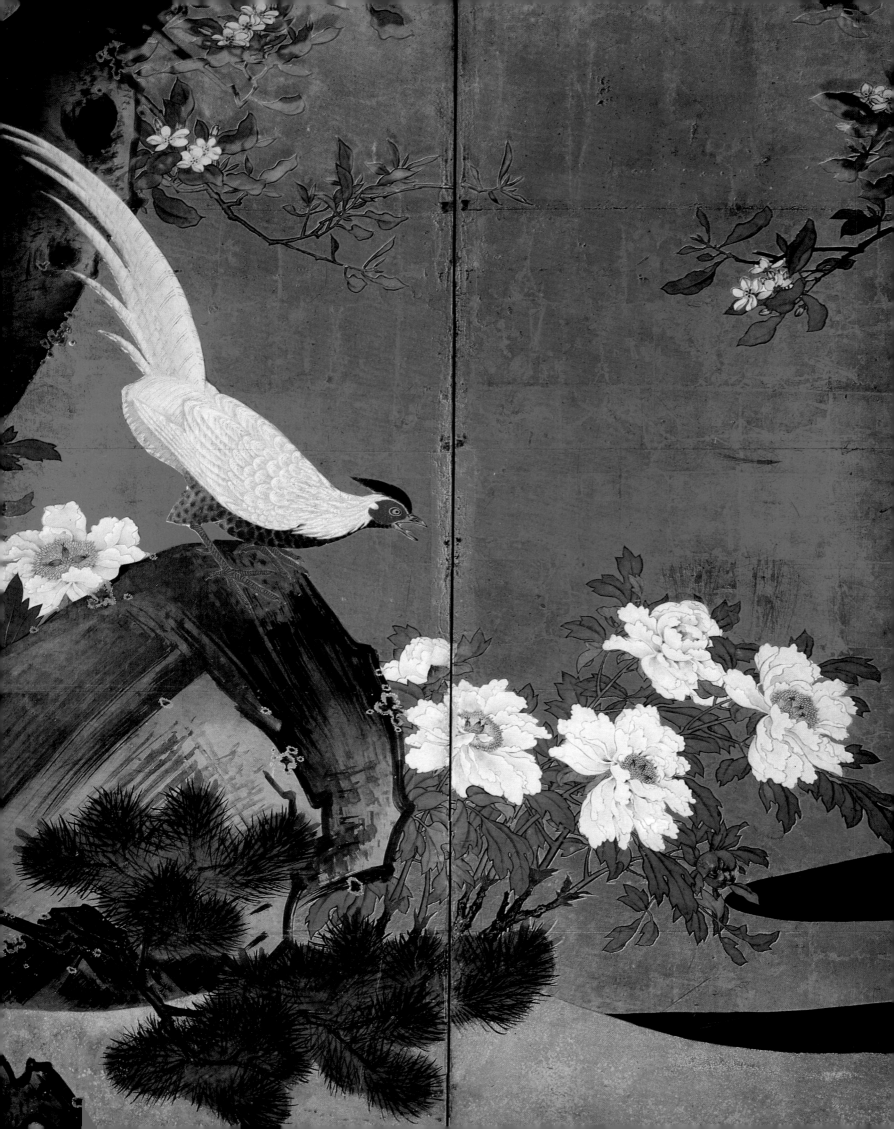

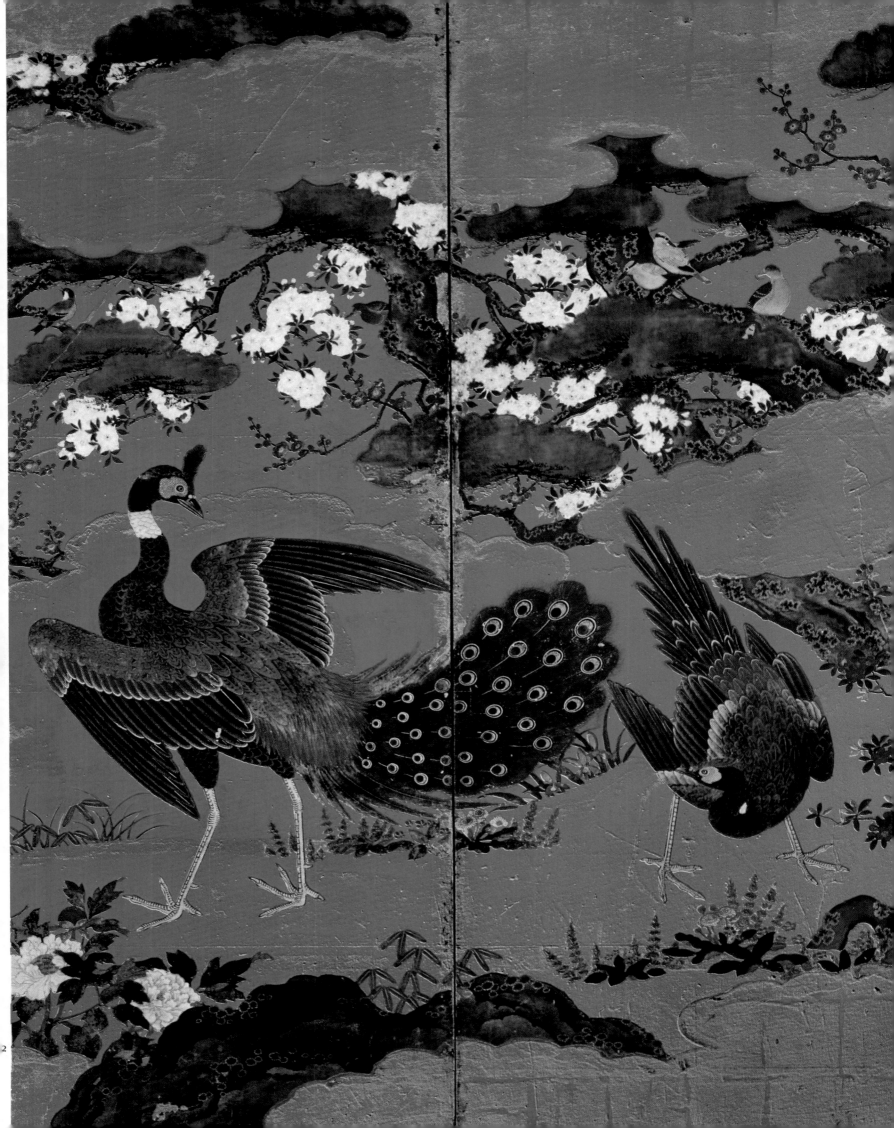

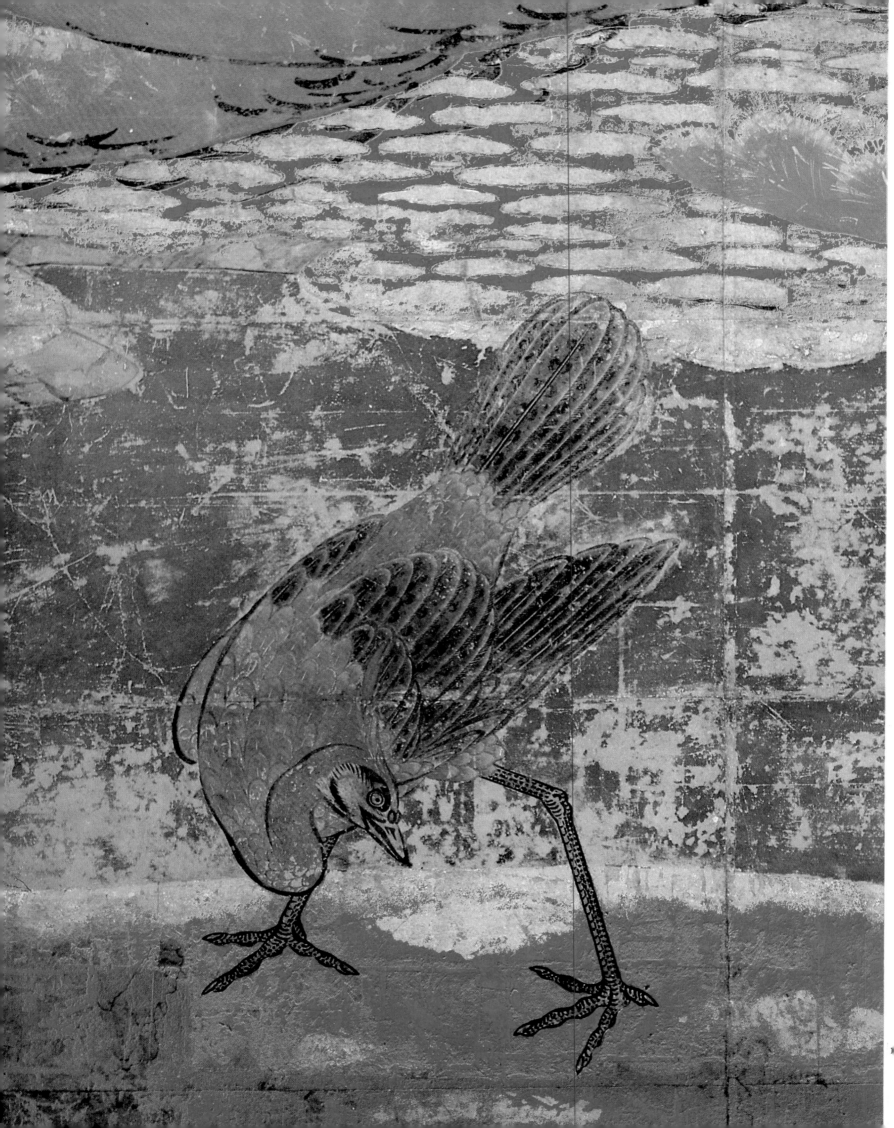

119–20 RED AND WHITE PLUM TREES
 By Ōgata Kōrin (Ōgata Koretomi, 1658–1716).
 Pair of two-fold screens.
 Color and gold on paper, 1.6 × 1.7 m.
 Edo Period.
 Kyūsei Atami Art Museum, Atami

121 PHEASANT, TREES, FLOWERS, AND BIRDS
 By Tōtetsu (Unkoku Tōtetsu).
 Detail of six-fold screen.
 Color and gold on paper, entire height 1 m.
 Edo Period, second half of 17th century.
 Museum of Fine Arts, Boston

122 SHIKI KACHŌZU BYŌBU (FLOWERS AND BIRDS OF
 THE FOUR SEASONS)
 Detail of screen.
 Color and gold on paper, entire height about 1.7 m.
 Momoyama Period, late 16th–early 17th century.
 Hakutsuru Art Museum, Kōbe

123 LANDSCAPE AND BIRD
 By Sakuma Tetsuen (1850–1921).
 Detail of fusuma *painting.*
 Color and gold on paper, entire height about 1.5 m.
 Zuiganji, Matsushima, Miyagi Prefecture

6. LITERATURE INTO PAINTING

6. LITERATURE INTO PAINTING

A single glance is all one needs to scan one length of a narrative handscroll painting from top to bottom, but the narrow height is more than offset by the unwieldy length. A continuous path unfolds before our eyes—and our mind's eye—as the illuminated strip of costly silk or ordinary paper is rolled up and unrolled, an arm's length at a time. In Western art, miniatures or engravings were part of books and were designed to present on one page a complete, self-contained episode (a "shot," as film makers would say); scrolls, however, were eminently suited to following the unbroken narrative thread that is the essence of storytelling.

Scroll painting is not peculiar to Japanese culture. The archipelago inherited the technique from China, where documentary evidence of scroll art can be traced as far back as the Han dynasty (3rd century B.C.–3rd century A.D.); the oldest known specimens of this art form were created by Gu Kaizhi (345–411) and other masters active during the Six Dynasties period (4th–6th centuries).

By their nature, scrolls are delicate and fragile objects. Although the scrolls produced over the centuries are as remarkable for their quantity as for their quality, we must remember that these works were necessarily costly and relatively rare, even when patently "simple," "picturesque," or "down to earth." Only institutions such as temples, or the elite among scholars, could afford them. However, scrolls could be put on temporary display before large audiences, and indeed, scrolls that were used in conjunction with religious instruction were always so displayed.

Undoubtedly scroll paintings were a favorite vehicle for stories of every sorts, and the bonds linking them to Japanese literature were close indeed. Yet, however unmistakably they overlap and allude to common sources of inspiration, these two areas of artistic activity weave different webs of fiction around essentially the same characters.

Moreover, the finest and most celebrated novels were not always the ones to be most frequently illustrated; perhaps pictures were sometimes substituted for a text that could not stand on its own merits. If we compare the principal themes that writers and painters selected time and again from the 10th to the 15th century, the Heian period is characteristically the era of greatest uniformity in its sources of inspiration. Love

stories from 11th-century novels provided painters with an inexhaustible store of pretexts for depicting the splendors of courtly life (although they chose their material for its visual impact, and thereby robbed their work of some of the richness of the textual counterparts). Apparently, historical narratives such as *Okagami* (*The Great Mirror*) had not yet captured the imagination of Japanese artists, who were still courtiers and poets rather than statesmen and warriors. By the 13th century, however, the joys and grisly tribulations of knightly adventure gave a sudden impetus to painting, which began to be a faithful reflection of the novels so popular in feudal Japan as it entered its heyday.

Thus the Kamakura period ushered in an era of unprecedented creativity, responsive to a wide range of literary genres. Certain themes from the Heian period remained popular, while tales of adventure and mortal combat, though their plots are somewhat puzzling to us today, provided scroll painters with a fresh supply of subjects and techniques. The old settings in houses and palaces was shattered; scenes were now set out-of-doors, along diagonal axes. Inexorable waves of horsemen filled entire scrolls, while the part played by the text—that is, what was left of it—became negligible. By the 14th century, however, people apparently tired of these gamboling exploits and painting gradually replaced the world of war with humorous subjects or scenes of dazzling fantasy. Splendid ceremonies held greater interest than the minutiae of court life, rituals, or dramatic knightly deeds. Bizarre ghost stories and the comical zest of everyday life, where all classes could rub elbows and jostle one another a bit, became primary sources of inspiration for scroll paintings. Some were more dynamic than others, but none was violent. In both style and content, they offer us a foretaste of the genre painting which would break free from the confines of books and albums, cover walls and partitions, and eventually take the form of "souvenir" prints.

The earliest illustrated scroll of *The Tale of Genji* marked the zenith of this typically Japanese art form in the 12th century. The pictorial accounts of the 10th-century novel by Lady Murasaki Shikibu (968–1016)—a literary masterpiece in its own right—have been casting their spell over admirers for some eight hundred years.

Although practical reasons dictate that only a few scenes from this novel are reproduced time and again, fifty-six leaves have survived, illustrating fifty-four scenes. Forty-three leaves are in the Tokugawa Reimeikai Foundation in Tokyo, thirteen are in the Gotō Art Museum in Tokyo (fig. 125). Recent studies of Chinese and Japanese material have shed new light on possible antecedents of *The Tale of Genji*: whatever these may have been, the supremely balanced scroll painting is unique in the insight it offers into the literary atmosphere of the imperial court of that era, bathed in an aura of reverie.

In this dreamlike atmosphere, the sole haven from overwhelming court ceremonies and a Chinese-language literature ill-suited to native sensibilities, lay the seeds of the literary efflorescence that was to give Japan its rich store of fiction. Curiously

enough, Lady Murasaki wrote her masterpiece, not in the Chinese usually reserved for lofty texts of an intellectual or literary tenor, but in the local dialect, yet she never takes the reader far from the imperial court. On the contrary, the court surrounds us, but what we find in it is a long way from the strictures and outlook brought in from China. In this respect, *The Tale of Genji* reflects an effort that was to remain constant in Japanese civilization, namely, to bring together and, as far as possible, to fuse an unyielding, "imported" politico-economic apparatus with the Japanese *kimochi*, the native way of living, of feeling, of reacting to things. In *The Tale of Genji* the focus sharpens on those aspects of native culture that did not fit the Chinese model that the Japanese otherwise so admired.

In literary and pictorial form, *The Tale of Genji* is a work of fiction, a figment of the imagination. Indeed, the Japanese terms for the style of *The Tale of Genji—tsukuri monogatari* for literature, *tsukuri-e* for painting—literally mean "fabricated" or "made up." Recent studies conclude that this type of novel developed in the 10th century, a date which satisfactorily accounts for the masterful technique so evident throughout the work. Pushing the birth of these "fabricated stories" back to the 900s also brings new light on the text itself, which perhaps was conceived with illustrations in mind. At any rate, art historians for the last fifteen years have been emphasizing the role of painting in the development of Japanese literature, which is all the more significant in that paintings inspired by a text often inspired, in their turn, new poems. This "crossbreeding" of words and colors generated a sphere of literary activity during the Heian period.

THE earliest references to illustrated novels provide us with titles as well as dates. For example, there is documentary evidence that an illustrated version of *Ikutagawa Otome*, or *The Virgin of the Ikuta River*—the cheerless story of a Japanese Ophelia written by the Empress Mother Onshi, wife of Emperor Uda (r. 888–897)—appeared as far back as 907. An early form of the *Sumiyoshi monogatari* (*The History of Sumiyoshi Temple*) was illustrated in the second half of the 10th century, and likewise, at the century's end, a travel diary (*Tosa Nikki*) written by Ki-no-Tsurayuki (883–946) in 935. According to Akiyama Terukazu, this evidence points to the possibility that Lady Murasaki conceived *The Tale of Genji* in pictorial terms, to make the story appeal both to the reader's eye and ear. Its aristocratic Epicureanism brought relief from the unremitting pressures of a merciless code of conduct and, in a more general sense, it made more bearable the passage of time, and life itself. (To be sure, Buddhist preachers maintained that the end of one life simply marked the beginning of another, and so on without end. But short of achieving *nirvāna*, a person's suffering was no less interminable.)

This gratification of many senses at one time through a kind of "total spectacle" accounts for the enormous success of *The Tale of Genji* and, indeed, of the *tsukuri* manner in general. To get a feeling for the theatrical quality of storytelling at the time—which scholars have traditionally, but incorrectly, divided into "literature" and "painting"— we must picture a princess and her circle of ladies-in-waiting, one reading aloud while another displays leaves or unrolls a scroll.

Next the question arises, how accurately did the paintings reflect the text? A quick survey of key literary genres and secular paintings during certain periods of Japanese history reveals unmistakable similarities in their sources of inspiration. At the same time, instances of exact correlation are virtually nonexistent. The only illustrations that seem to match episodes or chapters from novels with any degree of accuracy are those in *The Tale of Genji*, in particular, the Kashiwagi episode, available at both the Tokugawa Reimeikai Foundation and the Gotō Art Museum.

Does *The Tale of Genji* become, therefore, a mere "fluke"? Or, the more likely alternative, is it a superbly balanced form, a culmination disturbed later by social and psychological factors? A final analysis of *The Tale of Genji* is difficult to make, for only about half of the scenes that originally filled some ten scrolls of the matchless jewel have survived. Moreover, time has faded or altered the colors, and often we must imagine what they once looked like: subtle shades of red, mauve, and pale yellow, enhanced with tiny grains of sand, bits of wild grass, or particles of silver and gold. Ancient paintings from every culture are liable to such damage, but the loss is particularly grievous in the case of scroll paintings, for it interrupts the intricate visual rhythm of text, illustration, and decorative detail. This is not to be taken lightly: an *emaki*, however beautiful may be some of its individual scenes, must be evaluated as an organic whole, for it has a progressive movement akin to music, or to a film whose action has been "frozen" into certain key frames.

The first theme that writers and painters alike seized upon was that of the seasons. The seasons, in addition to governing the worlds of man and nature, were believed to transcend human life and to prompt man toward having "sympathy with all things." Heian civilization expressed this concept as *mono-no aware*, hinting at the Buddhist idea of impermanence (above all, that of denying the passions which would engender reincarnations), and at the fatalism of a culture which, for all its brilliance, felt defenseless against all of the physical constraints: extreme heat and cold, illness, untimely death.

Like all forms of artistic expression, the *monogatari* and its pictorial counterpart adhered to its own rules or conventions. The painter's task was to take the message stretched out in time by the rhythms of ordinary prose or poetry and translate this into an image that could be grasped almost immediately.

The *tsukuri-e* technique tried to meet this challenge. The painter did not begin by working directly on a scroll: his first step was to lay out an ink sketch of the whole in well-defined strokes, followed by a second sketch executed with greater freedom and fluidity. He then divided the plot into scenes and enlarged and copied these, one by one, directly onto a scroll or onto leaves that might be glued together or mounted on a different support. Next he would apply his colors, covering the entire surface with a layer of pigments carefully distributed; details such as ladies' headdresses and courtiers' ceremonial hats were added as finishing touches, punctuating the scenes with pure black accents. The faces of individual characters were left blank until the end, and only

275

after that—the Chinese marked this moment as "opening the eyes"—was the work considered to be finished.

Generally speaking, the composition was arranged along diagonal axes which afforded views from below as well as from above; the height and position of figures along these axes not only indicated their nearness or remoteness, but also subtly corresponded to their importance in the unfolding narrative. These slanting perspectives resulted in bird's-eye views, indiscreet glances into houses whose roofs were not so much "removed" (as the effect is so often described) as "blown away" (*fukinuki yatai*). A close inspection will find in every scene a vertical or oblique axis that leads the eye across a house, and thus the entire narrative is steeped in domestic intimacy. *The Tale of Genji* is truly a tale of the great indoors.

Probably nowhere else is the Japanese house—fragile, vulnerable, susceptible to momentary change, and yet so enigmatic—more spellbinding than it is here. Witness the subtle echoes between the colors of beams or balustrades and of clothing, all of them mirroring seasonal changes, the atmosphere of a house, and the soul of its master.

There is little reason to look for meaning in the facial expressions. Men, women, princes, retainers—all human figures fitted into a stylistic mold known as *hikime kagihana*: the ever-present white oval, two "dashes" for eyes, a simple "hook" for a nose, a stroke of red for a mouth and, lastly, two deftly drawn lines for the eyebrows that aristocrats redrew in the middle of their foreheads after shaving off their natural eyebrows.

People have often puzzled over the "depersonalized" heroes and heroines found in illustrated Japanese novels between the 10th and 12th centuries, and have sought explanations for this. Perhaps it was to create a sense of pictorial unity for its own sake, an almost mathematical kind of formal purity. For here color, not facial expression, is the real barometer of human emotion. Colors had not only descriptive value, but specific symbolic content. Let us be cautious therefore, in our approach to *The Tale of Genji*. Can we really perceive its colors the way the Japanese of the Heian period did? And even if we could, are we not thrown off by the changes that the pigments have undergone over the centuries? There might also be more prosaic reasons for this uniformity: the desire to avoid offence through the embarrassing implications of likeness, or, more likely, to give the reader a chance to identify himself with each character and slip as in a dream into the sumptuous attire that was "posed" in wait for the wearer who would act out its role. But this attitude was confined to the urban aristocracy of the Heian period: late in the 12th century, the chivalric world would use a more intense expressionism. *The Tale of Genji* was exclusively a product of the imperial court, and this seemed so obvious, that all of the scenes in the illustrated version of *The Tale of Genji* were attributed ever since the 19th century to Fujiwara Takayoshi, a court painter thought to have lived in the 12th century. That one artist was responsible for the entire work was accepted as a foregone conclusion. Recent studies focusing on the treatment of those supposedly identical faces, however, have found certain groups of facial "types," indicating different artists. The calligraphy of the text also reveals at least four styles.

It is now believed that the laborious task of producing the ten scrolls that proba-

bly made up the original *Tale of Genji* was divided among no fewer than five painters, members of the court who worked under the supervision of a person of the highest rank, such as an empress or abdicated emperor. Its homogeneous style (despite certain variations in details) might be explained by the strong social homogeneity of those who created and those who admired this, the most splendid of all Japanese scroll paintings.

As we contemplate these scenes—as fascinating now as they were eight centuries ago—it may be useful to reflect upon how the characters portrayed in this chronicle felt about painting back when *The Tale of Genji* was first written, some two hundred years before they themselves were transformed into paintings.

The light which *The Tale of Genji* sheds in this respect is both invaluable and disappointing. Invaluable, because the novel devotes an entire chapter (Book XVII) to a picture contest (*e-awase*), proof that people at the time were already looking to paintings as a source of fantasy or aid to meditation. Consider, for instance, the following description of a work probably portraying Sugawara-no-Michizane (845–903), the prime minister who was slandered and unjustly condemned to exile:

"Knowing that the final inning had come, the Kokiden faction too brought out a very remarkable scroll, but there was no describing the sure delicacy with which Genji had quietly set down the mood of those years. The assembly, Prince Hotaru [the judge of the contest] and the rest, fell silent, trying to hold back tears. They had pitied him and thought of themselves as suffering with him; and now they saw how it had really been. They had before their eyes the bleakness of those nameless strands and inlets. Here and there, not so much open description as poetic impressions, were captions in cursive Chinese and Japanese. There was no point now in turning to the painting offered by the right. The Suma scroll had blocked everything else from view. The triumph of the left was complete." (*The Tale of Genji*, trans. Edward G. Seidensticker, pp. 314–15)

This chapter will be something of a disappointment to art lovers, however, for the novelist limits herself to vague, soulless descriptions. She talks about "paintings of endless variety," or points out how Genji's rival "quite outdid himself with all the accessories, spindles and mountings and cords and the like" (*op. cit.*, pp. 310, 311). Clearly, she is more interested in the web of intrigue surrounding the paintings than in the paintings themselves. "He also commissioned paintings of the seasons and showed considerable flair with the captions. The emperor liked them all and wanted to share his pleasure with Akikonomu [the emperor's consort], but Tō-no-Chūjō objected. The paintings were not to leave the Kokiden apartments" (*op. cit.*, p. 310).

Painting seems to be an activity of secondary importance throughout *The Tale of Genji*, both as a narrative element and in the eyes of the characters; it is but one more "prop" of luxury for them. Is this Lady Murasaki's doing, or was this how people regarded a form of art that was then still groping for a purely Japanese idiom? The one aspect that is not overlooked is the sumptuousness of art: "The *Bamboo Cutter* illustration, by Kose-no-Omi [fl. 9th century], with a caption by Ki-no-Tsurayuki [883–

946], was mounted on cerise and had a spindle of sandalwood. . . ." And elsewhere: "On stiff white paper with a blue mounting and a spindle of yellow jade, it was the work of Tsunenori and bore a caption by Michikaze. The effect was dazzlingly modern" (*op. cit.*, p. 312).

But what exactly did these courtiers paint and in what style? There is no more to be learned from Murasaki Shikibu, for whom nothing counted but style and good form.

THE word *otogi* was used until recently, not without condescension, for "nursery tale," the meaning it had acquired by the end of the Edo period. However, the painstaking study of ancient texts (resumed after World War II in the manner of Western-style exegesis) has traced various forms of this concept back to the Heian period.

Thus *otogi* simply means to sit down beside a person and tell him stories because he is bored or feels lonely. His spirits must be lifted, and the narrator, with fables or other stories, helps him reenter the mainstream of life and forget the ultimate destiny of humankind (about which no Eastern philosophy has optimistic thoughts). *Otogi* is a form of communication through symbolic language—in this instance, stories. In a religious context, it was also a kind of confession. Long ago, when no downpour (*yūdachi*) brought relief on a sultry summer night, or when gleaming moonlight induced meditation instead of sleep, monks would gather together to recount the story of their lives, and to tell of the series of revelations or sins that had prompted them to choose the path of prayer for the rest of their days.

Upon reflection, all traditional Japanese literature seems to consist of dialogues. Its poems are not songs or hymns or cries hurled at Heaven or society, but snatches of encoded conversations that take on meaning only in the context of the reply that will be uttered. Add to this the theme of *ennui*—romantic or dramatic—that is latent throughout Japanese art and has become obsessive in the modern megalopolis of central Japan, and we are back to the concept of *otogi*, stories told to someone, or told in groups to pass the time. Westerners might better understand this term if they think of evenings spent around an outdoor fire. Japanese storytellers were equivalent to the European jester, and both had the job of following his superiors about and amusing them.

The *otogi* genre inspired more than three hundred illustrated narratives that we know, called *otogizōshi*. It is the pictorial character of these stories that concerns us here. The forms preferred by the *otogizōshi* artists were the *emaki*, or scroll painting, and the *Nara ebon*, or illustrated book. The pictures were accompanied by a text that might be read to oneself or recited aloud to an audience, large or small. If the latter, a narrator would display the pictures to draw his listeners into the story. If the audience was large, the story was not called *otogi*, but *etoki*, that is, a sort of *otogi* for a group of people: some scholars have even proposed that *The Tale of Genji* falls into the *otogi* category. In any case, the *otogi* and *etoki* literary forms reached maturity by the Muromachi period (14th–16th centuries), thanks to the increasing popularity of stories about knights and Buddhist saints. At this time the *otogizōshi*, or illustrated *otogi*, became an important tool of religion: the aim might be purely didactic, though the mere recounting of a religious

story was considered a form of prayer or a way of earning merits. The early illustrator's art had social meaning, for it offered the illiterate and the unimaginative a pathway into the boundless world of thought.

The *otogi* offer us a new angle for the appreciation of a whole area of Japanese painting. Many scrolls or fragments of volumes previously forgotten or subsumed under the vague term *emakimono* (scroll paintings) have been recognized for the "picture books" they really are, and this means reevaluating our criteria for assessing such works. We shall be seeking not innovation or daring symbolism, but meaningful details and the look of the world—then or earlier—that these Japanese illustrators formed not so long ago and thereby contributed to molding the outlook of their compatriots (figs. 125–35, 335–65).

As paintings, *otogizōshi* belong in the grand tradition of the imperial workshops, the most celebrated product of which was *The Tale of Genji*. To begin with their subject matter: by the late Kamakura period, the exploits of Prince Genji had developed into a number of plots, and numerous scrolls naturally took these sequences of events as their theme. One nun needed five years to paint a set of twenty-four scrolls about the adventures of Genji; she used luxurious paper originally intended for a copy of the *Hokkekyō*, or Lotus Sutra, and all twenty-four scrolls were deposited in a sutra-case. Of her *Genji Kuyō* (literally, *Requiem for Genji*) only four fragments survive, unfortunately, but comparison with the famous *Tale of Genji* reveals nothing new in technique, except that some elements only hinted at in the court painting are here spelled out to leave nothing to the reader's imagination. And this precision, especially in architectural details, allows us to date the work in the Muromachi period.

In addition to the several scrolls that use Genji as a pretext for depicting the life of the aristocracy, there are a number of tales that illustrate the lower classes, such as "The Judgment of the Bunsho Era" (*Bunshō no Sasshi*) of 1466–67 and "The Little Pebble" (*Sazare-ishi*). The latter belongs in a Buddhist cycle of legends dealing with Yakushi, the healing Bodhisattva who ministered to the soul as well as to the body.

Otogizōshi that narrated eventful stories in detail were apparently no more faithful to original texts than were the great scroll paintings. Doubtless the workshops that produced *emakimono* were also responsible for *otogizōshi*, and the differences between the two genres have more to do with when they were painted than with who painted them. The scrolls classified as *otogizōshi* are later than the masterworks of the Heian and Kamakura periods, and it is natural that in them the craft of the narrator had been somewhat modified as he became more of a technician and less of a creator. But in one respect there was no change: the same mistakes and liberties were taken with the text, and the story as it was told was entirely subservient to the visual—and, in a sense, theatrical—demands of the illustrations.

Otogizōshi artists became increasingly concerned with clarifying everything in their stories. Names of characters and places, little explanatory notes for an unfolding scene that might be difficult to follow—all of these were placed right in the middle of

124 BAN DAINAGON EKOTOBA (STORY OF BAN DAINA-
GON)
Detail of handscroll.
Color on paper, entire height 31.5 cm.
Late Heian Period, late 12th century.
Private collection, Tokyo

125 GENJI MONOGATARI EMAKI (TALES OF GENJI)
Detail of handscroll.
Color on paper, entire height 22 cm.
Kamakura Period, 12th century.
Gotō Art Museum, Tokyo

126 NEZAME MONOGATARI EMAKI (NEZAME TALES)
Detail of handscroll (Chapter 2).
Color and gold foil on paper, 25.8 × 508.1 cm.
Heian Period, second half of 12th century.
Yamato Bunkakan, Nara

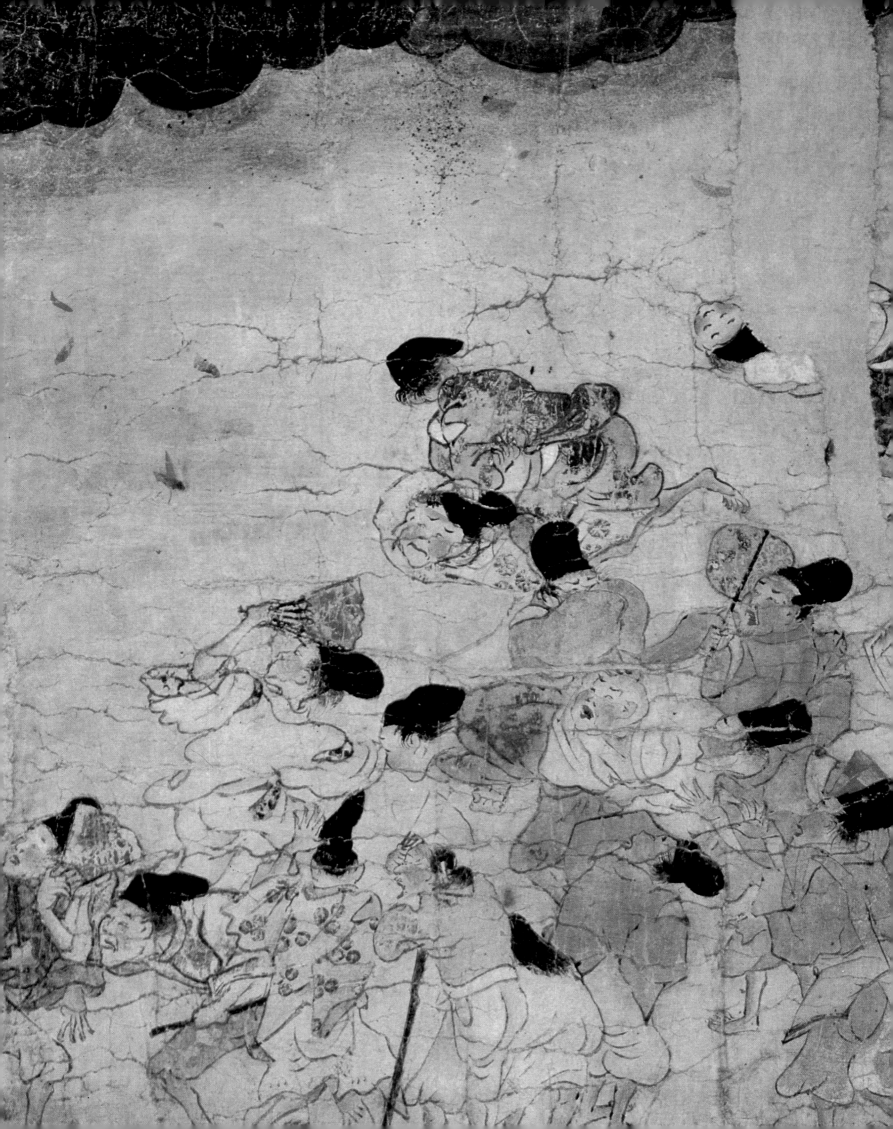

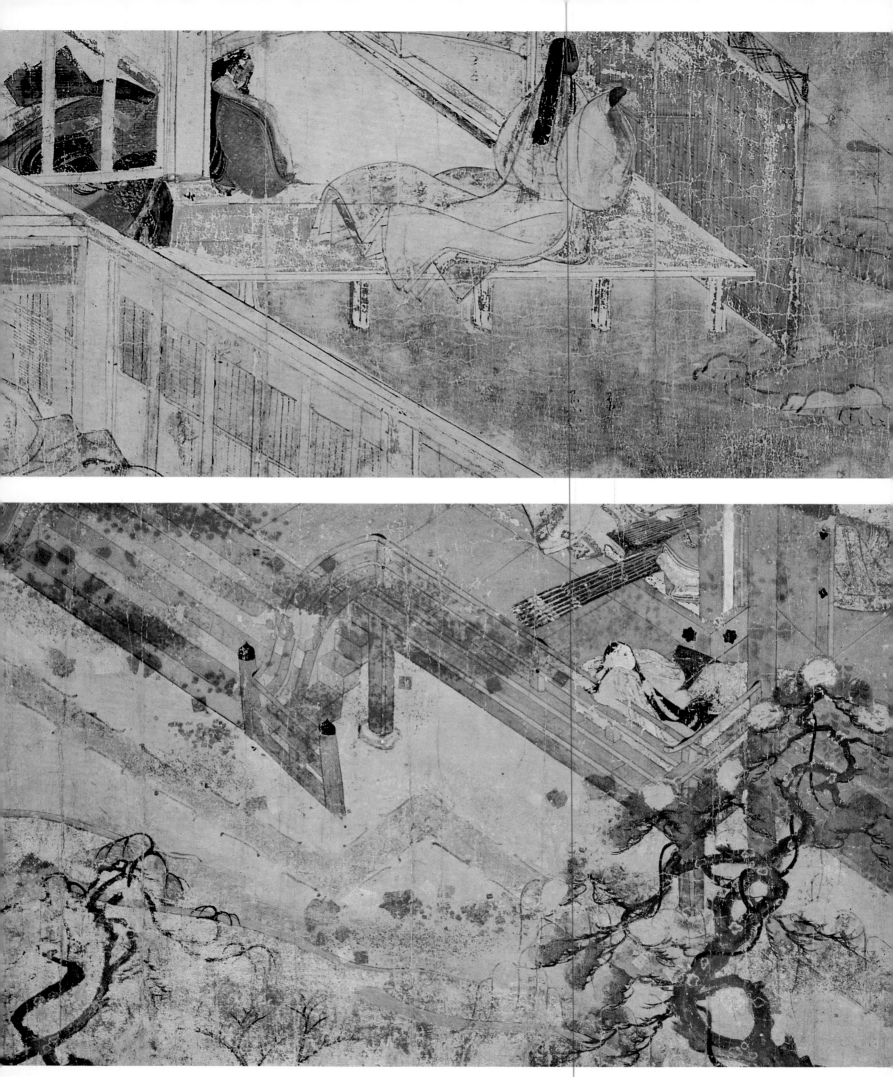

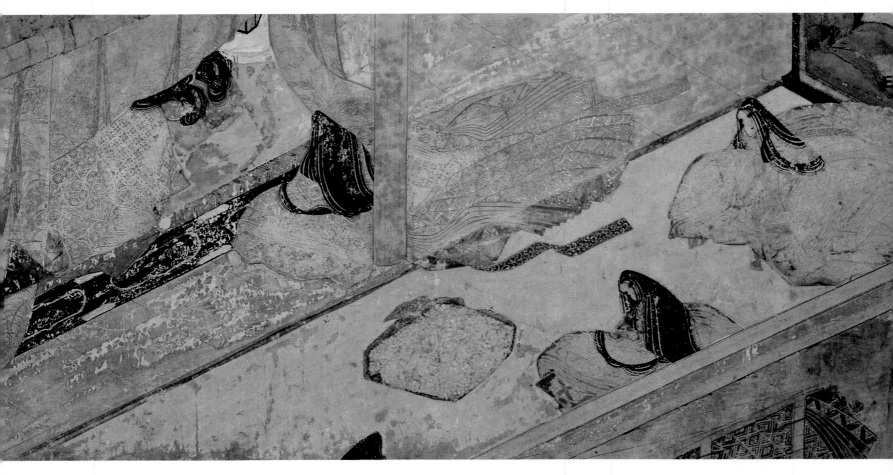

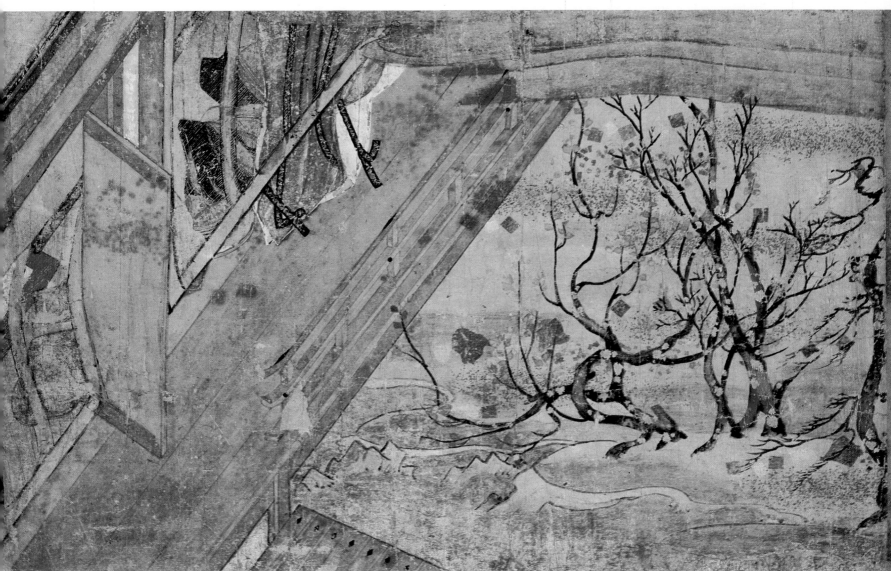

127, 128

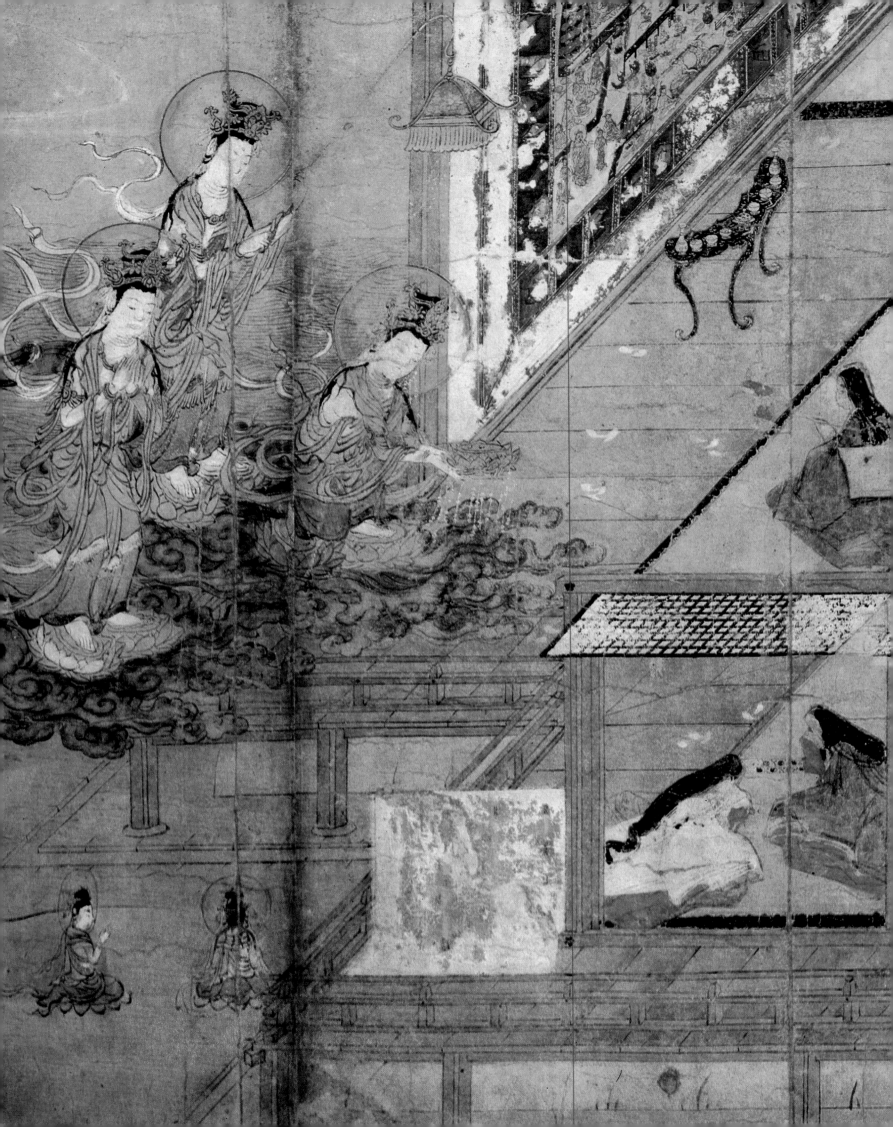

127 MURASAKI SHIKIBU NIKKI E KOTOBA
(DIARY OF LADY MURASAKI SHIKIBU)
Detail of handscroll.
Color on paper, entire height 22 cm.
Kamakura Period, 13th century.
Fujita Art Museum, Ōsaka

128 NEZAME MONOGATARI EMAKI (NEZAME TALES)
Detail of handscroll (Chapter 3).
Color and gold foil on paper, 25.8 × 508.1 cm.
Heian Period, second half of 12th century.
Yamato Bunkakan, Nara

129 TAIMA MANDARA ENGI
(LEGENDS OF THE TAIMA MANDARA)
Detail of handscroll.
Color on paper, entire height 48.8 cm.
Kamakura Period, 13th century.
Kōomyōji, Kamakura

a painting, often within swirling clouds that irresistibly bring to our mind the balloons of comic strips. Compared with "classic" scroll paintings, *otogizōshi* were insistent, indeed emphatic, about establishing the timeliness of people, places, and events.

DURING the Muromachi period and especially toward its end, this type of illustrated story became either relatively small in size, or larger, having to be folded and bound in book form instead of being rolled.

In these so-called *Nara ebon* (literally, "Nara picture-book") the pictures and text were thoroughly mingled. The characters begin to look more like oversized puppets: though depicted in poses that are less than dynamic, they have something of the caricature about them that has a comical vitality. The *Nara ebon* illustrators are anonymous, plebeian offshoots of the aristocratic *Yamato-e* school. The little world of their pictures does not always display the superbly balanced sense of composition of the classic scroll paintings; the colors, although arranged with unerring taste, are often violent; the scenes seem rather cluttered, for the text and all the explanatory notes tend to fill up whatever empty space there is; and a tendency toward bombast often leads the painter to overburden every scene with details, most of them patently comical. But let us enjoy the *Nara ebon* for what they are, not dwell on what they are not. For long they were dismissed as no more than nursery tales, but the modern trend toward synthesizing all aspects of art has given them their due. They provide a priceless key to understanding the society underlying 20th-century Japan, and from an artistic standpoint, both *otogizōshi* and *Nara ebon* help us identify those aspects of traditional scroll painting that had become matters of formula. And as we look at their often violent colors and invariably teeming crowds, we appreciate still more the unsurpassed balance of those celebrated scrolls that are the pride of Japanese art and undoubtedly one of its supreme contributions to world art.

EMAKIMONO painters watered down their literary themes until they were nothing more than pretexts, sparks that had little to do with the dazzling creations that originally inspired them. But in general, the Japanese showed throughout their history as much passion for literary illustration as for literature itself.

For Japanese literature, with its richer store of action and intense emotion than of intellectual elements, was particularly well suited to inspiring literary illustration. During the Tokugawa period (17th–19th centuries), when books came into their own, the illustrations were considered so important that those editions of text alone are often virtually meaningless. The illustrations may look like comic strips before their time, but they follow in the tradition of the scroll paintings: for was not *The Tale of Genji* itself displayed before an audience? The breach between text and picture did not appear until later to be more than an inadvertent slippage.

So influential were pictures that they affected the narration itself. Often the narrator, fearful that the plot might become bogged in descriptive sentences, left the

job of description to the illustrator and limited himself to "action" language: settings, physical appearance of characters, and clothing were left to the illustrator's imagination. The Japanese had returned to the old dictum of Chinese *literati*, from Wang Wei (699–759) to Su Tung-p'o (Su Shih: 1036–1101): "Let painting express that which cannot be sufficiently expressed through poetry, and vice versa."

No writer better illustrates the integration of words and pictures in Japanese books than Ihara Saikaku (1642–1693), who set the fashion for literary *ukiyo-e* by illustrating with woodcuts a number of his own works, including *Kōshoku Ichidai Otoko* (1682), *Shoen Ōkagami* (1684), and *Saikaku Shokoku Banashi* (1685). His success was so meteoric that in 1684, only two years after his first book had come out, an Edo publisher released a pirated edition of *Kōshoku Ichidai Otoko* with illustrations by no less an artist than Hishikawa Moronobu (d. 1694). A new genre had come into its own.

Two years later, in 1686, Moronobu brought out another edition in which the pictures and decorations had gained supremacy: the text, pared down, was now confined to the top of the page. Furthermore, the same kind of gap that had opened up between the *emaki* and its pictorial counterpart appeared once again. Even Kyoto illustrators such as Yoshida Hambei (fl. 1660–1692)—whose ties with Saikaku's town should have aroused caution in tampering with the texts—sometimes got carried away as they illustrated "classical" themes with inoffensive, comical genre scenes whose connection with the plot, if any, often seemed tenuous at best. Hambei, despite his fame as a matchless *ukiyo-e* artist, did strive for a sense of balance, never attempting to outshine the novelist by his facile renderings. The result is an agreeable blend that shows both artist and author to advantage. Certain other illustrators unhesitatingly subdivided the page into static cartoon-like insets that had none of the unity of the great scroll paintings (figs. 125–35, 333–81).

130 SHIGISAN ENGI EMAKI (LEGENDS OF MT. SHIGI)
Detail of handscroll.
Color on paper, entire height 31.5 cm.
Kamakura Period, second half of 12th century.
Chōgosonji, Nara

131 HŌNEN SHŌNIN EDEN
(PICTORIAL BIOGRAPHY OF PRIEST HŌNEN)
Detail of handscroll.
Color on paper, entire height 32.7 cm.
Kamakura Period, 1307–1317.
Chion-in Treasure House, Kyoto

132 ZUISHIN TEIKI EMAKI
(REVELS OF THE MOUNTED GUARD)
Detail of handscroll.
Slight color on paper, entire height 29 cm.
Kamakura Period, 1247.
Ōkura Museum, Tokyo

133 MŌKO SHŪRAI EKOTOBA
(PICTORIAL RECORD OF THE MONGOL INVASION)
Detail of handscroll.
Color on paper, entire height 39 cm.
Kamakura Period, c. 1293.
Imperial Household Collection, Tokyo

134 MŌKO SHŪRAI EKOTOBA
(PICTORIAL RECORD OF THE MONGOL INVASION)
Detail of handscroll.
Color on paper, entire height 39 cm.
Kamakura Period, c. 1293.
Imperial Household Collection, Tokyo

135 KITANO TENJIN ENGI
(LIFE AND DEATH OF SUGAWARA-NO-MICHIZANE)
Detail of one of eight handscrolls recounting the
life of Sugawara-no-Michizane (845–904) and his
ordeals in the six Buddhist hells after death.
Color on paper, entire height 52 cm.
Kamakura Period, 13th century.
Kitano Temmangū Treasure House, Kyoto

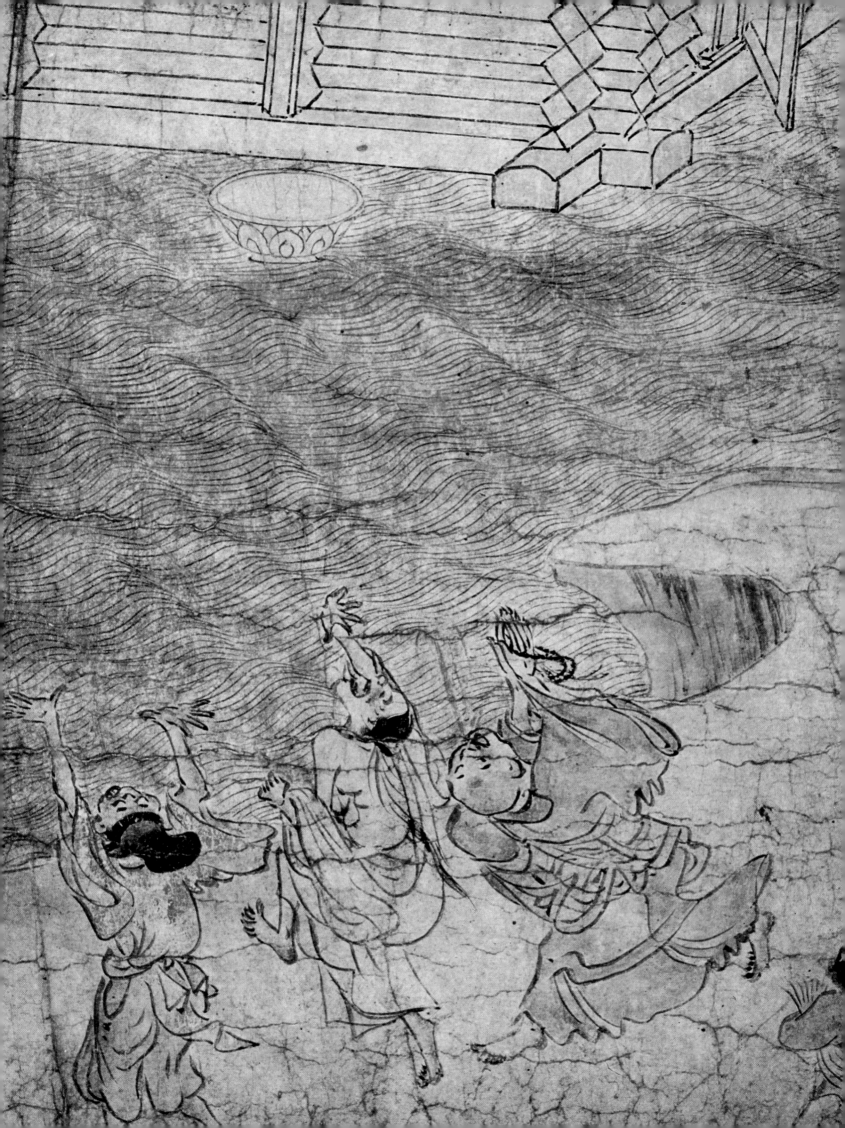

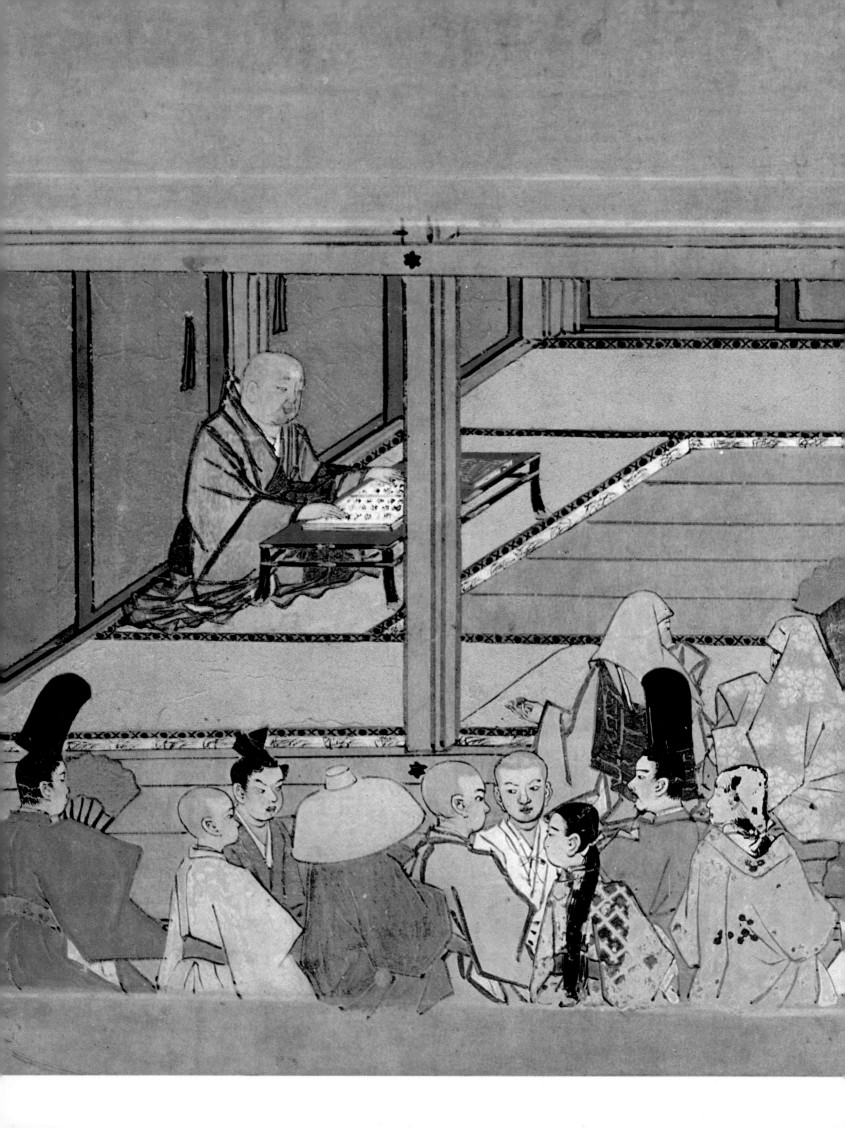

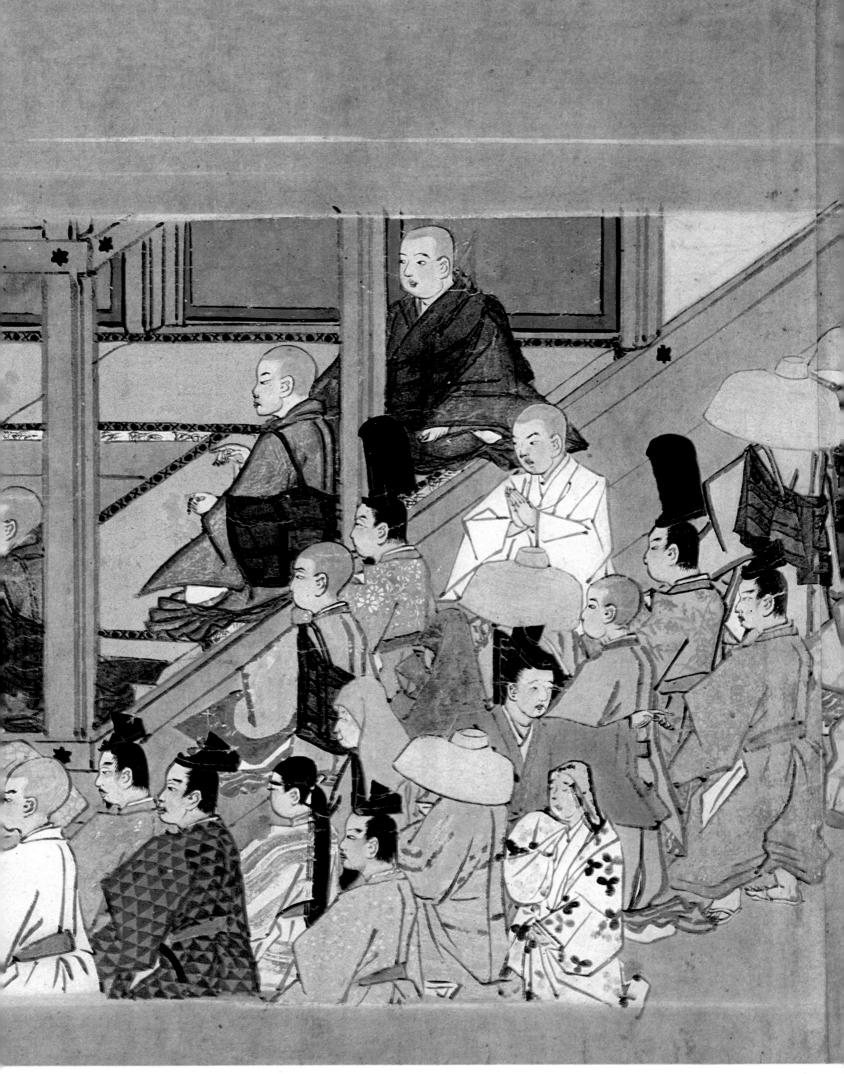

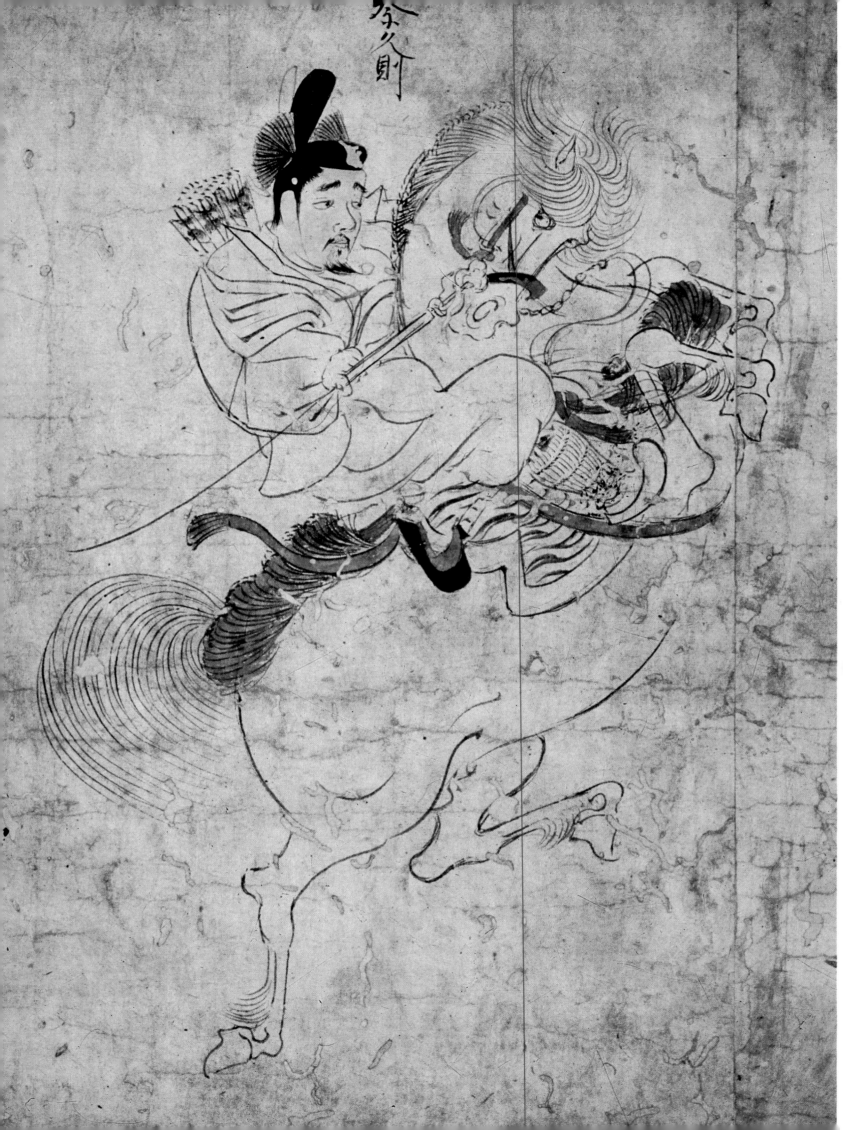

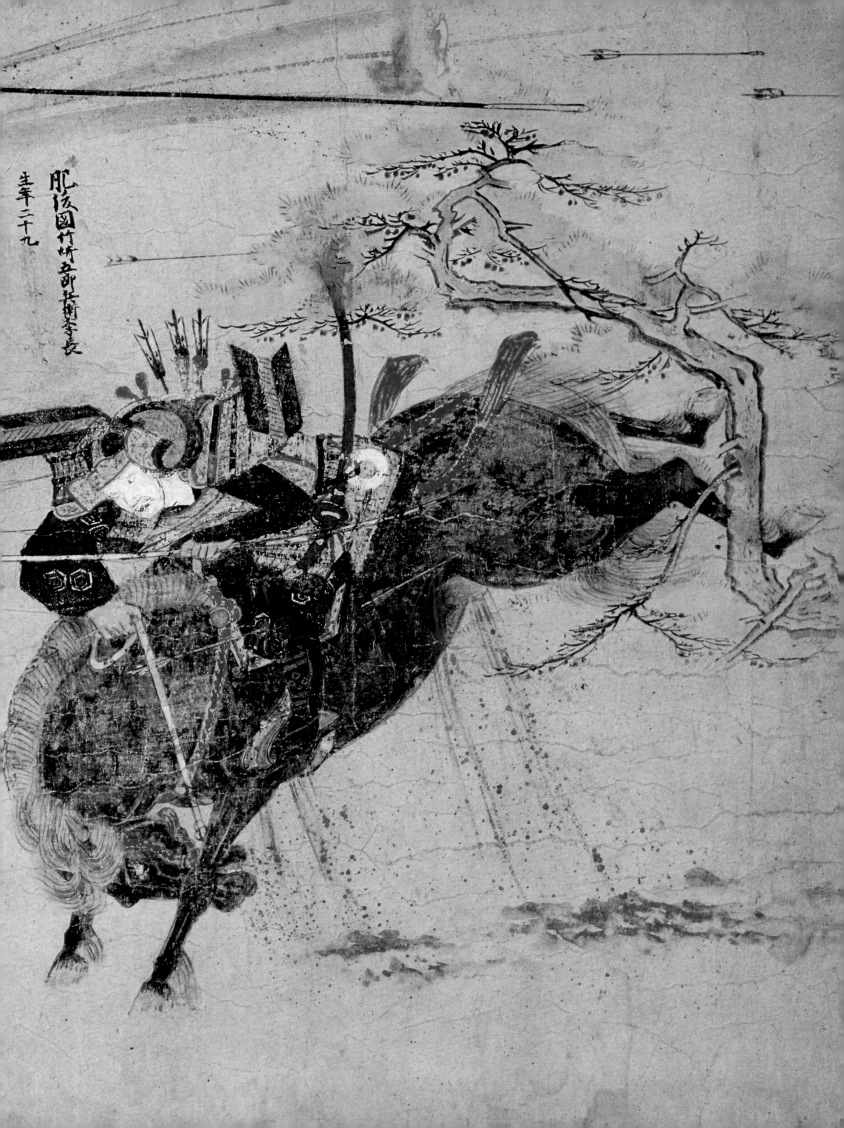

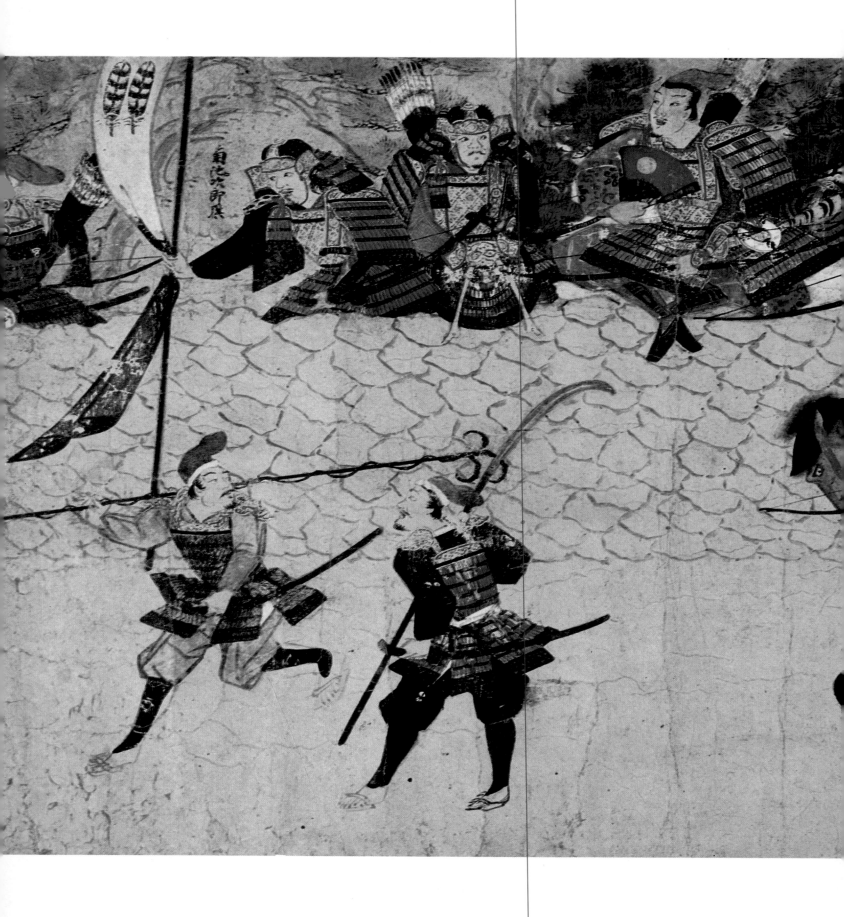

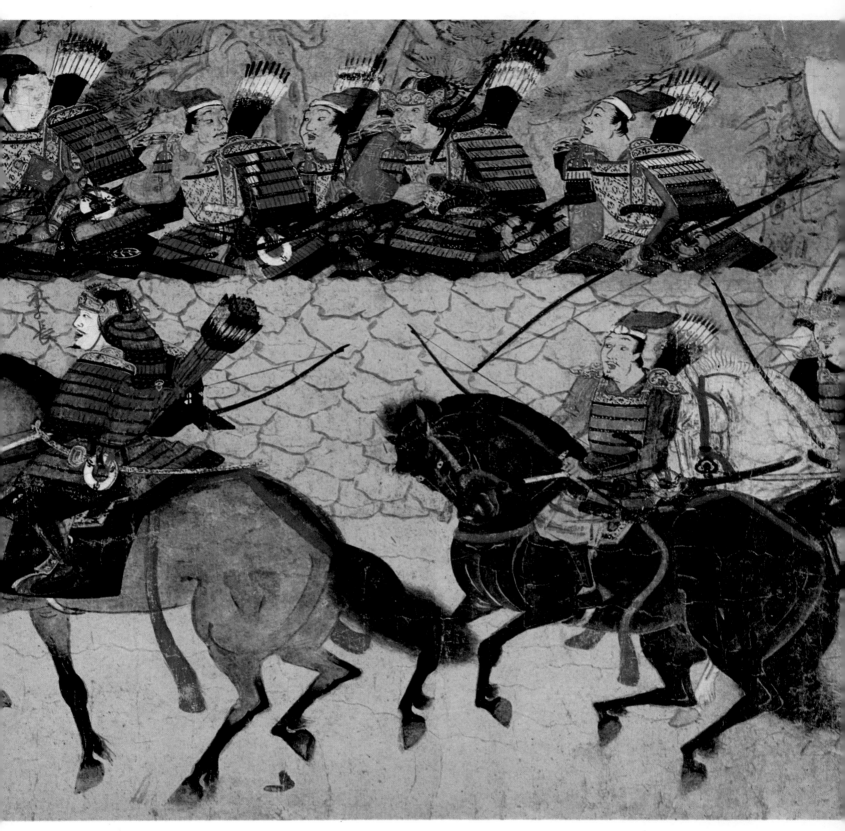

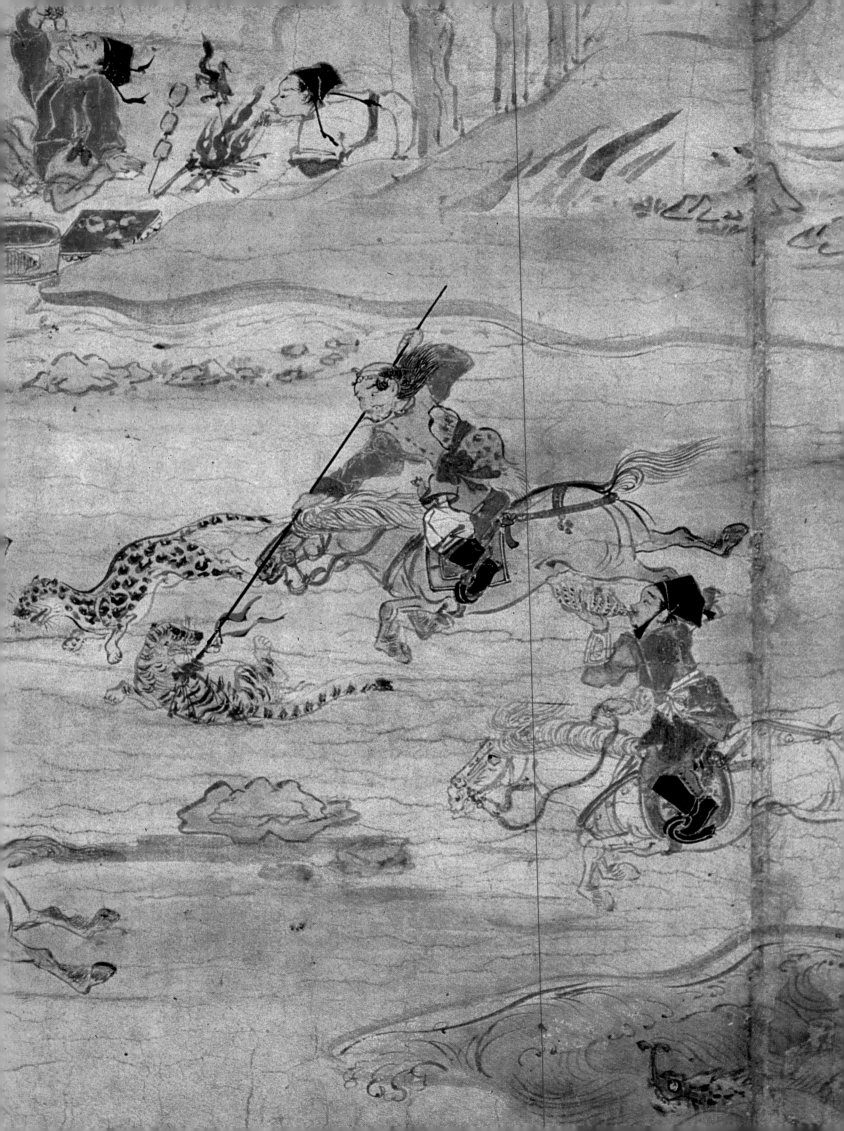

7. JAPAN AND THE WORLD OUTSIDE

7. JAPAN AND THE WORLD OUTSIDE

Ideas and Discoveries in the Far East

IT is widely acknowledged that to understand the art of a country, the conceptual framework that is nourished and expressed by that art must also be understood. Yet there seems to be a less than general awareness of the cosmopolitan threads that were woven into the rich tapestry of Japanese creativity. The archipelago was never as proudly isolated as its propaganda-minded leaders would have liked the world to believe. Archaeologists are continually unearthing new evidence that outside influences had a large part in Japan's cultural development, and indeed, the existence of such influences had been impressed upon the Japanese themselves since early in their history. Whether it was due to their exposure to the imaginary cosmogonies based on foreign myths (especially from China) or to philosophies from other lands (such as Buddhism), their belief that the world around them consisted of three regions—China, India, and Japan itself—dates back to the advent of Chinese-style government in the 7th century.

Before that, the Japanese saw the outside world as a "foreign land," ill-defined and embracing anything that was not Japanese. "Out there" was finally named when the Japanese sphere of influence was extended to Mimana, a 4th-century kingdom on the Korean peninsula then still called Kara. As ties between these two lands strengthened on either side of the Sea of Japan, Kara came to represent everything beyond the archipelago, an "overseas" that reflected the persistent Japanese concept of the world as an essentially two-part structure. And then the vast continent of China appeared on the horizon, to be called, too, by the all-purpose name of "Kara." When the splendors of the Tang dynasty (618–907) bedazzled the archipelago, China in turn became for the Japanese the "foreign land" *par excellence*, wellspring of wisdom and progress; people began to use "kara" to pronounce the Chinese character for "Tang," and ultimately Kara came to be exclusively the word for China as the islanders sorted out their idea of world geography. At the same time, the introduction of Buddhism brought another country into the scheme of things: Buddha's native land of India was known as Tenjiku, derived from the Chinese-language equivalent (Shendu) of an Indian place name.

The early Japanese world view underwent significant change as Buddhist beliefs—first in the four continents of Sumeru Paruvata, then in the countless worlds

promulgated by esoteric sects—overspread the archipelago. What had been the relatively uncomplicated native cosmogony (later known as Shinto) dissolved into a swirl of atoms.

The world was seen as four great continents situated at the cardinal points, and Japan took up the continent to the south known as Nantan Bushu. At the center of these four land masses lay seven craters that overlapped like a nest of bowls. These, in turn, enclosed eight seas, and the sky burst forth from the central sea like the petal of a golden lotus blossom. But there was a good deal more to creation than this one complex of lands and seas. A thousand of them were thought to make up what the Buddhists called a "little world"; a thousand "little worlds" made up a "middle world," and a thousand "middle worlds," a "large world." However strange or specious in practice, the Buddhist cosmogony with its plurality of possible worlds, unlike other major philosophical systems, demonstrated a very modern approach to the concept of infinity. This concept was often overshadowed on the mainland by the pre-Buddhist belief that China constituted a focal point of the universe, a "Middle Kingdom" (Zhongguo); this self-image was not unjustified, for until the 17th century China, notwithstanding its long, tumultuous, and tragic history, remained the hub of civilizing influence among a collection of peoples at different and, in some cases, less advanced stages of material and intellectual development.

The Japanese, however, fully aware that much of their own culture was inherited from China by way of Korea or the lower Yangtze River, or from India by way of China, worked out an evolving world view that blended the stories related by Japanese travelers with certain elements of native mythology—elements which, until recently, had been merely vague. The most striking artistic evidence of the belief in this "pluralistic" Buddhist creation appears, as we have seen, on the lotus petals of the renowned Great Buddha of Tōdaiji (fig. 212).

This outlook was based on metaphysical reasoning that nurtured keen intellectual curiosity. The oldest known Japanese bibliography, the *Honchō Shoseki Mokuroku* ("Index of National Books"), mentions a work entitled *Treatise on Lands Overseas* (*Kaigai Kokki*), which by 733 had grown to some forty volumes. During the century and a half before 894, when Sugawara-no-Michizane's isolationist police went into effect, there seemed no end to the Japanese appetite for Chinese treatises on geography or works by writers such as Yijing (635–713), whose travel books appear in the *Nihon Genzaisho Mokuroku* ("Index of Current Japanese Books"), a bibliography compiled by Fujiwara-no-Sukeyo (d. 898).

Nor did the Japanese lack knowledge of the men these books described. Many were Chinese, of course; but others were a Brahmin who presided over the dedication of Tōdaiji; an Annamese priest who introduced certain musical forms indigenous to his native land; a physician from Sumatra; disciples of the Chinese monk, Ganjin, including, the texts say, a "Westerner" (exact origin unknown), an Indonesian, and some person from Champa. It was this same Ganjin who, in 753, brought to Japan a copy of

Xuan-Zang's *Voyage of the Mighty Tang to the West*, a narrative that enjoyed remarkable and lasting success in the archipelago.

Sojourns to China for political or religious reasons coincided with the growing popularity of pilgrimages to India. The first Japanese to reach India is believed to have been Kongo-Zanmai, who visited the holy sites of Buddhism and returned to China in 818. Encouraged by Chinese travel books, the Japanese of the Heian (9th–12th centuries) and early Kamakura periods (13th–14th centuries) were all the more eager to make pilgrimages because, according to Buddhist belief, creation was undergoing a period of decline (*mappō*) that would usher in a new cycle once the known world had come to an end: in a climate of anxiety, pilgrimage seemed the only possible road to salvation.

As physical conditions of travel improved, the mystical attraction of holy sites played a decisive role in opening Japan to the world. This emotional impetus accounts for certain cultural interactions that would remain puzzling if evaluated solely in terms of official policy at the time. How else are we to explain the development and flourishing of the arts in Japan despite government restrictions? To take an obvious example, the Japanese evidently did not wait until the Kamakura period to discover Song China: well before Minamoto-no-Yorimoto (1147–1199) took over the reins of power, a number of monks had already journeyed to the mainland (first and most renowned of these was Chōnen of Tōdaiji, who died in 1016). Even if these travelers went for purely religious reasons, they could not have been entirely unaffected by what they saw in China, and they brought back religious and other objects that gave their compatriots an idea of current mainland styles and inspired them to develop styles of their own. Monks were also responsible for the growth of "literary painting" in Japan, of which Kōben (also known as Myōe: 1173–1232) of Kōzanji was the most celebrated exponent. In addition to his pioneering work with austere ink washes, he calculated, almost to the day, how much time would be needed to retrace the route that Xuan-Zang (602–664) followed during his trip to India. Myōe's notes—collectively entitled *Kinbun Gyokujitsu Shū*, or *Jewel of the Golden Letter*—contain the following marginal note: "India is the land where the Buddha was born. I cannot quell my yearning to go there. That is why I have made these calculations. Oh, how I long to go there!" Illness prevented Myōe from carrying out his plans, but one of his friends went to China in 1217.

Contrary to the hypothesis that is sometimes advanced, Japan's isolation from the outside world was less a deliberate than a temporary repudiation prompted by specific material causes. Perhaps the most serious obstacle was the Japanese "fleet" itself.

Although Japanese craft could accommodate one hundred to one hundred and fifty passengers, they lacked until quite late in Japanese history the sturdiness of the Korean vessels they were modeled after, and rough seas spelled their immediate destruction. They were far less seaworthy than the oceangoing ships of Song China, which could carry as many as one thousand passengers and had streamlined, ballasted keels and holds with watertight compartments in the event of leaks. Japan's isolationist policy that officially prohibited all overseas travel throughout the 10th century (that is, for

a hundred years or so after Sugawara-no-Michizane) only delayed improvements in shipbuilding and stifled all maritime interest by that much.

It was a long time before the Japanese grasped the dynamics of the monsoon at sea, and they stubbornly set sail against the treacherous winds. If Chinese reports concerning Japanese "pirates" (*wako*) are to be believed, the islanders—at least those without the foresight to obtain foreign-made vessels—were still using flat-bottomed boats as late as the 15th century, while the unwieldy sails were all fastened to a single mast that would be snapped by sudden shifts in the wind. Given this situation, the closing of Japan was perhaps a safety measure as much as an outburst of parochial nationalism. But it did not prevent educated monks and laymen—aware of the world's beauty, yet confined to the archipelago—from dreaming of adventure in far-off lands. Nor was their aspiration viewed as a rebellious act against the established order, for the government had not yet imposed the blanket prohibition on "foreign culture" that went into effect during the Edo period (17th–19th centuries). In evaluating this period of Japanese art, no term such as "cultural imperialism" should be used, for that simply did not exist at the time. Let us recall that the first wave of Chinese merchants to reach Japan in 978 must have been well received, since more than a hundred such voyages were made during the Song dynasty alone (averaging about one per year). This is hardly the "closed" Heian world that some have extended well into the 1100s, though it would be just as incorrect to push the period too far back in time.

The Dazaifu on Kyūshū closely monitored and severely restricted the number of foreign ships per year and the length of their stay in Japan, and the government assumed the right to seize unloaded merchandise. In all fairness, we must say that the Chinese had been implementing the same kind of protectionist policy as early as the Tang dynasty (618–907). But the feudal structure of Japanese society provided ways of dodging the system that were not possible under China's centralized administration. Song merchants wishing to circumvent governmental seizure could negotiate directly with the heads of major monasteries or *shōen* overlords who had managed to secure certain "prerogatives." But the ships still had to lie at anchor somewhere, and thus rose the fortunes of such ports as Hakata and Hirado in northern Kyūshū, and Bōnotsu in what is now Kagoshima Prefecture.

Song China had a large influence in the life of 11th-century Japan. The arrival of Chinese ships helped to satisfy the craving of priests for books and of feudal lords for rare and luxurious objects, but it also gave rise to a complex economic superstructure based on foreign trade through Japanese ports. Those who earned their living from it tried, in turn, to increase their profits, and so began the first modest, but steady exchanges as the Japanese fleet improved. However, the ships still did not inspire confidence, and for a long time Japanese merchants preferred to travel to the mainland by way of Korea. Direct trade with China did not start to surge until the 13th century, when Japanese seamen had learned to maneuver their craft across the China Sea without undergoing too much damage.

The doubtful seaworthiness of Japanese ships dampened the enthusiasm of investors and prospective travelers, but it did not inhibit the imaginations of those confined to the archipelago, who continued to be keenly interested in what was happening beyond their island home. True, they had their fair share of stories either wildly exaggerated—such as those reported in *Konjaku Monogatori*, or *Stories Saved from the Past* (12th century)—or entirely inspiring; such tales provided their readers with inexhaustible stores of reverie, and an awareness, however dormant or vague, that their concept of the world might be subject to change.

First Meetings with the Far West

THE Japanese also knew that groups of people lived in places beyond China (Kara) and India (Tenjiku). The Chinese, for their part, named these populations according to the cardinal points, but their customary disdain for anything not Chinese tinged these names with unfavorable connotations: the Dongyi, it was believed, lived to the east; the Xirong, to the west; the Beidi, to the north; and the Nam-Man, to the south. Consequently, the Japanese designated "Nam-Man" (*namban* in Sino-Japanese) all travelers who came to Japan from the south, regardless of their homeland, and the Portuguese put ashore in the 16th century on the southern coast of Kyūshū. But the foreigners brought along seacharts that were to correct the myopia of their hosts, and these maps were copied and mounted onto screens as early as 1570–80 (fig. 453). For the first time, the Japanese were able to pinpoint their true position on the globe, and doubtless it then struck them that they were part of a "Far East." Moreover, as blonder English and Dutch visitors followed the swarthy, tanned Portuguese, the local population learned to tell one kind of foreigner from another, and it became customary to refer to the Dutch as *komo*, or "the redheads." Both *namban* and *komo* were descriptive terms, with no pejorative overtones.

As it had been for Europe in the east and west directions, Japan's discovery of the "Far West" revolutionized its ideas concerning the earth's size and configuration. Yet, except for a small number of new converts to Christianity, this awakening seems to have triggered no nationwide crisis of consciousness. After all, since ancient times, Japan had known that it was but an island flung into a vast sea. Probably no people were less inclined to see themselves as the center of the world.

THE only concrete evidence that art enthusiasts have of Japan's first encounter with Europeans are the picturesque characters and the motley, comical scenes depicted on *namban byōbu*, those dazzlingly decorative "Portuguese screens" which today enjoy deserved popularity on the international art market (figs. 136–41, 435–46). Historians of art are examining these works to understand more fully the intriguing encounter that

took place in Japan during the second half of the 16th and first half of the 17th century.

Key elements of Western art were abruptly introduced into Japan just as the archipelago was undergoing the profound changes that would produce the constricted and untroubled society of the Edo period. In 1583, when the Kanō were fusing into a new style the highly colored *Yamato-e* art and Southern Song ink painting, an Italian Jesuit painter named Giovanni Niccolo (c. 1558–1626) landed in Japan. A few years later, in 1590 (the year the first mission to Rome returned to Japan), a school of Western-style painting was founded at Hachirao: a missionary undertaking prompted by the veritable craze for European art triggered by the many gifts that travelers were bringing back. The following year, 1591, Jesuit priests pulled from a printing press the first copperplate engravings ever seen in Japan. Oil painting, the engraver's burin, the use of nitric acid—these innovations proved in the long run as decisive for Japanese civilization as those famous cannons on the first Portuguese ships to put in at Tanegashima around 1543.

So-called Namban art has a double significance for it reflects the Japanese interpretation of two different, but equally unprecedented factors. On the one hand, it expressed in the traditional idiom the islanders' sense of astonishment at the impressive size and maneuverability of those towering Portuguese ships—an astonishment mixed with a benign mirth upon seeing the motley garb of the long-nosed foreigners. On the other hand, the Japanese discovered materials and techniques that were new to Far Eastern painting: how to thin oil pigments, how to use a printing press, how to produce copperplate engravings.

Technical considerations aside, Namban works belong to two main categories: those that reveal Japanese reactions to the newcomers, and those directly inspired by, and produced for, the dissemination of the new religion. It would be wrong to dismiss the latter as "minor" works, for they conveyed a well-defined set of religious themes from the West, and an entirely new way of perceiving and representing pictorial space. And when Francis Xavier (1506–1552) and the other Jesuit fathers landed at Kagoshima in 1549 and showed the Japanese a group of paintings illustrating the Catholic faith, it was the first demonstration of Western art in the Far East on a broad and "official" basis. (The evangelistically oriented school of painting at Goa, in western India, had not then been founded.)

The examples of Western art first seen by the Japanese—an artistic people if ever there was one—were, so to speak, imported directly from Europe; they were fresh, unadulterated, and not yet adapted to (or betrayed by) the needs of local preachers. Indeed, the baggage of the future St. Francis Xavier included two works painted in the Flemish style then popular in Portugal: one was a portrait of the Virgin, the other, a *Virgin and Child*. The *daimyō* Shimazu Takahisa (1514–1571) and his mother found these pictures so remarkable that the latter requested that copies of them be made (fig. 456). In a way, it was the dawn of a new art form. The Franciscans, in their turn, did their utmost to furnish their churches with suitable images: the Franciscan church in Kyoto boasted a *St. Francis of Assisi*.

Christianity is known to have had rapid success in Japan during those first years

of preaching. The new converts naturally included a certain number of painters, who immediately channeled their energies into creating works consistent with the spiritual training they were receiving. They endeavored to assimilate what European painting had to offer with the same, abiding thirst for knowledge that has motivated the Japanese at all turning points in their history, whether adopting the Chinese system of government, assimilating Buddhism, or bringing about the artistic, technical, and intellectual rebirth of the Meiji period in 1868.

By the 1580s, the missionaries had sensed the importance of the aesthetic factor in Japan and continually sent to Rome for paintings or prints of good quality, worthy of catching the eye of this highly civilized people. Japan was one of the few missionary fields in the Far East where the priests were impressed with the artistic style then favored by prominent feudal lords: the Kanō manner. In China it was a different story; there neither side had any understanding of the other's art, though a few religious illustrators tried to paint in a composite style to ingratiate themselves with the emperor.

WHEN the young Italian missionary and painter Giovanni Niccolo arrived in 1583, he brought an unexpected impetus to Christian art in Japan. Seemingly a relatively unprolific artist himself, his only surviving works are a painting in Macao, a *Trinity* (attributed) in the Ueno Royal Museum in Tokyo, and a few paintings for the churches of Nagasaki and Arima; perhaps other, more significant works were destroyed during later persecutions. He is also known to have hand-painted religious engravings in oils. After completing his ministry in China, he died at Macao in 1626. A book published in Macao in that year hailed Niccolo as a man of the Gospel and a "Renaissance man" who had taught painting and clockmaking to his Chinese and Japanese pupils in addition to religious values. Furthermore, we know that someone taught at the school of Western painting founded in 1590 at Hachirao, on the Shimabara peninsula, but only that he sparked great enthusiasm among his Japanese students: that teacher may have been Giovanni Niccolo.

Engraving was another form of artistic expression that grew out of missionary work in Japan. In theory there was nothing unheard-of about this technique, for woodcuts had been used to print Buddhist images in temples as early as the 8th century. Originally intended to act as aids to meditation, the images quickly became the equivalent of prayers to the blessed or to the deity represented, and hence a talisman. During the Heian period (9th–12th centuries), leading members of the laity possessed small carved plates—a sort of rubber stamp—and obtained merits or indulgences by printing as many sacred images as their religious fervor supported, each figure possessing invocatory power as well as symbolic meaning (figs. 296–307). By the Kamakura period, printed Buddhist images were so numerous that even the poor could buy a few at the temple for a small sum and take home religious images of their own (figs. 311–14).

The breadth of the dissemination of Buddhist prints has only recently been brought to light by archaeologists, and it helps to explain the relatively high number of engravings and illustrated catechisms that Christian priests published in Japan, con-

sidering that their mission lasted less than one hundred years. The prints that are being discovered inside of statues are also compelling evidence: some of these are entirely European in style, others, such as the intriguing oil-painted engraving in the Nakatani Gennosuke collection, are already thoroughly "Japanized." The artist of this sizable work (32.5 by 85.6 cm.) changed the original Christian subject almost beyond recognition: a Japanese mother is wrapped in a sumptuous kimono, its folds awkwardly drawn, and before her are traveling shoes and a walking-stick; she offers a flaccid breast to a tiny child. The disheveled clothing and the tragic expression on the mother's face as she gazes intently toward the right suggest that this is a Japanese interpretation of the Flight into Egypt (*The Kokka*, 751, 1954, p. 310).

IF the idea of religious teaching through pictures came as no surprise to the Japanese, the same cannot be said of the printing presses and copperplate engravings that were now replacing the time-honored woodcut and simple stamp. Alessandro Valignano was the person responsible for this technical upheaval (first visit to Japan, 1579–82; second, 1589–90); late in 1590, he set up a printing press on the Arima estate at Morutsu, in Kyūshū. Here not only religious pictures were printed, but bird's-eye views and descriptions of the great cities of Christendom—maps and plans that were later to inspire Japanese screen painters (figs. 447–50, 453–54). Whether it was through the initiative of Giovanni Niccolo or of his students or youthful catechists, a school of Western-style painting and drawing began to form in Japan as the year 1590 drew to a close.

There is also documentary evidence that by 1593, a number of students were attending classes in painting and engraving at the missionary school in Hachirao. Enrollment lists from that year indicate that eight pupils studied watercolor; eight, oil painting; and five, copperplate engraving. In all likelihood, the return from Rome of the first Japanese mission in 1590—they had set out in 1582—meant that the school of painting had access to the European paintings the Japanese envoys had brought back with them. These works were copied so faithfully that it is still sometimes difficult to distinguish Japanese copies from Italian originals. It is at last recognized today that certain works of Namban art that are not directly related to either the Italian or Japanese schools were copies of paintings originating in the Mexican missions, of which the Jesuit fathers exported a large part of the production.

None of these efforts, however, has ever been discussed outside of the narrow framework of "missionary activity." The sense of national consciousness, coupled with Japan's official rejection of the West beginning in the first half of the 17th century, has unjustly overshadowed both the long- and short-term effects of this first contact with Europe.

The important changes in strategy and military architecture brought about by the introduction of firearms are freely acknowledged, but often nothing is said about the seeds of artistic rebirth sown by the appearance of Western painting in Japan.

European art arrived just when court painting had fallen into a spiritless repetition of processes perfected during the captivating Fujiwara period. Social upheaval,

136 NAMBAN BYŌBU: THE PORTUGUESE LANDING
AT NAGASAKI
Detail of six-fold screen (see also figs. 138, 139).
Color on paper, entire screen 95 × 280 cm.
Momoyama Period, late 16th–early 17th century.
Namban Bunkakan, Ōsaka

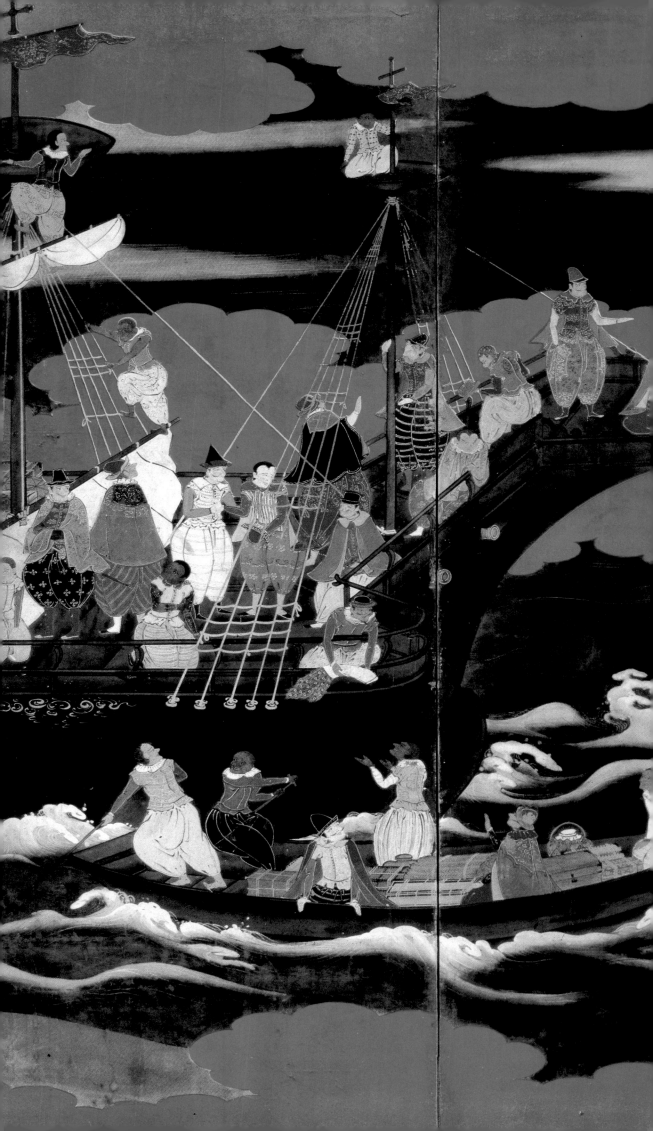

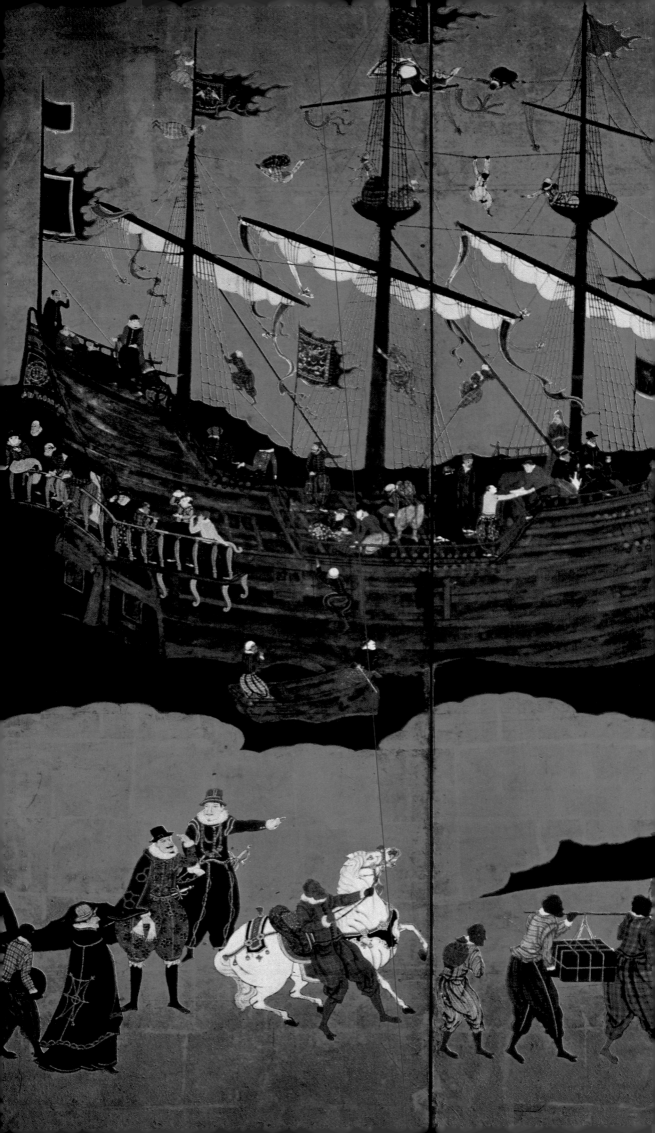

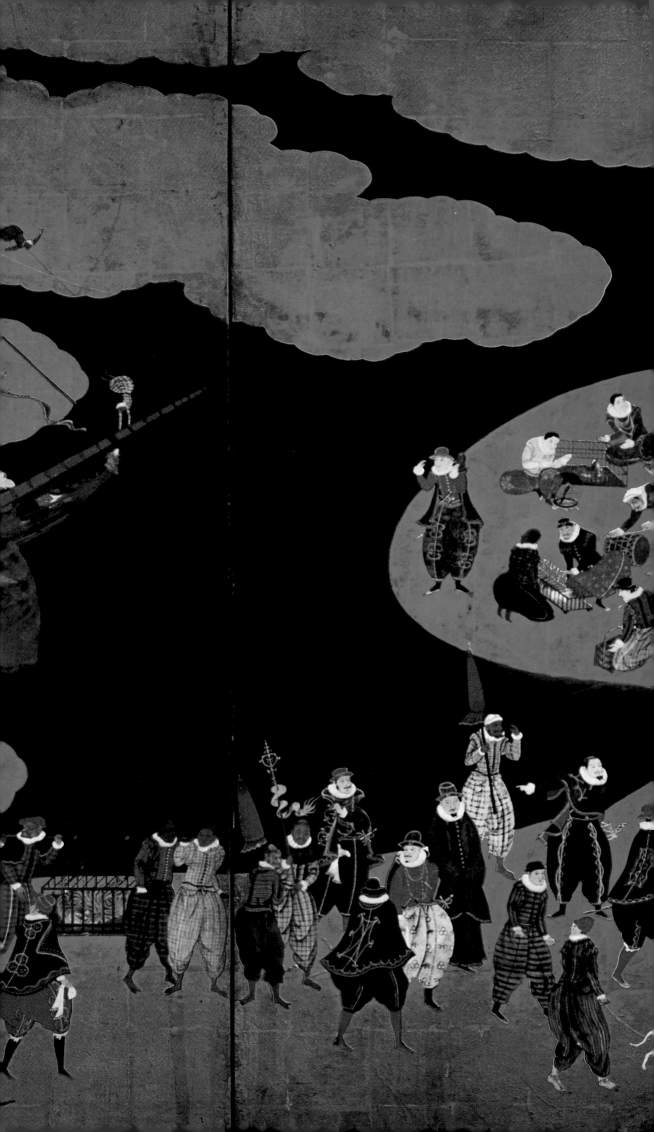

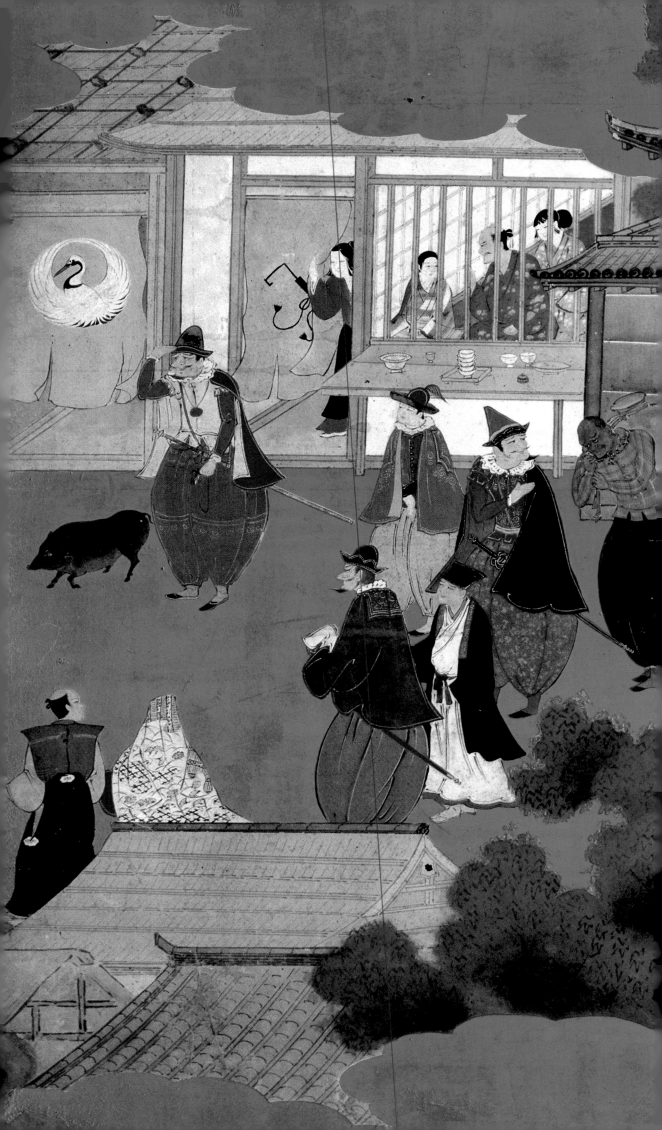

137 LANDNG OF THE PORTUGUESE
By Kanō Naizen (Kanō Shigesato, 1570–1616).
Detail of six-fold screen.
Color on paper, entire screen 1.6 × 3.6 m.
Muromachi Period, second half of 16th century.
Kōbe Municipal Museum of Namban Art

138 NAMBAN BYŌBU: THE PORTUGUESE LANDING
AT NAGASAKI
Detail of six-fold screen (see also figs. 136, 139).
Color on paper, entire screen 95 × 280 cm.
Momoyama Period, late 16th–early 17th century.
Namban Bunkakan, Ōsaka

coupled with the construction of feudal castles for knights whose penchant for authority was matched only by their love of ostentation, favored the growth of brilliant paintings in which the subjects so dear to earlier artists gradually gave way to austere, Chinese-style ink landscapes or to the picturesque scenes in which Namban art abounds (figs. 451, 452). These scenes unquestionably played a crucial role, for their appearance coincided with the full development of genre painting, favored by the rising fortunes of the new class of patrons, the wealthy merchants.

Thus something of Namban art slides unobtrusively into the style espoused by the Kanō school. Kanō Eitoku's famous *Rakuchū Rakugai* screens present a lively account of the arrival of the Portuguese at Kyoto, as well as a series of screens in the *Yamato-e* style depicting galleons, priests in long, black robes, Portuguese in baggy trousers, and scenes of Christian worship, all rendered in exuberant colors and framed by the typical gold and silver clouds of screen paintings. The far-flung missions of Jesuit priests to China and India also brought picturesque elements that the Japanese prized for their exotic flavor: little-known animals, such as elephants; palm trees and other tropical plants; the almost gaudy colors of buildings in southern China and Goa (figs. 136–41, 435–46).

Decorative objects—lacquer inlaid with mother-of-pearl or precious metals—and ceramic pieces borrowed ornamental motifs from Christian iconography: the most popular was the cross, usually assimilated, like most foreign motifs, into the native manner rather than instigating a newly created form. But in the long run they did act as catalysts, prompting intellectual more than artistic reactions. The training that the Japanese received at Hachirao bore fruit, for without it our understanding of Japanese painting during the 18th and 19th centuries would have significant gaps; ultimately, art generated a cultural exchange that ideas alone would not have brought about.

THE drama of the Christian mission in Japan, which would indelibly mark not only missionary activity in the Far East, but every aspect of relations between the archipelago and the West, quickly came to a head. The first contacts, seemingly warm and friendly, bred a euphoria which led the missionaries to believe they had won the country over to their cause, and the mercurial temperaments of despotic overlords did not seem to raise any lasting problems. Hideyoshi issued an edict in 1587 ordering the missionaries to leave the archipelago forthwith, but his ire quickly cooled, and a few months later he reversed himself completely. The expansionist policy he was planning into southern waters called for friendly ties with foreign priests and merchants, and Hideyoshi reopened the doors of Japan to outsiders; ten years later, however, another fit of anger drew blood: the decree ordering the crucifixion of the Twenty-six Martyrs of Nagasaki in 1597. Yet calm again settled over the land once more. Hideyoshi's successor, Ieyasu, did not look kindly on missionaries, but he encouraged European merchants and seamen to put in at Japanese ports.

However, all that changed in 1614. A fiat was issued condemning Christians, Japanese as well as foreign-born, to exile or banishment. What actually took place was not a "martyrdom"—though for individual Christians it amounted to that—so much

as the repudiation of a system of thought that had not been successful in penetrating the existing structure.

Had the Japanese actively sought any cultural assimilation? Probably not. As Anesaki astutely points out, St. Francis Xavier happened to step onto Japanese soil at a time when the archipelago found itself drained and demoralized by two centuries of civil wars, wars perceived as pointless for all but the antagonists directly involved. The dispirited local population was in this climate of suffering when they first heard the missionaries preach. The Christian message did not fall on deaf ears, particularly during the broad reconstruction efforts under the first dictator, Nobunaga (1534–1582). The downtrodden lower classes and the petty feudal lords who were now ruined, or those anxious to regain power in the newly troubled waters—all found the new philosophy appealing in what seemed the moral bankruptcy of their own religious heritage. Oda Nobunaga and his successor, Toyotomi Hideyoshi (1536–1598)—the latter styled himself *taikō*, or dictator, in 1592—accomplished the almost miraculous feat of restoring peace and prosperity in the relatively short space of twenty years. And the once-destitute, war-weary Japanese felt that the blessings of peace and plenty would not have materialized so quickly without the dictators. Consequently, the respect for knights, inherent in all feudal societies, fostered at this moment the cult of the leader, which for better or worse continued to overshadow Japan until 1945. The "leader" embodied the undying cultural vitality that the Japanese themselves had compromised by forgetting or failing to appreciate fully the richness of their native civilization. From then on, the Japanese no longer felt a need for foreign sources of inspiration: at the very least, such sources were now subject to the whims of Hideyoshi. In the eyes of his devoted servants, his Korean expeditions of 1592–98 not only added luster to his reputation, but revived the old Shinto concept of Japan as the "land of gods and heroes." What could a foreign god offer to a world already overflowing with divine spirits? Probably this reason underlay Japan's repudiation of the West, attributed by some to an excessive patriotism, by others to the vainglorious madness of a dictator who tried to become the object of mass religious fervor. But Japan's real resurgence stemmed from Zen Buddhism and its offer of a disciplined way of living and thinking long ingrained in Japanese society. The "new" Japanese did not seek outside himself for what he knew was to be found within him.

Lastly, these were nowhere tolerant times, either in Japan or Europe. As relentlessly as their Western counterparts, the leading feudal lords of the archipelago practiced the principle summed up as *cuius regio, eius religio* ("whoever reigns, his religion"). The Arima, Omura, and Takayama *daimyō* and others who had converted to Christianity insisted that their subjects do likewise, harassing the recalcitrant Buddhists. These compulsory conversions not only explain the rapid strides made by Christianity in certain fiefs, but account for the evidence of the decoration found on many objects. It also helps us to understand how the religious apparatus which the missionaries had established should have crumbled so precipitously once the archipelago was swept by the winds of change.

139 NAMBAN BYŌBU: THE PORTUGUESE LANDING
AT NAGASAKI
Detail of six-fold screen (see also figs. 136, 138).
Color on paper, entire screen 95 × 280 cm.
Momoyama Period, late 16th–early 17th century.
Namban Bunkakan, Ōsaka

140 NAMBAN BYŌBU: PRIESTS WELCOMING NEWLY
ARRIVED PORTUGUESE
By Kanō Sanraku (Kanō Mitsuyori, 1559–1635).
Six-fold screen.
Color and ink on paper, 1.6 × 3.6 m.
Momoyama Period.
Suntory Art Gallery, Tokyo

141 NAMBAN BYŌBU: THE LANDING OF THE
PORTUGUESE
Detail of six-fold screen (one of a pair)
attributed to the Kanō School; inscription by
Eitoku (Kanō Kuninobu, 1543–1590).
Ink, color, and gold on paper, entire screen 1.5 × 3.3 m.
Momoyama Period, c. 1610–1614.
Cleveland Museum of Art

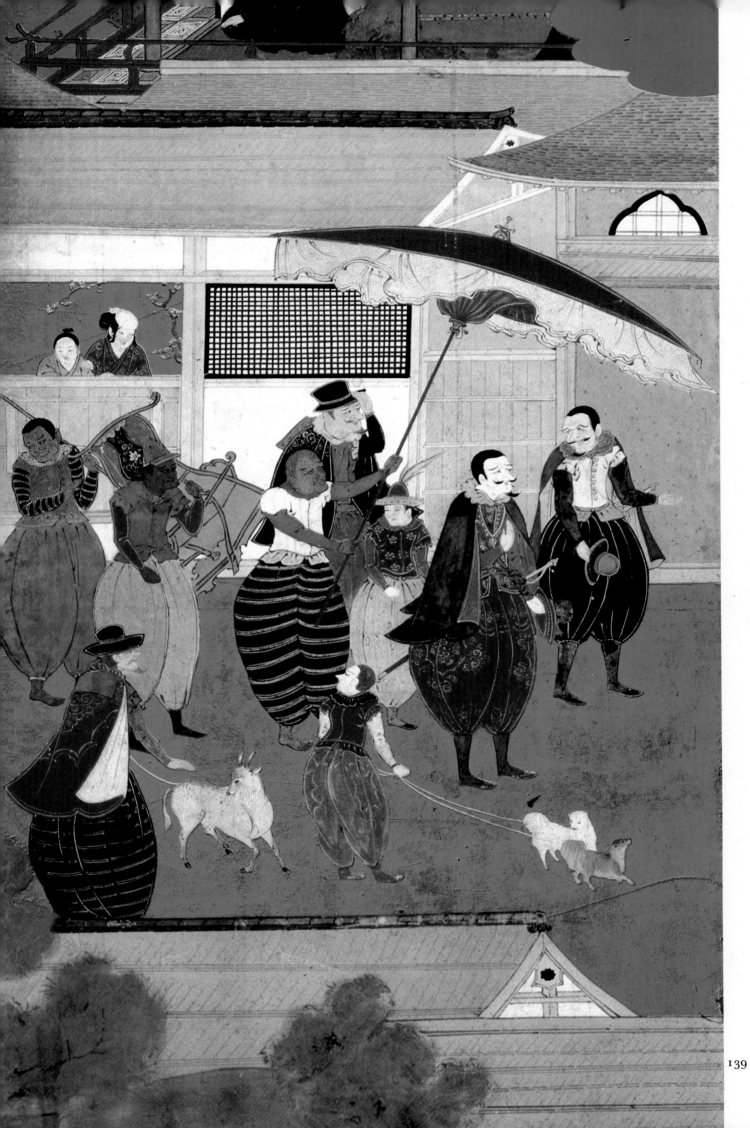

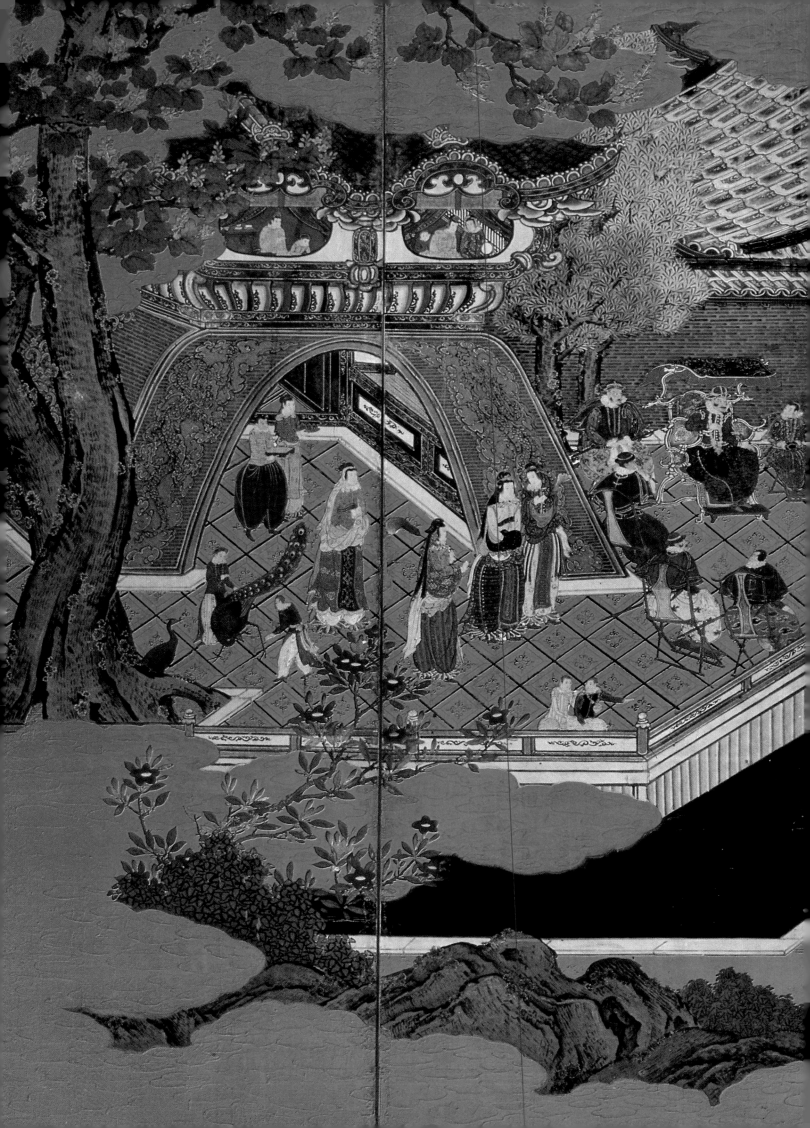

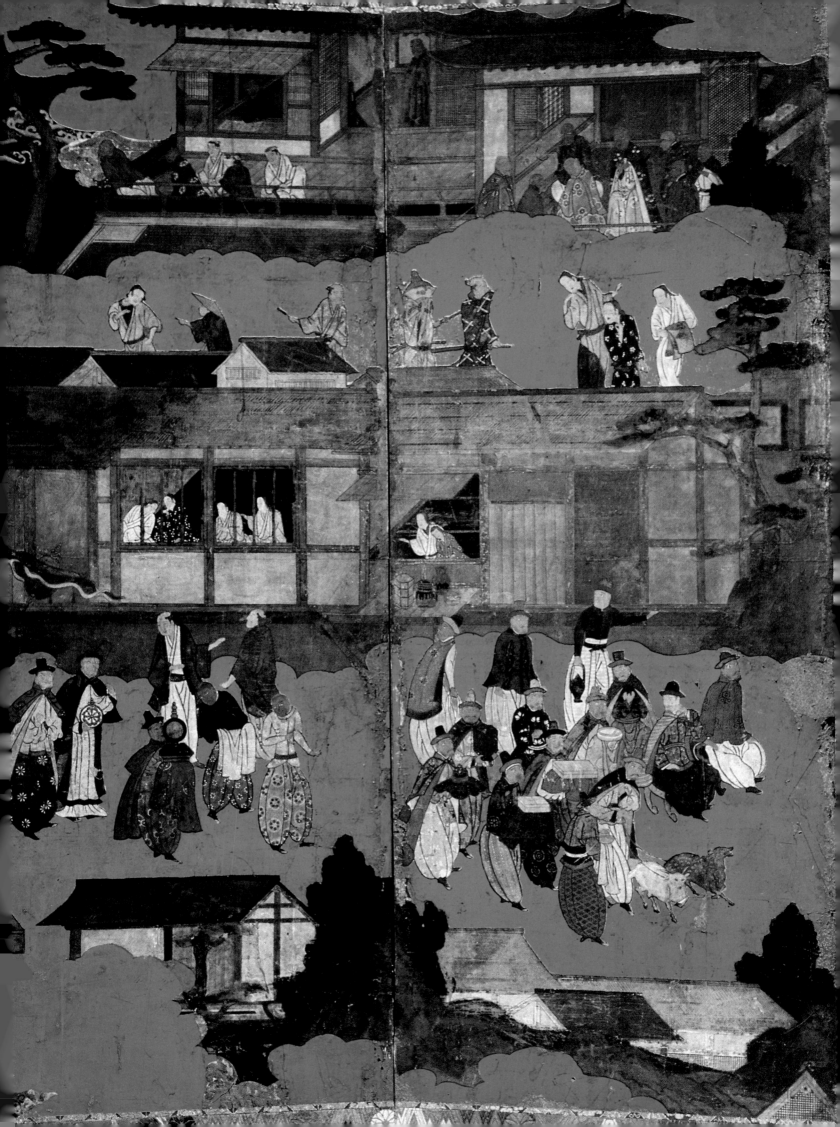

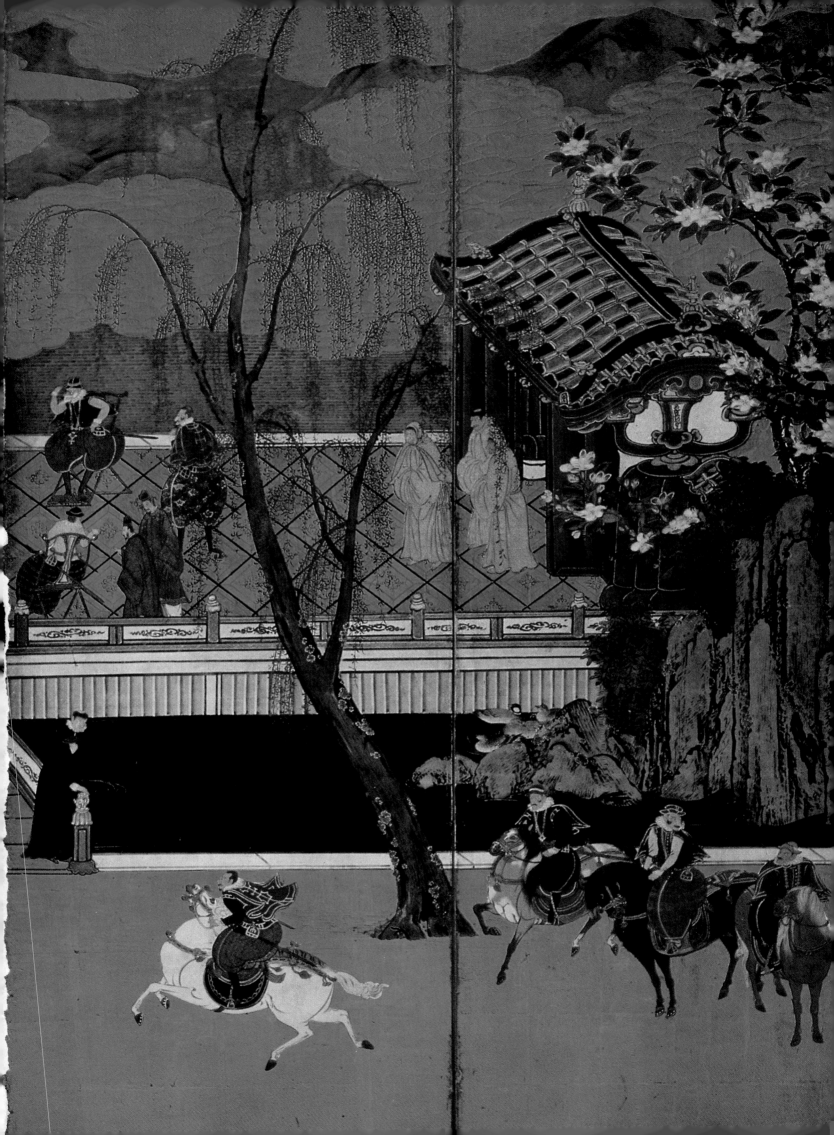

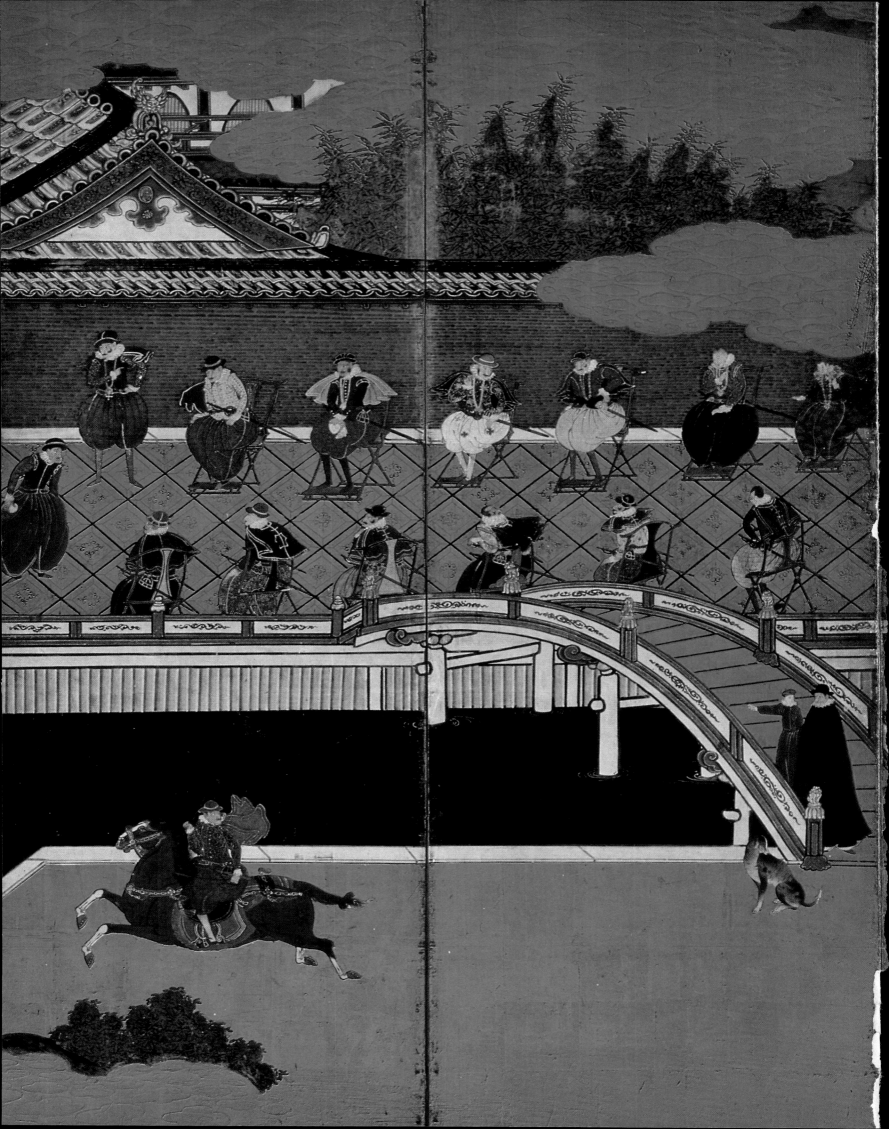

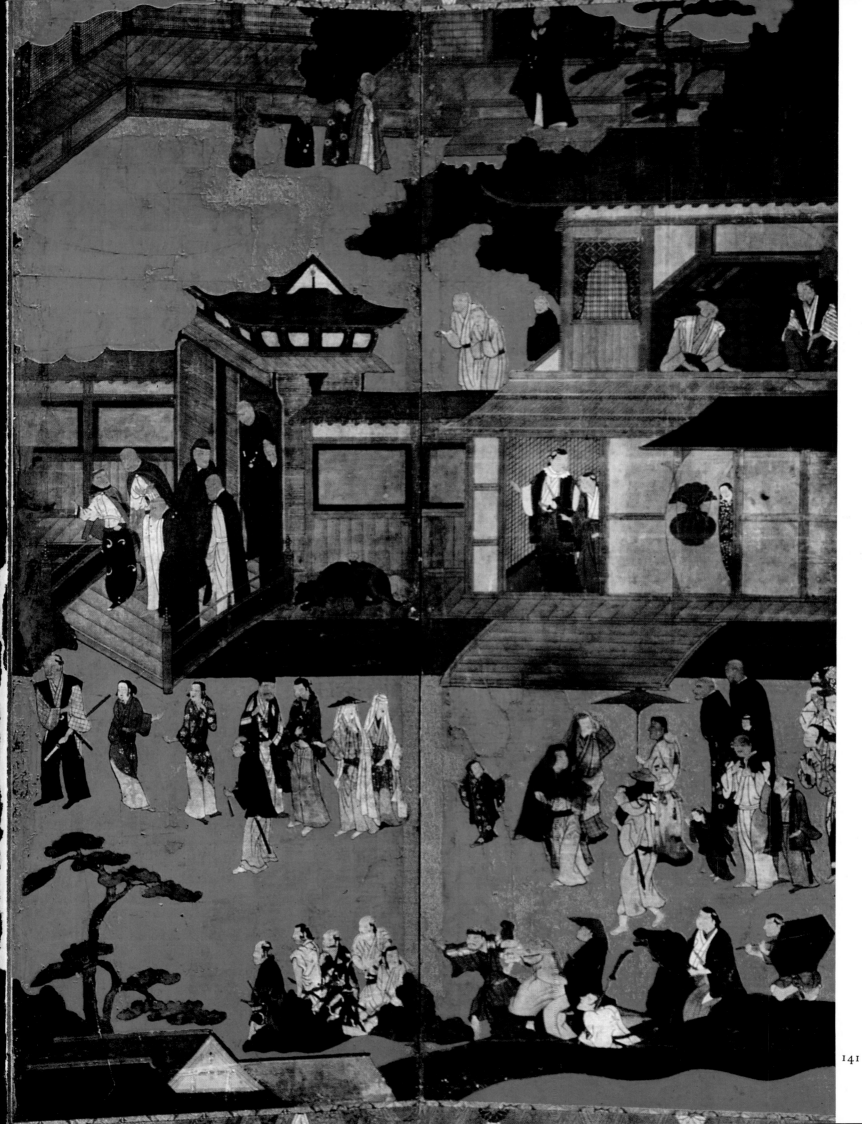

8. JAPAN AND LIFE'S PLEASURES

8. JAPAN AND LIFE'S PLEASURES

JAPANESE culture hinges on a number of concepts that are present in all agrarian civilizations: one is the idea of purity and impurity, another is fertility. Fertility is typical of popular forms of worship worldwide, which helps Westerners to acknowledge this current of symbolism that runs silently through what may appear to be an altogether ethereal form of artistic expression. These symbolic objects or reenactments lie just beneath that innocuous veneer of elegance—Westerners would call it "decorativeness"—that is inherent in Japanese art. Although one could cite numerous examples, we have decided to focus upon a study dealing with the fertility rites performed at the Tagata shrine (Aichi Prefecture), not far from Nagoya.

The main ceremony revolves around a form of phallic worship which participants believe to be pleasing to the god (in this instance, a female deity). The underlying symbolic message is the joining of male (humankind) and female (earth) in a kind of wedlock, a sacred bond without which man cannot ensure his survival. The most tangible manifestation of this union is a gigantic wooden phallus which here is attached to a straw puppet. The sight of this oversized male organ, although sacred (or perhaps because it *is* sacred), is supposed to send worshipers into fits of prolonged and deliberately raucous laughter. Might this response be a symbolic reenactment of the creative laughter that, the legend goes, enticed Amaterasu from her hiding place? In Japan, laughter is an individual's way of communicating with the unfathomable—life, death—and of "bearing the unbearable." To the Japanese, laughter provides man's surest access to the sacred forces that transcend him; thus laughter gives a philosophical cast to what otherwise appears to be a straightforward sphere of their art: humorous stories and caricature.

But was this caricature, in the ordinary sense of the word? Religion, laughter, and daily life overlapped and mingled in every area of Japanese society (save for that of the imperial court) to form one interdependent world: the world of life's tribulations—and pleasures.

FANTASTIC literature and the lives of the Buddhist saints so thoroughly permeated the objects and creatures of ancient Japan that stories about the founding of temples (*engi*), monasteries, or shrines took the form of lively illustrated tales in which, in the end, human beings always manage to win out over powerful forces threatening to transcend them.

In endless picturesque episodes, these fanciful accounts tell of people and events that are never entirely implausible: witness the Flying Storehouse (fig. 130), which Myōren has caused to transport the grain of the rich, self-centered squire to the poor people on Mt. Shigi, west of Nara. In another scroll, the turbulent life of Sugawara-no-Michizane unfolds before our eyes (fig. 135): the victim of an intrigue, he is slandered and banished for life only to become an importunate ghost after death. We see the once-distinguished statesman suffering a thousand torments in the Buddhist version of Hell, and returning to earth to bewail his desperate plight. Only the founding of a temple in his honor (Kitano Tenjin; fig. 699) can assuage his tormented spirit and turn him into a paradigm of virtue for future generations. The almost obligingly horrific vision of Buddhist Hell (there are actually eight principal hells and sixteen subsidiary hells) confronts us with a bewildering array of thieves and wicked men being endlessly crushed in an iron mortar, while animal butchers fall prey to a gigantic avenging rooster (figs. 142–44). We see the punishment meted out to inveterate pleasure-seekers: racked eternally by hunger and thirst, these grotesque ghosts (*pretas*) are condemned to wander the earth and look on helplessly while the living make merry (figs. 336, 337).

Buddhism in Japan and China inspired countless such stories (*setsuwa*). Every prominent monastery did its utmost to preserve in words and images not only the body of fact and myth surrounding its establishment, but also a certain number of stories suitable for instructing the faithful (figs. 392–94). Today they offer us more than information about religious beliefs; they provide the most accurate portrait we can ever hope to have of a vanished way of life (figs. 378–81). There was little in the 12th, 13th, and 14th centuries that the illustrated versions of these accounts did not touch upon: intellectual activity, the evolution of religion, the changing face of society, and the complex interaction of art forms that were inherited from China only to be reshaped into something uniquely Japanese.

UNSURPASSED as examples of satirical religious painting are the four scrolls comprising the *Satirical Tales of Birds and Animals (Chōju Giga)*, kept at Kōzanji (figs. 147–49), a monastery near Kyoto in a ravine famous for its autumnal maple trees (*Toganoo*). Each scroll has a distinctive flavor. The first focuses primarily on rabbits; the second, on horses, oxen, foxes, birds of prey, elephants, a tiger, even a dragon. This astonishing animal "presence" too often overshadows the last two scrolls, whose less striking character is more in keeping with the *Yamato-e* tradition: the situations and gestures are recognizably human, but now the cast of characters has abruptly changed into monkeys and frogs.

Although the scrolls are consistently satirical in tone and undeniably similar in

their approach, close inspection of certain stylistic variations indicates that they span a longer period than had been previously thought. Consequently, there are no grounds for subsuming all four scrolls under the single title *Chōju Giga* (probably a later addition). The first two scrolls portray their motley, highly imaginative worlds with a fresh sprightliness typical of the 12th century, the heyday of satirical drawing; the other, less inventive scrolls probably date from the middle of the Kamakura period (13th–14th centuries). This analysis of styles should disprove the time-honored attribution of all four *Satirical Tales of Birds and Animals* scrolls to the monk Toba Sōjō (1053–1140).

That each of these scrolls relates a story is self-evident, but we are still faced with the thorny task of "deciphering" them. Instead of courtly intrigue or accounts of knightly battles, they present us with jocular commentaries of monastic life, a socio-religious phenomenon with as many facets as there were sects, monasteries, or even individual monks. Today we cannot savor fully the piquancy of their timely wit. Within a scroll scenes follow one another in quick succession or even overlap, creating a seemingly self-propelled narrative rhythm that borders on syncopation. To our delight, they turn out to be Far Eastern counterparts of Western religious parodies, and now and again we come across a scene which, in its irreverence, has universal appeal. One shows a monkey dressed in ceremonial regalia delivering a homily (represented by an empty balloon) to a Buddha-frog seated on a lily pad, serenely propped up against a banana-leaf halo.

Scroll art runs the gamut of artistic approaches, from the richly colored style of *The Tale of Genji* to the monochromatic, linear draftsmanship of these satirical scenes, disembodied silhouettes of animals having human expressions. The genre is anything but homogeneous, but it was bound to influence the subsequent development of Japanese art. To be sure, it had certain limitations that made physical demands on the artist, but these are not of too much importance; scrolls offered one form of support for the illustrations, neither more nor less convenient to work with than books. Let us look to the spirit emanating from the physical page. The voice of an era speaks to us through these images with an immediacy that far surpasses anything in written texts. But as we examine the forms, there is a powerful temptation to dwell instead upon the technique; we must put this aside, for all the great masters constantly invented imaginative combinations of technical procedures drawn from different genres.

In the incredible diversity of their work, the recurrent theme of *oko* stands out, a theme that provokes a smile of complicity throughout Japanese art. *Oko* refers to the often demoralizing sensation of inadequacy, an idea so peculiarly Japanese that it can be adequately rendered only in the native *kana* system of writing, not with Chinese ideograms. It signifies a burlesque or humorous attitude toward things and categories, a sense of the ridiculous which, however absurd, is free from malice. This strain of humorous incongruity helps to give their unique flavor to the "fringe" cultures of Korea and Japan; humor is not unknown to the Chinese, but for them it was blacker, less focused, and more apt to come from the social ills that weighed so heavily on government and people alike. The defined levels in old Japanese society were better suited to the development of a lighthearted humor. The Chinese system of recruiting civil servants

through examinations permitted social mobility, at least in theory, whereas in Japan's feudal hierarchy people were assigned to niches and expected to remain in these. Except in times of crisis—though such periods were sometimes prolonged and tumultuous—the Japanese were by and large shielded from the emotional strains coming from unbridled ambition: they knew neither the giddiness of the rise nor the agony of the fall. Doubtless it was this balanced social structure that fostered the golden age of painting known as the Fujiwara culture (10th–12th centuries), which reached its zenith just as feudal Japan was coming of age (figs. 147–49).

An especially radiant example of this multifaceted and profoundly human climate is the *Legend of Mount Shigi* (*Shigisan Engi*; fig. 130), the first scroll of which was probably completed during the Shōan period (1171–1175), that is, about the same time as *The Tale of Genji*. But these stories do not tell about the aristocracy of the day; rather, they are a spirited portrayal of the "other half," of priests, artisans, peasants, and the new class of landowners. And how are these nonaristocrats presented to us? As embodiments of *okashi, oko*: peculiar, burlesque beings with caricatured features. Enormous mouths indicate garrulousness; pointed, clawlike fingers suggest greed and the violent, erratic pulse of the daily struggle for survival; excited eyes pop out of their sockets, and eyebrows are knitted with tension. Their clothing hangs in disheveled folds, absurdly ill-fitting. The women look like trollops in aprons, their hair hastily pulled together with an unsightly piece of cord, their legs revealed by impulsive, shameless movements.

The characters in *The Tale of Genji* are uniformly serene; those in the *Legend of Mount Shigi* fairly bristle with the sharp contrasts one would expect to find in a collection of lower-class types. This was far from a revolutionary approach: it had already been adopted in the earliest Chinese scrolls from the Tang dynasty, such as Yan Liben's *Scroll of the Emperors* (7th century). But the painters of the *Shigisan Engi* introduced one innovation: their "theatrical" overall approach, as at the Tagata shrine, mentioned earlier. This tendency to create spectacular effects coincided with the emergence of popular theater (*saru-gaku*), whose colorful, ribald parodies were surfacing at about this time (11th century). Space was created in Japanese art not by learned mathematicians of perspective, but by artists with a sense of histrionics.

Equally intriguing is the later *Life of Ippen* (figs. 159, 363). A comparison of the two surviving versions of this pictorial biography, at Kankikōji, Kyoto, and in the National Museum, Tokyo, reveals how, over the centuries, a sumptuous, refined work intended for a small circle of connoisseurs ended up as picture-books used to instruct the faithful masses. Only the Kankikōji set of scrolls really deserves to be ranked as a work of art, but it is nevertheless interesting to follow a subject as it underwent simplification or "popularization" in the second series. How to appeal to an informed audience who appreciated art, and also attract the unenlightened and win them over by depicting the world they knew, the world where they could feel comfortable? The pressure of a

new audience was moving the idea of art itself toward different horizons. Technique, style, and the subjects themselves were to undergo far-reaching changes before long.

Ippen, the monk who would unwittingly have so great an impact on the arts (we have mentioned him on page 227 in our discussion of ink landscapes), was born in Iyo Province (Shikoku) on February 15, 1239. Nothing is known about his parents, except that they were related to the Kawano, a clan that won fame in 1274 and 1281 for their part in resisting the Mongol invaders. Ippen's mother died when he was ten years old, at which time his father sent him to a temple. After becoming a monk at age thirteen, the young Ippen—we call him Ippen, though he took that name only later—went to Dazaifu and asked permission to study under Shōtatsu, patriarch of the Jōdo sect and an important figure in western Japan. Ippen remained there until his father died in 1263; after a period of mourning, he returned to Shōtatsu.

Such is the story of Ippen's youth as related by the two illustrated sources at our disposal, *Ippen Hijiri-e* and *Ippen Shōnin Eden,* though other traditions have it that he entered the monastery of Mount Hiei at the age of seven and became a monk at fifteen. If so, he would have first absorbed the teachings of the Tendai sect and studied under Shōtatsu at Dazaifu only later, at age twenty-six. These later versions of Ippen's life may have interpolated the lives of other religious figures; for both Hōnen (1133–1212) and Shinran (1174–1263) were affiliated at one time or another with the Tendai sect; probably the greatest single influence on Ippen's formative years was the Jōdo or Pure Land sect, as the illustrated biographies tell us.

Accounts of Ippen's life fall silent until he was thirty-three, when he returned to his native Iyo Province. He seems to have led a rather dissolute life for a few years, but while roaming the countryside as an intinerant monk he began to talk to children and humble people about religion. Recalling the teachings instilled in him as a youth, he preached in temples about the acceptance of life, death, and everyday hardships, but he found that his lowly audiences were capable only of simple and immediate emotions: terror at the thought of death, longings unfulfilled for justice, hope for an eternal reward. Ippen had these people in mind when he founded the Ji sect, which offered Paradise to the underprivileged of the world on the sole condition that they purify their hearts, even if only for an instant.

Upon his death in 1289, two of his disciples, Shōkai and Sōshun, set down accounts of Ippen's life, a life entirely devoted to the salvation of the humble. Their texts were, in turn, used as the basis for two illustrated biographies: the "Shōkai" version kept at Kankikōji (one set was completed in 1299, exactly ten years after Ippen's death), and the "Sōshun" version, its exact date not yet ascertained but its style, painted later in the 14th century, somewhat more labored and theatrical than that of the Shōkai scrolls. Ippen, for example, is depicted larger than the other characters to make him readily visible. In all probability, the Sōshun scrolls were intended to be displayed to an audience as it listened to preachers.

The Kankikōji scrolls are remarkable for their superb views. Parallel vanishing orthogonals create a straightforward succession of visual planes, structuring a landscape in which natural areas alternate with the dark roofs of palaces or temples. The land-

scapes, though faithfully reproducing the Japanese countryside, are rendered in a style directly inspired by the "blue and green" manner of Chinese painting (*kara-e*). The overall tone is one of tasteful reserve, with many elements to delight the eye: monks and pilgrims wending their way across the landscape, melancholy flights of wild geese, and a varicolored haze that creeps over the plain and adds mystery to the majesty of Mount Fuji.

The style of presentation in the Sōshun scrolls was supposed to address directly the hearts of the enlightened. Consequently it relied heavily on anecdotes aimed at catching the eye and stimulating the mind with farcical or compelling "genre" scenes, while leaving room for unusual or supernatural phenomena. This "popular" approach becomes especially evident in relatively later works, as in the scrolls at Kōmyōji (Yamagata Prefecture), which date from 1594 and are attributed to the son of Kanō Eitoku (1543–1590). However, it also crops up in earlier works, such as the scrolls at Shinkōji (Kyoto), which are closer in tone to the illustrated *otogi* that people read simply for entertainment.

The illustrated biographies of Hōnen (1133–1212), celebrated founder of the Pure Land (Jōdo) sect, are no less diverse and indicative of the major changes taking place at the time. None of the versions of Hōnen's life proceeds at the solemn, unruffled pace that gives the earlier scroll of Ippen's life its aristocratic charm. Even the oldest illustrated biography of Hōnen, in the Zōjōji, Tokyo, is filled with gamboling activity more in keeping with accounts of knightly exploits, while the ink draftsmanship in certain sections has a liveliness reminiscent of Song painting.

Some experts consider the forty-eight-roll copy at Chionin, Kyoto, the most beautiful of all *emakimono* (fig. 131), but its artists no longer seemed to draw inspiration from the long, narrow, fragile format of the scroll itself. For all their brilliance, the Chionin scrolls did not add to the new artistic climate of the times, they simply mirrored it. The deep, lapis-lazuli blues and pure emerald greens, the vibrant, calligraphic lines like streaks of lightning across the bold, bright flat tints—everything already evokes the aesthetic milieu of the late Muromachi period (15th–16th centuries), but the art of scroll painting, however dazzling as performance, was no longer in the forefront of innovation. It was becoming overshadowed by screen painting, a form geared to much larger surfaces and bound up of necessity with architecture. Before long, architecture proved to be not only a preeminent art form in its own right, but a splendid source of inspiration for painters. Their emotions, style, and—not to underestimate the prosaic side of things—patronage now depended upon a single source: the city.

Since time immemorial, cities, especially capital cities, have always fascinated those who have watched them grow and flourish. A remarkable Chinese interpretation of this theme is the scroll in which Zhang Deduan (second half of 12th century), a painter of boats and architecture, depicted the splendors of the Northern Song capital of Bian-

liang (modern Kaifeng). However, because the Chinese *literati* dismissed rather disdainfully these descriptive, "utilitarian" paintings as though they were so many survey maps, such works of art were never frequent in China. In Japan it was an altogether different story. There the deep appreciation of native landscape and the loyalty to traditional (that is, pre-Song) Chinese architecture fostered the enduring popularity of decoration on screens and sliding partitions. These paper surfaces became the preferred vehicle for painters, who did not abandon time-honored materials and techniques, but breathed new life into their subjects; in so doing, they helped their art to make a successful transition from the privacy of illuminated scrolls to the gentle and protective, yet vulnerable milieu of Japanese houses, whether simple dwellings or large palaces.

Within a relatively short time (from late in the Muromachi period to the Early Edo), there emerged full-blown the genre of painting known as *Rakuchū Rakugai,* or "the capital and its environs." Raku, the initial ideogram for the ancient Chinese capital of Loyang, had become the traditional way of designating Kyoto, the spiritual and administrative hub of the Japanese empire. These representations of upper- and lower-class Kyoto—an invaluable social chronicle of that key era known as the Momoyama period—usually cover a pair of large six-fold screens. The result is a sprawling composition divided into roughly equal areas by clouds that have been skillfully positioned to reveal a house here, some roofs there (figs. 160, 382–87). At times whole districts come into view, rendered with the same vividness and detail that gave scroll paintings their anecdotal appeal. Generally speaking, the *Rakuchū Rakugai* style may be summed up as a juxtaposition of countless small scenes over a very large surface. Here was a genre that used the episodic sequence of *emakimono,* perfected the bird's-eye view (*fukan*), and revived the descriptive rendering of everyday life so typical of religious scrolls and even *otogizōshi.*

So much for *Rakuchū Rakugai's* direct line of descent, one that is also indirectly linked to the Four Seasons manner, an offshoot of Chinese painting that became highly esteemed in Japan during the Fujiwara period (see figs. 374–76). But there is no need to trace an extended genealogy of this genre. A civilization, like an individual, is a complex phenomenon, carrying within itself the memory of past human experience as well as the seeds of future bursts of creativity. Diversity within a particular cultural system depends less upon its individual components than upon the value or importance it assigns to each component in proportion to the whole.

THESE extraordinary views of the capital can comprise as many as over two hundred little scenes. An example in the Uesugi Jinja Treasure House, for instance, has 113 scenes on the right six-fold screen and 103 on the left one. To broaden our understanding of this sometimes bewildering genre, we should recall certain geographic, historical, and cultural facts dear to Kyoto's admirers and remember that on these screens are represented buildings that have disappeared or since been forgotten.

In prehistoric times, the plain upon which the modern city of Kyoto now stands lay beneath an immense lake that flowed into Osaka Bay and thence to the Inland Sea.

Of this aquatic heritage there remain only a pond, Ogure-ike, and the babbling rivers and streams that still course down from the mountains and that gradually filled the great central lake with alluvial deposits.

When Emperor Kammu arrived there in 794 to build Heian and turn it into the new seat of government, he found a town that was virtually free of any administrative structure. Not that it was *terra incognita*: a number of energetic clans had been living there as far back as the Kofun, or Great Tomb Period (4th–7th centuries), and Korean immigrants had settled in the area, establishing stable, hard-working artisan families. The region was then known as Yamashiro, or "true mountain," a place name still used for a limited area today. Within the contemporary sprawl of unplanned and incongruous buildings, one can still make out the unbroken belt of mountainous, forest-clad terrain that hems in Kyoto on the east, north, and west, absent only on its southward outlet to the sea.

At the dawn of the Kofun Period (3rd–4th centuries) the center of the plain was the site of the Kamo shrine, thus named because it was under the jurisdiction of the Kamo family. Their totemic emblem was the Yatagarasu, a crow sent by Amaterasu, legend has it, to guide the mythic emperor Jimmu-tennō in his conquest of the Yamato plain. Thus, the very name of Kyoto's main waterway, the Kamogawa river, conjures up the stirring epics of its early history.

For over a millennium—from the founding of Heiankyō in 794 to the official transfer of the court to modern Tokyo in 1868—Kyoto was the site of the emperor's residence and the capital of the empire, and it remained the country's artistic and religious nucleus even after the intellectual center shifted in the 17th century to Edo, the city that was destined to lay the foundations of modern Japan. Notwithstanding its strife-ridden history that occasionally reduced all or parts of the city to ashes, Kyoto retained its reputation as the capital of life's pleasures, the real dwelling-place of *Yamato daishi,* the Japanese soul. This soul expressed itself, not in the stifling etiquette that a small circle of courtiers had to endure, but in festive occasions when the beating of the great drum (*taikō*) was said to rouse not only the people, but all of nature. Even today, festivals relieve the minds of summer crowds from the sometimes sordid business of tourism and lift them toward an intuition, if not a direct knowledge, of the cosmic mysteries around us.

The successive splendors of Kyoto's flora mark the changing seasons, a theme sounded time and again in Far Eastern painting. The plum and apricot trees of early spring give way to the cherry blossoms of April; azaleas burst into bloom at the Chishakuin temple in May, followed by iris; chrysanthemums and purple maple leaves signal the onset of autumn and the approach of winter (figs. 117–23, 431–34). Humidity serves as another barometer of seasonal change. The soft mists (*kasumi*) of spring thicken into sultry fogs as summer brings its brief, fierce downpours (*yūdachi*). For a thousand years travelers have been climbing the mountain to admire the city from above, and for a thousand years they have seen it enveloped in fog, from the diaphanous *moya* to the

pea-soup *kiri*; the varying textures and brightness of the fog have always been for them a kind of seasonal clock. Thus the Southern Song technique of clouds carefully arranged to create an effect of distinct, graduated levels found its way quite naturally into Japanese art: more than just another decorative device, this was a way to depict faithfully a landscape having a terrain and atmospheric conditions that lend themselves to the spatial divisions so typical of that artistic reconstruction of reality.

It is a nostalgic and entertaining experience to follow these vast picture-narratives. Many of the features or landmarks that have survived are lost today in a maze of cheap buildings and an encroaching web of electric wires. On the Machida screens alone one can pick out, south to north along the Kamo River, Tōfukuji, Kiyomizudera, Sanjūsangendō, the Yasaka pagoda, the Gion shrine, Chionin, Nampukuji, and Mount Hiei.

DURING the late 16th century the dictators were making Japanese society into an aggregate of disciplined and highly stratified units. They no longer wanted painters to depict the "capital and environs," but to work in the feudal castles they were so proud of and the towns that were mushrooming around them. Here lived ranking vassals and the craftsmen whose toil provided *daimyō* with life's necessities—weapons—and with comforts and luxuries as well. (One such feudal settlement appears on the Shurakudaizu screen in the Mitsui collection.)

From then on, and throughout the Edo period, painted screens came alive with all manner of hectic activity—lavish accounts of celebrations, ceremonies, exploits. These immense, elaborate compositions combine a sense of narrative movement that draws us into processions as they wind through the streets, a skillful handling of clouds to suggest motion and provide an overall, "syncopated" view, and a genius for vivid or humorous detail. The result is a feast for the eye that invites the onlooker to slip into a miniature world where all social classes are assembled into an all-embracing and decidedly optimistic view of life (figs. 155–57, 382–87, 470–72, 478–82).

142–43 JIGOKU ZŌSHI (SCROLL OF HELLS)
 Details of handscroll.
 Color on paper, entire height 26.5 cm.
 Kamakura Period, late 12th century.
 Tokyo National Museum

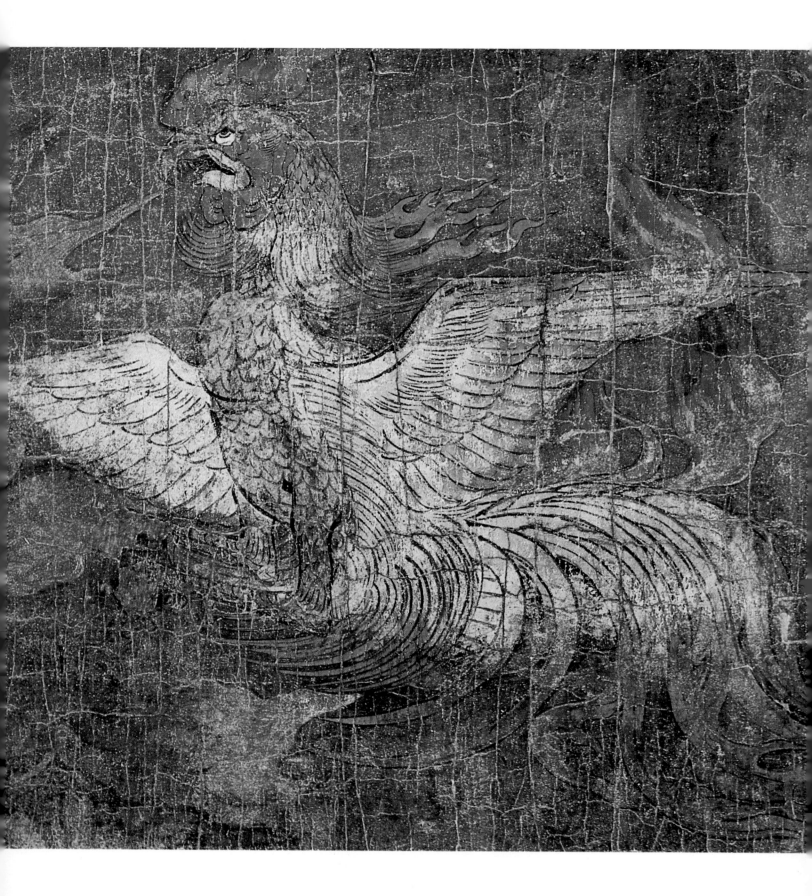

144 JIGOKU ZŌSHI (SCROLL OF HELLS):
GIGANTIC ROOSTER
Detail of handscroll.
Color on paper, entire height 26.5 cm.
Kamakura Period, late 12th century.
Tokyo National Museum

145–46 RAKUGAKI (SKETCHES FROM LIFE)
 Ink on wood, height of each head 6.5 cm.
 Late Asuka–early Nara Period, 7th–8th century.
 Hōryūji Great Treasure House, Nara

147–49 CHŌJU GIGA (CARICATURES OF BIRDS AND
 ANIMALS)
 Details of handscroll.
 Ink on paper, entire height 31.8 cm.
 Heian Period, 12th century.
 Kōzanji, Toganoo (Kyoto)

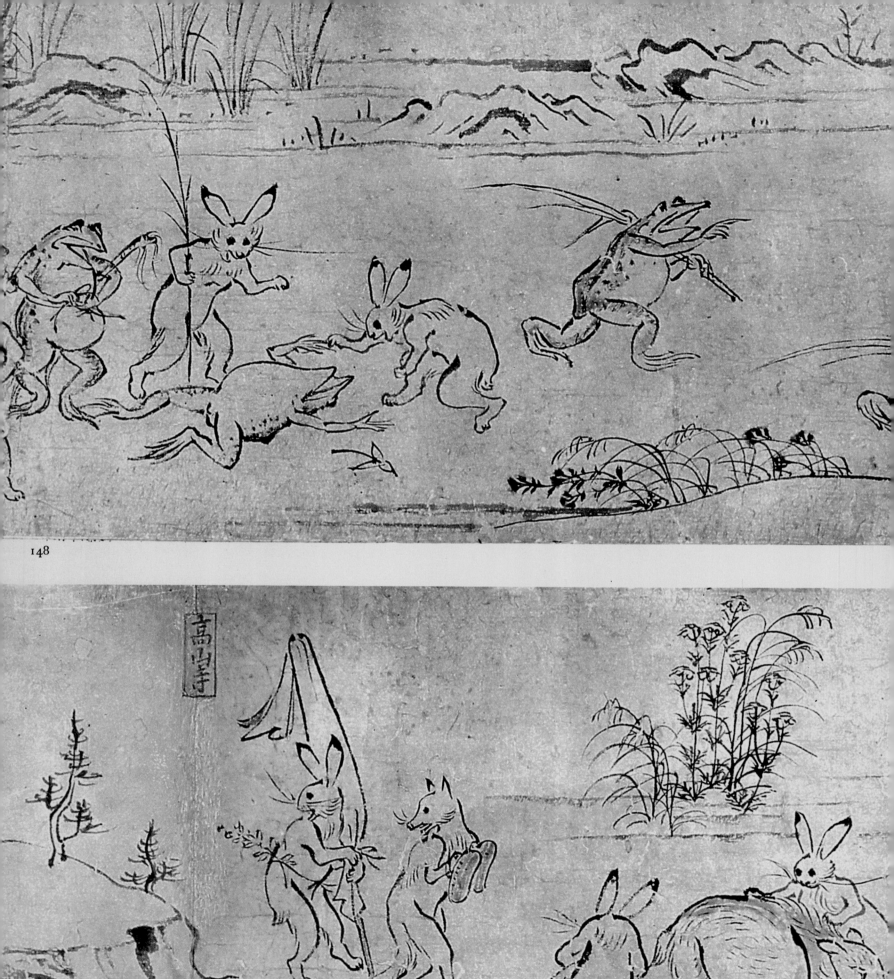

148

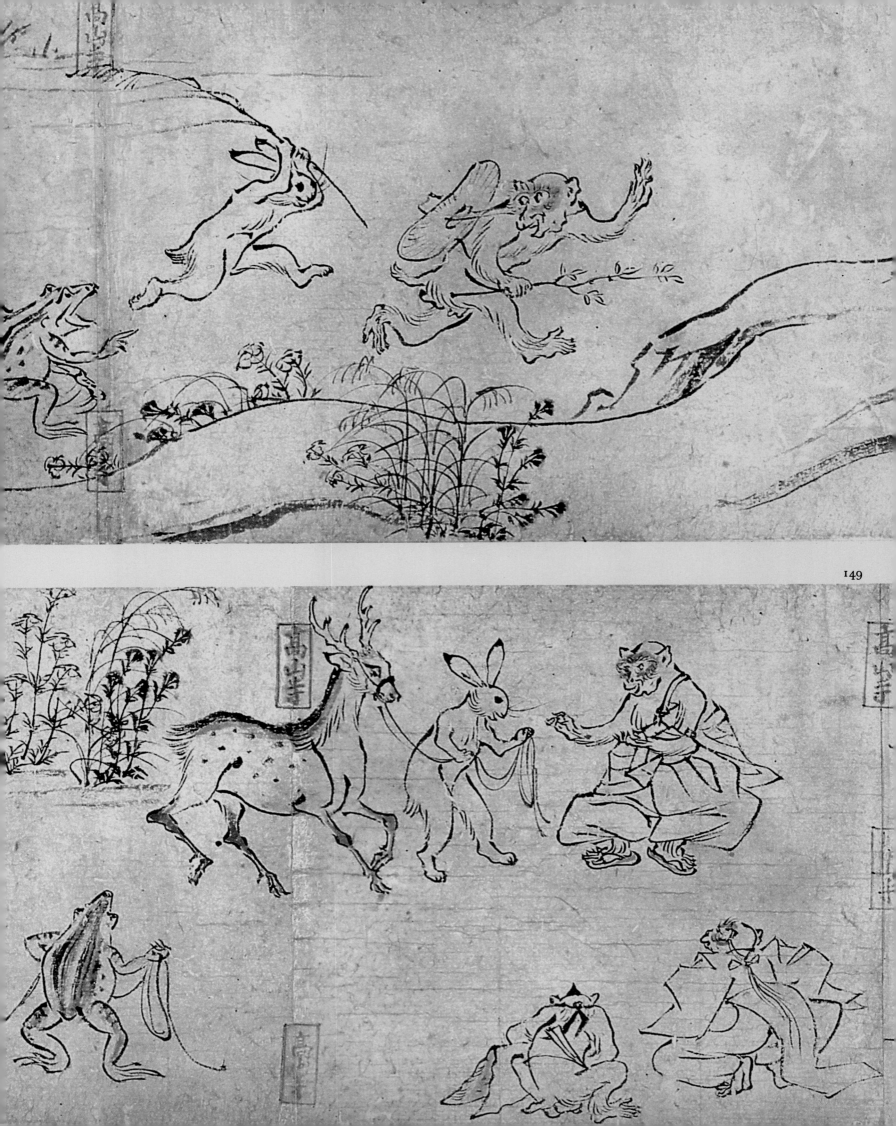

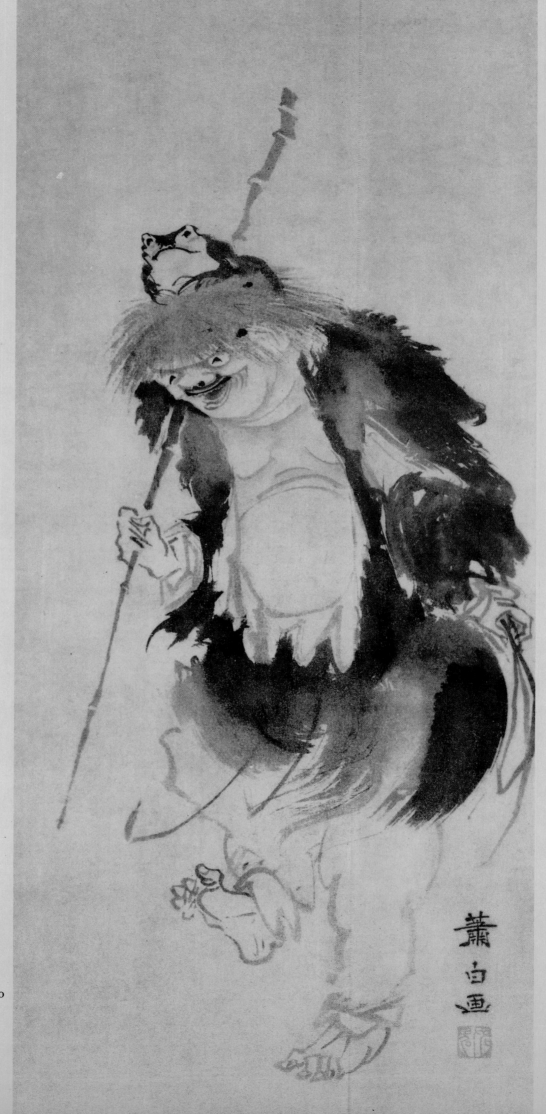

150

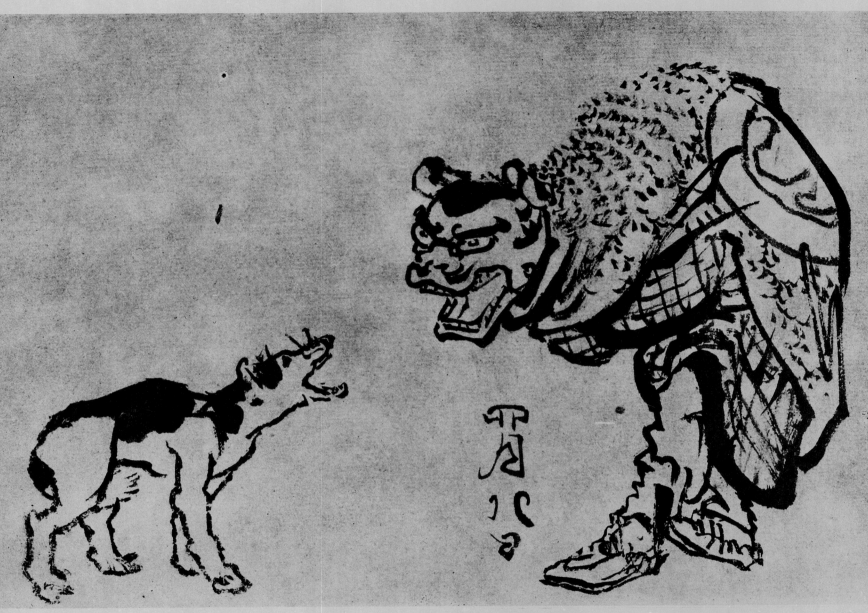

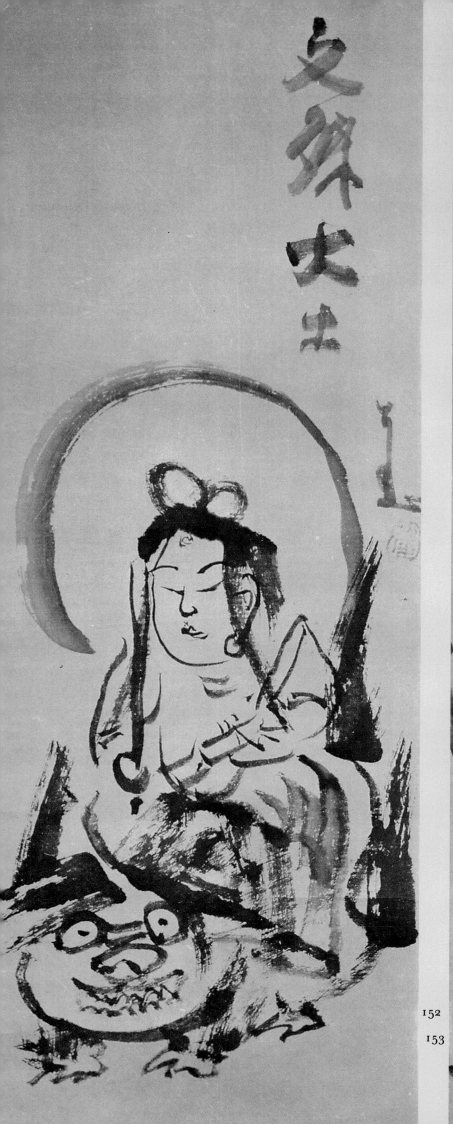

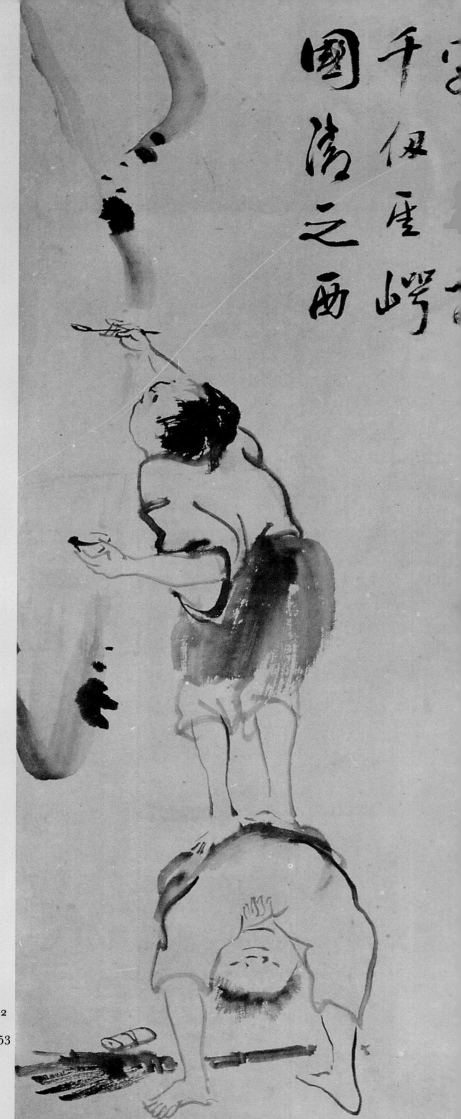

150 GAMA SENNIN (TAOIST IMMORTAL WITH FROG ON HEAD)
By Shōhaku (Soga Shiryū, 1730–1785).
Ink on paper, entire dimensions 109.1 × 42.2 cm.
Soga School, Edo Period.
Freer Gallery of Art, Washington, D.C.

151 DOG AND MAN IN LION COSTUME
By Katsushika Hokusai (Katsushika Tamekazu, 1760–1849).
Ink on paper, 17.2 × 24.1 cm.
Edo Period, 1844.
Private collection, Tokyo

152 MONJU BOSATSU (MANJUSRI)
By Sengai (1750–1837).
Ink on paper.
Edo Period.
Private collection, Tokyo

153 KANZAN AND JITTOKU
By Sengai (1750–1837).
Ink on paper.
Edo Period.
Private collection, Tokyo

154 KUMANO MANDALA: THE THREE SACRED KUMANO SHRINES (WAKAYAMA PREFECTURE)
Hanging scroll.
Ink and color on silk, 134 × 62 cm.
Kamakura Period, c. 1300.
Cleveland Museum of Art

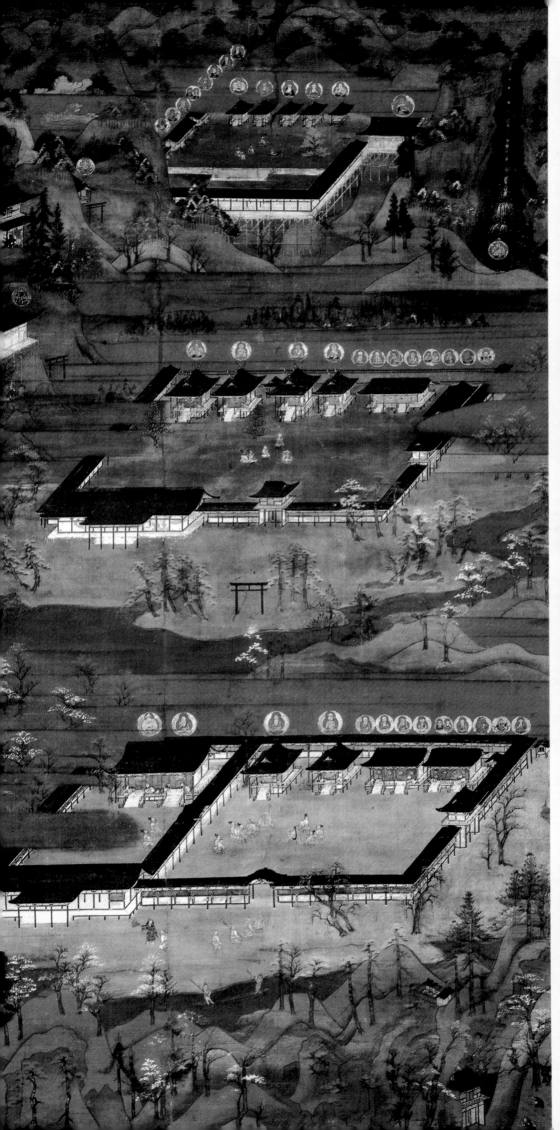

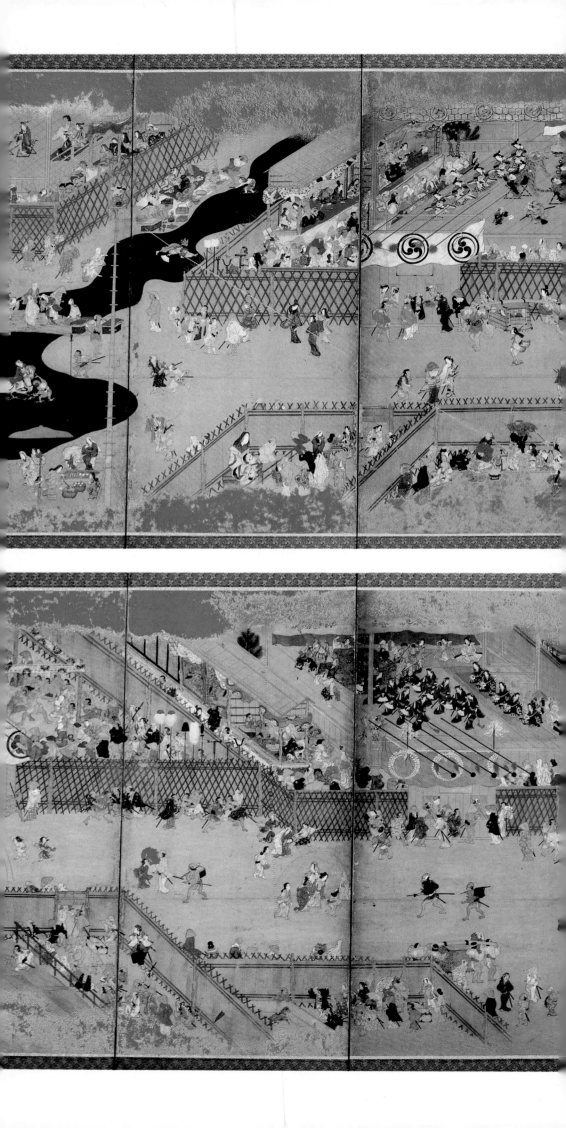

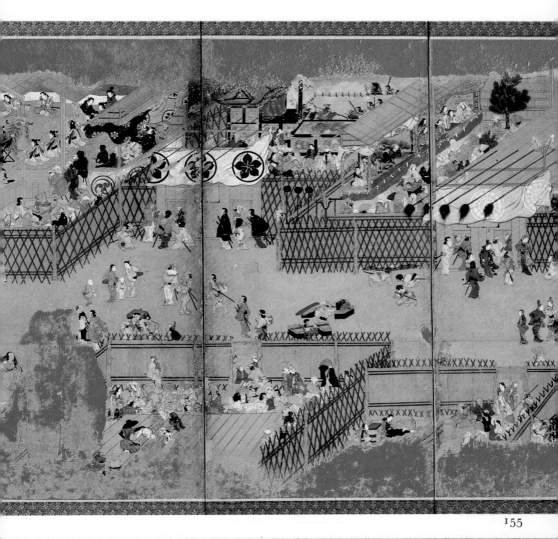

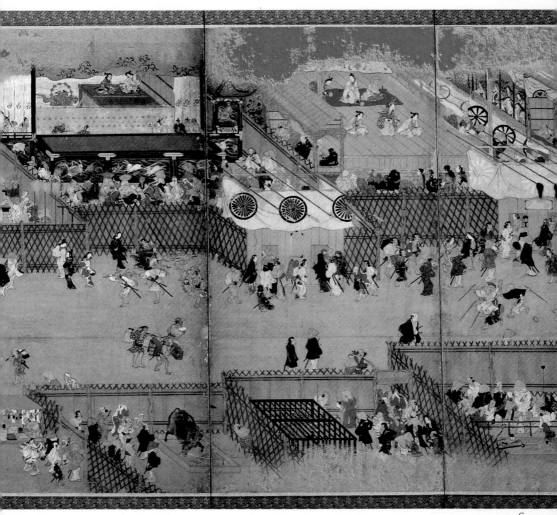

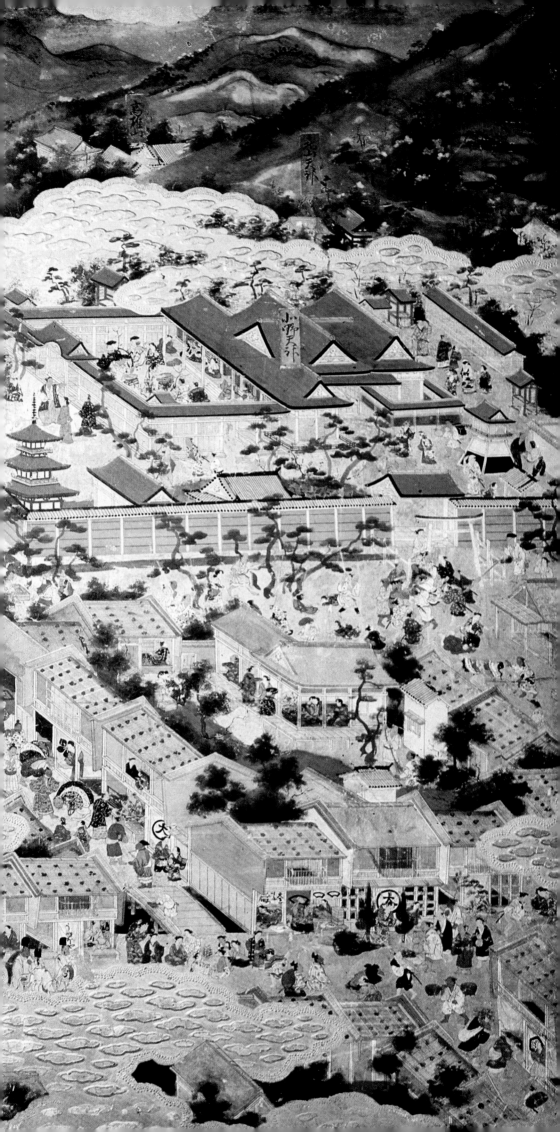

155–56 SHIJŌ SQUARE, KYOTO
 Pair of six-fold screens.
 Color and gold on paper, 61.9 × 161 cm.
 Genre painting, Edo Period, early 17th century.
 Museum of Fine Arts, Boston

157 VIEW OF KYOTO (RAKACHU RAKUGAIZU BYŌBU)
 Detail of six-fold screen (one of a pair).
 Color and gold on paper, entire screen 94.1 × 272 cm.
 Early Edo Period, c. 1615–1623.
 Namban Bunkakan, Ōsaka

353

158 ESHI ZOSHI (THE TALE OF A PAINTER)
Detail of handscroll.
Slight color on paper, entire height 30 cm.
Kamakura Period, 14th century.
Imperial Household Collection, Tokyo

159 IPPEN SHŌNIN EDEN
(PICTORIAL BIOGRAPHY OF PRIEST IPPEN, 1239–1289).
Detail of handscroll.
Color on silk, entire height 38 cm.
Kamakura Period, 1299.
Tokyo National Museum

160 RAKACHU RAKUGAIZU BYŌBU (VIEW OF THE CAPITAL)
A group of European travelers approaches Nijō Palace.
Detail of six-fold screen (one of a pair).
Color and gold on paper, each screen 94 × 272 cm.
Early Edo Period, 1615–1625.
Namban Bunkakan, Ōsaka

161 ŌEYAMA EMAKI (TALE OF ŌEYAMA)
Attributed to Takanobu (1571–1618).
Detail of handscroll.
Color on paper, entire height about 30 cm.
Momoyama Period.
Tokyo National Museum

162 SHIGURE MONOGATARI (THE HEAVY SHOWER)
Color and gold on paper, height about 30 cm.
Edo Period, 17th century.
Musée Cernuschi, Paris

163 GENRE PAINTING (UKIYŌ-E): COURTESANS
Detail of six-fold screen.
Ink, color, and gold on paper, entire screen 1.5 × 3.5 m.
Momoyama Period, late 16th–early 17th century.
Freer Gallery of Art, Washington, D.C.

164 GENRE PAINTING (UKIYŌ-E): WINTERTIME PARTY
By Toyoharu (Utagawa Masaki, 1735–1814).
Detail. Ink, color, and gold on silk, entire dimensions
52.7 × 96.3 cm.
Edo Period.
Freer Gallery of Art, Washington, D.C.

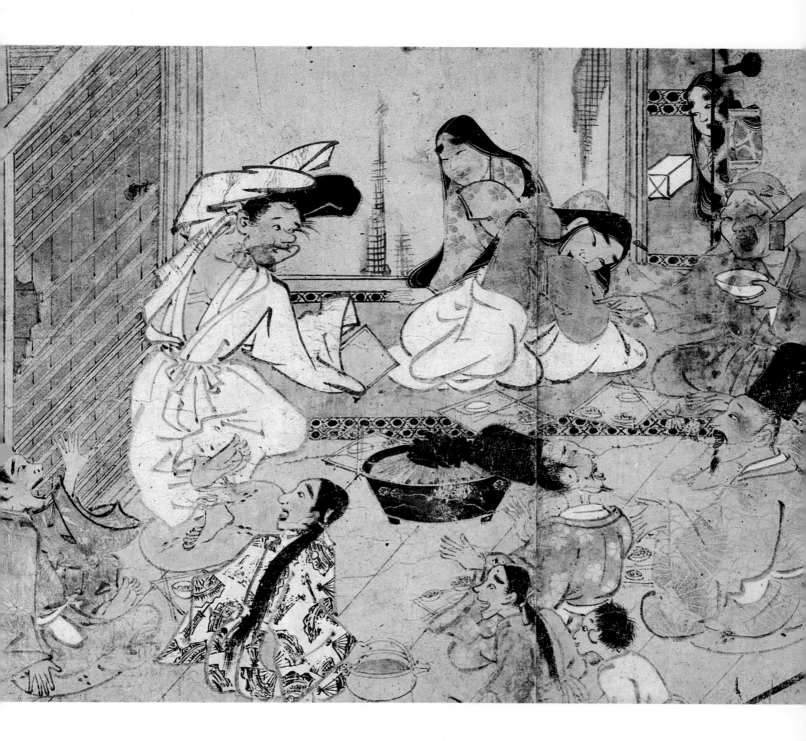

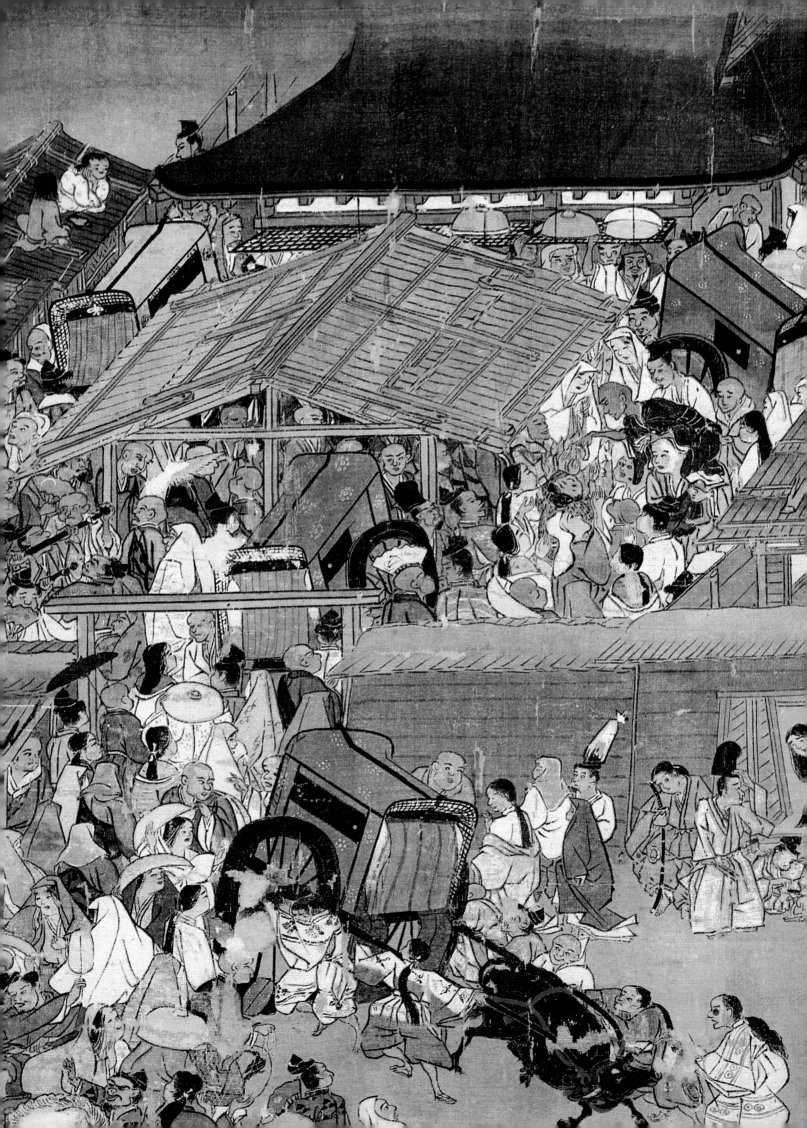

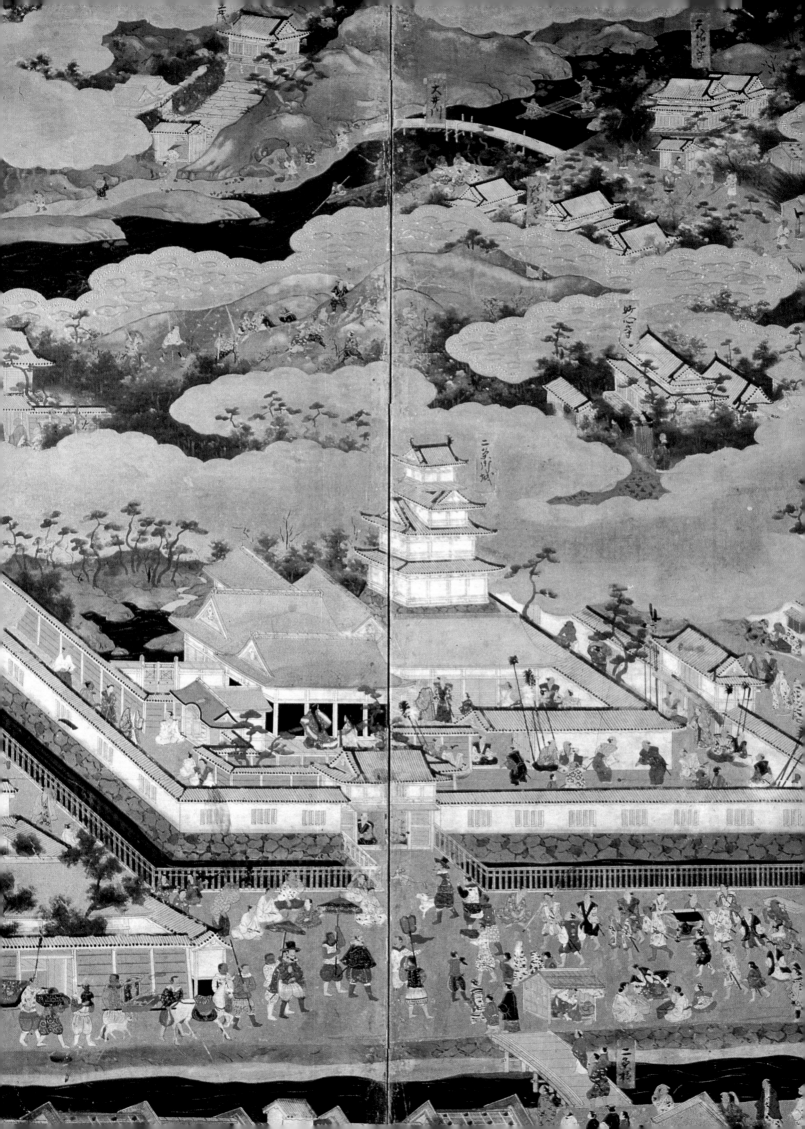

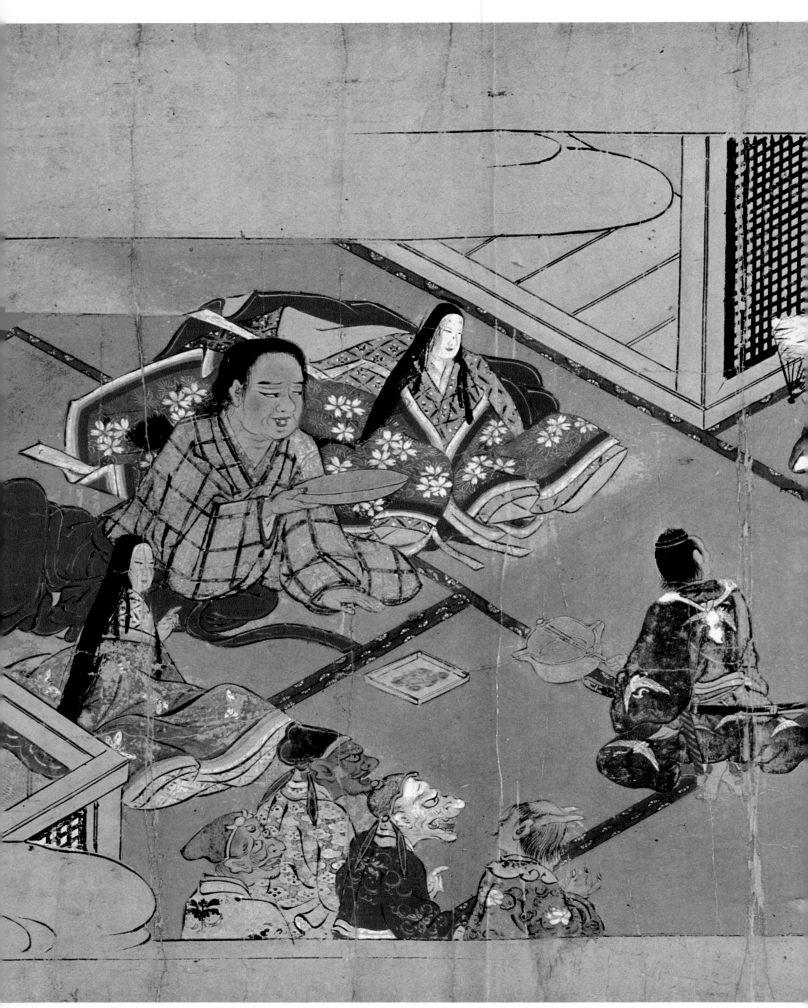

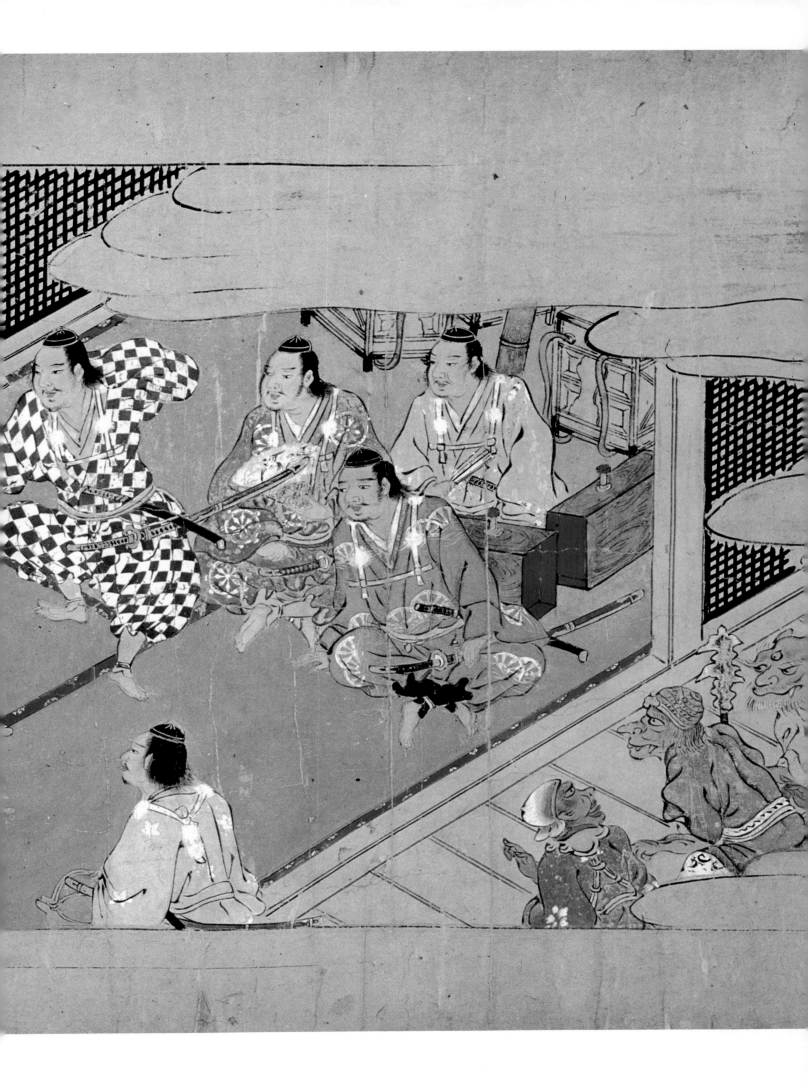

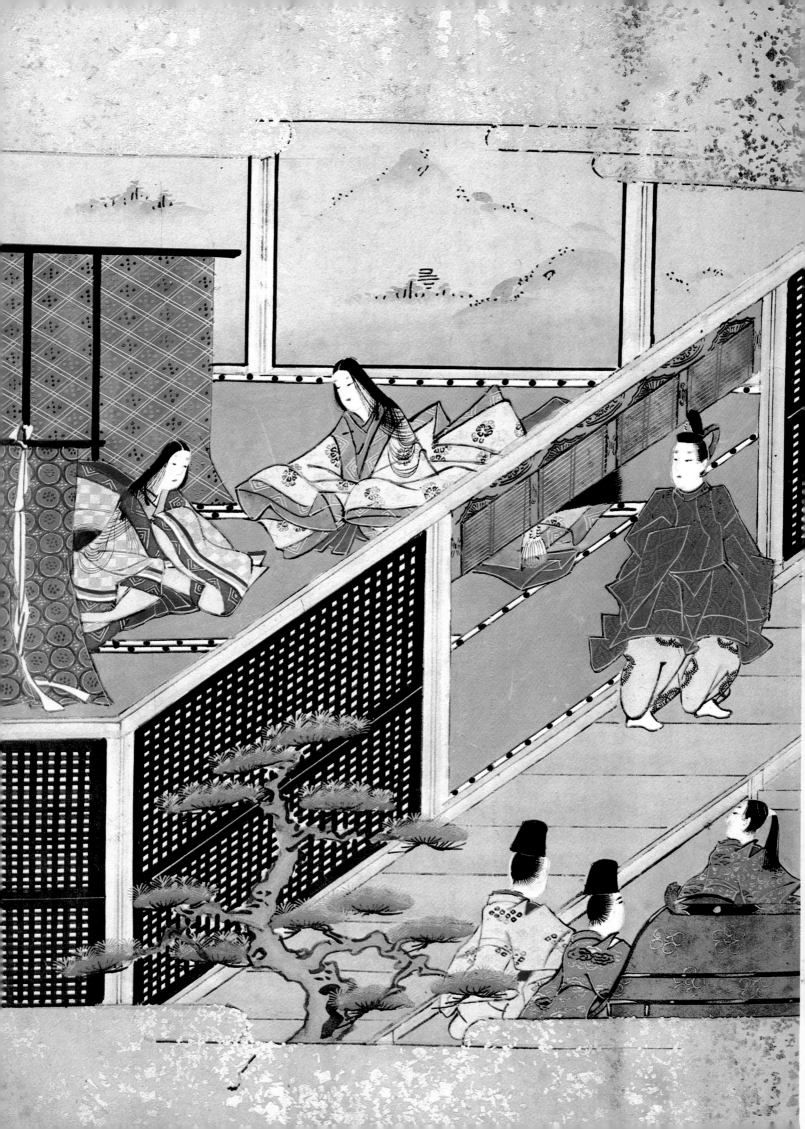

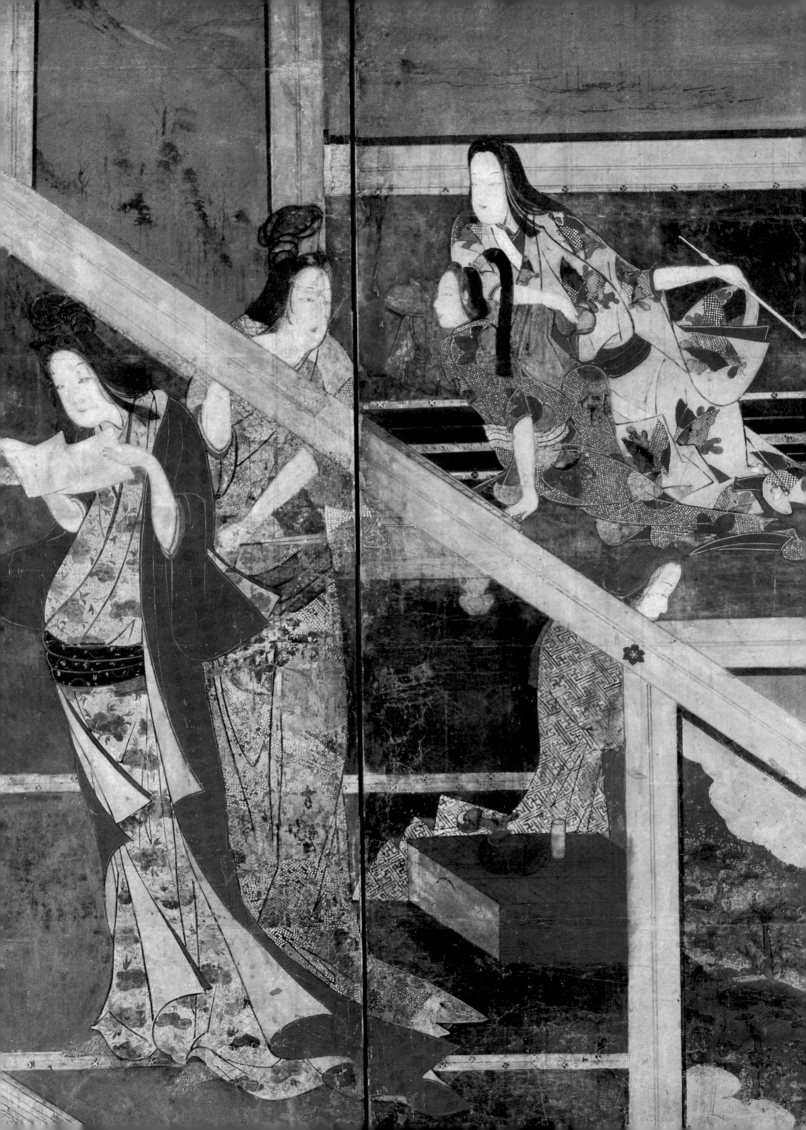

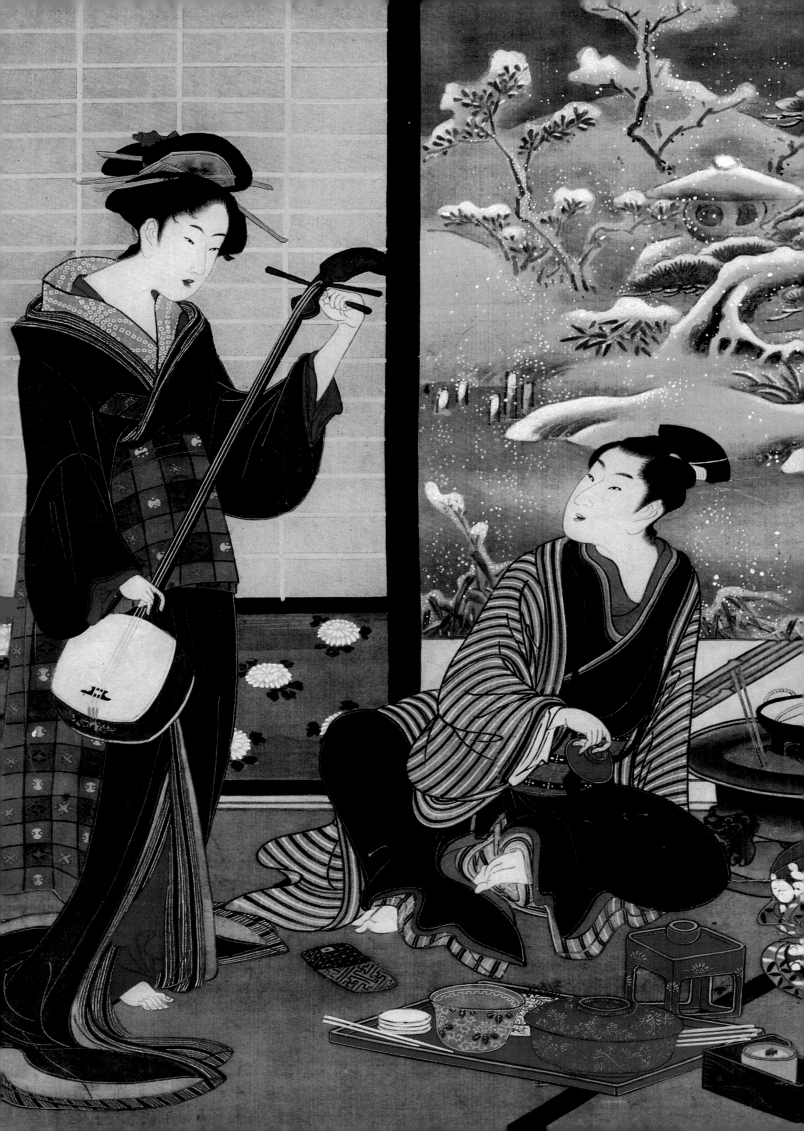

9. CERAMIC ART

9. CERAMIC ART

IT is often difficult for a Westerner to understand and appreciate Japanese pottery. Instead of the flawless uniformity of materials and style that one associates with Chinese ware from the beginning of the Song dynasty, Japanese ceramics exhibit a different concept of perfection or conscious imperfection, as well as a bewildering array of manners and techniques. These emerged in the various centers of creativity that developed under the aegis of feudal lords or prominent monks. Lacking the industrialized production that gave overall consistency and regularity to their Chinese counterparts, they consequently also avoided the pitfalls of standardization. It is this warmth and depth of feeling that give Japanese pottery its inimitable charm.

The potters of the archipelago always sought the gentle, sensory quality of curved surfaces or of glazes having expressive irregularity rather than the attributes deemed essential by Chinese artisans, impeccable uniformity, hardness, and luster. The precise designs in blue underglaze on a good Chinese piece fairly glow from the depths of the material: on a Japanese piece, they seem to float upon the surface, but the loss of depth is offset by the intricate, lively play of colors in the overglaze enamels that are the object's true glory. The surface of the vessel seems merely to support the decoration of the object. Thus the goals of the Japanese potters were not those of their mainland counterparts, even in porcelain.

The master potters of China had been intrigued since ancient times with bronze and jade, materials they considered nobler than ordinary clay or even kaolin, porcelaneous clay. Jade was so highly prized that it has become synonymous with Chinese civilization, though it is not indigenous to China and could be found only in Central Asia. This did not discourage the Chinese, seemingly spellbound by the colors of the gleaming stone, from gray to grayish white and pale ocher to green. Jade, it was said, could prevent bodies from decaying, a belief attested by the fabulous jade burial suits recently excavated at Mancheng (Hebei Province) and other sites.

Chinese potters worked almost like alchemists, obsessed by their desire to create with their own materials a facsimile of this rare and precious substance. The growing popularity of the "tea taste" under the Tang dynasty—tea, too, was green—only

spurred them on. For this reason Chinese ceramic craftsmen, until the Yuan dynasty, channeled their energies into making fine, lustrous, "sonorous" pieces whose color approximated that of jade.

It is highly unlikely that Japanese potters were guided by anything like the same obsession. As a people living in forested lands (not so in China since the Warring States period), the Japanese were fond of simple and natural things. Irregularity, imperfection, unpredictability—these were the qualities they prized in pottery. The aura of modesty surrounding their work seems to recall the attitude of the cathedral builders of Europe, who delighted in incompleteness and asymmetry, it is said, in order to leave to God the glory of perfection. In addition, fire seems to have held an endless fascination for the Japanese, and they referred to the products of the unpredictable union of fire and earth as *yōhen*, or "transformations wrought by fire."

Medieval Japanese ceramics developed in markedly different circumstances from those fostering the creation of China's finest celadons. The latter—at least the best of them—were produced expressly for court use, whereas lacquer was the favored medium of Japanese aristocrats throughout the Heian period, as it had been on the mainland before the Tang dynasty. The real testing ground for Japanese pottery was in the provinces. There craftsmen worked under the aegis of prominent monasteries, and a sense of earnestness and solemnity has always emanated from these works, for through them was conveyed the Buddhist awareness that all things are ephemeral. Runnings and flaws in the glaze were intended to evoke a world in constant movement; irregular shapes guaranteed that no two pieces would be alike, illustrating the Shinto belief that everything is endowed with uniqueness. Probably nowhere were objects more independent of their creators than in Japan.

Ceramic art the world over raises questions that are all the more perplexing for their apparent simplicity. In the course of our discussion of Japanese pottery we shall investigate certain technical matters that will give us a deeper appreciation of its qualities, but we must never lose sight of the substantial gray area that lies between the spark of creative genius that defies analysis and the basic chemical procedures involved in production. Jealously guarded workshop secrets were handed down by a master to only one of his pupils, a custom entirely unaffected by the opening today of certain pottery centers to amateurs anxious to learn the rudiments of the craft. There are always two bodies of knowledge: the "ordinary" tradition taught to average pupils, and the "secret" tradition (the only complete and authentic tradition) bestowed by a master potter upon the disciple he considers his successor, the pupil privileged to keep alive the memory of his teacher through an unbroken chain of creativity.

Any piece of pottery is a vessel made of a clay suitable for building, or for throwing on a potter's wheel. In most cases, this "potter's clay" (*tōdo*) contains or is mixed with quartz, feldspar, aluminium oxide, or some other substance that will "flux" or

soften at a high temperature and thus act as a binding agent. The most celebrated potter's clay is kaolin, having a low iron content and a high proportion of kaolinite, which melts at a high temperature into a white, homogeneous, and almost completely vitreous material. However, the Japanese learned of kaolin's properties or, for that matter, that such a substance even existed, only near the end of the 16th century.

Prior to use, the clay is allowed to rest in water and absorb it until the consistency is that of thick mud; subsequent washing and soaking yield a uniform clay that is free from impurities, and the actual working and throwing of the clay now begins. Once the piece has been shaped, it must be sun-dried or baked in a kiln.

Firing-kilns capable of generating a relatively high temperature first appeared in Japan around the middle of the 5th century. The technique had originated in Korea, and was a model of simplicity. The underground pit-kiln (*anagama*) was a long, narrow corridor (6 to 10 meters long, roughly 1.5 meters wide) with clay-lined walls and ceiling, in shape rather like a bottle lying on its side. There were two openings at each end: a lower aperture through which fire was introduced, and an upper aperture for escaping smoke and flue gas. Generally these kilns were aligned up a hill or manmade slope at no more than a thirty-degree angle.

Some of the larger pit-kilns that have been discovered in Japan date from the 12th century and remained in use until the 16th century. "Oxidizing" fires were the rule during this entire period: hot air was allowed to circulate freely inside the kiln, causing oxygen to react with metallic compounds in the pottery. The quality of the resulting oxides depended on the amount of oxygen and the composition of the clay materials: iron oxides yielded dark brown, copper oxides, dark green, and so forth. In time, potters learned to plug up the openings gradually, thereby regulating the air supply or even cutting it off entirely. With the process of oxidation impeded or completely blocked, the reduction of metals at high temperatures was apt to produce a wider range of chromatic effects, from soft, subtle shades to brilliant hues. This was the so-called "reduced" atmosphere which, in China, made possible the production of celadons.

But for pottery to be nonporous and suitable for holding liquids, it must be coated with a glaze (*yūyaku* in Japanese), that is, a translucent layer of a substance that will tend to vitrify at a fairly high temperature. The depth to which this coating penetrates the body of a vessel depends upon the quality of the clay, and the finest porcelain, when examined in cross section, shows no break whatever between body and glaze. Variously colored slips may also be applied directly on pottery before glazing, depending on the substances used and the heat of the fire.

From the Heian period (9th–12th centuries) to the Kamakura period (13th–14th centuries), the only effects Japanese potters knew how to obtain were from natural ash deposits during firing—the most brilliant pieces were those fired at the very heart of the kiln—or from hand-applied glazes, which were also made with large amounts of

ash. Only in the Kamakura period did feldspathic glazes (*chōseki*), which vitrify at high temperatures, gradually begin to be used.

Potters were using iron oxides by the Muromachi period, extracting them from the iron-rich waters of mountain streams and rice paddies; the procedure consisted simply of washing or soaking pottery in ferruginous water, and is not to be confused with iron-oxide glazes, a Song technique inspired by Cizhou ware which the Japanese did not master until the 16th century.

THE firing process itself is a subject which still gives rise to lively debate. Apparently Japanese potters were quick to master iron-oxide reactions, learning how to regulate and coax the kiln-firing technique into yielding various shades of red and brown. They also discovered the secret of obtaining a jet-black glaze which immediately won the praises of tea enthusiasts: the operation involved pouring a stream of ice-cold air over the pottery as it was being fired. The resulting iron-oxide glaze turned a velvety black that resembled lacquer.

Yet much uncertainty still surrounds the questions of fire and clay. Until the discovery of kaolin in the late 16th century, Japanese potters usually used an ordinary siliceous clay—only rarely the high-firing clay that yields bright colors and thorough vitrification—and apparently they had already restricted themselves to these primitive methods and materials at an early stage of development. Therefore, the diversity of their crude, yet quietly elegant ceramics can only be accounted for by the use of other expedients.

The rich variety of trees blanketing Japan's mountains, for example, was a virtually inexhaustible resource that no doubt enabled potters to maintain intense, long-lasting fires without fear of running out of wood. The ashes of the different woods blended with glazes in unexpected ways, and felicitous effects could also be obtained by blending the slips with varying amounts of lead, gold, or other substances, to lower the temperature at which vitrification occurred.

POTTERY with incised underglaze decoration was first produced in Japan at Seto, a town in Owari Province (modern Aichi Prefecture): hence the name Old Seto ware (*ko-Seto*). Seto craftsmen utilized a technique the Chinese had already perfected for their white Ding and green Yue wares and the celadons of the Tang and Song dynasties.

The earliest Seto pieces—unpretentious coiled pottery smoothed on the wheel and decorated with designs reminiscent of Song ceramics—date from the 13th century, or perhaps earlier; some scholars have even proposed that Japanese potters, inspired by the success of white ceramics in China (especially among tea enthusiasts, monks, and intellectuals), were producing a white ware of their own as early as the Heian period. Indeed, no sooner did *samurai* and Japanese monks discover the virtues of tea than they probably began to use vessels designed expressly for it.

The two-fold stimulus of imperial and monastic commissions doubtless had

much to do with the gradual improvement and refinement of these drinking bowls, which were produced at the Higashiyama kiln east of Nagoya as well as throughout Hokuriku and Tōhoku. Though quite different in style from Chinese tea ware, they eventually rivaled their mainland models in quality, and some scholars have gone so far as to propose a direct link between Seto ware and Chinese ceramics. According to this school of thought, Dōgen (1200–1252), founder of the Sōto sect of Zen Buddhism, traveled to China in 1223 with a potter named Katō Shirōzaemon Kagemasa, who returned five years later with skills that were immediately put to use in Japan. In this case, Shirōzaemon would have been the first potter to find Seto rich in suitable clay and to settle there.

Notwithstanding a number of distorted or specious details, this "international" argument has the virtue of being logical and coherent in art historical terms. Other scholars, however, subscribe to a narrower "nationalist" hypothesis, according to which Ko-Seto ceramics appeared spontaneously in the middle of the Kamakura period, the innovative Seto glaze (mixed with ash or produced by natural ash deposits inside the kiln) resulting from a chance occurrence. This view is held by Akatsuka Mikiya (Kanya), Miyaishi Munehiro, and many other Seto potters. The truth probably lies somewhere between the two hypotheses, since Chinese potters also discovered that natural ash deposits inside kilns abetted vitrification. (Indeed, potters the world over must have had the same experience at one time or another). However, one cannot easily disregard the priority of Chinese ceramics and the relationship with Japanese ware, however distant, that must have existed.

For the most part, the kilns at Seto produced plump jars covered with a greenish or brownish glaze (fig. 170). Decoration was in relief (rosettes and thick lines between registers) or, more often, by designs incised under the glaze. The latter ranged from fish and chrysanthemums to Chinese-style blossoms or Japanese-style wild grasses. In some cases the decoration was no more than a simple votive or commemorative inscription traced with a stylus. At first glance, Old Seto pieces seem crude indeed compared with the chaste perfection of Chinese pottery, and it is tempting to dismiss them as the clumsy attempts of artisans who had not mastered the subtleties of firing. Yet in all fairness, their degree of technical backwardness should not be allowed to overshadow entirely a sensitive perception of their merits.

No real understanding of Japanese pottery can develop without mention of the controversy surrounding the noblest liquid it ever was to contain: tea. The coarse ceramics being made in Japan at the time were probably considered ill-suited to the tea ceremony during its early, more elaborate phase, and consequently people imported tea-ceremony "services" from China. The Japanese showed great enthusiasm for mainland wares, including conical bowls (*temmoku*) that seemed to capture the entire universe in their iridescent, softly scintillating glaze. But when Sen-no-Rikyū introduced a less

ostentatious approach to the tea ceremony, its votaries turned to Korean ware, which blended technical sophistication with a simplicity in keeping with the nascent "tea architecture" of Japan.

Suddenly, Japanese pottery entered its golden age—a creative period as concentrated in space as it was in time. For a few brief decades, the Gifu region became the focus of diverse styles immortalized by the names of the kilns that created them: Shino, Mino, Oribe, Iga, Bizen. No less noteworthy were the celebrated "Raku" tea bowls of Kyoto (figs. 171, 172, 529).

These thickly glazed, brownish-black bowls, though deservedly renowned, defy analysis. The simple procedure devised by a Kyoto potter named Chōjirō (1516–1592) involved a quick firing (less than an hour) at a low temperature of between 600 and 700 degrees Celsius. The bowls were immediately acclaimed as embodiments of the lofty ideals set forth by Sen-no-Rikyū and dubbed *Rikyū-chawan,* or "Rikyū bowls." They were also referred to as *ima-yaki* ("pottery of now"), for they replaced the comparatively opulent Chinese ware in use not long before. Finally they were given the name Raku ("joy," i.e., "the capital") after the mark stamped on the foot.

In what lay the superb quality of Raku ware? It was the careful consideration of its makers both to depth of color and to the way a tea drinker touches the vessel at several crucial points in the ceremony: the texture of the bowl's unglazed foot, the glazed rim that is brought to the lips, the body he cradles in his hands. In addition to these immediate sensations, five other essential qualities were to be appreciated. The glow of subtle half-tints had to be in keeping with the tea-ceremony precept of *wabi-sabi,* or shape, for a bowl was supposed to create an impression of boldness and majesty despite its small size. The color of the glaze had to bring an infinite variety of shades into a deliberately restricted range of hues. Weight and design: the bowl was supposed to slip gently into the drinker's hands without seeming either too heavy or too light. And the conductivity of a bowl would cool the steaming tea while transmitting a pleasant warmth to the hands.

Nor were these all the attributes a sophisticated tea drinker looked for and appreciated in a bowl. Was the uneven rim, shaped off of the potter's wheel, pleasing to the eye? Did it, for example, remind him of the five peaks of the Sacred Mountains in China? Did it meet the lips in a comfortable manner? The shape of the foot was equally crucial, for it alone determined how the bowl "sat." In addition, the lower part of the body had to be modeled in a way that ensured a proper feel when held in the hands.

The interior of the vessel was as important as the exterior. After the tea had been drunk, the bit of liquid remaining in the slight depression (*cha-damari*) at the bottom of the bowl was supposed to look like a raindrop on a stone once the rain has ended, and if the *cha-damari* looked too contrived, the effect was lost. Finally, the inner walls of the bowl had to flare out toward the bottom, not only to accentuate the bowl's depth but to allow the tea whisk to move about freely inside. Any interference while mixing the powder with boiling water might affect the quality of the tea.

How did the Japanese first become aware of the properties of kaolin, and what led to the finding of kaolin deposits on Japanese soil in the late 16th century? Like all simple discoveries, the first stages of porcelain making are veiled in mystery, and only one thing is sure: the Japanese were intrigued at this time by Chinese and Korean prototypes, and determined to create comparable ware themselves. We also know that the development of this new type of pottery grew in large part from the patronage (and, at times, tyrannical demands) of *daimyō*. Any discussion of Kyūshū porcelain must include the Nabeshima *daimyō* family, of Hizen Province. All too often the fact is overlooked, that even before the style was conceived that eventually blossomed into some of Japan's most breathtaking pottery, the Nabeshima patrons were lavishing their support on anyone within their jurisdiction who made high-quality porcelain. And the Nabeshima were more than patrons: they actually helped to establish the course of experimentation and production.

The discovery of kaolin in 1592 in the Arita region is attributed to a potter by the name of Ri Sampei, a Korean whom Nabeshima Naoshige (1537–1619) had brought back among his prisoners from the second Korean campaign. Then throughout the 17th century, the Nabeshima subsidized the kilns in which the earliest Imari (*shoki Imari*) was made, as well as the works of a family, the Tsuji, which the Nabeshima traditionally offered to the imperial court; the imperial archivists registered all such gifts under the general heading of "Arita pottery," which complicates the task of identification that art historians face today.

The earliest of all Japanese porcelain, called Kakiemon ware, came into being when a person known only by his dates, 1596–1666, met Takahara Goroshichi, a potter who had probably emigrated from Korea and settled at the Nangawara kiln around 1624. Porcelain attributed to Goroshichi has decoration only in blue underglaze, but the so-called Kakiemon, with the help of Toshima Tokuemon, took what he had learned from Goroshichi and also, perhaps, a Chinese potter living in Nagasaki, and devised a technique for polychrome overglaze decoration on porcelain.

The workshop quickly prospered. Its account books for 1646 record sales of "Kakiemon" porcelain to Dutch customers as well as to Japanese from Kaga Province (modern Ishikawa Prefecture), buying for the Maeda family. A shipment of nearly 45,000 Kakiemon pieces reached Holland eighteen years later (1664). Demand at home and abroad became so great that copies and counterfeits appeared in ever-increasing numbers, even within the Kakiemon sphere: in 1662 a potter living at Akaemachi is said to have enticed away the most gifted associates of the Kakiemon family and tapped their skills to produce forgeries. Clients, however, kept a safe distance from these disputes: in their desire for fine porcelain they were satisfied with appreciating the delicacy and "feel" of a Kakiemon design even if the piece had not actually emerged from a Kakiemon kiln. The Meissen factory in Germany was established in 1710 for the express purpose of copying this superb Japanese porcelain.

The hallmark of Kakiemon ware is the qualitative balance of the three principal colors used in its decoration: blue, red, and green; other signs of a good Kakiemon piece are its slender shape and originality in the use of conventional floral motifs, either set

370

within patterned spaces or splashed against an empty background (figs. 531, 533). It was not until the end of the 17th century that another member of the Kakiemon family, Shibuemon, came up with more geometric designs and those glossier, milkier glazes known as *tōfu*, a somewhat humorous allusion to their resemblance to bean curd. Throughout the 18th century, the Kakiemon workshops remained more open to influences from other Arita kilns, just as the latter felt the impact of Kakiemon creativity. A conspicuous example is the unprecedented adoption of gold and purple highlights, never found on early Kakiemon ware.

THERE is general agreement that so-called Nabeshima ware first appeared in 1722, around the time the Okōchi kiln between Arita and Imari was becoming a major porcelain center.

The innovations of the Okōchi potters were less in what they depicted (mostly flowers and a few fantastic animals borrowed from Chinese imagery) as in the remarkably bold conceptions of their designs. They approached porcelain decoration as if it were painting, covering the entire surface of a piece with a single motif (figs. 523–25). Their liberal use of available space produced an effect not unlike that of classic Chinese flower painting, but the deep colors of Nabeshima designs always burst with a joyous vigor of inspiration that is uniquely and unmistakably Japanese.

Nabeshima ware differs from the work of, say, Kōrin (1658–1716) or Ninsei (17th century) in possessing a heightened sense of naturalness, a rustic flavor absent in the work of those great potters from the capital (figs. 175, 510, 512, 514, 515, 527, 528, 532). Shall we ascribe this to "provincial" ingenuousness or to the influence of Chinese naturalistic painters on a school that was very active in Nagasaki at the time? The Nabeshima palette, limited to three basic colors (red, yellow, green), also fostered a stylized approach that let the "earthen" quality of the ceramic object come through: it was not treated like painting on porcelain, so often the case in China.

Produced exclusively for *daimyō* use, Nabeshima ware became in every respect the *ne plus ultra* of Arita porcelain. The quality of raw materials; the blue underglaze, sometimes deep and dark, but more often pale and delicate; the snowy white glaze, free from both the milkiness of Kakiemon ware and the greenish cast so typical of Imari "export ware"; the motifs carefully rendered in underglaze blue and overglaze enamel; the use of raised surfaces to suggest depth—everything conspires to create an impeccably designed art form of matchless beauty.

MORE familiar to foreigners is Imari porcelain, which was turned out in massive amounts for the Japanese middle class and, above all, the foreign market. It should come as no surprise that this ware is considerably less accomplished than are the Nabeshima pieces.

In defining Imari porcelain, one notes that the word Imari is merely the name of the Kyūshū port from which many different Arita wares were exported to the West,

and that characteristics must be sought which are common to the majority of merchandise shipped through Imari from the archipelago and throughout the world.

Brightly decorated Imari ware makes generous use of red and blue designs, often with gold highlights and set within brocade-like compartments (*nishikide*). These pieces exude a feeling of lavishness and extravagance that is the antithesis of both the knightly ideal of austere reserve and the tasteful splendor favored by courtly society. But there is nothing mysterious about this incongruity, for Imari ware was intended for neither *samurai* nor aristocrats, but for the rising class of *chōnin* that lived in the great commercial centers of Japan—hardworking and business-minded, the lives of this jovial group were free from the moral codes that shackled the nobles and knights.

Most Imari porcelains that we see are pieces of pedestrian "export ware"; if a fair assessment is to be made, we must select examples for evaluation that were intended for use in Japan. A number of respectable 17th-century Imari pieces resemble the Kakiemon manner; even with their gold highlights, they radiate a blithe, gentle freshness that is closer in spirit to primitive Japanese earthenware than to porcelain.

The more dazzling, "showier" examples of Imari ware still tend to preserve a chromatic balance that is the hallmark of superior porcelain. In such cases, Imari potters exploited the gamut of techniques handed down to them by Ming artisans, from joyous contrasts of red and green to sumptuous gold designs on a red ground (*kinran-de*). They paid further homage to their mainland precursors by dating their work according to Chinese eras. This is not to be interpreted as a deliberate attempt to mislead porcelain enthusiasts, but as a heartfelt desire on the part of Japanese craftsmen to acknowledge their source of inspiration. The practice of decorating insets and background areas with repeated geometric patterns was decidedly un-Chinese, yet it met with such success outside the archipelago that eventually things had come full circle: the Chinese themselves started to copy the "Imari style."

At first produced almost exclusively in northern Kyūshū, Japanese porcelain soon spread northward into the heartland of the empire—to Kutani (Kaga Province), not far from Kyoto. The *daimyō* of Kaga Province, the Maeda family, apparently acquired early a taste for porcelain, since family archives mention purchases of Kakiemon ware in 1646. Some twenty years later, during the Manji era (1658–1660), they sent a man named Gotō Saijirō to Arita, on a mission to learn the secret of making the flawless pottery for which the region was becoming famous. Did Saijirō obtain his information by actually spying on Arita workshops? Or did he wrest the secrets from a Chinese potter from Nagasaki, as is traditionally believed? The latter seems plausible in light of the unmistakably Chinese flavor of many Kutani designs, although technical and industrial espionage between fiefs was a common practice during this period of burgeoning economic growth.

A number of characteristics distinguish Kutani ware from pieces made on Kyūshū: a comparative lack of gaiety in spite of lively colors, a degree of stiffness with respect to draftsmanship, and above all a tendency to use Chinese-style landscapes in the Kanō

manner. Furthermore, Kutani potters limited their palette to violet, bluish green, greenish yellow, and dark pink. Designs were outlined in brownish black. In its overall feeling of austere splendor, earnestness, and restraint, with only a touch of ostentation, Kutani ware captures the spirit of the feudal lords who ruled Japan at the time. Experts refer to these pieces as "Old Kutani" (ko-Kutani), for production came to a sudden halt when the direct line of descent in the Maeda family died out (figs. 173, 174, 516–18).

It is all the more startling that the Kutani kilns should be turning out porcelain today, and with such vigor. This began in 1806 when a famous Kyoto potter, Mokubei, and a friend of his from Hizen Province, Honda Sadakichi, traveled to Kutani, revived the fashion for Kutani porcelain, and passed their expertise on to their pupils, Aoya Genemon and Toyoda Denemon. The success of the Kutani workshops was meteoric, albeit sometimes at the cost of lower quality. By the early 20th century, the use of industrial enamels imported from Germany led to establishing factories in place of the earlier kilns, and today the Kutani factory is one of the most prosperous in Japan. But the fiery glow of the venerable kilns at Seto, Bizen, and Karatsu has not been dimmed: their aesthetic aims remain the same, even if huge mounds of pinewood have given way to gas or electricity. Fortunately for us, the potters of Japan, torn between two extremes, waver to this day and continue to produce a wide range of ceramics of high quality.

165 CHEST FOR SHAWL, WITH MARINE MOTIFS
Lacquer and gold powder (maki-e), *11.5 × 47.8 × 39 cm.*
Heian Period, first half of 10th century.
Kyōōgokokuji (To-ji Treasure House), Kyoto

166 SUTRA BOX DECORATED WITH A BUDDHIST LEGEND
Lacquer with gold inlay, 16.5 × 32.7 × 23.3 cm.
Heian Period, late 10th century.
Fujita Art Museum, Ōsaka

167 BOX WITH HALF-WHEEL DECORATION
Lacquer and gold powder (maki-e), *with mother-of-pearl*
inlay, 13 × 22.5 × 30.5 cm.
Heian Period, 11th century.
Tokyo National Museum

168 WRITING DESK
By Honami Kōetsu (1558–1637).
Lacquer and gold, 11.8 × 24.2 × 22.6 cm.
Edo Period.
Tokyo National Museum

169 ASHIYA KETTLE WITH DEER MOTIF
Cast iron, height 19.3 cm., diameter 21.2 cm.
Kamakura Period, 13th century.
Fujita Art Museum, Ōsaka

170 TEA JAR, SETO WARE
Stoneware, height 9.6 cm.
Muromachi Period, 14th–16th century.
Fujita Art Museum, Ōsaka

171 VESSEL FOR EMBERS, SHINO WARE
Stoneware, height 7.9 cm.
Momoyama Period, late 16th–early 17th century.
Fujita Art Museum, Ōsaka

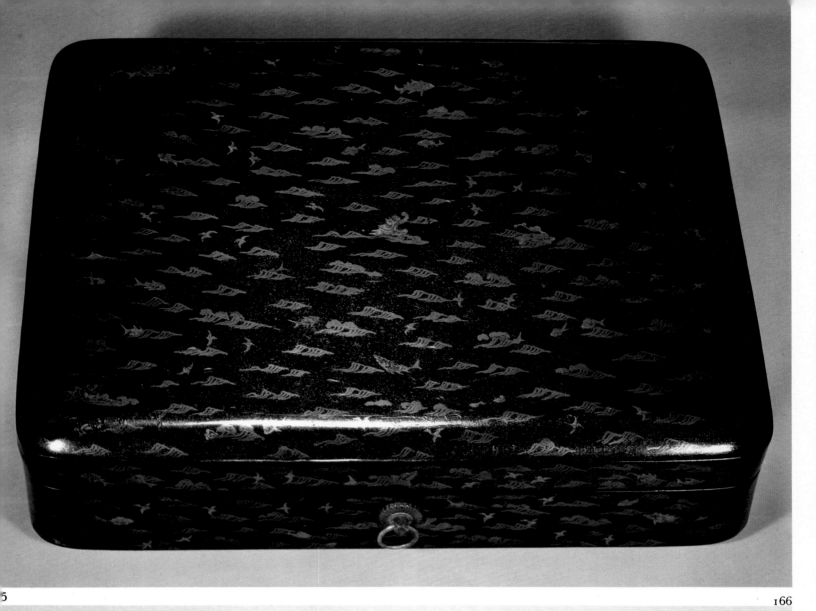

170

171

173

174

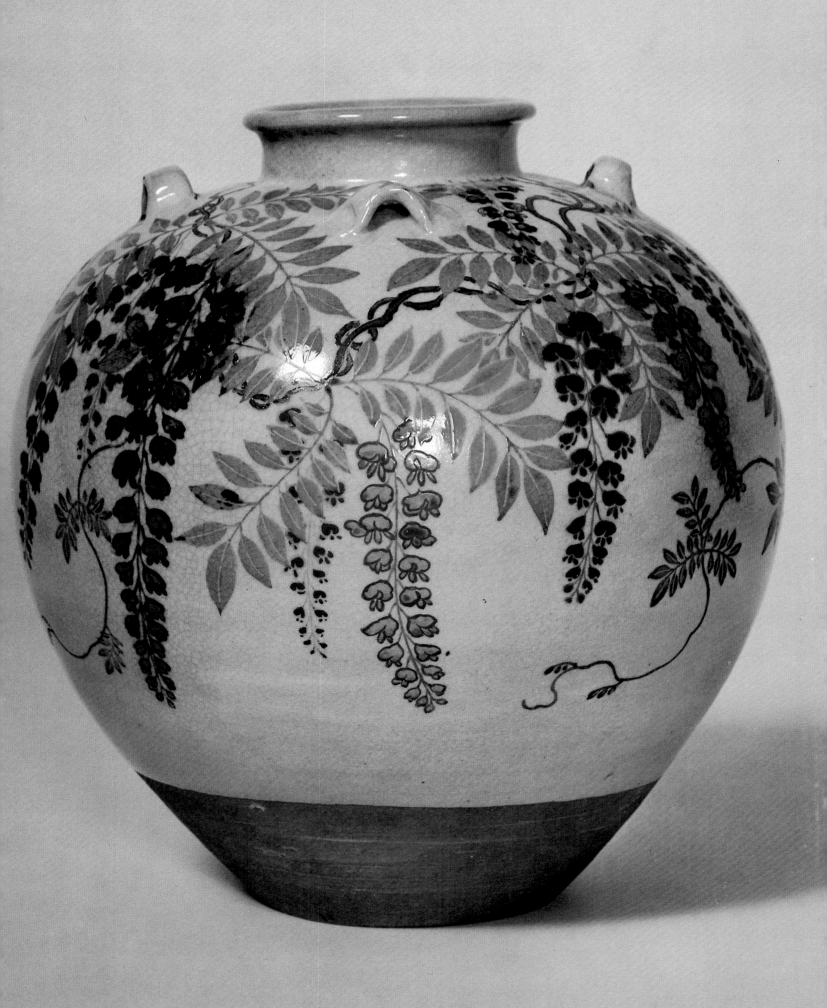

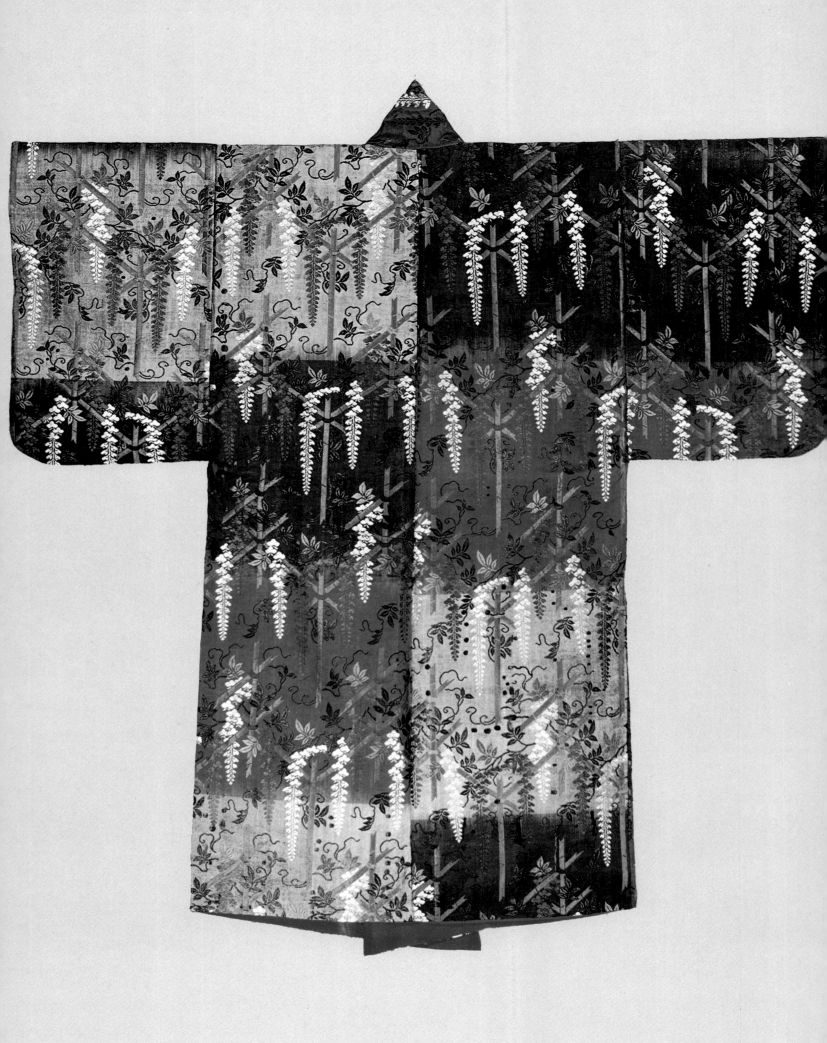

172 VESSEL WITH PERSIMMON MOTIF, KARATSU WARE
Stoneware, height 17.1 cm.
Momoyama Period, 16th century.
Idemitsu Art Gallery, Tokyo

173 PLATE WITH BIRD MOTIF, KO-KUTANI:
OLD KUTANI WARE
White porcelain, diameter 42.7 cm.
Edo Period, 17th century.
Tokyo National Museum

174 PLATE, KO-KUTANI: OLD KUTANI WARE
White porcelain, diameter 40.5 cm.
Early Edo Period, 17th century.
Asian Art Museum, San Francisco

175 VESSEL WITH WISTERIA MOTIF
By Ninsei (Nonomura Seiemon, d. c. 1660).
Stoneware with multicolored overglaze enamels,
height 29 cm.
Edo Period.
Kyūsei Hakone Art Museum, Hakone

176 NŌ COSTUME WITH WISTERIA MOTIF
Kara-on cloth, height 1.5 m.
Edo Period, 17th–18th century.
Fujita Art Museum, Ōsaka

PART TWO: DOCUMENTATION

10. DOCUMENTARY PHOTOGRAPHS

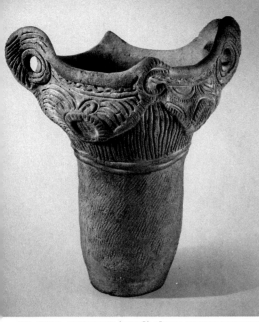

177 VESSEL. TERRACOTTA (KANTŌ). JŌMON, 1ST MILLENNIUM B.C.

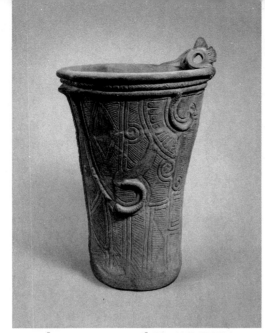

178 VESSEL. TERRACOTTA. JŌMON, 3RD CENTURY B.C.

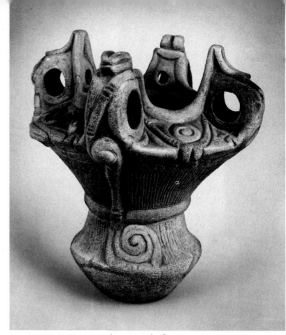

179 VESSEL. TERRACOTTA (TAKIKUBO). JŌMON, 1ST MILLENNIUM B.C.

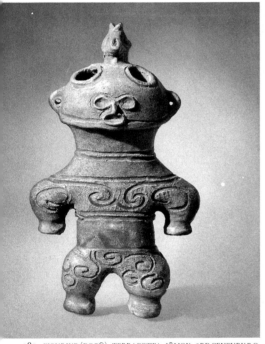

180 FIGURINE (DOGŪ). TERRACOTTA. JŌMON, 3RD CENTURY B.C.

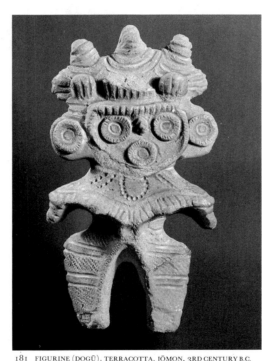

181 FIGURINE (DOGŪ). TERRACOTTA. JŌMON, 3RD CENTURY B.C.

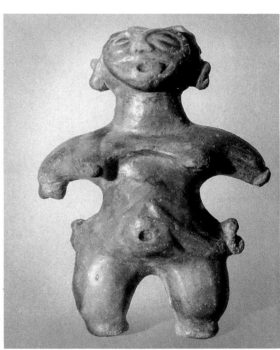

182 FIGURINE (DOGŪ). TERRACOTTA. JŌMON, 3RD CENTURY B.C.

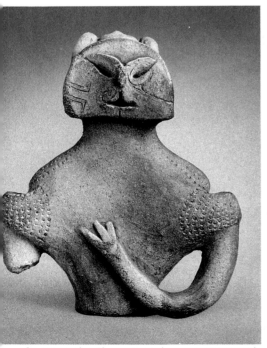

183 FIGURINE (DOGŪ) TERRACOTTA (YAMANASHI PREFECTURE). JŌMON, 3RD CENTURY B.C.

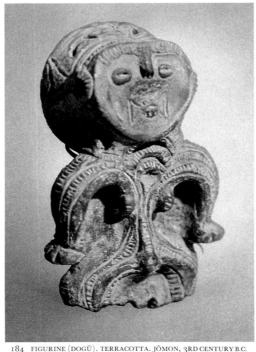

184 FIGURINE (DOGŪ). TERRACOTTA. JŌMON, 3RD CENTURY B.C.

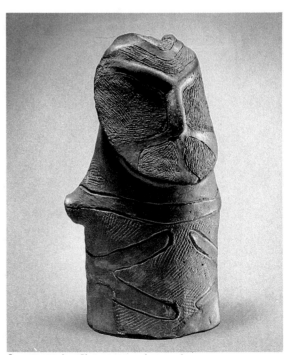

185 FIGURINE (DOGŪ). TERRACOTTA (UENOJIRI). YAYOI, 1ST CENTURY B.C.—1ST CENTURY A.D.

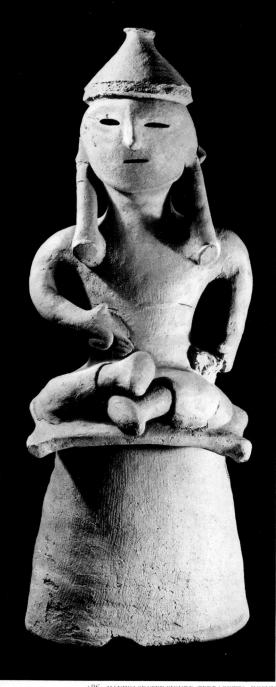

186 HANIWA SEATED FIGURE. TERRACOTTA. KOFUN, 4TH–6TH CENTURY A.D.

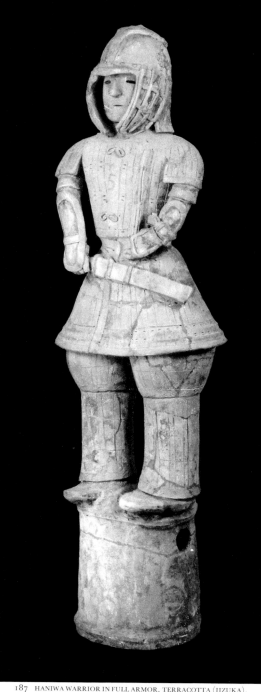

187 HANIWA WARRIOR IN FULL ARMOR. TERRACOTTA (IIZUKA). KOFUN, 4TH–6TH CENTURY A.D.

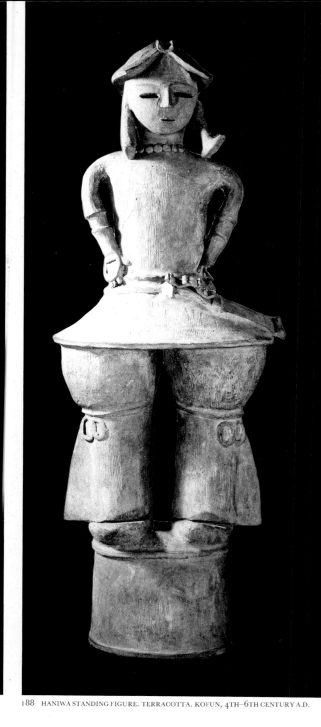

188 HANIWA STANDING FIGURE. TERRACOTTA. KOFUN, 4TH–6TH CENTURY A.D.

189 SUEKI VESSEL. TERRACOTTA. KOFUN, 4TH–6TH CENTURY A.D.

190 HANIWA HORSE. TERRACOTTA. KOFUN, 4TH–6TH CENTURY A.D.

191 HANIWA HOUSE. TERRACOTTA (MIYAYAMA). KOFUN, 5TH CENTURY A.D.

192 MIRROR WITH ABSTRACT AND ANIMAL MOTIFS. BRONZE. 4TH–9TH CENTURY A.D.

193 MIRROR WITH STYLIZED ANIMALS. BRONZE (MIYANOSU KUDAMATSU). KOFUN, 4TH–6TH CENTURY A.D.

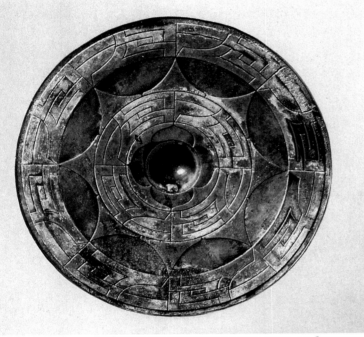

194 MIRROR WITH CHOKKOMON DESIGNS. BRONZE. KOFUN, 4TH–6TH CENTURY A.D.

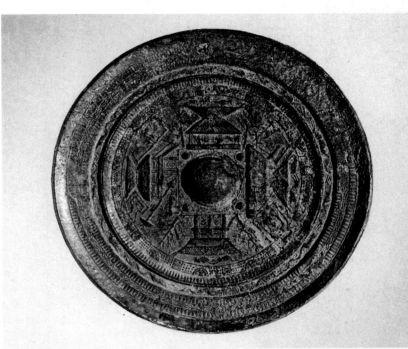

195 MIRROR WITH HOUSE MOTIF. BRONZE. KOFUN, 4TH–6TH CENTURY A.D.

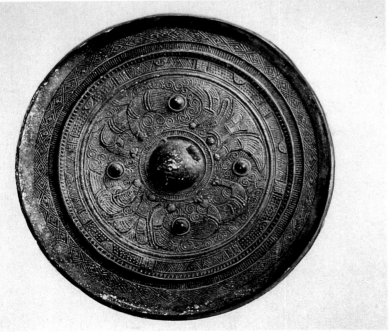

196 MIRROR WITH STYLIZED FIGURES. BRONZE. 4TH–9TH CENTURY A.D.

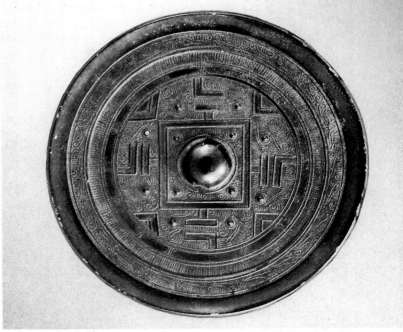

197 MIRROR WITH "TLV" DESIGN. BRONZE. 4TH–9TH CENTURY A.D.

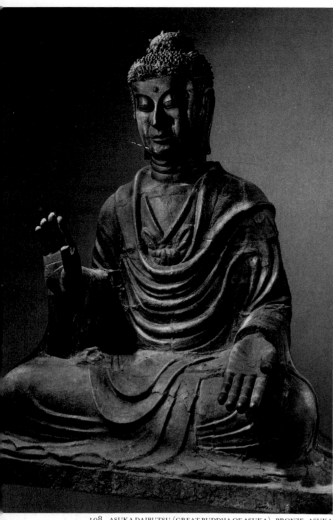

198 ASUKA DAIBUTSU (GREAT BUDDHA OF ASUKA). BRONZE. ASUKA, 6TH–7TH CENTURY A.D.

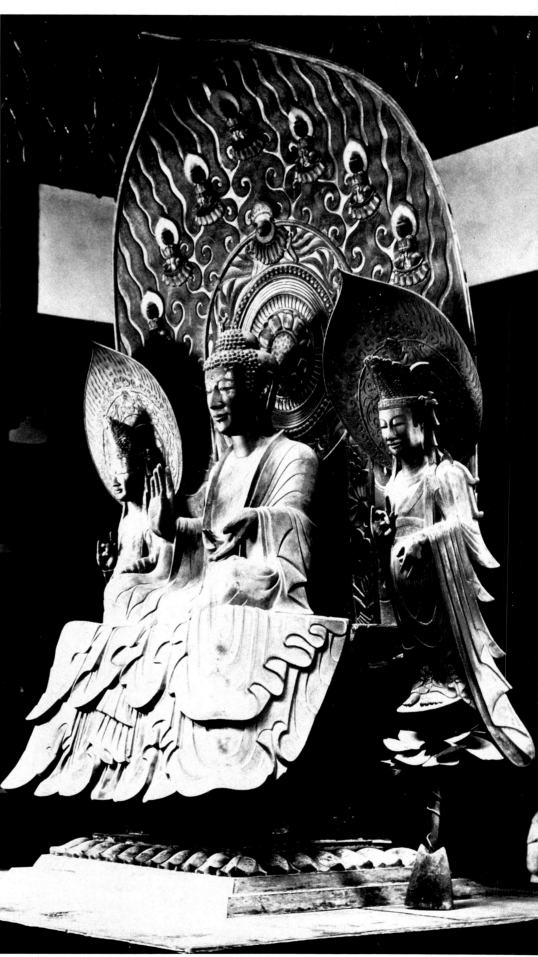

200 TORI (FL. EARLY 7TH CENTURY): SHAKA TRIAD. GILT BRONZE. ASUKA, 623 A.D.

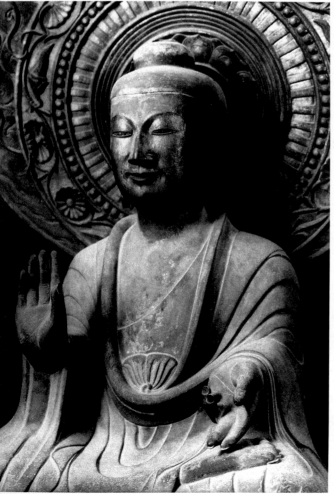

199 TORI? : YAKUSHI NYORAI (BHAISAJYAGURU). BRONZE. ASUKA, 607 A.D.

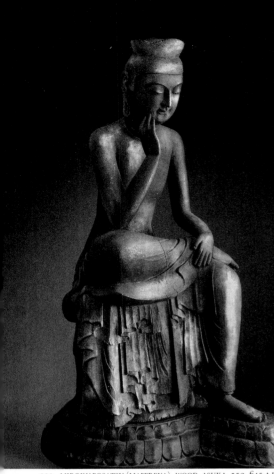

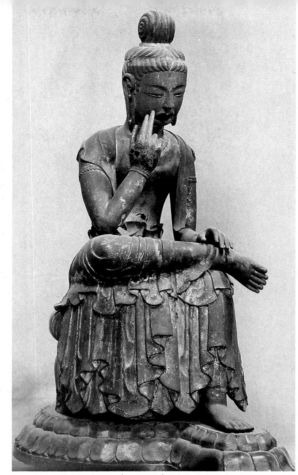

201 MIROKU BOSATSU (MAITREYA). WOOD. ASUKA, 552–645 A.D.

202 MIROKU BOSATSU (MAITREYA). WOOD. ASUKA, SECOND HALF 7TH CENTURY A.D.

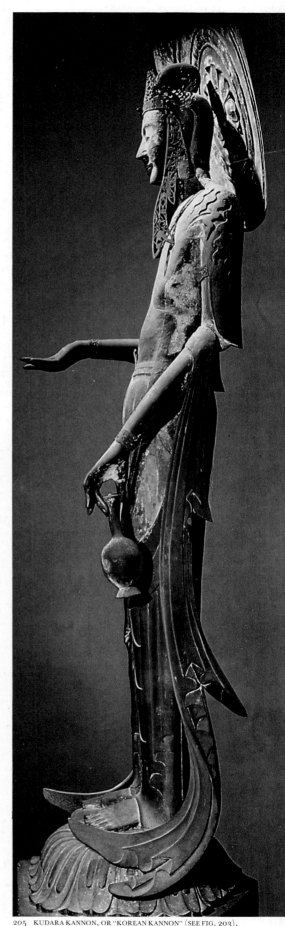

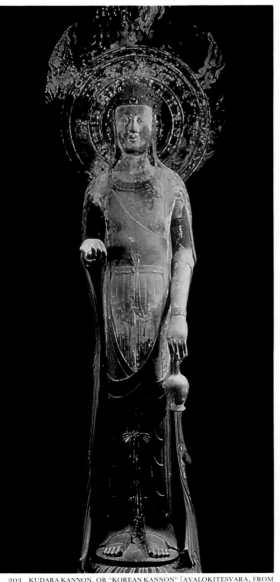

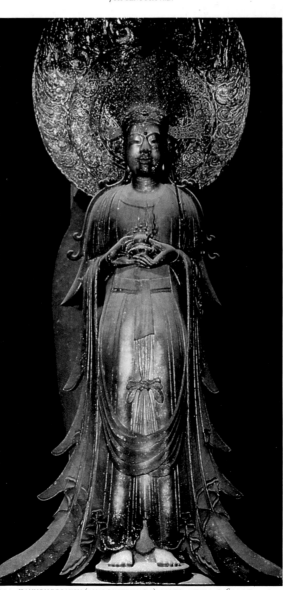

205 KUDARA KANNON, OR "KOREAN KANNON" (SEE FIG. 203), PROFILE. WOOD. ASUKA. MID-7TH CENTURY A.D.

203 KUDARA KANNON, OR "KOREAN KANNON" (AVALOKITESVARA, FROM KUDARA OR PAEKCHE, KOREA): FRONT. WOOD. ASUKA, MID–7TH CENTURY

204 KANNON BOSATSU (AVALOKITESVARA). WOOD. ASUKA, C. 624 A.D.

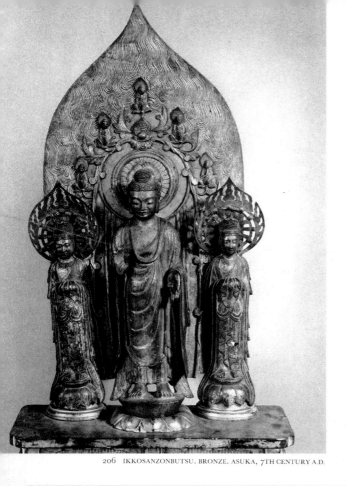

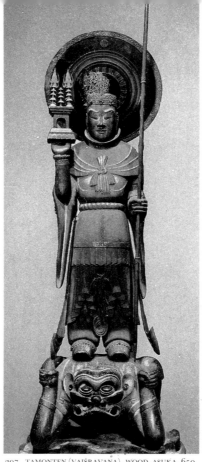

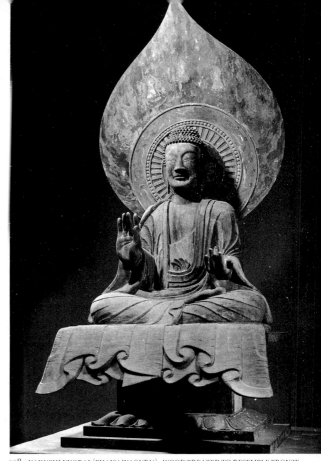

206 IKKOSANZONBUTSU. BRONZE. ASUKA, 7TH CENTURY A.D.

207 TAMONTEN (VAIŚRAVAŅA). WOOD. ASUKA, 650

208 YAKUSHI NYORAI (BHAISAJYAGURU). WOOD TREATED TO RESEMBLE BRONZE. ASUKA, 7TH CENTURY A.D.

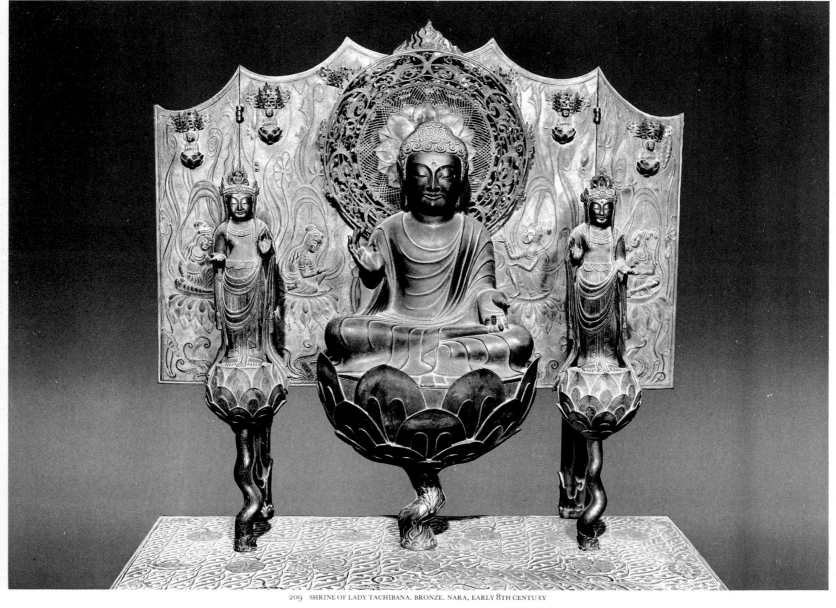

209 SHRINE OF LADY TACHIBANA. BRONZE. NARA, EARLY 8TH CENTURY

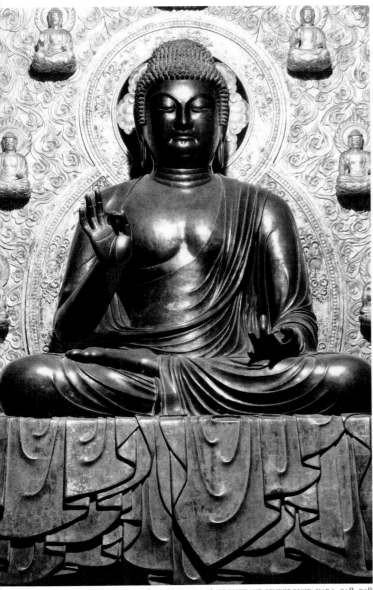

210 YAKUSHI NYORAI (BHAISAJYAGURU). BRONZE AND GILT BRONZE. NARA, 718-728

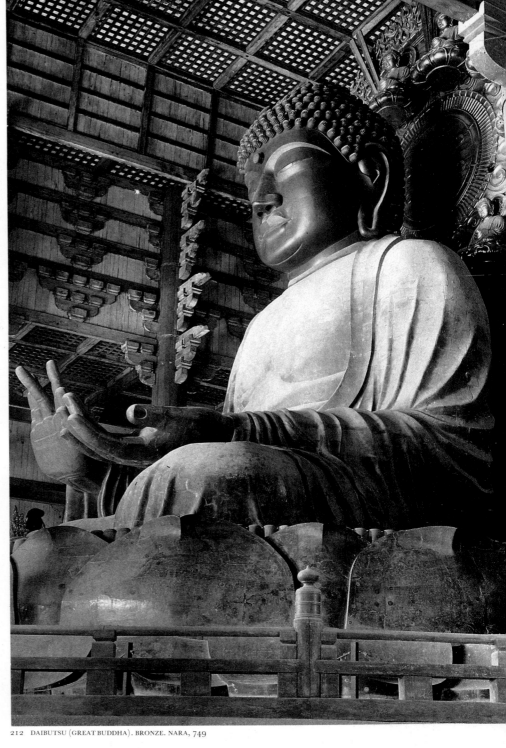

212 DAIBUTSU (GREAT BUDDHA). BRONZE. NARA, 749

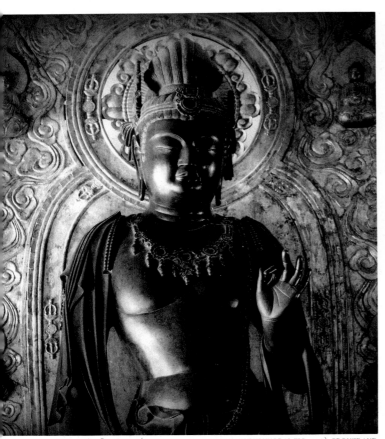

211 GAKKŌ BOSATSU (ATTENDANT AT LEFT OF YAKUSHI NYORAI: FIG. 210). BRONZE AND
GILT BRONZE. NARA, 8TH CENTURY

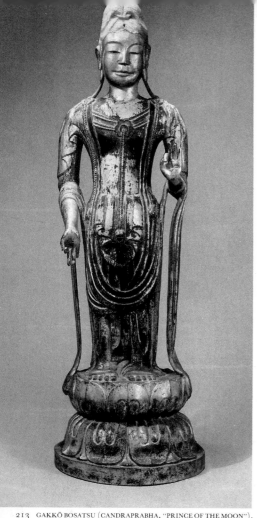

213 GAKKŌ BOSATSU (CANDRAPRABHA, "PRINCE OF THE MOON"). WOOD. ASUKA, 7TH CENTURY A.D.

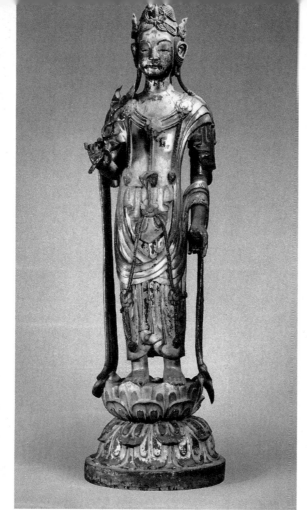

214 SEISHI BOSATSU (MAHĀSTHĀMAPRĀPTA). WOOD. ASUKA, 7TH CENTURY A.D.

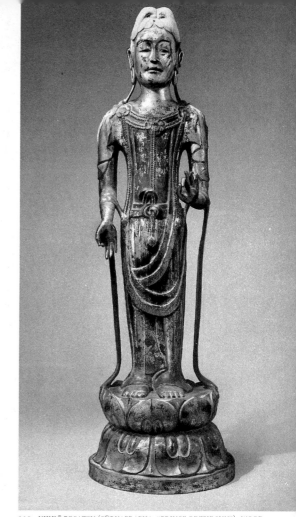

215 NIKKŌ BOSATSU (SŪRYAPRABHA, "PRINCE OF THE SUN"). WOOD. ASUKA, 7TH CENTURY A.D.

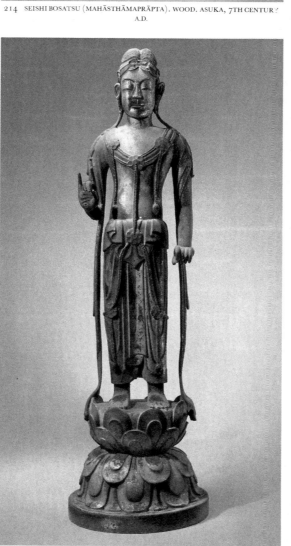

216 KANNON BOSATSU (AVALOKITEŚVARA). WOOD. ASUKA, 7TH CENTURY A.D.

217 FUGEN BOSATSU (SAMANTABHADRA). WOOD. ASUKA, 7TH CENTURY A.D.

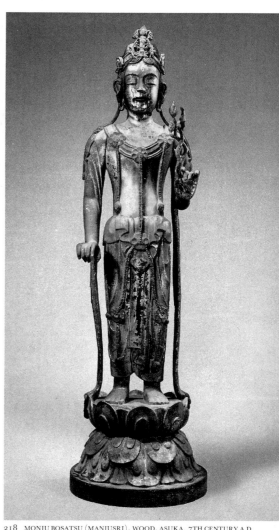

218 MONJU BOSATSU (MANJUŚRI). WOOD. ASUKA, 7TH CENTURY A.D.

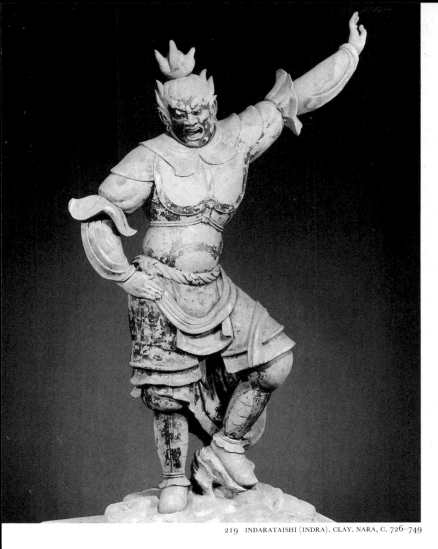

219 INDARATAISHI (INDRA). CLAY. NARA, C. 726–749

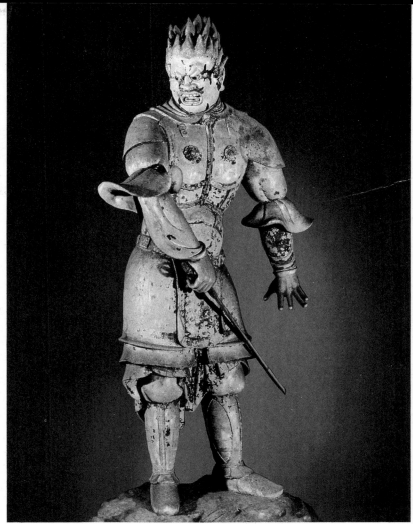

220 BAZARATAISHO (VAJRA). CLAY. NARA, 8TH CENTURY

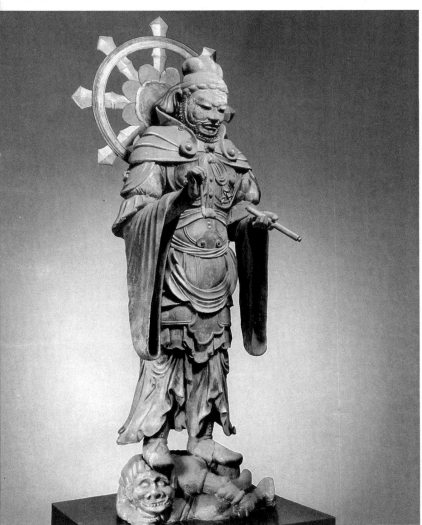

221 KŌMOKUTEN (VIRŪPĀKSA). DRY LACQUER. NARA, SECOND HALF 7TH CENTURY

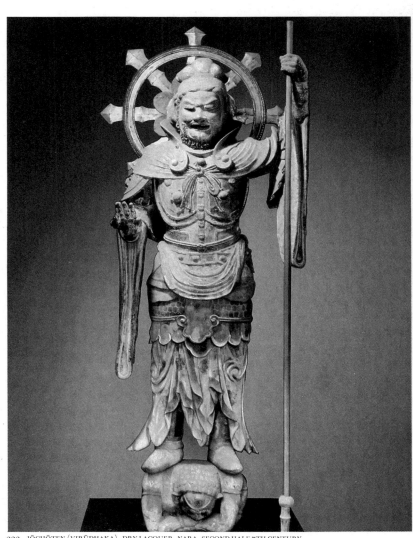

222 JŌCHŌTEN (VIRŪDHAKA). DRY LACQUER. NARA, SECOND HALF 7TH CENTURY

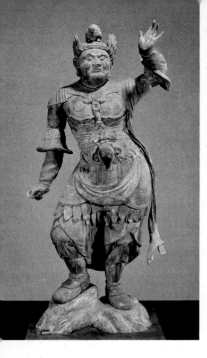 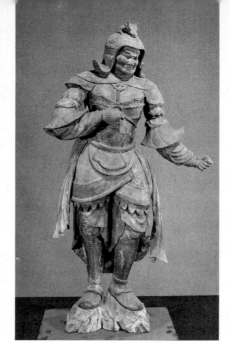 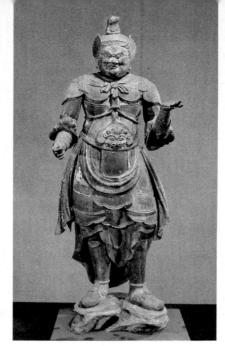 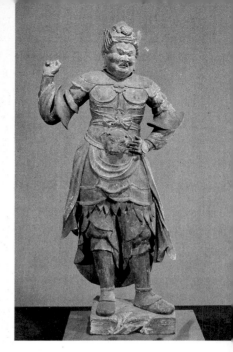

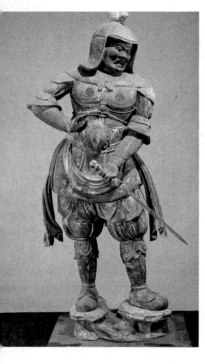 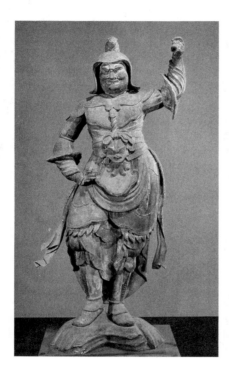 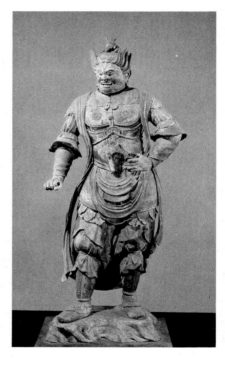 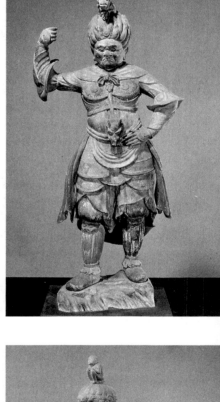

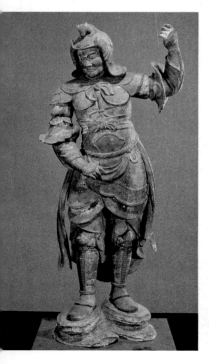 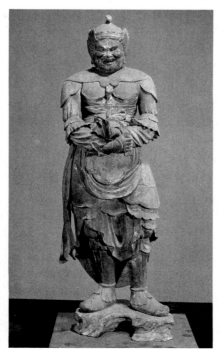 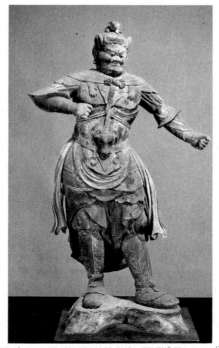 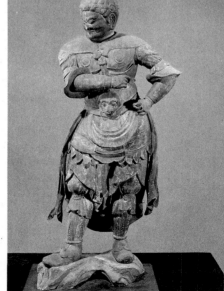

223–34 JUNI-JINSHŌ (THE TWELVE GUARDIANS OF YAKUSHI NYORAI). CLAY, TRACES OF COLOR. NARA, TEMPYŌ ERA, 729–766

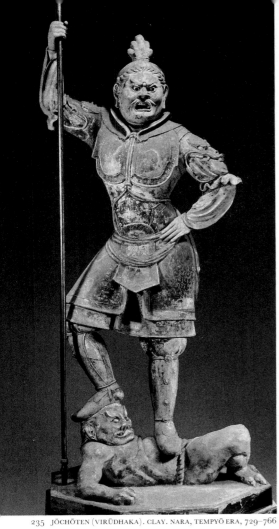

235 JŌCHŌTEN (VIRŪDHAKA). CLAY. NARA, TEMPYŌ ERA, 729–766

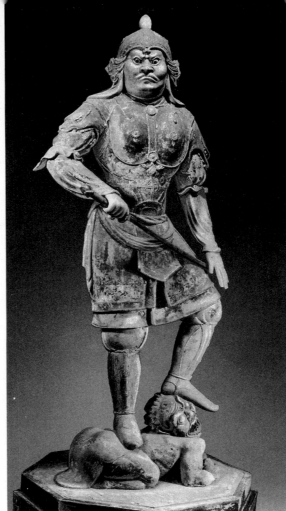

236 JIKOKUTEN (DHRTARĀSTRA). CLAY. NARA, TEMPYŌ ERA, 729–766

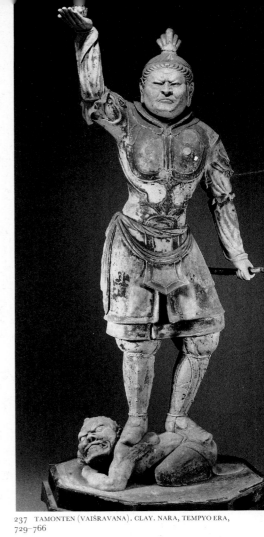

237 TAMONTEN (VAIŚRAVANA). CLAY. NARA, TEMPYŌ ERA, 729–766

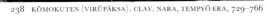

238 KŌMOKUTEN (VIRŪPĀKSA). CLAY. NARA, TEMPYŌ ERA, 729–766

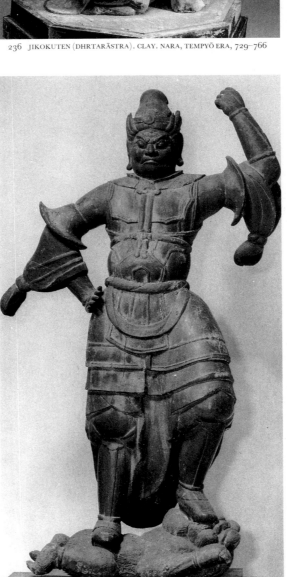

239 JIKOKUTEN (DHRTARĀSTRA). WOOD. LATE HEIAN, 12TH CENTURY

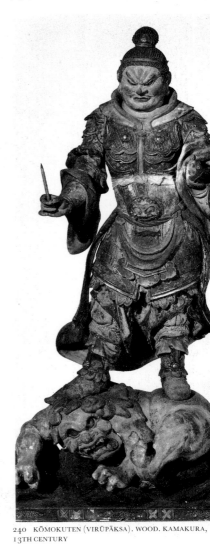

240 KŌMOKUTEN (VIRŪPĀKSA). WOOD. KAMAKURA, 13TH CENTURY

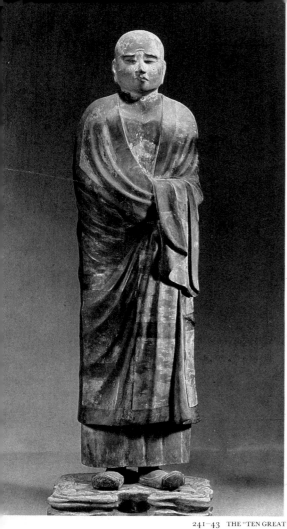 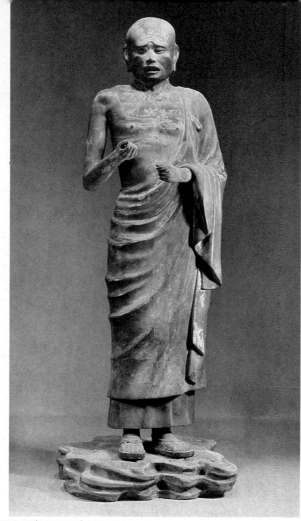 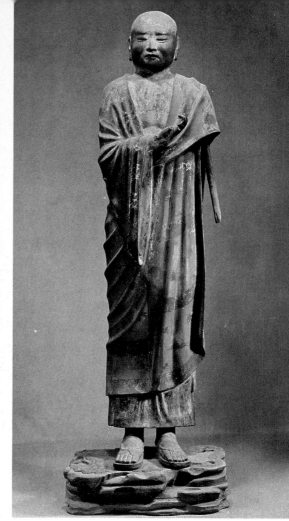

241–43 THE "TEN GREAT DISCIPLES" (JUDAIDESHI). DRY LACQUER. NARA, 734 241 RAGORA 242 KASENEN 243 SHARIHOTSU

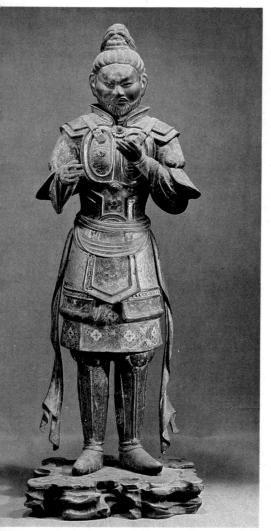 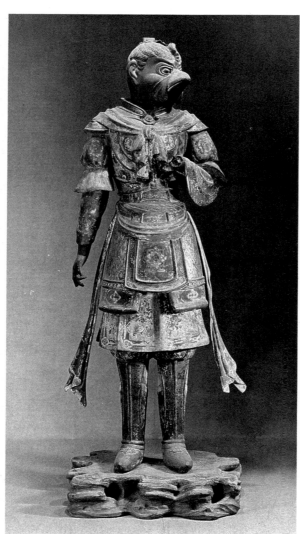 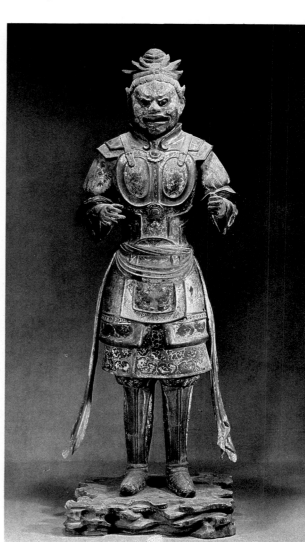

244–46 HACHIBUSHŪ (GUARDIANS OF SHAKA NYORAI). DRY LACQUER. NARA, 8TH CENTURY 244 BIBAKARA 245 KARURA 246 KUHANDA

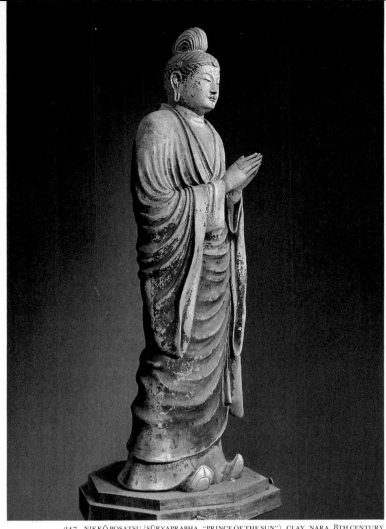

247 NIKKŌ BOSATSU (SŪRYAPRABHA, "PRINCE OF THE SUN"). CLAY. NARA, 8TH CENTURY

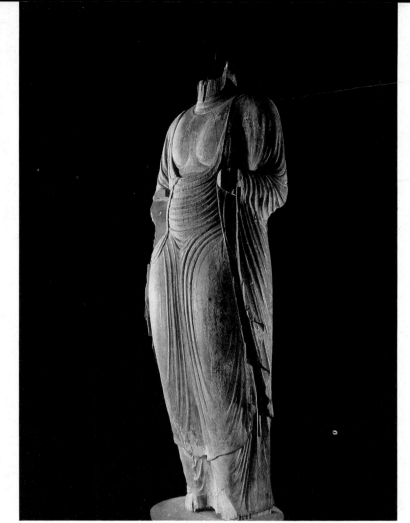

248 STATUE OF BUDDHA. WOOD. HEIAN, 9TH CENTURY

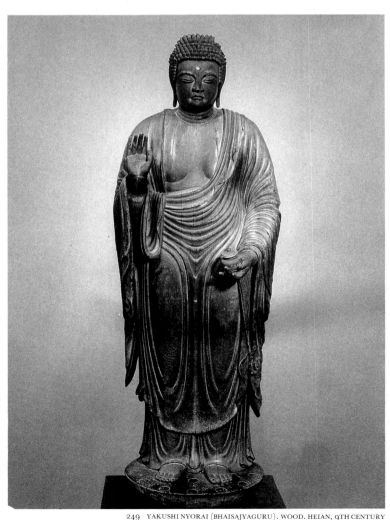

249 YAKUSHI NYORAI (BHAISAJYAGURU). WOOD. HEIAN, 9TH CENTURY

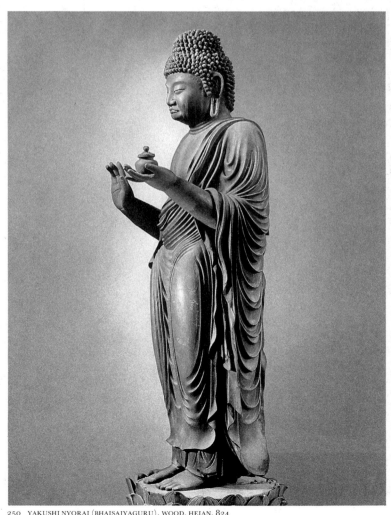

250 YAKUSHI NYORAI (BHAISAJYAGURU). WOOD. HEIAN, 824

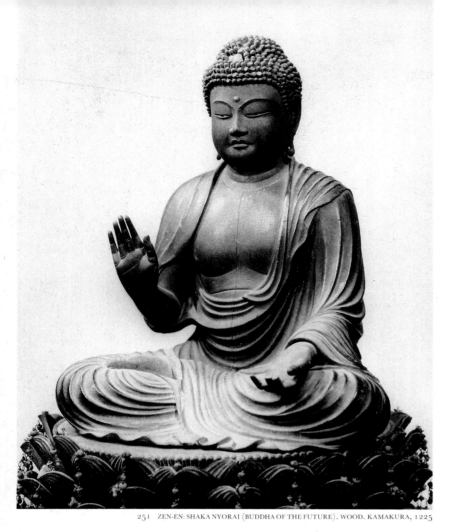

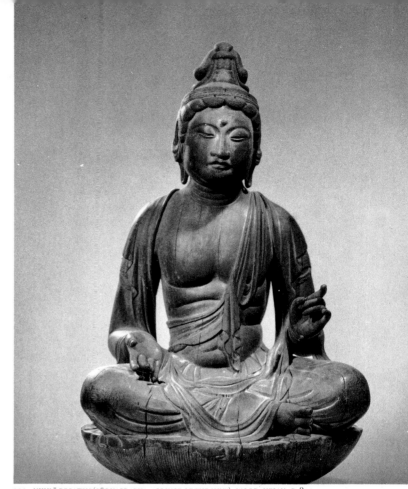

251 ZEN-EN: SHAKA NYORAI (BUDDHA OF THE FUTURE). WOOD. KAMAKURA, 1225

252 NIKKŌ BOSATSU (SŪRYAPRABHA, "PRINCE OF THE SUN"). WOOD. HEIAN, C. 800

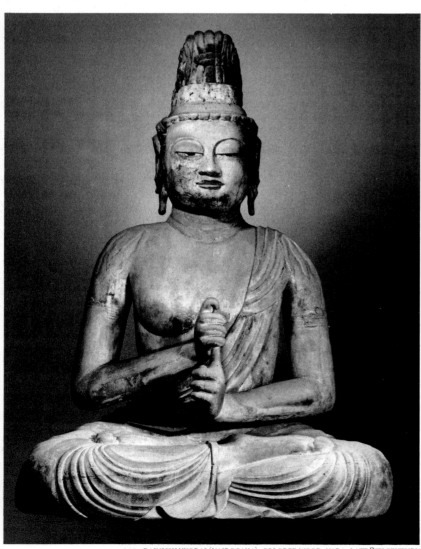

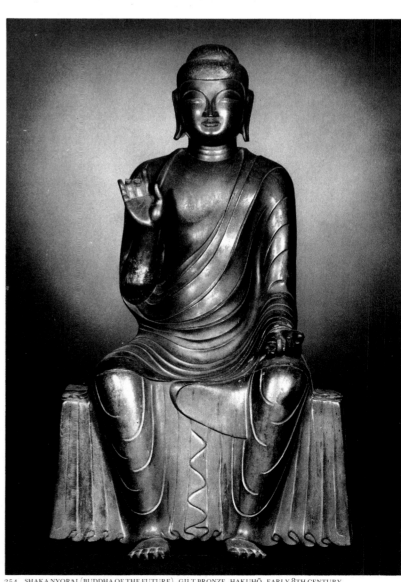

253 DAINICHI NYORAI (VAIROCANA). COLORED WOOD. NARA, LATE 8TH CENTURY

254 SHAKA NYORAI (BUDDHA OF THE FUTURE). GILT BRONZE. HAKUHŌ, EARLY 8TH CENTURY

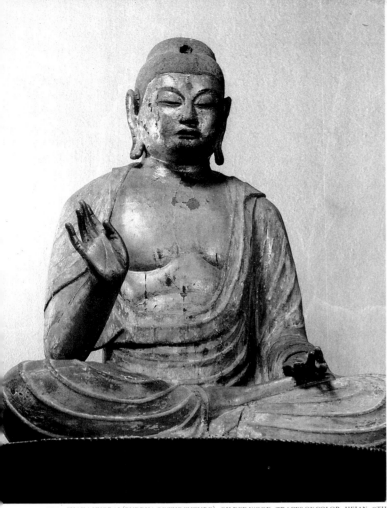

255 SHAKA NYORAI (BUDDHA OF THE FUTURE). GILDED WOOD, TRACES OF COLOR. HEIAN, 9TH CENTURY

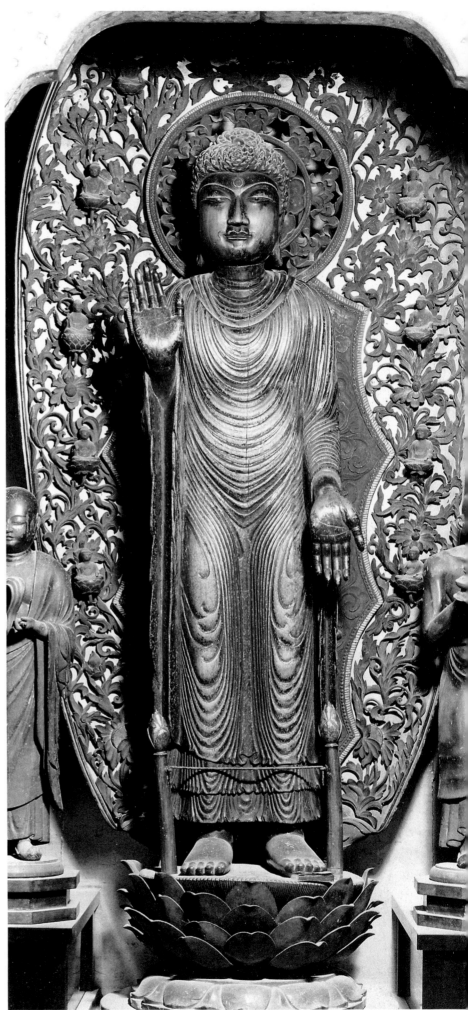

257 SHAKA NYORAI (BUDDHA OF THE FUTURE: UDYĀNA COPY). SANDALWOOD. HEIAN, 985

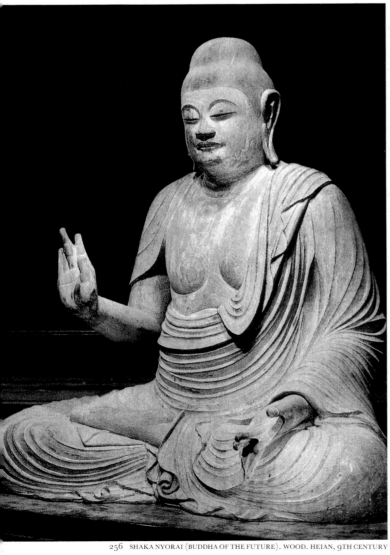

256 SHAKA NYORAI (BUDDHA OF THE FUTURE). WOOD. HEIAN, 9TH CENTURY

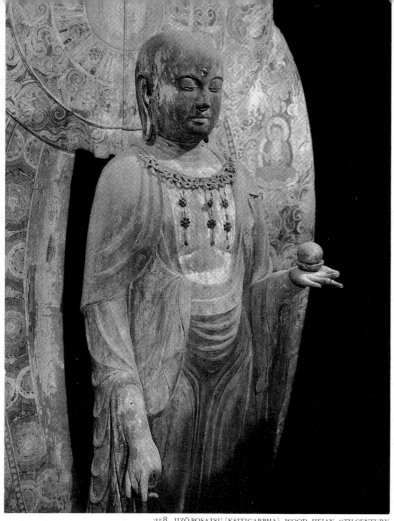

258 JIZŌ BOSATSU (KSITIGARBHA). WOOD. HEIAN, 9TH CENTURY

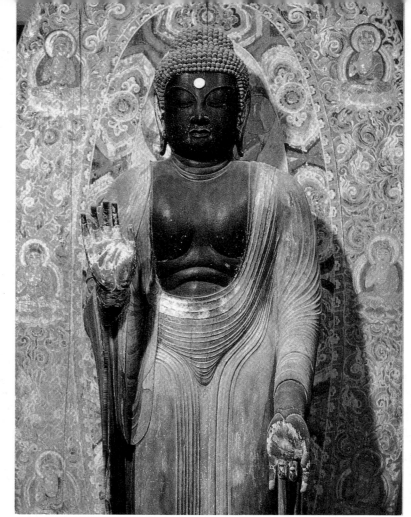

259 SHAKA NYORAI (BUDDHA OF THE FUTURE). WOOD, LACQUER. HEIAN, 9TH CENTURY

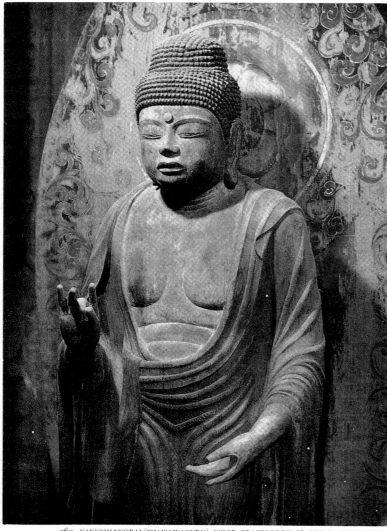

260 YAKUSHI NYORAI (BHAISAJYAGURU). WOOD, TRACES OF COLOR. HEIAN, 9TH CENTURY

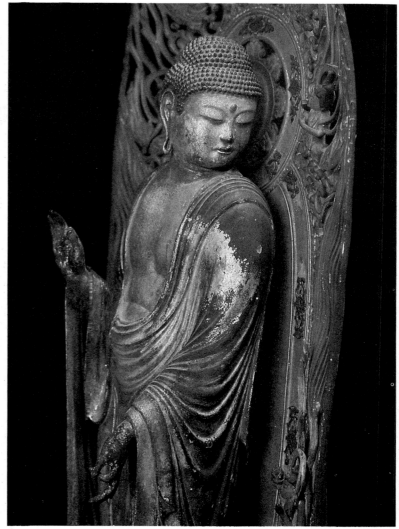

261 MIKAERI-NO-AMIDA, AMIDA (AMITĀBHĀ) WHO TURNS ASIDE. WOOD. HEIAN, 9TH–12TH CENTURY

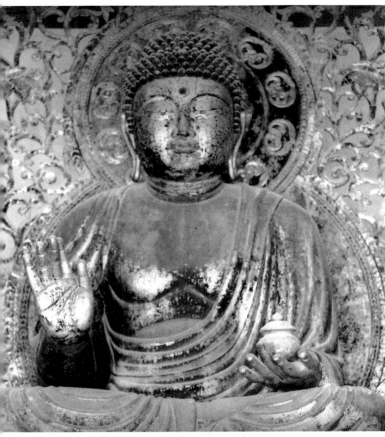

262 YAKUSHI NYORAI (BHAISAJYAGURU). GILDED WOOD. HEIAN, 10TH CENTURY

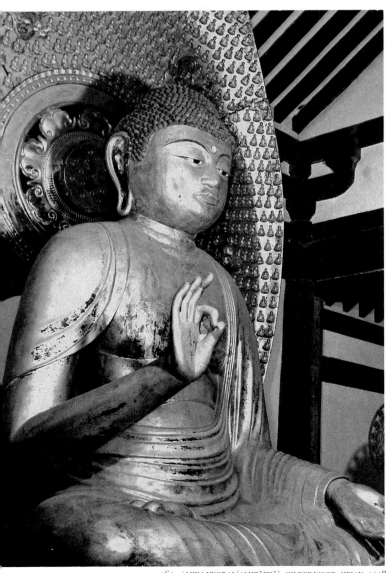

263 AMIDA NYORAI (AMITĀBHĀ). GILDED WOOD. HEIAN, 1108

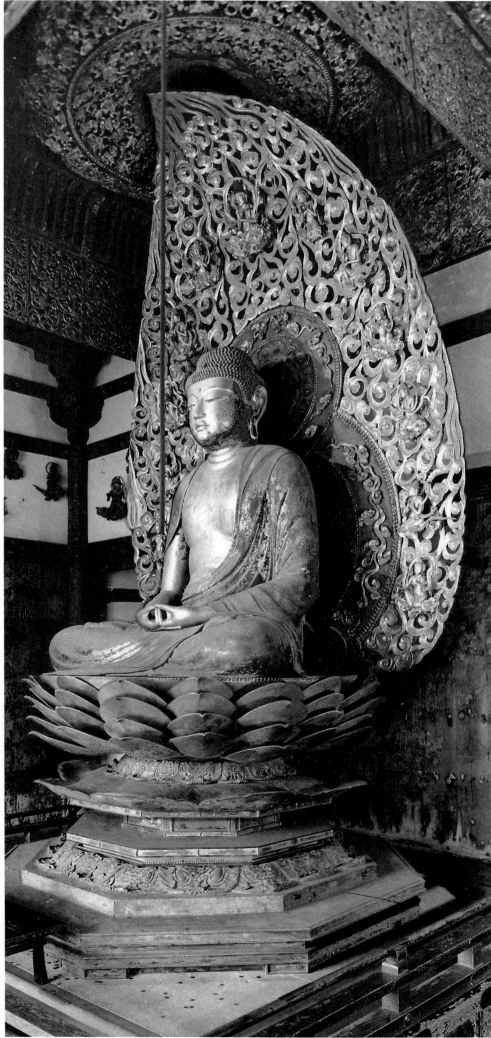

264 JŌCHŌ (D. 1057): AMIDA NYORAI (AMITĀBHĀ). GILDED WOOD. HEIAN, 1053

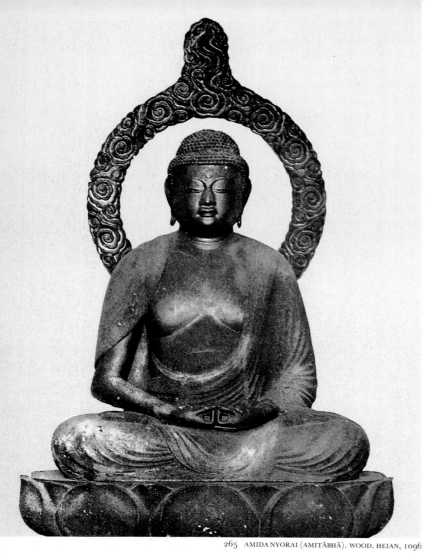

265 AMIDA NYORAI (AMITĀBHĀ). WOOD. HEIAN, 1096

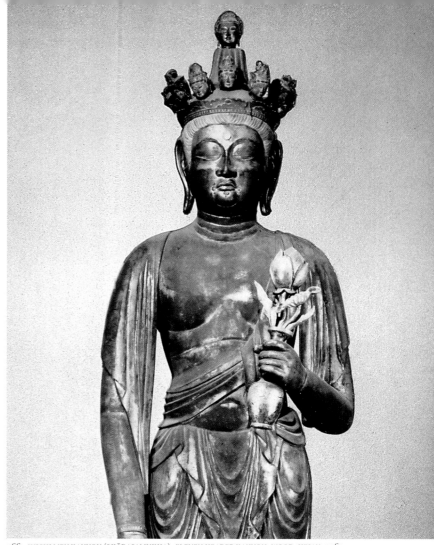

266 JUICHI MEN KANNON (IKĀDASAMUKHA), ELEVEN-HEADED KANNON. WOOD. HEIAN, 1069

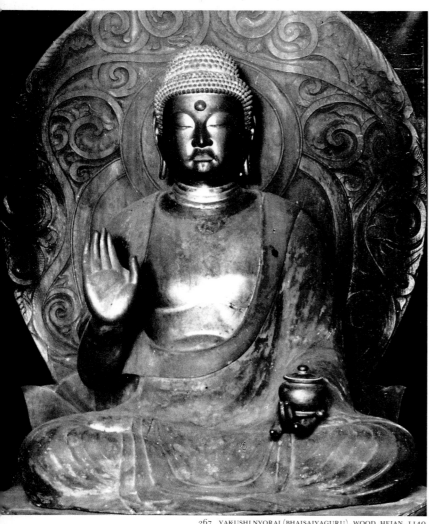

267 YAKUSHI NYORAI (BHAISAJYAGURU). WOOD. HEIAN, 1140

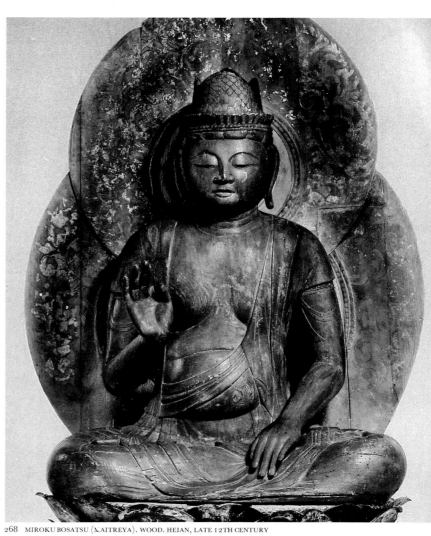

268 MIROKU BOSATSU (MAITREYA). WOOD. HEIAN, LATE 12TH CENTURY

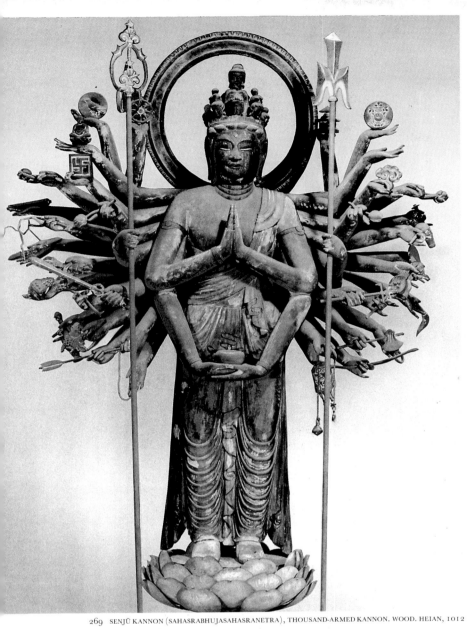

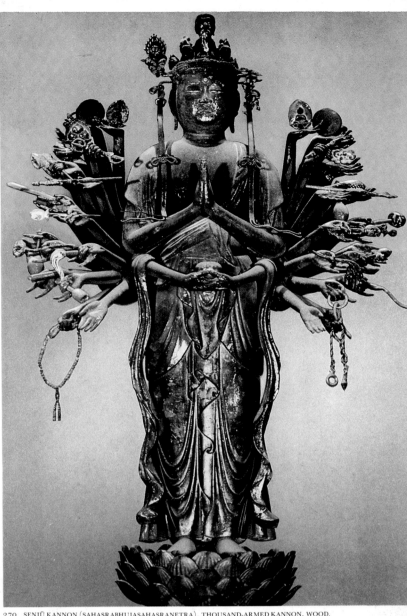

269 SENJŪ KANNON (SAHASRABHUJASAHASRANETRA), THOUSAND-ARMED KANNON. WOOD. HEIAN, 1012

270 SENJŪ KANNON (SAHASRABHUJASAHASRANETRA), THOUSAND-ARMED KANNON. WOOD. KAMAKURA, 13TH–14TH CENTURY

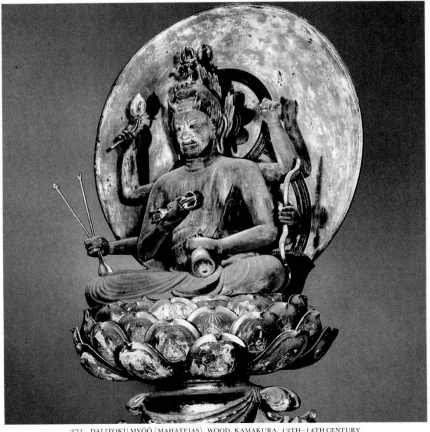

271 DAI ITOKU MYŌŌ (MAHATEJAS). WOOD. KAMAKURA, 13TH–14TH CENTURY

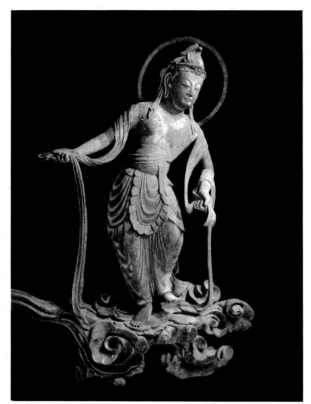
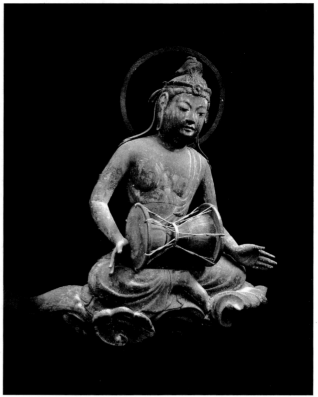

272-73 CLOUD-BORNE DEITIES. WOOD RELIEFS FROM HŌŌDŌ. HEIAN, 11TH CENTURY

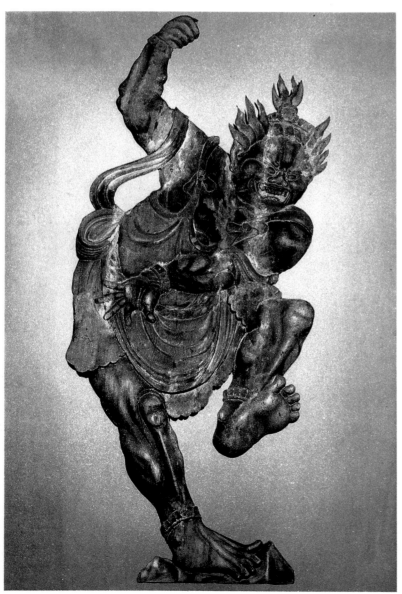
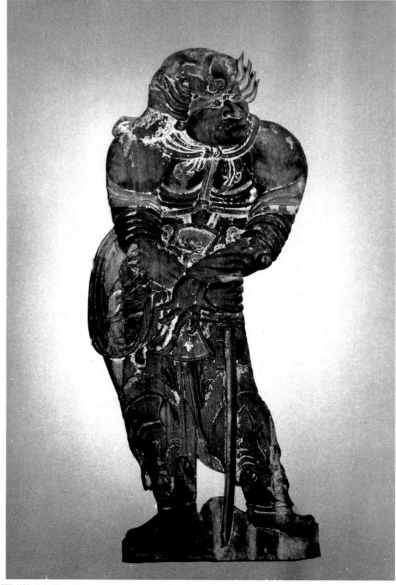

274-75 TWO OF THE TWELVE JŪNI-JINSHŌ. WOOD RELIEFS. HEIAN, LATE 10TH–EARLY 11TH CENTURY

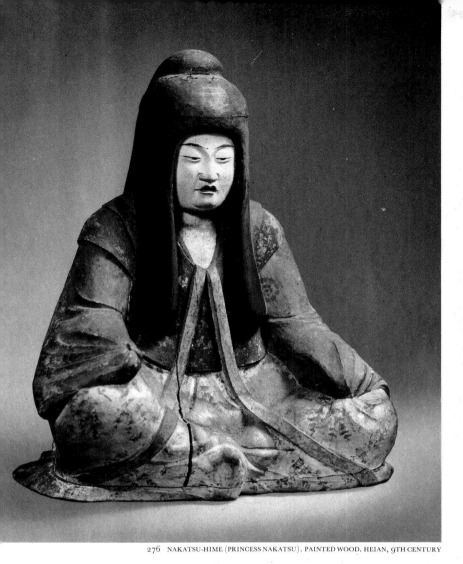

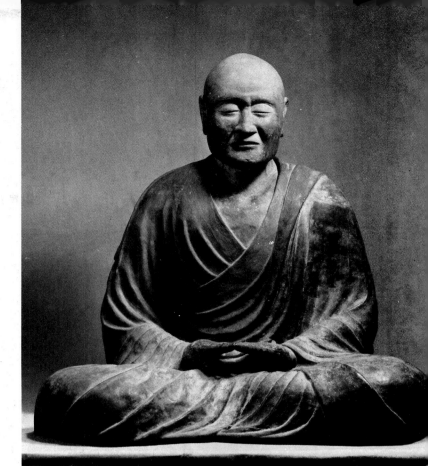

277 GANJIN. DRY LACQUER. NARA, 8TH CENTURY

276 NAKATSU-HIME (PRINCESS NAKATSU). PAINTED WOOD. HEIAN, 9TH CENTURY

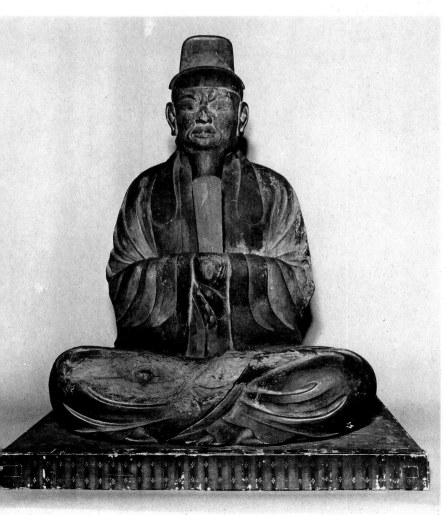

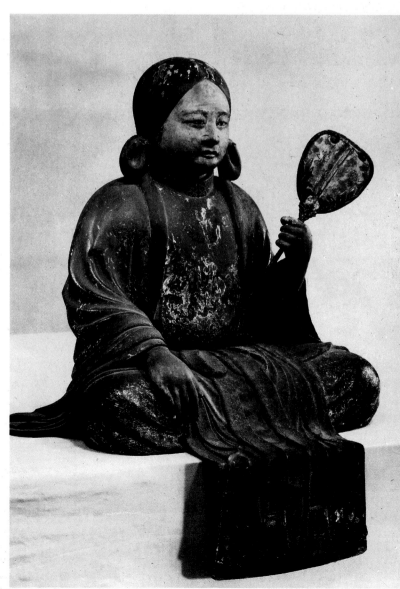

278 SHINTŌ GOD. PAINTED WOOD. HEIAN, 10TH CENTURY

279 ENKAI (FL. 11TH CENTURY): PRINCE SHŌTOKU-TAISHI (574–622 A.D.). WOOD. HEIAN, 1069

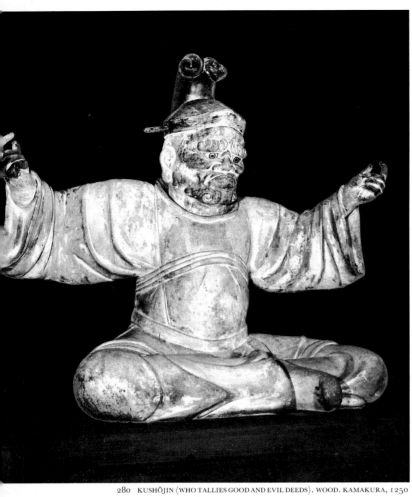

280 KUSHŌJIN (WHO TALLIES GOOD AND EVIL DEEDS). WOOD. KAMAKURA, 1250

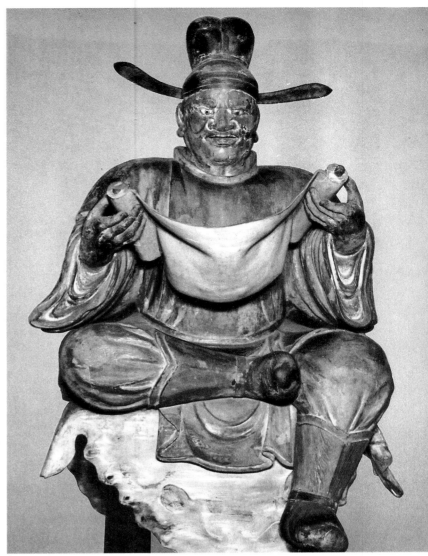

281 JUDGE IN BUDDHIST HELL. PAINTED WOOD. KAMAKURA, 13TH CENTURY

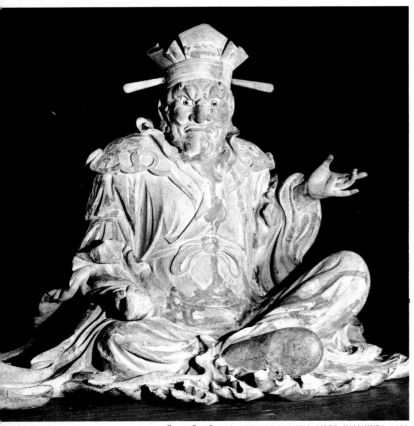

282 SHŌKOŌ, A KING OF BUDDHIST HELL. WOOD. KAMAKURA, 1251

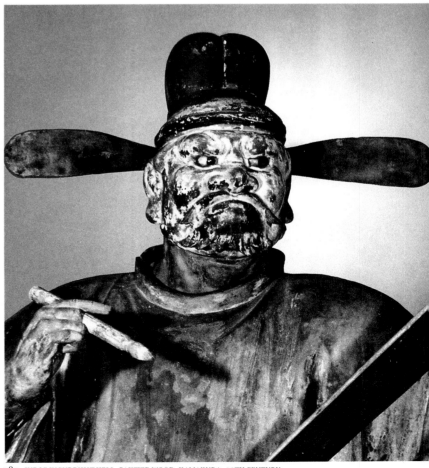

283 JUDGE IN BUDDHIST HELL. PAINTED WOOD. KAMAKURA, 13TH CENTURY

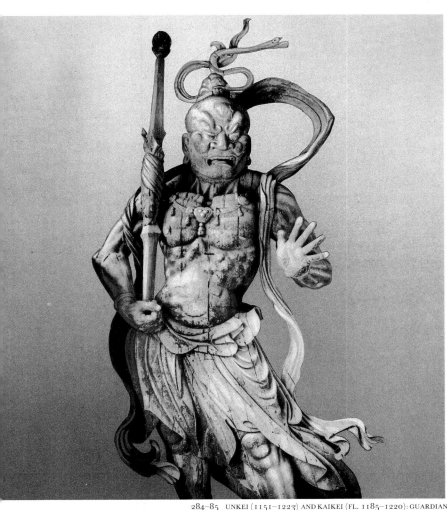
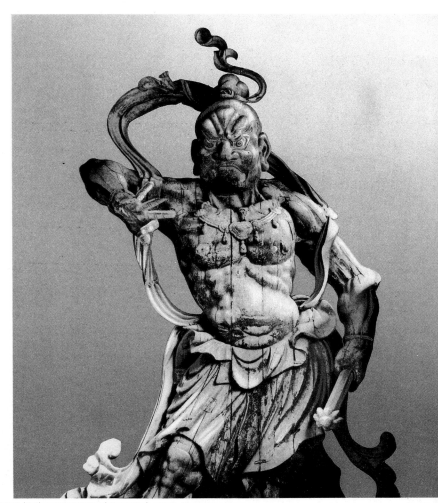

284-85 UNKEI (1151-1223) AND KAIKEI (FL. 1185-1220): GUARDIAN KINGS (NIŌ), KONGŌRIKISHI (VAJRAPĀNI). WOOD. KAMAKURA, 1203

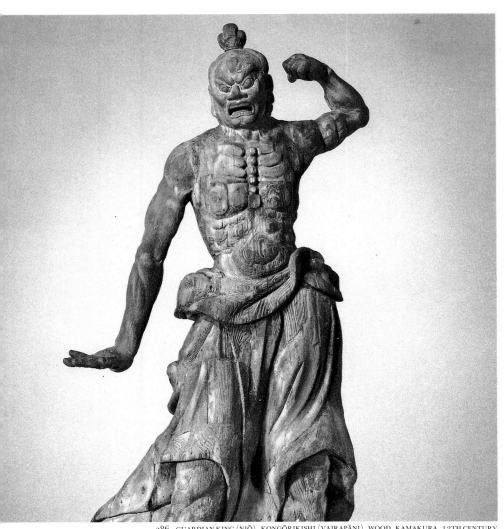
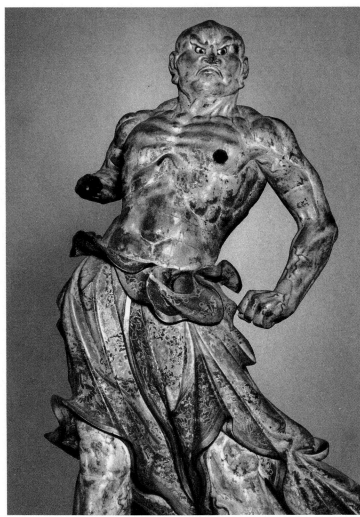

286 GUARDIAN KING (NIŌ), KONGŌRIKISHI (VAJRAPĀNI). WOOD. KAMAKURA, 13TH CENTURY

287 JOKEI (FL. 1184-1212): GUARDIAN KING (NIŌ), KONGŌRIKISHI (VAJRAPĀNI). WOOD. KAMAKURA

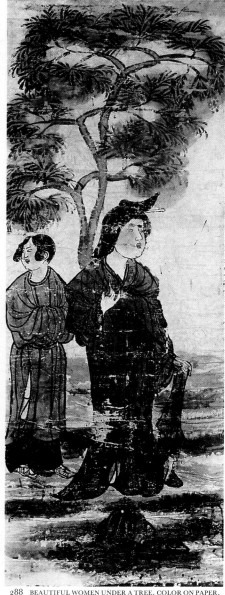

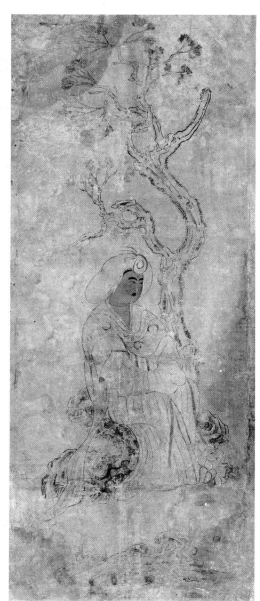

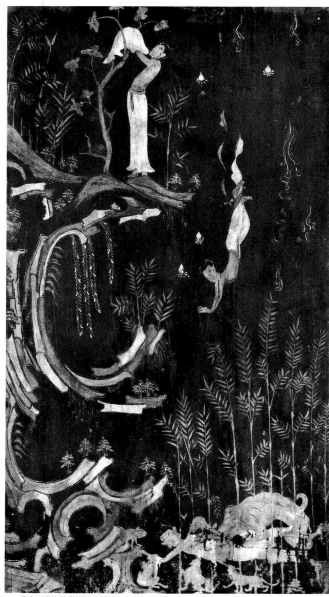

288 BEAUTIFUL WOMEN UNDER A TREE. COLOR ON PAPER. NARA, 8TH CENTURY

289 BEAUTIFUL WOMAN UNDER A TREE, DETAIL OF SCREEN. COLOR, FEATHERS ON PAPER. NARA, 752-756

290 TAMAMUSHI-ZUSHI, DETAIL. PAINT ON LACQUERED WOOD. NARA, C. 700

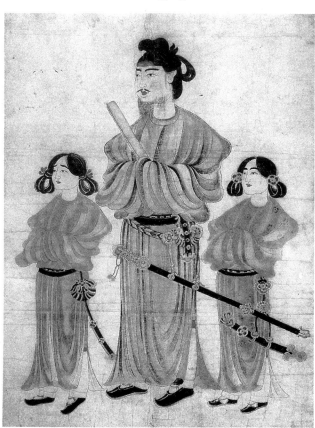

291 PRINCE SHŌTOKU-TAISHI WITH TWO SONS. COLORS ON SILK. NARA, EARLY 8TH CENTURY

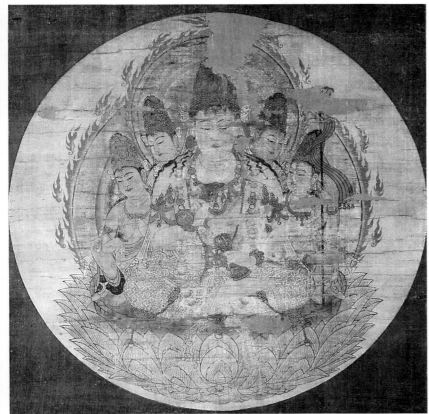

292 GOHIMITSU BOSATSU (RETICENT BUDDHA). INK, COLOR, ON SILK. KAMAKURA, 12TH–13TH CENTURY

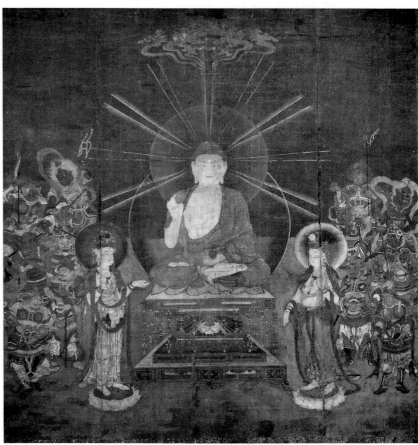

293 YAKUSHI TRIAD (BHAISAJYAGURU). COLOR ON SILK. KAMAKURA, 13TH–14TH CENTURY

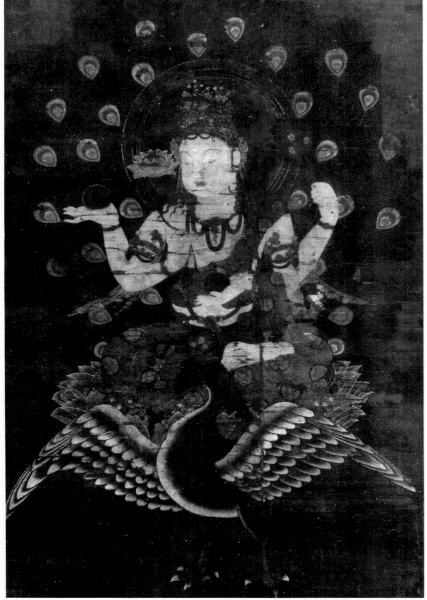

294 KUJAKU MYŌŌ (MAHĀMAYURI). COLOR ON SILK. KAMAKURA, 1250

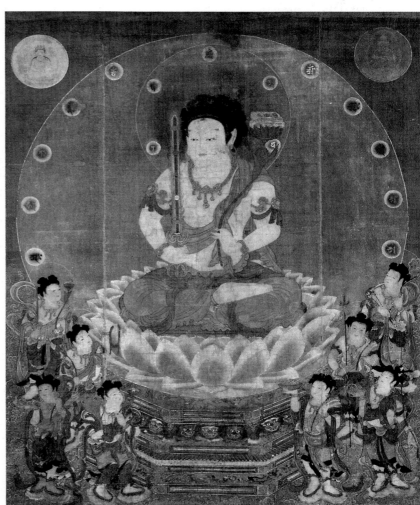

295 MONJU BOSATSU (MANJUSRI) AND HIS EIGHT ATTENDANTS. COLOR ON SILK. KAMAKURA, 13TH CENTURY

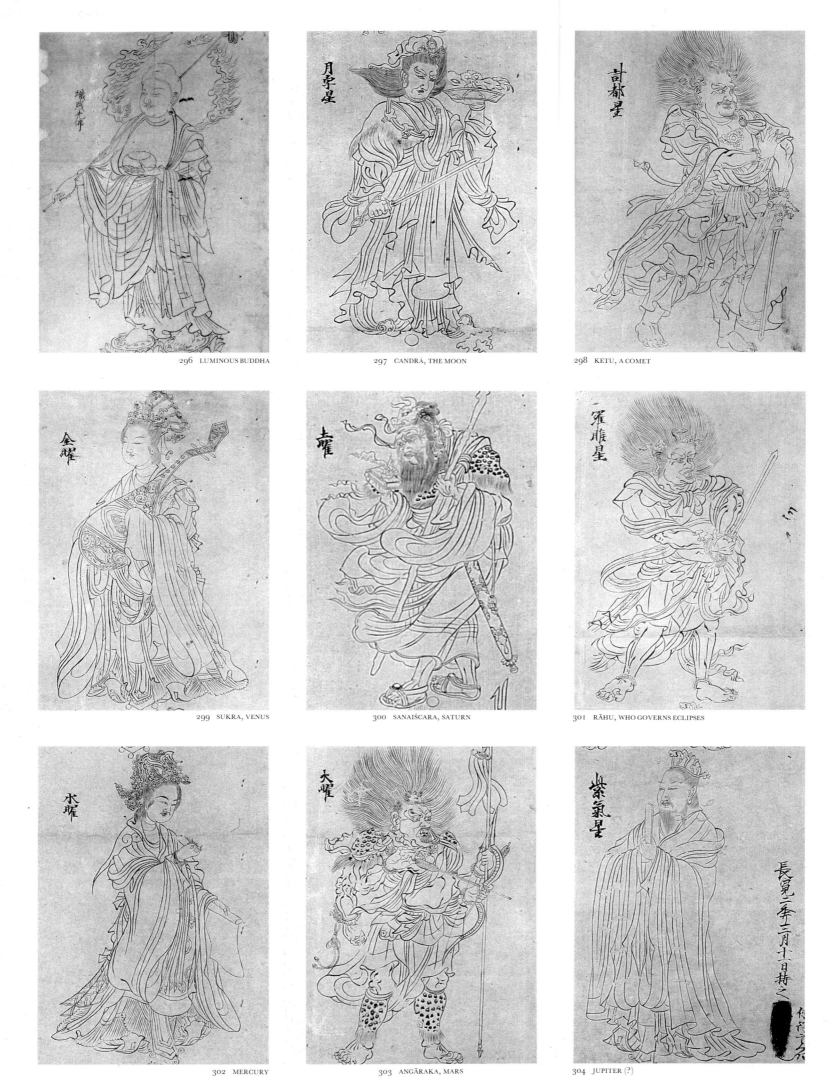

296 LUMINOUS BUDDHA

297 CANDRÁ, THE MOON

298 KETU, A COMET

299 SUKRA, VENUS

300 SANAIŚCARA, SATURN

301 RĀHU, WHO GOVERNS ECLIPSES

302 MERCURY

303 ANGĀRAKA, MARS

304 JUPITER (?)

296–304 THE NINE CELESTIAL BODIES (NAVAGRAHA). WOODCUT. HEIAN, MARCH 11, 1164

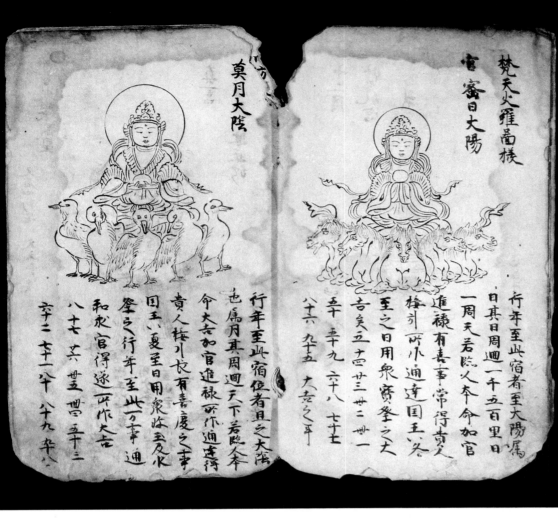

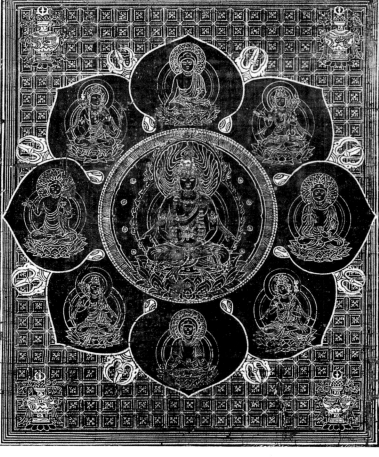

308–10 RYŌKAI MANDARA, TAIZŌ-KAI (ABOVE) AND KONGŌ-KAI (BELOW). GOLD ON PURPLE-DYED SILK. HEIAN OR EARLY KAMAKURA, LATE 12TH CENTURY

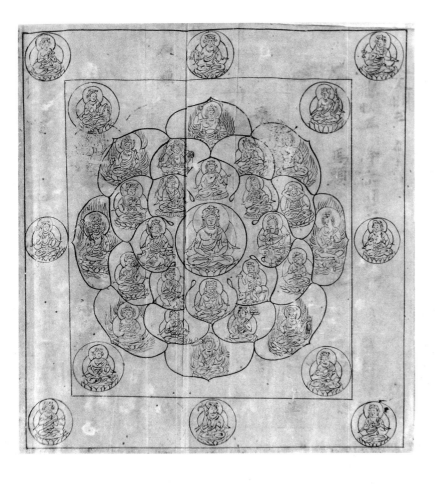
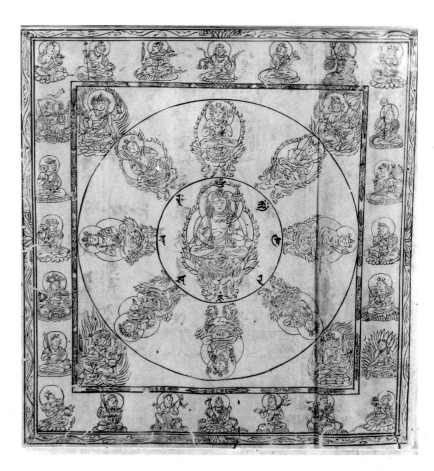
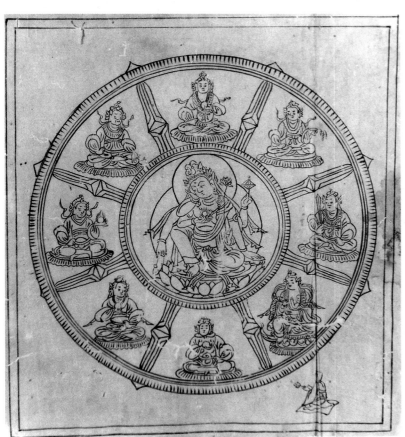
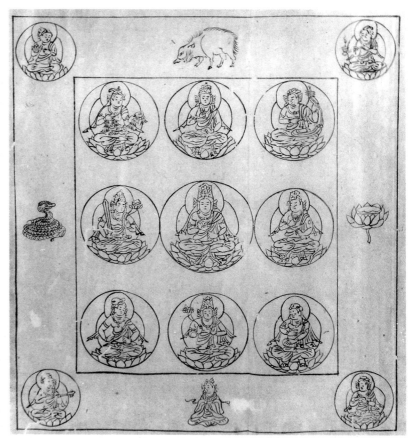

311–14 FOUR MANDALAS. WOODCUT. KAMAKURA, 13TH CENTURY

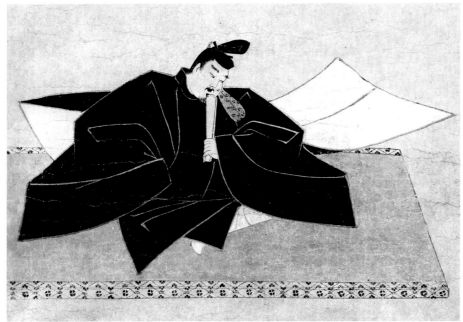

315 THE POET TAIRA-NO-KANEMORI. INK, SLIGHT COLOR, ON PAPER. KAMAKURA, 13TH–14TH CENTURY

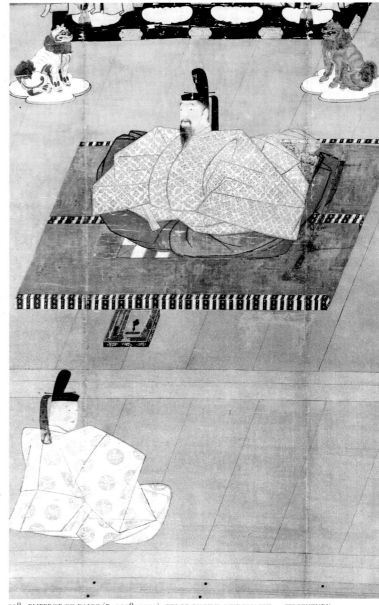

318 EMPEROR GO-DAIGO (R. 1318–1339). COLOR ON SILK. MUROMACHI, 14TH CENTURY

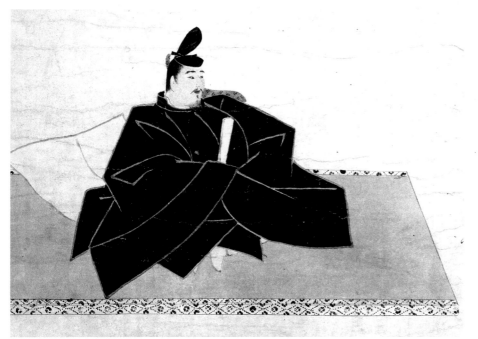

316 FUJIWARA-NO-NOBUZANE (1176–1266), ATTR.: THE POET MINAMOTO-NO-KINTADA. INK, COLOR, WHITE ON PAPER.
KAMAKURA, 13TH–14TH CENTURY

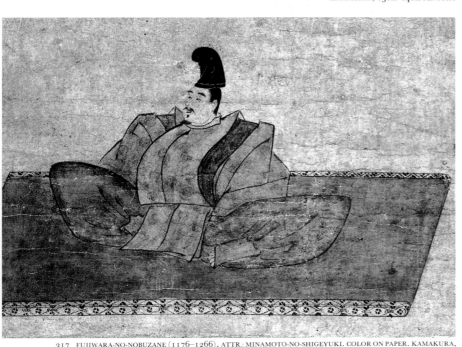

317 FUJIWARA-NO-NOBUZANE (1176–1266), ATTR.: MINAMOTO-NO-SHIGEYUKI. COLOR ON PAPER. KAMAKURA,
13TH–14TH CENTURY

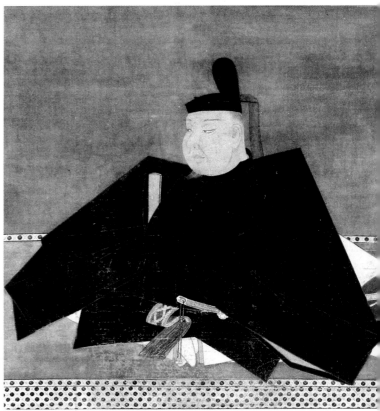

319 MINAMOTO-NO-YORIMASA (1106–1180). COLOR ON SILK. MUROMACHI, 14TH CENTURY

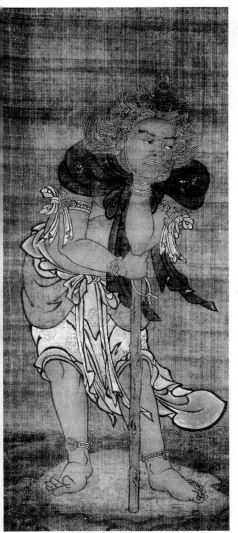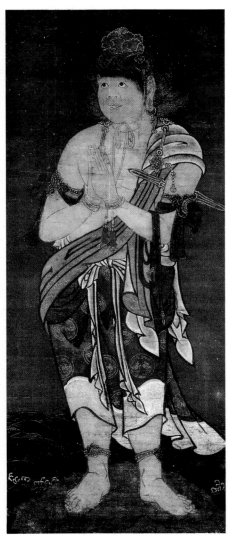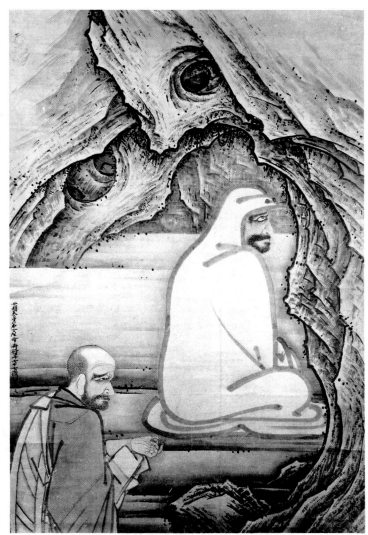

320-21 GHŌGA (FL. C. 1250-1270): KONGARA AND SEITAKA, ATTENDANTS OF FUDŌ.
INK, COLOR, GOLD ON SILK. KAMAKURA, 13TH CENTURY

322 SESSHŪ (1420-1506): DARUMA AND HIS DISCIPLE EKA. INK ON PAPER. MUROMACHI

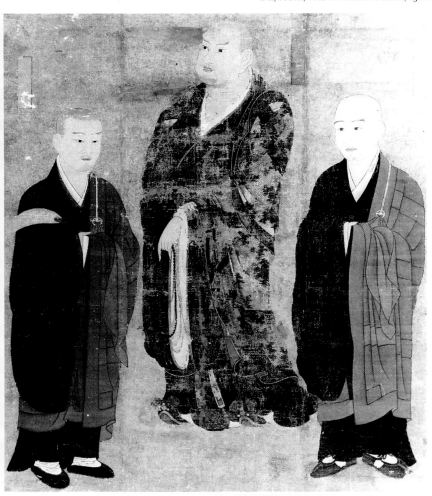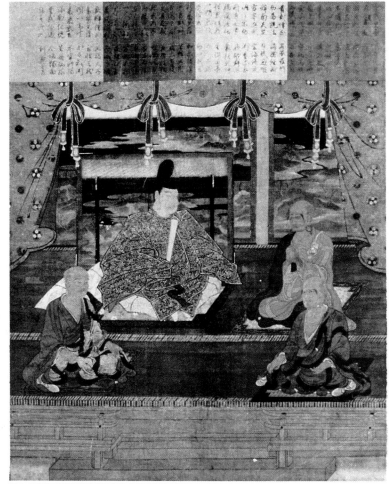

323 THE CHINESE PRIESTS CHU-EN, LIU-CHU, AND PU-YANG.
COLOR ON SILK. KAMAKURA, 13TH-14TH CENTURY

324 FOUR VENERABLE FIGURES, EMPEROR SHŌMU AND THREE PRIESTS. HANGING SCROLL,
COLOR ON SILK. MUROMACHI, NORTHERN DYNASTY, 1377

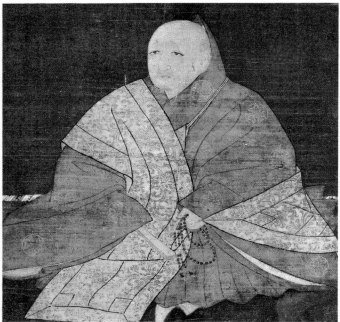

325 ASHIKAGA YOSHIMITSU (1358–1408). COLOR ON SILK. MUROMACHI,
LATE 14TH CENTURY

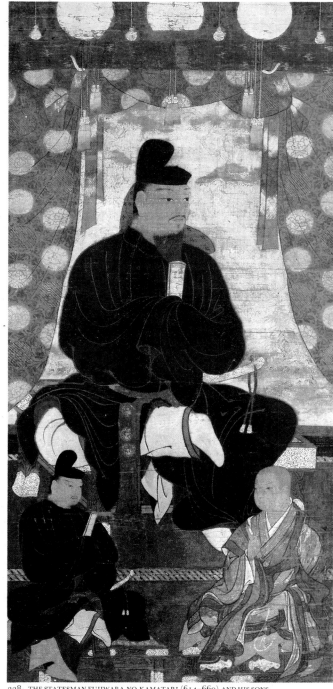

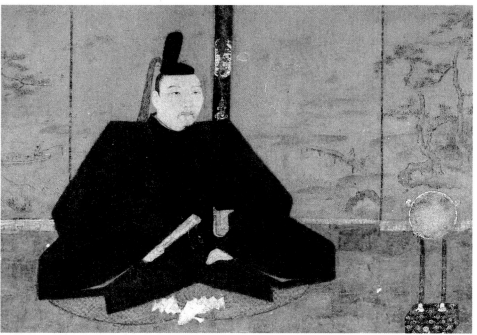

326 ASHIKAGA YOSHIMASA (1435–1490). COLOR ON SILK. MUROMACHI, 15TH–16TH CENTURY

328 THE STATESMAN FUJIWARA-NO-KAMATARI (614–669) AND HIS SONS.
COLOR ON SILK. MUROMACHI, 15TH CENTURY

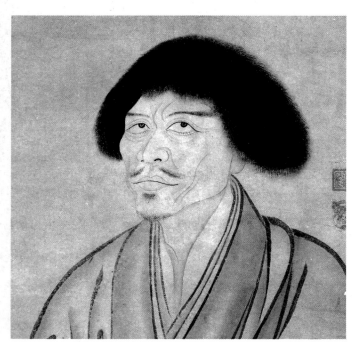

327 CHŪAN SHINKŌ (FL. MID-15TH CENTURY): THE PRIEST KAO-FENG YÜAN-MIAO
(1238–1295), DETAIL. INK ON PAPER. ASHIKAGA

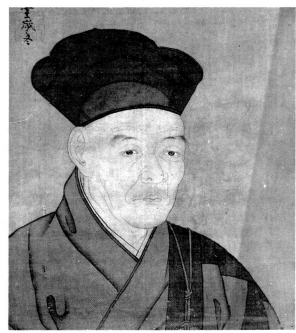

329 THE PAINTER SESSHŪ (1420–1506), DETAIL. INK, SLIGHT COLOR
ON PAPER. MUROMACHI, 16TH CENTURY

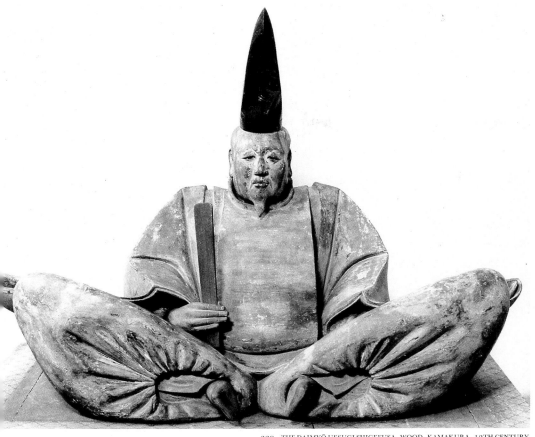

330 THE DAIMYŌ UESUGI SHIGEFUSA. WOOD. KAMAKURA, 13TH CENTURY

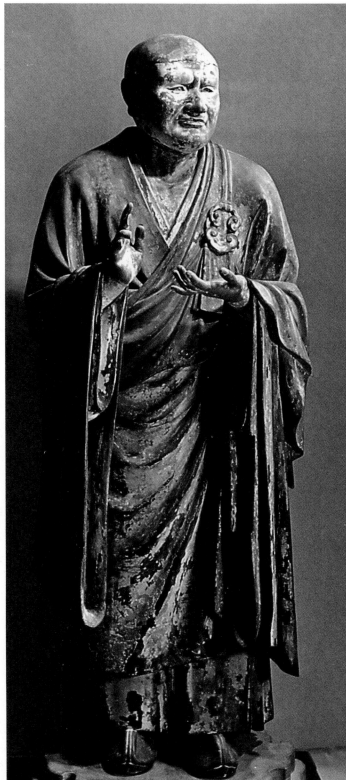

332 UNKEI (1151–1223): SESSHIN BOSATSU (PATRIARCH OF HOSSŌ SECT). WOOD. KAMAKURA

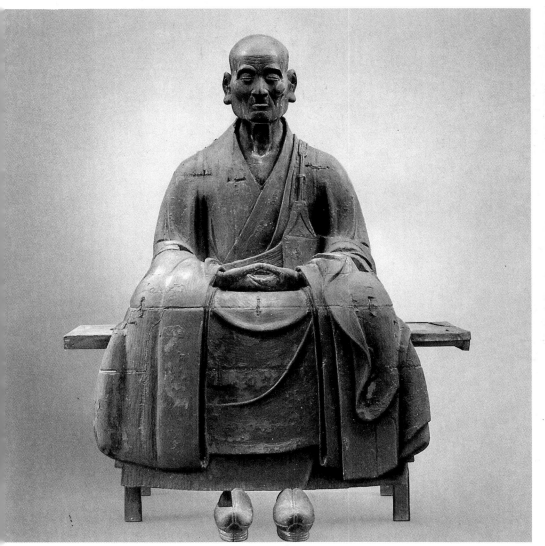

331 THE PRIEST KAKUSHIN (HOTO KOKUSHI). WOOD, TRACES OF LACQUER. KAMAKURA, C. 1286

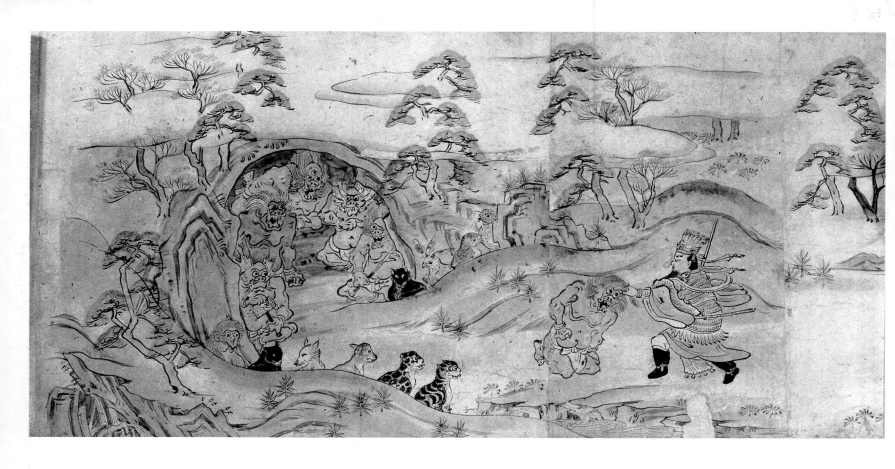

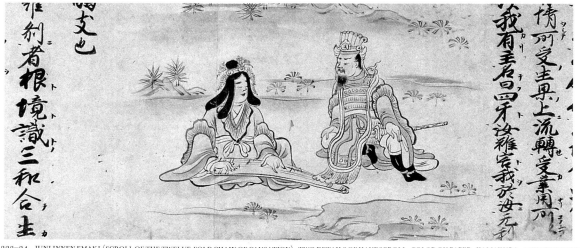

333-34　JUNI INNEN EMAKI (SCROLL OF THE TWELVE-FOLD CHAIN OF CAUSATION), TWO DETAILS OF HANDSCROLL. COLOR ON PAPER. KAMAKURA, 13TH CENTURY

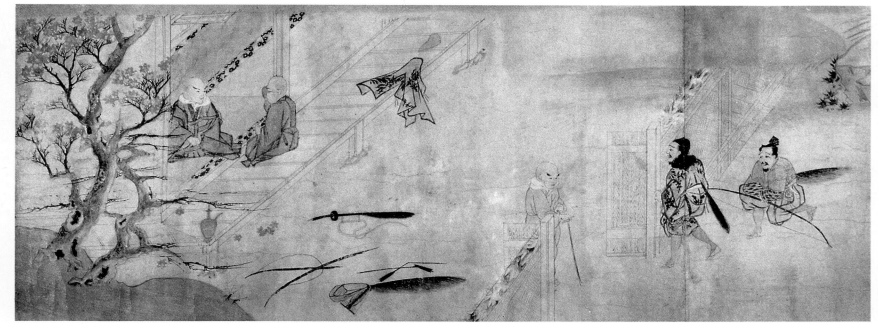

335　SHINRAN SHŌNIN EDEN (LIFE OF SHINRAN: 1174–1268), DETAIL OF HANDSCROLL. COLOR ON PAPER. KAMAKURA, 13TH–14TH CENTURY

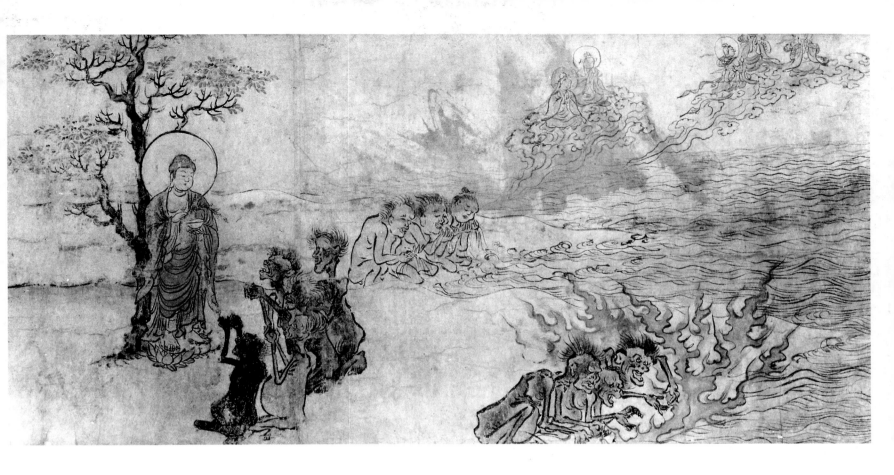

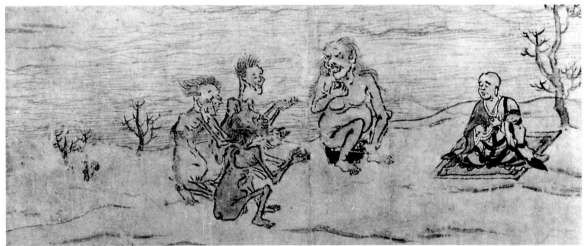

336–37 GAKI ZŌSHI (TALE OF THE HUNGRY DEMONS), TWO DETAILS OF HANDSCROLL. INK, SLIGHT COLOR, ON PAPER. HEIAN, SECOND HALF 12TH CENTURY

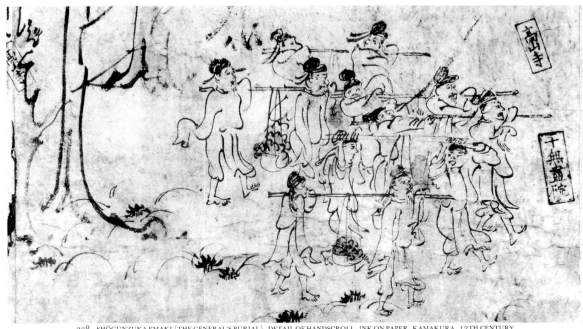

338 SHŌGUNZUKA EMAKI (THE GENERAL'S BURIAL), DETAIL OF HANDSCROLL. INK ON PAPER. KAMAKURA, 13TH CENTURY

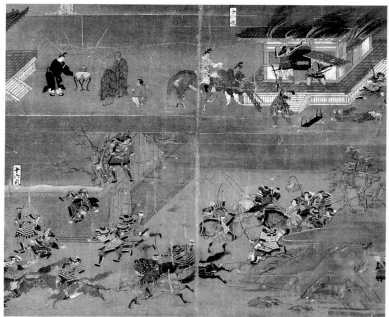

339 TOSA TSUNETAKA (LATE 12TH–EARLY 13TH CENTURY), ATTR.: SCENES FROM THE LIFE OF PRINCE
SHŌTOKU-TAISHI (574–622 A.D.), HANGING SCROLL. COLOR ON SILK. KAMAKURA

340–42 TOSA TSUNETAKA (LATE 12TH–EARLY 13TH CENTURY), ATTR.: SCENES FROM THE LIFE OF
PRINCE SHŌTOKU-TAISH , THREE DETAILS OF HANGING SCROLL. COLOR ON SILK. KAMAKURA

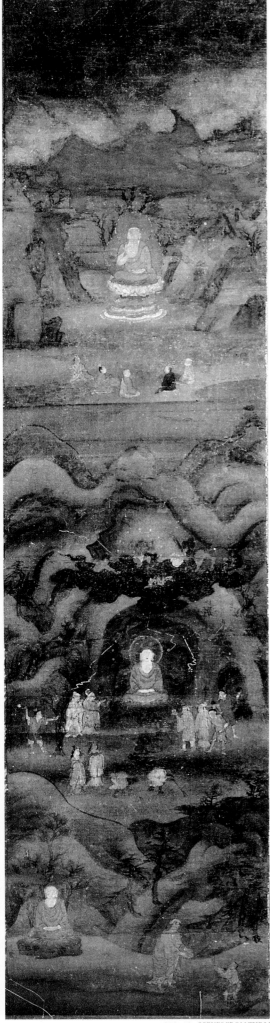 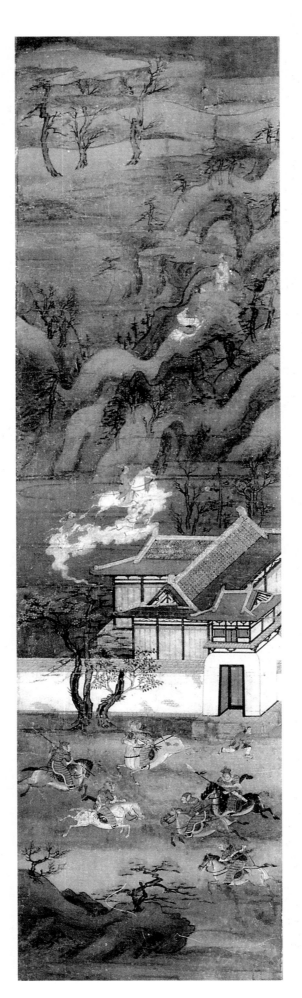 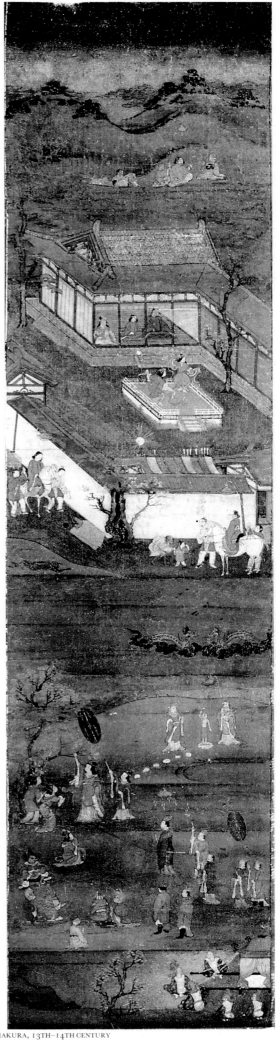

343-45 SCENES FROM THE LIFE OF THE BUDDHA, THREE DETAILS FROM FOUR HANGING SCROLLS. COLOR ON SILK. KAMAKURA, 13TH–14TH CENTURY

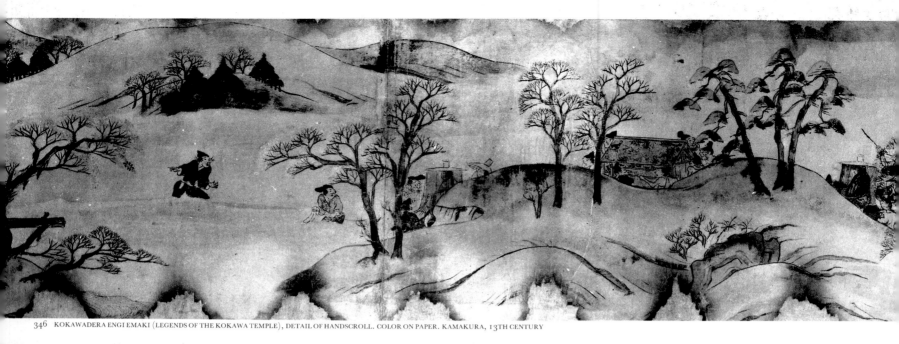

346 KOKAWADERA ENGI EMAKI (LEGENDS OF THE KOKAWA TEMPLE), DETAIL OF HANDSCROLL. COLOR ON PAPER. KAMAKURA, 13TH CENTURY

347 TAIMA MANDARA ENGI (LEGENDS OF THE TAIMA MANDARA), DETAIL OF HANDSCROLL. COLOR ON PAPER. KAMAKURA, 13TH CENTURY

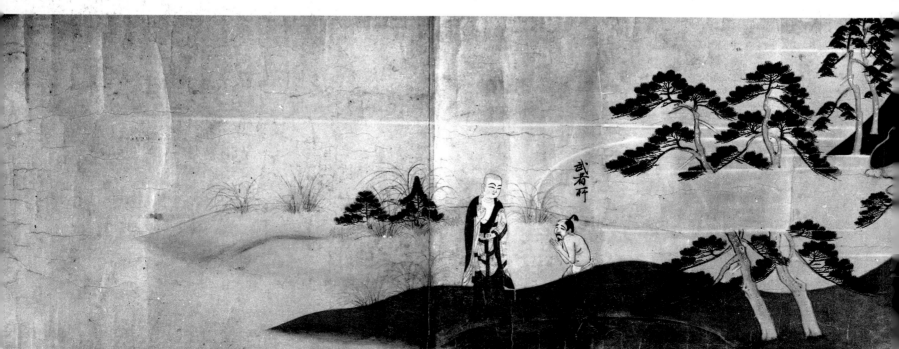

348 YATA JIZŌ ENGI (LEGENDS OF THE JIZŌ OF YATA), DETAIL OF HANDSCROLL. COLOR ON PAPER. KAMAKURA, 14TH CENTURY

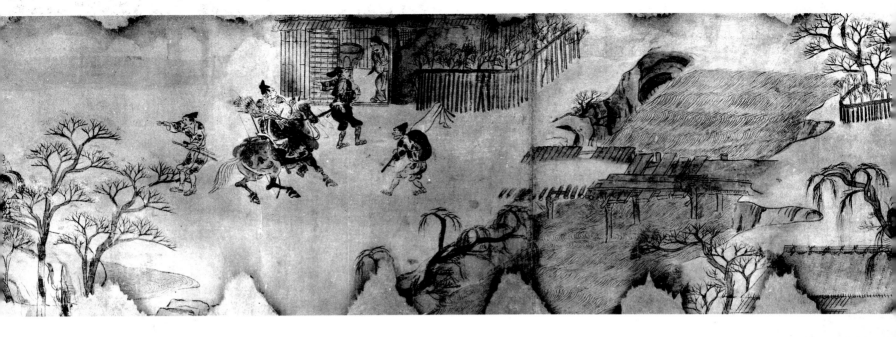

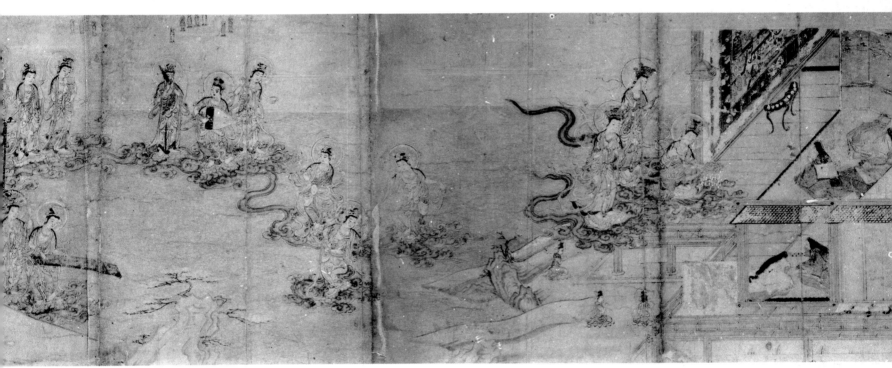

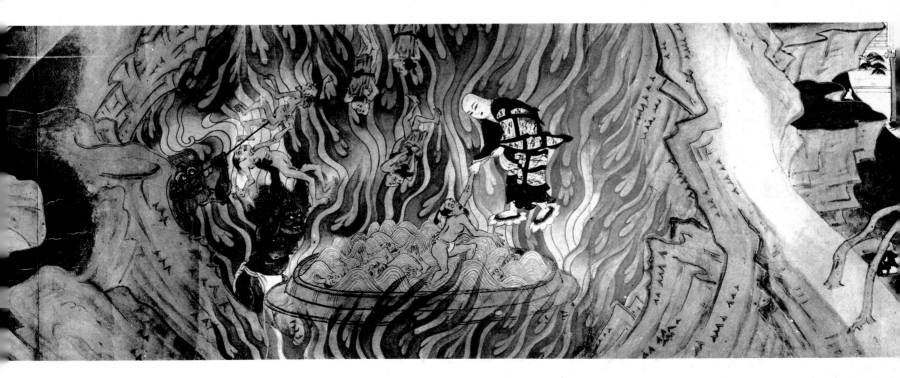

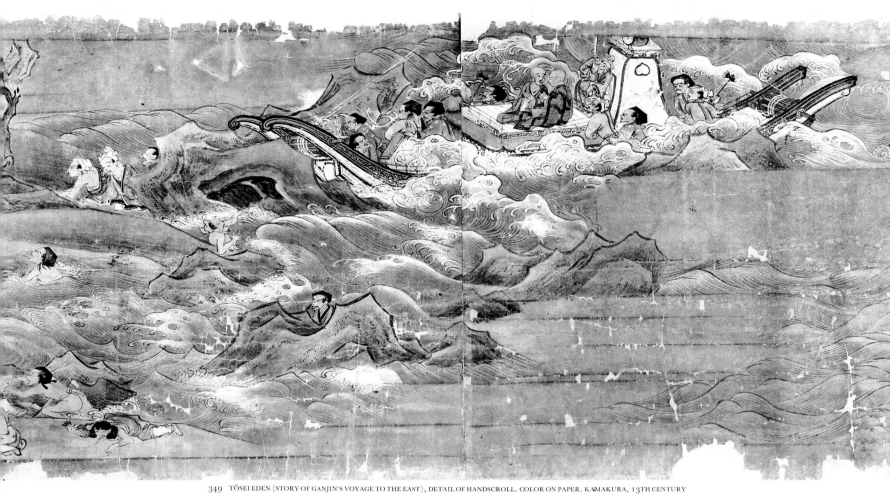

349 TŌSEI EDEN (STORY OF GANJIN'S VOYAGE TO THE EAST), DETAIL OF HANDSCROLL. COLOR ON PAPER. KAMAKURA, 13TH CENTURY

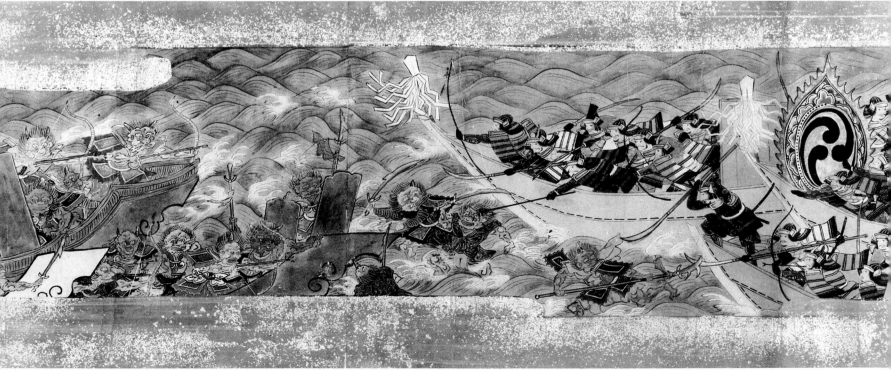

350 YURIWAKA DAIJIN MONOGATARI (TALE OF THE HERO YURIWAKA), DETAIL OF HANDSCROLL. COLOR ON PAPER. MUROMACHI, 15TH–16TH CENTURY

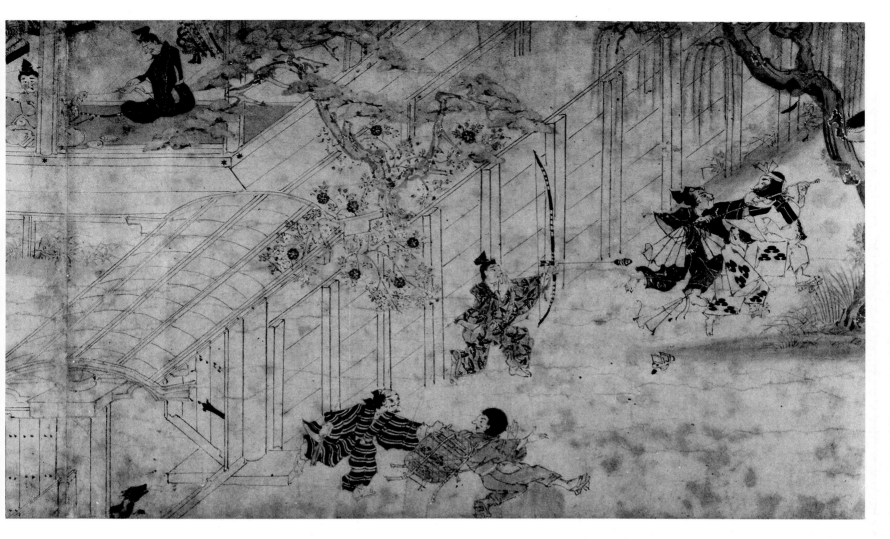

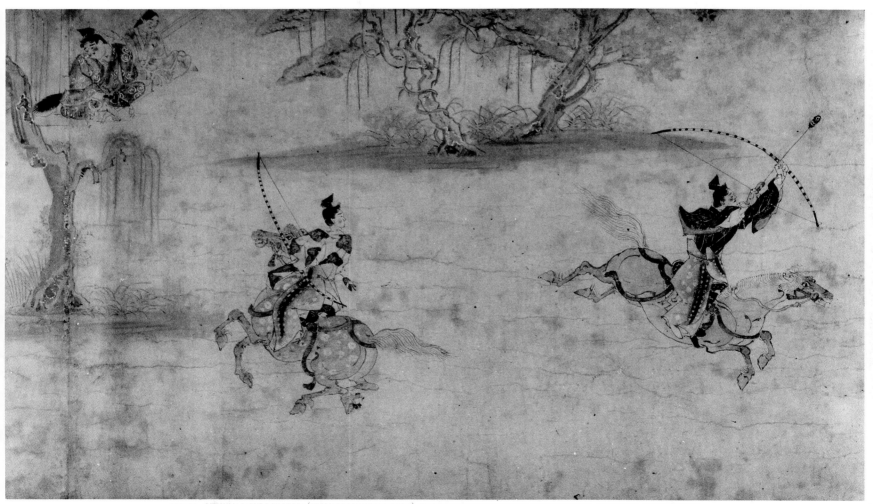

351-52 OBUSUMA SABURO EKOTOBA (STORY OF OBUSUMA SABURO), TWO DETAILS OF HANDSCROLL. COLOR ON PAPER. KAMAKURA, 13TH CENTURY

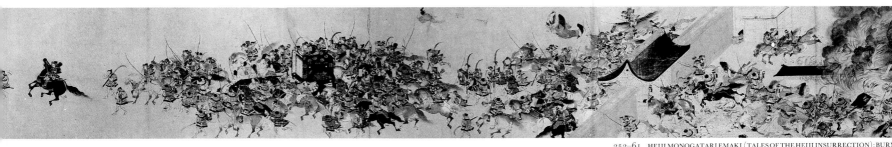

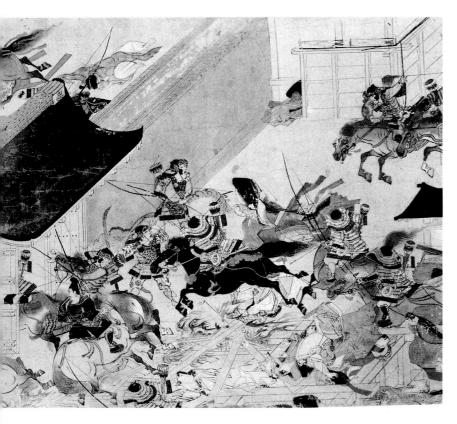

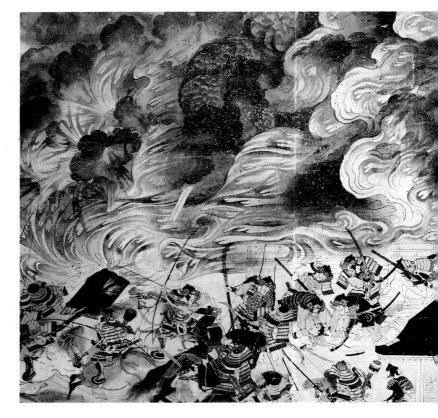

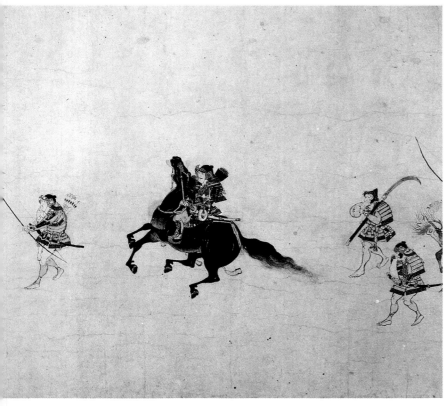

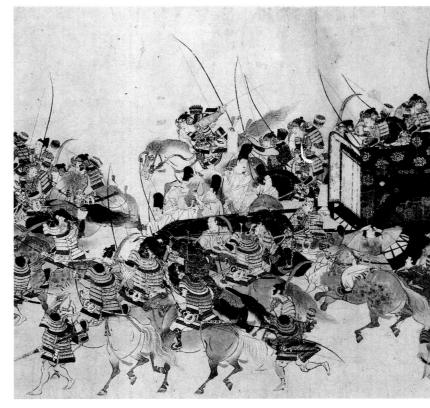

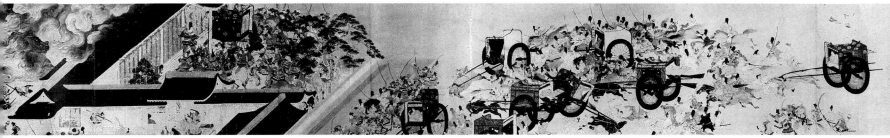

PALACE, HANDSCROLL AND EIGHT DETAILS. COLOR ON PAPER. KAMAKURA, 13TH CENTURY

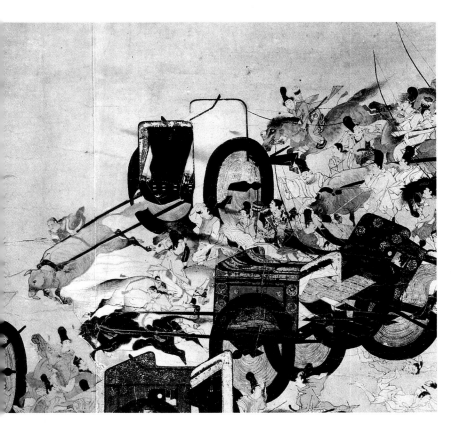

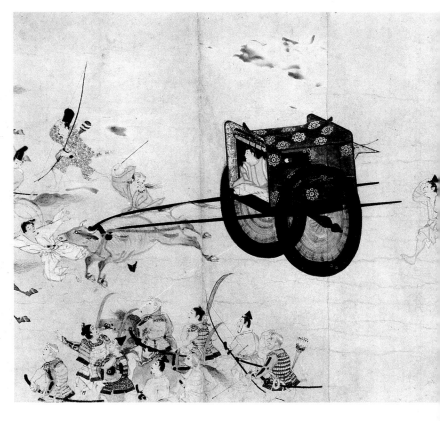

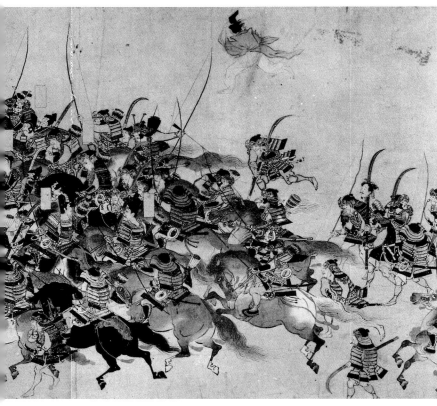

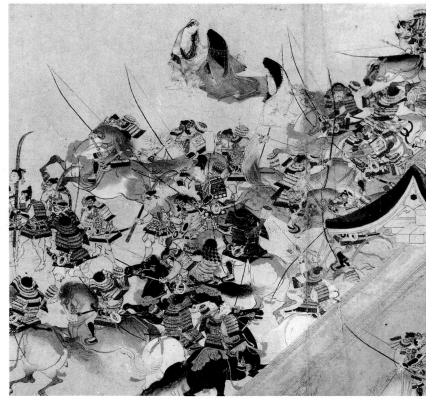

362 TAIMA MANDARA ENGI (LEGENDS OF THE TAIMA MANDARA), DETAIL OF HANDSCROLL. COLOR ON PAPER. KAMAKURA, 13TH CENTURY

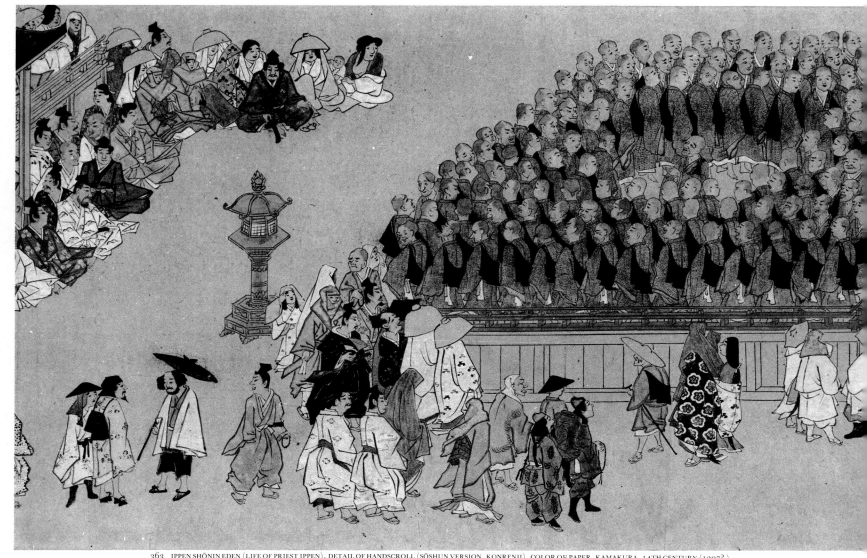

363 IPPEN SHŌNIN EDEN (LIFE OF PRIEST IPPEN), DETAIL OF HANDSCROLL (SŌSHUN VERSION, KONRENJI). COLOR ON PAPER. KAMAKURA, 14TH CENTURY (1307?)

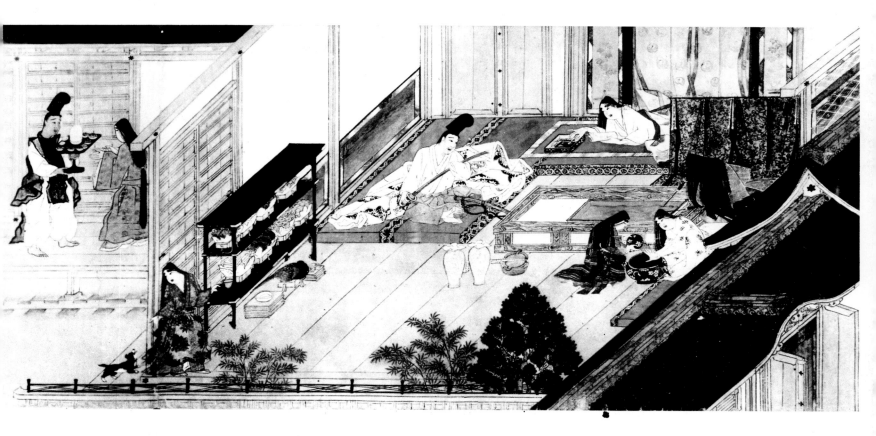

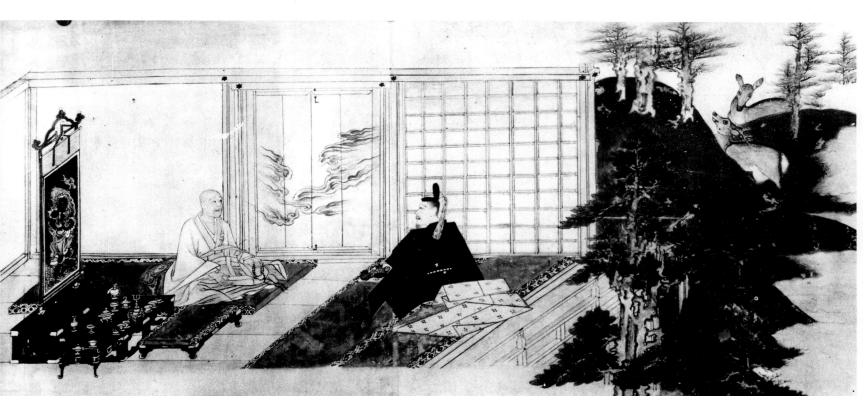

364–65 MATSUZAKI TENJIN ENGI (LEGENDS OF THE MATSUZAKI SHRINE), TWO DETAILS OF HANDSCROLL. COLOR ON PAPER. KAMAKURA-MUROMACHI, 1311

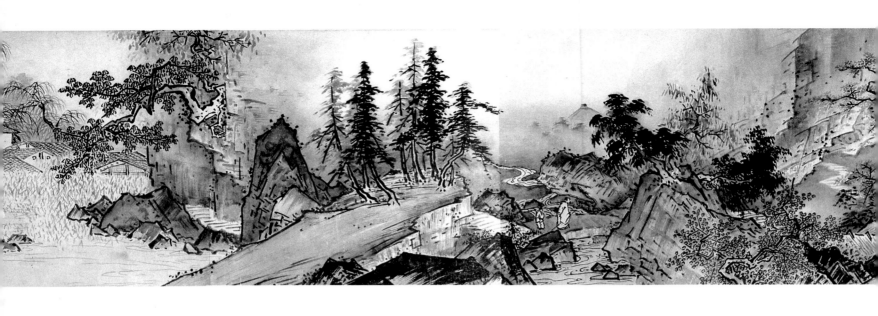

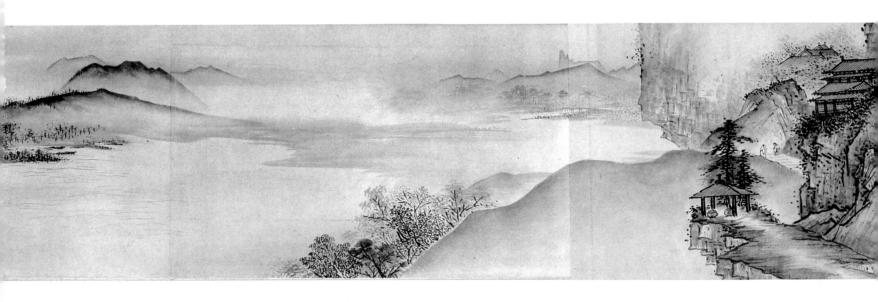

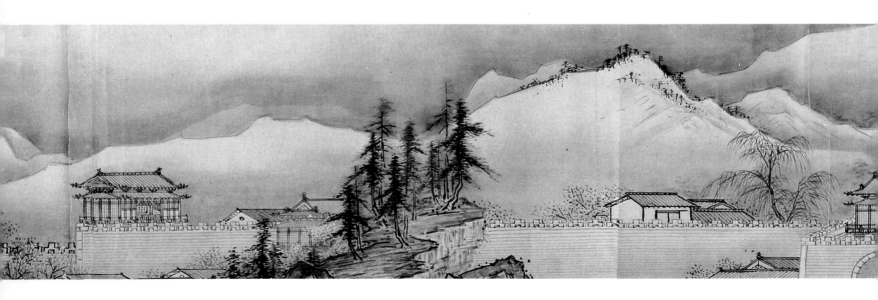

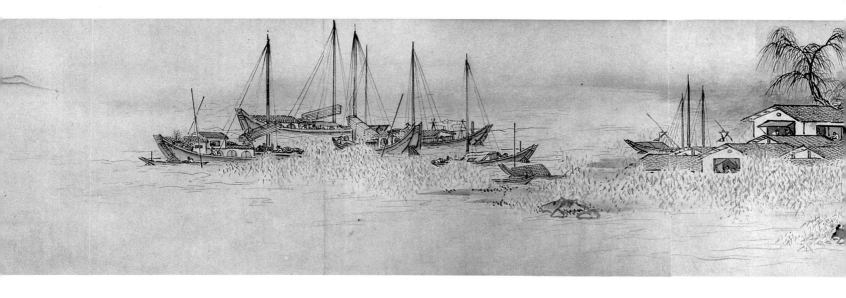

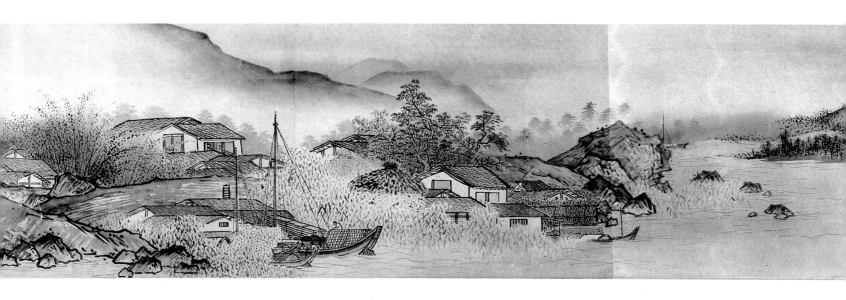

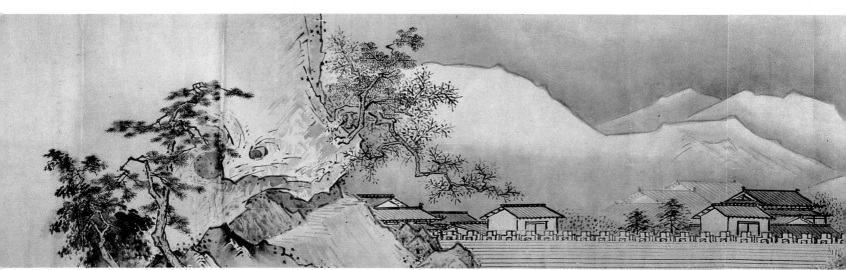

374-76 SESSHŪ (1420-1506): THE FOUR SEASONS, HANDSCROLL. INK, SLIGHT COLOR ON PAPER. MUROMACHI, C. 1486

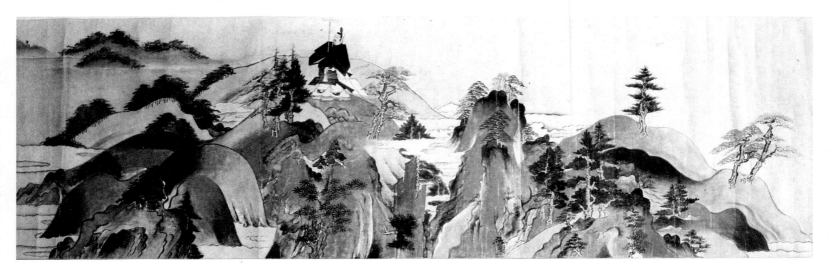

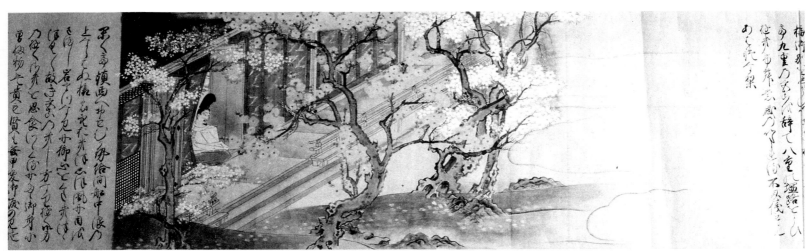

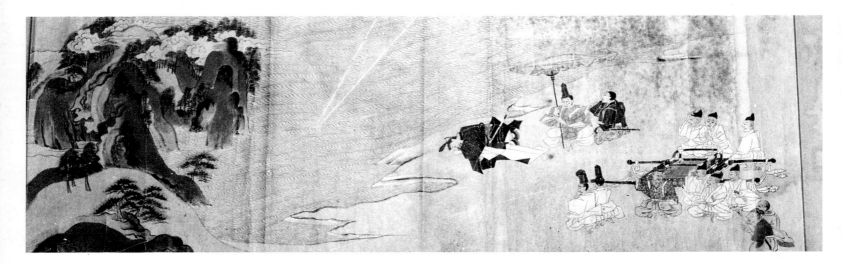

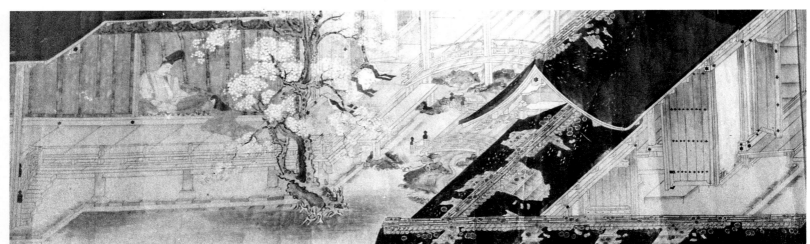

366–69 MATSUZAKI TENJIN ENGI (LEGENDS OF THE MATSUZAKI SHRINE) FOUR DETAILS FROM SIX HANDSCROLLS. COLOR ON PAPER. KAMAKURA-MUROMACHI. 1311

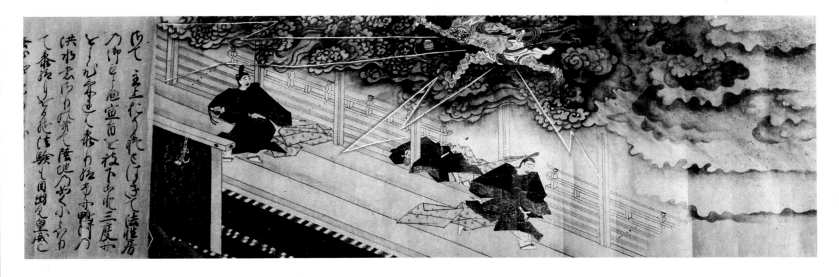

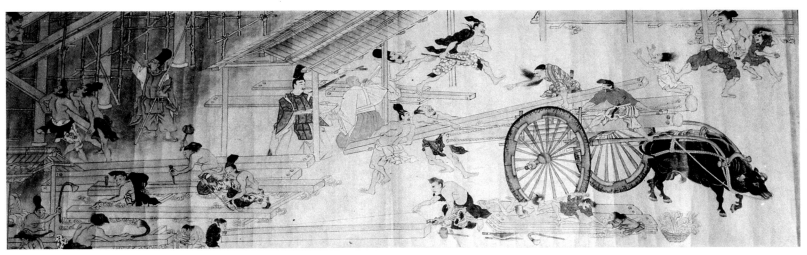

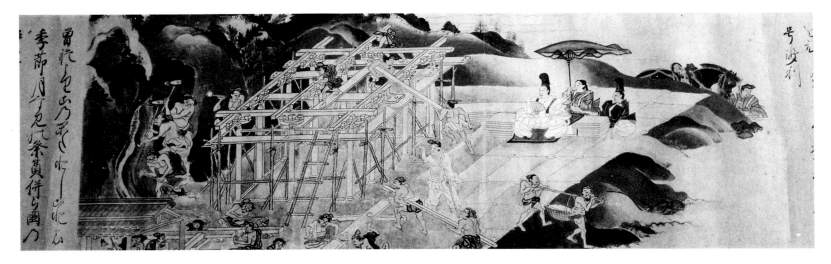

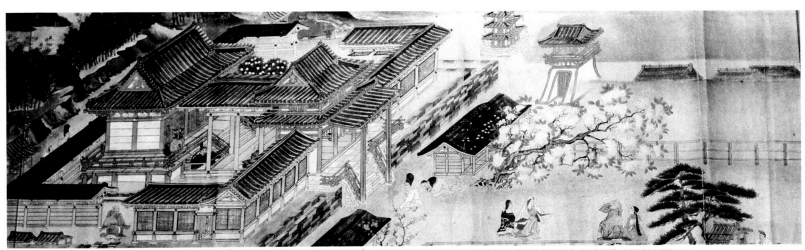

370–73 MATSUZAKI TENJIN ENGI (LEGENDS OF THE MATSUZAKI SHRINE), FOUR DETAILS FROM SIX HANDSCROLLS. COLOR ON PAPER. KAMAKURA-MUROMACHI, 1311

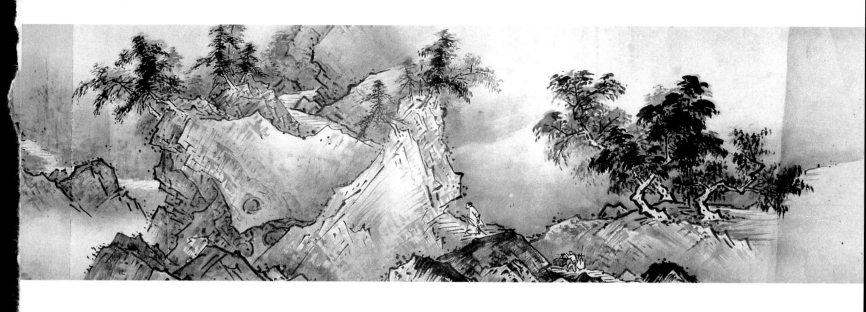

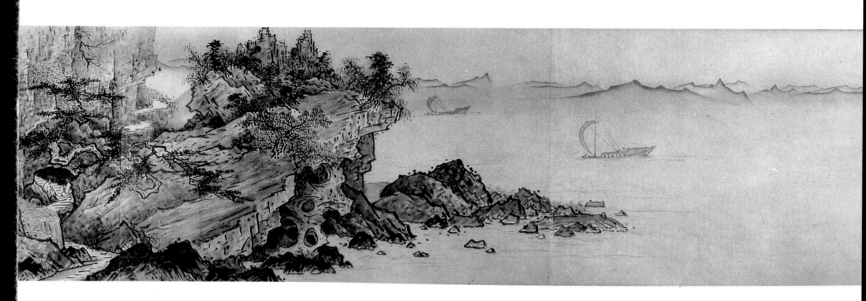

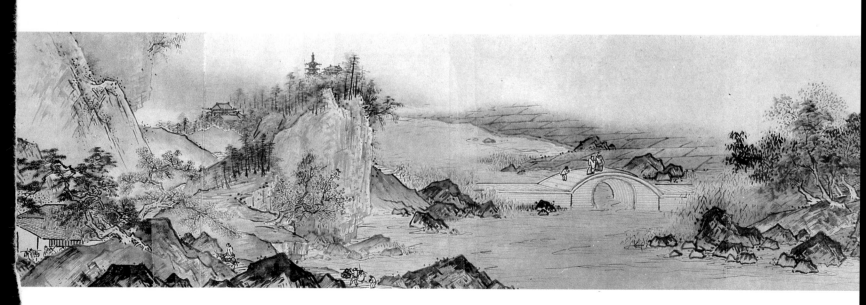

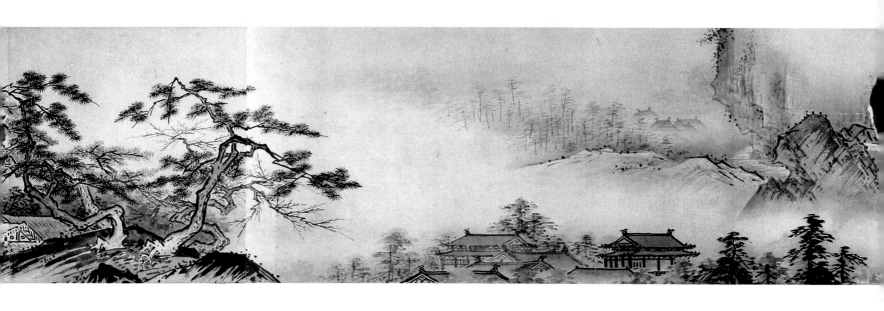

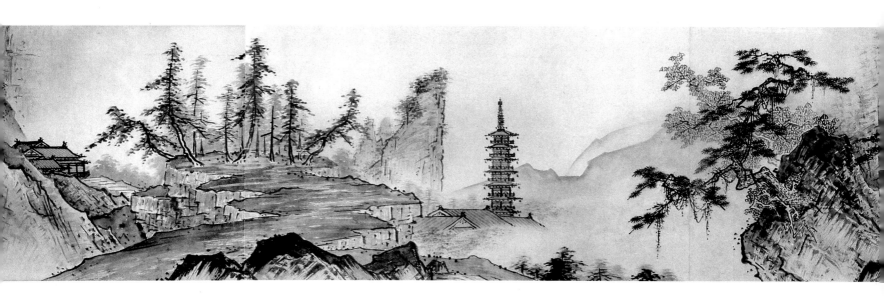

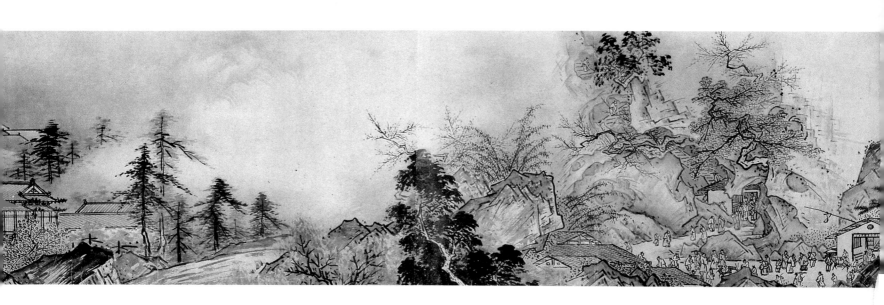

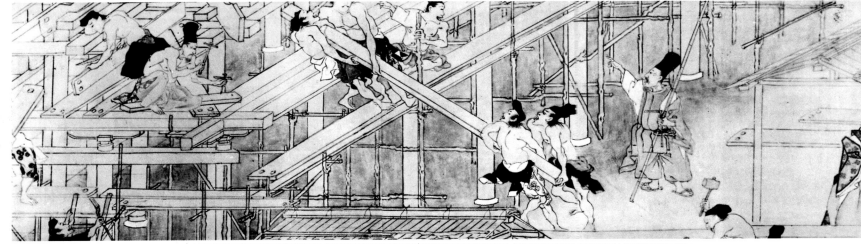

377 MATSUZAKI TENJIN ENGI (LEGENDS OF THE MATSUZAKI SHRINE) DETAIL OF HANDSCROLL. COLOR ON PAPER. KAMAKURA-MUROMACHI, 1311

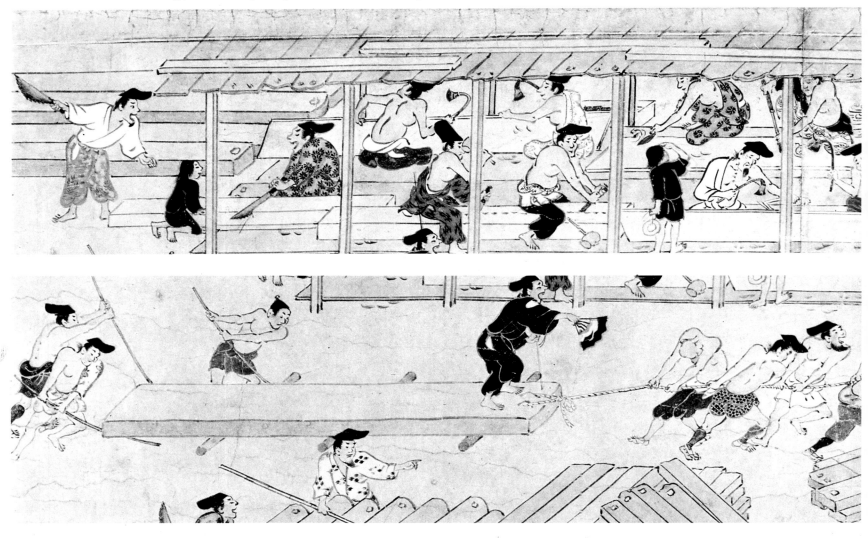

378-81 ISHIYAMADERA ENGI (LEGENDS OF ISHIYAMA TEMPLE), FOUR DETAILS OF HANDSCROLL I. COLOR ON PAPER. KAMAKURA-MUROMACHI, 14TH CENTURY

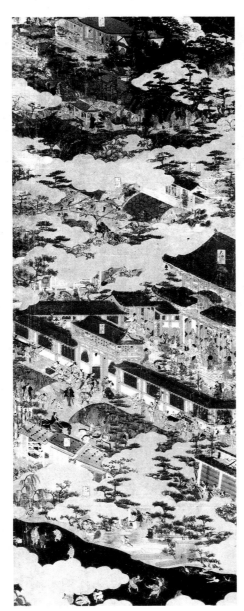
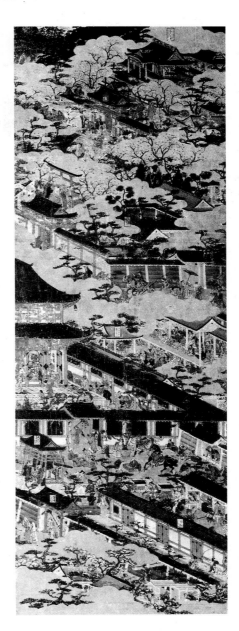

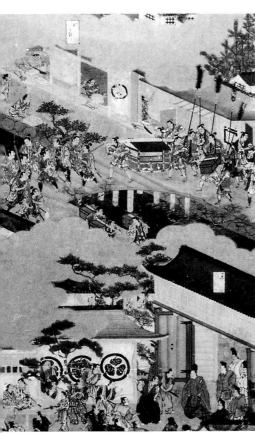
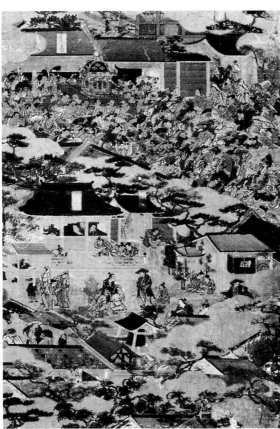

382–87 FUZOKU ZU BYŌBU (GENRE SCENES, KYOTO), SIX DETAILS OF TWO EIGHT-FOLD SCREENS. COLOR ON PAPER. MUROMACHI, 16TH CENTURY

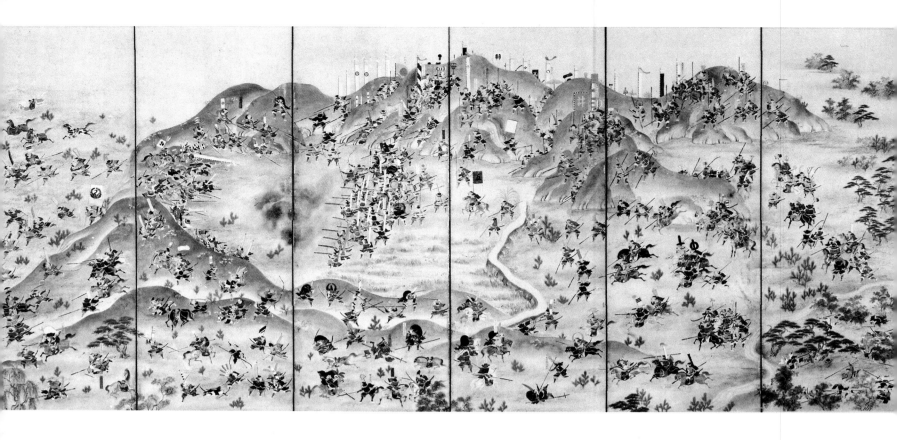

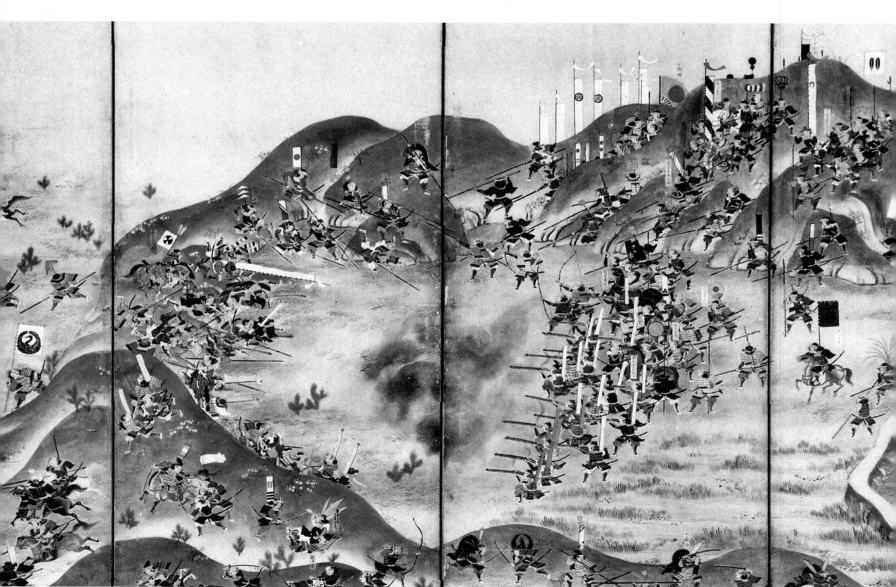

388–89 THE BATTLE OF NAGAKUTE (1584), SIX-FOLD SCREEN AND DETAIL. COLOR ON PAPER. MOMOYAMA, LATE 16TH–EARLY 17TH CENTURY

440

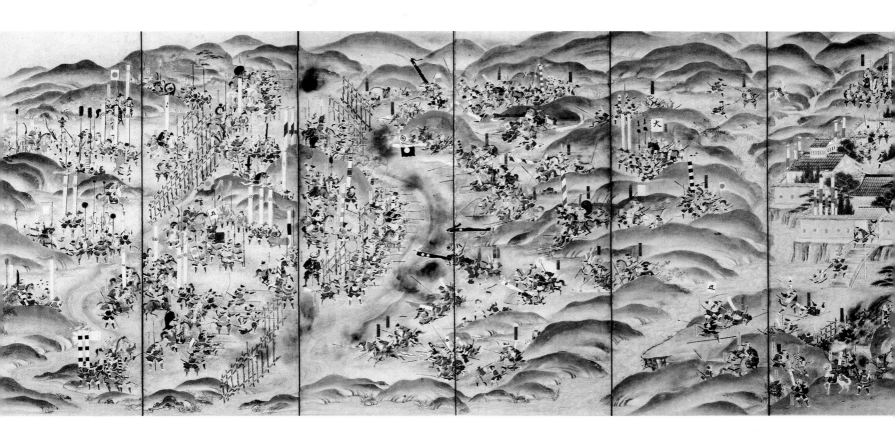

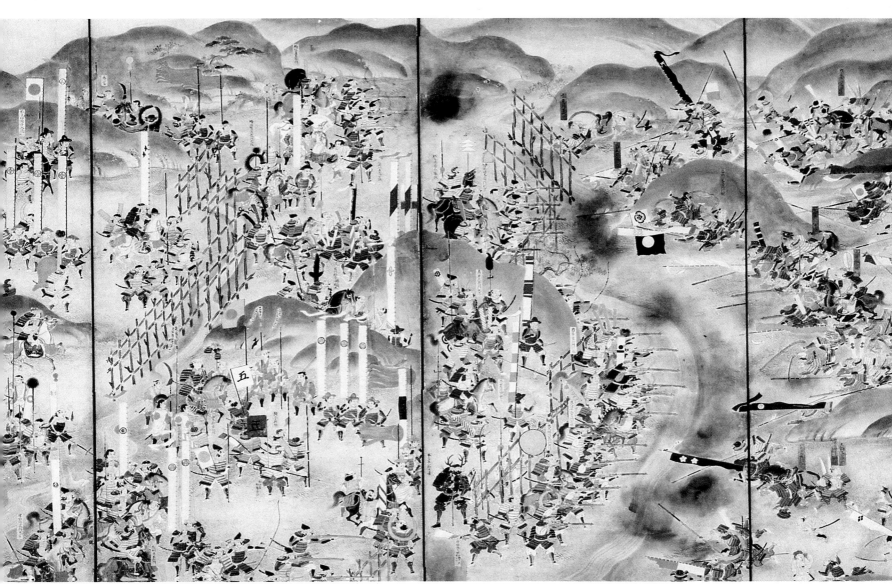

390–91 THE BATTLE OF NAGASHINO (1575), SIX-FOLD SCREEN AND DETAIL. COLOR ON PAPER. MOMOYAMA, LATE 16TH CENTURY

392–94 DŌJŌJI ENGI (LEGENDS OF DŌJŌJI): ENAMORED OF A MONK, A REJECTED YOUNG WOMAN HAUNTS HIM BY TURNING HERSELF INTO A DRAGON, THREE DETAILS OF TWO HANDSCROLLS. COLOR ON PAPER. MUROMACHI, 16TH CENTURY

442

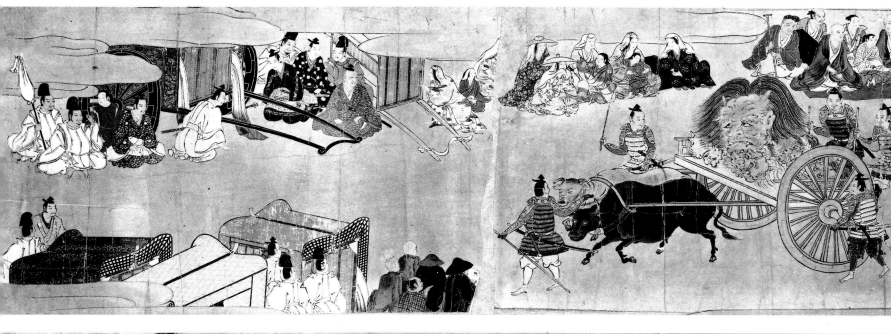

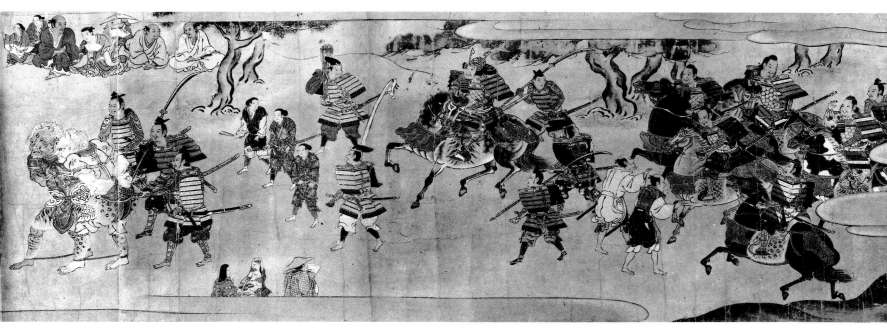

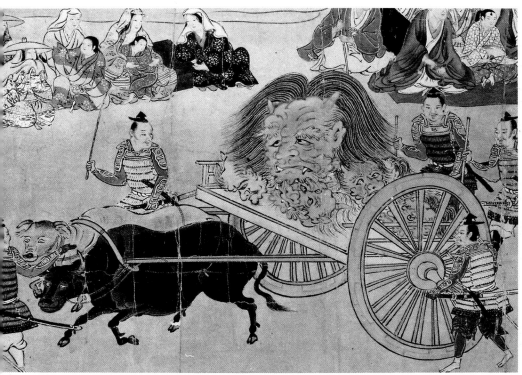

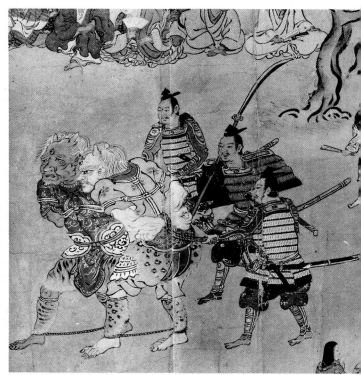

395–98 TAKANOBU (1571–1618), ATTR.: ŌEYAMA EMAKI (LEGEND OF ŌEYAMA), FOUR DETAILS OF HANDSCROLL. COLOR ON PAPER. MOMOYAMA

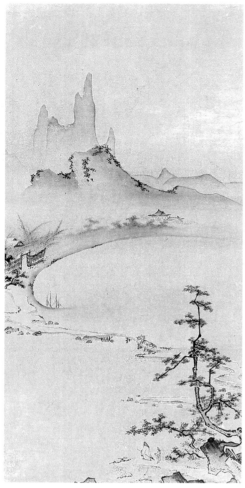

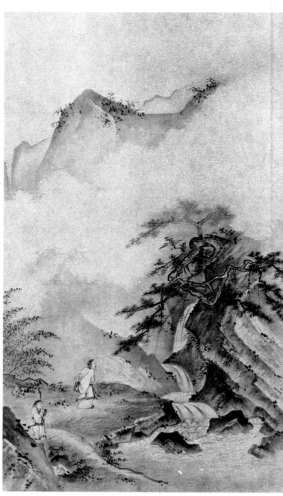

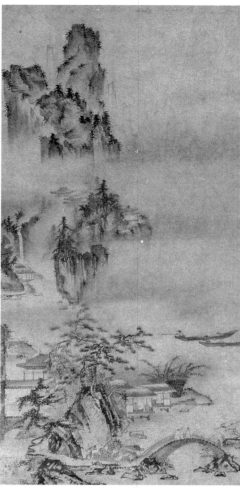

399 KANŌ MASANOBU (1434–1530), ATTR.: LANDSCAPE. INK, SLIGHT COLOR, ON PAPER. MUROMACHI

400 SŌAMI (1485?–1525), ATTR.: LI TAI-PO LOOKING AT A WATERFALL, HANGING SCROLL. INK ON PAPER. MUROMACHI

401 SŌHA (FL. 15TH CENTURY): LANDSCAPE IN THREE SECTIONS, HANGING SCROLL. INK ON PAPER. MUROMACHI

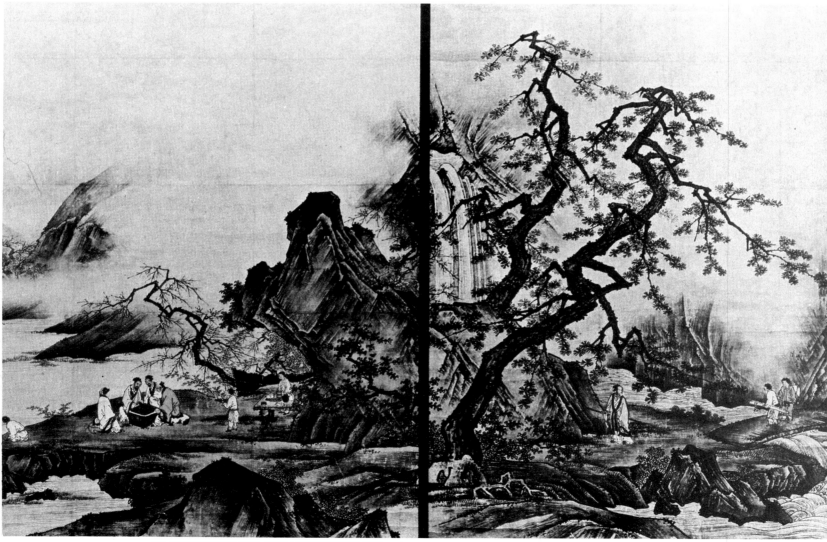

402 KANŌ MOTONOBU (1476–1559): LANDSCAPE WITH WATERFALL, PAINTING FROM FUSUMA AT REIUNIN. INK, COLOR ON PAPER. MUROMACHI

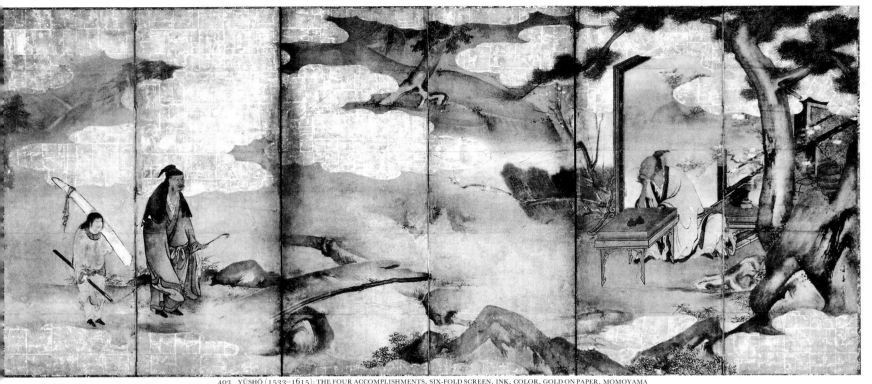

403 YŪSHŌ (1533–1615): THE FOUR ACCOMPLISHMENTS, SIX-FOLD SCREEN. INK, COLOR, GOLD ON PAPER. MOMOYAMA

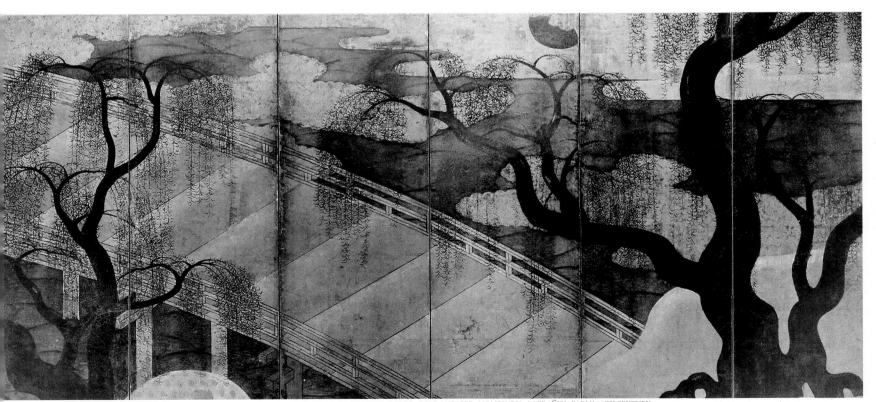

404 BRIDGE AT UJI RIVER, SIX-FOLD SCREEN. COLOR, GOLD ON PAPER. MOMOYAMA, LATE 16TH–EARLY 17TH CENTURY

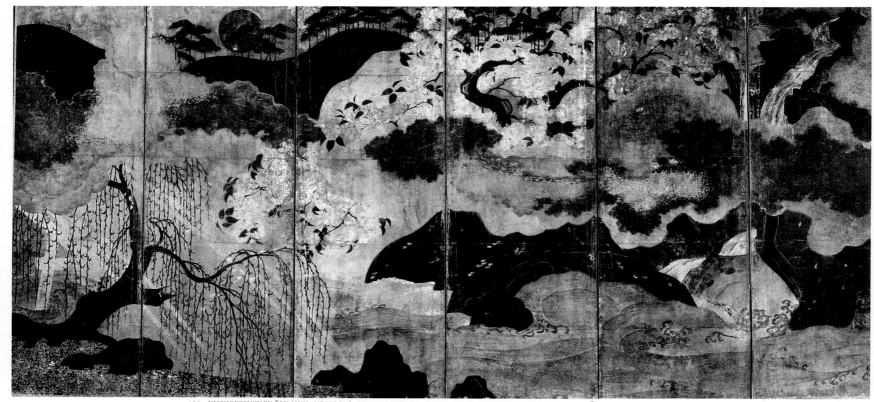

405 NICHIGETSUZU BY ŌBU (SUN AND MOON), SIX-FOLD SCREEN. COLOR, GOLD, ON PAPER. MOMOYAMA, LATE 16TH–EARLY 17TH CENTURY

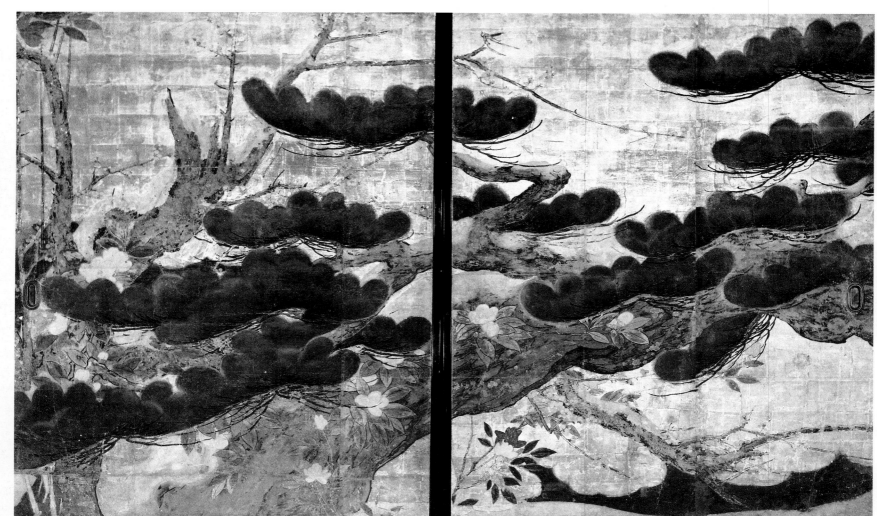

406 PINES AND CHERRY TREES, DETAIL OF FUSUMA (SLIDING SCREEN) PAINTING. COLOR, GOLD ON PAPER. MOMOYAMA, LATE 16TH–EARLY 17TH CENTURY

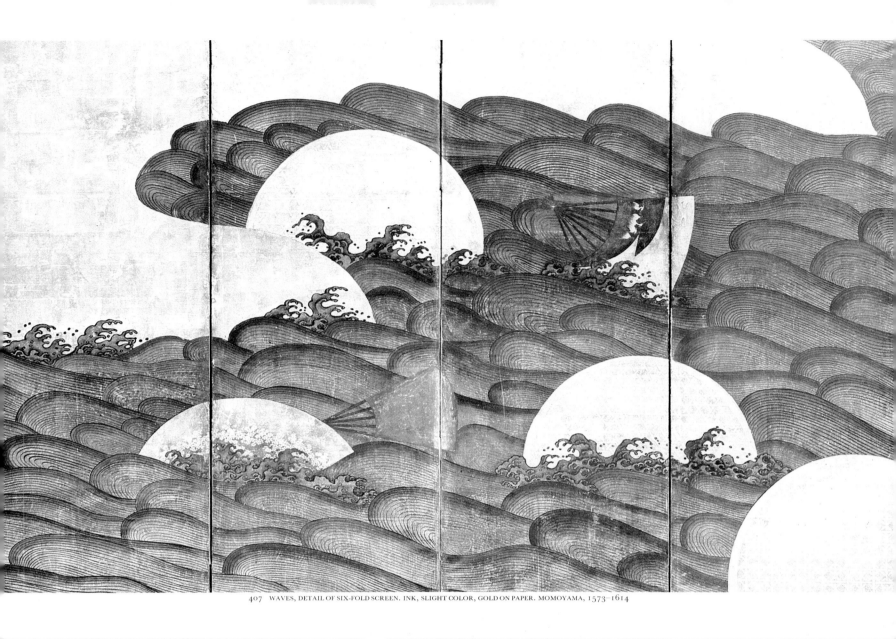

407 WAVES, DETAIL OF SIX-FOLD SCREEN. INK, SLIGHT COLOR, GOLD ON PAPER. MOMOYAMA, 1573–1614

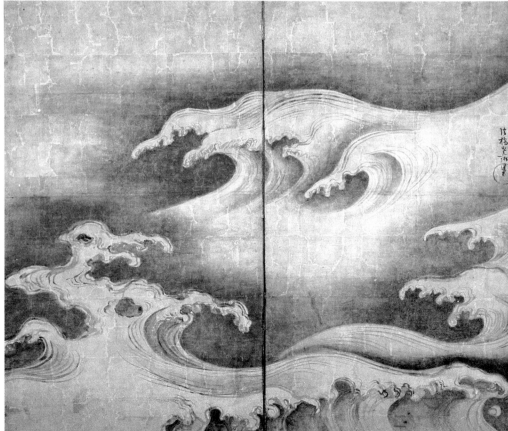

408 SŌTATSU (1575–1643): WAVES AT MATSUSHIMA, DETAIL OF SIX-FOLD SCREEN. INK, COLOR, GOLD ON PAPER. EDO

409 KŌRIN (1658–1716): WAVES, TWO-FOLD SCREEN. COLOR, GOLD, INK ON PAPER. EDO

447

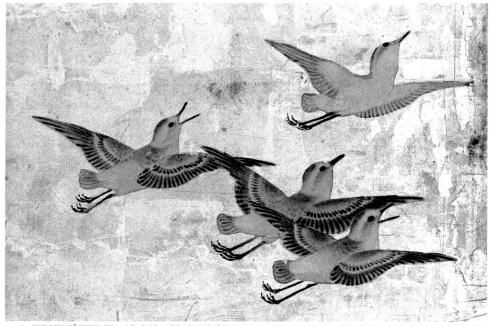

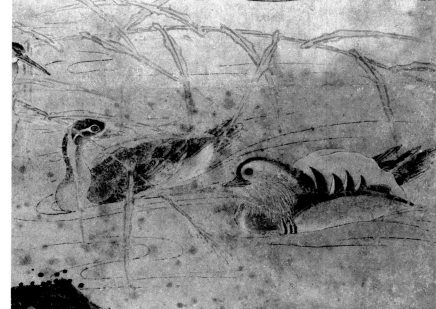

410 UNKOKU TŌTETSU (FL. 2ND HALF 17TH CENTURY): PHEASANT, TREES, FLOWERS, AND BIRDS, DETAIL OF SIX-FOLD SCREEN.
COLOR, GOLD ON PAPER. EDO

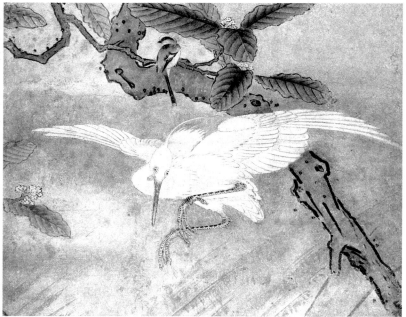

411–13 SESSHŪ (1420–1506), ATTR.: FLOWERS AND BIRDS, THREE DETAILS OF SIX-FOLD SCREEN. INK, COLOR ON PAPER. MUROMACHI

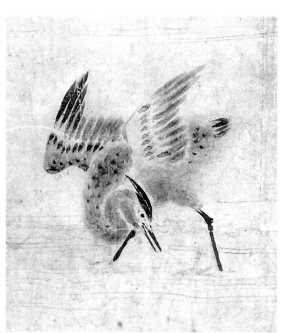

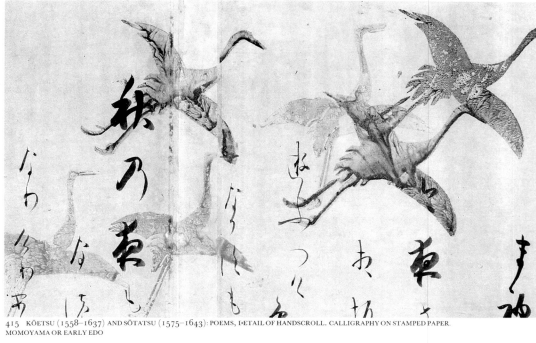

414 SHOEI (1519–1592): LANDSCAPE AND BIRDS FOR THE
JUKŌIN, DETAIL. INK, COLOR ON PAPER. MUROMACHI, 1566

415 KŌETSU (1558–1637) AND SŌTATSU (1575–1643): POEMS, DETAIL OF HANDSCROLL. CALLIGRAPHY ON STAMPED PAPER.
MOMOYAMA OR EARLY EDO

448

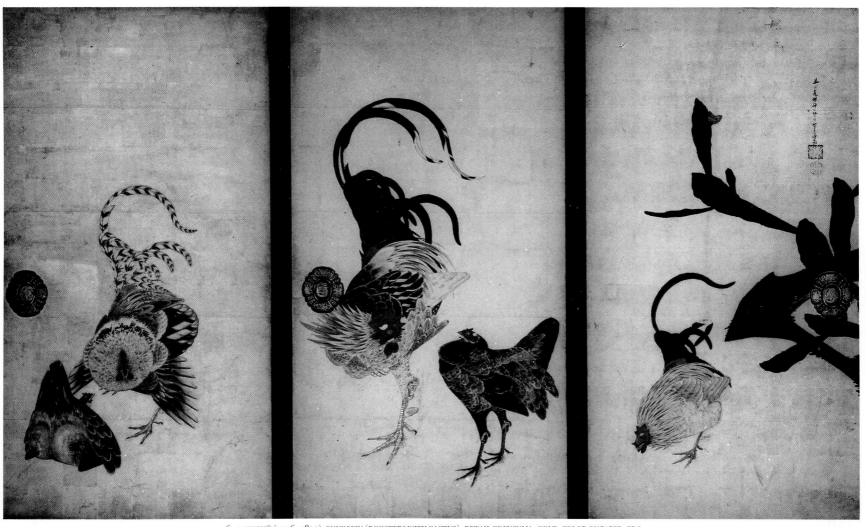

416 JAKUCHŪ (1716–1800): GUNKEIZU (ROOSTERS WITH CACTUS), DETAIL OF FUSUMA. GOLD, COLOR ON PAPER. EDO

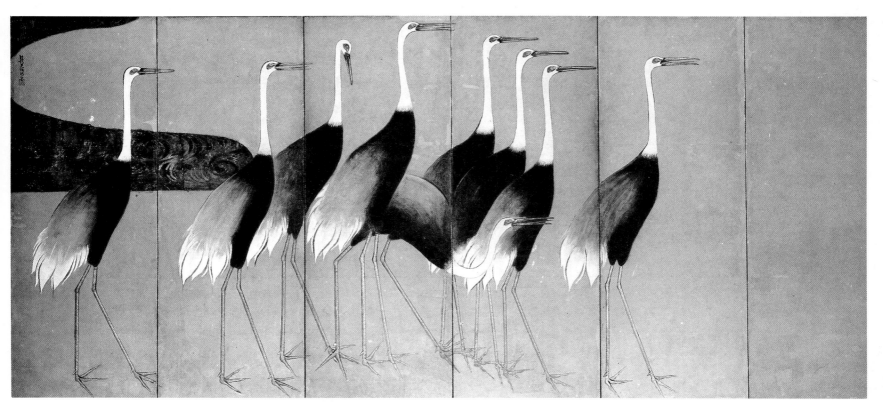

417 KŌRIN (1658–1716): CRANES, SIX-FOLD SCREEN. INK, COLOR, GOLD, ON PAPER. EDO

418 THE SPIRITED BULL. SLIGHT COLOR ON PAPER. KAMAKURA, LATE 13TH CENTURY

419-20 SEKKYAKUSHI (FL. EARLY 15TH CENTURY): BOY ON A WATER BUFFALO; BOY WRESTLING A WATER BUFFALO; DETAILS OF TWO HANGING SCROLLS. INK ON PAPER. MUROMACHI

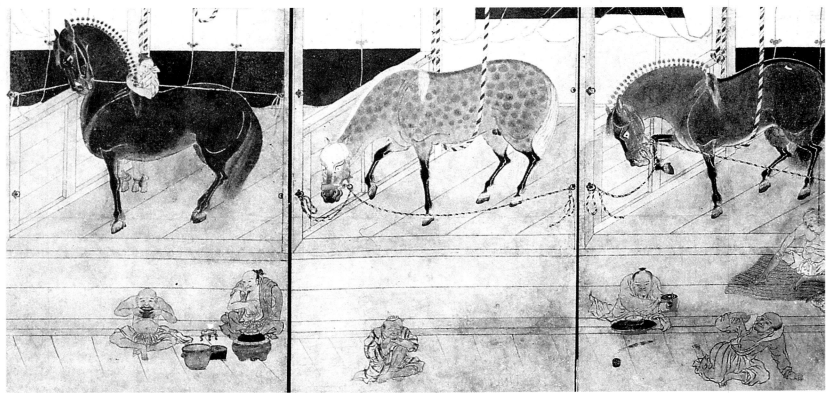

421 HORSES AND GROOMS, DETAIL OF SIX-FOLD SCREEN. COLOR ON PAPER. MUROMACHI-MOMOYAMA, 16TH CENTURY

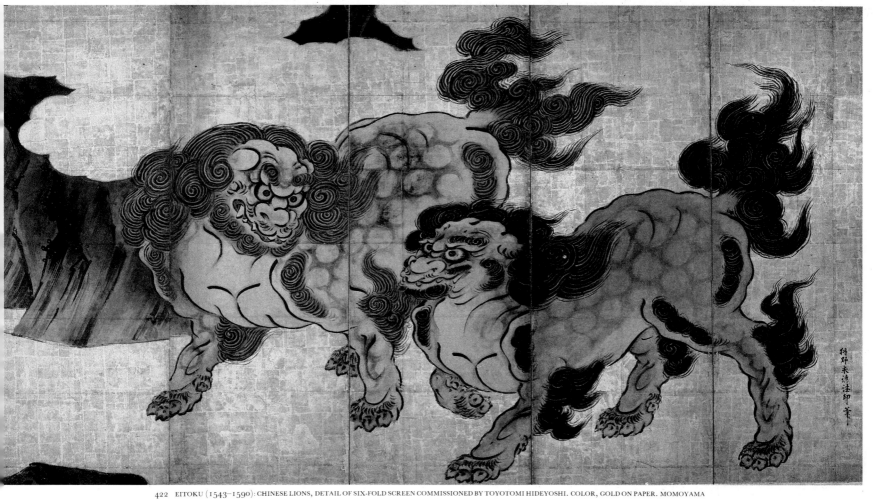

422 EITOKU (1543–1590): CHINESE LIONS, DETAIL OF SIX-FOLD SCREEN COMMISSIONED BY TOYOTOMI HIDEYOSHI. COLOR, GOLD ON PAPER. MOMOYAMA

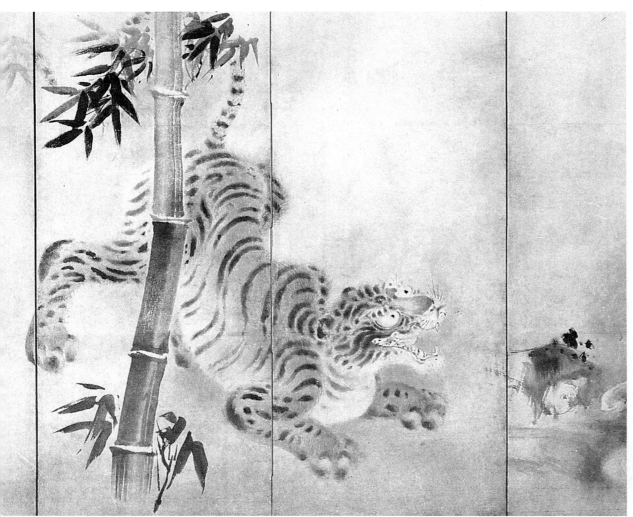

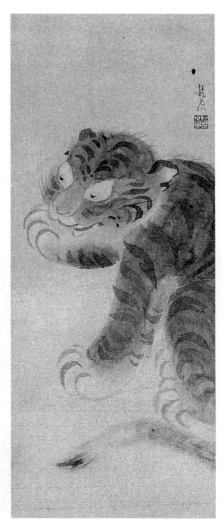

423 TAN'YŪ (1602–1674): TIGERS, DETAIL OF SIX-FOLD SCREEN. INK ON PAPER. EDO

424 KŌRIN (1658–1716): TIGER, HANGING SCROLL. INK ON PAPER. EDO

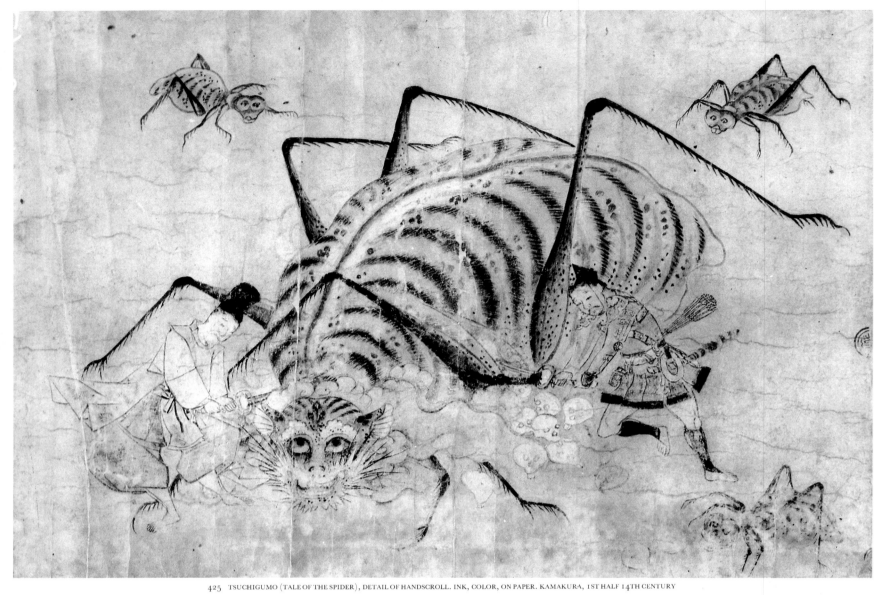

425 TSUCHIGUMO (TALE OF THE SPIDER), DETAIL OF HANDSCROLL. INK, COLOR, ON PAPER. KAMAKURA, 1ST HALF 14TH CENTURY

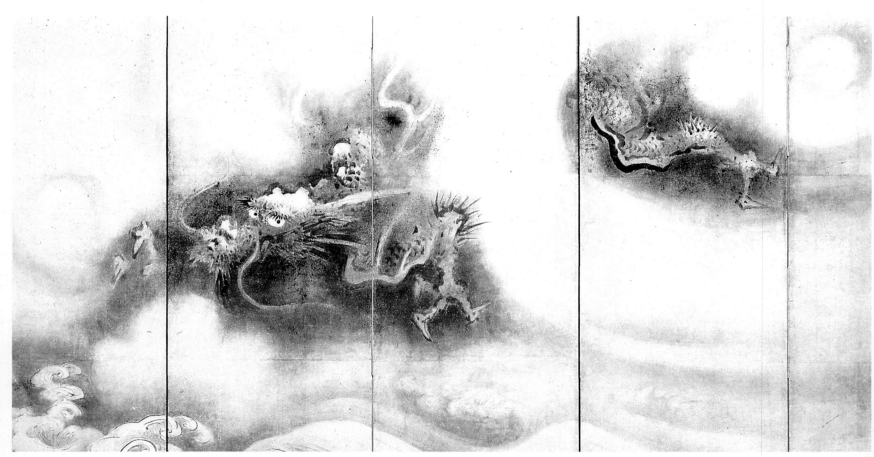

426 TAN'YŪ (1602-1674): DRAGONS, DETAIL OF SIX-FOLD SCREEN. INK ON PAPER. EDO

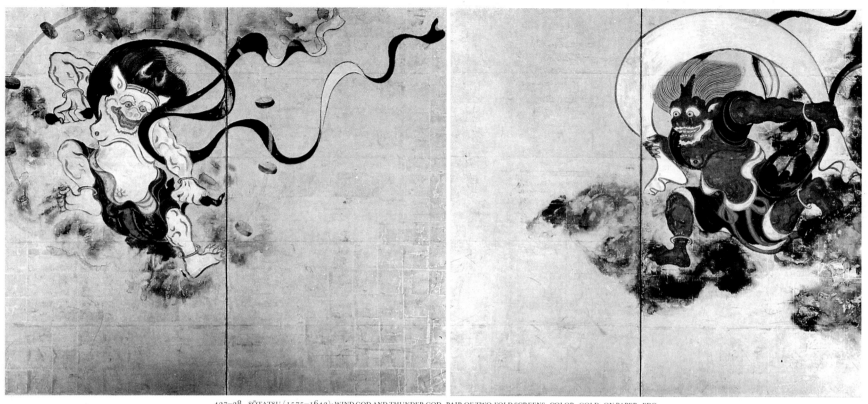

427-28 SŌTATSU (1575-1643): WIND GOD AND THUNDER GOD, PAIR OF TWO-FOLD SCREENS. COLOR, GOLD, ON PAPER. EDO

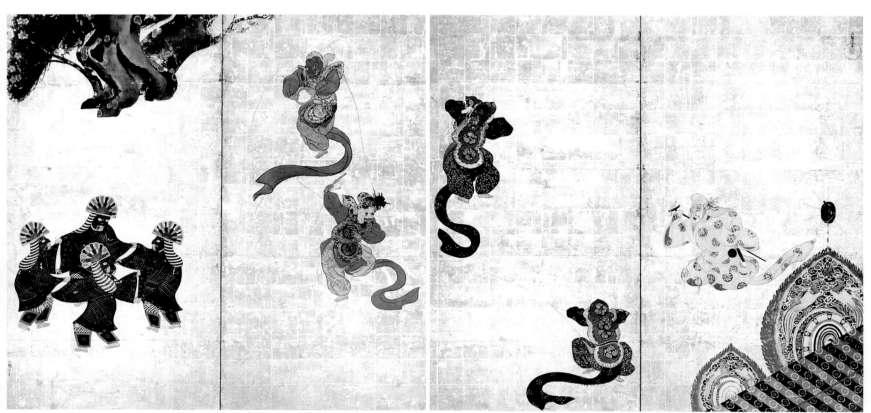

429-30 SŌTATSU (1575-1643): BUGAKU DANCERS, PAIR OF TWO-FOLD SCREENS. COLOR, GOLD ON PAPER. EDO

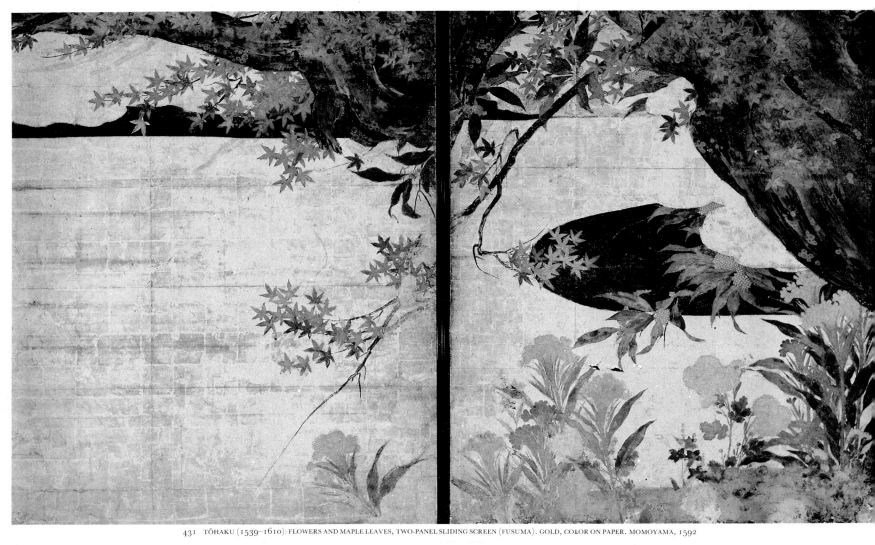

431 TŌHAKU (1539–1610): FLOWERS AND MAPLE LEAVES, TWO-PANEL SLIDING SCREEN (FUSUMA). GOLD, COLOR ON PAPER. MOMOYAMA, 1592

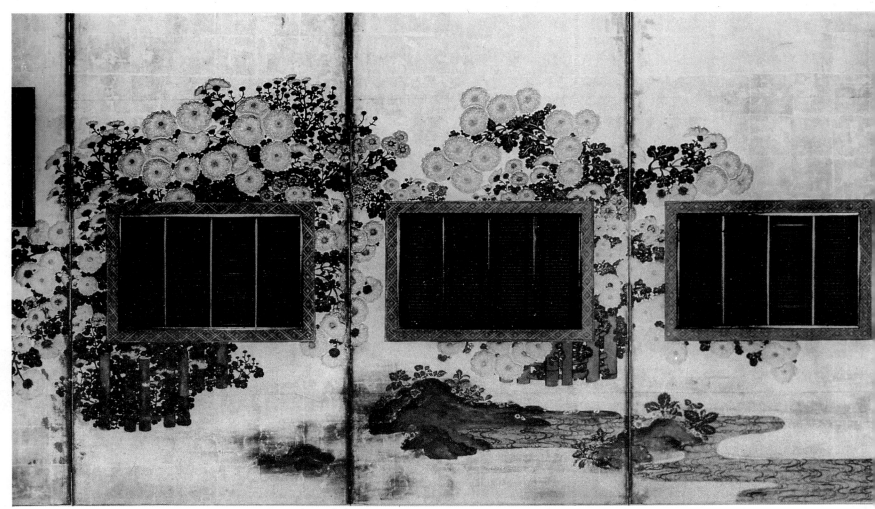

432 SŌTATSU (1575–1643): CHRYSANTHEMUMS, DETAIL OF SIX-FOLD SCREEN. COLOR, GOLD ON PAPER. EDO

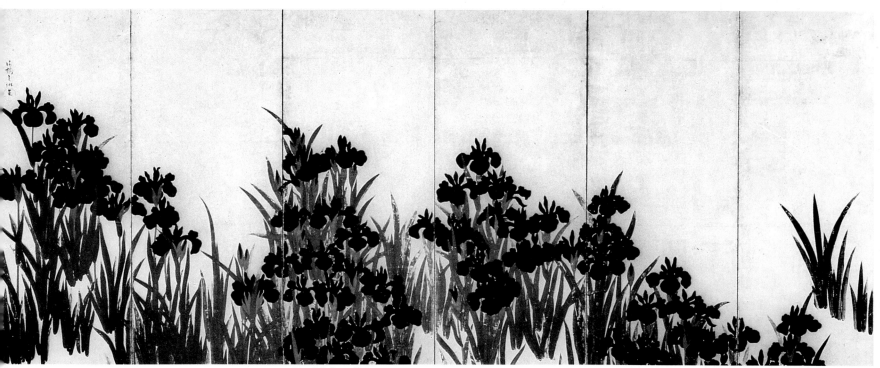

433 KŌRIN (1658–1716): IRISES, SIX-FOLD SCREEN. COLOR, GOLD ON PAPER. EDO, BEFORE 1704

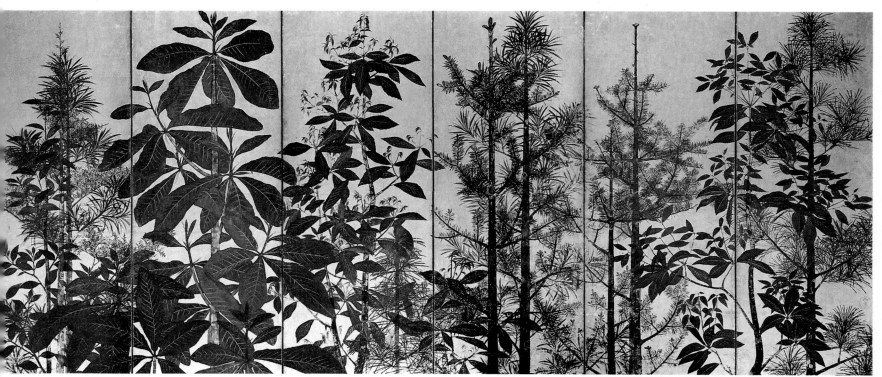

434 SŌTATSU (1575–1643): TREES, SIX-FOLD SCREEN. INK, COLOR ON GOLD LEAF. EDO

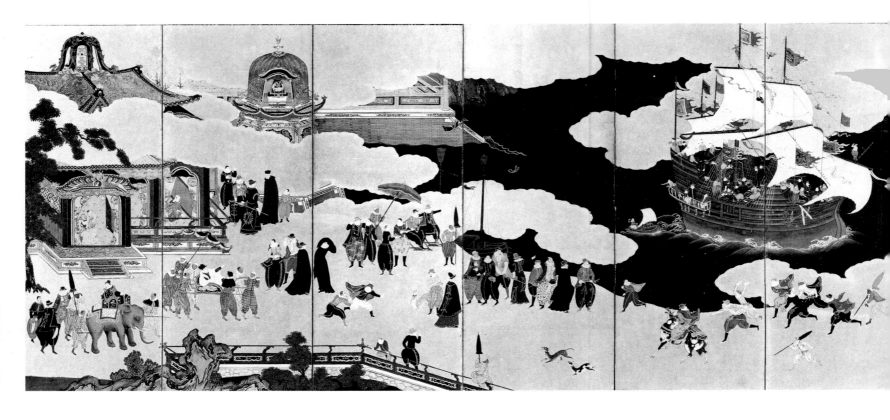

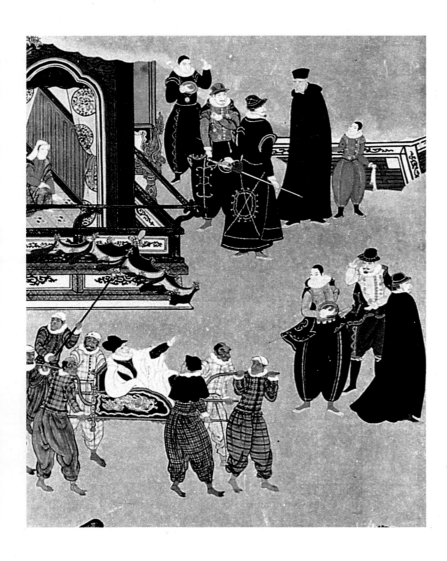

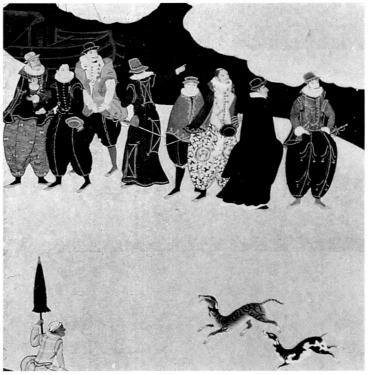

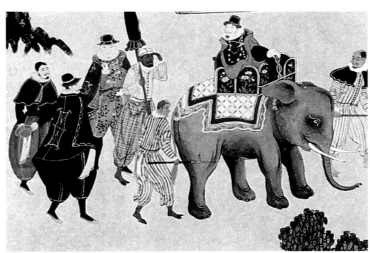

435–38 KANŌ NAIZEN (1570–1616): DEPARTURE OF FOREIGN SHIP FOR JAPAN, PAIR OF SIX-FOLD SCREENS AND THREE DETAILS. MOMOYAMA

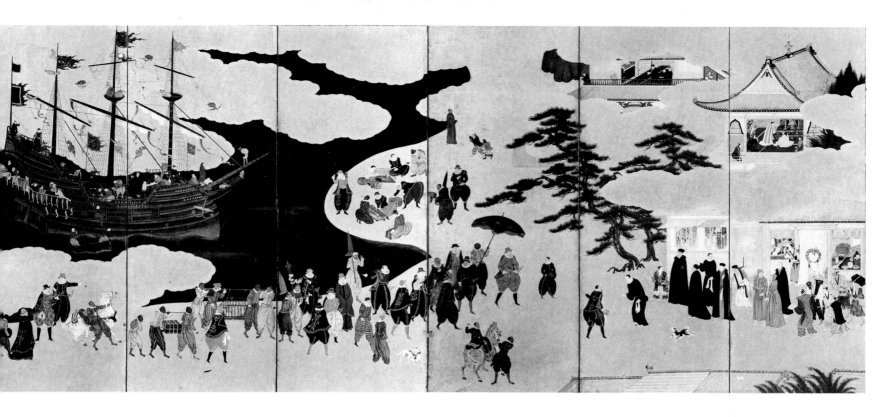

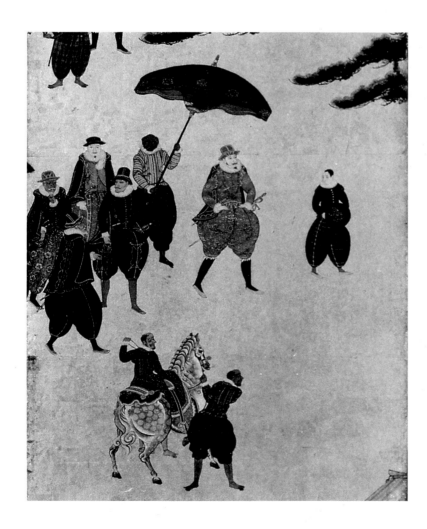

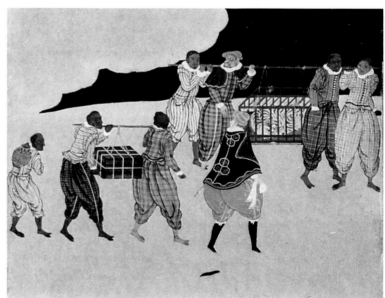

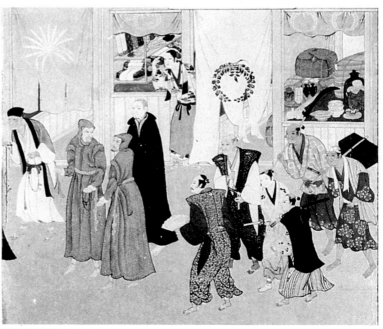

439–42 KANŌ NAIZEN (1570–1616): ARRIVAL OF FOREIGN SHIP AT NAGASAKI, PAIR OF SIX-FOLD SCREENS AND THREE DETAILS. MOMOYAMA

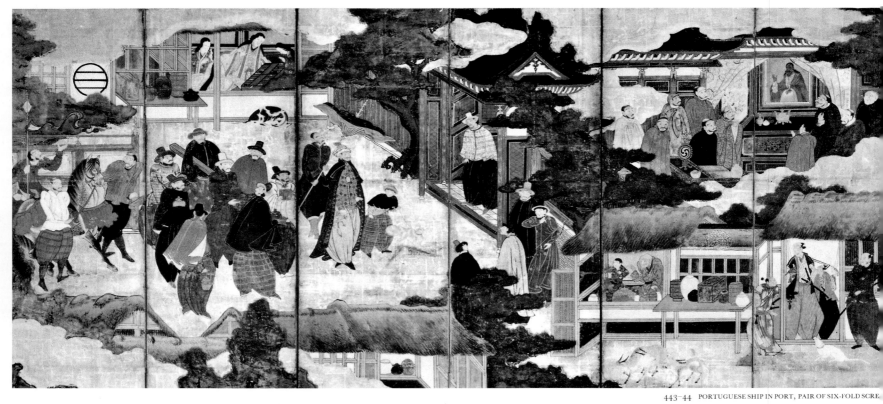

443-44 PORTUGUESE SHIP IN PORT, PAIR OF SIX-FOLD SCRE

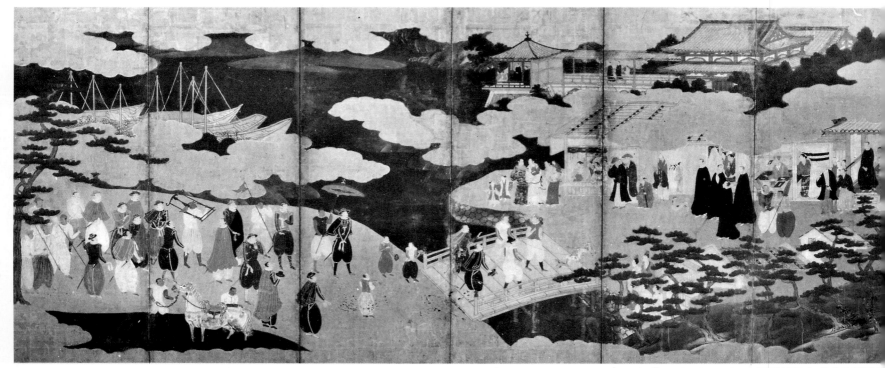

445-46 WATCHING THE ARRIVAL OF THE PORTUGUESE, PAIR OF SIX-F

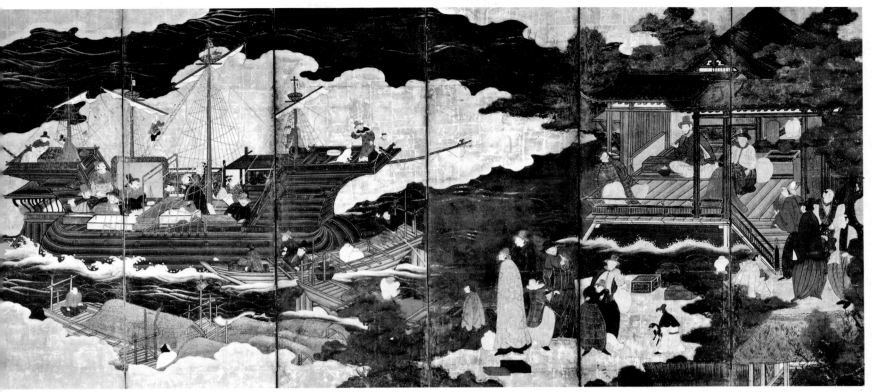

R ON PAPER. MOMOYAMA, LATE 16TH–EARLY 17TH CENTURY

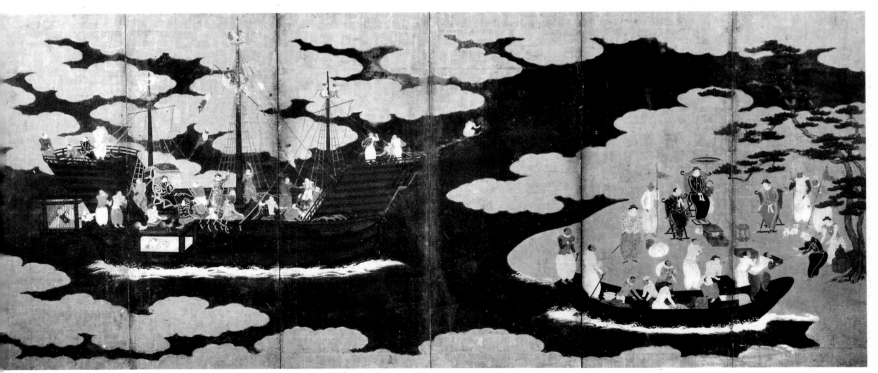

ENS. COLOR ON PAPER. MOMOYAMA, LATE 16TH–EARLY 17TH CENTURY

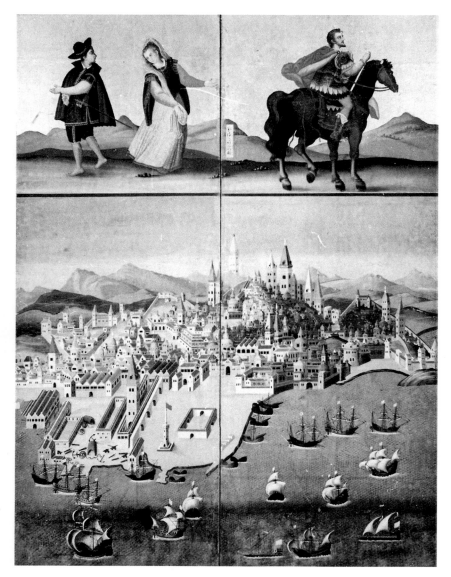

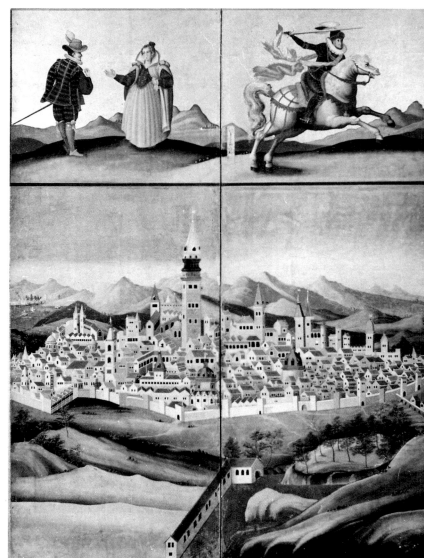

447–50　FOUR GREAT CITIES OF THE WEST: LISBON, MADRID, ROME

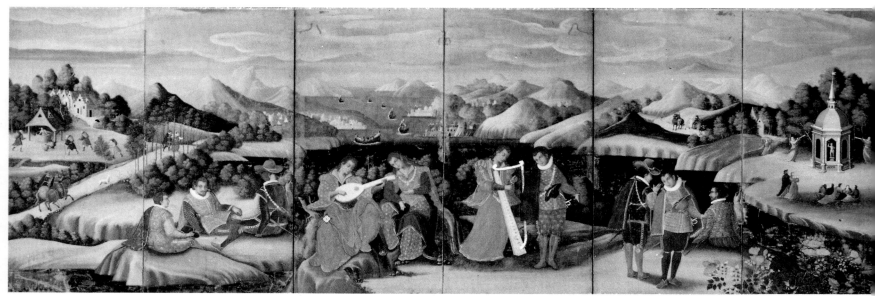

451–52　SOCIAL CUSTOMS OF FOREIGNERS, PA

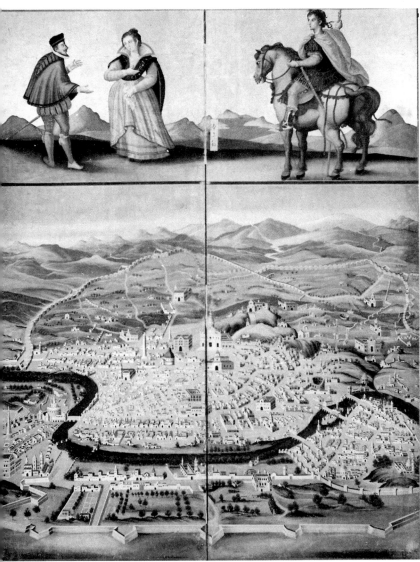
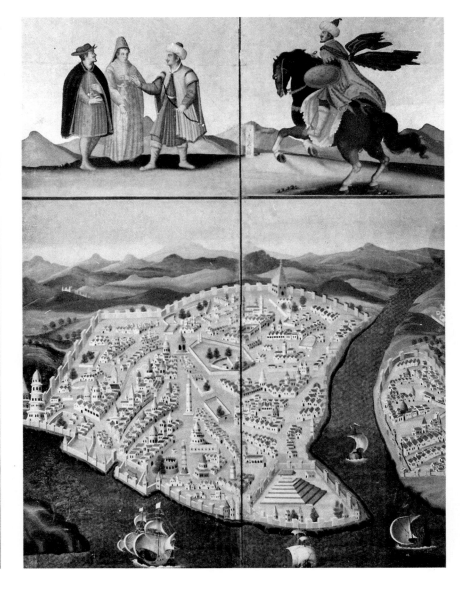

STANTINOPLE, EIGHT-FOLD SCREEN (SEE FIG. 453). MOMOYAMA, C. 1593

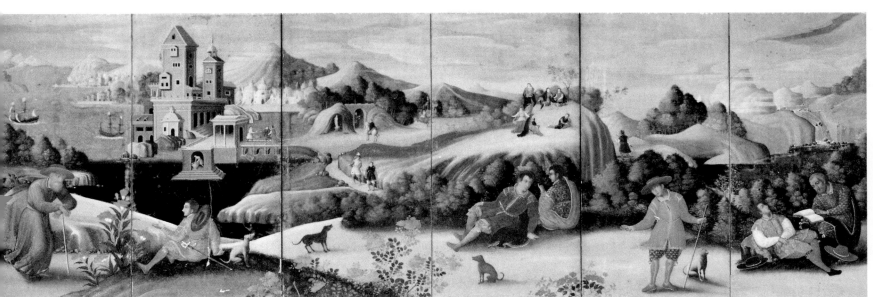

OLD SCREENS. INK, COLOR ON PAPER. MOMOYAMA, C. 1610

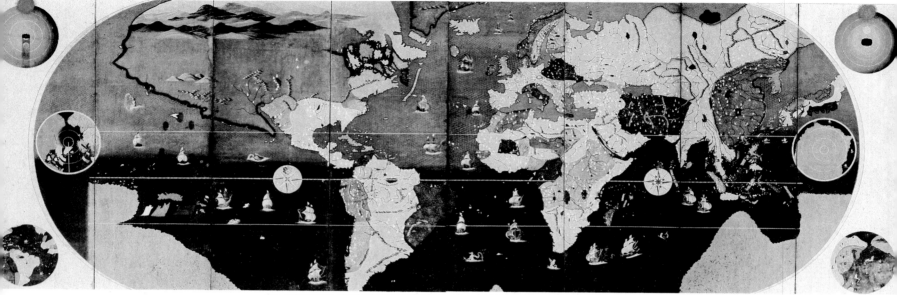

453 PLANISPHERE, EIGHT-FOLD SCREEN (SEE FIGS. 447–50). COLOR ON PAPER. MOMOYAMA. C. 1593

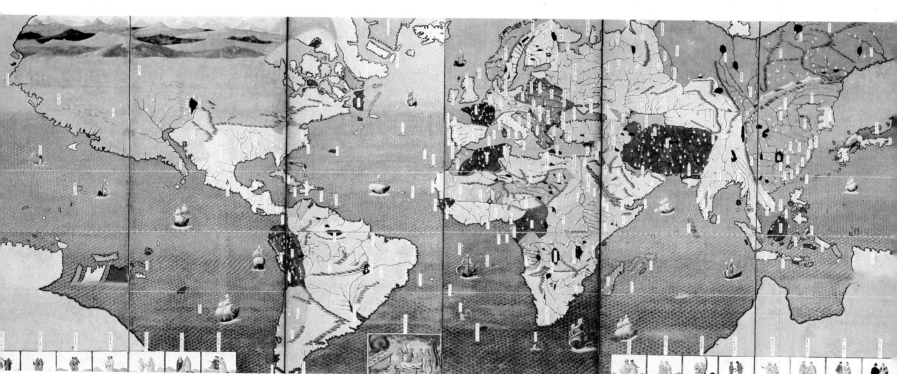

454 PLANISPHERE, SIX-FOLD SCREEN. COLOR ON PAPER. MUROMACHI-MOMOYAMA, LATE 16TE CENTURY

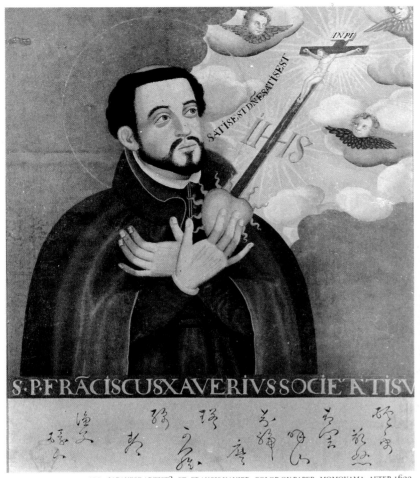

455 JAPANESE ARTIST? : ST. FRANCIS XAVIER. COLOR ON PAPER. MOMOYAMA, AFTER 1623

456 SPANISH ARTIST: VIRGIN OF SORROWS. OIL ON CANVAS. IMPORTED 16TH–17TH CENTURY

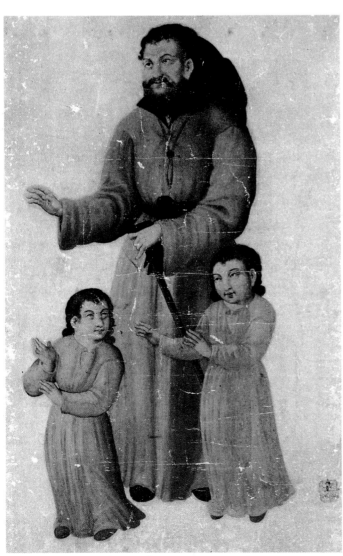

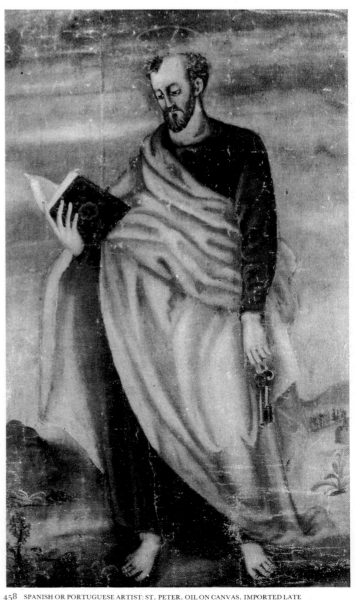

457 NOBUKATA (FL. LATE 16TH–EARLY 17TH CENTURY), ATTR.: PRIEST AND TWO CHILDREN. COLOR ON PAPER. MOMOYAMA

458 SPANISH OR PORTUGUESE ARTIST: ST. PETER. OIL ON CANVAS. IMPORTED LATE 16TH CENTURY

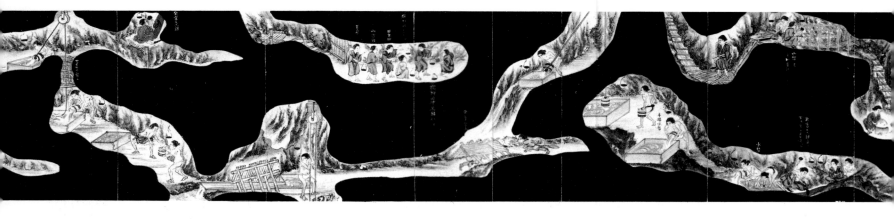

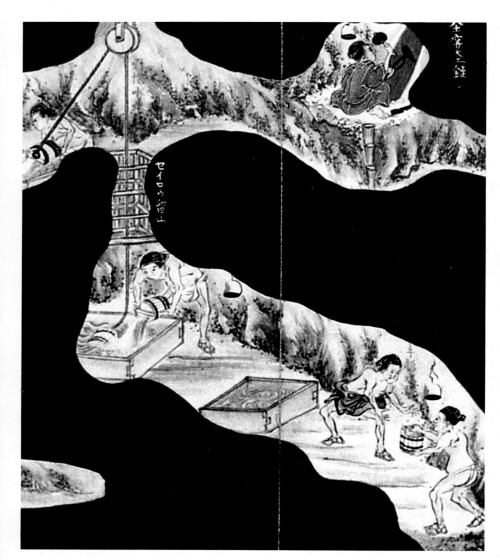

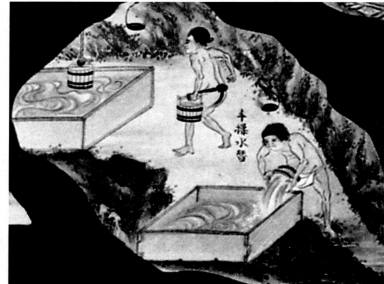

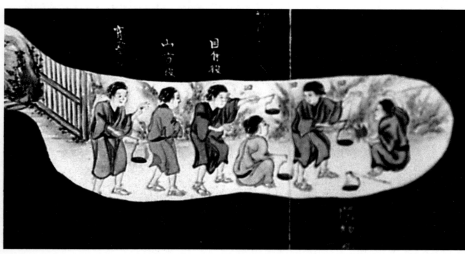

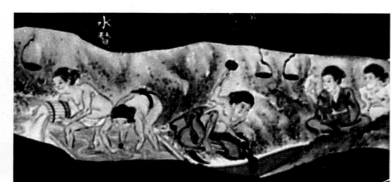

459–64 INSIDE A COPPER MINE: REMOVAL OF ORE AND INITIAL PROCESSING, SIX DETAILS OF HANDSCROLL. COLOR ON PAPER. EDO

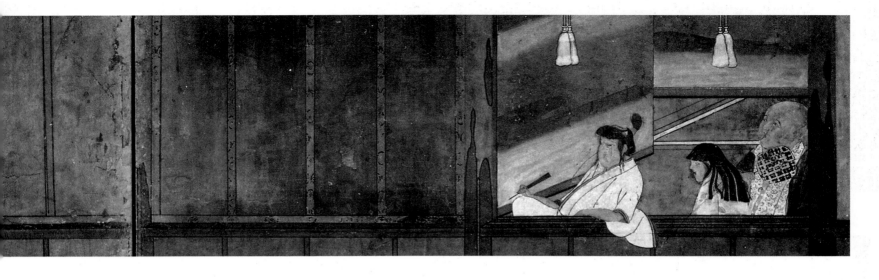

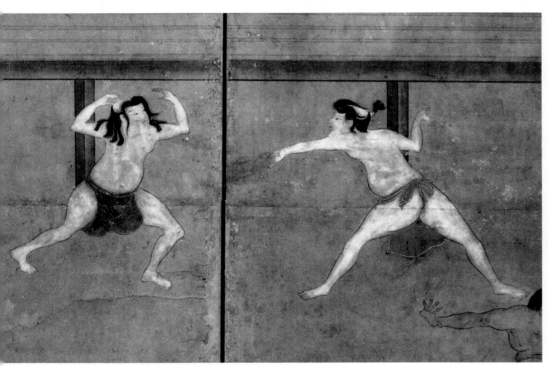

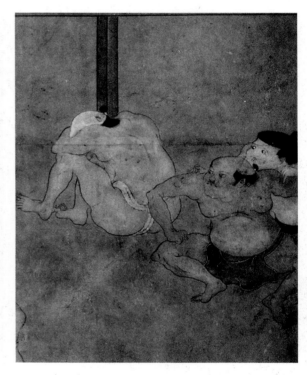

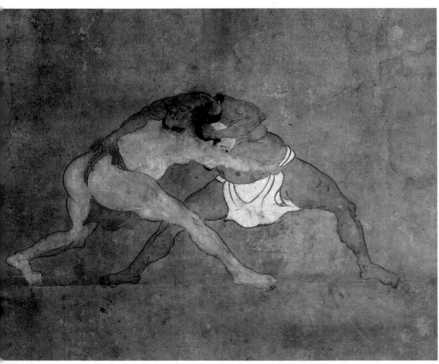

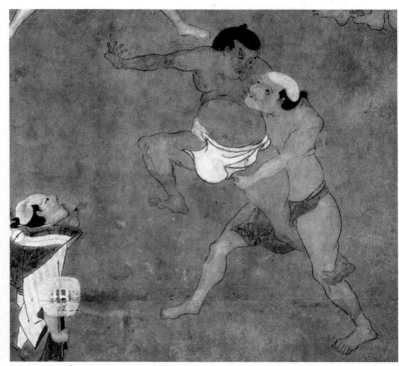

465–69 WRESTLERS, FIVE DETAILS. COLOR, INK ON PAPER. MOMOYAMA, LATE 16TH–EARLY 17TH CENTURY

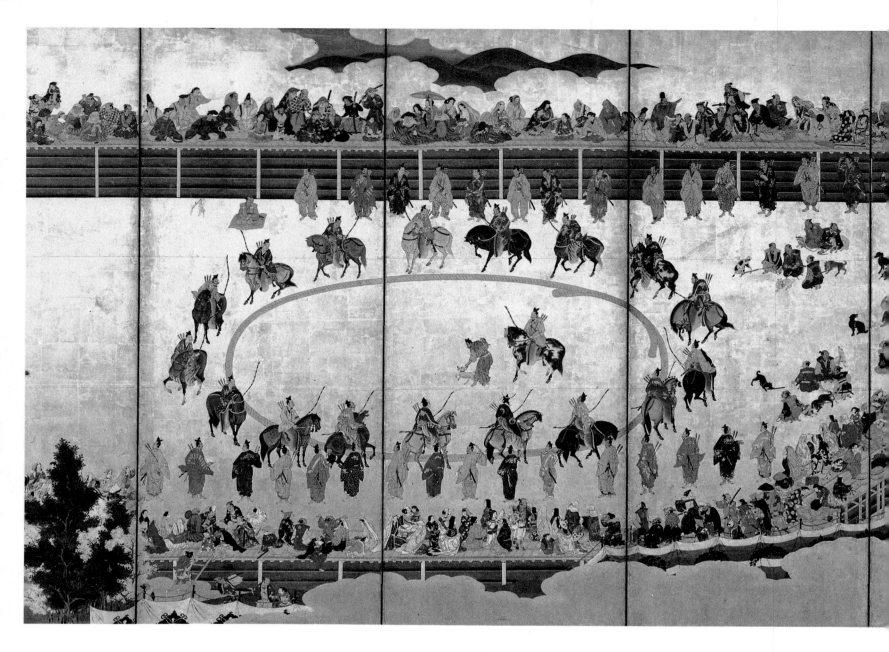

470–72 SAMURAI GAME OF INU-OU-MONO (DOG CHASE), THREE DETAILS OF SIX-FOLD SCREEN. COLOR ON PAPER. EDO, 17TH CENTURY

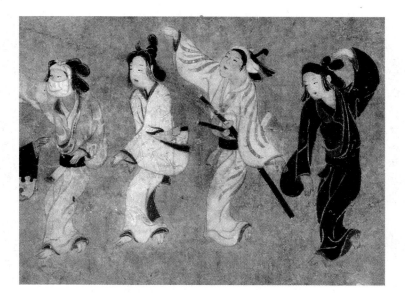

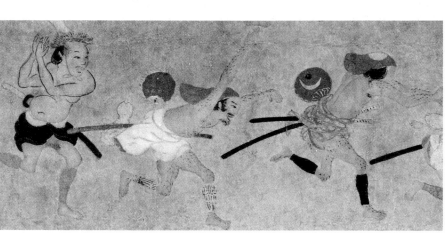

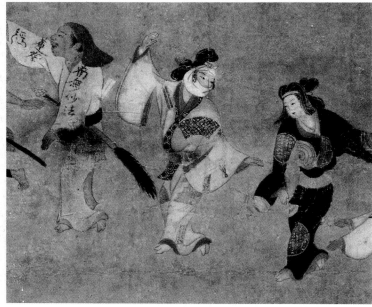

473-77 BON ODORI (DANCE OF THE FEAST OF THE DEAD), ENTIRE PAINTING AND FOUR DETAILS. COLOR, GOLD ON PAPER. EDO, 17TH–19TH CENTURY

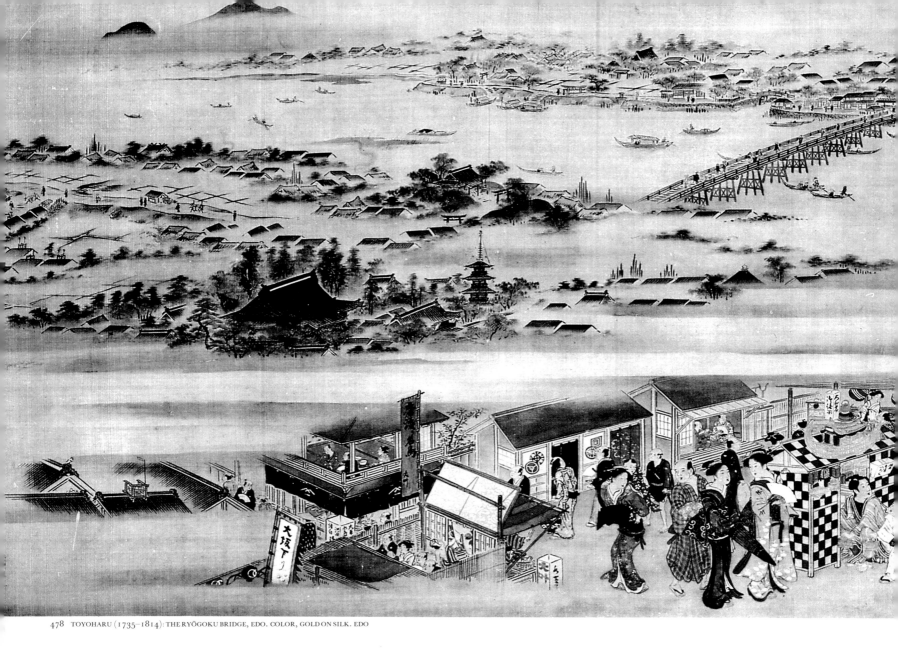

478 TOYOHARU (1735–1814): THE RYŌGOKU BRIDGE, EDO. COLOR, GOLD ON SILK. EDO

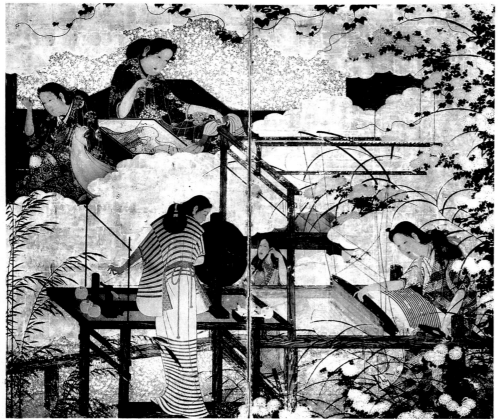

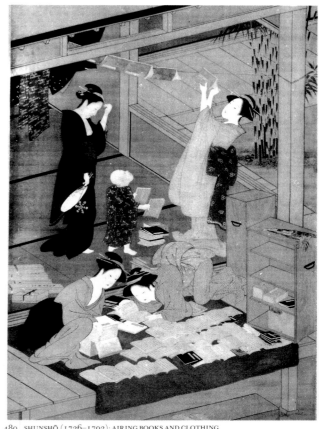

479 WOMEN WEAVING, TWO-FOLD SCREEN. COLOR ON PAPER. EDO, 18TH CENTURY

480 SHUNSHŌ (1726–1792): AIRING BOOKS AND CLOTHING. COLOR, GOLD ON SILK. EDO

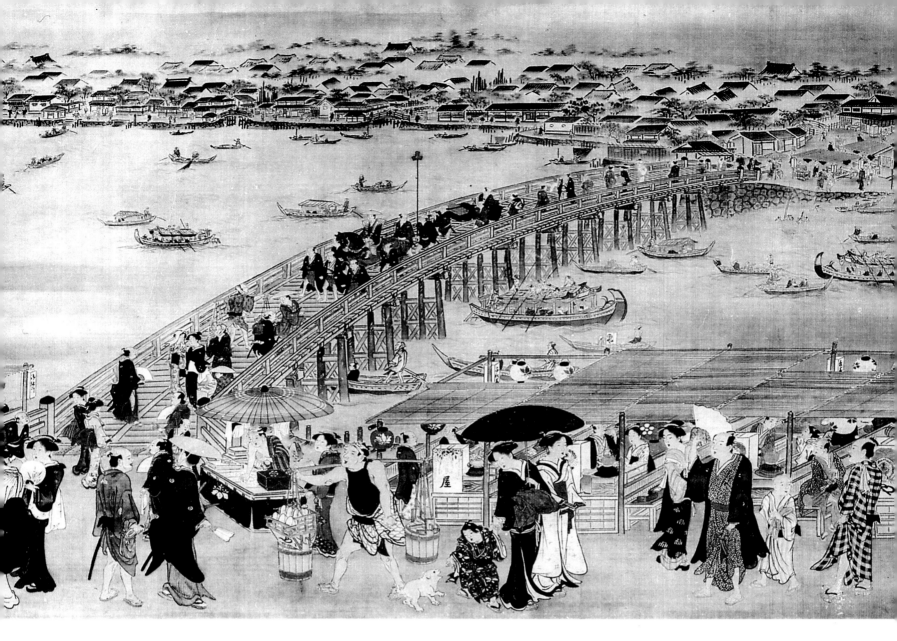

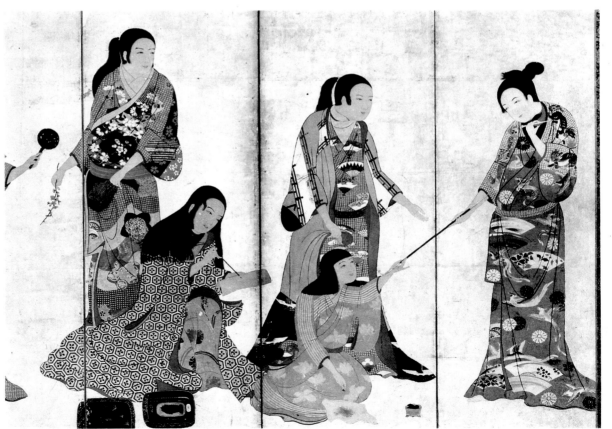

481 TOYOHIRO (1773–1828): THE FOUR ENJOYMENTS. COLOR, INK ON PAPER. EDO

482 WOMEN OF FASHION AT LEISURE, DETAIL OF SIX-FOLD SCREEN (MATSUURA BYŌBU). COLOR ON GOLD PAPER. EDO, 17TH CENTURY

483 HOKUSAI (1760–1849): COUNTRY SCENES, SIX-FOLD SCREEN. COLOR, GOLD ON PAPER. EDO

484 HOKUSAI (1760–1849): COUNTRY SCENES, SIX-FOLD SCREEN. COLOR, GOLD ON PAPER. EDO

485 HOKUSAI (1760–1849): MERRYMAKING UNDER THE CHERRY BLOSSOMS, SIX-FOLD SCREEN. INK, COLOR ON PAPER. EDO

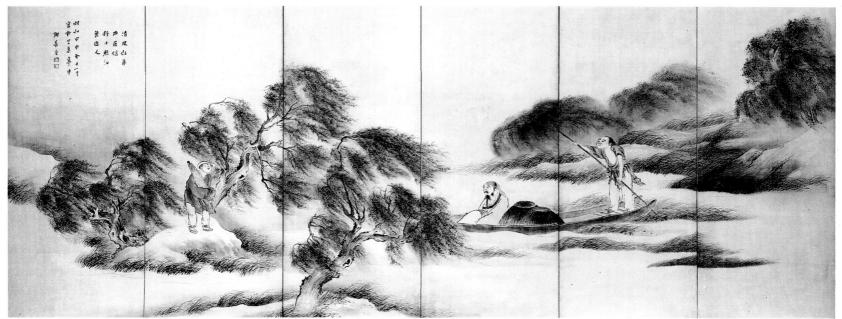

486 BUSON (1716-1783): WINDSWEPT LANDSCAPE, SIX-FOLD SCREEN. INK, COLOR ON SILK. EDO

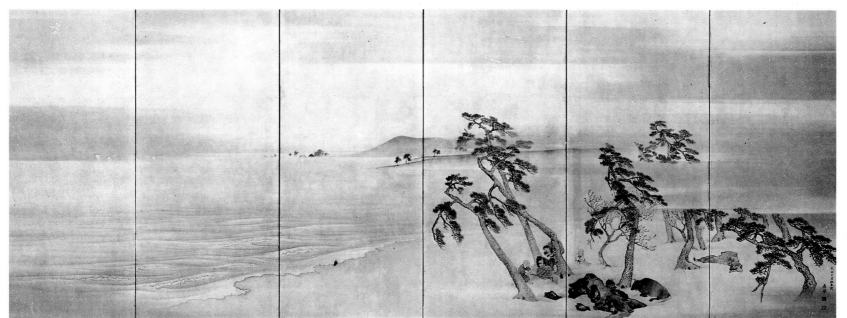

487 MARUYAMA ŌKYO (1733-1795): CHILDREN PLAYING AT THE SEASHORE, SIX-FOLD SCREEN. INK, COLOR, GOLD ON PAPER. EDO, 1782

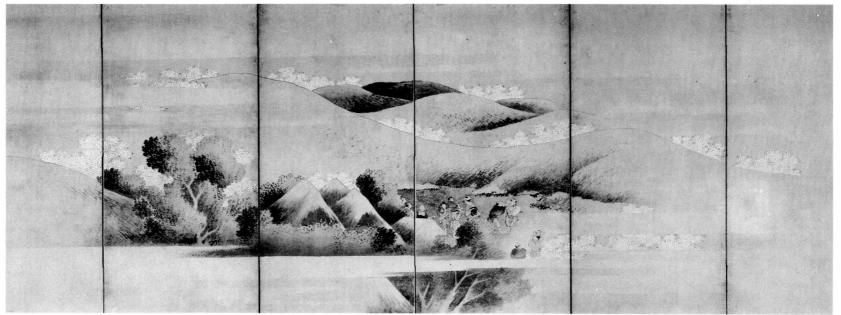

488 HOKUSAI (1760-1849): MERRYMAKING UNDER THE CHERRY BLOSSOMS, SIX-FOLD SCREEN. COLOR, INK ON PAPER. EDO

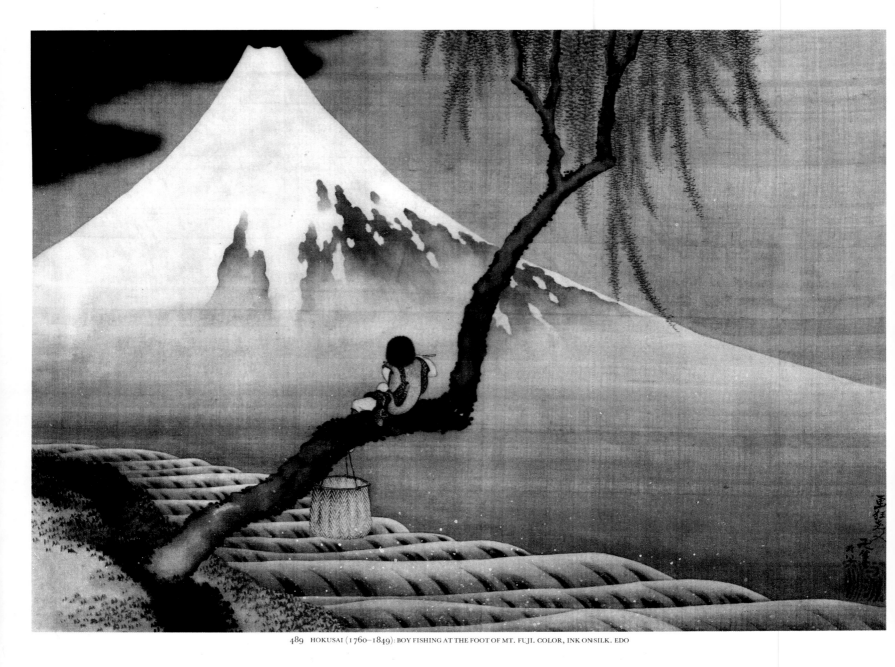

489 HOKUSAI (1760–1849): BOY FISHING AT THE FOOT OF MT. FUJI. COLOR, INK ON SILK. EDO

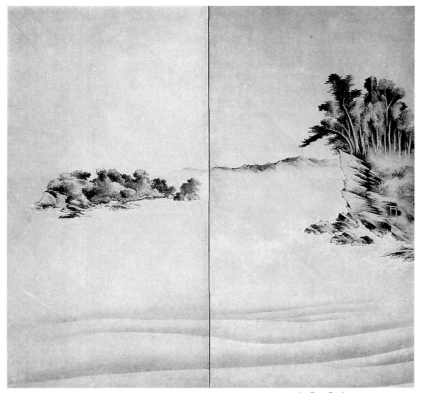
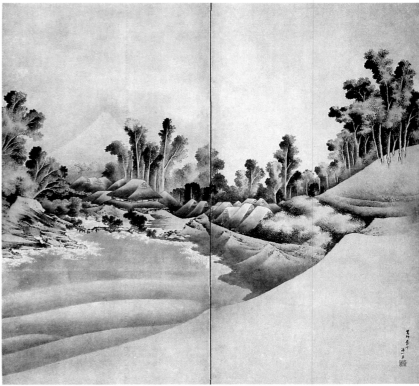

490–91 HOKUSAI (1760–1849): MT. FUJI AND ENOSHIMA, PAIR OF TWO-FOLD SCREENS. COLOR, INK ON PAPER. EDO

Masks

Armor

Lacquered Wood

Lacquer

Silver

Pottery

Porcelain

Textiles

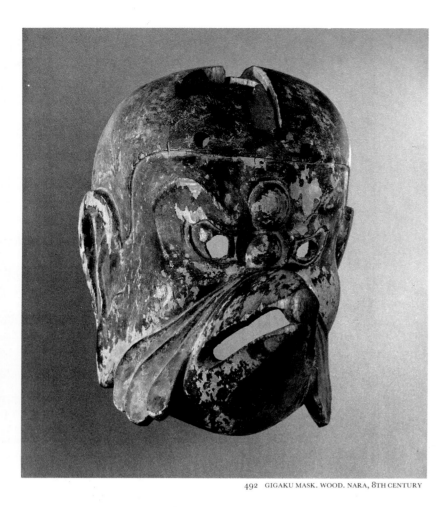

492 GIGAKU MASK. WOOD. NARA, 8TH CENTURY

493 GIGAKU MASK. WOOD. NARA 8TH CENTURY

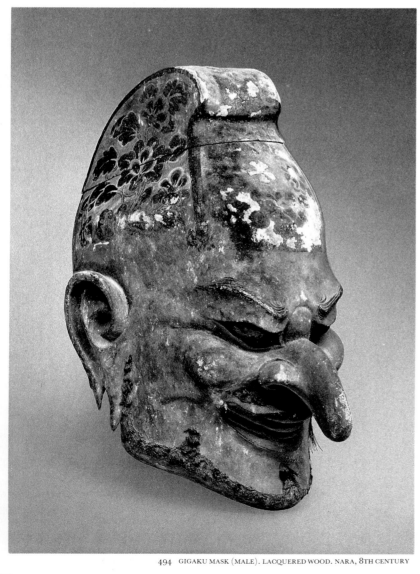

494 GIGAKU MASK (MALE). LACQUERED WOOD. NARA, 8TH CENTURY

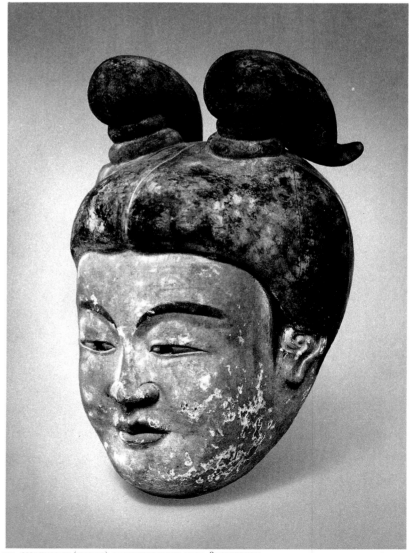

495 GIGAKU MASK (FEMALE). LACQUERED WOOD. NARA, 8TH CENTURY

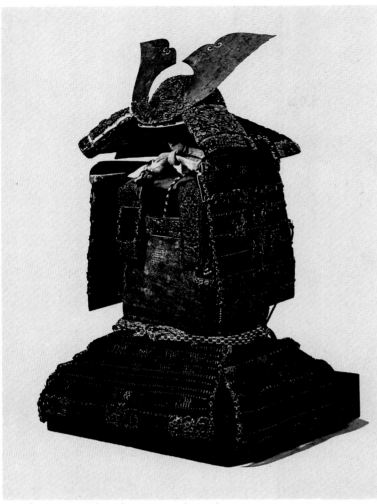

496 GRAND ARMOR (YOROI). METAL PLATES (KOZANE) AND LEATHER WITH LACING; IRON HELMET. LATE HEIAN, 12TH CENTURY

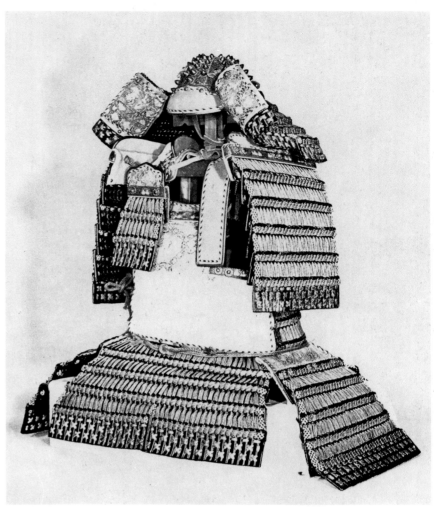

497 GRAND ARMOR (YOROI). METAL PLATES (KOZANE) AND LEATHER WITH LACING. LATE KAMAKURA, 14TH CENTURY

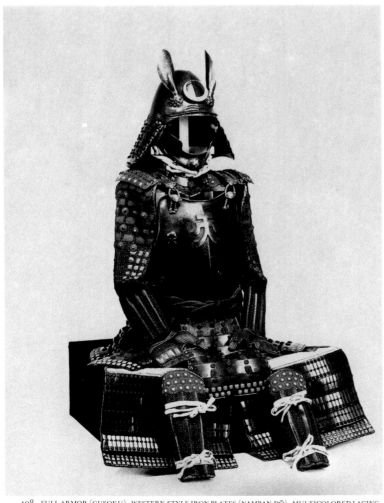

498 FULL ARMOR (GUSOKU). WESTERN-STYLE IRON PLATES (NAMBAN-DŌ), MULTICOLORED LACING. MOMOYAMA, 16TH CENTURY

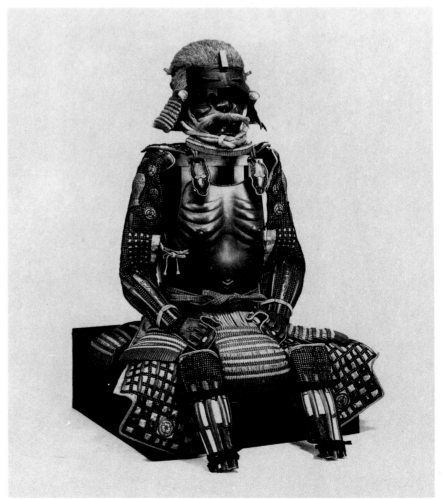

499 FULL ARMOR (GUSOKU). NIŌ-DŌ-STYLE METAL PLATES. MOMOYAMA, LATE 16TH CENTURY

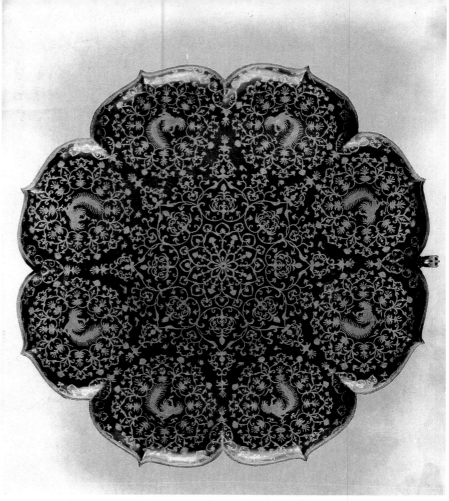

501 MIRROR CASE WITH FLORAL AND PHOENIX MOTIFS. LACQUERED WOOD. NARA, 8TH CENTURY

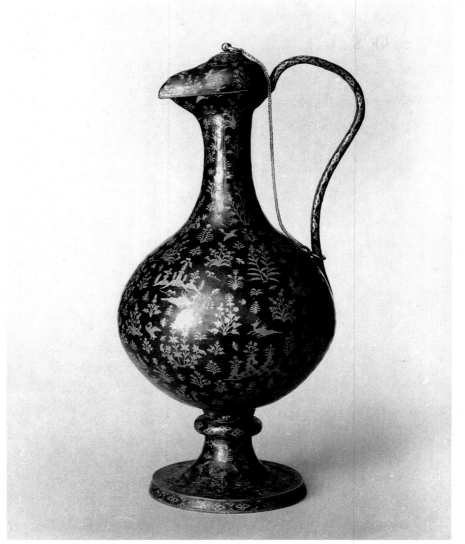

502 BIRD-SHAPED EWER. LACQUER. NARA, 8TH CENTURY

500 BOW DECORATED WITH ACROBATS AND MUSICIANS, TWO DETAILS.
PAINTED WOOD. NARA, 8TH CENTURY

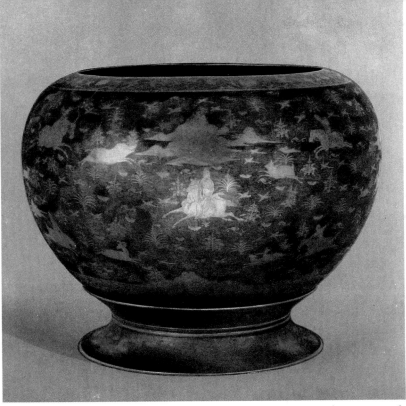

503 VESSEL WITH HUNTING SCENES. SILVER. NARA, 764

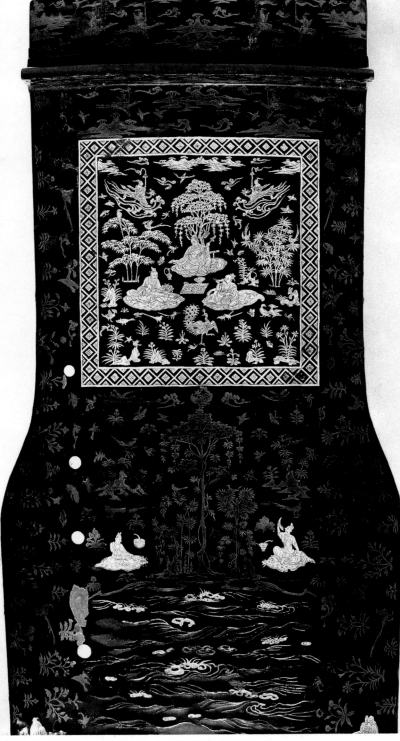

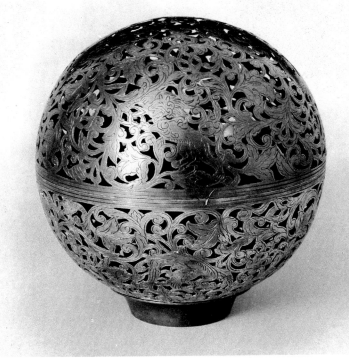

504 OPENWORK INCENSE BURNER WITH ANIMAL AND PLANT MOTIFS. SILVER. NARA, 8TH CENTURY

505 KOTO (FRAGMENT). LACQUER WITH GOLD AND SILVER INLAY. NARA, 735

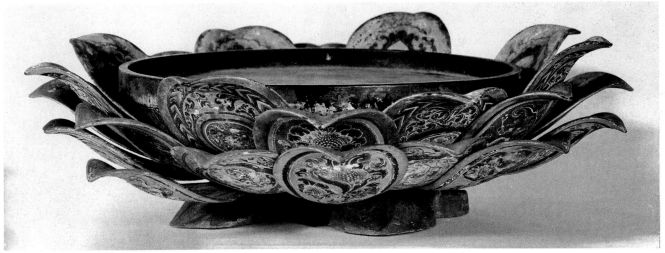

506 INCENSE-BURNER STAND IN SHAPE OF LOTUS BLOSSOM. LACQUERED WOOD. NARA, 8TH CENTURY

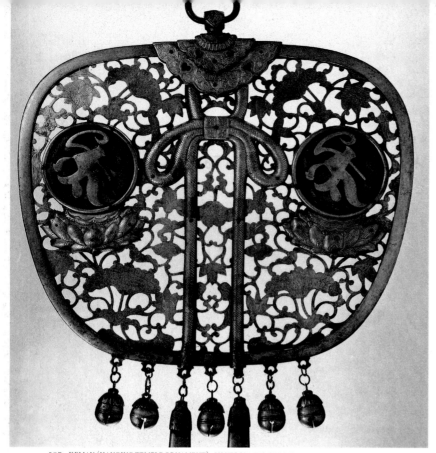

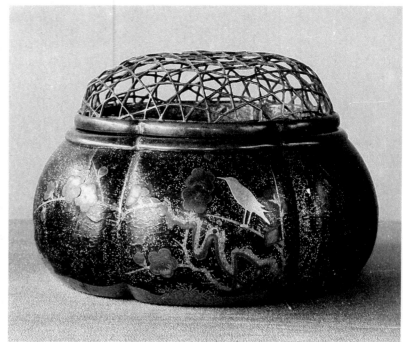

508 INCENSE BURNER WITH NIGHTINGALE AND PLUM BLOSSOMS. LACQUER WITH GOLD INLAY. MUROMACHI, 14TH–15TH CENTURY

507 KEMAN (HANGING TEMPLE ORNAMENT). SILVERPLATED COPPER. KAMAKURA, 13TH–14TH CENTURY

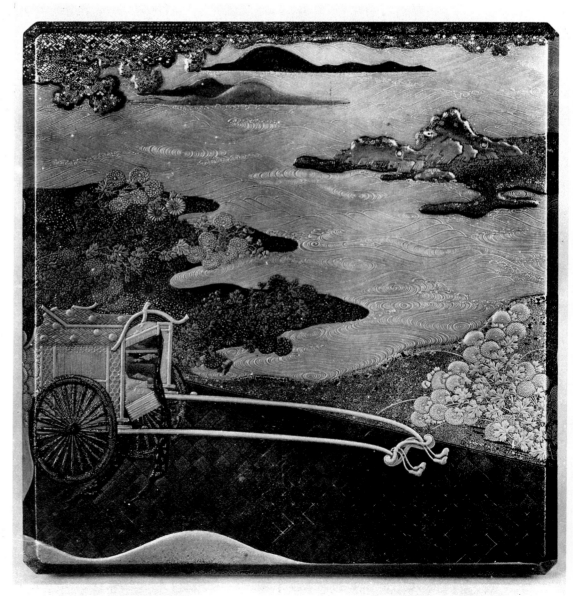

509 WRITING DESK WITH CARRIAGE AND CHRYSANTHEMUMS. LACQUER WITH GOLD INLAY. EDO, 17TH–18TH CENTURY

510 KŌRIN (1658–1716): PLATE WITH GOD OF GOOD FORTUNE (DAIKOKU). STONEWARE. EDO

511 PLATE WITH GOD OF GOOD FORTUNE (HOTEI). STONEWARE. EDO, 17TH CENTURY

514 KŌRIN (1658–1716): PLATE WITH POET WATCHING WILD GEESE. STONEWARE. EDO

512 KŌRIN (1658–1716) AND KENZAN (1663–1743): PLATE WITH REED, STORK, AND CALLIGRAPHY. CERAMIC. EDO

513 KENZAN (1663–1743): PLATE WITH PLUM BLOSSOMS AND CALLIGRAPHY. STONEWARE. EDO

515 KŌRIN (1658–1716): PLATE WITH GOD OF LONGEVITY. STONEWARE. EDO

516 LARGE PLATE WITH GEOMETRIC PATTERN. "OLD KUTANI" PORCELAIN. EDO, 17TH CENTURY

517 LARGE PLATE WITH BANQUET SCENE. "OLD KUTANI" PORCELAIN. EDO, 17TH CENTURY

518 LARGE PLATE WITH PEONIES AND BUTTERFLIES. "OLD KUTANI" PORCELAIN. EDO, 17TH CENTURY

519–22 KENZAN (1663–1743), ATTR.: FOUR DISHES. PORCELAIN. EDO

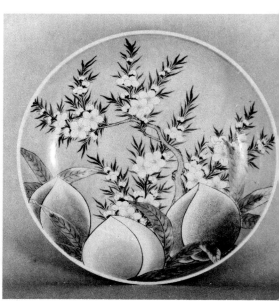

523 PLATE WITH LEMON TREE. NABESHIMA PORCELAIN. EDO, 18TH CENTURY

524 PLATE WITH FLOWERS, MATS, AND WATER. NABESHIMA PORCELAIN. EDO, 18TH CENTURY

525 PLATE WITH PEACHES AND FLOWERS. NABESHIMA PORCELAIN. EDO, 18TH CENTURY

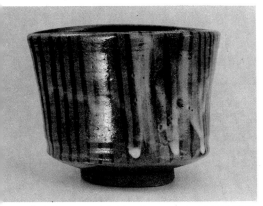

526 VESSEL WITH STRIPED DECORATION. KARATSU STONEWARE. MOMOYAMA, 16TH–17TH CENTURY

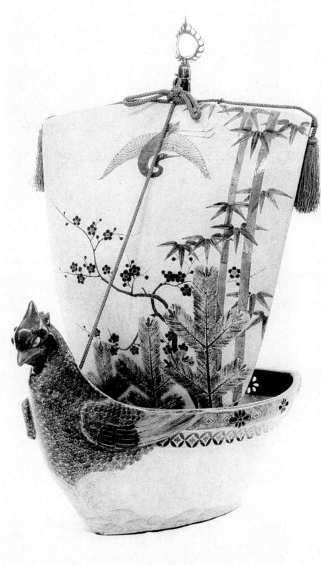

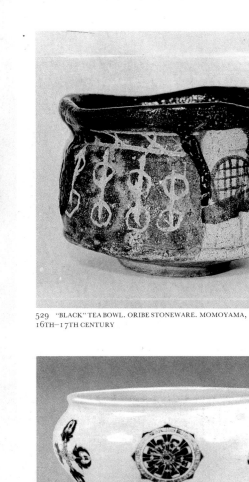

529 "BLACK" TEA BOWL. ORIBE STONEWARE. MOMOYAMA, 16TH–17TH CENTURY

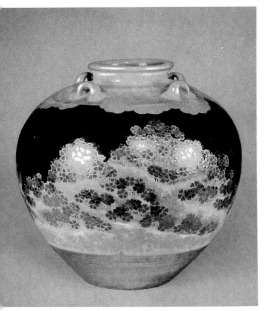

527 NINSEI (D. C. 1660): VASE WITH "YOSHINO MOUNTAINS" DESIGN. STONEWARE. EDO

528 NINSEI (D. C. 1660), ATTR.: TAKARABUNE ("TREASURE SHIP") LUCKY CHARM. STONEWARE. EDO

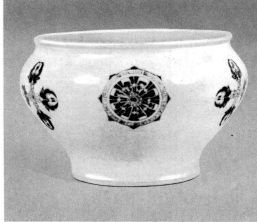

530 NINSEI (D. C. 1660), ATTR.: INCENSE BURNER WITH "RIMPO" AND "KATSURA" MOTIFS. STONEWARE. EDO

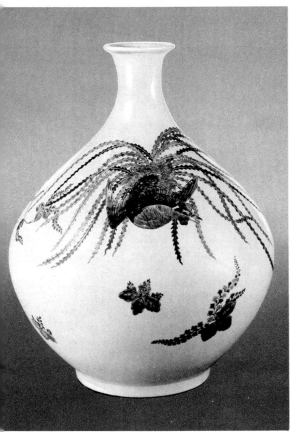

531 FLASK WITH WISTERIA AND PHOENIX. KAKEIMON PORCELAIN. EDO, 17TH CENTURY

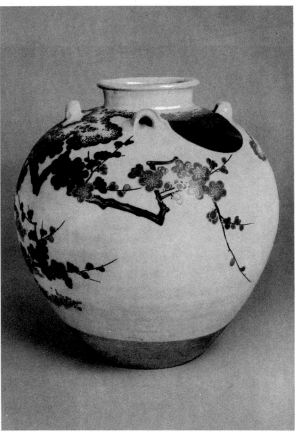

532 NINSEI (D. C. 1660): FLASK WITH PLUM TREE BENEATH THE MOON. STONEWARE. EDO

533 VASE WITH WISTERIA. KAKEIMON PORCELAIN. EDO, LATE 17TH CENTURY

534 SCREEN PANEL WITH DEER UNDER A TREE. STENCILED DESIGNS ON SILK. NARA, 8TH CENTURY

535 PEACOCK BANNER, DETAIL. EMBROIDERY. NARA, 8TH CENTURY

536 SCREEN PANEL WITH RAM UNDER A TREE. SILK WITH BATIK DESIGNS. NARA, 751

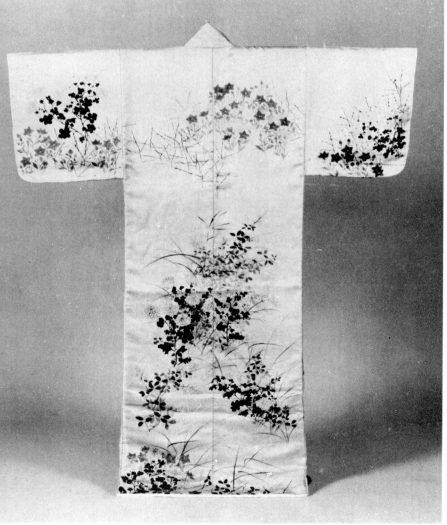

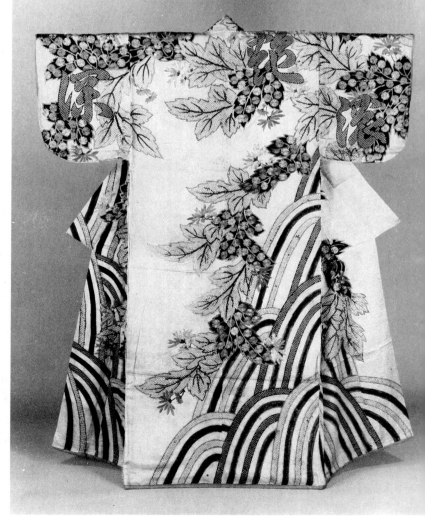

537 KŌRIN (1658–1716): KOSODE (SHORT-SLEEVED KIMONO). PAINTED SILK. EDO, C. 1705

538 KOSODE (SHORT-SLEEVED KIMONO). SILK. EDO, 18TH–19TH CENTURY

CAPTIONS TO THE DOCUMENTARY PHOTOGRAPHS

CAPTIONS TO THE DOCUMENTARY PHOTOGRAPHS

177 VESSEL
Terracotta, Kantō region, height
40 cm.
Middle Jōmon Period, 1st
millennium B.C.
Musée Guimet, Paris (photo
Lauros-Giraudon)

178 VESSEL
Terracotta, height 38 cm.
Jōmon Period, 3rd century B.C.
Freer Gallery of Art, Washington,
D.C. (Museum photo)

179 VESSEL
Terracotta, Takikubo, height
35.5 cm.
Middle Jōmon Period, 1st
millennium B.C.
Kokubunji Municipal Archaeological
Gallery, Tokyo (photo Zauho-Press)

180 FIGURINE (DOGŪ)
Terracotta, height 12 cm.
Jōmon Period, 3rd century B.C.
Musée Guimet, Paris (photo
Giraudon)

181 FIGURINE (DOGŪ)
Terracotta, height 11 cm.
Jōmon Period, 3rd century B.C.
Tokyo National Museum (photo
Bulloz)

182 FIGURINE (DOGŪ)
Terracotta, height 14 cm.
Jōmon Period, 3rd century B.C.
Musée Guimet, Paris (photo Shibata)

183 FIGURINE (DOGŪ)
Terracotta, Yamanashi Prefecture,
height 25.6 cm.
Jōmon Period, 3rd century B.C.
Tokyo National Museum (photo
Zauho-Press)

184 FIGURINE (DOGŪ)
Terracotta, height 9.5 cm.
Jōmon Period, 3rd century B.C.
Musée Guimet, Paris (photo Shibata)

185 FIGURINE (DOGŪ)
Terracotta, Uenojiri (Fukushima),
height 18.5 cm.
Middle Yayoi Period, 1st century
B.C.–1st century A.D.
Uenojiri, Fukushima Prefecture
(photo Heibonsha)

186 HANIWA SEATED FIGURE
Terracotta, height about 1 m.
Kofun Period, 4th–6th century A.D.
Tokyo National Museum (photo
Bulloz)

187 HANIWA WARRIOR IN FULL ARMOR
Terracotta, Iizuka (Gumma),
height 1.3 m.
Kofun Period, 4th–6th century A.D.
Tokyo National Museum (photo
Zauho-Press)

188 HANIWA STANDING FIGURE
Terracotta, height about 1 m.
Kofun Period, 4th–6th century A.D.
Musée Guimet, Paris (photo
Giraudon)

189 SUEKI VESSEL
Terracotta, height 45 cm.
Kofun Period, 4th–6th century A.D.
Asian Art Museum, San Francisco
(photo Jean Mazenod)

190 HANIWA HORSE
Terracotta, height about 80 cm.
Kofun Period, 4th–6th century A.D.
Tokyo National Museum (photo
Bulloz)

191 HANIWA HOUSE
Terracotta, Miyayama, height about
70 cm.
Kofun Period, 5th century A.D.
Yamato Historical Museum, Unebi
(photo Louis Frédéric-Rapho)

192 MIRROR WITH ABSTRACT AND ANIMAL
MOTIFS
Bronze, diameter 22.2 cm.
4th–9th century A.D.
Munakata Taisha Treasure House,
Okinoshima (photo Zauho-Press)

193 MIRROR WITH STYLIZED ANIMALS
Bronze, Miyanosu Kudamatsu,
diameter 38.8 cm.
Kofun Period, 4th–6th century A.D.
Tokyo National Museum (photo
Zauho-Press)

194 MIRROR WITH CHOKKOMON DESIGNS
Bronze, diameter 28 cm.
Kofun Period, 4th–6th century A.D.
Imperial Household Collection,
Tokyo (photo Zauho-Press)

195 MIRROR WITH HOUSE MOTIF
Bronze, diameter 23 cm.
Kofun Period, 4th–6th century A.D.
Imperial Household Collection,
Tokyo (photo Zauho-Press)

196 MIRROR WITH STYLIZED FIGURES
Bronze, diameter 22 cm.
4th–9th century A.D.
Munakata Taisha Treasure House,
Okinoshima (photo Zauho-Press)

197 MIRROR WITH "TLV" DESIGN
Bronze, diameter 27.1 cm.
4th–9th century A.D.
Munakata Taisha Treasure House,
Okinoshima (photo Zauho-Press)

198 ASUKA DAIBUTSU (GREAT BUDDHA OF
ASUKA)
Bronze, height about 1 m.
Asuka Period, 6th–7th century A.D.
Gangoji, Nara (photo Zauho-Press)

199 YAKUSHI NYORAI (BHAISAJYAGURU)
By Tori (?).
Bronze, height of statue 62 cm.
Asuka Period, 607 A.D.
Kondō, Hōryūji, Nara (photo
Iwanami Shoten)

200 SHAKA TRIAD
By Tori (fl. early 7th century).
Gilt bronze, height of central figure
93.9 cm.
Asuka Period, 623 A.D.
Kondō, Hōryūji, Nara (photo
Iwanami Shoten)

201 MIROKU BOSATSU (MAITREYA)
Wood, height 1.2 m.
Asuka Period, 552–645 A.D.
Kōryūji Treasure House, Kyoto
(photo Ziolo)

202 MIROKU BOSATSU (MAITREYA)
Wood, height 90.2 cm.
Asuka Period, second half of 7th
century A.D.
Kōryūji Treasure House, Kyoto
(photo Sakamoto)

203, 205 KUDARA KANNON, OR "KOREAN
KANNON" (AVALOKITESVARA, FROM
KUDARA OR PAEKCHE, KOREA)

Front and profile. Wood, painted,
height 2.1 m.
Asuka Period, mid–7th century A.D.
Hōryūji Great Treasure House
(formerly in Kondō), Nara (photos
Shueisha and Sakamoto)

204 KANNON BOSATSU (AVALOKITESVARA)
Wood, height 2.1. m.
Asuka Period, c. 624 A.D.
Hōryūji, Yumedono, Nara (photo
Sakamoto)

206 IKKOSANZONBUTSU
Bronze, height of central figure
34.1 cm.
Asuka Period, 7th century A.D.
Tokyo National Museum (photo
Zauho-Press)

207 TAMONTEN (VAISRAVANA)
Wood, height 1.3 m.
Asuka Period, 650 A.D.
Hōryūji, Nara (photo Sakamoto)

208 YAKUSHI NYORAI (BHAISAJYAGURU)
Wood treated to resemble bronze,
height 1.1. m.
Asuka Period, 7th century A.D.
Hōrinji, Nara (Temple photo)

209 SHRINE OF LADY TACHIBANA
Bronze, height of central figure 33
cm.
Nara Period, early 8th century.
Hōryūji Great Treasure House, Nara
(photo Sakamoto)

210 YAKUSHI NYORAI (BHAISAJYAGURU; see
figs. 48, 211).
Bronze and gilt bronze, entire
height 2.6 m.
Nara Period, 718–728.
Yakushiji, Nara (photo Sakamoto)

211 GAKKŌ BOSATSU (ATTENDANT AT LEFT
OF YAKUSHI NYORAI; see figs. 48, 210).
Bronze and gilt bronze, entire height
3.2 m.
Nara Period, 8th century.
Yakushiji, Nara (photo John Hymas)

212 DAIBUTSU (GREAT BUDDHA)
Bronze, height 16 m.

Nara Period, 749.
Tōdaiji, Nara (photo Benrido)

213 GAKKŌ BOSATSU (CANDRAPRABHA,
"PRINCE OF THE MOON")
Wood, height about 70 cm.
Asuka Period, 7th century A.D.
Hōryūji, Nara (photo Sakamoto)

214 SEISHI BOSATSU (MAHĀSTHĀMAPRĀPTA)
Wood, height about 70 cm.
Asuka Period, 7th century A.D.
Hōryūji, Nara (photo Sakamoto)

215 NIKKO BOSATSU (SŪRYAPRABHA,
"PRINCE OF THE SUN")
Wood, height about 80 cm.
Asuka Period, 7th century A.D.
Hōryūji, Nara (photo Sakamoto)

216 KANNON BOSATSU (AVALOKITESVARA)
Wood, height about 70 cm.
Asuka Period, 7th century A.D.
Hōryūji, Nara (photo Sakamoto)

217 FUGEN BOSATSU (SAMANTABHADRA)
Wood, height 69 cm.
Asuka Period, 7th century A.D.
Hōryūji, Nara (photo Sakamoto)

218 MONJU BOSATSU (MANJUSRI)
Wood, height about 70 cm.
Asuka Period, 7th century A.D.
Hōryūji, Nara (photo Sakamoto)

219 INDARATAISHI (INDRA)
Clay, height 1.6 m.
Nara Period, c. 726–749.
Shin-Yakushiji, Nara (photo
Sakamoto)

220 BAZARATAISHO (VAJRA)
Clay, height 1.7 m.
Nara Period, 8th century.
Shin-Yakushiji, Nara (photo Mireille
Vautier-Decool)

221 KŌMOKUTEN (VIRŪPĀKSA)
Dry lacquer, height 2.2 m.
Nara Period, second half of
7th century.
Taimadera, Nara (photo Sakamoto)

222 JŌCHŌTEN (VIRŪDHAKA)
Dry lacquer, height about 2 m.

Nara Period, second half of
7th century.
Taimadera, Nara (photo Sakamoto)

223–34 JUNI-JINSHŌ (THE TWELVE GUARDIANS
OF YAKUSHI NYORAI)
Clay with traces of color, height of
each statue about 1.6 m.
Nara Period (Tempyō Era), 729–749.
Shin-Yakushiji, Nara (photos
Iwanami Shoten)

235–40 GUARDIAN KINGS:

235 JŌCHŌTEN (VIRŪDHAKA)
Clay, height 1.6 m.
Nara Period (Tempyō Era), 729–766.
Sangatsudō, Tōdaiji, Nara (photo
Sakamoto)

236 JIKOKUTEN (DHRTARĀSTRA)
Clay, height 1.6 m.
Nara Period (Tempyō Era), 729–766.
Sangatsudō Tōdaiji, Nara (photo
Sakamoto)

237 TAMONTEN (VAIŚRAVANA)
Clay, height 1.6 m.
Nara Period (Tempyō Era), 729–766.
Sangatsudō, Tōdaiji, Nara (photo
Sakamoto)

238 KŌMOKUTEN (VIRŪPĀKSA)
Clay, height 1.6 m.
Nara Period (Tempyō Era), 729–766.
Sangatsudō, Tōdaiji, Nara (photo
Sakamoto)

239 JIKOKUTEN (DHRTARĀSTRA)
Wood, height 1.7 m.
Late Heian Period, 12th century.
Asian Art Museum, San Francisco
(photo Jean Mazenod)

240 KŌMOKUTEN (VIRŪPĀKSA)
Wood, height about 1.6 m.
Kamakura Period, 13th century.
Freer Gallery of Art, Washington,
D.C. (Museum photo)

241–43 THE "TEN GREAT DISCIPLES"
(JUDAIDESHI)
Only six of the original group have
survived; those pictured here are
Ragora, Kasenen, and Sharihotsu.

Dry lacquer, height about 1.5 m.
Nara Period, 734.
Kōfukuji Treasure House, Nara
(photos Sakamoto)

244 BIBAKARA, ONE OF THE EIGHT
GUARDIANS (HACHIBUSHŪ) OF SHAKA
NYORAI
Dry lacquer, height about 1.5 m.
Nara Period, 8th century.
Kōfukuji Treasure House, Nara
(photo Sakamoto)

245 KARURA, ONE OF THE EIGHT
GUARDIANS (HACHIBUSHŪ) OF SHAKA
NYORAI (see fig. 74).
Dry lacquer, height 1.5 m.
Nara Period, 8th century.
Kōfukuji Treasure House, Nara
(photo Sakamoto)

246 KUHANDA, ONE OF THE EIGHT
GUARDIANS (HACHIBUSHŪ) OF SHAKA
NYORAI
Dry lacquer, height about 1.5 m.
Nara Period, 8th century.
Kōfukuji Treasure House, Nara
(photo Sakamoto)

247 NIKKŌ BOSATSU (SŪRYAPRABHA,
"PRINCE OF THE SUN")
Solid clay, height 2.1 m.
Nara Period, 8th century.
Sangatsudō, Tōdaiji, Nara (photo
Sakamoto)

248 STATUE OF BUDDHA
Wood, height 1.7 m.
Early Heian Period, 9th century.
Tōshōdaiji, Nara (photo Kozo
Ogawa-Ziolo)

249 YAKUSHI NYORAI (BHAISAJYAGURU)
Wood, height 1.7 m.
Heian Period, 9th century.
Gangōji, Asuka (photo Bulloz)

250 YAKUSHI NYORAI (BHAISAJYAGURU)
Wood, height 1.7 m.
Heian Period, 824.
Jingōji, Kyoto (photo Sakamoto)

251 SHAKA NYORAI (BUDDHA TATHAGATA,
BUDDHA OF THE FUTURE)

By Zen-en (fl. first half of 13th
century).
Wood, height about 40 cm.
Kamakura Period, 1225.
Tōdaiji, Nara (photo Iwanami
Shoten)

252 NIKKŌ BOSATSU (SŪRYAPRABHA,
"PRINCE OF THE SUN")
Wood (one block of Japanese yew),
height 46.7 cm.
Early Heian Period, c. 800.
Cleveland Museum of Art (John L.
Severance Fund) (Museum photo)

253 DAINICHI NYORAI (VAIROCANA)
Colored wood, height 3.3 m.
Late Nara Period, late 8th century.
Kondō, Tōshōdaiji, Nara (photo
Sakamoto)

254 SHAKA NYORAI (BUDDHA TATHAGATA,
BUDDHA OF THE FUTURE)
Gilt bronze, height 83 cm.
Hakuhō Period, early 8th century.
Jindaiji, Tokyo (photo Mireille
Vautier-Decool)

255 SHAKA NYORAI (BUDDHA TATHAGATA,
BUDDHA OF THE FUTURE)
Gilded wood with traces of color,
height 85 cm.
Early Heian Period, 9th century.
Museum of Fine Arts, Boston (photo
Jean Mazenod)

256 SHAKA NYORAI (BUDDHA TATHAGATA,
BUDDHA OF THE FUTURE)
Wood, height 1.4 m.
Early Heian Period, 9th century.
Mirokudō, Murōji, Nara (Temple
photo)

257 SHAKA NYORAI (BUDDHA TATHAGATA,
BUDDHA OF THE FUTURE: UDYĀNA
COPY)
Chinese. Lacquer over sandalwood,
height about 2.3 m.
Heian Period, 985.
Seiryōji, Kyoto (photo Sakamoto)

258 JIZŌ BOSATSU (KSITIGARBHA)
Wood, height 1.7 m.
Heian Period, 9th century.
Murōji, Nara (Temple photo)

259 SHAKA NYORAI (BUDDHA TATHAGATA, BUDDHA OF THE FUTURE)
Wood and lacquer, height 2.5 m.
Heian Period, 9th century.
Murōji, Nara (Temple photo)

260 YAKUSHI NYORAI (BHAISAJYAGURU)
Wood with traces of color, height 1.8 m.
Heian Period, 9th century.
Murōji, Nara (Temple photo)

261 MIKAERI-NO-AMIDA, AMIDA (AMITĀBHĀ) WHO TURNS ASIDE
Wood, height about 1.5 m.
Heian Period, 9th–12th century.
Zenrinji, Kyoto (Temple photo)

262 YAKUSHI NYORAI (BHAISAJYAGURU)
Gilded wood, height 2.6 m.
Heian Period, 10th century.
Hōryūji, Nara (photo John Hymas)

263 AMIDA NYORAI (AMITĀBHĀ)
Gilded wood, height 2.3 m.
Heian Period, 1108.
Jōruriji, Kyoto (photo Mireille Vautier-Decool)

264 AMIDA NYORAI (AMITĀBHĀ)
By Jōchō (d. 1057).
Gilded wood, height 3.3 m. (see fig. 51).
Heian Period, 1053.
Hōōdō, Byōdōin, Uji (photo Sakamoto)

265 AMIDA NYORAI (AMITĀBHĀ)
Wood, height about 1 m.
Heian Period, 1096.

266 JUICHI MEN KANNON (EKĀDASAMUKHA), ELEVEN-HEADED KANNON
Wood, entire height about 1.8 m.
Heian Period, 1069.
Kannonji, Fukuoka (Temple photo)

267 YAKUSHI NYORAI (BHAISAJYAGURU)
Wood, height about 2 m.
Heian Period, 1140.
Jōruriji, Kyoto (photo Zauho-Press)

268 MIROKU BOSATSU (MAITREYA)
Wood, height 2.1 m.

Heian Period, late 12th century.
Freer Gallery of Art, Washington, D.C. (Museum photo)

269 SENJŪ KANNON (SAHASRABHUJA-SAHASRANETRA), THOUSAND-ARMED KANNON
Wood, height about 1.3 m.
Heian Period, 1012.
Kōryūji Treasure House, Kyoto (photo Sakamoto)

270 SENJŪ KANNON (SAHASRABHUJA-SAHASRANETRA), THOUSAND-ARMED KANNON
Wood, height about 1.2 m.
Kamakura Period, 13th–14th century.
Chikurinji (photo Mireille Vautier-Decool)

271 DAI ITOKU MYŌŌ (MAHATEJAS)
Wood.
Kamakura Period, 13th–14th century.
Kōchi (photo Mireille Vautier-Decool)

272–73 CLOUD-BORNE DEITIES
Wood reliefs from the Hōōdō, height about 40 cm.
Heian Period, 11th century.
Byōdōin Treasure House, Uji (Temple photo)

274–75 TWO OF THE TWELVE JŪNI-JINSHŌ
Wood reliefs, height about 90 cm.
Late 10th–early 11th century.
Kōfukuji Treasure House, Nara (photos Mireille Vautier-Decool)

276 NAKATSU-HIME (PRINCESS NAKATSU)
Painted wood, height 36.8 cm.
Heian Period, 9th century.
Yakushiji Treasure House, Nara (photo Sakamoto)

277 PORTRAIT OF GANJIN
Dry lacquer, height 80.4 cm.
Nara Period, 8th century.
Tōshōdaiji, Nara (photo Sakamoto)

278 SHINTŌ GOD
Painted wood, height about 70 cm.
Heian Period, 10th century.

Kyoto National Museum (photo Mireille Vautier-Decool)

279 PRINCE SHŌTOKU-TAISHI (574–622)
By Enkai (fl. 11th century).
Wood, height 58.2 cm.
Heian Period, 1069.
Hōryūji Great Treasure House, Nara (photo Sakamoto)

280 KUSHŌJIN (WHO TALLIES GOOD AND EVIL DEEDS)
Wood, height about 80 cm.
Kamakura Period, 1250.
Kamakura National Treasure House (photo Mireille Vautier-Decool)

281 JUDGE IN BUDDHIST HELL
Painted wood, height about 1 m.
Kamakura Period, 13th century.
Kyoto National Museum (photo Mireille Vautier-Decool)

282 SHŌKŌŌ, A KING OF BUDDHIST HELL
Wood, height 1 m.
Kamakura Period, 1250.
Kamakura National Treasure House (photo Mireille Vautier-Decool)

283 JUDGE IN BUDDHIST HELL
Painted wood, height about 1 m.
Kamakura Period, 13th century.
Kyoto National Museum (photo Mireille Vautier-Decool)

234–85 GUARDIAN KINGS (NIŌ), KONGŌRIKISHI (VAJRAPĀNI)
By Unkei (1151–1223) and Kaikei (fl. 1185–1220).
Wood, height of each about 8.4 m.
Kamakura Period, 1203.
Sangatsudo, Tōdaiji, Nara (photos Sakamoto)

286 GUARDIAN KING (NIŌ), KONGŌRIKISHI (VAJRAPĀNI)
From the Kagenji or Ieharadera, Sakai (?).
Wood, height 2.3 m.
Kamakura Period, 13th century.
Freer Gallery of Art, Washington, D.C. (Museum photo)

287 GUARDIAN KING (NIŌ), KONGŌRIKISHI (VAJRAPĀNI)
By Jōkei (fl. 1184–1212).
Wood, height about 1.7 m.
Kamakura Period.
Kōfukuji Treasure House, Nara
(photo Mireille Vautier-Decool)

288 BEAUTIFUL WOMEN UNDER A TREE
Color on paper, 141.1 × 56.3 cm.
Nara Period, 8th century.
Kyūsei Atami Museum of Art, Atami
(Museum photo)

289 BEAUTIFUL WOMAN UNDER A TREE
Detail of screen.
Color and feathers applied to paper,
136 × 56 cm.
Nara Period, 752–756.
Shōsōin, Nara (photo Benrido)

290 TAMAMUSHI-ZUSHI (BEETLE-WING SHRINE)
Detail, showing Buddha's Self-
sacrifice to a Hungry Tigress
Painted on lacquered wood, panel
size 65 × 35.5 cm.
Nara Period, c. 700.
Hōryūji Great Treasure House, Nara
(photo Sakamoto)

291 PRINCE SHŌTOKU-TAISHI WITH TWO SONS
Light colors on silk.
Early Nara Period, early 8th century.
Imperial Household Collection,
Tokyo (photo Benrido)

292 GOHIMITSU BOSATSU (RETICENT BUDDHA)
Ink and color on silk, 56.8 × 42.5 cm.
Kamakura Period, late 12th or early
13th century.
Freer Gallery of Art, Washington,
D.C. (Museum photo)

293 YAKUSHI TRIAD (BHAISAJYAGURU)
Color on silk, 1.2 × 1.1 m.
Kamakura Period, 13th–14th
century.
Fujita Art Museum, Ōsaka (Museum
photo)

294 KUJAKU MYŌŌ (MAHĀMAYURI)
Color on silk, 210.5 × 91.4 cm.

Kamakura Period, 1250.
Nelson Gallery-Atkins Museum,
Kansas City (Museum photo)

295 MONJU BOSATSU (MANJUSRI) AND HIS EIGHT ATTENDANTS
Color on silk, 108.1 × 86.1 cm.
Kamakura Period, 13th century.
Kyūsei Atami Art Museum, Atami
(Museum photo)

296–304 THE NINE CELESTIAL BODIES (NAVAGRAHA)
Woodcut, 29 × 333 cm.
Luminous Buddha; Candrá, the
Moon; Ketu, a comet; Sukra, Venus;
Sanaiścara, Saturn; Rāhu, who
governs eclipses; Mercury; Angāraka,
Mars; Jupiter (?).
Heian Period, March 11, 1164.
Kyūsei Atami Art Museum, Atami
(Museum photos)

305–7 LEAVES FROM THE HŌSHI MANDARA
Ink on paper, 28 × 16 cm.
Heian Period, June 23, 1113.
Kyūsei Atami Art Museum, Atami
(Museum photos)

308–10 RYŌKAI MANDARA (MANDALA OF THE TWO WORLDS)
Figs. 308–9, Taizō-kai ("womb
world"); fig. 310, Kongō-kai
("diamond world").
Gold tracery on purple-dyed silk,
74.3 × 64.8 cm.
Heian or early Kamakura Period,
late 12th century.
Freer Gallery of Art, Washington,
D.C. (Museum photo)

311–14 FOUR MANDALAS
Woodcut, 31 × 23 cm.
Kamakura Period, 13th century.
Kyūsei Atami Art Museum, Atami
(Museum photos)

315 PORTRAIT OF THE POET TAIRA-NO-KANEMORI (d. 990).
Portion of handscroll mounted as
hanging scroll.
Ink, white, and slight color on paper,
entire dimensions 28.6 × 46.7 cm.
Yamato-e School, Kamakura Period,
13th–14th century.

Cleveland Museum of Art (John L.
Severance Fund) (Museum photo)

316 PORTRAIT OF THE POET MINAMOTO-NO-KINTADA (fl. 10th century).
Attributed to Fujiwara-no-Nobuzane
(1176–1266).
Portion of handscroll, detail.
Ink, color, and white on paper, entire
dimensions 27.9 × 51.1 cm.
Yamato-e School, Kamakura Period.
Freer Gallery of Art, Washington,
D.C. (Museum photo)

317 PORTRAIT OF MINAMOTO-NO-SHIGEYUKI
Attributed to Fujiwara-no-Nobuzane
(1176–1266).
Color on paper, 28.6 × 48.5 cm.
Yamato-e School, Kamakura Period.
Kyūsei Atami Art Museum, Atami
(Museum photo)

318 PORTRAIT OF THE EMPEROR GO-DAIGO
(r. 1319–1339).
Color on silk, 131.4 × 77.6 cm.
Muromachi Period, 14th century.
Daitokuji, Kyoto (photo Sakamoto)

319 PORTRAIT OF MINAMOTO-NO-YORIMASA
(1106–1180).
Color on silk, 98.3 × 67.3 cm.
Muromachi Period, 14th century.
Kyūsei Atami Art Museum, Atami
(Museum photo)

320 KONGARA (attendant of the
Enlightened King Fudō).
By Chōga (Takuma Chōga, fl. c.
1250–1270).
Ink, color, and gold on silk,
125 × 41.5 cm.
Kamakura Period.
Freer Gallery of Art, Washington,
D.C. (Museum photo)

321 SEITAKA (attendant of the
Enlightened King Fudō).
By Chōga (Takuma Chōga, fl. c.
1250–1270).
Ink, color, and gold on silk,
125 × 41.5 cm.
Kamakura Period.
Freer Gallery of Art, Washington,
D.C. (Museum photo)

322 PORTRAIT OF DARUMA AND HIS DISCIPLE EKA (carrying his severed arm as a token of his sincerity). By Sesshū (1420–1506). Detail. Ink on paper, entire painting 2 × 1 m. Muromachi Period. Sainenji, Aichi Prefecture (photo Bulloz)

323 PORTRAITS OF THE CHINESE PRIESTS CHU-EN, LIU-CHU, AND PU-YANG. Color on silk, 1.3 × 1.1 m. Kamakura Period, 13th–14th century. Fujita Art Museum, Ōsaka (Museum photo)

324 FOUR VENERABLE FIGURES: EMPEROR SHŌMU (r. 724–749) AND THREE PRIESTS Hanging scroll. Color on silk, 2 × 1.5 m. Muromachi Period (Eiwa era, Northern Dynasty), 1377. Tōdaiji, Nara (photo Asahi)

325 PORTRAIT OF THE SHŌGUN ASHIKAGA YOSHIMITSU (1358–1408). Color on silk, 79.9 × 39.6 cm. Muromachi Period, late 14th century. Rokuonji (Kinkakuji), Kyoto (photo Kodansha)

326 PORTRAIT OF THE SHŌGUN ASHIKAGA YOSHIMASA (1435–1490). Color on silk, 44.2 × 56 cm. Muromachi Period, 15th–16th century. Tokyo National Museum (photo Zauho-Press)

327 PORTRAIT OF THE CHINESE ZEN PRIEST KAO-FENG YÜAN-MIAO (1238–1295). By Chūan Shinkō (fl. mid-15th century). Detail. Ink on paper, entire painting 58.4 × 36.8 cm. Suiboko School, Ashikaga. Muromachi Period. Freer Gallery of Art, Washington, D.C. (Museum photo)

328 PORTRAIT OF THE STATESMAN FUJIWARA-NO-KAMATARI (614–669) AND HIS TWO SONS Color on silk, 84.5 × 38.1 cm. Muromachi Period, 15th century. Freer Gallery of Art, Washington, D.C. (Museum photo)

329 PORTRAIT OF THE PAINTER SESSHŪ (1420–1506). Detail. Ink and slight color on paper, entire painting 59.3 × 28.4 cm. Muromachi Period, 16th century. Fujita Art Museum, Ōsaka (Museum photo)

330 PORTRAIT OF THE DAIMYŌ UESUGI SHIGEFUSA (13th century). Wood, height 68.2 cm. Kamakura Period, 13th century. Meigetsuin, Kamakura (photo Bulloz)

331 PORTRAIT OF THE PRIEST KAKUSHIN (HOTO KOKUSHI) From Myōshinji. Wood with traces of lacquer, height 91.4 cm. Kamakura Period, c. 1286. Cleveland Museum of Art (Museum photo)

332 PORTRAIT OF SESSHIN BOSATSU (patriarch of Hossō sect). By Unkei (1151–1223). Wood, height 1.92 m. Kamakura Period, first decades of 13th century. Kōfukuji Treasure House, Nara (photo Asuka-en)

333–34 JUNI INNEN EMAKI (SCROLL OF THE TWELVE-FOLD CHAIN OF CAUSATION) Two details of handscroll. Color on paper, entire scroll 26.8 × 676.4 cm. Early Kamakura Period, 13th century. Nezu Art Museum, Tokyo (Museum photos)

335 SHINRAN SHŌNIN EDEN (LIFE OF SHINRAN: 1174–1268). Detail of handscroll.

Color on paper, entire height 41 cm. Kamakura Period, 13th–14th century. Nishi Honganji, Kyoto (photo Honpa Hongwanji)

336–37 GAKI ZŌSHI (TALE OF HUNGRY DEMONS) Two details of handscroll. Ink and slight color on paper, Sogenji, entire handscroll 26.8 × 541 cm. Heian Period, second half of 12th century. Tokyo National Museum (photo Zauho-Press)

338 SHŌGUNZUKA EMAKI (THE GENERAL'S BURIAL) Detail of handscroll. Ink on paper, entire handscroll 31.1 × 384 cm. Kamakura Period, 13th century. Kōzanji, Kyoto (photo Benrido)

339 SCENES FROM THE LIFE OF PRINCE SHŌTOKU-TAISHI (574–622). Attributed to Tosa Tsunetaka (late 12th–early 13th century). Hanging scroll. Color on silk, 172 × 84.5 cm. Kamakura Period, 13th–14th century. Metropolitan Museum of Art, New York (Bequest of Mrs. H.O. Havemeyer, 1929. The H.O. Havemeyer Collection) (Museum photo)

340–42 SCENES FROM THE LIFE OF PRINCE SHŌTOKU-TAISHI (574–622). Attributed to Tosa Tsunetaka (late 12th–early 13th century). Three details of hanging scroll. Color on silk, entire scroll 172 × 84.5 cm. Kamakura Period, 13th–14th century. Metropolitan Museum of Art, New York (Bequest of Mrs. H.O. Havemeyer, 1929. The H.O. Havemeyer Collection) (Museum photos)

343–45 SCENES FROM THE LIFE OF THE BUDDHA Three details from eight scenes on

four hanging scrolls.
Color on silk, 110×32.2 cm.;
114.8×32.2 cm.
Kamakura Period, 13th–14th
century.
Kyūsei Atami Art Museum, Atami
(Museum photos)

346 KOKAWADERA ENGI EMAKI (LEGENDS
OF THE KOKAWA TEMPLE)
Detail of handscroll.
Color on paper, entire height
30.3 cm.
Kamakura Period, 13th century.
Kokawadera, Wakayama (photo
Zauho-Press)

347 TAIMA MANDARA ENGI (LEGENDS OF
THE TAIMA MANDARA)
Detail of handscroll (see also fig. 362).
Color on paper, entire height
48.8 cm.
Kamakura Period, 13th century.
Kōmyōji, Kamakura (photo
Sakamoto)

348 YATA JIZŌ ENGI (LEGENDS OF THE JIZŌ
OF YATA)
Detail of handscroll.
Color on paper, entire height about
35 cm.
Kamakura Period, 14th century.
Yatadera, Kyoto (photo
Zauho-Press)

349 TŌSEI EDEN (STORY OF GANJIN'S
VOYAGE TO THE EAST)
Detail of handscroll recounting the
Chinese monk Ganjin's voyage to
Japan and his founding of the
Tōshōdaiji at Nara.
Color on paper, entire height 37 cm.
Kamakura Period, 13th century.
Tōshōdaiji New Treasure House,
Nara (photo Sakamoto)

350 YURIWAKA DAIJIN MONOGATARI (TALE
OF THE HERO YURIWAKA)
Detail of handscroll recounting heroic
naval battles.
Color on paper, entire height about
30 cm.
Muromachi Period, 15th–16th
century.

Tokyo National Museum (photo
Zauho-Press)

351–52 OBUSUMA SABURO EKOTOBA (STORY OF
OBUSUMA SABURO)
Two details of handscroll.
Color on paper, entire height 20 cm.
Kamakura Period, 13th century.
Tokyo National Museum (photo
Zauho-Press)

353–61 HEIJI MONOGATARI EMAKI (TALES OF
THE HEIJI INSURRECTION, 1159): THE
BURNING OF SANJŌ PALACE
Handscroll (one of three), almost
entire, and eight details.
Color on paper, 41.3×695 cm.
Kamakura Period, 13th century.
Museum of Fine Arts, Boston
(Museum photos)

362 TAIMA MANDARA ENGI (LEGENDS OF
THE TAIMA MANDARA)
Detail of handscroll (see also fig. 347).
Color on paper, entire height 48.8
cm.
Kamakura Period, 13th century.
Kōmyōji, Kamakura (Temple photo)

363 IPPEN SHŌNIN EDEN (LIFE OF THE
PRIEST IPPEN, 1239–1289).
Detail of handscroll (Sōshun version,
Konrenji).
Color on silk, entire height 34.2 cm.
Kamakura Period, 14th century
(1307?)
Kyoto National Museum (Museum
photo)

364–65 MATSUZAKI TENJIN ENGI (LEGENDS OF
THE MATSUZAKI SHRINE)
Two details of handscroll.
Color on paper, entire height about
30 cm.
Kamakura-Muromachi Period, 1311.
Hōfu Temmangū History Hall, Hōfu
(photos Zauho-Press)

366–73 MATSUZAKI TENJIN ENGI (LEGENDS OF
THE MATSUZAKI SHRINE)
Eight details of six handscrolls.
Color on paper, entire height of each
about 30 cm.
Kamakura-Muromachi Period, 1311.

Hōfu Temmangū History Hall, Hōfu
(Temple photos)

374–76 THE FOUR SEASONS
By Sesshū (1420–1506).
Handscroll.
Ink and slight color on paper, height
39.7 cm.
Muromachi Period, c. 1486.
Mōri Museum, Hōfu (Museum
photos)

377 MATSUZAKI TENJIN ENGI (LEGENDS OF
THE MATSUZAKI SHRINE)
Detail of handscroll.
Color on paper, entire height about
30 cm.
Kamakura-Muromachi Period, 1311.
Hōfu Temmangū History Hall, Hōfu
(photo Zauho-Press)

378–81 ISHIYAMADERA ENGI (LEGENDS OF THE
ISHIYAMA TEMPLE)
Four details of Handscroll 1.
Color on paper, entire height
33.6 cm.
Kamakura-Muromachi Period, 14th
century.
Ishiyamadera, Ishiyama (photo
Japan Historical Photo Library)

382–87 FUZOKU ZU BYŌBU (GENRE SCENES,
KYOTO)
Six details of two eight-fold screens.
Color on paper, 41.8×67.3 cm.
Muromachi Period, 16th century.
Tokyo National Museum (photos
Zauho-Press)

388–89 THE BATTLE OF NAGAKUTE (1584)
Six-fold screen and detail.
Color on paper, about 1.5×3.2 m.
Momoyama Period, late 16th–early
17th century.
Tokugawa Reimeikai Foundation,
Tokyo (Foundation photo)

390–91 THE BATTLE OF NAGASHINO (1575)
Six-fold screen and detail.
Color on paper, about 1.5×3.2 m.
Momoyama Period, late 16th
century.
Tokugawa Reimeikai Foundation,
Tokyo (Foundation photo)

392–94 DŌJŌJI ENGI (LEGENDS OF DŌJŌJI)
Enamored of a monk (Anchin), a
rejected young woman (Kiyohime)
haunts him by turning herself into a
dragon.
Three details of two handscrolls.
Color on paper, entire height of each
31.5 cm.
Muromachi Period, 16th century.
Dōjōji, vicinity of Wakayama
(Temple photos)

395–98 ŌEYAMA EMAKI (LEGEND OF THE
BANDIT ŌEYAMA)
Attributed to Takanobu
(1571–1618).
Four details of handscroll.
Color on paper, entire height about
30 cm.
Momoyama Period.
Tokyo National Museum (photos
Zauho-Press)

399 LANDSCAPE
Attributed to Kanō Masanobu
(1431–1530).
Ink and slight color on paper,
68 × 33 cm.
Muromachi Period.
Fujita Art Museum, Ōsaka (Museum
photo)

400 LI TAI-PO LOOKING AT A WATERFALL
Attributed to Sōami (1485?–1525).
Hanging scroll.
Ink on paper, height 62.5 cm.
Muromachi Period.
Asian Art Museum, San Francisco
(photo Jean Mazenod)

401 LANDSCAPE IN THREE SECTIONS
By Sōha (fl. 15th century).
Hanging scroll.
Ink on paper, height 83 cm.
Muromachi Period.
Los Angeles County Museum of Art
(photo Jean Mazenod)

402 LANDSCAPE WITH WATERFALL
By Kanō Motonobu (1476–1559).
Painting from *fusama* at the Reiunin,
Kyoto, mounted as a scroll.
Ink and color on paper, 1.8 × 1.2 m.
Muromachi Period, 1543–1549.
Myōshinji, Kyoto (Temple photo)

403 THE FOUR ACCOMPLISHMENTS
(calligraphy, painting, music, chess).
By Yūshō (Kaihō Shōeki,
1533–1615).
One of a pair of six-fold screens.
Ink, color, and gold on paper,
1.6 × 3.5 m.
Momoyama Period.
Nelson Gallery-Atkins Museum,
Kansas City (Museum photo)

404 BRIDGE AT UJI RIVER
One of a pair of six-fold screens.
Color and gold on paper, 1.7 × 3.4 m.
Momoyama Period, late 16th–early
17th century.
Nelson Gallery-Atkins Museum,
Kansas City (Museum photo)

405 NICHIGETSUZU BYŌBU (SUN AND MOON)
Six-fold screen.
Color and gold on paper, about
1.5 × 3.0 m.
Momoyama Period, late 16th–early
17th century.
Tokyo National Museum (photo
Zauho-Press)

406 PINES AND CHERRY TREES
Detail of *fusuma* painting.
Color and gold on paper, height
about 1.7 m.
Momoyama Period, late 16th–early
17th century.
Chishakuin Storehouse, Kyoto
(photo Sakamoto)

407 WAVES
Detail of six-fold screen.
Ink, slight color, and gold on paper,
entire screen about 1.5 × 3.0 m.
Momoyama Period, 1573–1614.
Nelson Gallery-Atkins Museum,
Kansas City (Museum photo)

408 WAVES AT MATSUSHIMA
By Sōtatsu (Tawaraya, Nonomura
Ietsu, 1575–1643).
Detail of six-fold screen (Rimpa
School).
Ink, color, and gold on paper, entire
screen 1.5 × 3.6 m.
Edo Period.
Freer Gallery of Art, Washington,
D.C. (Museum photo)

409 WAVES
By Kōrin (Ōgata Koretomi,
1658–1716).
Two-fold screen, signed HOKKYO
KŌRIN (seal: DOSO).
Color, gold, and ink on paper,
1.5 × 1.7 m.
Edo Period.
Metropolitan Museum of Art, New
York (photo Jean Mazenod)

410 PHEASANT, TREES, FLOWERS, AND BIRDS
By Unkoku Tōtetsu (fl. second half of
17th century).
Detail of six-fold screen.
Color and gold on paper, entire
height 1 m.
Edo Period.
Museum of Fine Arts, Boston (photo
Jean Mazenod)

411–13 FLOWERS AND BIRDS
Attributed to Sesshū (1420–1506).
Three details of six-fold screen.
Ink and color on paper, entire height
1.6 m.
Muromachi Period.
Asian Art Museum, San Francisco
(photos Jean Mazenod)

414 LANDSCAPE AND BIRDS FOR THE JUKŌIN
OF DAITOKUJI, KYOTO
By Shōei (Kanō Tadanobu,
1519–1592).
Detail. Ink and color on paper,
Muromachi Period, 1566.
Daitokuji, Kyoto (photo Sakamoto)

415 POEMS
By Kōetsu (Honami Kōetsu,
1558–1637) and Nonomura Sōtatsu
(1575–1643).
Detail of handscroll (Rimpa School).
Calligraphy by Kōetsu on paper,
stamped with silver and gold designs,
entire scroll 33 × 994.2 cm.
Momoyama or Early Edo Period.
Freer Gallery of Art, Washington,
D.C. (Museum photo)

416 GUNKEIZU (ROOSTERS WITH CACTUS)
By Jakuchū (Ito Shunkyō,
1716–1800).
Detail of *fusuma*.

Gold and color on paper, each panel
176.9 × 91.5 cm.
Edo Period.
Saifukuji, Ōsaka (photo Kodansha)

417 CRANES
By Kōrin (Ōgata Koretomi,
1658–1716).
One of a pair of six-fold screens.
Ink, color, and gold on paper, each
screen 1.7 × 3.7 m.
Edo Period.
Freer Gallery of Art, Washington,
D.C. (Museum photo)

418 THE SPIRITED BULL
Slight color on paper, 27.2 × 42.7 cm.
Kamakura Period, late 13th century.
Fujita Art Museum, Ōsaka (Museum
photo)

419 BOY ON A WATER BUFFALO
By Sekkyakushi (fl. early 15th
century).
Detail of hanging scroll.
Ink on paper, entire painting
97.2 × 35.6 cm.
Muromachi Period.
Freer Gallery of Art, Washington,
D.C. (Museum photo)

420 BOY WRESTLING A WATER BUFFALO
By Sekkyakushi (fl. early 15th
century).
Detail of hanging scroll.
Ink on paper, entire height 47.6 cm.
Muromachi Period.
Asian Art Museum, San Francisco
(photo Jean Mazenod)

421 HORSES AND GROOMS
Detail of six-fold screen.
Color on paper, entire screen
1.1 × 3.7 m.
Muromachi-Momoyama Periods,
16th century.
Nelson Gallery-Atkins Museum,
Kansas City (Museum photo)

422 CHINESE LIONS (KARA-SHISHI)
By Eitoku (Kanō Kuninobu,
1543–1590).
Detail of six-fold screen commissioned
by Toyotomi Hideyoshi.

Color and gold on paper, entire
screen 2.3 × 4.6 m.
Momoyama Period.
Imperial Household Collection,
Tokyo (photo Zauho-Press)

423 TIGERS
By Tan'yū (Kanō Morinobu,
1602–1674).
Detail of six-fold screen.
Ink on paper, entire screen
1.5 × 3.6 m.
Edo Period.
Nelson Gallery-Atkins Museum,
Kansas City (Museum photo)

424 TIGER
By Kōrin (Ōgata Koretomi,
1658–1716).
Hanging scroll.
Ink on paper, 105 × 37.4 cm.
Edo Period.
Nelson Gallery-Atkins Museum,
Kansas City (photo Jean Mazenod)

425 TSUCHIGUMO (TALE OF THE SPIDER)
Detail of handscroll.
Ink and color on paper, entire height
about 30 cm.
Kamakura Period, first half of 14th
century.
Tokyo National Museum (photo
Zauho-Press)

426 DRAGONS
By Tan'yū (Kanō Morinobu,
1602–1674).
Detail of six-fold screen.
Ink on paper, entire screen
1.6 × 3.6 m.
Edo Period.
Nelson Gallery-Atkins Museum,
Kansas City (Museum photo)

427–28 WIND GOD AND THUNDER GOD
By Sōtatsu (Nonomura or Tawaraya
Ietsu, 1575–1643).
Pair of two-fold screens.
Color and gold on paper, each screen
1.5 × 1.7 m.
Edo Period.
Kenninji, Kyoto (photos
Zauho-Press)

429–30 BUGAKU DANCERS
By Sōtatsu (Nonomura or Tawaraya
Ietsu, 1575–1643).
Pair of two-fold screens.
Color and gold on paper,
1.56 × 1.71 m.
Edo Period.
Daigoji Treasure House, Kyoto
(photos Sakamoto)

431 FLOWERS AND MAPLE LEAVES
By Hasegawa Tōhaku (Kyūroku,
1539–1610).
Two-panel *fusuma*.
Gold and color on paper, entire
screen 1.8 × 5.6 m.
Momoyama Period, 1592.
Chishakuin Storehouse, Kyoto
(photo Sakamoto)

432 CHRYSANTHEMUMS
By Sōtatsu (Nonomura or Tawaraya
Ietsu, 1575–1643).
Detail of six-fold screen.
Color and gold on paper, entire
screen 1.5 × 3.7 m.
Edo Period.
Kyoto National Museum (Museum
photo)

433 IRISES
By Kōrin (Ōgata Koretomi,
1658–1716).
One of a pair of six-fold screens.
Color and gold on paper, 1.5 × 3.6 m.
Edo Period, before 1704.
Nezu Art Museum, Tokyo (Museum
photo)

434 TREES
By Sōtatsu (Nonomura or Tawaraya
Ietsu, 1575–1643).
One of a pair of six-fold screens.
Sōtatsu and Kōetsu (1558–1637)
founded the Rimpa School, which
combined "black and white" (ink)
technique with the naturalistic style
of *Yamato-e*.
Ink and color on gold leaf,
1.5 × 3.6 m.
Rimpa School, Edo Period.
Freer Gallery of Art, Washington,
D.C. (Museum photo)

435–42 DEPARTURE OF FOREIGN SHIP FOR JAPAN; ARRIVAL OF FOREIGN SHIP AT NAGASAKI
By Kanō Naizen (1570–1616).
Pair of six-fold screens, entire view and six details.
Color on paper, each screen 1.6 × 3.7 m.
Momoyama Period.
Kobē Municipal Museum of Namban Art (photos Sasabe-Shibata)

443–44 PORTUGUESE SHIP IN PORT
Pair of six-fold screens.
Color on paper, each screen 1.6 × 3.3 m.
Momoyama Period, late 16th–early 17th century.
Imperial Household Collection, Tokyo (photos Sakamoto)

445–46 WATCHING THE ARRIVAL OF THE PORTUGUESE
Pair of six-fold screens.
Color on paper, each screen 1.5 × 3.6 m.
Momoyama Period, late 16th–early 17th century.
Private collection, Tokyo (photos Sakamoto)

447–50 FOUR GREAT CITIES OF THE WEST: LISBON, MADRID, ROME, AND CONSTANTINOPLE
One of a pair of eight-fold screens (see "Planisphere," fig. 453).
Color on paper, 1.6 × 4.8 m.
Momoyama Period, c. 1593.
Kōbe Municipal Museum of Namban Art (photos Sasabe-Shibata)

451–52 SOCIAL CUSTOMS OF FOREIGNERS
Pair of six-fold screens.
Ink and color on paper, each screen 93 × 302 cm.
Momoyama Period, c. 1610.
Eisei Bunko Foundation (Hosokawa Collection), Tokyo (photos Sakamoto)

453 PLANISPHERE (WORLD MAP)
One of a pair of eight-fold screens (see "Four Great Cities of the West," figs. 447–50).
Color on paper, 1.6 × 4.8 m.
Momoyama Period, c. 1593.
Kōbe Municipal Museum of Namban Art (photo Sasabe-Shibata)

454 PLANISPHERE (WORLD MAP)
One of a pair of six-fold screens, other shows "The Battle of Lepanto."
Color on paper, 1.5 × 3.7 m.
Muromachi-Momoyama Period, late 16th century.
Kōsetsu Art Museum, Ōsaka (Museum photo)

455 ST. FRANCIS XAVIER
Probably by Japanese artist.
Color on paper, 61 × 49 cm.
Momoyama Period, after 1623.
Kōbe Municipal Museum of Namban Art (photo Sasabe-Shibata)

456 VIRGIN OF SORROWS
16th-century Spanish artist.
Oil on canvas, 52.5 × 40 cm.
Brought to Japan in late 16th or early 17th century.
Namban Bunkakan, Ōsaka (Museum photo)

457 PRIEST AND TWO CHILDREN
Attributed to Nobukata (fl. late 16th–early 17th century).
Color on paper, 115 × 54 cm.
Momoyama Period.
Kōbe Municipal Museum of Namban Art (photo Sasabe-Shibata)

458 ST. PETER
16th-century Spanish or Portuguese artist.
Oil on canvas, 19 × 69 cm.
Brougth to Japan in late 16th century.
Namban Bunkakan, Ōsaka (Museum photo)

459–64 INSIDE A COPPER MINE: REMOVAL OF ORE AND INITIAL PROCESSING
Six details of handscroll.
Color on paper, entire height about 25 cm.
Edo Period.

Shiryōkan, Tokyo (photos Shogakan-Tuttle-Mori)

465–69 WRESTLERS
Five details.
Color and ink on paper, entire dimensions 1.4 × 1.6 m.
Momoyama Period, late 16th–early 17th century.
Freer Gallery of Art, Washington, D.C. (Museum photo)

470–72 SAMURAI GAME OF INU-OU-MONO (DOG CHASE)
Three details of six-fold screen.
Color on paper, entire screen 1.6 × 3.6 m.
Edo Period, 17th century.
Freer Gallery of Art, Washington, D.C. (Museum photo)

473–77 BON ODORI (DANCE OF THE FEAST OF THE DEAD)
Entire painting and four details.
Color and gold on paper, 33 × 76.8 cm.
Edo Period, 17th–19th century.
Freer Gallery of Art, Washington, D.C. (Museum photos)

478 THE RYŌGOKU BRIDGE, EDO
By Toyoharu (Utagawa Masaki, 1735–1814).
Color and gold on silk, 73.1 × 185.9 cm.
Edo Period.
Freer Gallery of Art, Washington, D.C. (Museum photo)

479 WOMEN WEAVING
Two-fold screen.
Color on paper, 1.5 × 1.7 m.
Edo Period, 18th century.
Kyusei Atami Art Museum, Atami (Museum photo)

480 AIRING BOOKS AND CLOTHING
Shunshō (Katsukawa Shunshō, 1726–1792).
Color and gold on silk, 157.1 × 82.6 cm.
Edo Period.
Freer Gallery of Art, Washington, D.C. (Museum photo)

481 THE FOUR ENJOYMENTS
By Toyohiro (Utagawa Toyohiro, 1773–1828).
Color and ink on paper, 101.4 × 41.2 cm.
Edo Period.
Freer Gallery of Art, Washington, D.C. (Museum photo)

482 MATSUURA BYŌBU (SCREENS WITH WOMEN OF FASHION AT LEISURE, FORMERLY MATSUURA COLLECTION)
Portion of six-fold screen, one of a pair (see front endpaper).
Color on gold paper, each screen 1.5 × 3.7 m.
Early Edo Period, first half of 17th century.
Yamato Bunkakan, Nara (photo Sakamoto)

483 COUNTRY SCENES
By Hokusai (Katsushika Tamekazu, 1760–1849).
Six-fold screen.
Color and gold on paper, 1.5 × 3.5 m.
Edo Period.
Freer Gallery of Art, Washington, D.C. (Museum photo)

484 COUNTRY SCENES
By Hokusai (Katsushika Tamekazu, 1760–1849).
Six-fold screen.
Color and gold on paper, 1.5 × 3.5 m.
Edo Period.
Freer Gallery of Art, Washington, D.C. (Museum photo)

485 MERRYMAKING UNDER THE CHERRY BLOSSOMS
By Hokusai (Katsushika Tamekazu, 1760–1849).
Six-fold screen, one of a pair (see fig. 488).
Color and ink on paper, 82.4 × 218.3 cm.
Ukiyo-e School, Edo Period.
Freer Gallery of Art, Washington, D.C. (Museum photo)

486 WINDSWEPT LANDSCAPE
By Buson (Yosa Nobukai, 1716–1783).
Six-fold screen.

Ink and color on silk, 1.7 × 3.7 m.
Nanga School, Edo Period.
Freer Gallery of Art, Washington, D.C. (Museum photo)

487 CHILDREN PLAYING AT THE SEASHORE
By Maruyama Ōkyo (Maruyama Masataka, 1733–1795).
Six-fold screen.
Ink, color, and gold on paper, 1.7 × 3.8 m.
Edo Period, 1782.
Nelson Gallery-Atkins Museum, Kansas City (Museum photo)

488 MERRYMAKING UNDER THE CHERRY BLOSSOMS
By Hokusai (Katsushika Tamekazu, 1760–1849).
Six-fold screen, one of a pair (see fig. 485).
Color and ink on paper, 82.4 × 218.3 cm.
Ukiyo-e School, Edo Period.
Freer Gallery of Art, Washington, D.C. (Museum photo)

489 BOY FISHING AT THE FOOT OF MT. FUJI
By Hokusai (Katsushika Tamekazu, 1760–1849).
Color and ink on silk, 36.2 × 51 cm.
Edo Period.
Freer Gallery of Art, Washington, D.C. (Museum photo)

490–91 MT. FUJI AND ENOSHIMA
By Hokusai (Katsushika Tamekazu, 1760–1849).
Pair of two-fold screens.
Color and ink on paper, each screen 1.6 × 1.6 m.
Edo Period.
Freer Gallery of Art, Washington, D.C. (Museum photo)

492 GIGAKU MASK
Wood, height 30 cm.
Nara Period, 8th century.
Musée Guimet, Paris (photo Giraudon)

493 GIGAKU MASK
Wood, height about 30 cm.
Nara Period, 8th century.

Musée Guimet, Paris (photo Giraudon)

494 GIGAKU MASK (MALE)
Lacquered wood, height 44.8 cm.
Nara Period, 8th century.
Shōsōin, Nara (photo Benrido)

495 GIGAKU MASK (FEMALE)
Lacquered wood, height 34.5 cm.
Nara Period, 8th century.
Shōsōin, Nara (photo Benrido)

496 GRAND ARMOR (YOROI)
Metal plates (kozane) and leather with lacing; iron helmet.
Late Heian Period, 12th century.
Oyamazumi-jinja Treasure House, Ehime (photo Musée Cernuschi, Paris)

497 GRAND ARMOR (YOROI)
Metal plates (kozane) and leather with lacing.
Late Kamakura Period, 14th century.
Hachiman Shrine, Aomori (photo Musée Cernuschi, Paris)

498 FULL SUIT OF ARMOR (GUSOKU)
Western-style iron plates (namban-dō) with multicolored lacing.
Momoyama Period, late 16th century.
Tokyo National Museum (photo Musée Cernuschi, Paris)

499 FULL SUIT OF ARMOR (GUSOKU)
Niō-dō-style metal plates (shaped to resemble the chest of a Niō, Buddhist Guardian King).
Momoyama Period, late 16th century.
Tokyo National Museum (photo Musée Cernuschi, Paris)

500 BOW DECORATED WITH ACROBATS AND MUSICIANS
Two details.
Painted wood, figures 3 to 7 cm. high, entire length 1.6 m.
Nara Period, 8th century.
Shōsōin, Nara (photo Benrido)

501 MIRROR CASE WITH FLORAL AND
PHOENIX MOTIFS
Lacquered wood, diameter 36.5 cm.
Nara Period, 8th century.
Shōsōin, Nara (photo Benrido)

502 EWER WITH BIRD-SHAPED MOUTH AND
LID
Lacquer, height 41.3 cm.
Nara Period, 8th century.
Shōsōin, Nara (photo Benrido)

503 VESSEL WITH HUNTING SCENES
Silver, height 43 cm.
Nara Period, 764.
Shōsōin, Nara (photo Benrido)

504 OPENWORK INCENSE BURNER WITH
ANIMAL AND PLANT MOTIFS
Silver, height 21 cm.
Nara Period, 8th century.
Shōsōin, Nara (photo Benrido)

505 KOTO (FRAGMENT)
Lacquer with gold and silver inlay,
height 1.1 m.
Nara Period, 735.
Shōsōin, Nara (photo Benrido)

506 INCENSE-BURNER STAND IN THE SHAPE
OF A LOTUS BLOSSOM
Lacquered wood, diameter 56 cm.
Nara Period, 8th century.
Shōsōin, Nara (photo Benrido)

507 KEMAN (HANGING ORNAMENT IN
BUDDHIST TEMPLE)
Silverplated copper, height 27.3 cm.
Kamakura Period, 13th–14th
century.
Freer Gallery of Art, Washington,
D.C. (Museum photo)

508 INCENSE BURNER WITH NIGHTINGALE
AND PLUM BLOSSOMS
Lacquer and gold powder *(maki-e)*
with gold inlay, height about 20 cm.
Muromachi Period, 14th–15th
century.
Tōkeiji, Kamakura (Temple photo)

509 WRITING DESK WITH CARRIAGE AND
CHRYSANTHEMUMS
Lacquer with gold inlay,
22.4 × 20.9 × 3.9 cm.

Edo Period, 17th–18th century.
Tokyo National Museum (photo
Zauho-Press)

510 PLATE WITH GOD OF GOOD FORTUNE
(DAIKOKU)
By Kōrin (Ōgata Koretomi,
1658–1716).
Stoneware, 22.1 cm. square.
Ed Period.
Fujita Art Museum, Ōsaka (Museum
photo)

511 PLATE WITH GOD OF GOOD FORTUNE
(HOTEI)
Ceramic, 22.1 cm. square.
Edo Period, 17th century.
Fujita Art Museum, Ōsaka (Museum
photo)

512 PLATE WITH REED, STORK, AND
CALLIGRAPHY
By Kōrin (Ōgata Koretomi,
1658–1716) and Kenzan (Ōgata
Koremasa, 1663–1743).
Stoneware, 22.1 cm. square.
Edo Period.
Fujita Art Museum (Museum photo)

513 PLATE WITH PLUM BLOSSOMS AND
CALLIGRAPHY
By Kenzan (Ōgata Koremasa,
1663–1743).
Stoneware, 22.1 cm. square.
Edo Period.
Fujita Art Museum, Ōsaka (Museum
photo)

514 PLATE WITH POET WATCHING WILD
GEESE
By Kōrin (Ōgata Koretomi,
1658–1716).
Stoneware, 22 cm. square.
Edo Period.
Tokyo National Museum (photo
Zauho-Press)

515 PLATE WITH GOD OF LONGEVITY
By Kōrin (Ōgata Koretomi,
1658–1716).
Stoneware, diameter 27 cm.
Edo Period.
Ōkura Museum, Tokyo (Museum
photo)

516 LARGE DISH WITH GEOMETRIC
PATTERN, KO-KUTANI: OLD KUTANI
WARE
White porcelain with multicolored
overglaze enamels, height 7 cm.,
diameter 35 cm.
Edo Period, 17th century.
Freer Gallery of Art, Washington,
D.C. (Museum photo)

517 LARGE PLATE WITH BANQUET SCENE,
KO-KUTANI: OLD KUTANI WARE
White porcelain, diameter 40.9 cm.
Edo Period, 17th century.
Hakonejinja Treasure House,
Hakone (Museum photo)

518 LARGE PLATE WITH PEONIES AND
BUTTERFLIES, KO-KUTANI: OLD KUTANI
WARE
White porcelain, diameter 41.2 cm.
Edo Period, 17th century.
Umezawa Memorial Gallery, Tokyo
(Museum photo)

519–22 FOUR DISHES
Attributed to Kenzan (Ōgata
Koremasa, 1663–1743).
Porcelain, diameter of each 11.2 cm.
Edo Period.
Fujita Art Museum, Ōsaka (Museum
photo)

523 PLATE WITH LEMON TREE, NABESHIMA
WARE
Porcelain, diameter 30.2 cm.
Edo Period, 18th century.
Sekai Kyūseikyō, Shizuoka (Museum
photo)

524 PLATE WITH FLOWERS, MATS, AND
WATER, NABESHIMA WARE
Porcelain, diameter 22.2 cm.
Edo Period, 18th century.
Hakonejinja Treasure House,
Hakone (Museum photo)

525 PLATE WITH PEACHES AND FLOWERS,
NABESHIMA WARE
Porcelain, diameter 31.5 cm.
Edo Period, 18th century.
Hakonejinja Treasure House,
Hakone (Museum photo)

526 VESSEL WITH STRIPED DECORATION, KARATSU WARE
Stoneware, height 8.8 cm, diameter 11.8 cm.
Momoyama Period, 16th–17th century.
Nezu Art Museum, Tokyo (Museum photo)

527 VASE WITH "YOSHINO MOUNTAINS" DESIGN
By Nonomura Ninsei (d. c. 1660).
Stoneware, height 28.6 cm.
Edo Period.
Seikadō, Tokyo (photo Takahashi)

528 TAKARABUNE ("TREASURE SHIP" LUCKY CHARM)
Attributed to Nonomura Ninsei (d. c. 1660).
Stoneware, height 66.2 cm., length 53.4 cm.
Edo Period.
Fujita Art Museum, Ōsaka (Museum photo)

529 "BLACK" TEA BOWL, ORIBE WARE
Stoneware, height 12 cm., diameter 13.7 cm.
Momoyama Period, 16th–17th century.

Nezu Art Museum, Tokyo (Museum photo)

530 INCENSE BURNER WITH "RIMPO" AND "KATSUMA" MOTIFS ASSOCIATED WITH SHINGON BUDDHISM
Attributed to Nonomura Ninsei (d. c. 1660).
Stoneware, height 13 cm.
Edo Period.
Fujita Art Museum, Ōsaka (Museum photo)

531 FLASK WITH WISTERIA AND PHOENIX, KAKIEMON WARE
White porcelain, height 32.2 cm.
Edo Period, 17th century.
Seikadō, Tokyo (photo Takahashi)

532 FLASK WITH PLUM TREE BENEATH THE MOON
By Nonomura Ninsei (d. c. 1660).
Stoneware, height 30 cm.
Edo Period.
Tokyo National Museum (photo Zauho-Press)

533 VASE WITH WISTERIA, KAKIEMON WARE
White porcelain, height 29.4 cm.
Edo Period, late 17th century.
Asian Art Museum, San Francisco (photo Jean Mazenod)

534 SCREEN PANEL WITH DEER UNDER A TREE
Stenciled designs on silk, 149.5 × 56 cm.
Nara Period, 8th century.
Shōsōin, Nara (photo Benrido)

535 PEACOCK BANNER
Detail. Embroidery.
Nara Period, 8th century.
Shōsōin, Nara (photo Benrido)

536 SCREEN PANEL WITH A RAM UNDER A TREE
Silk with batik designs, 163 × 56 cm.
Nara Period, dated 751.
Shōsōin, Nara (photo Benrido)

537 KOSODE (SHORT-SLEEVED KIMONO)
By Kōrin (Ōgata Koretomi, 1658–1716).
Painted silk, height 1.5 m.
Edo Period, 1705.
Tokyo National Museum (photo Zauho-Press)

538 KOSODE (SHORT-SLEEVED KIMONO)
Embroidered silk, height about 1.5 m.
Edo Period, 18th–19th century.
Tokyo National Museum (photo Zauho-Press)

11. ARCHEOLOGICAL SITES AND PRINCIPAL MONUMENTS

Map of Japan

Plans of Kyoto and Nara

List of Sites and Monuments

Gardens

Calligraphy and Handwritten Documents

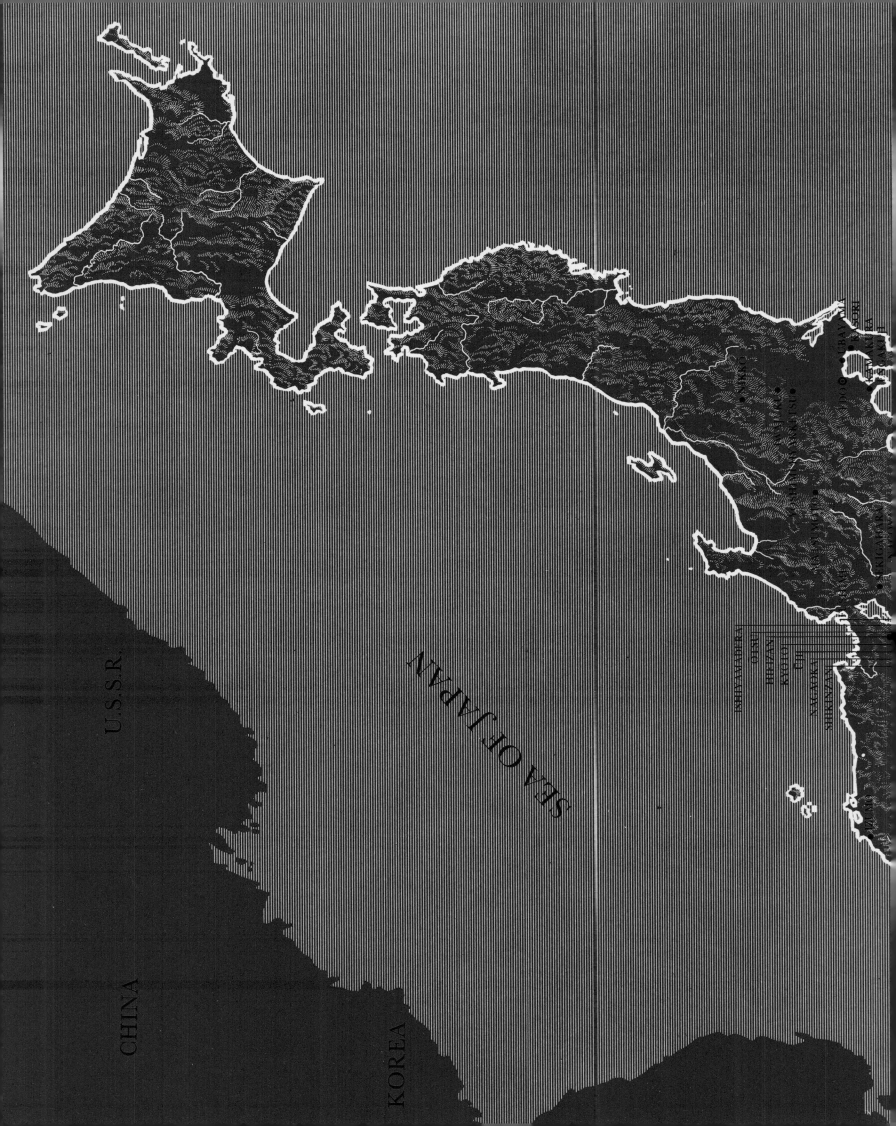

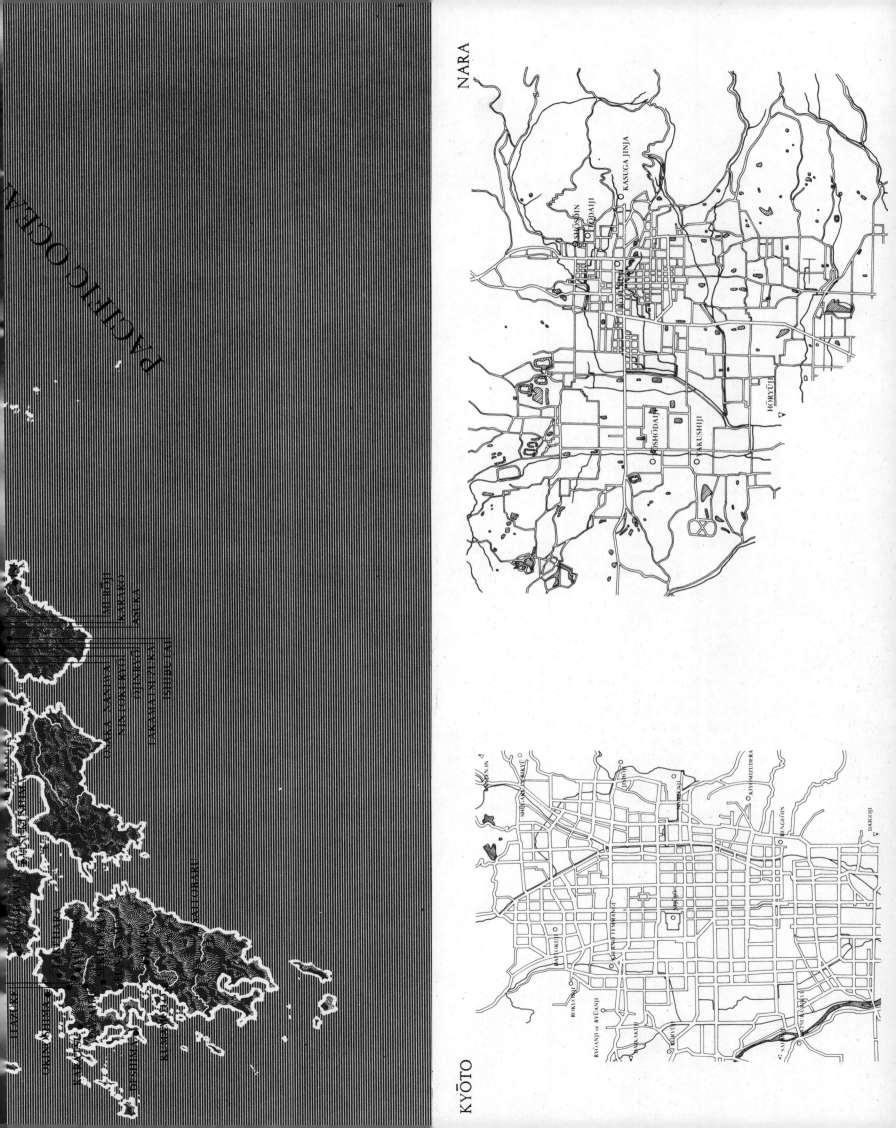

NARA

KYŌTO

LIST OF SITES AND MONUMENTS

KANTŌ AND CHŪBŪ

EDO
ENGAKUJI (Kamakura)
IWAJUKU (Gumma Prefecture)
KAMAKURA (Kanagawa Prefecture)
KASORI (Chiba Prefecture)
MATSUMOTO (Nagano Prefecture)
NAGOYA (Aichi Prefecture)
NIKKŌ (Tochigi Prefecture)
SEKIGAHARA (Gifu Prefecture)
SHŌRINZAN (Shizuoka Prefecture)
TŌKAIDŌ
TORO (Shizuoka Prefecture)
UBAYAMA (Chiba Prefecture)
YOSHIMI HYAKKETSU (Saitama Prefecture)

KANSAI

ASUKA (Nara Prefecture)
AZUCHI (Shiga Prefecture)
DOIGAHAMA (Yamaguchi Prefecture)
HIMEJI (Hyōgo Prefecture)
ISE (Mie Prefecture)
ISHIBUTAI (Nara Prefecture)
ISHIYAMA (Mie Prefecture)
ITSUKUSHIMA (Miyajima, Hiroshima Prefecture)
IZUMO (Shimane Prefecture)
KARAKO (Nara Prefecture)
NAGAOKA (near Kyoto)
NANIWA (Ōsaka)
NINTOKURYŌ (Ōsaka)
ŌJINRYŌ (Ōsaka)
OKAYAMA (Okayama Prefecture)
ŌSAKA
SHIKINZAN (Greater Ōsaka)
SENZOKU (Okayama Prefecture)
SHITENNŌJI (Ōsaka)
SHŌTOKU-TAISHI HAKA (Ōsaka)
SUMIYOSHI TAISHA (Ōsaka)
TAKAMATSUZUKA (Nara Prefecture)

KYŪSHŪ

DAZAIFU (Fukuoka Prefecture)
DESHIMA (Nagasaki Prefecture)
FUNAYAMA (Kumamoto Prefecture)
IDERA (Kumamoto Prefecture)
ITAZUKE (Fukuoka Prefecture)
IWATOYAMA (Fukuoka Prefecture)
KARATSU (Saga Prefecture)
KUMAMOTO (Kumamoto Prefecture)
OKINOSHIMA (Fukuoka Prefecture)
ŌTSUKA (Fukuoka Prefecture)
SAITOBARU (Miyazaki Prefecture)
SEKIJINYAMA (Fukuoka Prefecture)
TAKEHARA (Fukuoka Prefecture)

KYOTO AND VICINITY

KYOTO
BYŌDŌIN (Uji, near Kyoto)
DAIGOJI
DAIKAKUJI
DAITOKUJI
FUSHIMI
HIEIZAN
ISHIYAMADERA (Shiga Prefecture)
JISHŌJI (Ginkakuji)
KATSURA RIKYŪ
KITANO TEMMANGŪ
KIYOMIZUDERA
KŌRYŪJI
NANZENJI
NIJŌJŌ (Kyoto)
RENGEOIN (Sanjūsangendō)
ROKUONJI (Kinkakuji)
RYŌANJI
SAIHŌJI (Kokedera)
SANZENIN
SHŪGAKUIN RIKYŪ

NARA

HEIJŌKYŌ
HŌRYŪJI
KASUGAJINJA
KŌFUKUJI
MURŌJI
SHŌSŌIN
TŌDAIJI
TŌSHŌDAIJI
YAKUSHIJI

KANTO AND CHŪBŪ

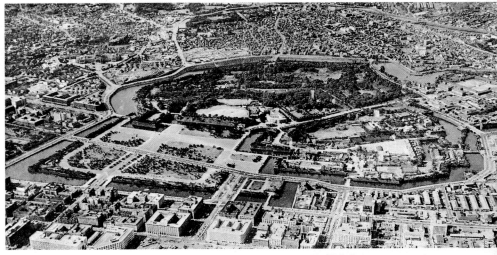

540 EDO. RECENT AIR VIEW OF IMPERIAL PALACE

EDO 江戸

For many years, the city destined to become the capital of Japan in 1868 was nothing more than a little fishing village deep within what we now call Tokyo Bay. Edo, which literally means "mouth of the river," sprang up along the waterways that make up the Sumida River delta. Until nearby Kamakura became the headquarters of the Bakufu (military government) in the late 12th century, the Edo region stood on the sidelines while the kingdom of Yamato, much farther west, emerged as the hub of the Japanese empire. It was not until the middle of the 15th century (1456) that Ōta Sukenaga (also called Ōta Dōkan: 1433–1486) chose Edo as the site of his castle. Two years earlier, in 1454, Uesugi Fusaaki (1432–1466), a member of the family to whom Ōta Dōkan owed allegiance, had been appointed *Kantō kanryō*, or governor of the Kantō region. With his newly constructed fortress as command post, Ōta Sukenaga waged war against his *daimyō* neighbors and desisted only after bringing all of Musashi Province (today's greater Tokyo, and Saitama and Kanagawa prefectures) under his sway. However, strife between the two branches of the Uesugi clan led to his assassination.

Edo and its castle passed to the *kubō* (lord) of Koga (in Shimosa Province, or modern Chiba and Ibaraki prefectures), but in 1524 it fell into the hands of Hōjō Ujitsuna (1487–1541), who wrested control of Kantō from his implacable enemies, the Uesugi. The heyday of the Hōjō was equally short-lived: by 1590 Toyotomi Hideyoshi (1536–1598) and his then lieutenant, Tokugawa Ieyasu (1542–1616), had brought them to their knees.

After receiving the Kantō region as a fief from the grateful Hideyoshi, Ieyasu decided to make the gently rolling countryside of Edo his home and proceeded to enlarge Ōta Dōkan's castle. Seat of the shogunate and nerve center of what came to be generally known as the Edo regime, this magnificent palace was the real administrative nucleus of Japan from 1603 to 1868.

Converted into the Imperial Palace in 1868, Edo Castle sits unperturbed in the heart of the modern capital to this day, an everlasting symbol of a Japan that is no more. Stately moats encircling this vast oasis of green inject a sense of timelessness and serenity into the bustling business districts that surround the castle on all sides.

These moats, with their impressive earthen embankments, and some cyclopean masonry are all that remain of the residential West Tower (Nishinomaru) that Ieyasu built in 1592. Tokugawa Hidetada (1579–1632), Ieyasu's third son and the second Tokugawa shōgun (1605–1622), enlarged and improved the Nishinomaru, which thereafter served as the castle's *honmaru*, or donjon. In 1636, during the shogunate of Iemitsu (sh. 1622–1651), it became the center of a sprawling palace complex built with contributions exacted from all of the shōgun's vassals. Over the years, chroniclers and *literati* alike sang the praises of the imposing central tower, 70 meters high and covered with lead "tiles" and, in keeping with tradition, crowned with a pair of golden dolphins. The palace was entirely destroyed by fire in 1657; the cost of the original building had been so prohibitive that later shōguns were reluctant to call on their vassals yet again to finance its reconstruction.

Consequently, private apartments as well as administrative offices were relocated to outbuildings that could be repaired and maintained at lower cost: the *Fujimi no yagura* ("Tower from which to see Mt. Fuji"), the Tatsumi Tower (*Tatsumi no yagura*), and the Fushimi Tower (*Fushimi no yagura*). This network of connecting gateways and enclosing walls collapsed during the devastating earthquake that reduced much of Tokyo to rubble in 1923. World War II finished off what had survived or been rebuilt in the wake of the earthquake, and the government authorized special grants that have led to recent construction at the site.

With the shōgun's headquarters as its hub, the one-time fishing village mushroomed into a fortress town

541 EDO. PLAN OF EDO CASTLE, C. 1800
(drawing by Giroux, after Hirai Satoru)

542 EDO. EDO CASTLE SHORTLY BEFORE
THE 1657 FIRE

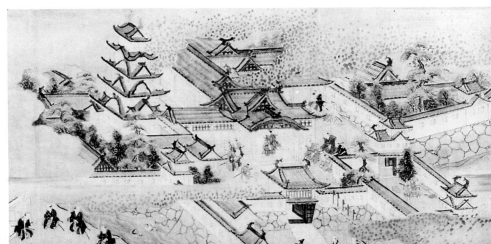

503

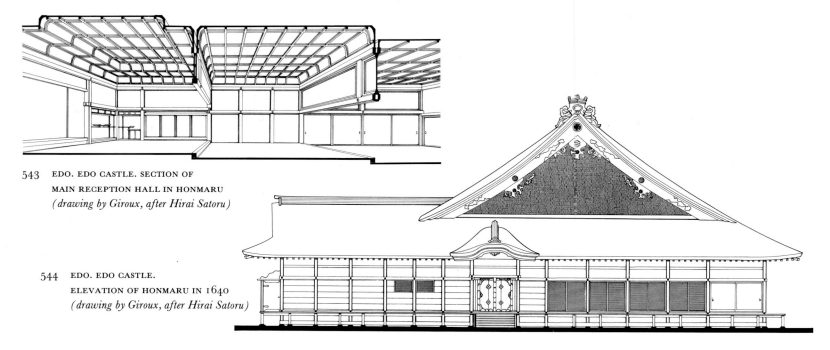

543 EDO. EDO CASTLE. SECTION OF
MAIN RECEPTION HALL IN HONMARU
(drawing by Giroux, after Hirai Satoru)

544 EDO. EDO CASTLE.
ELEVATION OF HONMARU IN 1640
(drawing by Giroux, after Hirai Satoru)

and, ultimately, a huge metropolis. The *sankin-kodai* law enacted in 1634, which obliged all *daimyō* to divide their time between Edo and their regional power centers and to leave their families in the capital, was expressly designed to crush Japan's often unruly feudal aristocracy, morally as well as financially. This system had a positive side, however, for within it lay the seeds of Edo's spectacular economic growth; it was only natural that merchants and gifted craftsmen who wished to place themselves at the disposal of noble families should gravitate to the shōguns' capital. It was an era of far-reaching change, not just in Edo, but throughout Japan, and the repercussions of rapid urban growth were soon felt in the surrounding countryside. Ihara Saikaku (1642–1693) describes how peasant youths in the vicinity of Ōsaka defied Toyotomi Hideyoshi's edict of 1582 forbidding changes in the social order (*taikokenchi*), and migrated to the city to swell the ranks of the artisan class. (These "reform" measures were aimed primarily at curbing the growth of the lower military aristocracy.) Daimyō, for their part, found it necessary to build prestigious residences in Edo, which provided shelter for family members and retainers while serving as a mark of rank. Although most of Edo's architecture from this period has vanished—save for the renowned Red Gate (Aka-mon) at the University of Tokyo and a few other buildings—visitors may still admire the enchanting gardens that once surrounded city residences or suburban villas, such as at Rikugien (1695–1702) and Hamamatsu-rikyū (1710).

The Tokugawa were fond of their city and did their utmost to beautify it. In addition to fostering the creation of religious institutions, such as the temple of Kannon at Asakusa (1618) and of Keneiji at Ueno (the largest Buddhist temple in the city), they ordered the construction of bridges to connect, as artfully as possible, the banks of Edo's main waterway and of its tributaries: the celebrated Nihonbashi (Bridge of Japan) in 1603, from which all distances in Japan were measured; the Ryōgokubashi in 1659; and the Eitaibashi in 1698.

Few of the world's cities have reeled so often under staggering catastrophes, yet gone to such lengths to ensure safety. For instance, Edo was crisscrossed by a grid of broad, well-defined thoroughfares and easily pinpointed blocks (incidentally facilitating surveillance by the police, who do not divulge the city's real street plan). Furthermore, the use of plaster and tile was encouraged over less fire-resistant materials, such as rammed earth and thatch. A concise list of only the most tragic of these calamities speaks volumes: general fire in 1621; devastating earthquakes in 1633 and 1650; another fire in 1657–58; more earthquakes in 1703 and 1707; fire in 1845; earthquakes in 1855 and 1923. Survivors of this last earthquake still tell of how the havoc wrought by nature, dreadful enough, was compounded by the saturation bombings of 1945.

Little remains of old Edo, or, for that matter, of old Tokyo. But now and again, surrounded by the concrete buildings of a great metropolis, a startlingly musical or bucolic name recalls activities of days past (Ginza, "money" or "currency") or describes what was once a rustic site (Ueno, "the plain above"; Ochanomizu, "water for tea"; Sakuradamon, "gate of the cherry-tree field").

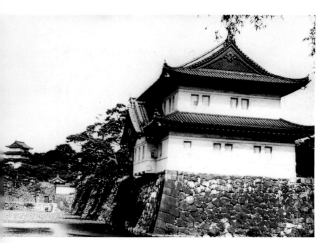

545 EDO. CORNER TOWER OF IMPERIAL PALACE

546 EDO. PLAN OF DAIMYŌ RESIDENCE (YASHIKI),
18TH CENTURY *(drawing after Hirai Satoru)*

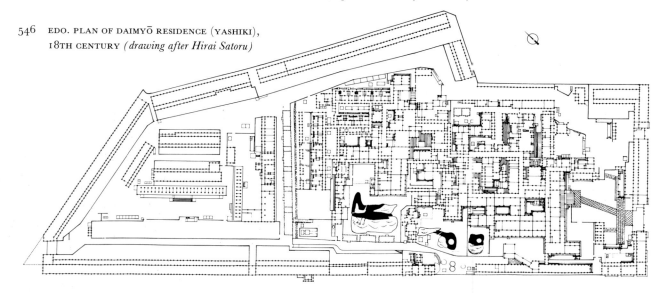

ENGAKUJI (Kamakura) 圓覺寺

Hōjō Tokimune (1252–1284), the sixth Kamakura *shikken* (regent), founded Engakuji in 1282 in memory of Tse-Yüan (Shigen) and Tsu-Yüan (Sogen), two Chinese monks who had perished during Japan's campaign to drive back the Mongol invaders. Perhaps this explains the unmistakable Chinese flavor of the temple, whose first abbot was indeed a Chinese priest. The buildings themselves were patterned after the "Indian" style of architecture (Tenjikuyō)—though introduced from Song China—that was so called to distinguish it from the Chinese style of Chan (Zen) monasteries.

The Shariden, or relic hall (probably built about 1285), underwent significant restoration only after the earthquake of 1923. Consequently, it is all that remains of the temple as it originally appeared. Broken only by small, lyre-framed windows, the solid wood structure is crowned by a massive thatched roof whose underside is bordered by elegant eaves. These elements, combined with the comparatively delicate beams and bracketing under the eaves, create an astonishing tracery. Here the style popular in Song China joined forces with the Japanese predilection for natural materials, resulting in a happy blend that manages to be both austere and sophisticated, with just a hint of rustic simplicity. A model of Kamakura architecture, the relic hall is bound up both with the *samurai*, who held the real reins of power in Japan, and with Zen Buddhism, the religion and philosophy that shaped the thinking of all prominent figures at the time.

The Shariden of Engakuji was not the first pavilion of its kind: Minamoto-no-Sanetomo (1192–1219), the great poet who also happened to be the third and last Minamoto shōgun, had already built one at Daijiji, but the building that is admired today is a much later reconstruction, the original structure having been destroyed by fire in 1653.

The other buildings of Engakuji fell victim first to the civil wars of the 15th century, then to the earthquake of 1923. The Shariden remains as the sole authentic survivor of a temple which once ranked second among the "Five Mountains," or five great Zen temples of Kamakura.

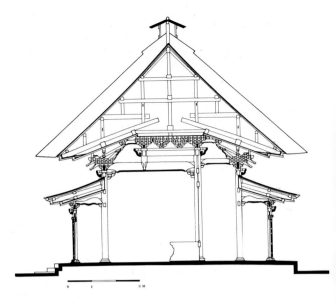

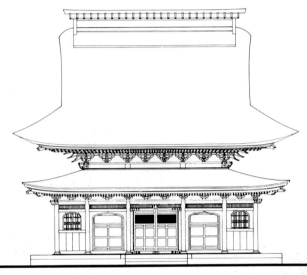

547 THE SHARIDEN (RELIC HALL) OF ENGAKUJI, SECTION AND ELEVATION
(*drawing by Giroux, after Ota Hirotarō*)

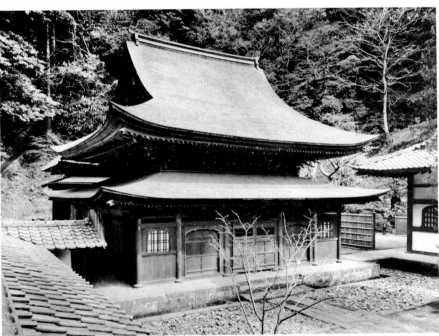

548 THE SHARIDEN OF ENGAKUJI

IWAJUKU (Gumma Prefecture) 岩宿

Excavations undertaken by Meiji University in 1949–50 revealed the remains and stratigraphic deposits of a pre-Jōmon culture—that is, a pre-pottery and, typologically speaking, Paleolithic culture—that was active between the 2nd millennium B.C and the 3rd century B.C. Scholars were intrigued by the discovery. The only indisputable fact about this so-called loam deposit was that it could be dated from the same period as the great volcanic eruptions that have helped give the archipelago its present configuration. However, this was enough to throw a radically new light on previous thinking about the human industries of ancient Japan, for the presence of chipped-stone tools raised the possibility that a full-fledged culture existed here in Paleolithic times. Moreover, the evidence of these industries turned up amid volcanic ash and rock, suggesting that the eruptions

549 IWAJUKU. STRATIGRAPHIC SECTION OF EXCAVATIONS

505

must have caught the members of this culture by surprise. After the discoveries at Iwajuku, scholars no longer explained human presence in Japan solely by an influx of populations skilled enough in navigation to negotiate the sea that separates Japan from the Asian continent. This new data gave added strength to the hypothesis that groups had migrated to Japan by an overland route, when a crescent of land still joined Japan to Asia at its northern and southern tips and volcanic activity had not yet produced the archipelago we see today. Archaeologists wasted no time in extending the possibility of a truly chronological Paleolithic culture to other sites in Japan. However, with the passing of thirty years and much intensive research, a more probable and logical opinion has won out: only a Paleolithic typology could have existed at the time. A chronological gap between Japan and Asia is still considered inescapable. Thanks to interest sparked by the discovery at Iwajuku, we have been able to piece together many aspects of the pre-Jōmon culture (still vaguely termed *sendōki* or *sentōki*, "prepottery") found here and at other sites throughout Japan.

KAMAKURA (Kamakura Prefecture) 鎌倉

This little town in Sagami Province (present-day Kanagawa Prefecture) was for several centuries the political capital of Japan. Paradoxically, the reason for its distinguished status in the 12th to 14th centuries can be traced to an episode involving defeat and ignominy. The Heiji civil war of 1159 had ended in the triumph of Taira-no-Kiyomori (1118–1181) over his rival, Minamoto-no-Yoshitomo (1123–1160), and the victorious Kiyomori exiled Yoshitomo's thirteen-year-old son, Yoritomo (1147–1199), to Izu Province (Shizuoka Prefecture), where he remained for twenty years. In 1180 Yoritomo set out to wage war against the Taira, emerging victorious five years later.

During his stay in Izu, Yoritomo decided to reside in Kamakura, the same village where his ancestor Yoriyoshi (995–1082), once master of Sagami Province (Kanagawa Prefecture) and Mutsu Province (all of northeastern Honshū), had settled a century earlier. With the triumph of the Minamoto and the establishment of the shogunate in 1192 began the transformation of what had been an unremarkable provincial town into the second capital of the empire.

Yoritomo's choice was a wise one. Situated on Sagami Bay and to the west of the Miura peninsula, Kamakura occupies a small, pine-clad plain. Nearby mountains offer protection from north winds but are not so close as to hem in the town, and the geography had a great deal to do with orienting the Minamoto toward the sea. Well before the shogunate came into being, they welcomed ships from the continent and occasionally chartered them for their own use. In so doing, they ensured an influx of Chinese objects that not only increased their personal wealth, but also fostered an appreciation in Japan for a new form of art. Moreover, the Chinese offered subsidies in the form of bronze coins, a currency traditionally valued as legal tender in a land where bronze mining was still comparatively underdeveloped. After Yoritomo's death in 1199, however, the shogunate—theoretically conceded to members of the Fujiwara clan—was in fact taken over by the Hōjō regents (*shikken*), who were descendants of Taira-no-Sadamori (died 940) but related to the Minamoto by marriage. Although Japan's political center thus partially shifted back to Kyoto and marked the beginning of Kamakura's decline, the city remained a hub of activity for several decades: its population at the time is believed to have exceeded one million. The wars that ended the Kamakura regime in the 14th century left part of the city ravaged, especially during the assault mounted by Nitta Yoshisada (1301–1338) at the time of his campaign (1333) against Hōjō Takatori (1303–1333).

The Ashikaga shōguns, although resident in Kyoto, were most responsible for reviving the fortunes of Kamakura by turning it into the administrative nucleus of eastern Japan. In 1349 Ashikaga Takauji (1305–1358), the first shōgun of the Muromachi period (1338–1573), entrusted the government of the eastern provinces to his son Motouji (1340–1367), who received the title of *Kantō-kanryō*, or governor of the Kantō region. This act raised serious problems, however, and a measure of peace was not restored in Kantō until all of the Ashikaga's enemies and rivals were defeated in 1358. The peace was at best uneasy, marred by turbulence and anxiety, and a century later the Uesugi family wrested the office of *kanryō* from the Ashikaga (1439), thereby precipitating yet another round of wars. During the civil strife of the 15th century the city was besieged (1454) and later ravaged by fire (1526). After the Tokugawa won out completely over their enemies at the battle of Sekigahara (1600), they resumed the Minamoto policy of withdrawal from the intrigue and compromises of court life by shifting their government headquarters still farther east, to Edo (the future Tokyo). Laid waste and abandoned, Kamakura, the former capital of the Minamoto and the Ashikaga, found itself reduced again to a village of fishermen. Today its captivating scenery and proximity to Tokyo have helped to bring it renewed prominence as a fashionable resort and residential area.

All that remains of Kamakura's past riches are the renowned Great Buddha in its open-air setting (fig. 56), the Shariden (relic hall) of Engakuji (c. 1285; figs. 547, 548), and the shrine of Tsurugaoka-Hachimangū, dedicated to Emperor Ōjin (r. 270–310), later apotheosized as the god of war (fig. 551). Although the present shrine was built in 1828 in the Muromachi style, the surrounding pines and cherry trees give some idea of how enchanting the site must have been back in 1073, when Minamoto-no-Yoriyoshi (995–1082) decided to create a shrine in honor of Hachiman or Yawata (Ōjin), tutelary god of the Minamoto family. Originally built at Yuigahama, on the coast near Kamakura, it was transferred inland to a site within the city proper by Minamoto-no-Yoritomo, who established the shogunate in 1193. For a description of Engakuji, see page 505.)

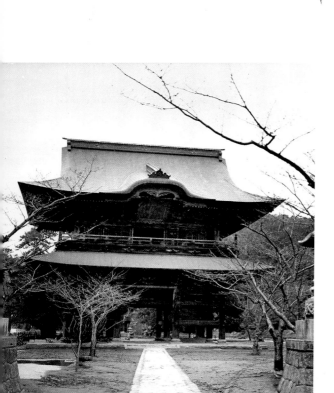

550 KAMAKURA. SANMON (MOUNTAIN GATE)
OF KENCHOJI

551 KAMAKURA. THE SACRED TREE
OF TSURUGAOKA-HACHIMANGŪ

KASORI (Chiba Prefecture) 加曽利

Discovered in 1887 and excavated in 1923, Kasori, near the town of Chiba, lies on an alluvial plain thirty meters above sea level, overlooking a valley. Its most remarkable feature is an impressive *kaizuka*, or kitchen midden of shells, which wends its way like a massive, undulating band around the plateau, describing an area 400 meters long (north–south) and 200 meters wide (east–west). The double-horseshoe configuration is the result of the accumulation of shells and other waste materials around nearby settlements. Parts of older dwellings and tombs were apparently buried beneath the *kaizuka*, which is approximately one meter thick. That Kasori was occupied for a considerable length of time is confirmed by pottery and pottery fragments dating from at least the Middle and Late Jōmon periods (16th–4th centuries B.C.), when a hunting-and-fishing economy prevailed.

The pottery discovered at Kasori well exemplifies the developed pottery in the Kantō region, being restrained in style compared with that produced farther north, in Tōhoku. Certain influences from as far west as Kyoto and as far north as Aomori must have made themselves felt here from a very early period. The *kaizuka* proper—often used as a burial ground, for shells were thought to prevent bodies from decaying—is additional proof that an unbroken occupation of sites was indeed the rule throughout Japan; the cultural strata and the generations they represent are so intermingled that stratigraphy is often in a state of complete disorder.

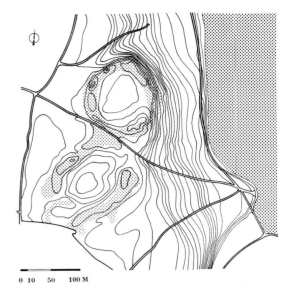

0 10 50 100 M

552 KASORI. CONTOUR MAP OF DOUBLE HORSESHOE-
SHAPED KAIZUKA (KITCHEN MIDDEN OF SHELLS)
(drawing by Giroux, after Sugihara Chōsuke)

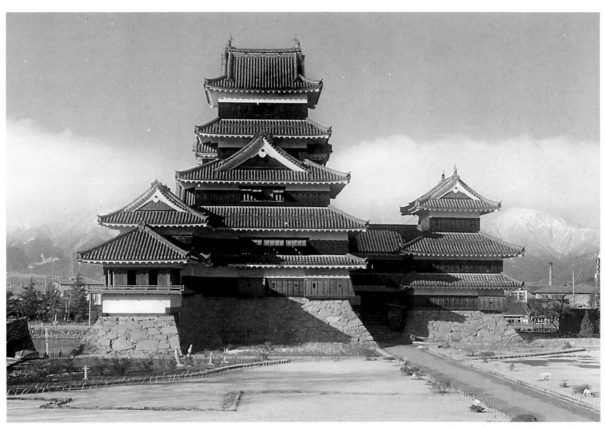

553 MATSUMOTO. MATSUMOTO CASTLE

MATSUMOTO (Nagano Prefecture) 松本

Matsumoto was known as Fukashi when it was the capital of Shinano Province (Nagano Prefecture). In 1504, Shimadate Sadanaga, a vassal (*kerai*) of the Ogasawara family that governed the province, built the castle that still stands in a park in modern Matsumoto. The structure we see today, built in the latter part of the 16th century, consists of the five-story central tower west of the enclosing wall, and the second, smaller tower that guards its northern flank. A central courtyard separates the two donjons, and a double wall shields the south side of the castle. The entire complex, built on level ground in a valley ringed with mountains, is surrounded by the customary deep moats.

White plaster coats the upper part of each story; the part below is sheathed in black-painted wood panels that help the structure withstand the snowfalls of the region's harsh winters and give the castle walls their distinctive pattern of alternating bands of white and black (fig. 39).

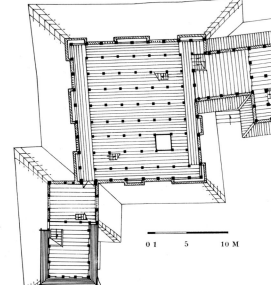

554 MATSUMOTO. PLAN OF CASTLE
(drawing by Giroux, after Kokuho)

The fortress witnessed a turbulent era in Japanese history and had ample opportunity to prove its worth as a military stronghold. In 1582, Fukashi Castle passed to Toyotomi Hideyoshi (1536–1598), and the vassal he established there, Ishikawa Kazumasa, in 1594 built the central tower that is the finest element of the fortress.

During the Tokugawa period, the castle was occupied by its former masters, the Ogasawara (1613), then by the Toda (1617), the Matsudaira (1663), the Hotta (1638), and the Mizuno (1642) before reverting to the Toda (1725), who made it their residence until 1868.

NAGOYA (Aichi Prefecture) 名古屋

"In the fortress town of Nagoya, in Owari province, canals were dug for small craft. These excavations had been imposed as forced labor on the people of Ise, in Mino province. Everyone whose income equaled a thousand *koku* of rice was required to send a laborer." (*History of Taitokuin*, posthumous name of Tokugawa Hidetada [1579–1632], second Tokugawa shōgun.)

Chroniclers in the 17th century speak of Nagoya as a fortress town, and with good reason: a city had mushroomed around the 16th-century citadels, and it was to grow into the drab, sprawling metropolis that now stretches all the way to Ise Bay. Located midway between Tokyo and Kyoto, modern Nagoya is the third largest city in Japan.

The first Nagoya Castle was built about 1525 by the governor of the province, Shiba Yoshimune. Not long after its completion, the fortress, which Shiba Yoshimune had entrusted to his son-in-law Imagawa Ujitoyo, was taken (1532) by Ōda Nobuhide (died 1549). However, Nobuhide decided to move from Nagoya to nearby Kiyosu Castle, also in Owari Province, and Nagoya was soon abandoned (fig. 555). The city's rebirth began in 1610, when Tokugawa Ieyasu (1542–1616) granted Owari Province as a fief to his seventh son Yoshinao (1600–1650) and forced all the *daimyō* to contribute to the construction of a splendid castle. Yoshinao's descendants (the Owari branch of the Tokugawa family) resided there until 1868.

Situated in the northeastern part of the city, Nagoya Castle consists of a five-story central tower crowned with two golden dolphins. An unusual adventure befell one of the dolphins in 1873: sent to Europe for the Vienna Exposition of 1872, the ship transporting it back to Japan was lost off Izu Peninsula, but the dolphin was found in the water six months later.

This accident may have foreshadowed the tragic fate which awaited the castle of the Tokugawa. Travelers marveled at one of the best-preserved fortresses in Japan until it was completely destroyed during a bombing raid on May 14, 1945. Rebuilt in 1959 (fig. 8), it was crowned once again with two golden dolphins that symbolize the resurgence of postwar Japan.

555 NAGOYA. RUINS OF 16TH-CENTURY CENTRAL TOWER

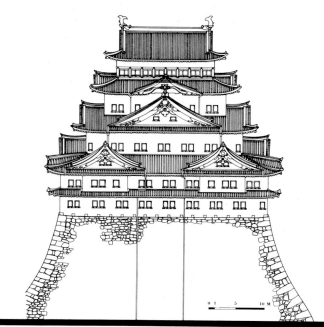

556 NAGOYA. ELEVATION OF NAGOYA CASTLE (1612)
(drawing by Giroux, after Hirai Satoru)

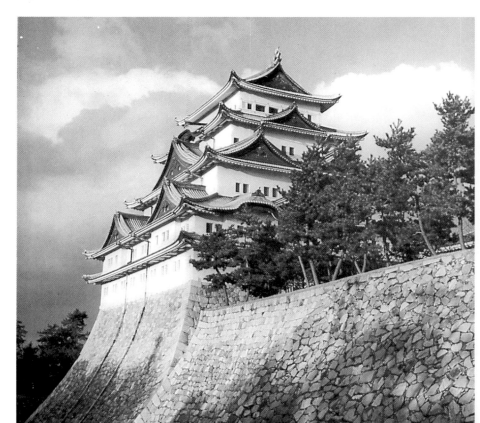

557 NAGOYA. NAGOYA CASTLE
(RECONSTRUCTED 1959)

NIKKŌ (Tochigi Prefecture) 日光

The Tokugawa mausoleums at Nikkō, in Shimotsuke Province (Tochigi Prefecture), are justly renowned for their opulent decoration. Their forest setting, one of the loveliest in all Japan, is equally marvelous: mountains, cliffs, lakes, untamed waterfalls, towering cryptomeria trees half-shrouded in mist—everything about the region creates an aura of legend.

In 766, a priest named Shōdō-shōnin (735–817) chose this site for a temple that Tachinaba Toshitō, governor of the province, rebuilt and enlarged in 808. Some fifteen years later (820), Kūkai (posthumous name, Kōbō Daishi: 774–835), who founded the Shingon sect of esoteric Buddhism, visited the site and changed its name to Nikkō ("daylight" or "sunlight"). Thirty years later, Jikaku Daishi (794–864), a celebrated master of the Tendai sect, was so taken with Nikkō that he erected three large temples and thirty-six smaller ones. Over the centuries, emperors and shōguns alike bestowed property grants on the temples, which by the early 13th century possessed no fewer than seventy villages.

However, the Momoyama dictators had as a prime objective the prevention of the monasteries from becoming a state within a state, and the monks of Nikkō felt the full brunt of this authority. In 1590, Toyotomi Hideyoshi (1536–1598) confiscated their domains and left them only a single village and nine temples. Other structures were demolished or transported elsewhere.

Prosperity, however, soon returned to Nikkō, and in 1617 the body of Tokugawa Ieyasu (1542–1616), first buried at Mt. Kunō, near Shizuoka, was transferred to Nikkō, where a temple was built to receive his remains. It was rebuilt in 1634–36 on a much larger scale. Set amid trees especially planted for the occasion, the splendid monument arose that we see today (fig. 38). In 1645, Ieyasu's tomb was designated an official pilgrimage site: Emperor Go-kōmyō (r. 1643–1654) not only decreed that an imperial messenger should bring an annual offering to the tomb, but he conferred on Ieyasu the pompous posthumous title of Tōshō-daigongen, or "Incarnation of Bodhisattva Illuminating the East." In Daiyūin, another temple built expressly as a Tokugawa mausoleum, the shōgun Iemitsu (d. 1651) was laid to rest; in 1654, no less a personage than the grandson of Iemitsu, upon becoming a master of the Tendai sect, took up residence at the old Buddhist temple, thereafter known as Rinnōji, that has since always had a prince of the blood as its head. In 1868, the entire domain revert-

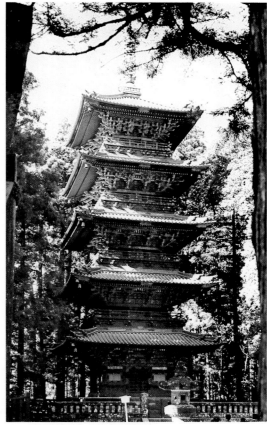

558 NIKKŌ. TŌSHŌGŪ. PAGODA (1636)

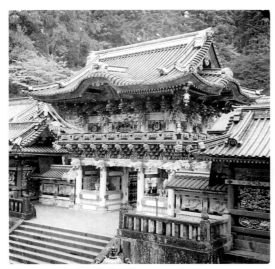

559 NIKKŌ. TŌSHŌGŪ. YŌMEI-MON (PORTAL OF SUNLIGHT)

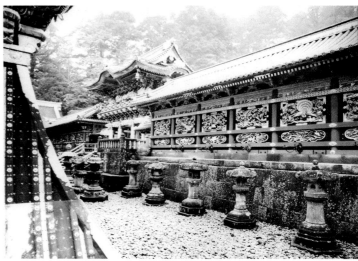

560 NIKKŌ. TŌSHŌGŪ. ENCLOSING WALL

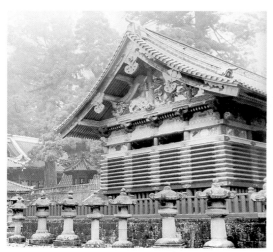

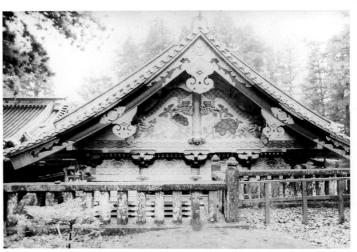

561 NIKKŌ. TŌSHŌGŪ. ARCHITECTURAL DETAILS

509

ed to the emperor: the temple of Ieyasu (Tōshōgū) became a Shinto shrine, the temple of Iemitsu remaining Buddhist.

Pilgrims flock to Nikkō to this day, to pray before the mausoleums of Japan's former masters or to marvel at the astounding monuments, whose traditional design is laden with decoration in high relief and covered with gaudy colors and generous amounts of gold leaf. There can be no doubt that Kanō Tanyū (1602–1674), Kanō Yasunobu (1616–1685), and other eminent artists of the time worked on the decoration of Nikkō interiors in the Chinese style so dear to the Tokugawa, which also typifies Edo art in general. At times, architectural lines seem lost amid a Baroque profusion of carving reminiscent of the Chinese Ming and Qing styles. This almost excessive lavishness is a departure from the tendency in Japan to subordinate even the most deliberate ostentation to an overall rhythm or larger concept of the whole design (fig. 30).

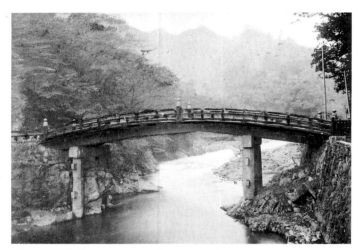

562 NIKKŌ. PLAN OF TŌSHŌGŪ
(drawing after Kokuhō)

563 NIKKŌ. "SACRED BRIDGE" OF NIKKŌ (PHOTOGRAPHED BEFORE 1868)

SEKIGAHARA (Gifu Prefecture) 關 ガ 原

One of the three principal barrier gates of Japan (*sekisho*, "gate"; *sankan*, "three gates") once stood on a plain near Sekigahara, a village in Mino Province (modern Gifu Prefecture). At these frontier checkpoints travelers were required to state the reasons for their crossing from one region to another. Originally, the gates enabled government officials, and later, feudal lords, to monitor all movement through their realms and collect taxes from travelers for the privilege of passing through. The shōguns' policy was two-fold: to remove the numerous small checkpoints that impeded trade, and to retain the gates on dividing lines between major geographical areas, thereby ensuring surveillance over movement from one end of the empire to the other.

The main gate erected in 702 at Suzuka, in Ise Province (Mie Prefecture) marked the limits of Iga and Ōmi provinces (Mie and Shiga prefectures), thus safeguarding the capital. A third gate at Arachi (Echizen Province, modern Fukui Prefecture) straddled the road to regions bordering the Sea of Japan.

The gate at Sekigahara was located in the Chūbū region, between Kantō and the capital, Kyoto. There, on October 21, 1600, more than 150,000 men took part in the battle that is considered the most crucial in Japanese history. The complete triumph of the Tokugawa over the supporters of the Toyotomi family ushered in the heyday of the Tokugawa shogunate, which, for all its miscalculations, eventually managed to turn 19th-century Japan into the only Far Eastern power capable of understanding and bridging the gap that for so long had put them at the mercy of the industrialized nations of the West.

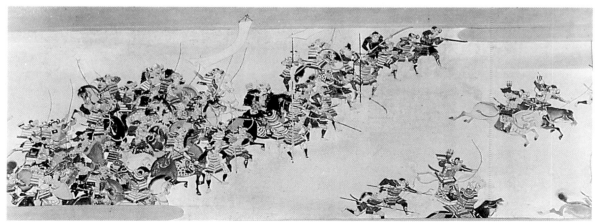

564 THE BATTLE OF SEKIGAHARA (1600) AS DEPICTED IN TŌSHŌ DAIGONGEN ENGI, SCROLL PAINTING (1639)

SHŌRINZAN (Shizuoka Prefecture) 松林山

The *zempōkoen*, or "keyhole" burial mound of Shōrinzan, near Iwata, stands on an alluvial embankment; the square end faces southeast, the round section projects over the low-lying area stretching toward the west. The tumulus has a total length of 116 meters, but a section of the square end was damaged during the construction of the Tōkaidō Railway. The round section contains a burial vault in the shape of a long corridor on a north–south axis (7.9 meters long, 1.3 meters wide, 1.6 meters deep). Excavations in 1931 uncovered a rich store of tomb furnishings that bear some resemblance to comparable objects from regions along the eastern Inland Sea: four exceptionally beautiful mirrors, pearls, *magatama* (comma-shaped stone beads), a set of armor complete with breastplate, long sword and dagger, and bronze and iron arrowheads.

Although the burial mound at Shōrinzan is but one of many *kofun*, or tumuli, scattered throughout the Iwata region, the objects discovered in the tomb suggest that it is the earliest and that other tumuli were gradually built around it.

565 SHŌRINZAN. CONTOUR MAP OF
BURIAL MOUND, 5TH (?) CENTURY A.D.
(drawing by Giroux, after Kobayashi Ikuo)

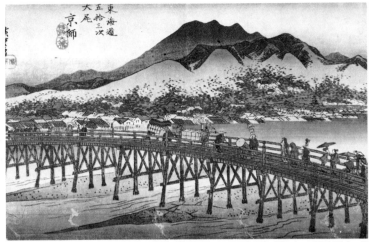

TŌKAIDŌ
東海道

566 TŌKAIDŌ. UTAGAWA HIROSHIGE (1797–1858): APPROACH TO
KYOTO, FROM FIFTY-THREE STATIONS ON THE TŌKAIDŌ HIGHWAY.
COLORED WOODCUT. EDO, 1833

Tōkaidō (literally, "region of the eastern ocean") was originally the name of one of the seven great regions into which Japan was subdivided. Beginning with the Early Heian period, the area east of Kyoto included, from north to south: Hokurikudō ("northern region"); Tōsandō ("region of the eastern mountains"); and Tōkaidō. West of the capital lay Sanyōdō ("exposed region of the mountains"), Sanindō ("land in the shade of the mountains"), Nankaidō, or present-day Shikoku ("region of the southern ocean"), and Saikaidō, or present-day Kyūshū ("region of the western ocean").

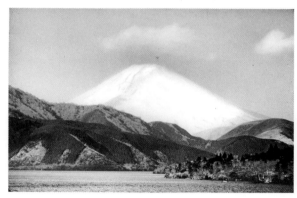

567 TŌKAIDŌ. MOUNT FUJI

Tōkaidō extended southward from the southernmost Abukuma Mountains to the Suzuka Mountains in Ise Province, and included fifteen provinces in all: Iga, Ise, Shima, Owari, Mikawa, Tōtōmi, Suruga, Kai, Izu, Sagami, Musashi, Awa, Kazusa, Shimosa, and Hitachi.

During the Edo period, "Tōkaidō" was also the name of the road along the southeast coast of Honshū which linked Edo, the administrative hub of Japan, with Kyoto, where the emperor resided. Actually, the Tokugawa built no fewer than five great highways, all converging on the Nihonbashi, or Bridge of Japan, in the heart of Edo. Thus Japan was covered by a network of government roads that *daimyō* had to use during their constant journeys between the capital and their provincial domains. In addition to the Tōkaidō Highway, there was the Nakasendō (or Kisokaidō), the mountain route between Edo and Kyoto; the Nikkōkaidō leading to Nikkō, site of the Tokugawa mausoleums; the Kōshūkaidō connecting Edo with the shōgun's personal domain, Kōfu (Yamanashi Prefecture); and the Ōshūkaidō northward to Aomori, the seat of modern Aomori Prefecture. Although a road system had existed in the Kansai region as far back as Heian times, the mountainous terrain limited road construction to two major arteries north and south of the Chūgoku range.

568 THE TŌKAIDŌ HIGHWAY LINKING EDO (A) AND
KYOTO (B), ONE OF JAPAN'S FIVE MAJOR ARTERIES
(drawing by Giroux, after Danielle Elisseeff)

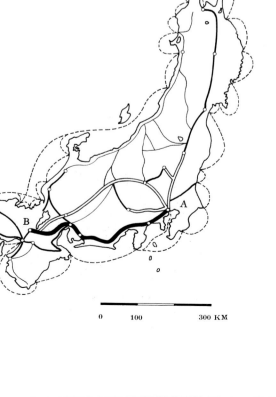

0 100 300 KM

569 THE TŌKAIDŌ HIGHWAY TODAY

At the start of the Edo period, it was only natural that the roads linking Kyoto to the Kantō region should take on added importance, and Tokugawa Ieyasu (1542–1616) completely restructured Japan's highway system in 1601. Ieyasu learned through his advisors that the Tang emperor Teh-Tsung (779–805) had established fifty-three stations along China's trunk roads, stops mentioned by writers and poets during the Northern Song dynasty (960–1125). True to the Sinophile tastes of the Tokugawa family, Ieyasu ordered the installation of fifty-three stations along the 514 kilometers separating the Nihonbashi (Bridge of Japan) in Edo from the Gosanjō-no-Ōhashi (Great Bridge of the Third Avenue) in Kyoto. Tolls, distances between stations, and the number of pack or saddle horses allowed on the road were determined by the government, and reciprocal recognition between the union of palanquin-bearers and owners of horses for hire.

This system fostered "tourist" activity and also proved a boon to police surveillance: passports or papers could be checked at the tollgates at Hakone (station 10) in Sagami Province (Kanagawa Prefecture), and at Arai (station 31) in what is now Shizuoka Prefecture. A number of guilds of merchants and financiers employed their own messengers, famed for their speed, to relay information about accounts and other news from home offices in Osaka and Kyoto to branches in Edo.

These roads brought together people from every walk of life, from crown princes to the lowliest employees, in a patchwork world which soon inspired writers and illustrators. Of the latter, the most gifted and deservedly famous is Utagawa Hiroshige (1797–1858), whose *Fifty-three Stations on the Tōkaidō Highway (Tōkaidō gojūsan tsugi)* was published in separate prints in 1833.

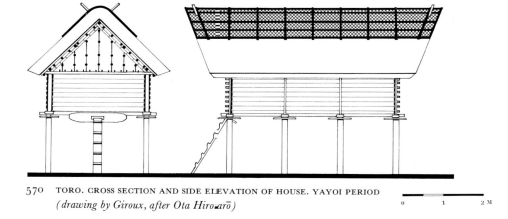

570 TORO. CROSS SECTION AND SIDE ELEVATION OF HOUSE. YAYOI PERIOD
(drawing by Giroux, after Ota Hiroarō)

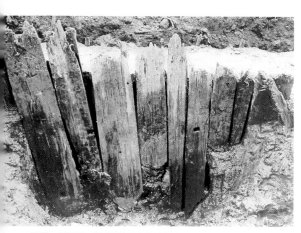

571 TORO. STAKES SUPPORTING
PATHWAY BETWEEN RICE FIELDS

TORO (Shizuoka Prefecture) 登呂

The discovery of this site in 1943 was a rare find: a Yayoi complex (3rd century B.C.–3rd century A.D.) consisting of a village and rice fields that had been buried, and thus preserved, by river deposits.

The village is made up of three storehouses and twelve large, oval houses that range from 7.7 by 6.7 meters to 12.2 by 10.6 meters, one of each short end aligned to face south. To draw conclusions about the reasons for this orientation is problematical, since the location of the door is not known, nor whether these prehistoric Japanese had assimilated Chinese concepts of geographic direction and divination. A straw roof rested on columns, probably with a central opening to let out smoke from the hearth. The barns are smaller, 2.4 by 2.6 meters; they faced the same direction and included five columns, four at the corners and one at the center.

The rice fields extended south of these dwellings in areas ranging from 200 to 720 *tsubo* (roughly 600 to 2200 square meters), with meter-thick dikes bounding the quadrilateral sections. Excavations from 1947 to 1950 revealed an impressive array of farm implements and tools (many of wood) as well as pottery and plant material, data invaluable for our picture of people's life at the time.

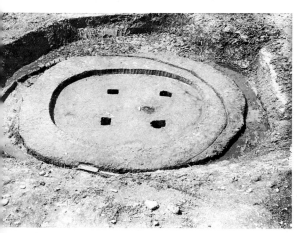

572 TORO. FOUNDATION OF HOUSE

573 TORO.
GENERAL VIEW OF SITE

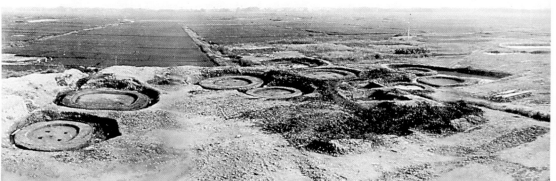

UBAYAMA (Chiba Prefecture) 姥山

Located on the Edo River, which empties into Tokyo Bay east of the Sumida River, the site of Ubayama extends over an alluvial plain of 13,000 square meters, twenty-five meters above sea level. Well-preserved remains from the Jōmon period (2nd millennium–3rd century B.C.) were found here amid a huge *kaizuka*, or kitchen midden of shells. Excavations conducted in 1926 by the University of Tokyo revealed twenty square or rectangular hut foundations and the remains of eleven tombs. The discovery of Ubayama was a major event, the first entire village complex from this era found in Japan. Excavations in 1940, 1948, and 1949 brought the number of tombs to thirty-seven.

Archaeological remains were found in the shell stratum 20 to 160 centimeters thick, and in a thinner underlying layer of black earth ranging from 20 to 90 centimeters thick. This lower level contained pottery from the Middle Jōmon period (c. 1500–100 B.C.), proving that it indeed reflects the earliest cultural level known. The potsherds found in the *kaizuka*, albeit related to similar remains at Kasori and other nearby sites, were later and more original in design.

Archaeologists made a startling discovery in excavating the foundations of the dwellings: one contained the skeletons of five individuals who had not been interred in tombs, and must have been left behind in the house after simultaneously meeting death. What calamity had befallen them? Never before had archaeologists been given the chance to reconstruct life and death in a prehistoric Japanese village with such immediacy. Further study led to the discovery of plant ash, suggesting that all of the dwellings had been destroyed by a large fire. The mystery of Ubayama so intrigued Japanese scholars that, after prodding by foreign colleagues, they decided to try carbon-14 analysis, which placed the conflagration at about 2500 B.C., though criteria for this type of dating can vary from country to country, making its appraisals not fully conclusive. Archaeologists using pottery types as their fundamental "clock" have pushed back the date of occupation of the site to about 1500 B.C. In any event, the discoveries made at Ubayama have played a pivotal role in encouraging Japanese scholars to adopt modern archaeological techniques.

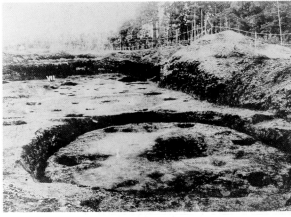

574 UBAYAMA. HUT FOUNDATION
DISCOVERED IN A KAIZUKA
(KITCHEN MIDDEN OF SHELLS)

YOSHIMI HYAKKETSU (Saitama Prefecture) 吉見百穴

Excavated in 1887 by the renowned archaeologist Tsuboi Shōgorō, the site of Yoshimi Hyakketsu consists of a hill in which 207 small burial chambers were carved in the living rock. Each chamber contained two or three coffins, arranged on either side and at the back of the vault. The coffins have disappeared, but the slabs of the approach corridors and at the entrances to the burial vaults are still in place. The many objects recovered at the site include elongated pearls, *magatama* (comma-shaped ornaments), swords, daggers, arrowheads, and Sueh-type pottery.

Tomb clusters of this sort are rare, and none quite like this one is known elsewhere in Japan. In all likelihood, these were tombs of warriors, and this hill must for centuries have been a place of worship, if not of pilgrimage. Ancient tombs abound in the Jōmō region (which includes Saitama Prefecture): round or "keyhole"-type burial mounds (*zempōkoen*) are so numerous here that the surrounding lowlands seem studded with islands of earth. This suggests that in its social structure, the region was probably parceled out into small chiefdoms, not dominated by a single powerful clan. Yoshimi Hyakketsu would appear to repeat in this respect the kind of tomb cluster that dots the lowlands, here shifted to mountainous terrain. But much is still unanswered concerning the identity of the deceased and the underlying religious beliefs associated with this mode of burial.

575 YOSHIMI HYAKKETSU.
ENTRANCES OF TOMBS
CARVED IN HILL

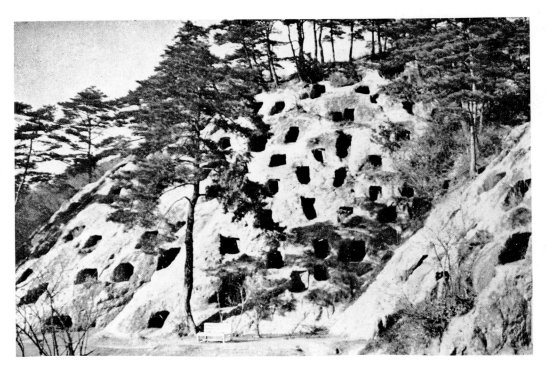

KANSAI

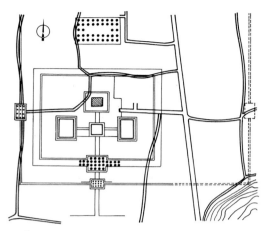

ASUKA (Nara Prefecture) 飛鳥

It is only natural that the Asuka period, a key period in ancient Japanese history, should be named after the undisputed cradle of historical Japan. Although the Asuka period is generally acknowledged to stretch from the traditional date of the introduction of Buddhism, in 559 A.D., to the Taika reform of 645–46, when the foundations of Chinese-style government were laid in Japan, some historians would like to extend the era to the year 710, when the court was relocated to Nara. The most prominent figure of the day was Prince Shōtoku-Taishi (574–622), during whose reign the imperial government asserted its authority over the great clans of Japan (figs. 279, 339–42).

Few places in old Japan are as steeped in history as Asuka, a level area studded in the middle and along the periphery with rounded hillocks. The large number of burial mounds (*kofun*) and the remains of some fifty temples or palaces indicate how active a place was Asuka. In the *Man-yōshū*, the late-8th-century anthology of ancient Japanese poems, every place in the region is listed.

Sushun (r. 587–592) had just become emperor when the Asukadera, still the most impressive and revered building at Asuka, was built in 588. Sushun was to meet a tragic fate, assassinated when his redoubtable minister and champion of the new faith, Soga-no-Umako (d. 626), learned that the emperor had resolved to get rid of him.

The surviving pavilion at Asuka, which houses the oldest bronze statue of Buddha known in Japan (see fig. 198), is but one section of the sprawling complex originally constructed under the supervision of Soga-no-Umako. Additional information about the Asukadera came to light during the excavations which the Bunkazai (Nara section) undertook in 1956 and 1957: archaeologists pinpointed the location of the enclosing wall, the main building, the preaching and reading hall, and the central gateway, structures at the cardinal points around a central relic hall/pagoda.

Construction of the temple was completed in 596. Over a century later, in 719, the Asukadera suffered the fate shared by all of Japan's major temples: it was transferred to Heijōkyō (Nara), and renamed Gangōji. But a devastating fire in 1196 spared only 8th-century buildings, and today the oldest structures of Gangōji date back no further than the Kamakura period.

AZUCHI (Shiga Prefecture) 安土

In 1576, Oda Nobunaga (1534–1582), first of the three great dictators who founded modern Japan, selected the northeastern shore of Lake Biwa, in Ōmi Province (Shiga Prefecture), as the site of a splendid castle. Built in 1576–79 under the supervision of Niwa Nagahide (1535–1585), Azuchi Castle became the prototype of an architectural style designed to fulfill both military and residential needs. In order to withstand the firearms that the Portuguese had recently brought into the country, the newer type of Japanese fortress included a massive cyclopean foundation that supported the buildings proper. The superstructures, however, albeit sturdier than the usual combination of rammed earth and trellis-work, utilized a thick construction of plaster and wood that was highly susceptible to fire. In the final analysis, these fortifications relied most on the channeling of would-be assailants into a bewildering network of pathways that would bring them unsuspectingly within range of the defenders.

The design of Azuchi Castle was copied throughout Japan. Nobunaga summoned the most gifted artists of the day to decorate his seven-story fortress-residence but a few years later, in 1582, it was plundered by Akechi Mitsuhide (1526–1582), who had sworn vengeance against Nobunaga. Besieged by his former lieutenant in the Honnōji temple in Kyoto, the betrayed Nobunaga had no alternative but to commit suicide.

After Nobunaga's death, the devastated castle was occupied for a while by the dictator's grandson and heir, Sambōshi, and by Oda Nobuo (1558–1630), one of Sambōshi's two uncles who acted as regents. But Nobuo's unfortunate decision to side against Tokugawa Ieyasu in 1600 resulted in the confiscation of his property. He abandoned Azuchi Castle and withdrew to Ōsaka. Like so many buildings scarred by the events leading up to the establishment of the Edo regime, the fortress seemed to vanish from the history of Japan.

514

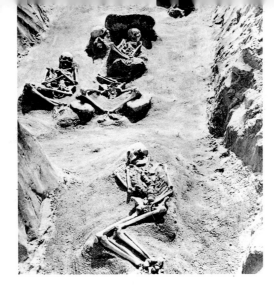

土井ガ浜
DOIGAHAMA
(Yamaguchi Prefecture)

Discovered in 1931 and excavated between 1953 and 1957, this sizable necropolis from the Yayoi period (3rd century B.C.–3rd century A.D.) lies 300 meters from the shoreline and four meters above sea level (based on present geographic conditions).

Here archaeologists found more than two hundred bodies enclosed in stone cists, one to five bodies in each cist and most of the heads facing east. Although the dental mutilations observed in a number of the skeletons are typical of the Jōmon phase (2nd millennium–3rd century B.C.), their relatively tall stature suggests the comparative abundance of food which came with the agricultural growth of Yayoi times.

Apparently the western half of the burial ground contained more women than men, the eastern half, more men than women. The bodies were covered with ocher, a practice commonly found in other Bronze Age civilizations, but the stones placed on their heads or chests have yet to be explained. The treasures interred with the deceased included round or elongated pearls, tiny glass beads, and bracelets and other ornaments made of shell. There were also tools of chipped or polished stone, as well as bulging Early Yayoi vessels (3rd–2nd centuries B.C.) incised with shell or leaf designs. (These pieces belong to the Ongagawa type, indigenous to western Japan.) However, ceramic figures from Middle Yayoi times (1st century B.C.–1st century A.D.) were found in other sections of the cemetery.

The evidence provided by the excavation at Doigahama sheds considerable light on Yayoi burial practices and, more generally, on Japanese society during the Bronze Age. The presence of iron objects and Sueki pottery from the Kofun era (3rd–6th centuries A.D.) suggests that the site was occupied and used as a burial ground for a long period of time, although it is also possible that these more recent objects were left behind by worshipers still drawn to Doigahama long after the bodies had been laid to rest.

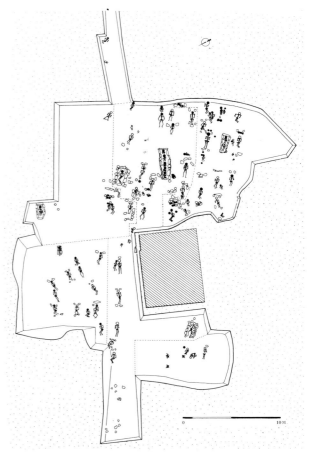

579 DOIGAHAMA. TOMB CLUSTERS
IN NECROPOLIS OF DOIGAHAMA

HIMEJI (Hyōgo Prefecture) 姫路

Himeji Castle, in Harima Province (Hyōgo Prefecture), may well be the most beautiful structure of its kind in Japan (fig. 40). It stands on the site of an older fortress built about the middle of the 14th century by Akamatsu Sadanori, a scion of a venerable aristocratic family from the region. Sadanori had placed it in the care of his vassal, Kodera Yorihide. Feudal wars led to the temporary overthrow of the Akamatsu at the hands of the Yamana (1441), but the star of the Akamatsu rose again, and with it that of the Kodera, who gradually man-

580 HIMEJI. VIEW OF
CENTRAL TOWER

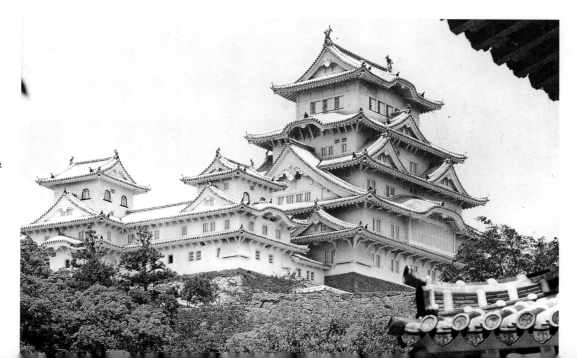

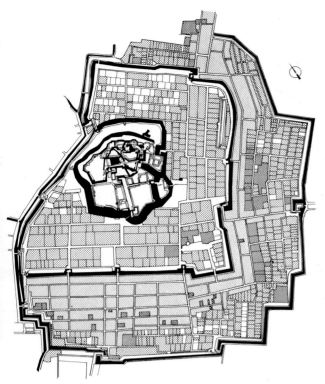

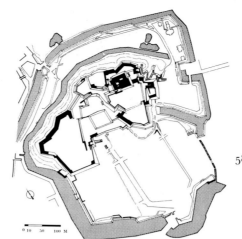

582 HIMEJI. PLAN OF HIMEJI CASTLE
(drawing by Giroux, after Ota Hirotarō)

581 HIMEJI. PLAN OF
CASTLE AND SURROUNDING TOWN
(drawing by Giroux, after Hirai Satoru)

☐ The Castle ▨ Religious Buildings
▨ Vassals' Residences ▨ Artisans and Tradespeople

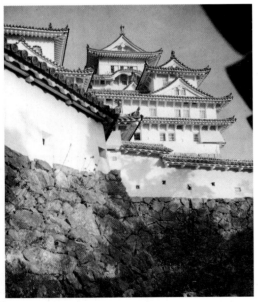

583 HIMEJI. WALLS OF CENTRAL TOWER

aged to become independent. Indeed, the Kodera grew so powerful that Oda Nobunaga (1534–1582), in the latter part of the 16th century, sent Toyotomi Hideyoshi (1536–1598) to subdue them. After taking the castle in 1577, Hideyoshi saw in his victory an opportunity to rebuild the vanquished fortress on a larger scale. It was at this time that Himeji took its place in the defense system of Japan, a system that answered to the powerful central government and was designed to quell strife among local feudal lords.

The three towers of Himeji Castle, which stands slightly to the north of the town that sprang up around it, rest on a massive foundation of cyclopean masonry. Together with the central tower they form a quadripartite donjon that was not completed until the time of Tokugawa Ieyasu (1608 and 1609). Independent units within a single, compact whole, these towers are joined by posterns and a network of small inner courtyards, creating self-contained chambers to halt an advancing enemy. Whatever path the assailants chose, they would find themselves under heavy fire. No two points are connected by a straight line. Every conceivable means, including deception, was brought into play to draw would-be intruders into a cul-de-sac where they could be easily routed. The roof tops the five-story structure, but there are two underground levels to make a total of seven stories within the donjon walls.

The complexity of Himeji's fortifications in no way detracts from its beauty. Situated atop Himeyama, a hill that rises at the center of the surrounding lowlands, the citadel blends the majestic "mountain castle" type of fortification with the "level ground" type designed to repulse aggressors from all directions. The shell-based plaster used to coat its walls inspired people to dub the castle Hakurojō, the "White Heron" perched like a vigilant bird at the edge of the town.

Little by little, the town of Himeji breached the outer enceinte of the fortress and encroached on the residential district of prominent vassals, also used as their headquarters. Just beyond the enclosing wall of the castle proper had lived a multitude of warriors and lesser nobles: the higher their rank, the closer they lived to the central tower. Beyond came the town itself, a hodgepodge of merchants and artisans organized into guilds. Himeji Castle was the nerve center of a densely populated area and a "market" for many different services— weaponry, food, clothing, assorted objects for ceremonial and everyday use—and thus gave rise to the city we see today.

After the battle of Sekigahara (1600), Tokugawa Ieyasu entrusted the castle to one of his sons-in-law, Ikeda Terumasa (1564–1613), who was thereafter known as Matsudaira (a surname bestowed upon a number of families related to the Tokugawa). The fortress and its fief subsequently changed hands several times and were occupied by the Sakakibara (1649–1667), the Honda (1684), and the Sakai, who resided in the castle from 1749 until the demise of the shogunate in 1868. But as the calm of the Tokugawa era settled over Japan, life within the fortified towers must have seemed increasingly uncomfortable. A residence was added at the base of the central tower, followed by another at the foot of the hill. These more agreeable quarters were protected, in turn, by a fortified wall studded with bastions. The result was the intricate structure that today towers above the surrounding pines and cherry trees. The combination of foliage and architectural elegance creates the appearance of a prestigious, but peaceful residence, though the walls of Himeji Castle still echo with the memory of knightly exploits. To the southeast of the central tower stands the *harakiri-maru*, the pavilion where *samurai* committed suicide by *seppuku*, or thrusting a sword into the abdomen.

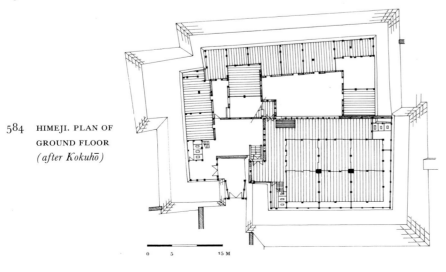

584 HIMEJI. PLAN OF
GROUND FLOOR
(after Kokuhō)

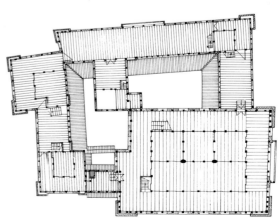

585 HIMEJI. PLAN OF SECOND FLOOR
(after Kokuhō)

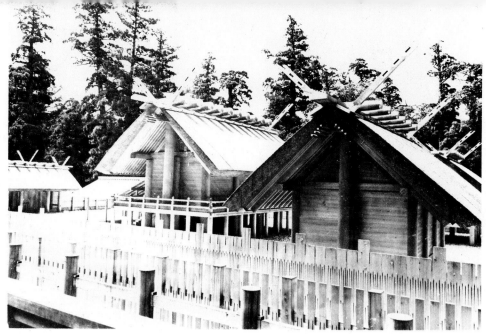
586　ISE. THE NAIKŪ

ISE (Mie Prefecture) 伊 勢

In ancient times, Ise was the name of a province that is known today as Mie Prefecture. But its Shinto shrines, among the oldest anywhere in Japan (5th–6th century?), were considered so sacred—or gained such prominence as emperor worship took root under the Tokugawa—that today "Ise" evokes more than just a geographical area—the very name conjures up the mystery that is old Japan. The sea, the beautiful cedar and cryptomeria groves, the superb pearls (symbols of purity and perfection) and other astounding riches to be found on these shores—everything heightens the aura of magic which envelops the region.

The most revered place at Ise is the Naikū ("inner shrine"), dedicated to the Shinto sun goddess Amaterasu-ō-mikami, wellspring of life and, according to Japanese mythology, ancestor of the imperial line. This rectangular wood-and-thatch building, resting on piles reminiscent of the Bronze Age dwellings of the Yayoi period (3rd century B.C.–3rd century A.D.), is entered through a door on one of the long sides. Here is kept one of the three "jewels" or emblems of imperial authority: the mirror of Amaterasu.

The world was plunged into darkness, the legend goes, when the sun goddess withdrew into a cave. To entice her from her hiding place, the gods attempted to excite her curiosity; no sooner had she emerged from the cave than she saw herself in the mirror, and thus her light was restored to the archipelago: the myth goes on to tell how Amaterasu handed the mirror to her grandson Ninigi when he set out to recapture Izumo, which had fallen into the hands of the goddess's tempestuous brother, Susano-o. In ancient times the mirror was customarily kept in the imperial palace, but it was soon feared that contact with mortals might profane the sacred talisman. Consequently, it was removed far from the Court, first to Kasanui (Yamato), a village near Nara (where, tradition has it, it remained for eighty-eight years), then to its final resting place in Ise.

Whether or not the mirror at Ise is actually the mirror of Amaterasu, there is still the question of its age. The earliest mirrors, probably brought in from the Yueh region of China (mouth of the Yangtze River), must have appeared in Japan around the 6th century B.C. Verifiable evidence of the use of mirrors dates back as far as the 3rd century B.C., that is, well before Japan had become an empire and entered the historical era. But the spirit of the matter counts more in this case than does the letter, the symbol more than the object; since ancient times, bronze mirrors are known to have played an important role in Far Eastern civilizations—in Japan even more than in China—a role perhaps rooted in shamanistic rituals.

All wooden structures are by nature perishable and easily demolished, and those at Ise, in keeping with a time-honored Shinto custom, are pulled down and rebuilt every twenty years. The two precincts ("east" and "west"), used alternately and covered with white pebbles, are especially arranged for this purpose; the most recent reconstruction took place in 1974, following that of 1954. Thus, life at Ise is punctuated by a rhythm of presence and absence, a rhythm that recalls the Chinese notion of the yin-yang cycle. This comes as no surprise, for Shintoism absorbed a number of concepts from ancient China, some Confucian in origin.

A *torii*, or gateway, marks the symbolic boundary of the Naikū. About seven kilometers away, nestled in a lovely cedar forest, lies the Gekū, or outer shrine. It is dedicated to Toyouke-ō-mikami, goddess of farms, crops, and silkworm breeding; like the inner shrine, two precincts of the Gekū are reconstructed alternately every twenty years.

Both shrines include several buildings of a less sacred or utilitarian nature that are open to pilgrims and visitors. To reach the holy precinct one must pass through a certain number of enclosures; only the emperor or his delegated representatives may pass through the four nearest the shrine.

As the focus of intense religious activity entirely devoted to venerating the indigenous gods of Japan, rather than the alien deities of Buddhism, the shrines at Ise inspired a superb scroll painting in the late 13th century, the *Shinmeishō-e Uta-awase Emaki*, or "Scroll of the Poetry Competition, Illustrated with New Celebrated Sites." In 1295, the priests attached to the Naikū, together with a few Buddhist patriarchs, selected ten sites near the Naikū as subjects for a poetry competition. The poems were transcribed onto a scroll and combined with illustrations to form a captivating synthesis of literature and painting. Of the several scrolls that originally

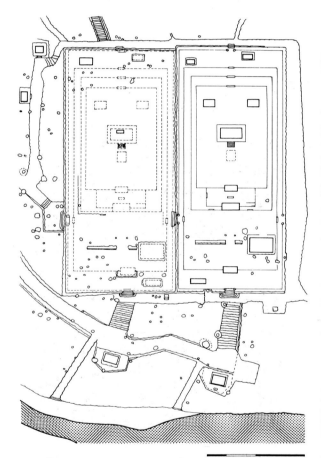
587　ISE. PLAN OF THE NAIKŪ　　0　10　　　　50 M
(drawing by Giroux, after Ota Hirotarō)

517

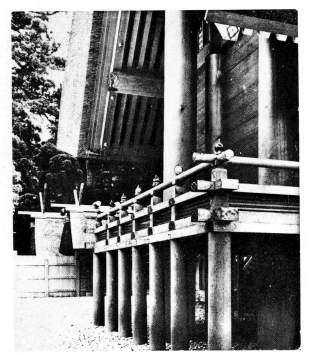

589 ISHIBUTAI. BURIAL VAULT

comprised the work, only one has survived, unique in its focus on landscape, a subject usually reserved in that era for screens, sliding doors, wooden panels, and other interior surfaces deemed suitable for decoration. Its delicate draftsmanship and soft colored washes capture in painting the mood of court literature at the time.

Ise was also a place where the public at large came to worship, and as such it earned a place in popular fiction. Like all places of pilgrimage, Ise, for all its grandeur, fell victim to an uncanny proliferation of vendors. This inspired Ihara Saikaku (1642–1693), renowned creator of the modern, "middle-class" novel in Japan, to write a brilliant description whose message is as universal as its wit is caustic:

"Honest dealing among men is a tradition which originated in Ise, the province of the gods. Besides the two main shrines at Ise, of course, there are one hundred and twenty flimsy-looking side-shrines, each of which displays a picture of its god on a paper poster. These shrines are not in the best of taste, perhaps, but in the hearts of the deities themselves, as in their crystal mirrors, there is no trace of deceit. In the attendants' hearts too there is nothing but innocence and purity; and it is in this knowledge that people from every quarter of our Land of Autumn Harvests make the pilgrimage to Ise. But who, one wonders, was the petty-minded genius who started the custom of 'pigeons' eyes,' those curious lead *zeni* which are sold to pilgrims, sixty on a 'hundred string,' as offering money on their tour? What stingy creatures men are! The wealthy gods of luck would laugh outright at such an offering.

"The business done at this place, I need hardly say, is a roaring one. Contributions flow in without a moment's pause: mountains of gold and silver for ritual dances, thousands of dozens of momme for answers to prayers. Souvenir dealers, making their livings by selling toy whistles, sea-shell spoons, and edible seaweed, are as countless as the grains of sand on the seashore. Besides this, the lesser pilgrim-agents, men without private scribes, pay a zeni a copy to anyone who will write out the routine New Year messages they must carry round to their patrons in the provinces, and there are hundreds of people who support wives and families throughout the year by this alone.

"No one fails to get a living of some sort here. Salesmanship by courting the customer is the specialty of the people of Ise province. Even the female beggars along the Ai-no-yama road [between the Naikū and the Gekū] are patient practitioners of this art, and by making eyes at every passing pilgrim they never go cold or hungry. Dressed in gay silks, strumming samisens in time with their neighbour, they sing their one and only song—'Oh, how sad to be single!' No one has ever heard them sing a new one, and the three-mile road from the outer to the inner shrine would lose its special flavour if they did." ("Showers of Zeni," in *The Japanese Family Storehouse*, Book IV, 3, translated by G.W. Sargent

588 ISE. THE NAIKŪ (DETAIL)

ISHIBUTAI (Nara Prefecture) 石舞臺

The tomb at Ishibutai, remarkable for its fine cyclopean masonry, was first excavated in 1933 by the eminent archaeologist Hamada Kōsaku. The burial chamber, roughly rectangular in shape, measures 7.7 by 3.5 meters inside, and 4.7 meters from the floor to the top of the vault. The access corridor is 11 meters long and 2.5 meters wide. The entire stone structure was covered over with a square mound measuring 51 meters on each side, then surrounded by a ditch 80 meters long that varies in depth from 5.5 to 8.2 meters. Work begun in 1954 has been aimed at restoring the original grandeur of the site, obliterated over the centuries by wild grass and slowly shifting earth.

The tomb is believed to have held the remains of Soga-no-Umako (d. 626), the irascible prime minister and aggressive champion of Buddhism, who had no qualms about having Emperor Sushun assassinated in 592, but who also helped Empress Suiko (r. 592–628) ascend the throne; he had a decisive voice during the regency of Shōtoku (574–622). Nothing either confirms or discredits this hypothesis, and perhaps it was only an ancient rumor. People must have felt that only a distinguished and memorable figure could be laid to rest in so imposing a tomb, but this is altogether uncertain.

590 ISHIBUTAI. GENERAL VIEW OF
REMAINS OF BURIAL MOUND

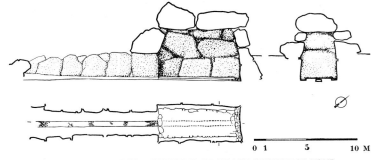

591 ISHIBUTAI. PLAN AND SECTION OF TOMB
(*after Sekaikōkogaku Taikei*)

ISHIYAMA (Mie Prefecture) 石 山

The builders of this *zempōkoen*, or "keyhole" grave mound, made ingenious use of a natural rise known as Ishiyama ("stone mountain") from its rocky appearance. The tumulus (total length: 120 meters) is noteworthy for the three rows of *haniwa* which were set in the ground to strengthen the tomb's earth embankments. Although many of them were nothing more than utilitarian cylinders of terracotta, the tops of the *haniwa* in the upper part of the round section were decorated with the houses and other figures that, still rustic and naïve, are the earliest masterworks of Japanese sculpture.

It was customary for the burial vault to occupy the round part of a keyhole tomb, and this one is no exception. What is so intriguing at Ishiyama is the fact that the three wooden coffins inside the vault were carefully enveloped in clay. Each coffin consisted of a hollow tree trunk in which the deceased and certain offerings were laid to rest. The wealth of furnishings discovered both inside and outside the coffins included sets of fighting gear complete with armor, swords, and arrowheads; pearls; stones in the shape of wheels and plowshares; and mirrors. On the basis of these objects and the overall design of the tomb, the archaeologist Kobayashi Yukio, who excavated Ishiyama between 1948 and 1951, dated it in the second half of the 4th century A.D.

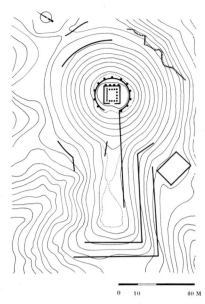

592 ISHIYAMA. CONTOUR MAP OF BURIAL MOUND *(drawing by Giroux, after Mizuno S. and Kobayashi Y.)*

593 ISHIYAMA. HANIWA PLACED ALONG EDGE OF THE MOUND

ITSUKUSHIMA (Miyajima, Hiroshima Prefecture) 嚴 嶋

Built on piles to keep it above the placid waters of the Inland Sea at high tide, the island shrine of Itsukushima is a marvelous blend of architecture and natural setting. Long considered one of the three scenic wonders of Japan (*Nihon Sankei*), it is also famous for having been dedicated to the three daughters of Susano-o and constructed by the most distinguished member of the Taira family, Taira-no-Kiyomori (1118–1181), who died after an unsuccessful attempt to defeat Minamoto-no-Yoritomo (1147–1199), first shōgun and founder of the *bakufu* at Kamakura.

As is often seen in countries having an ancient cultural tradition, the new shrine was founded on a spot long hallowed by religious beliefs. Shintoism's oldest and most revered sites—such as Okinoshima and Izumo, although the latter is now landlocked—were located on tiny, mountainous islands, far enough from the coast and sufficiently mist-covered to convey the mystery of nature, yet close enough to be the focus of regular worship. The idea of choosing rugged islands of this sort, so ill-suited to construction, as the sites for architectural

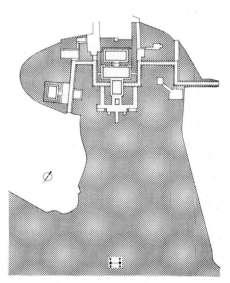

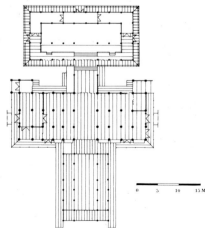

594 ITSUKUSHIMA. LOCATION OF BUILDINGS IN BAY AND PLAN OF MAIN BUILDING *(drawings by Giroux, after Kokuhō)*

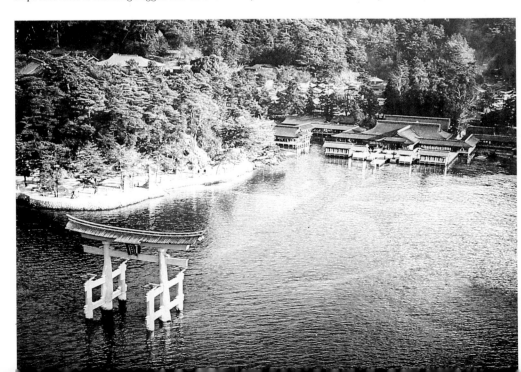

595 ITSUKUSHIMA. AERIAL VIEW

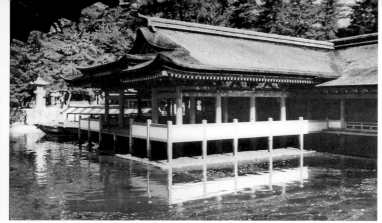

596 ITSUKUSHIMA. A SIDE PAVILION AT HIGH TIDE

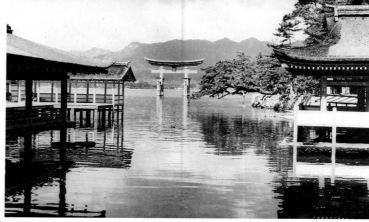

597 ITSUKUSHIMA. SHRINE AT HIGH TIDE

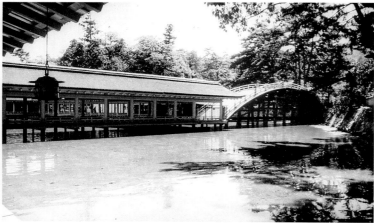

598 ITSUKUSHIMA. VERANDA CORRIDORS AND BRIDGE AT HIGH TIDE

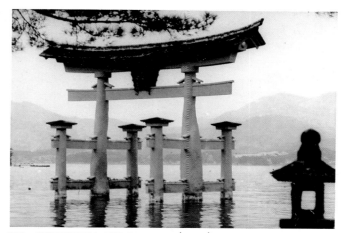

599 ITSUKUSHIMA. THE GATEWAY (TORII) AT HIGH TIDE

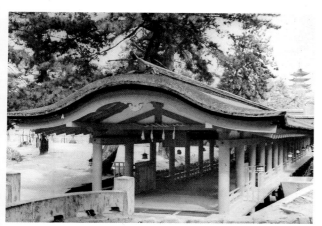

600 ITSUKUSHIMA. VERANDA CORRIDOR AT LOW TIDE

complexes apparently did not crystallize until the end of the Heian period. Several such buildings date from this time, including an island palace reportedly built for court use in 1168 for the *kannushi* (head of a Shinto shrine) Saeki Kagehiro.

Actually, the concept had already been worked out by Fujiwara Yoshimori, *kokushi* (governor) of Aki Province (now Hiroshima Prefecture). Taira-no-Kiyomori, who was appointed *kokushi* of Aki in 1146, doubtless admired his predecessor's initiative, and construction at Itsukushima probably began shortly after he assumed his post as provincial governor.

The original shrine was not destined to survive. Ravaged by fire in 1207, it was rebuilt in 1215 only to burn again in 1223. Although reconstruction began immediately, the main building was not completed until 1241, and the rest of the complex remained unfinished. Fire has not since damaged Itsukushima, and the buildings have been kept in good repair.

In 1569, Mōri Motonari (1497–1571), known as the "master of ten provinces" (*jūkoku no taishū*), redesigned and reinforced the foundation of the main building against signs of structural weakness. Mōri Motonari, the most powerful feudal lord of his time, earned a place in Japanese history by assuming the expenses incurred by the coronation of Emperor Ogimachi (r. 1557–1586), who could not be crowned for two years for lack of funds to finance the ceremony. Records kept at Itsukushima tell us that within two years the entire complex was restored; the workers at the time took such pains to preserve the spirit of the Heian original that today we do not see the improvements they made on the beautiful Heian work.

IZUMO (Shimane Prefecture) 出雲

Originally built on an island just off the coast, the great temple (Oyashiro) of Izumo, the province "whence emerge the clouds," is in what is now Shimane Prefecture. Deposits flowing from the nearby Hii River into the ocean have gradually filled the narrows once separating the holy site from the shores of Honshū, and today Izumo is landlocked. Facing the China Sea and Korea, Izumo hallows the northern, "far" side of the archipelago, which, legend has it, was ruled by the mighty Susano-o, the unruly brother of the sun goddess Amaterasu. It was his progeny whom Ninigi had to vanquish in order to unite and bring peace to the fledgling empire of Japan.

The archaeologist who notes the proximity of the mainland will also realize that more than religion is at work here: he will sense the survival of an age-old power on the fringes of the ancient Yamato state, which, in the end, was destroyed by its own vigor.

Notwithstanding its mountains and secluded valleys, its fertile river lowlands and wealth of creeks teem-

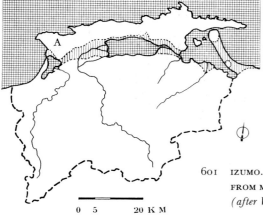

601 IZUMO. THE SHRINE OF IZUMO (A), ONCE CUT OFF
FROM MAINLAND BY WATER (SHADED AREA)
(*after Watanabe Yasutada*)

0 5 20 K M

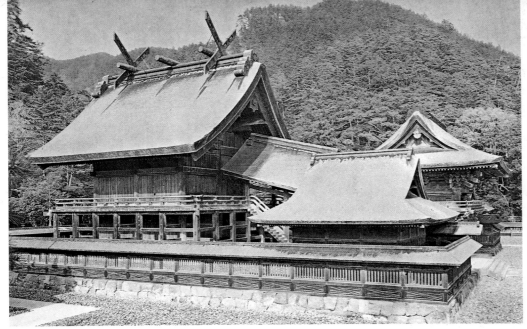

602 IZUMO. GENERAL VIEW OF SHRINE

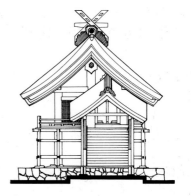

ing with fish, the province of Izumo is cut off from the rest of Japan by formidable mountain chains that make it a "fringe area" and isolate it from the main highways running along the southern coast of Honshū, from what is now Tokyo down to Kyūshū.

Built, like Ise, in a style typical of Bronze Age architecture (Yayoi period, 3rd century B.C.–3rd century A.D.), the Shinto shrine at Izumo, the oldest in Japan, is dedicated to Ōkuninushi-no-kami, a descendant of Susano-o. The origins of what people today call Izumo Oyashiro, or the Great Shrine of Izumo, are lost in mists of legend. When Emperor Ninigi, grandson of Amaterasu, came to bring the country under his sway, Ōkuninushi consulted his two sons. One consented to waive his rights, the other refused to submit and was slain. Faced with this situation, Ōkuninushi withdrew to Kizuki, where Ninigi had a residence built for him.

Like all myths dealing with the imperial family, this one is occasionally "adjusted" for the sake of timeliness and political expediency. Today people tend to regard Ōkuninushi as a figure who, by wisely relinquishing his authority, cleared the way for a peaceful, unified nation, but earlier popular religious belief held that he was the god of work, marriage, and fortune. He is also thought to have taught the Japanese about medicine, silkworm breeding, and fishing.

The style of the Izumo shrines is similar to that at Ise. The door, asymmetrically located on the short side of a rectangular building, is approached up a majestic stairway supported on piles. Inside, the shrine is divided by a partition running parallel with the wall of the door; outside, a balcony surrounds the entire structure. The buildings we see today are modest compared with the colossal size of the original shrine. According to a 10th-century text, the main temple was then the largest in Japan, even larger than the structure built for the Great Buddha of Tōdaiji at Nara. However, it collapsed no fewer than seven times in the 11th and 13th centuries, perhaps from its excessive size. In 1248, it was rebuilt on a smaller scale and it continued to shrink in successive rebuildings until the reconstructions undertaken between 1744 and 1874. The shrine is approached by a walk lined with pine trees dwarfed and gnarled by ocean winds.

Of the many pilgrimages and celebrations that punctuate the year at Izumo, two are especially colorful and stirring. One takes place at Shōgatsu, the New Year: the high priest of Izumo, bearing a sacred rice cake (mochi), goes to the shrine of Kumano, nestled in a secluded valley, and there asks the god to grant him new fire. (The previous year's fire has already been extinguished to avoid the possibility of defilement.) It is ritually rekindled at the Kumano shrine with a sharp staff and a hardwood plank, a practice dating back to Yayoi times. The other solemn ceremony takes place every year on May 14th, when an imperial representative officially opens the temple.

Legend has it that all of Japan's gods gather every October in the matching rectangular structures that flank the main building on the east and west. At Izumo, October is called Kami-arizuki, "the month of the gods," while elsewhere in Japan it is often referred to as Kannazuki, "the month without gods."

Exposed to the windswept shores of the Sea of Japan, the Shinto shrine of Izumo once included an "official" provincial Buddhist temple (Kokubunji), long since destroyed. Although an archaeological inventory of 1653 mentions that it was then "in ruins," its original location was ascertained during excavations in 1950.

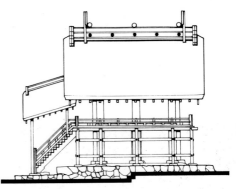

603 IZUMO. FRONT AND SIDE ELEVATION
OF PRESENT SHRINE
(drawing by Giroux, after Ota Hirotarō)

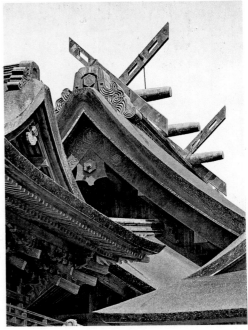

604 IZUMO. DETAIL OF THE ROOF

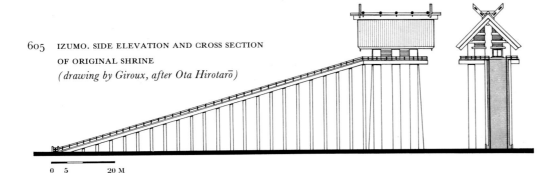

605 IZUMO. SIDE ELEVATION AND CROSS SECTION
OF ORIGINAL SHRINE
(drawing by Giroux, after Ota Hirotarō)

0 5 20 M

606 KARAKO. GENERAL VIEW

KARAKO (Nara Prefecture) 唐古

In 1937, the University of Tokyo began excavating the remains of a sizable Yayoi settlement at Karako, on the Nara plateau. Long submerged beneath Karako-ike, a lake which once covered the site, the building fragments, stakes from irrigated fields, and other pieces of wood found here have been splendidly preserved over the ages. Subsequent rebuilding and restoration at Karako have given us a much clearer picture of how the inhabitants of Bronze Age villages lived and worked.

This cluster of more than one hundred dwellings revealed a series of three "cultural strata," indicating that the period of occupation spanned the entire Yayoi period (3rd century B.C.–3rd century A.D.). Inside the "houses" (the surviving foundations of huts, that is) was found all kinds of wooden, ceramic, and stone material. These articles are of great interest for any number of reasons, but certain pieces of pottery proved especially enlightening: judging by the traces of rice grains on the bottom of the vessels, it is reasonably certain that agriculture at Karako had reached a fairly advanced stage of development. And while similar pieces have turned up elsewhere, Karako yielded yet another significant treasure: remains of rice husks, a cereal whose varieties and history in Japan are currently being studied by agricultural experts. A group of wooden farming implements discovered at the site, together with the stakes and posts, leave little doubt that the inhabitants of this settlement cultivated rice in irrigated fields. This, in turn, points to relatively sophisticated technical knowledge as well as to a society structured into permanent communities. This element of permanence distinguishes Yayoi society from Late Jōmon society (2nd millennium–3rd century B.C.), for although the latter engaged in certain forms of agriculture, it did so on nonirrigated terrain and probably combined this activity with a seminomadic existence.

607 NAGAOKA. PLAN OF OLD
IMPERIAL CAPITAL (784–794)
(after Nihon Kōkogaku Taikei)

NAGAOKA (environs of Kyoto) 長岡

In 784, Emperor Kammu (r. 781–806) selected this place southwest of Kyoto, in what was once Yamashiro Province, as his residence. Yet ten years later, the court was relocated to Heiankyō (Kyoto).

The reasons for abandoning the recently founded palace remain a mystery and, at best, can only be conjectured. The edict ordering the transfer of the capital to Heiankyō mentions only that the latter site was more beautiful and that contact with the rest of the empire would be easier. But what actually prompted the authorities to move the capital a second time within ten years?

Shortly before Nagaoka was founded, the powerful Fujiwara-no-Tanetsugu (737–785) had supervised the departure from Heijōkyō (Nara) to escape the influence of the leading temples. However, the decision to settle at Nagaoka was not without personal reasons: Tanetsugu's maternal grandfather supplied not only the land, but the funds needed for relocation.

In 785, while construction of the new capital was proceeding and everything seemed to be going well, Tanetsugu was assassinated. Moreover, a prince of the blood, Sawara-shinnō (757–785), fifth son of Emperor Kōnin (r. 770–781) and brother of the reigning emperor, was implicated in the murder. If we knew the motives for the assassination, the circumstances surrounding the transfer of the capital might be somewhat clearer, but the protagonists of this intrigue took the secret with them to the grave. It is likely that this crime, together with the unexplained death of Prince Sawara en route to his place of exile, made it imperative to get away from an accursed place that might be haunted by two dreaded ghosts crying for vengeance.

Apparently Wake-no-Kiyomaro (733–799), who had recently demonstrated his loyalty to the emperor by helping to prevent the monk Dōkyō (d. 772) from usurping the throne, assumed the difficult task of amassing, for the second time in ten years, the funds needed to build a new capital.

608 NANIWA. PLAN OF PALACE
BUILT BY EMPEROR KŌTOKU
(r. 645–654)
AND EMPEROR TEMMŪ
(r. 673–686) (after
K. Kasawara)

609 NANIWA. PLAN OF PALACE BUILT BY
EMPEROR SHŌMU (r. 725–749), WHEN NARA WAS CAPITAL
OF THE EMPIRE (after K. Kasawara)

NANIWA (Ōsaka) 難波

In 1952, while digging at a construction site south of Ōsaka Castle, workers discovered the remains of a palace built by Kōtoku (r. 645–654), the emperor whose so-called Taika Reform marked the beginning of Chinese-style government in Japan. From these subterranean holes there emerged a plan—a ghostly "negative," so to speak— of what must have been one of Japan's first seats of government, if not one of her earliest imperial capitals. A permanent court did not come into being until the move to Nara in the 8th century; strictly speaking, neither was there an itinerant court, like the French court that followed Francis I wherever political action or royal whim dictated. But the Japanese people at the time, as in ancient China, believed that the dead continued to "occupy" their houses so long as their memory was kept alive and honored, which meant leaving otherwise inhabitable places behind as a gesture to the deceased owners.

522

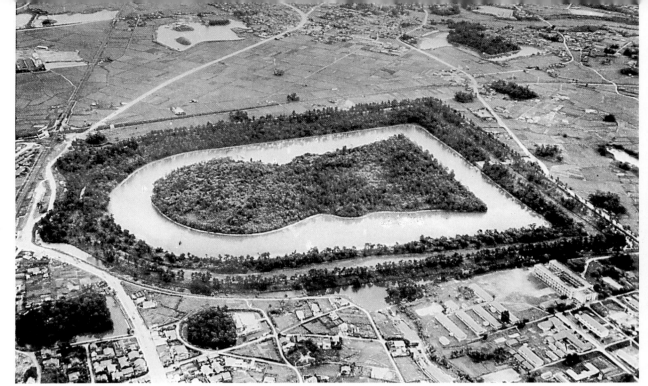

610 NINTOKURYŌ. GRAVE MOUND OF EMPEROR NINTOKU. AERIAL VIEW

NINTOKURYŌ (Ōsaka) 仁徳陵

Of the comparable monuments erected during the Kofun Jidai, or Great Tomb period, the grave mound of Emperor Nintoku (313–399) is probably the most striking. This perfect "keyhole" tumulus (*zempōkoen*) measures 725 meters long by 305 meters wide, covers an area of over 200,000 square meters, and lies 35 meters above the surrounding plain.

The circular section rises in three huge tiers to the top of the mound, considered by some the largest in the world. The archaeologist Umehara Sueji estimated that it must have taken a thousand laborers four years to complete the earthen embankments alone.

The top was strewn with cut blocks of stone and plain, cylindrical *haniwa*, remains of the tomb's original sloped facing and of the pieces needed to strengthen the embankment. The entire inner wall of the inner moat was ringed with a row of decorated *haniwa* (17,775 pieces in all), shaped aboveground into human figures, horses' heads, birds' heads, and other subjects (average height of sculptures: 33 cm.).

The mound is surrounded by two moats—the outer one narrow, the inner one broad—and two borders of wooded land.

When the approach path to the burial vault was found in September 1872, the chamber proper (3.63 by 3.94 by 2.42 meters) and the stone sarcophagus (2.42 by 2.72 by 1.45 meters) were soon measured. The tomb furnishings (notably armor of gilt bronze) were examined, then left exactly as the archaeologists had found them.

It is likely that prominent persons were laid to rest in the dozen or so small, circular tombs in the vicinity of Nintokuryō. In the 1912 excavation, one of them yielded an abundance of mirrors, pearls, and various "jewels" including an unusual jadelike *magatama* (comma-shaped ornament) over 8 centimeters long.

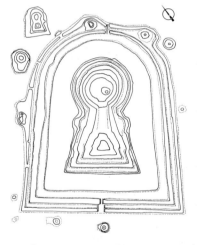

611 NINTOKURYŌ. CONTOUR MAP
(*drawing by Giroux,
after Sekaikōkogaku Taikei*)

ŌJINRYŌ (Ōsaka) 應神陵

The huge "keyhole" tumulus (*zempōkoen*) of Emperor Ōjin (201–310), father of Emperor Nintoku (313–399), rises amid a group of smaller grave mounds.

The tomb faces northwest, and is 672 meters long, 330 meters wide, and 35 meters high. It is about 60 meters shorter than the tomb of Nintoku (see above), but otherwise the burial sites of father and son are of comparable size.

Cut blocks of stone and cylindrical *haniwa* were used to shore up the tiered earthen embankment at the top of the tumulus. A single moat (perhaps the only one) has survived; its perimeter was studded with large numbers of decorated *haniwa* that are now kept in the imperial collections and the Tokyo Museum.

Soundings taken in the moat in 1892 brought to light some interesting material, including animal remains (bits of whalebone) and fragments of Yayoi pottery. Questions arose about the age of these remains compared with that of the grave mound, which seem to date from the Chalcolithic culture of the Yayoi period (2nd–3rd centuries A.D.). Apart from substantiating imperial chronology, this would mean that Iron Age and Bronze Age societies had merged without undergoing the brutal socio-economic changes that a number of scholars in the postwar era have suggested.

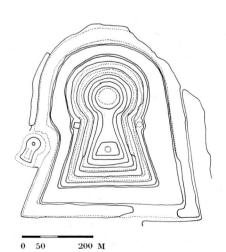

0 50 200 M

612 ŌJINRYŌ. CONTOUR MAP
(*drawing by Giroux,
after Sekaikōkogaku Taikei*)

523

OKAYAMA (Okayama Prefecture) 岡山

The pride of Okayama, capital of Bizen Province (now Okayama Prefecture), was a splendid castle built in the middle of the 16th century by Ukita Naoie (1530–1581), who had become sole master of Bitchū Province (now part of Okayama Prefecture). Oda Nobunaga (1534–1582) then formally acknowledged Ukita's possession.

Although Okayama and Himeji were both essentially "level-ground" fortresses, Okayama Castle differed from the "White Heron" in having a natural barrier, the Asahi River, that protected its eastern flank. Its square central tower rose in levels above a ground floor in the shape of an irregular pentagon. There were six stories in all, including a three-story roof. With its Chinese-style overhangs *(kara-hata)* and lyre-shaped windows *(kato)*, Okayama Castle in its heyday during the Edo period was not without charm, despite the fact that its blackened walls earned it the nickname of the "Crow," in contrast with the "White Heron" of Himeji.

After the battle of Sekigahara (1600), Okayama passed from the Ukita to the Kobayakawa; then, for lack of heirs, it reverted to the Ikeda, who remained there until the end of the shogunate in 1868. Unfortunately, the citadel was destroyed in World War II.

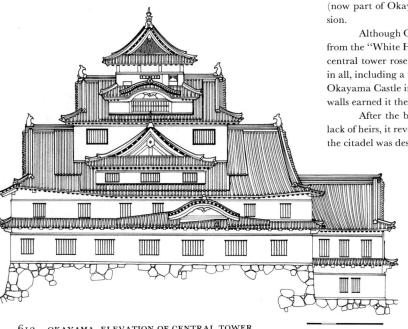

613 OKAYAMA. ELEVATION OF CENTRAL TOWER
(drawing by Giroux, after Ota Hirotarō)

0 5 25 M

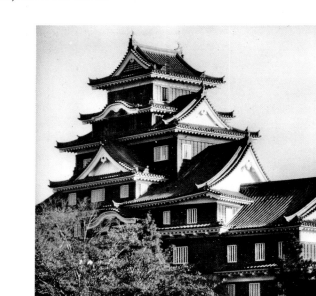

614 OKAYAMA. CENTRAL TOWER

ŌSAKA 大坂

Sheltered at the far end of an accessible bay, the strategically located city of Ōsaka stands at what was once the juncture of Settsu, Itzumi, and Kawachi provinces. Thus, it provided the entire Kyoto region (and indirectly, the Nara region) with a link to the sea.

The modern city of Ōsaka extends over an alluvial plain where silt deposits have preserved remains from every phase of Japanese civilization, from Jōmon *kaizuka* (kitchen middens of shells, 2nd millennium–3rd century B.C.) and the massive tombs of the Kofun period to the earliest imperial palaces and, later on, such prominent temples as Shitennōji. However, about the time Shitennōji was completed (593), Buddhism so completely eclipsed everything before it that the Japanese forgot to whom belonged those grandiose tombs strewn across the plain. The "abandoned tombs of Naniwa" (*Naniwa zo ara haka*), people wistfully called them; all they could remember about their lost culture was that at one time Naniwa had been the site of an imperial residence.

The present-day metropolis of Ōsaka, hub of Japanese industry and trade, developed around an area once occupied by the ancient district of Naniwa, which included the palace of Emperor Kōtoku (r. 645–654). One of Ōsaka's wards is called *Naniwaku* to this day. The palace of Naniwa was abandoned on Kōtoku's death, but Ōsaka compensated for this loss in political prestige by assuming leadership in business and commerce. In time, it became a center of Japanese trade, a gigantic warehouse into which coastal shipping unloaded goods destined for the capital cities of Heijō (Nara), then Heian (Kyoto). Until the late 16th century, Ōsaka shared

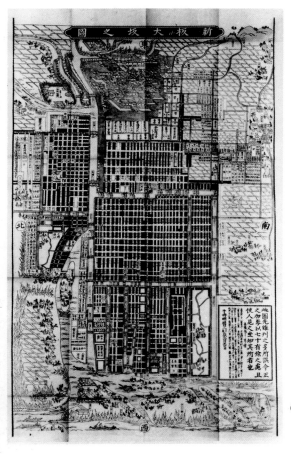

615 ŌSAKA. PLAN DRAWN IN 1657

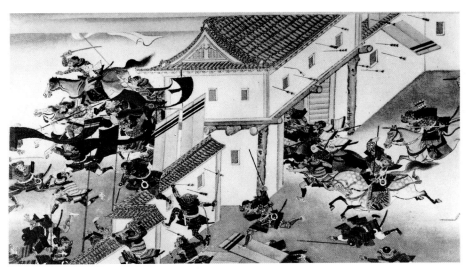

616 ŌSAKA. STORMING OF ŌSAKA CASTLE BY TOKUGAWA IEYASU IN 1615

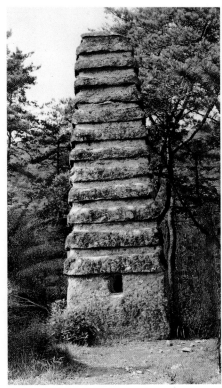

617 ŌSAKA. THIRTEEN-STORY PAGODA
(7TH CENTURY)

the honor of being the "belly of the capital" with the nearby port of Sakai (Izumi Province) just south of the Yamato River (now the boundary between the two cities).

During the Ashikaga period (14th–16th centuries), Sakai was considered the busiest port in Japan. It even boasted a castle—Ōsaka's had yet to be constructed—which the governor of the province, Yamana Ujikiyo (1345–1392), built in 1373 in the futile hope of rising up against the Ashikaga and overthrowing them. Although Ujikiyo failed in his bid for power, the castle gave to the town of Sakai a new political and military preeminence which Ōsaka seemed destined never to achieve.

Ōsaka remained primarily a trading town until 1532, when the monks of Honganji in Kyoto, the principal temple of the Jōdō Shinshū, or "Pure Land" sect founded by Shinran (1174–1263) in 1224, built a castle, Ishiyamajō, and erected their temple there. For several centuries the monks of Shinshū (popularly known as Ikko) waged fratricidal war against the monks of Mt. Hiei, the cradle of all new sects in medieval Japan. In the second half of the 16th century, the Ikko warrior-monks, famous for their overzealous participation in wars of the time, were driven from Kyoto by the monks of Mt. Hiei and kept at bay until 1591, when the dictatorial Toyotomi Hideyoshi (1536–1598) intervened, took them under his wing, and allowed them to return to the capital; their presence in Ōsaka had come to an end when Oda Nobunaga (1534–1582) emerged victorious (1580) after a dramatic ten-year siege. Ōsaka did not come into its own until 1583, the year Toyotomi Hideyoshi chose the city for his residence and had a castle built there.

All of the prominent families of the day followed him by setting up at least one residence in Ōsaka. According to contemporary accounts, the castle of the Toyotomi was no less magnificent than the one he built (1593) ten years later at Fushimi: having fathered a son at last, he intended to retire and leave to his heir the city and its castle, seats of political and economic power. Like Fushimi, however, Ōsaka Castle did not survive the terrible feuds which erupted after Hideyoshi died in 1598 between the supporters of his son and the Tokugawa faction.

As events dragged on, it seemed that the situation might resolve itself of its own accord. Hideyoshi's son, Hideyori (1593–1615), was only seven years old when his faction was defeated at Sekigahara (1600). Tokugawa Ieyasu, who feared the dire consequences of laying hands on a child he had sworn to protect, allowed Hideyori to retain his castle and granted him a fief consisting of the three neighboring provinces of Settsu, Kawachi, and Izumi. He even went so far as to betroth his granddaughter to him.

But circumstances were to decide otherwise. A number of Hideyori's supporters, who had variously come to grief after the victory of the Tokugawa, gravitated to the residence of their former master's son. As the Tokugawa saw it, Ōsaka was fast turning into a hotbed of seething hostility, if not of outright revolt, and he mustered an army of 150,000 men and brought them before Ōsaka in November 1614. Hideyori had no choice but to sue for peace (January 1615) on the humiliating condition that the castle should be destroyed. But when troops arrived to begin demolition, Hideyori and his vassals took refuge inside the fortifications, and the ensuing siege lasted one month; part of the castle was put to the torch, and the lineage of the Toyotomi came to an end.

The outer wall and part of the central tower were left standing and put to use once again, but in 1868, when the emperor assumed power, troops faithful to the Tokugawa set fire to it themselves before retreating. A concrete reconstruction (five-story roof outside, seven stories inside) is all that remains today of these buildings; work began in 1931 and was resumed after World War II. Had the original castle survived, how steeped in history it would be!

The many branches of the Yodo River delta that were converted into canals to accommodate water traffic led to Ōsaka's being dubbed the "Venice of Japan" by early European visitors. The bombings of 1945 and the economic boom of the postwar era have changed that image. Ōsaka's canals vanished, as did most of its monuments; but the city took up where it had left off, fulfilling its destiny as a focal point of business and trade.

Perhaps the Ōsaka of today will again influence Japan's art and life as it did at the dawn of the Edo period. The caustic accounts of Ihara Saikaku (1642–1693) notwithstanding, Ōsaka must be credited with creating and fostering Bunraku theater and other original forms of culture.

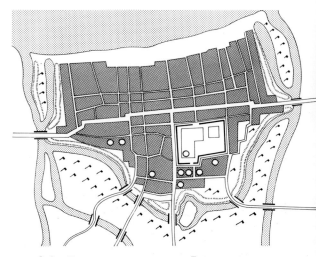

618 ŌSAKA. PLAN OF ANCIENT ŌSAKA. BUDDHIST TEMPLES WERE ERECTED OVER THE OLD KAIZUKA (KITCHEN MIDDEN OF SHELLS), LEAVING RICE FIELDS UNDISTURBED
(drawing by Giroux, after K. Kasawara)

Water Rice fields
Kaizuka Temples

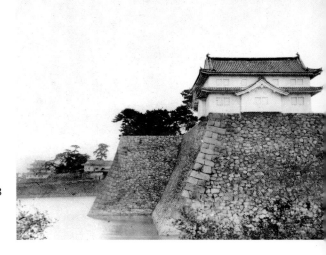

525

619 ŌSAKA. ŌSAKA CASTLE
PHOTOGRAPHED BEFORE 1868

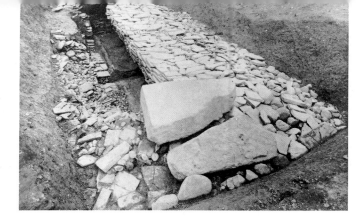

621 SHIKINZAN. TOMB EXTERIOR

620 SHIKINZAN. VIEW OF TOMB INTERIOR WITH CRADLE-SHAPED FLOOR

622 SHIKINZAN. CONTOUR MAP
(drawing by Giroux, after Sekaikōkogaku Taikei)

SHIKINZAN (environs of Ōsaka) 紫金山

This large "keyhole" tumulus (*zempōkoen*), which measures over 100 meters in length, is located on what are now the grounds of the Ibaragi police infirmary near Ōsaka.

The low, elongated burial vault (7 meters long, .1 meter wide, 1.2 meters high) is a combination of burial chamber and sarcophagus; offerings were probably placed in the narrow passageway after the coffin was slipped inside. The "floor" of this uncomplicated tomb consists of concave slabs set end to end, resulting in a cradle-like floor. Enormous stone slabs make up the flat roof, while the load-bearing walls are built of irregular stone masonry.

In 1947, the excavations of the archaeologist Umehara Sueji revealed an impressive array of tomb furnishings: fighting gear (suit of armor, sword, arrowheads, quiver, axe) as well as a number of farming tools and mysterious hoe-shaped objects. In addition to the usual assortment of round and elongated pearls and *magatama* (comma-shaped pendants), there were twelve beautiful bronze mirrors, not a common find in graves of this type. Eleven mirrors, in two groups, were placed at either end of the burial vault; the twelfth was placed inside the coffin, flush with the head of the deceased.

The Shikinzan grave mound is believed to date from the early part of the Kofun period (4th–5th centuries A.D.).

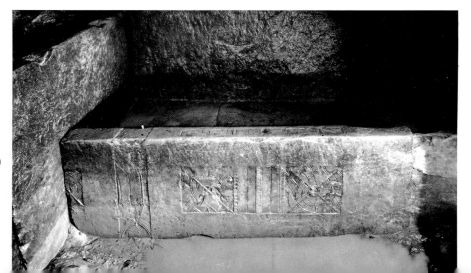

SENZOKU (Okayama Prefecture) 千足

This large "keyhole" tomb (total length: 76.8 meters) has an unusual shape the Japanese refer to as *tategaishiki*, or "scalloped." It is renowned for its wealth of tomb furnishings and the *chokkomon* (literally, "decorative lines and curves") carved into the walls.

The *chokkomon* here is a repeated square motif that looks like an object fragmented in a kaleidoscope. A low slab placed at the far end of the chamber defines the space set aside for the sarcophagus; the designs were found on this cut block of stone.

The burial chamber is 3.45 meters long and 2.60 meters wide. Enormous slabs set on edge around the sides of the tomb create an impression of smoothness which contrasts sharply with the rough masonry of the irregular vault overhead.

The reign of Emperor Meiji (r. 1868–1912) was drawing to a close when archaeologists discovered the tomb furnishings that had been placed in front of the sarcophagus. There were mirrors bearing a "five-animal" motif, pearls, and *magatama* (comma-shaped "jewels"). But still more splendid objects were found nearby: hoe-shaped ornaments, elongated or round pearls, a set of fighting gear complete with sword, axe, and a suit of armor.

As usual, the identity of the deceased remains a mystery. The Okayama region, which abounds in large keyhole tumuli, may have been the homeland of the Kibi, a clan mentioned in the early history of Japan, so rich with legends; indeed the vast region comprising Bizen, Bitchu, Bingo, and Mimasaka provinces was known as "Kibi." Thus, the large number of *kofun* (tombs) in Kibi points to the presence of a powerful family that took its name from the region, or vice versa. A member of this clan was laid to rest at Senzoku, but that is probably all we shall ever know about him.

623 SENZOKU. TRANSVERSE AND LONGITUDINAL SECTIONS; FLOOR PLAN *(after Kobayashi Yukio)*

624 SENZOKU. SLAB WITH INCISED CHOKKOMON MOTIF

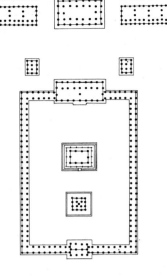

625 SHITENNŌJI.
STONE GATEWAY (ISHITORII)

四天王寺
SHITENNŌJI (Ōsaka)

Founded in 593 by the regent Shōtoku (574–622), Shitennōji (literally, "Temple of the Four Guardian Kings") is one of the oldest temples in Japan, although the one we see today is but the most recent (1964) in a long series of restorations. The previous buildings, dating back to 1812, were completely destroyed in the bombing of May 13–14, 1945.

The original plan of Shitennōji came to light after a fire in 1925. In 1934, the relic hall collapsed during a typhoon, and subsequent excavations revealed that the foundation of the ancient pagoda lay 3.5 meters below the present level of the ground. When archaeologists uncovered a section of the preaching hall in 1950, it was concluded that, although it had been rebuilt time and again over the centuries, its plan and size had remained virtually unchanged.

Excavated also were a large number of objects from every phase of Japanese history as far back as the Asuka period. Shitennōji's past riches offer more than archaeological "data," for the great stone *torii* (gateway) still standing at the temple entrance is the oldest of its kind in Japan (1294).

626 SHITENNŌJI. PLAN OF TEMPLE
(after Sekaikōkogaku Taikei)

SHŌTOKU-TAISHI HAKA (Ōsaka) 聖 德 太 子 墓

Prince Shōtoku-Taishi (574–622) and his mother, the wife of Emperor Yōmei (r. 586–587), were laid to rest in the same tomb, which is covered over with a round tumulus 54 meters in diameter and over 7 meters high. Probably looted by grave-robbers even in ancient times, it was inspected by the government in 1879, at which time Prof. Uemehara Sueji discovered three coffins: those of Shōtoku-Taishi, his wife, and the empress mother.

627 SHŌTOKU-TAISHI HAKA.
PLAN OF TOMB
(after Fujita Ryosaku)

SUMIYOSHI TAISHA (Ōsaka) 住 吉 大 社

The Shinto shrine of Sumiyoshi, in Ōsaka, is one of the oldest and most popular in Japan. It was built for the worship of four deities, three of them believed to protect sailors and travelers on the high seas. Stone lanterns—thank-offerings for a safe journey—envelop the shrine in the mysterious aura of fire; they are a picturesque reminder of the gods in whose honor Sumiyoshi was created.

Legend has it that these deities watched over the overseas expedition of Empress Jingō-kōgō (170–269 A.D.), who before going off to wage war in Korea put a stone in her sash to delay the birth of the child she was carrying (the future Emperor Ōjin). The temple buildings, originally constructed on Kyūshū (Chikuzen Province) as a thank-offering, are believed to have been transferred to their present location by Ōjin's son, Emperor Nintoku (313–399).

In addition to enjoying imperial protection, the Sumiyoshi shrine is famous for having been the place where Emperor Go-Murakami (r. 1339–1368) sought refuge when dynastic schism divided Japan into the so-called Northern and Southern courts or dynasties. Later it figured in the intrigue surrounding the advent of the Tokugawa shōguns. After Shimazu Yoshihiro's (1535–1619) defeat at Sekigahara (1600), he took refuge there before returning to Hyūga Province (Miyazaki Prefecture) on Kyūshū. A few years later, it became the headquarters of Tokugawa Ieyasu (1542–1616) during the first siege of Ōsaka (1614).

Sumiyoshi displays one of the major shrine-types of Shinto architecture: the main sanctuary, entered through a door on the shorter side, is divided into two rooms, one behind the other. Although akin to the Taisha style adopted at Izumo, the Sumiyoshi style differs in that the door, instead of being shifted to the right, is centered in the temple façade.

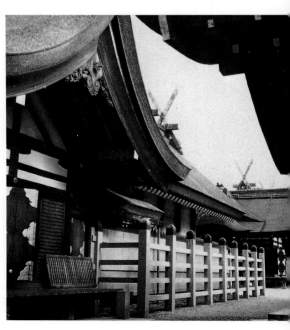

527

628 SUMIYOSHI TAISHA SHRINE.
MAIN BUILDING

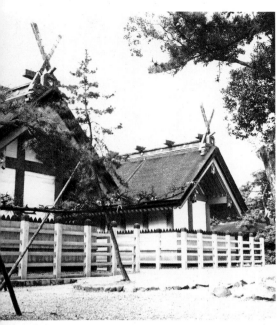

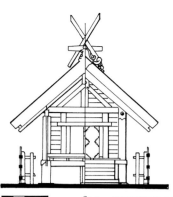

630 SUMIYOSHI TAISHA SHRINE. FRONT AND SIDE ELEVATIONS AND PLAN
(drawings by Giroux, after Ota Hirotarō)

0 1 2 M

The Sumiyoshi shrine, like all Shinto edifices, was at one time rebuilt every twenty years. Since the civil wars of the 15th century, however, it has been rebuilt only in the wake of disaster. The structures we see today date from 1804–11, and have been restored a number of times since.

The picturesque arched bridge leading pilgrims into the sacred precinct was designed by a woman: Yodogimi (1569–1615), niece of Oda Nobunaga (1534–1532) and wife of Toyotomi Hideyoshi (1536–1598). She met a tragic death during the great fire of Ōsaka, and thus was sealed the fate of those who supported her son, Toyotomi Hideyori (1593–1615).

629 SUMIYOSHI TAISHA SHRINE.
SIDE BUILDINGS

TAKAMATSUZUKA (Nara Prefecture) 高松塚

Discovered in March 1972, the painted tumulus of Takamatsuzuka, southwest of Asuka, is perhaps the most beautiful in Japan, and the most astonishing. No tomb so sophisticated for the period had yet been found outside of China or northern Korea.

Actually, the tomb had not been a secret, and as far back as the Edo period archaeologists surmised that the bamboo-clad hillock was an imperial grave mound. But no one had investigated the contents.

Excavations in 1972 revealed a small, single-room burial vault in the shape of an elongated parallelepiped (2.65 by 1.04 meters) and a lacquered coffin (2.02 by 0.57 meters) containing some human remains. They were examined, then replaced exactly as found. The public, though not allowed into the tomb, may visit a reconstructed version nearby. The tomb's chief glory is its wall paintings, faithful copies of subjects previously developed in China. These include animals of the cardinal points (green dragon, east; white tiger, west; red bird, south; snake twisted round a tortoise, north); the sun in the east, the moon in the west; the ceiling spangled with the principal constellations. The faces, clothing, and general demeanor of the male and female figures escorting the deceased into the afterlife are direct offshoots of Chinese tomb paintings from the Tang dynasty, and indicate that the Takamatsuzuka tumulus could not have been completed before the 7th century; and since Emperor Kōtoku (r. 645–654) prohibited the construction of *kofun* in 648, there is every reason to think that this one dates from the first half of the seventh century. (There is always the possibility that somehow the *kofun* survived the imperial interdiction, but its date could still be no later than 707, when the court was established at Nara.)

The furnishings in the coffin included a mirror decorated with sea creatures, silver ornaments from a Tang sword, glass and jade beads, and silver ornaments on the coffin proper.

The discovery of the Takamatsuzuka grave mound raised many more questions than it answered. Who had been buried there? Who designed and built this impressive monument? Are there comparable sites elsewhere in Japan? and if not, why should this be the only one of its kind?

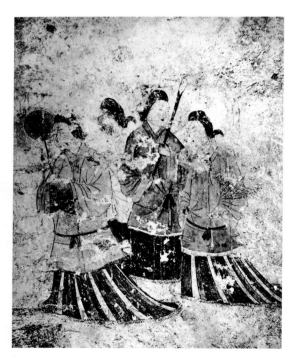

631 TAKAMATSUZUKA. WALL PAINTING:
TANG-STYLE LADIES-IN-WAITING

632 TAKAMATSUZUKA.
AERIAL VIEW OF TUMULUS

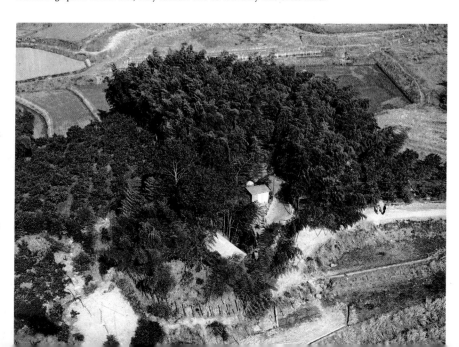

KYŪSHŪ

DAZAIFU (Fukuoka Prefecture) 大宰府

Little is known about the ancient history of Dazaifu, except that it was once called Omikotomochi-notsukasa and that it did not enter the mainstream of Japanese history until the 7th century.

A year after the combined forces of China and Korea drove the Japanese army out of Korea, Emperor Tenchi (r. 662–671) selected Dazaifu as the site of a palace and fortified complex that could serve as a western outpost of the central government. This was tantamount to an admission by the Japanese that their policy of overseas expansion had ended in failure. Gaining control of the Korean kingdom of Mimana in the 4th century, they had lost it to the Korean kingdom of Silla by 562, a full century before Dazaifu was turned into an outpost of power. Thus, Dazaifu did not come into its own, either militarily or politically, until the dawn of the Nara period.

The few civil services operating in Korea during those hundred years of Japanese hegemony were relocated to the coastal town of Nanotsu (present-day Hakata, historical hub of Fukuoka Prefecture) until a larger city could be built further inland.

All that remains of the original administrative center are a few column bases scattered about a grassy plain ringed by the gently rolling countryside so typical of Japan. Using these bases as reference points, we know that the main building stood just inside the outer wall (fragments of which are still standing), that there were two side buildings (East and West Palaces), a middle gate, and a main gate at the southern end of the enclosure. A short distance northwest of the palace lie the ruins of a government temple (*kokubunji*) from the Nara period and, to the east, the ruins of a temple dedicated to Kannon. To safeguard against possible attack—the threat of a Korean raid was ever-present, or an outburst from the still independent local populace—Emperor Tenchi also ordered the construction of a combined defensive wall and moat. (More than a kilometer of this fortification may still be seen.) Built in accordance with the ancient Chinese rammed-earth technique (fig. 28), the wall was quite broad at the base (37 meters) and gradually tapered toward the top, 14 meters above the ground—impressive dimensions by any standard—with two gates in the section still standing. The Dazaifu complex was completed by two "mountain" castles (*yamashiro*) which Emperor Tenchi had built in 665 on Mt. Ono (410 meters) and Mt. Kiyama (414 meters), to provide the enclosure with fortified observation posts for warning and defense in case of attack. Five kilometers of the rammed-earth walls surrounding these citadels stand to this day.

Dazaifu was established primarily to monitor the coastline, but the administrators of the city soon added all the civil services and, in so doing, kept government running smoothly on Kyūshū until the end of the Heian period (12th century). In 1186 the Minamoto created the title of *chinzei-bugyō* (military governor of Kyūshū), changed in 1275 to that of *Kyūshū-tandai*. The first person appointed to the latter post was Hōjō Sanemasa, who coordinated the Japanese defense against the Mongol invaders.

Although the ruins at the site are few, the ancient stronghold of Dazaifu reminds us of more than a faroff time when the Japanese empire was still in the making, for it was a bastion which protected the archipelago at one of its few vulnerable spots.

633 DAZAIFU. REMAINS OF FORMER ADMINISTRATIVE CENTER

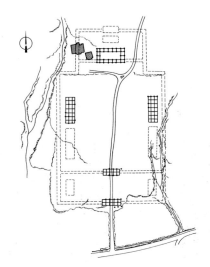

634 DAZAIFU. PLAN OF ADMINISTRATIVE OUTPOST CREATED IN 664 *(drawing by Giroux, after Nihon Bunkashi Taikei)*

DESHIMA (Nagasaki Prefecture) 出嶋

Deshima (De-Jima) was once a tiny artificial island in Nagasaki Bay that lay just off the northwestern part of the city. A little bridge connected the curious, fan-shaped parcel of land (total area: 3,924 *tsubo*, or roughly 3 acres) to the Edo-machi district of Nagasaki. Deshima was established as a foreign trading post in 1609, in

635 DESHIMA. COPY (1852) OF A DUTCH PLAN OF DESHIMA

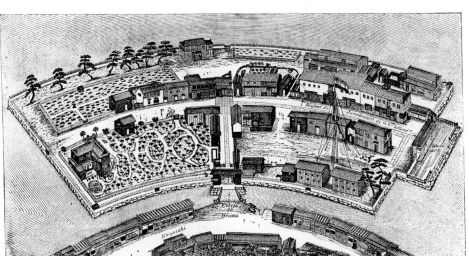

529

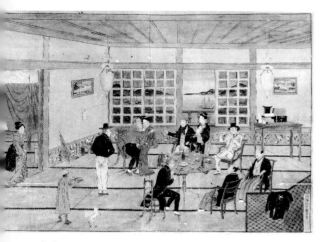

636 DESHIMA. BANQUET IN A DUTCH HOUSE. WESTERN-STYLE WATERCOLOR BY KAWAHARA KEIGA (EARLY 19TH CENTURY)

those halcyon days when Japan first opened its doors to the outside world and permitted European merchants to do business out of Hirado. Two intersecting thoroughfares divided Deshima into four sectors, where more than forty establishments were clustered to provide all the services needed to sustain everyday life and the island's limited commercial activity. Ships could dock at the northwest side of Deshima, but only long enough to unload their merchandise, and all goods had to be sold as one lot—tantamount to an embargo, by reducing the chances for different bids.

With the advent of the Tokugawa shogunate, only the Dutch were allowed to remain on Deshima, but in 1689 Chinese ships were granted permission to berth nearby. During the period of Japanese isolation (1635–1854), a limited number of Japanese civil servants were admitted to Deshima, apart from merchants and prostitutes, to maintain a semblance of contact with overseas countries. In time, however, curiosity got the better of the Japanese, who would claim "official business" to get a closer look at this Western-style island town. What they saw was a scaled-down version of life in Holland. The Dutch lived in sturdy, multistory houses furnished with tables, chairs, stoves, and mirrors; they tended modest gardens, and prepared their own dishes using butter, a product previously unknown to the non-nomadic peoples of the Far East. Residents of Deshima also arranged concerts (especially for guitar music) and balls, which the Japanese considered unseemly and laughable.

When the narrows separating the foreign enclave from Nagasaki were filled in with earth in 1868, Deshima, already a virtual extension of the city, ceased to be an island. Urban sprawl has since engulfed the area, making it difficult to imagine that a place like Deshima ever existed. A lone ditch in the Edo-machi district bears witness to how Europeans had once been confined on the fringes of Japanese society in the hope of prospering. A narrowminded shogunate notwithstanding, they were the unwitting *agents provocateurs* of a new outlook which developed behind the scenes and assisted the astounding revitalization of the Meiji period.

FUNAYAMA (Kumamoto Prefecture)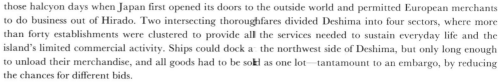

The "keyhole" tumulus (*zempōkoen*) of Funayama rises amid a tomb cluster (*kofungun*) on a terrace-like tract overlooking the left bank of the Kikuchi River, which empties from there into Shimabara Bay. The tomb is 47 meters long, its west side somewhat damaged. In the circular portion was lodged a large *iegata*, or house-shaped sarcophagus with a sloping, four-sided lid and an opening on one of the short sides. The *sekijin* (primitive anthropomorphic statues) that are strewn about outside must have once stood on top of the circular section of the mound.

Archaeologists excavating the site in 1873 removed a large quantity of tomb furnishings from the sarcophagus, including six mirrors, a crown, various jewels, harnesses, fighting gear (armor and weapons), and Sue pottery. The openwork crown and gold earrings appear to have been patterned after Korean models. The most remarkable object in this already impressive collection was a massive straight sword with an inscription that dates it 438, one of the earliest occurrences of Chinese script found in Japan.

IDERA (Kumamoto Prefecture) 井寺

When opened and excavated toward the end of the Edo period (1857), the circular tumulus at Idera was found to contain a considerable number of incised and painted stone slabs. Some fifty years later, in 1902, a hole was made in the top of the burial vault, and the tomb furnishings were pulled out. Of these mirrors and weapons—alas, scattered and lost over the years—only four straight swords survive. The bombings of World War II also took their toll, causing some incised designs and traces of paint to disintegrate.

The Idera *kofun*, its diameter 14 meters and its height 6.5 meters, is set on a knoll. The burial chamber (2.94 by 2.47 meters), built entirely of volcanic rock from Mt. Aso, is crowned with an irregular vault rising 3.08 meters above the floor. The inside of the chamber is ringed with slabs 0.85 meters high, set edgewise in

637 IDERA. VAULT SEALED BY TWO STONE SLABS

638 IDERA. ENTRANCE TO BURIAL CHAMBER

a way that exposes smooth, flat surfaces suitable for decoration. Access to the burial vault is through a short corridor, bringing the total length of chamber and corridor to 4.88 meters. Architecturally speaking, Idera is a splendid example of a *kofun* type quite widespread in Kumamoto Prefecture and southern Fukuoka Prefecture.

The tomb's most impressive aspect, however, is its decoration. All of the stone slabs, in addition to being painted red, bear incised *chokkomon* ("straight and curved") designs alternating with incised circles generally thought to be solar motifs. The entire vault overhead appears to have once been painted red. Mineral-based pigments were probably mixed with a solvent (chemical composition unknown) to produce a lacquer-like sheen that is detectable to this day. The motifs so shallowly incised must have looked as though drawn on a gleaming surface.

The Idera tomb can be linked to other *kofun* in Kumamoto Prefecture as well as to the one at Segonko (Okayama Prefecture, Honshū), all having the same type of *chokkomon* motifs. Unfortunately, the sarcophagus and what must have been a superb collection of tomb furnishings are missing, making it impossible to determine an exact date or attribution.

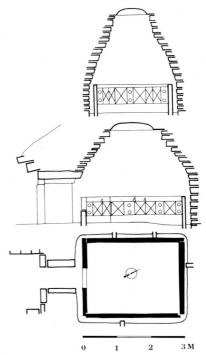

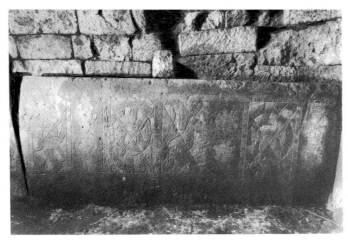

639 IDERA. SLABS WITH INCISED CHOKKOMON AND CIRCLE MOTIFS

640 IDERA. LONGITUDINAL AND TRANSVERSE SECTIONS AND PLAN (*after Kobayashi Yukio*)

ITAZUKE (Fukuoka Prefecture) 板付

Itazuke, a key site from the Yayoi period (3rd century B.C.–3rd century A.D.), offers a glimpse of life at the dawn of the Bronze Age, when the cultivation of rice was still in its infancy.

The site was discovered in 1916; archaeologists unearthed a burial ground with pairs of pottery urns set mouth to mouth, and inside they found three spearheads and six bronze needles. Excavations completed after World War II (1951–54) revealed a sizable complex adjoining the burial ground: hut foundations, wells, remains of embankments for pathways, and the moat surrounding the village. There were also slightly flaring urns shaped like truncated cones, the most ancient type of Yayoi pottery yet known.

All of these remains are scattered north to south over a flat expanse now covered by rice fields. Assuming that the settlement was roughly quadrilateral in shape, the dwellings stood in the western half, the urn-tombs in the eastern half.

Of the thirty or so small houses found at the site, none exceeds two to three meters in length; some are circular, others square. Apparently the village also had a well-like silo in which reserve provisions could be stored. V-shaped pieces driven two meters into the ground reinforced the earthen embankment of the moat, which doubtless provided not only a line of defense, but a water supply for irrigation and everyday use.

The entire site abounded in farming tools of polished stone, and there were traces of cooked rice. As at Karako (Nara Prefecture) and other comparable settlements, this suggests that by the early Bronze Age (Yayoi period) a number of far-flung communities had mastered the necessary skills and planning to make agriculture the mainstay of their economy.

641 ITAZUKE. SITE AT THE TIME OF THE 1951 EXCAVATIONS

IWATOYAMA (Fukuoka Prefecture) 岩戸山

Located at Yame, near Fukuoka, the "keyhole" tumulus (*zempōkoen*) of Iwatoyama is one of the largest found on Kyūshū, approximately 140 meters long and 50 meters wide, not including the moats. The burial vault lodged in the circular section faces south. The entire grave mound, and especially the top, was once ringed

531

642 ITAZUKE. GENERAL PLAN OF SITE SHOWING LOCATION OF SETTLEMENTS AND REMAINS OF MOAT (*after Nihon Nōgyō Bunka no Seisei*)

643 IWATOYAMA. STONE FIGURINE OF WARRIOR

with cylindrical or carved *haniwa* as well as highly stylized stone statues of human figures and weapons, or pieces of fighting gear (quivers).

Iwatoyama must always have been considered an intriguing site, since a date (6th century A.D.) and an account of how the *haniwa* and stone statues were arranged appear in the *Chikugo Kuni Fudoki* ("Description of Chikugo Province") and the *Nihon Shoki*, both of the 8th century. As usual with tombs known and admired since ancient times, the decorative pieces it contained have long been scattered. A look at the stone horse in Shōfukuji (Yame), one of the few surviving pieces, makes the loss seem all the more grievous. Most of the statues, doubtless beautiful specimens for their day, probably stood at least a meter high. Their sculptors carved either in shallow relief or in the round, and in style the works are stone counterparts of *haniwa*.

Entirely sheathed in slabs or pebbles taken from nearby shores, punctuated by *haniwa*, crowned with monumental stone statues over the vault entrance or atop the mound, tombs such as the one at Iwatoyama must have seemed all the more overwhelming in contrast with the rustic wood-and-thatch abodes of the living.

644 IWATOYAMA.
GENERAL VIEW OF TUMULUS

KARATSU (Saga Prefecture)

The name of this coastal town (Karatsu literally means "Port of China") neatly sums up the cultural, if not the political role it played in Japanese history. From the accessible shores of Karatsu Bay (Hizen Province), sheltered by three small mountain chains, beckons Iki, an island visible in clear weather; from Iki is seen the coastline of the island of Tsushima; from Tsushima, Korea. Little wonder that despite the perils of sailing across treacherous waters in unseaworthy craft, the flow of people, objects, and ideas in this region has been ceaseless since ancient times. Karatsu was a natural way station between the Asian continent and the island of Kyūshū.

A sea teeming with fish, the fertile alluvial plains, and the sheltering highlands suitable for orchards explain the importance of this settlement, which reaches back into the mists of prehistory. Archaeological finds in the area include: over forty pre-pottery sites; more than fifty Jōmon sites (2nd millennium–3rd century B.C.); more than fifty Yayoi sites (3rd century B.C.–3rd century A.D.), including a large urn-tomb burial ground excavated by a French and Japanese team in 1965–66 at Ukikunden; and more than one hundred and ten sites from the Kofun period (4th–6th centuries A.D.). The diversity of grave types in the Karatsu region—cists, dolmens, burial vaults—makes it clear that Korea was a major source for Japanese tomb architecture during the Kofun period. No less impressive are the tomb furnishings, in quality as well as quantity: Chinese weapons and mirrors of bronze, as well as original pieces by local artisans (sun-shaped ornaments [*tomoe*] and clasped bracelets discovered at Sakuranobaba).

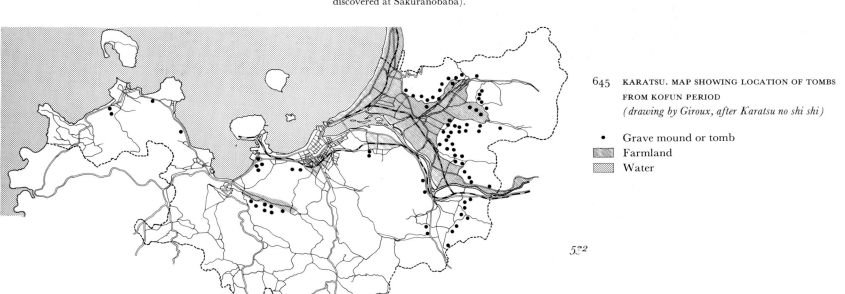

645 KARATSU. MAP SHOWING LOCATION OF TOMBS
FROM KOFUN PERIOD
(*drawing by Giroux, after Karatsu no shi shi*)

- Grave mound or tomb
- Farmland
- Water

522

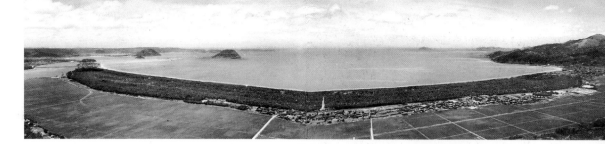

646 KARATSU. GENERAL VIEW OF BAY

For centuries Karatsu enjoyed relative peace, shattered now and again by the terrible *Toi no zoku*, pirates from Manchuria and Korea who put ashore and plundered the region. In 1019 the chiefs of the Dazaifu repulsed fifty ships and took prisoners, horses, and cattle, and the region was troubled no more. Karatsu appears to have been on the sidelines of major events until the abortive Mongol invasions of 1274 and 1281. At that time, every province in Japan contributed toward the building of the Genkōbori (farther northeast, near Hakata, Fukuoka), a defensive wall of earthen embankments and cyclopean masonry; the remains of this modest fortification are the only visible evidence of those years of intense military activity. But is was Toyotomi Hideyoshi (1536–1598) who really swept the region into the mainstream of Japanese history. Once his hold on Kyūshū was assured in 1587, the dictator chose Karatsu, gateway to Korea, as the site of a large castle and entrusted it to Terazawa Hirotaka (1536–1633), a noted *daimyō*, who, after being baptized in 1596, renounced Christianity and joined the ranks of their persecutors. The newly built citadel proved its military worth during the Korean expeditions of 1592–97, and although Hideyoshi's mission ended in defeat, the war brought far-reaching changes to Karatsu as it entered the modern era. Korean potters who had been taken prisoner and transported to Japan settled in Karatsu and, working from a local tradition dating back to the 14th century, developed a painted ware inspired by the style then prevalent in their homeland. Thus, Karatsu became (and remains to this day) a major producer of a much-sought-after type of tea pottery whose dark designs and softly colored glazes are reminiscent of Korean pieces from the Yi period (fig. 172).

647 KUMAMOTO. GENERAL VIEW OF CASTLE

KUMAMOTO (Kumamoto Prefecture) 熊 本

Capital of Kumamoto Prefecture, the city of Kumamoto boasts a magnificent castle originally built in the 15th century by Ideta Hidenobu, a vassal of the Kikuchi. This noted Kyūshū family traced its roots to Fujiwara-no-Takaie (979–1044), governor first of Izumo Province, then of Dazaifu. The first castle, now called Chibajō, was enlarged about 1525 by Kanokogi Chikamasa and passed first to the Ōtomo—one of its scions, Yoshishige (1530–1587), took in the Jesuit missionary Francis Xavier in 1551—then to the Ōtomo's enemies, the Shimazu.

533

648 KUMAMOTO. CORNER TOWER ON CYCLOPEAN
MASONRY FOUNDATION

In an attempt to establish order and quell feudal strife, Toyotomi Hideyoshi (1536–1598) bestowed the castle on Sasa Narimasa (1539–1588) and, after forcing Narimasa to commit suicide, to Katō Kiyomasa (1562–1611), hero of the Korean expeditions of 1592 and 1597 and implacable foe of Christianity.

In 1599 Kiyomasa undertook to rebuild the castle on a grander scale, and even today we can imagine how impressive it must have been. The Katō, however, incurred the wrath of the Tokugawa, who dispossessed them in 1632 and handed over the castle to the Hosakawa, who remained there until 1868.

With the Meiji Restoration, war seemed about to sweep again over Kumamoto: in 1876 some former *samurai* rose up against the government decree abolishing their class and shut themselves up in the old castle. The smoldering Korean question led to the Satsuma revolt in 1877. Saigō Takamori (1827–1877), a champion of imperial restoration but not of the government views concerning Korea, mustered an army and laid siege to Kumamoto, which was defended by Colonel Tani Takeki (born 1837). Fifty days later, the government army was rescued by Kuroda Kiyotaka (1840–1900). Kumamoto Castle suffered greater damage during the weeks of this bloody siege than in the previous three centuries. All that remains today are a few splendid towers perched above cyclopean foundations and some gateways linked by defensive walls.

OKINOSHIMA (Fukuoka Prefecture) 沖ノ嶋

The turbulent waters of the Genkai Sea provide the setting for Okinoshima, an island off the coast of northern Kyūshū, near Fukuoka. Revered by Shintoists and forbidden to women, to this day it is part of the waterside shrine of Munakata and thus under imperial jurisdiction.

Excavations were undertaken in 1954 toward a better understanding of how to restore and protect the holy site. Most of the objects discovered at that time date from the Kofun period (4th–6th centuries A.D.): splendid mirrors of Chinese origin, as well as Japanese copies; harness ornaments of gilt bronze; several kinds of armor and swords; *haniwa* in the form of ships and horses; and assorted pieces of pottery. The collection of articles was the most striking ever found outside a tomb. In addition to the surprising fact that they were never buried, some of the pieces date from the Jōmon period (2nd millennium–3rd century B.C.), suggesting that worshipers visited the island at that early time. Equally intriguing is the similarity between material left at the site during the Kofun period and tomb furnishings found in the southern Korean kingdoms of Silla, Paekche, and Mimana. Tombs in southern Korea, generally speaking, have yielded little in the way of mirrors, and it would appear that Okinoshima's location made it a crossroads for Korean and southern Chinese cultures and Japanese civilization. This conclusion may not seem revolutionary today, but it did at the time of the first excavations. Okinoshima provided proof that the Japanese had indeed woven their culture from many different threads.

There is a lighthouse on Okinoshima, and fishermen now put in here; the old taboo has been violated and the island has lost much of its mysteriousness. But these changes cannot erase the memory of the faithful who for so many years looked at Okinoshima with reverence and awe.

649 OKINOSHIMA. THE ISLAND SEEN FROM THE SEA

ŌTSUKA (Fukuoka Prefecture) 王塚

On a knoll overlooking the southwest bank of a nearby river, the Ōtsuka grave mound (opened 1934) no longer has a "square end," that is, an approach corridor leading to the burial vault proper. As far as we can make out from surviving structures, this was undoubtedly a large tumulus, about 78 meters long and 30 meters high in the round section that contained the burial vault.

The burial chamber consists of two sections: a vestibule (2 meters long, 2.8 meters wide, 2.2 meters high) and the chamber proper (4.3 meters long, 3.1 meters wide, 3.8 meters high), which has a ceiling in the shape of a truncated pyramid. The lower half of the walls is made up of enormous slabs set edgewise to expose large, smooth surfaces suitable for painting. The massive lintels which rest on these cut stones at either end of the chamber (entrance and far walls) were probably also painted, but it is difficult to make out the subjects today. Stones set at the far end frame a niche designed to hold two sarcophagi, one slightly below the other. No other tomb from this period has an interior plan of such complexity.

The entire burial vault is decorated with paintings in four colors (red, yellow, green, black), including intricate designs on the slabs and traces of circles that create a stippled pattern on the ceiling walls. The meaning of the geometric motifs on the slabs—diamonds, palms, concentric circles, "towers" or "quivers"—remains a mystery. Two mounted warriors, one black, the other red, were painted on the huge corner blocks that mark the threshold of the chamber; although the paint is worn they seem as watchful as ever, astride their harnessed steeds. The "realistic" details of these two paintings are intriguing despite their awkward rendering, for they suggest that everything here, including the geometric motifs, conveys a meaningful message in a language we no longer comprehend. At least two different styles are present, indicating a stage beyond haphazard individual creation, perhaps even a group enterprise.

But its paintings are not Ōtsuka's only claim to fame. Its furnishings may well be the most splendid of

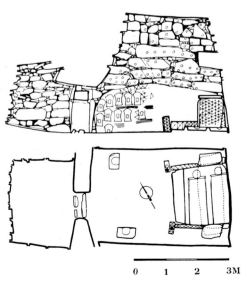

0 1 2 3M

650 ŌTSUKA. LONGITUDINAL SECTION AND PLAN
(after Kobayashi Yukio)

534

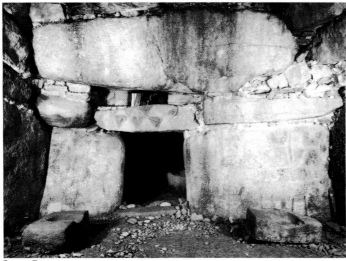

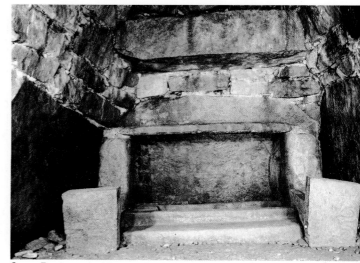

651 ŌTSUKA. ENTRANCE TO BURIAL CHAMBER

652 ŌTSUKA. PLACE OF THE TWO SARCOPHAGI
AT END OF BURIAL CHAMBER

any tomb on Kyūshū: pearls of various kinds, silver bells and ornaments, Japanese mirrors based on Chinese prototypes, fighting gear (armor, swords, iron daggers), and pieces of harness with silver decoration. The presence of Haji and Sue pottery indicates that the mound dates from the middle of the 6th century A.D.

SAITOBARU (Miyazaki Prefecture) 西 都 原

Saitobaru is the name of a large, terrace-like expanse (2600 by 4200 meters) strewn with 330 large and small grave mounds, some "keyhole" (zempōkoen), others round, still others square. The tomb cluster is divided into two sections, one for male and female dignitaries, the other for individuals of lesser rank. Excavation began in 1912.

Some of the tumuli are on a truly impressive scale. Of the thirty-two large "keyhole" mounds, those built for men are as long as 219 meters, those for women, 174 meters. Others measure 90 meters in length, while a few are noticeably shorter (32 meters in one instance).

All of the Saitobaru tumuli, regardless of size, seem to have been constructed with utmost care. The kofun lined up along the eastern edge of the terrace have the shape of symmetrical hand-mirrors rather than keyholes. Nearly all of the tombs were decorated with generous numbers of splendid haniwa.

This tomb cluster spans a relatively long period, probably over the 5th and 6th centuries A.D. Saitobaru differs from the other grave mounds of northern Kyūshū in many ways: in addition to their somewhat exceptional size, quality, and location, the tomb furnishings suggest ties with the Kinai region near Kyoto rather than with China or Korea. Apparently, Hyūga Province (now Miyazaki Prefecture), which faces Shikoku and the Inland Sea, was following the lead of the Japanese culture already crystallizing in Yamato: the continent no longer provided all the new ideas.

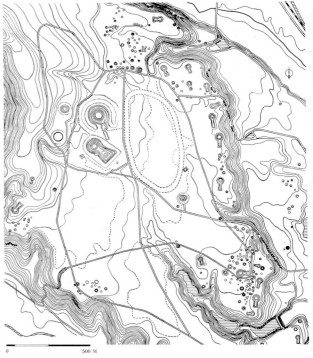

653 SAITOBARU. CONTOUR MAP SHOWING
LOCATION OF GRAVE MOUNDS AT EDGE OF
SAITOBARU PLATEAU
(drawing by Giroux, after Sekaikōkogaku Taikei)

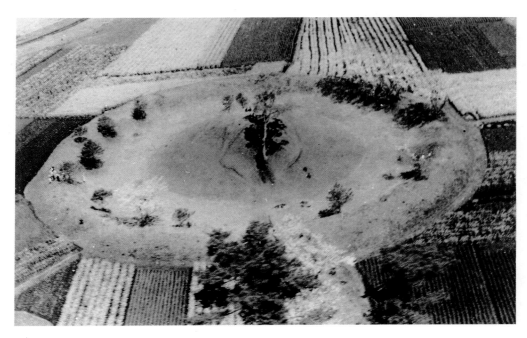

654 SAITOBARU. ONI-NO-IWAYA, ONE OF THE ROUND TUMULI

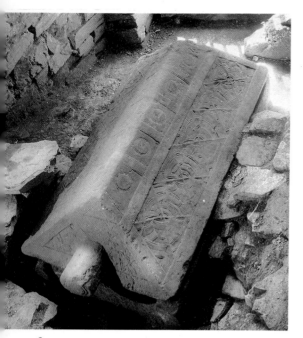

The tomb cluster of Saitobaru is peculiar to this region, but it is not unique in Japan. There are similar concentrations in Jōmō (Tochigi Prefecture), Nōbi (Gifu and Aichi prefectures), Kinai, and Izumo (Tottori and Shimane prefectures)—an indication of the authority wielded by local clans at the time. However, at no other site can one find such concern for regular construction of high quality, standards maintained by the people of the region for two hundred years.

655 SEKIJINYAMA. ROOF-SHAPED
SARCOPHAGUS LID (YANEGATA)

SEKIJINYAMA (Fukuoka Prefecture) 石 人 山

This ancient tomb (*kofun*) in Fukuoka Prefecture is in the classic "keyhole" shape (*zempōkoen*), but it includes a *sekijin* (literally, "stone man"), or primitive anthropomorphic carving, at the entrance to the circular tumulus above the burial vault. The figure is dressed in short armor and bears traces of red paint.

Given its total length of 110 meters, the Sekijinyama tumulus was obviously conceived on a fairly grand scale, and remains of the moats which once encircled it can still be detected along the periphery. The grave mound is too heavily damaged to determine the original height of the burial vault; it was 4 meters long and 2.1 meters wide, narrowing to 1.6 meters at the far end. The top of the tumulus is strewn with stones, including flat slabs which must once have decorated the interior.

The monument now appears much destroyed, and archaeologists excavating the site in 1938 found the tomb furnishings missing. The sarcophagus, however, one of the most splendid ever discovered, is still in place. Its magnificent roof-shaped lid (*yanegata*), hewn from a single block of stone, is embellished with *chokkomon* motifs, and massive handles at either end are extensions of the same block. The lid (2.8 by 1.5 by 1.3 meters), once lifted into place, was apparently never moved again. But a "door" is cut into one of the short sides, probably for offerings (assuming there were any) to be slipped inside the sarcophagus. Time has robbed the incised designs (*chokkomon* and circles in squares) of their original sharpness, but the low-relief technique and double lines are similar to motifs in the Senzoku tumulus (fig. 624).

This superb *kofun* probably included other stone figures as well as decorative *haniwa*, but the tomb has been known since ancient times, and most have now vanished. It is worth noting that the Sekijinyama tumulus is located in southern Fukuoka Prefecture, a region where *kofun* are relatively abundant and appear to be concentrated north of the Yabe River, which empties into Ariake Bay.

656 SEKIJINYAMA. SECTION OF THE
SARCOPHAGUS AND DRAWING OF SIDE "DOOR"
LEADING INTO THE SARCOPHAGUS
(*after Kobayashi Yukio*)

TAKEHARA (Fukuoka Prefecture) 竹 原

The far wall of the small tomb at Takehara (discovered 1956) is covered with an astonishing painting (fig. 17) which makes it one of the most original, if not the most beautiful, of the archipelago's "decorated tombs" (*sōshoku kofun*).

The tumulus we see today is round, but probably it was once a "keyhole" mound (*zempōkoen*) which lost its projecting square section over the years. The mound must have stood 5 meters high and had a total length of approximately 30 meters, including entrance passageway.

The present length of the tomb, which is entered from the southwest, is but 6.7 meters; for so complex a plan (corridor, anteroom, vault), it is a diminutive monument indeed. The remarkable paintings inside are mostly in red and black with traces of green.

Paintings decorate the walls of both the anteroom and the burial vault. Although they clearly "represent" something, their exact meaning has yet to be determined. However, the dragon that dominates the composition on the far wall (1.4 by 2 meters) of the burial vault is almost certainly one of the animals used by the

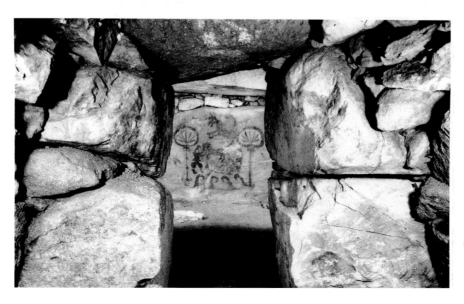

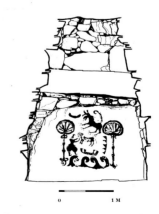

657 TAKEHARA. BURIAL CHAMBER,
AND PAINTING ON THE FAR WALL

Chinese to symbolize the cardinal points (in this case, east). Presumably the main subject—a man, a horse, a ship and waves, framed by a pair of fans or parasols—has something to do with the voyage of the deceased into the hereafter, at least so we infer by comparing it with certain tomb paintings in China from the Northern Wei dynasty (386–534 A.D.), or in the kingdom of Kokuryō in northern Korea. There can be little doubt that the Takehara frescoes reflect an important continental influence, here perhaps more clearly, near Fukuoka, than in other regions of Kyūshū.

Naturally, much has been written about this large painting. Some believe it to be a Chinese-style scene depicting the kingdom of the dead; others, such as Prof. Kanaseki Takeo, lean toward a more "Japanese" interpretation, and see a link to local legends. Perhaps it tells how the dragon, a sea god, created horses for man's use; perhaps this horse is an emissary of the dragon god. Everyone agrees that there is no other painting in Japan quite like the one at Takehara and that the artists borrowed heavily from the continent.

One last mystery: the district in which Takehara is located has only two circular *kofun* and no "keyhole" tumuli (*zempōkoen*). Judging by the sumptuous decoration, the person interred at Takehara must have been someone of special rank, most likely the head of a clan. Tsukushi Kurahashi, legend has it, founded Tsukushi, a region that became Chikuzen and Chigugo provinces, then Fukuoka Prefecture; it has been suggested that this was his tomb.

658 TAKEHARA. SECTION OF ANTEROOM
(after Kobayashi Yukio)

659 TAKEHARA. PLAN OF TOMB
(after Kobayashi Yukio)

KYOTO AND VICINITY

KYOTO 京 都

Like Japan's first permanent capital at Heijōkyō (Nara) in the 8th century, Kyoto, first named Heian, the present-day cultural capital of the nation, was laid out on the model of Changan (Xian), the Chinese capital of the Sui (581–618) and Tang (618–907) dynasties. This rectilinear checkerboard plan, as old as the Chinese empire itself, took into account the peculiarities of wooden architecture as well as a concept of space based on five cardinal points (the four Easts and the center) and five elements (wood, fire, earth, metal, water); the smooth progress of world history was thought to depend on the joining or alternating domination of these elements. This plan was particularly well suited to the vast lowlands of the Yellow River basin, where a society had grown which tended toward intense spurts of centralization. To shift this layout to the mountainous terrain of Japan might have presented difficulties had not local architects adjusted the scale of the original plan to suit the reduced area of their geographical region.

660 KYOTO. RECONSTRUCTION OF
PALACE FROM THE HEIAN PERIOD
(after Dr. Mori Osamu)

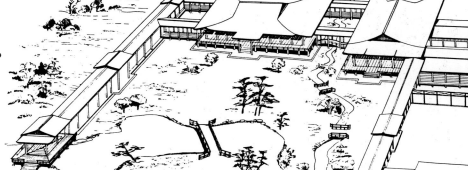

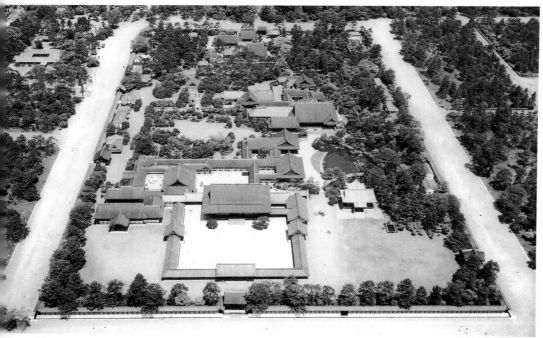

661 KYOTO. IMPERIAL PALACE TODAY

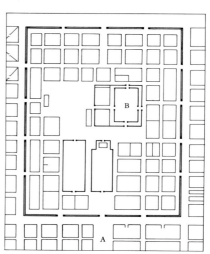

662 KYOTO. PLAN OF IMPERIAL PALACE COMPOUND
(HEIAN PERIOD) *(after Nihon Bunkashi Taikei)*
A Sujaku-mon Gate
B Dairi (imperial residence)

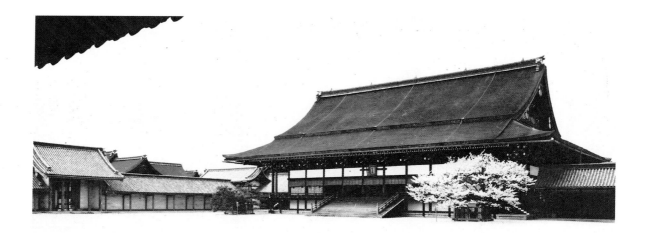

663 KYOTO. IMPERIAL PALACE. AUDIENCE HALL (SHISHINDEN)

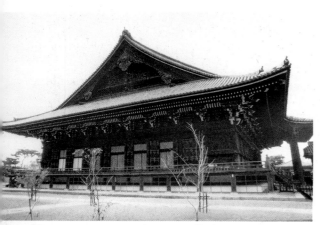

664 KYOTO. CHIONIN (REBUILT 1639)

The city was a perfect rectangle divided into countless small blocks defined by straight, perpendicular streets (see p. 501). A broad thoroughfare ran directly up the middle from the southern gate of the city, dividing it into Sakyō on the left (east) and Ukyō on the right (west). At the northern end stood the imperial palace.

The intersection of two north–south streets and two east–west streets—these could be either wide roads (ōji) or narrow lanes (kōji) with small adjoining canals—formed the basic urban unit, the *chō* or *machi* (a "block" of about three acres). Four *chō* made up a *hō* (district); four *hō*, a *bō* (ward). All eight *bō* ran east to west along the wider arteries (numbered one through nine, like New York's avenues), which thus formed the boundaries of the city's major subdivisions.

This rigorous grid was used in China for walled cities, to make enclosures whose every district was a self-contained unit with its own administrative center and police force. A number of complex factors had transformed the walled city of the Tang dynasty into a kind of gargantuan administrative machine designed to keep the government running smoothly and potentially rebellious groups in line. But in Japan, this city structure was usually more open, more elastic. Momoyama fortress towns fostering a rigid social stratification were not uncommon in the late 16th and early 17th centuries, but concentrations of this type were geared to defense, not administration. Although Heian was, it appears, originally ringed with an earthen embankment broken by eighteen gates, most Japanese cities have as their official limits only roads, rivers, or gates, and however intimidating or coercive these may seem, their value is primarily symbolic.

The two most celebrated gates in Kyoto are *Sujeku-mon* ("Sparrow Gate") in the southern wall of the

532

imperial palace and, at the southern end of the city, the *Rasei-mon* (or *Rashōmon*) which marks the beginning of the thoroughfare that divides the city into "left" (east) and "right" (west) sectors. This splendid two-story structure straddling the road consists of two pavilions and a gallery, its tiled roof resting on Chinese-style vermil-ion columns. An example of the essentially intellectual role of these symbolic boundaries, Rashōmon was origi-nally left unguarded, and consequently all sorts of vagrants and hapless creatures came here in search of lodging. (The account in the story of the novelist Akutagawa Ryūnosuke, written in 1915, was to inspire the screenplay of one of the finest films made in postwar Japan.)

In view of the Chinese cosmogony that inspired Kyoto's plan, it was said that the city was like a mandala, a prayer map or world map whose every element had universal meaning—a notion that crystallized only after esoteric Buddhism spread throughout Japan, however, over a century after the city was founded.

By looking at modern Kyoto we can tell that the city grew more or less along the lines of its original plan, but Heian saw its "right capital" to the west (Ukyō) fall into decay, while the "left capital" (Sakyō) flour-ished and spread to the foot of Higashiyama, the mountains which rise to the east of Kyoto. This lopsided devel-opment began to manifest itself soon after the city was founded, and reflected certain factors that made growth in Ukyō unfeasible. By 825 the Dajokan (chief sub-imperial office) was so concerned about the "decline" that it granted Ukyō exclusive rights to sell fabric, leather, oil, and pottery: Ukyō, if not successful as a residential area, could perhaps be encouraged as a commercial district. The official in charge of the "Eastern Market" (Higashi Ichibe) protested in 849 against these unfair monopolies, which were then lifted. When the western side of the capital again degenerated into a wasteland, the government reintroduced special trade licenses, but only the northern reaches of Ukyō retained the semblance of a city; the southern part quickly reverted to rice fields.

Heian continued to grow from Sakyō eastward. Although Emperor Saga (r. 809–823) tried to reverse the eastward trend by building a summer residence west of the city, Heian soon expanded beyond what had been Sakyō's eastern boundary, the Kamo River.

The city was favorably located on a plain that stretched southward to Ōsaka Bay; it was the hub of the highway system leading to the east, the west, and the Sea of Japan (and from there, to Korea). Its network of strategically positioned canals minimized the danger of fire. It did endure a thousand years, but time and again it reeled from the blows of its chief scourge, feudal strife, which, in a country so sheltered from foreign invaders, meant civil war. In the 12th century came the struggles between the Minamoto and Taira families, then the chaotic wars of the 15th century under the Ashikaga: both times Kyoto was reduced to ashes. It seems miraculous that even a single palace, the Byōdōin, should have escaped the flames, probably saved by its loca-tion outside the city enclosure. Nor were all the disasters Kyoto suffered the work of man. There were a number of earthquakes, and not a summer passes that the Kansai region is not battered by typhoons.

Today we admire the gorgeous Momoyama monuments which survived those turbulent years and were maintained and in some cases completed and embellished during the three centuries of peace that the Tokugawa government brought to Japan. But the inhabitants of Kyoto themselves were rarely in a position to appreciate the aura of grandeur and might surrounding them, and ancient texts give a truer picture of their life. The *Diary of Sarashina*, written by the daughter of Sugawara-no-Takasu, who in 1017 was appointed lieutenant governor of Kazusa Province (now Chiba Prefecture), describes her return to the city in 1020, after a three-year absence: "We stop at Awazu and enter the city on the second day of the twelfth moon. Since we wished to arrive at nightfall, we do not depart until the Hour of the Monkey. On a hillside near the gate we notice the head of a 16-foot-high Buddha, scarcely roughed in, peeking at us above a flimsy fence. We pass by, admiring from afar this Buddha in its touching solitude. In all the provinces we have traveled through [since Kazusa], no place moved me as much as the Kiyomi Gate in Suruga Province and the Ōsaka Gate here. It is pitch black as we enter the city west of the Sanjō Palace: this place is so vast and desolate that you think yourself to be not in the city, but in the highlands. The immense trees here create a feeling that is every bit as sinister as the moun-

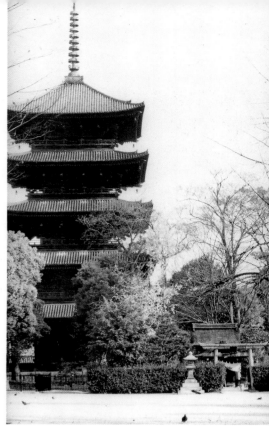

665 KYOTO. TŌJI PAGODA

666 KYOTO. AN ENTRANCE TO THE CITY

667 KYOTO. AN ENTRANCE TO NISHI-HONGANJI

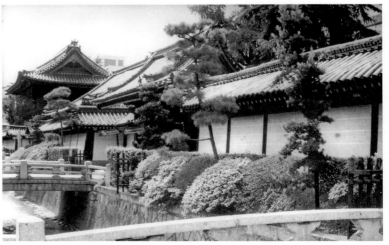

668 KYOTO. ENCLOSING WALL OF NISHI-HONGANJI (REBUILT IN 18TH CENTURY)

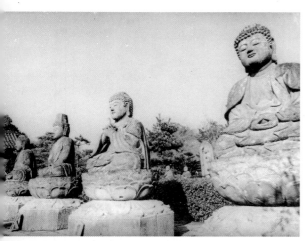

669 KYOTO. "PATH OF THE BUDDHAS" IN NINNAJI

670 KYOTO. MOSS GARDEN IN TŌFUKUJI
(see fig. 773)

tains we have just crossed." One building in disrepair does not mean that the entire city had gone to ruin, but Sarashina's account has unsettling overtones when we recall that the Sanjō intersection was only two blocks from the imperial palace.

The imperial palace compound was known as Daidairi, literally "great great inner place," and within stood an unusually dense cluster of more than fifty buildings (apart from the imperial residence) as well as the audience courts (Chōdōin or Hasshōin). This Heian grouping was the culmination of a development which probably began with the "itinerant capitals" period of the Sucho era (686–701) and ended when the palace was abandoned in the Antei era (1227–1229) after real power had shifted to Kamakura.

Fourteen gates led into the palace compound (450 by 384 *jo*, about 1300 by 1100 meters): four on each east–west side, three on each north–south side. The main entrance to Daidairi was the great central gateway facing south, the Sujaku-mon, but every gate, regardless of location, stood at the terminus of an avenue. Within the enclosure buildings were grouped so that their pavilions, gardens, and courtyards formed self-contained units reminiscent of Chinese urban design.

The actual imperial residence was called Dairi (or Kōkyō, as people still call it in Tokyo today). Unlike the layout at Nara, the imperial residence of Heian was in the northeast sector of the Daidairi precinct, not in the center. Within its walls stood more than twenty-five pavilions connected by veranda corridors.

Construction of the new capital began at the Kōkyō in 793; Emperor Kammu moved in the following year. The imperial residence was continually being rebuilt or repaired in the wake of the calamities and accidents it endured during the next four hundred years. A list of only the major disasters would include: the catastrophic fire of 960 (fourth year of the Tentoku era); a fire in 1005 so intense that the sacred Sword and Mirror (albeit only copies, even then) melted in the inferno; another fire in 1058, even as reconstruction was under way, and yet another in 1082; a typhoon in 1150 which left practically the entire compound in ruins; the so-called Bunji fire (named after the Bunji era: 1185–1189) during the wars that marked the creation of the shogunate and the *bakufu* at Kamakura. In 1189 the emperor called upon Minamoto-no-Yoritomo (1147–1199) to rebuild the imperial residence, who in turn called upon all the provinces to contribute to the project, but ultimately the work itself became the obligation of the court. The emperor moved into the new buildings in 1212, but his stay was short, for in 1219 the Dairi was destroyed in the fire which Minamoto-no-Yorishige, accused of conspiracy while on palace duty, set before committing suicide. Attempts at rebuilding were thwarted by the uprisings which left imperial authority weakened forever: first the Jōkyū Rebellion (1219), which pitted faction against faction within the *bakufu*; then the Engen Rebellion (1336), which led to the division of Japan into Northern and Southern dynasties and to the advent of the Ashikaga shōguns.

This will help to explain why the emperors, ever since moving to Kyoto, built or arranged to live in "detached palaces" (*rikyū*) or "country palaces" (*sato-dairi*). Aside from the pleasant change of scenery and the respite from stifling ceremonial life, it afforded a solution to the problem of where to "lodge" the court in an emergency, a matter originally arranged by temples or by ministers who offered the emperor a place to stay. This had first happened in 976, when Emperor Enyu stayed with a high-ranking government official—Fujiwara-no-Kinsue (958–1029), prime minister and president of the Supreme Council (*dajodaijin*), and such arrangements eventually became a tradition.

In time the very concept of imperial authority became raised—or reduced—to a purely symbolic level, and the architects of "detached palaces" tended to include increasing emphasis on leisure and relaxation in their designs: the *rikyū* came to represent an aesthetic masterwork of the country. This first began in the 17th century, when the transfer of the shogunate to the Kantō region caused Japan's political center of gravity to shift away from Kyoto.

In the four hundred years which have since elapsed, the capital has basked in the memory of its former grandeur, but this dream was haunted by the nightmarish specter of civil war, and by the trauma of savoring momentary joys only to see them engulfed in flames. Perhaps nostalgia for a bygone age accounts for the sensation one experiences only in Kyoto, despite the bustle and congestion of a city which can often lack other redeeming aesthetic values.

For Kyoto had the wisdom to protect its so-called "living treasures" (craftsmen who hold on to time-honored techniques) and traditional industries. Today the city is known for being one of the few places where the small-scale production of luxury items still thrives. Probably the most venerable of these "Kyoto trades" is weaving: weavers set up shop there when the court did, in 794, and the courtiers came to depend on them for their indispensable ceremonial brocades. Chinese artisans arrived during the Kamakura and Muromachi periods to swell the ranks of the weaving industry, which halted temporarily during the civil strife of the 15th century, then revived again under the Tokugawa. Lacquerware, embroidery, and dyeing followed a similar pattern of growth. A more recent addition was pottery, which flourished thanks to the tea ceremony—Raku tea bowls are an instance (figs. 171, 529), and the genius of such artisans as Nonomura Ninsei (d. c. 1660), who worked delightful magic with colored enamels (figs. 527, 528, 530).

Kyoto is a city of countless temples, which seems curious when we realize that none was built in the city at first, to ensure no recurrence in the new city of Nara's dangerous blend of religious and political power—the emperor's main reason for leaving the old capital. However, temples established outside the city were soon engulfed by it, and many pavilions or dwellings which aristocratic families used as private chapels became converted into places of meditation or worship upon the owner's death. The law forbidding anyone to build a monastery within the walls of Kyoto was no longer in force by the early Kamakura period and, indeed, had not been operative as far back as the second half of the Heian period (c. 11th–12th centuries).

Admiring citizens of Kyoto say that theirs is a city of "two thousand temples"; we shall not attempt to describe or even to enumerate them all, but will confine ourselves to those temples or palaces that typify

the Kyoto style and witnessed—and weathered—turbulent, often tragic events of the city's past. They remain the incarnation of that "Japanese soul" (*Yamato Daishi*), and one must appreciate these buildings if one is to understand the Japan of today.

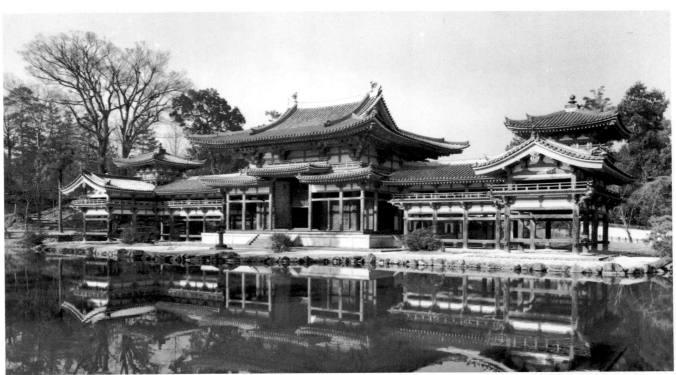

671 BYŌDŌIN. GENERAL VIEW

BYŌDŌIN (Uji, near Kyoto) 平等院

Uji, a town near Kyoto, is famous for its superb tea and its beautiful Uji River, an overflow of Lake Biwa (fig. 404). South of Kyoto, the Uji merges with the Katsura to form the Yodo River, which empties into Ōsaka Bay.

Fujiwara-no-Michinaga (966–1027)—the noted *kampaku* ("Mayor of the Palace") who for thirty years was *de facto* head of the Japanese government—chose the east bank of Uji-gawa as the site of his residence. His elder son, Yorimichi (992–1074), wielded much the same authority for half a century and replaced Michinaga's unremarkable house with a fairy-tale palace, a replica of the Western Paradise as depicted in the Dunhuang cave paintings in western China of the Tang dynasty. The pivotal role played by the concept of paradise in the development of Chinese landscape painting is well known, but its impact on architecture is often underestimated or overlooked. Starting with the system of columnar buildings on stone platforms and connected by covered corridors, Chinese painters and architects alike visualized enchanting successions of pavilions and covered galleries where the blessed were believed to walk endlessly as they viewed gardens filled with peacocks and fabulous birds. The "heavenly vision" theme doubtless affected the evolution of Tang architecture, but the cave paintings at Dunhuang are our only evidence that this form of building ever existed, for the Chinese buildings inspired by this theme vanished in the wake of the ban on foreign religions in 845 and other events in China's turbulent medieval history.

It was much the same story in Japan, for virtually nothing built during the Heian period has survived. Thus, it seems miraculous that any building, much less Yorimichi's spectacular villa, should have emerged unscathed from that strife-ridden era. More than an example of the *shinden* style of Japanese architecture, it is a living embodiment of the spirit of the Heian times, steeped in the serene visions of a redeeming and compassionate Buddhism. But precisely this state of mind led its aristocratic votaries toward political inefficiency and decline. Safe within the capital and wholly absorbed in artistic pursuits, the Fujiwara found themselves, a century later, eclipsed by the Taira, the Minamoto, and other powerful military clans from the provinces, groups

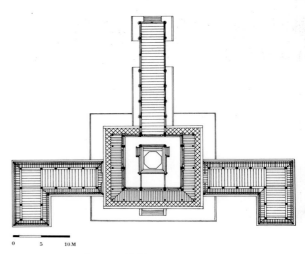

0 5 10 M

672 BYŌDŌIN. PLAN
(drawing by Giroux, after Ota Hirotarō)

541

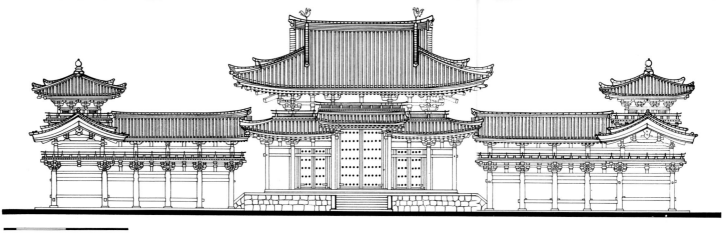

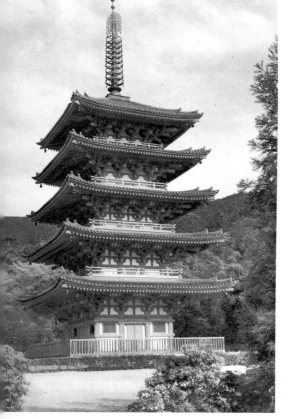

673 BYŌDŌIN. FRONT ELEVATION
*(drawing by Giroux,
after Nihon Bunkashi Taikei)*

better attuned to the social and economic needs of the time and thus able to swell their ranks with devoted followers. The Byōdōin was built in 1053: Yorimichi retired there in 1068 after transferring the office of *kampaku* to his brother Norimichi (996–1075).

The main building, including the long rear gallery extension, is flanked by wing corridors which lead to outer pavilions at either end (fig. 32); the suggested resemblance of this plan to the silhouette of a bird in flight—plus the bronze finials of male and female phoenixes on the roof of the main building—inspired the name Hōōdō, or Phoenix Hall. The complex is mirrored in a lotus-flecked lake which reflects the cadenced procession of lacquered red columns and green-tiled roofs. Here Yorimichi presided over magnificent celebrations, while his son-in-law, Emperor Go-Reizei (r. 1046–1068), came to savor the pleasures of boating.

The Byōdōin was apparently intended from the start to be both a residence and a temple, as was often the case in Japan; after Yorimichi's death it continued to be a place of worship. The renowned gilt-wood statue of Amida in the Phoenix Hall (Hōōdō) is attributed to Jōchō (figs. 51, 264), the noted 11th-century sculptor credited with perfecting the *yosegi*, or "joined-wood" technique of wood sculpture using several pieces of wood. Captivating low reliefs representing music-playing deities hang all along the lower register of the walls (figs. 272, 273). Painted floral designs strew the coffered ceiling, partly decorated also with bronze mirrors. The paintings which once covered the stationary and movable wooden partitions are virtually undecipherable today, but those on the wooden doors to the left of the effigy of Amida have been restored, perhaps overzealously (fig. 45), and tranquil scenes of the Kyoto countryside unfold before us in the blue and green style typical of Tang painting. On the opposite side of the lake, directly across from the Hōōdō, Yorimichi had a smaller structure built, and when the doors of the Phoenix Hall were opened the sacred countenance of Amida could be seen from this vantage point, looming through a break in the wooden trellis which was designed to block out the rest of the temple.

In addition to being a rare and impressive example of Fujiwara culture, the Byōdōin at Uji recalls the many fatalities that occurred in the feudal wars over control of the bridge spanning the Uji River, built, it is said, by the monk Dōchō in 647 (fig. 404). The Uji bridge not only stands near a ford, but it overlooks the best road leading from Kyoto to Yamato and all of eastern Japan.

In 1189, after being defeated by Taira-no-Kiyomori (1118–1181), Minamoto-no-Yorimasa (1106–1180) committed suicide in the Byōdōin enclosure by *seppuku*, a swordthrust to the abdomen. But four years later the wheel of fortune came full circle at Uji, for there Minamoto-no-Yoshitsune (1159–1189) routed the forces of Taira-no-Yoshinaka, an event which marked the demise of the Taira and the ascendancy of the Minamoto. Legend has it that during this battle, two of Yoshitsune's generals, Sasaki Takatsuna and Kajiwara Kagetori, jousted for the honor of being the first to cross the river on horseback into enemy fire. This epic theme became a favorite subject among screen painters.

DAIGOJI 醍醐寺

Daigoji was founded in 874 by Shōbō (posthumous name Rigen Daishi, 832–909), the son of a prince of the imperial family. An affiliate of the Shingon sect of esoteric Buddhism, this temple is one of the two great centers of the ascetic Shugendō movement which stresses self-denial, self-discipline, and deep devotion.

674 DAIGOJI. FIVE-STORY PAGODA

675 DAIGOJI. SEIRYŌGŪ HAIDEN
(GOLDEN HALL)

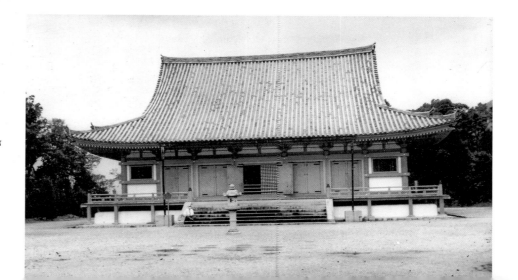

The Seiryōgū Haiden (Golden Hall) of Daigoji is a large structure with a central aisle and two narrower side aisles. Originally built in 1089, it burned down in 1410 in the civil wars which devastated much of Kyoto. The building we see today is a reconstruction dated 1434.

A thatched roof enhances the majestic, evenly balanced proportions of the Seiryōgū Haiden; on the short side containing the door, the elegant front porch is an example of the opulence already working its way into late Muromachi and Momoyama architecture.

The five-storied red pagoda, built in 951 at the behest of Emperor Murakami (r. 947–967), is a marvelous example of Heian art at its purest (fig. 34).

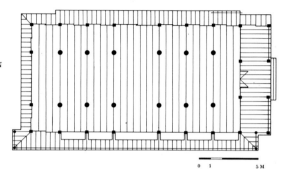

676 DAIGOJI. PLAN OF SEIRYŌGŪ HAIDEN
(drawing by Giroux, after Kokuhō)

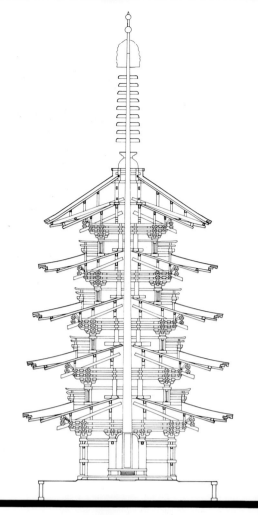

677 DAIGOJI. CROSS SECTION OF PAGODA
(drawing by Giroux, after Propyläen Verlag)

DAIKAKUJI 大覚寺

Three emperors are venerated at the Shingon temple of Daikakuji: Saga (r. 809–823), Go-Uda (r. 1274–1287), and Go-Mino-o (r. 1612–1629). Here, too, people come to pay homage to the temple's distinguished founder, Kūkai (posthumous name Kōbō Daishi; 774–835), who, with Saichō (767–822), brought their esoteric Buddhism to Japan.

The history of Daikakuji is complicated because it was originally the palace of Emperor Saga, and even today the temple has a "residential" air about it. The emperor selected this spot northwest of Heian as the site for a *rikyū*, or detached residence. Artists and men of letters gathered at the villa at his behest, and he retired there after his abdication in 823. His sister, a nun, soon joined him and stayed on after Saga's death in 843. When she died (876), the residence was converted into a temple by Emperor Junna. But the hold exerted over the imperial family by this *rikyū* was still strong four and a half centuries later; Emperor Go-Uda decided to join his father, ex-Emperor Kameyama (r. 1260–1274), at the villa after abdicating in 1287, and Daikakuji became the home of an entire branch of the imperial family that is known as the "Daikakuji line."

Daikakuji ceased to be an imperial residence from Emperor Go-Kameyama (r. 1373–1392) onward, but the son of Emperor Go-Mino-o, Sōshin Hōshinnō, served there as abbot in the 17th century, adding luster to its already distinguished history. The buildings we see today, albeit designed in accordance with the *shinden* style of Heian architecture, date only from the Empō era (1673–1681). They are rich in paintings by Motonobu, Eitoku, Sanraku, Tan-yū, Kōrin, and others.

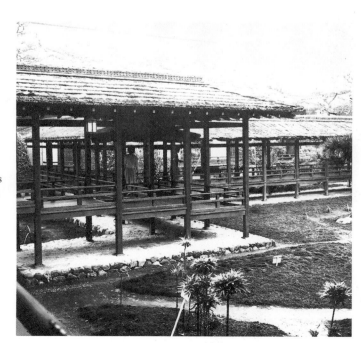

678 DAIKAKUJI. COVERED GALLERIES
CONNECTING TEMPLE BUILDINGS

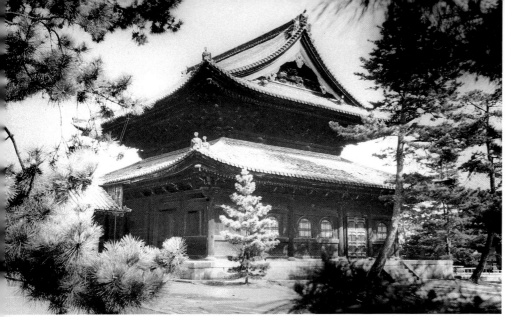

679 DAITOKUJI. LECTURE HALL (HATTŌ)
IN THE DAITOKUJI ENCLOSURE

DAITOKUJI 大徳寺

Daitokuji, head monastery of the Rinzai sect of Zen Buddhism, had a lasting effect on religious activity in Kyoto during the Muromachi period. Even today, sightseers and pilgrims alike settle into a tranquil, meditative mood as they stroll about the many buildings and small temples which comprise this sprawling complex.

Before gaining imperial protection and its present name, Daitokuji (literally, "Temple of Great Virtue") was an unremarkable little sanctuary which Akamatsu Norimura (1277–1350)—a prominent general-monk whose crucial support helped bring the Ashikaga shōguns to power—built in 1309 to honor the Zen priest Myō-chō (1282–1337). The combined reputations of Akamatsu Norimura (religious title: Enshin) and Myōchō soon caught the attention of Emperor Go-Daigo (r. 1319–1338), who ordered the construction of a *garan*, or full-fledged monastery enclosure. Abdicated Emperor Hanazono (r. 1308–1318) waxed still more enthusiastic about Daitokuji, ranking it above even the *Gosan*, the five great Zen monasteries of Kyoto. In 1324, the privileged status of Daitokuji was made official: Hanazono and Go-Daigo each issued a document proclaiming it the preferred Zen monastery of the imperial court.

When work was completed in 1326, the monastery consisted of four temples situated at the four points of the compass. Unfortunately, everything burned in 1453, and attempts at reconstruction were repeatedly interrupted by the civil wars which devastated the Kyoto region during the 15th century. In 1473, Emperor Go-Tsuchimikado (r. 1466–1500) ordered work resumed, and slow progress was made despite a dramatic depletion of the imperial and public coffers.

Daitokuji reached its zenith in the 17th century, particularly during the Kambun era (1661–1673), when no fewer than twenty-four sub-temples lay within the sacred precinct of 71,700 *tsubō* (more than 9 acres), many boasting masterpieces of ancient Japanese art. The celebrated tea master Kobori Enshū (1579–1647) designed the garden for the main building (Hōjō); the Hōjō contained sculptures from the former palace of Toyotomi Hideyoshi (1536–1598) at Momoyama (Fushimi). Here, too, stood the palace of the empress—wife of Ogimachi (r. 1558–1586)—with its famous sliding screens (*fusuma*) decorated by Sōami (1485?–1525) and Kanō Eitoku (1543–1590). The spirit of Sōami also pervades the celebrated dry-landscape garden of Daisen-in, or abbot's residence, which Kogaku Sōkō opened in 1509 (fig. 764): here the aim was to create an entire world in minia-

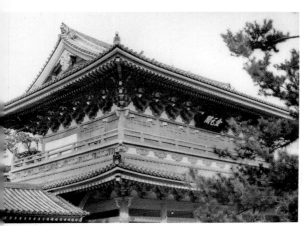

680 DAITOKUJI. PAVILION OF BUDDHA HALL

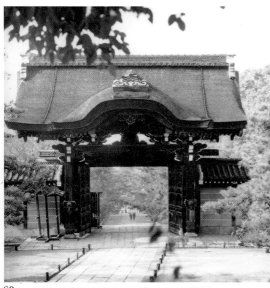

681 DAITOKUJI. CHOKUSHI-MON GATEWAY
(IMPERIAL MESSENGERS GATE)

682 DAITOKUJI. "MORNING OCEAN"
SOUTH GARDEN OF DAISEN-IN

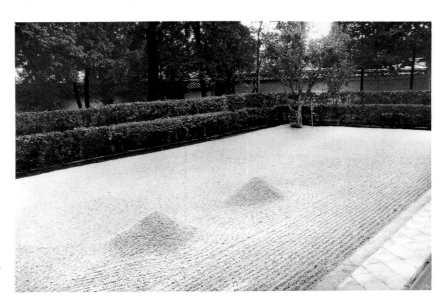

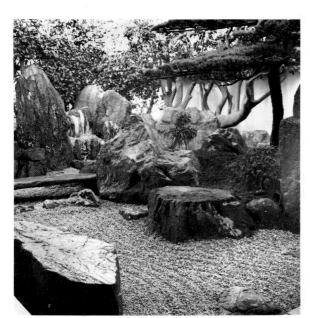

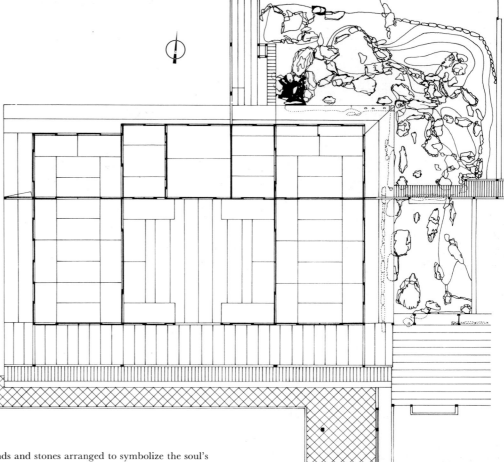

683 DAITOKUJI. DRY-LANDSCAPE EAST GARDEN OF DAISEN-IN

ture—lawns, rivers, forests, mountains—using only different sands and stones arranged to symbolize the soul's journey on earth. From the Island of the Turtle (material life), one makes one's way to the Rock of Mercy and the Bridge of Existence, then to the Island of the Crane (spiritual life) and finally to the Sea of Eternity. The "morning ocean" garden on the south side is an area of light-colored sand, carefully raked into hypnotic parallel lines and concentric "waves" rippling about two conical mounds and one small tree recalling that under which the Buddha died. The Daitokuji gardens can be fully appreciated only in favorable weather, when the *shoji* (sliding doors of wooden frames and translucent paper) are open and viewers contemplate the scene from indoors while seated on mats, experiencing simultaneously the allegorical journey through the dry-landscape gardens and the spectacular, but austere *fusuma* paintings of Kanō Motonobu (1476–c. 1559).

For devotees of Zen and the tea ceremony, one of the most moving spots at Daitokuji is the Juko-in at the extreme northwest corner of the enclosure. Here is the tomb of Sen-no-Rikyū (1521–1591), the favorite of Toyotomi Hideyoshi (1536–1598), who was forced to commit suicide for refusing to offer the dictator his daughter's hand in marriage.

684 DAITOKUJI. PLAN OF DAISEN-IN
(drawing by Giroux, after Ota Hirotarō)

FUSHIMI 伏見

Today, nothing remains of the castle to which Toyotomi Hideyoshi (1536–1598) planned to retire after handing the reins of government to his son, born in 1593. Begun in 1594, then demolished a quarter century later by Ieyasu, it must have been one of the most splendid fortified castles on Japanese soil. No doubt this is why it remained so deeply etched in the nation's memory.

According to contemporary accounts, it consisted of a three-story central tower (*honmaru*) flanked by four wings (Tenshudai on the northwest, Nishimaru on the southwest, Matsunomaru on the northeast, and Nagoya-maru on the southeast). Within the castle enclosure proper, which lay north of the Uji River, stood the head-quarters of the Masuda, the Ishida, the Nagatsuka, and other feudal lords on friendly terms with the dictator; other *daimyō* resided on a level stretch of land to the west. Ships could make their way from the sea directly into the citadel by way of a canal running through the castle enclosure to the southeast. Fushimi Castle was renowned for its tiles covered with gilt decoration, and judging by the few pieces found recently by archaeologists, the dwellings of the *daimyō* boasted gilt tiles as well.

There was nothing haphazard about Hideyoshi's choice: Fushimi was strategically located almost directly on the road linking Ōsaka to Kyoto. Moreover, it was here that the poet and statesman Fujiwara-no-Yoshi-tsune (1169–1206) had built an imperial "villa" (*rikyū*) that became a favorite residence of Emperor Go-Saga (r. 1243–1246). In 1401, however, that *rikyū* burned down, and though rebuilt, it had ceased to be the residence of emperors in the 16th century, but the temples established on the site helped to keep alive the days of imperial glory. The long, distinguished history of Fushimi doubtless affected Hideyoshi's decision to move here.

545

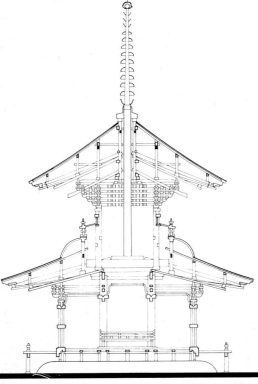

685 ISHIYAMADERA
(drawing by Giroux, after Ota Hirotarō)
Top: Diagram of structural framework of the Tahōtō, the square roof positioned above the domed lower story
Above: Section of the Tahōtō

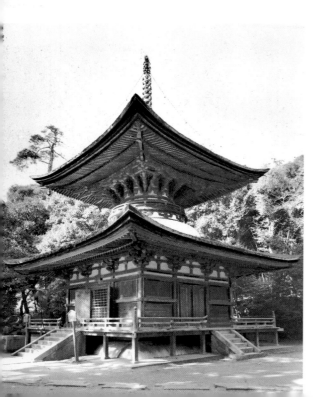

Built on the massive masonry foundations that were typical of military architecture at the time, the fortress first met with disaster in the violent earthquake of August 1596 which caused widespread damage throughout the Kyoto region. Repairs must have proceeded briskly, for two months later Hideyoshi was making preparations to welcome emissaries from the Chinese emperor Wan-Li (r. 1573–1615). Even the dictator's death in 1598 did not interfere with the ongoing reconstruction of the stronghold. The star of Fushimi began to fall in 1600, however, when the castle was stormed and taken by that enemy of the Tokugawa, the *daimyō* Ishida Mitsunari, though Mitsunari was defeated by the Tokugawa at the battle of Sekigahara (October 21, 1600), taken prisoner, and beheaded.

A pall of death seemed to hang over the castle, and it was decided that the place where so many courageous warriors had perished should not be defiled by human feet. The citadel was gradually dismantled, its treasures transferred to nearby temples.

About a century after Ieyasu's death in 1616, peach trees were planted at Fushimi and the place came to be known as Momoyama, or Peach Hill. Today, Momoyama is the name of a key period in Japanese history which saw the dictators come to power and the Tokugawa shogunate begin its rule at Edo. And at Momoyama are buried Emperor Meiji (r. 1868–1912) and his wife, Empress Shōken.

HIEIZAN 比叡山

Mount Hiei, the mountain just to the east of Kyoto, forms a natural boundary between Yamashiro Province (the Kyoto region) and Ōmi Province (modern Shiga Prefecture). Apart from its inherent grandeur, Mt. Hiei is also a strategic site because it overlooks the Kyoto plain, and a place where monasteries could find austerity far from the compromises of city life.

The first temple to appear on Mt. Hiei was Enryakuji, founded in 788 by Saichō (Dengyō-daishi; 767–822), the monk who together with Kūkai (774–835) later brought esoteric Buddhism from China, and here they established the first Tendai (T'ien-t'ai) sanctuary. Thus, Enryakuji predated even Heian, the capital of Japan after 794. Since the capital was located with Mt. Hiei soaring to the northeast—a direction considered ill-omened by the geomancers—its inhabitants looked to the monks of Mt. Hiei for protection against demonic forces. As a propitiatory gesture, Saichō built there the Komponchūdō (Central Hall) and gradually the mountain became studded with temples. But the safety of their unassailable retreat spawned an arrogance in the monks, and the residents of Kyoto found themselves in the tyrannical grip of their supposed guardians. From Emperor Shirakawa onward (r. 1073–1087), there were public outcries against the *sōhei* (literally, "troops") of Mt. Hiei, who would swoop down on the city, weapons in hand, to defend their candidates or exact subsidies from the state.

It took the "new order" of a dictator, Oda Nobunaga (1534–1582), to put a stop to this constant threat which had caused much destruction in Kyoto during the 15th century. The temples and other buildings on the mountain were completely dismantled, most of the monks slain, and the survivors scattered to other monasteries throughout Japan. When Toyotomi Hideyoshi (1535–1598) and Tokugawa Iemitsu (1603–1651) reinstated the monasteries, the monks were careful to devote themselves solely to religious matters.

ISHIYAMADERA (Shiga Prefecture) 石山寺

Rōben (fig. 83), a priest affiliated with Tōdaiji in Nara, founded Ishiyamadera in 749. The rocky knoll that is the temple's setting—and after which it was named (Ishiyama means "stone mountain")—offers a view of Lake Biwa. Over the years, the temple suffered extensive damage that was partially or entirely repaired after each disaster: at the end of the Heian period, during the Kamakura period, and at the end of the 16th century. Except for the *tahōtō*-style pagoda, nearly all of the buildings we see today date from the most recent reconstruction.

Unlike Chinese-style pagodas, a *tahōtō* is a translation into wood of the Indian stupa. In ascending order, it consists of a base, roof, flattened hemispheric dome, and a second roof more sharply pitched; the architect faced the dilemma of setting the square upper roof above the circular dome. The elegantly proportioned *tahōtō* of Ishiyamadera embodies a type of pagoda that was introduced and widely copied during the Heian period as esoteric and sentimental Buddhism was spreading throughout Japan. There is also a connection between the *tahōtō*-style pagoda and the cult of Dainichi Nyorai, the Buddha of the Future. An inscription on the altar informs us that the building dates from 1194, making it the oldest surviving example of this pagoda type in Japan as well as the most original piece of architecture in this particular monastery.

Within the Ishiyamadera precinct can also be found a touching reminder of the most famous work in Japanese literature. Legend has it that one of the temple's smaller pavilions, the Genji-no-ma, is a replica of the one in which Lady Murasaki Shikibu (975–1031) supposedly wrote her celebrated novel, *The Tale of Genji (Genji Monogatari)*.

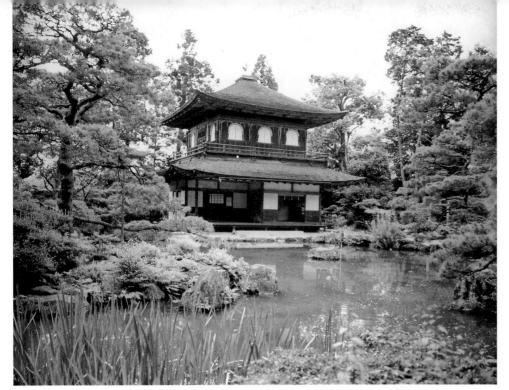

687 JISHŌJI. SILVER PAVILION (GINKAKU) AND POND

688 JISHŌJI. SILVER PAVILION AND SAND MOUND

JISHŌJI (GINKAKUJI) 慈照寺

The miniature paradise which Ashikaga Yoshimasa (1435–1490) created at the foot of Kyoto's "Eastern Mountains" (Higashiyama) was intended to be a terrestrial counterpart of the Pure Land that awaited true believers after death. Work was finished in 1489, but the complex (meeting hall, residence, small temple dedicated to Kannon, all arranged around a skillfully designed garden) was not given the religious title of Jishōji until after Yoshimasa's death.

Two-story pavilions were fashionable at the time so that blossoming cherry trees might be contemplated at leisure from above or below, and there is one such pavilion at Jishōji. One quarter of the ground floor is taken up by a small, "six-mat" room (approximately ten square meters) which overlooks the pond; the rest is floored with wood; on the second story is a Buddhist temple originally dedicated to Kannon.

The "Golden Pavilion" (Kinkakuji) built by Ashikaga Yoshimitsu (1358–1408) a century earlier, west of Kyoto, was actually gilded overall (figs. 716, 717). Yoshimasa's was popularly known as the Ginkaku, or "Silver Pavilion," but the only silver to be seen was the moonlight reflected on its surface, for Yoshimasa died before his intention to have it sheathed in silver could be carried out. The bronze phoenix perched on top of the building recalls the vanished palaces of the Heian period, whose enthralling beauty is captured in the Phoenix Hall of Byōdōin at Uji.

Of the original complex there remain the Ginkaku and the Tōgudō. Designed to fulfill the material and spiritual needs of a life both prosperous and tranquil, open to friends but free from politics and court ceremonial, Ashikaga Yoshimasa's residence was the marvel of his age. Contemporaries immediately copied its conveniences and elegant touches: library nooks with asymmetrical shelves (chingai-dana), alcoves for displaying works of art (toko-no-ma), little rooms entirely covered with straw mats (tatami) and surrounded by unadorned cypress-wood pillars. This setting, steeped in the monastic austerity of the Zen ethic, uncluttered yet refined, had a lasting effect on Japanese art.

689 JISHŌJI. TŌGUDŌ

Small wonder that everything here suggests withdrawal, for escape and meditation were precisely Yoshimasa's desires after the terrible civil wars of the Ōnin era (1467–1477). He abdicated in 1473, handing over the responsibilities of the shogunate to his son, Yoshihisa, who ruled from 1474 to 1489. Yet it is difficult to believe that the construction, begun in 1479–80, was going on while the Kyoto region was a wasteland of war and of famine so severe that people were dying everywhere.

The site Yoshimasa selected belonged to the Kei-un-in temple, already famous for the tranquil beauty of its mountains and waterways. The garden is believed to have been designed by Sōami (1485?–1525). The twelve buildings of the original complex suffered extensive damage during the civil unrest of 1547 and again when Miyoshi Chōkei (1523–1564) set fire to it in 1551. Only in the Edo period, with tenacious efforts by its abbots, did the temple slowly regain its former charm.

Amid this beauty, however, there is an unexpected element: the huge flat-topped conical heap of sand (traditionally thought to represent Mt. Fuji) and large platform of sand that gleam in sunlight and moonlight. The story goes that Yoshimasa happened one evening upon some sand the workmen had left behind, and found its appearance so entrancing that he ordered it left in place, added mica to make it more glistening at night, and arranged it exactly as it is today. That explanation is the most widely accepted one, and no doubt the most poetic, but some believe that sand was simply spread over an area where destroyed buildings once stood.

690 JISHŌJI. PORCH OF TŌGUDŌ

547

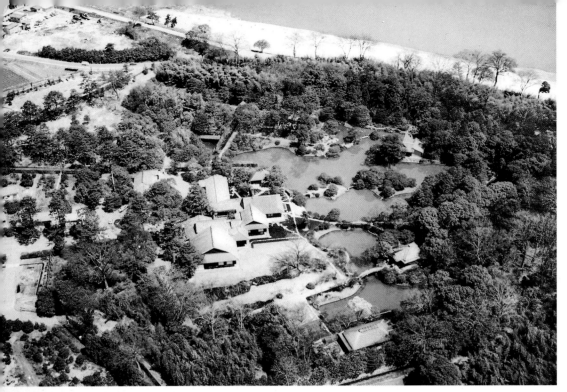

691 KATSURA RIKYŪ. AERIAL VIEW

KATSURA RIKYŪ 桂離宮

The Katsura imperial detached villa is a masterful, complex blend of architecture and garden design, a tribute to both the genius who conceived it and the patron whose generosity made it possible. Its creator laid down three stipulations before accepting the commission: that money should be unlimited, that he need not hurry the completion, and that he need not present his work until satisfied with its execution.

According to one account of this *rikyū*'s beginnings—none of the accounts is authoritative—the undertaking was launched at the end of the 16th century, during the Tenshō era (1573–1591). Toyotomi Hideyoshi (1536–1598), second of the three dictators who forged modern Japan, had adopted Prince Tomohito, younger brother of reigning Emperor Go-Yozei (r. 1587–1611), and wanted to have built for him a residence on the outskirts of Kyoto.

Hideyoshi selected a site on the west bank of the Katsura River, just south of Arashimaya. At about this time a tea master and aristocrat, Kobori Masakazu (later called Enshū: 1579–1647), became supervisor of the project and laid down his three celebrated conditions mentioned above. Hideyoshi's death did not impede the work, which was carried forward from 1620 to 1624 by the Tokugawa, resumed and expanded from 1642 to 1647 by Prince Hachijō Noritada, son of Hachijō Toshihito (1579–1629), and finally completed in 1658 for the visit of abdicated Emperor Go-Mino-o.

The general plan was to arrange several low pavilons into an understated residence and to use the winding shores of an enormous central lake as the focal point of an equally understated garden of trees, plants, and rocks. In sharp contrast to Nijō Castle (Kyoto) and other gorgeous palaces of the Momoyama period, the overall design of the Katsura villa is so calculated in its simplicity as to seem almost belabored. But inside these spare buildings of wood, thatch, paper, and bamboo there are sliding screens (*fusuma*) decorated with black-and-white or subtly colored ink washes by Kanō Eitoku (1543–1590), Kanō Tanyū (1602–1674), and Kanō Naonobu (1607–1650), three of the most gifted artists of their day. Attention was lavished on such details as *fusuma* handles and *shoji* keys, fashioned of rare or sumptuous materials: gold, silver, and, apparently for the first time in Japan, cloisonné.

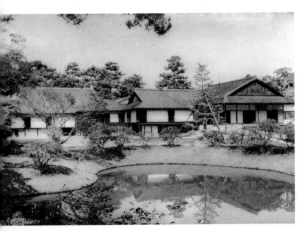

692 KATSURA RIKYŪ. OLD SHOIN HALL
(FURUSHOIN) AND POND

693 KATSURA RIKYŪ. NEW SHOIN HALL
(NAKASHOIN) AND ADJOINING LAWN

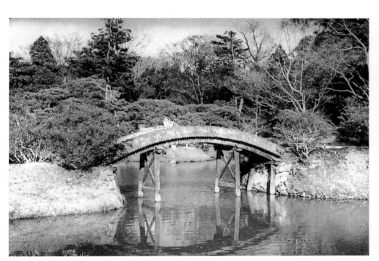

694 KATSURA RIKYŪ. ARCHED BRIDGE

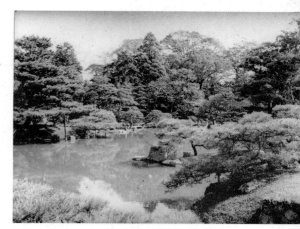

696 KATSURA RIKYŪ. GARDENS AND POND

The lanterns and the unusually shaped rocks on the two little islands in the lake recall the style that the monks and *literati* of China had favored since the 10th-century Song dynasty.

The limited size of the buildings—or was it Katsura's unappealing site, which only the gifted Kobori Enshū could turn into something beautiful?—apparently caused the imperial family to spend little time at this "detached palace." Perhaps they were put off by the geomancers' old taboos concerning direction (*kata-imi*), by which Katsura was unfavorably aligned with the imperial palace in Kyoto. The name of the villa changed several times—Kyōgoku, and Tokiwai (the name of the princes residing there)—but almost no texts mention the Katsura villa, even those recounting the history of the imperial family. By the late 19th century it had fallen into disrepair, but in 1883 the *rikyū* was restored not so much for infrequent visits by the imperial family as for the enjoyment of the public, from then on admitted to Katsura by request.

The prevailing simplicity at the Katsura villa belies the wealth of refinement hidden just below the surface. The gardens, though apparently scattered at random, follow a strict tripartite layout: the garden of Shōkintei, the tea-ceremony house; the lake and two small islands in front of the Old Shoin Hall; and the lawn in front of the New Shoin Hall. In a departure from Heian custom, the Katsura gardens seem to have been laid out for strolling rather than for meditation. Wherever the visitor walks, he feels that he has made his way into the heart of a subtle arrangement that shifts with every step. It was the first attempt in Japan to strike a balance between curved and winding pavements of irregular stones (*tatami-ishi*) and pavements made of straight lines (*shin-no-shikiishi*) in solemn uniformity. Admirers of the Heian style even fault Katsura for its visibly human construction, its geometry seeming to control nature's naturalness.

In the interiors the only animation comes from the rhythm of the asymmetrical shelves; no two are positioned on the same level. Designed to be admired precisely for their spareness, these unadorned buildings are nonetheless fashioned of sandalwood and ebony—costly exotic woods whose brown and black tones create a harmonious play of muted colors.

Though empty most of the time, the Katsura *rikyū* played a pivotal role in the artistic development of the Tokugawa era. It served as a beacon, a model of "good taste" in contrast to the more opulent art favored by the shōguns and especially to the "city" style which began to flourish as the artisan and merchant classes came into their own.

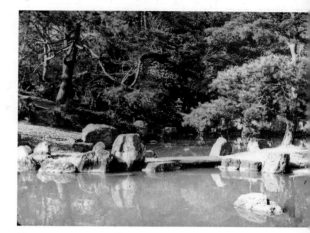

697 KATSURA RIKYŪ. STEPPING STONES ACROSS POND

698 KATSURA RIKYŪ.

GENERAL PLAN OF THE GARDEN
(*drawing by Giroux, after Ota Hirotarō*)
A Main Gate
B Ama-no-Hashidate
C Mausoleum of Enrindo
D Archery Ground
E New Shoin Hall
F Old Shoin Hall

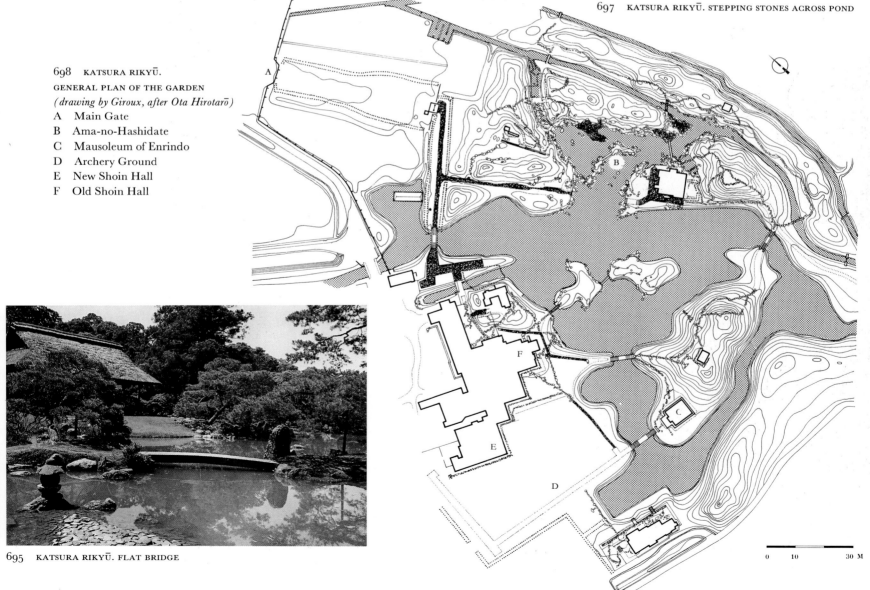

695 KATSURA RIKYŪ. FLAT BRIDGE

0 10 30 M

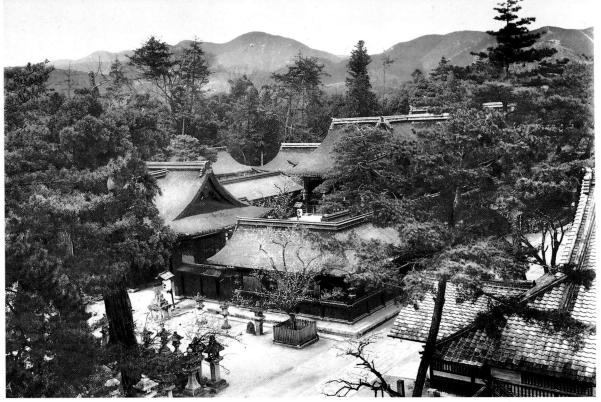

699 KITANO TEMMANGŪ. GENERAL VIEW

北野天満宮
KITANO TEMMANGŪ (KITANO TENJIN)

Located in northwest Kyoto, near the famous weavers' district of Nishijin, the Kitano shrine is dedicated to the memory of Sugawara-no-Michizane (845–903), the prominent figure later honored as Temmangū, who in 894 founded the isolationist policy of the Heian period. A slanderous report had led to his exile, and his death in Kyūshū was believed to be the cause of unsettling calamities in Kyoto: a relentless succession of tornadoes and earthquakes, as though the great statesman's ghost were crying out for justice. In 947, this shrine was built to honor—and appease—his spirit. Emperors made a point of visiting the sacred precinct, and Fujiwara-no-Nobuzane (1176–1266), painter to the imperial court, devoted a nine-scroll work to Michizane's life and deeds. The subject proved so successful that Tosa Yukimitsu returned to it in the 14th century, as did Tosa Mitsuoki (1617–1691) in the 17th century (see also fig. 135).

The present complex, ordered in 1607 by Toyotomi Hideyori (1593–1615), son of Hideyoshi (1536–1598), includes three main structures connected by wing corridors. In their intricacy and opulence they are typical of architecture at that time, but the plan suggests a prototype in the Late Heian period (12th century). The main hall for public worship and the shrine are joined in an ingenious cluster of roofs covering not only the structures but the spaces between them; the ground beneath is paved. This elegant blend of a stone base and an open wood framework overhead is a hallmark of the *gongen* style of Shinto shrine architecture. Only later did architects add floors and ceilings that conceal the basic structural elements.

It was here that Toyotomi Hideyoshi presided over the most elaborate tea festival of all time: the Kitano *dai-cha-no-yū* of 1588. On the pretext of a tea ceremony, the dictator convened his vassals (i.e., the wealthy element of Japan's population) at a colossal ten-day party. Each guest was obliged to bring with him his most beautiful object or else "forever lose the taste of tea," for did not the tea ceremony demand that only the most beautiful objects be displayed? Hideyoshi thus ferreted out and amassed treasures that the *daimyō* might otherwise have kept hidden. Posterity has never forgiven him his self-serving interpretation of the tea aesthetic.

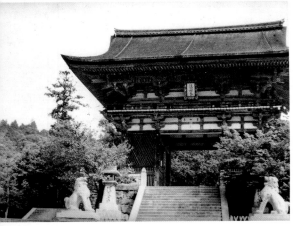

700 KIYOMIZUDERA. MAIN ENTRANCE, WEST GATE

KIYOMIZUDERA 清水寺

Dedicated to Eleven-headed Kannon, the celebrated Kiyomizudera temple is perched atop a ravine. Its founding predates that of Heian itself. Texts tell us that in 784, when the imperial court left Nara for Nagaoka, the noted general Sakanoe-no-Tamuramaro (758–811) donated a house of his at Yasaka, on Mt. Kiyomizu, to the priest Yenshin to be converted into a temple. When the court moved on from Nagaoka to Heian ten years later, Tamuramaro was given a share of wooden structural pieces from the Shishinden Hall, a building in the Nagaoka imperial compound, and he reassembled these on Mt. Kiyomizu into the core structure of the temple, which apparently was in full operation by 805. The panoramic view of the city from its terraces were a popular attraction even then, and worshipers came for the miraculous waters of the waterfall below. The faithful still come

701 KIYOMIZUDERA. THREE-STORY PAGODA AND SUTRA HALL

to venerate the guardian king of the underworld Fudō Myōō, an awesome Shingon deity having powers to punish wicked beings.

Kiyomizudera was not spared the misfortunes which befell all of Kyoto during the Muromachi period. The buildings we see today are reconstructions which the third Tokugawa shōgun, Iemitsu (1603–1651), ordered in 1633. Of particular interest are the three-story pagoda and the extraordinary wooden scaffolding supporting the main temple (*hondō*) and terrace, which clings to a cliff some thirty meters above the valley and waterfall. The Kiyomizu terrace has always been admired: genre paintings and *Nara ebon* (literally, "Nara picture-books") often depict elegant young ladies strolling at Kiyomizu in their spring kimonos.

The stalls along the lanes winding down from the foot of the temple specialize in the blue-and-white Kiyomizu-yaki (Kiyomizu ware) produced in nearby kilns since the Edo period.

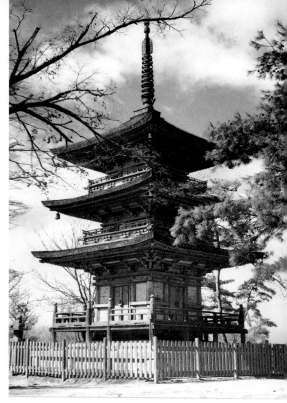

702 KIYOMIZUDERA. THREE-STORY PAGODA

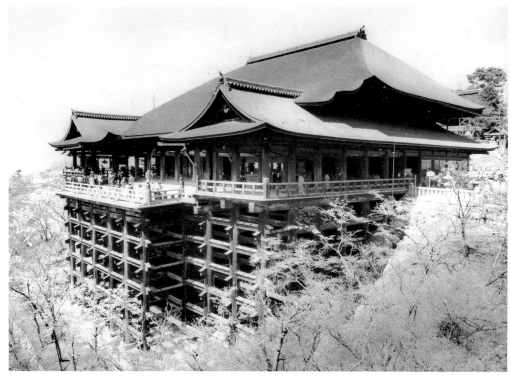

703 KIYOMIZUDERA. MAIN TEMPLE AND TERRACE

0 1 5 10 M

704 KIYOMIZUDERA.
PLAN OF MAIN TEMPLE AND TERRACE
(*after Kokuhō*)

KŌRYŪJI 廣隆寺

Kōryūji, often known as Uzumasadera, was founded in 622 near Arashiyama by Hata Kawakatsu, scion of an ancient Korean-born family credited by legend with the development of silkworm breeding in Japan. This holy site was set aside for the repose of the spirit of Prince Shōtoku-Taishi, who died in that year. The two wooden statues in Kōryūji are said to be self-portraits of the Crown Prince at ages sixteen and thirty-three.

705 KŌRYŪJI. TAISHIDŌ

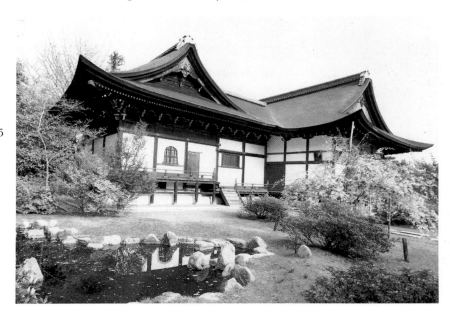

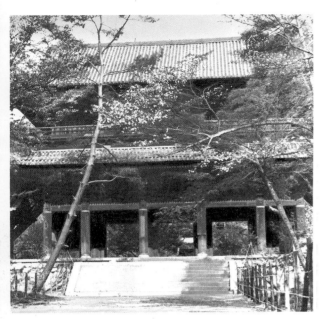

706 NANZENJI. GREAT MAIN GATE

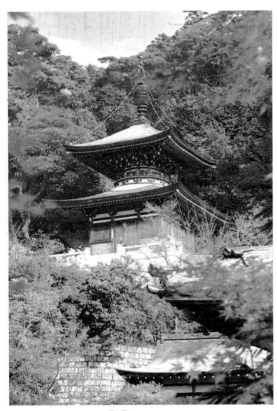

707 NANZENJI. TAHŌTŌ-STYLE PAGODA OF ZENRINJI

The temple's real treasure is the preaching hall, built in 1165 and sharing with a few vestiges of Heian architecture the distinction of being the oldest buildings in the former capital. There is also a marvelous Asuka wooden statue of Miroku Bosatsu, the Buddha of the Future, seated in meditation, elbow resting on a crossed leg while his hand delicately touches his cheek. Certain stylistic differences notwithstanding, this effigy is akin to the earlier Miroku in Chūgūji (Hōryūji, Nara; fig. 41), but has a Korean-style headdress indicative of its iconographic roots. It is not only the oldest piece of sculpture in Kyoto, but also one of the most beautiful.

NANZENJI 南禅寺

Nanzenji, an affiliate of the Rinzai branch of Zen Buddhism (introduced to Japan in 1191), is located in southeast Kyoto, at the foot of Higashiyama, or Eastern Mountains. It stands on the site of the old Zenrinji-dono palace built by abdicated Emperor Kameyama (r. 1260–1274; d. 1304) during the Kōan era (1278–1288).

Emperor Kameyama's palace had pleasant gardens and two buildings, an upper residence (*Kami*) for the summer (*Natsu no miya*) and a lower residence (*Shimo*) for the winter (*Fuyu-no-miya*). Soon, however, bizarre occurrences there made him summon Fumon, a priest attached to the Rinzai temple Tōfukuji in southeast Kyoto (built 1236–55), to exorcise the palace, and in gratitude the Emperor left the Winter Palace (*Fuyu-no-miya*) to Fumon; much later it was converted into a temple and renamed Zenrinji. Zenrinji still stands at the northern edge of Nanzenji; it contains the celebrated Mikaeri-no-Amida, or "Amida who turns aside" (fig. 261), an effigy of the deity with its head turned to the left (said to be calling to a praying priest, Eikan).

Kameyama continued to live in the Summer Palace—where present-day Nanzenji now stands—and to follow the teachings of Fumon. The aura of magic, mystery, and intellectual inquiry which surrounded the palace made it natural that this, too, should become a temple; abdicated Emperor Go-Uda (r. 1275–1287) went so far as to send a document in his own hand, bearing the name of the new monastery. Work on the Butsuden ("Buddha Hall" for a sacred effigy) began in 1297, and a full monastic enclosure (*garan*) gradually took shape. In 1334, during the dynastic schism, Kogon, an emperor of the so-called Northern Court, visited the temple and ranked it first among the *Gosan*, or five great monasteries of Kyoto. This accolade brought Nanzenji's triumph—and its undoing, for the soldier-monks of Enryakuji, on Mt. Hiei, were incensed that Nanzenji should eclipse their own institution. After futile protests to the imperial court, they took their own counsel, and on September 28, 1393, they came down from their retreat and put Nanzenji to the torch.

Misfortune seemed to dog the monastery: structures were rebuilt only to be destroyed in civil war (1447 and 1467); the monks fled, and not until 1597 did Toyotomi Hideyoshi (1536–1598) have the Buddha Hall (Butsuden) rebuilt. In 1611, Go-Yozei (r. 1587–1611) donated the wooden framework of the Seiryōden, a building in the imperial palace compound which had been rescued from the fire set by Hideyoshi in 1590, and this became the Hōjō of Nanzenji. A few years later, Tokugawa Ieyasu (1542–1616) donated a portion miraculously saved from Hideyoshi's castle on Fushimi Hill, including the renowned *fusuma*, the gold-leaf "Tiger Screens" by Tan'yū (Kanō Morinobu; 1602–1674), and this building became the core of the apartments known as the Ko-Hōjō. In 1627 Tōdō Takatora (1556–1630), a monk from Koyasan and commander of the Japanese fleet at the time of the Korean expedition (1592), rebuilt the Sam-mon, the great gate nearest the main sanctuary. In 1691, the mother of the shōgun Yoshimune (1677–1751) completed the monastery complex in accordance with its original plan. Nanzenji was restored to its former glory except for the Butsuden, which was burned in 1895 and rebuilt in 1908.

NIJŌJŌ (Kyoto) 二条城

When Tokugawa Ieyasu (1542–1616) assumed control of the government, he moved his headquarters to Edo, in the Kantō region of Japan, but he thought it desirable to maintain a residence in the imperial capital from which he could monitor possible unrest among court dignitaries, especially supporters of Hideyori (1593–1615), the son of Toyotomi Hideyoshi (1536–1598). And so Nijōjō, or "Palace of the Second Avenue," was built on what had been the southeast sector of the old imperial compound (*Daidairi*). Work began in 1602 under the supervision of Itakura Katsushige (1542–1624), a former monk who had exchanged his robes for armor to fight at Ieyasu's side. Progress must have been rapid, for Ieyasu inspected the first stages of his new castle the following year (1603). Apparently he visited the site again only in 1611 and 1615, but the complex was maintained as though he lived there (the *Kōryōki* and the *Taihei Nempyō* record major repairs in 1619 and 1625).

This impressive fortress-residence, which incorporated parts from Oda Nobunaga's castle at Fushimi (fig. 36), covers a moated area of 62,304 *tsubo*, about 70 acres. There once stood at the southwest corner of the Honmaru (main building) a five-story tower (*tenshu-kaku*; fig. 160) flanked by smaller watchtowers, but it was partially dismantled in 1640 according to Tokugawa Iemitsu's policy of destroying citadels before they could shelter hotbeds of resistance. But the five buildings comprising the Ni-No-Maru, a later addition, may still be seen east of the Honmaru. The sumptuous decoration of its apartments and audience rooms is as marvelous today

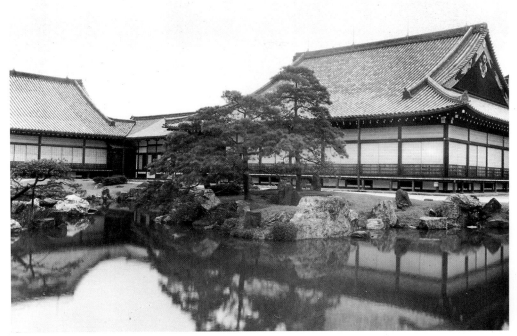

708 NIJŌJŌ. NI-NO-MARU AND POND

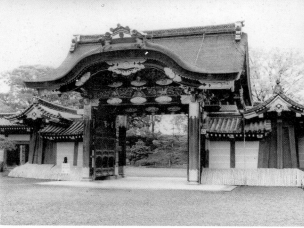

709 NIJŌJŌ. HIGASHI-Ō-TEMON,
MAIN GATE OF NIJŌ PALACE

as when the Kanō artists stamped them with their genius centuries ago. Perhaps its most beautiful rooms are the immense Audience Hall (*Ōhiroma*) and the shōgun's private apartment (*shiro-shoin*). One of the most impressive features of the garden off the southwest corner of Ni-No-Maru is a man-made pond fed by conduits which channel water from Nishikamo. (Recently planted trees have altered the original treeless design; fig. 767.)

For all its splendor and apparent sturdiness, Nijō Castle was also destined to fall victim to fire. In 1791, lightning during a typhoon totally demolished the tower (*tenshu-kaku*), which was never rebuilt. Residents of the district fought the blaze and saved the Ni-No-Maru with its spectacular paintings and sculpture. The palace again suffered extensive damage when it became an administrative center for prefectural services in 1871 and for the armed forces in 1873, but fortunately it reverted to the Imperial Household (*Kunaisho*) in 1884 and was granted "detached palace" (*rikyū*) status. Nijōjō was restored to its former grandeur, and in 1939 the Imperial Household donated it to the city of Kyoto.

Although Nijō Castle stood empty for comparatively long periods of time, it had its moments in history. Emperor Go-Mino-o (r. 1612–1629), together with his wife, mother, and one daughter, visited the castle in

710 NIJOJŌ. GARDENS OF HONMARU

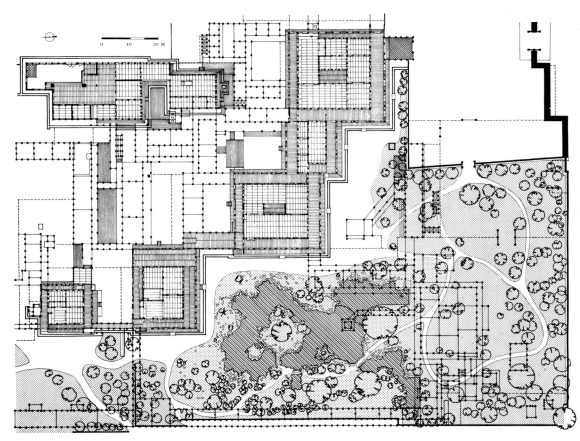

711 NIJŌJŌ. PLAN OF NI-NO-MARU

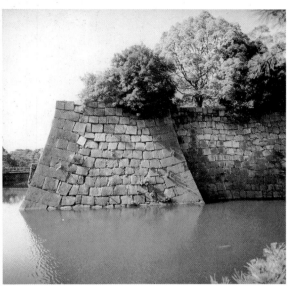

712 NIJŌJŌ. MOAT

October 1626. Solemn music and dance, poetry readings, lavish gifts—the Tokugawa spared no expense to impress the court with their power, and surely no one failed to notice that the state reception took place in the Honmaru, a building designed expressly for defense. Kobori Enshū (1579–1647) was commissioned to build the Miyuki-den for the occasion. Although no longer extant, it was, according to contemporary accounts, a magnificent design that contrasted sharply with the usually reserved tastes of the Tokugawa.

A few years later (August 1634), Iemitsu put on a staggering show of military might by mustering an army of three hundred thousand men at the castle. After he returned to Edo the splendid Nijōjō then languished for more than two hundred years.

No shōgun resided there again until Iemochi (sh. 1858–1866) moved in during the troubled days just before the Meiji Restoration (1868). It was from this stronghold of the shōguns that the fledgling Meiji government issued its first decrees—including the abolition of the shogunate itself. Never again would Nijō Castle embody a challenge to imperial authority.

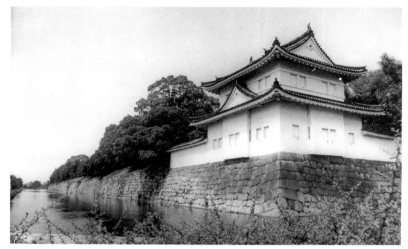

713 NIJŌJŌ. CORNER TOWER

RENGEŌIN (Sanjūsangendō) 蓮華王院

There is no mistaking Rengeōin, situated in the Higashiyama district, for any other monastery in the old imperial capital. Its exceptionally long main temple is popularly known as Sanjūsangendō, or "thirty-three-bay building," for the spaces between its many pillars (118.22 meters long, 16.44 meters wide).

Emperor Go-Shirakawa (r. 1156–1158) upset the original plan of the capital by building a residence (later converted into a temple, Hōjūji) east of the Kamo River, which had been until then the city's eastern boundary. Rengeōin, which rises to the west of Hōjūji, was built in 1164 to house a thousand statues of the Thousand-armed Kannon, and this accounts for an east–west plan whose simplicity—a succession of uniform bays—in no way detracts from its impressive appearance.

In the Edo period the long Sanjūsangendō was often used for archery contests with the large, powerful bows that Japanese warriors handled so expertly on horseback and on foot. (These tests of skill and endurance are mentioned in a *jōruri* puppet play and a *kabuki* play.) In the courtyard behind the temple targets were set up along the entire length of the main building, and the object was to shoot for the greatest number of bull's-eyes

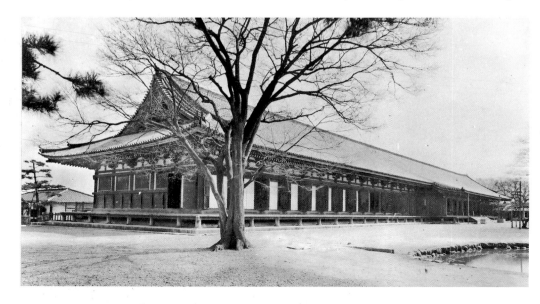

714 RENGEŌIN.
GENERAL VIEW

between sunrise and sunset. During a single day in 1696 Wasa Daihachiro, a *samurai* from Kii Province (Mie and Wakayama prefectures), is said to have shot 13,053 arrows—8,153 of them bull's-eyes.

The present building was reconstructed in 1253–54 after a fire (1249). The main image of the Thousand-armed Kannon—flanked by the thousand gilt-wood Kannons, five hundred on each side—was set in place in 1255 and dedicated in 1266.

There is a porchlike extension seven bays long at the center of the south or front side of the building. Erected in 1650, it was a restoration of a feature of the original layout that had been discarded in the rebuilding during the Kamakura period.

According to archives dating from the Heian period, similar places of worship were designed to make it easier for throngs to get closer to sacred effigies. Staggering though its plan may seem to us today, Rengeōin was not the only temple of its kind in Japan.

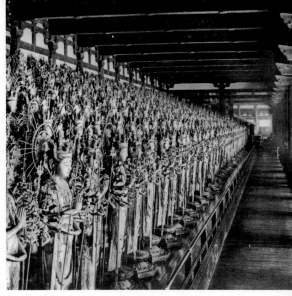

715 RENGEŌIN. THE THOUSAND STATUES OF THOUSAND-ARMED KANNON (SENSHŪ KANNON) INSIDE THE MAIN BUILDING

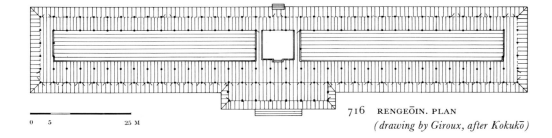

0 5 25 M

716 RENGEŌIN. PLAN
(drawing by Giroux, after Kokukō)

ROKUONJI (KINKAKUJI) 鹿苑寺

Known the world over for its famous Golden Pavilion, Rokuonji stands on the site of an established villa and temple which Saionji Kintsune (1171–1244) had built at Kinugasa-mura, northwest of the capital, two years after being appointed prime minister (*Dajo-Daijin*) in 1222. The beauty of the buildings which rose at that time is mentioned in the *Masu Kagami*, a chronicle of Japanese history from 1184 to 1333.

A century later, the proprietor at the time, Saionji Kimmune (1309–1335), was assassinated under the reign of Emperor Go-Daigo (r. 1318–1339) which ushered in the schism between the Northern and Southern dynasties. The estate seemed destined to fall into irreversible disrepair.

But in 1394, two years after ending the schism in favor of the Northern Dynasty, the shōgun Ashikaga Yoshimitsu (1358–1408), though still the de facto ruler of Japan, abdicated in favor of his nine-year-old son Yoshimochi (1386–1428), and decided to reside in the old Saionji villa. He turned an already impressive setting into a complex of buildings and gardens patterned after Saihōji (figs. 720–22), designed by Muso Kokushi (1271–1346; fig. 13). In 1397 Yoshimitsu moved into his new quarters, known as Kitayama-dono, or Palace of the Northern Mountains, from its picturesque location at the foot of the mountains northwest of Kyoto. Given his son's tender age, Yoshimitsu continued to oversee government business from this retreat, and the fanciful,

717 ROKUONJI. AERIAL VIEW OF GOLDEN PAVILION (KINKAKU) AND ADJOINING POND

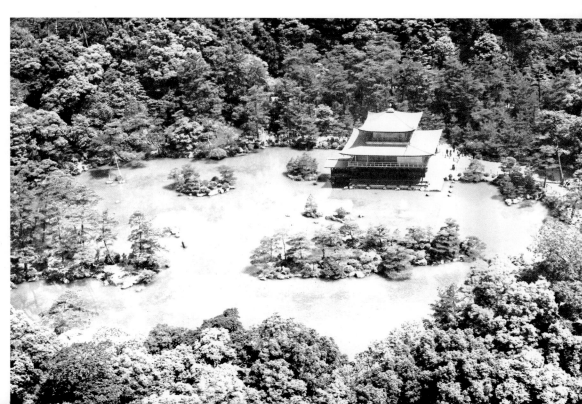

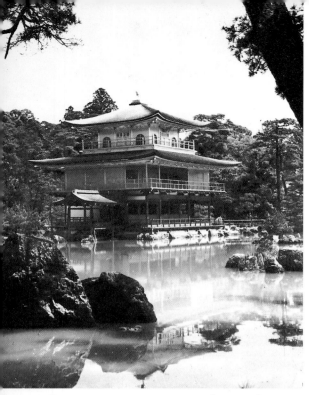

718 ROKUONJI. GOLDEN PAVILION (KINKAKU)

but tranquil surroundings may have influenced his flexible handling of affairs of state. Emperor Go-Komatsu (r. 1393–1412), the imperial court, the intelligentsia and artists of Kyoto—all of these visited the former shōgun, and the name of his residence became synonymous with the civilization of the period as a whole: *Kitayama-bunka*, the "Kitayama culture."

In accordance with Yoshimitsu's last will and testament, Kitayama-dono was converted into a Zen Buddhist temple and placed under the moral authority of Musō Kokushi. The temple was named Rokuonji, after Yoshimitsu's posthumous name, Rokuon-in.

Nothing remains of the original buildings, except for the tea pavilion. Although restored in 1874, it is believed to have risen during the reign of Emperor Go-Mino-o (r. 1612–1629) above a still earlier structure commissioned by the Hōjō. Most other buildings now at the site are late 16th- or 17th-century reconstructions at best. Almost all of Rokuonji burned down during the calamitous Ōnin civil war (1467–1477), and again in the strife of the Eiroku era (1558–1570), which set the stage for the dictators' rise to power.

Miraculously, one pavilion managed to escape these dangers: the Golden Pavilion (Kinkaku), a small relic hall poised at the edge of a pond. Its upper two stories were completely overlaid with gold leaf (the temple proper occupied the top story), and a golden phoenix finial crowned the roof. The pond mirrored in its shimmering waters the pavilion and the surrounding maples, cedars, and pines, whose reflections took on a different cast in each time of day.

But the Kinkaku, too, joined in the misfortunes that seemed to haunt Yoshimitsu's dream palace. In July 1950, a deranged monk set fire to the Golden Pavilion, and the building burned down before help could arrive. People were so shaken by this catastrophe that reconstruction was begun at once, and an exact replica was opened to the public in October 1955. The madness that prompted this misdeed inspired Mishima Yukio (1925–1970) to write *Kinkakuji* (1951), a novel about the possible motives behind the Kinkaku fire.

RYŌANJI 龍安寺

Ryōanji is the head temple of Rinzai, a branch of Zen Buddhism which Eisai (1141–1215) brought to Japan in 1191. The temple was built in 1473 at the behest of Hosokawa Katsumoto (1430–1474), who, in a dispute over shogunal succession, devastated the Kyoto region during the Ōnin civil war (1467–1477). This formidable warrior was laid to rest in the monastery enclosure.

Ryōanji is most celebrated for its arresting sand-and-rock garden, said to have been designed by Sōami, the noted 15th-century artist and tea master (fig. 400). Sōami's direct participation can only be surmised, but certainly the spirit here is that of an extreme, almost aggressive austerity which is the hallmark of Zen Buddhism. The garden consists of a flat, skillfully raked area of sand from which emerge five clusters of moss-girt rocks and stones (fifteen in all). They are arranged in such a way that anyone seated on the veranda, or on *tatami* in the adjoining hall, will always see every stone but one.

The unseen stone, that completion seemingly within one's grasp yet ever elusive, recalls man's unending quest for truth. If the Ryōanji garden was supposed to have been above all an aid to meditation, it has served that purpose admirably, judging by the wide range of interpretations it has inspired for over five centuries. The low wall at the far end formed of sand and earth of many textures and colors adds its jarring and stimulating character to the overall design; it would be incorrect to see in it any decorative or even pictorial connotation.

Visitors today may find it difficult to bring themselves to the level of concentration needed to appreciate the garden. Ryōanji is one of the jewels of ancient Japan that has suffered most from today's grand-scale sightseeing. When the small garden area is flooded with pilgrims and curiosity seekers, the lost silence is a betrayal

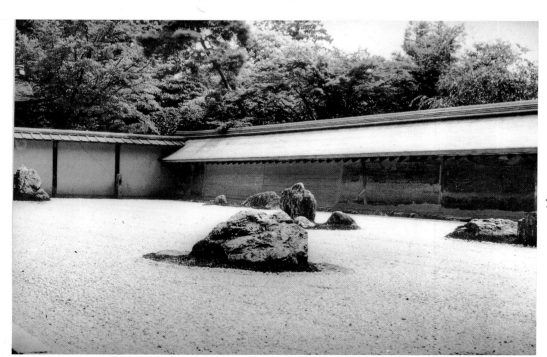

719 RYŌANJI.
ROCK AND SAND GARDEN

of the aesthetic spirit of the work. Even the picturesque rocks which the monks have recently placed in the adjoining park for neophytes spoil the effect by diverting their attention and dulling their emotions.

On the other side of the building there extends a kind of pendant to Sōami's dry-landscape composition: a little moss garden beneath maple trees, a combination that is especially admirable in autumn when the earth and foliage display their respective values of green and red.

SAIHŌJI (Kokedera) 西芳寺

This ancient temple in the shadow of Mt. Arashiyama is said to have been founded by Emperor Shōmu (r. 724–749). However, Saihōji entered a new phase when Musō Kokushi (1271–1346; fig. 13) turned it into an affiliate of the Rinzai branch of Zen Buddhism and incorporated it into Tenryūji, the temple he founded in 1340 under the auspices of Ashikaga Takauji (1305–1358).

The value of Saihōji lies in its extraordinary garden designed by Musō Kokushi himself, a marvelous distillation of the Kamakura civilization that sought out the "essential nature" (*yūgen*) of all things.

Musō Kokushi's aim at Saihōji was to create a garden that would be the equivalent of the ideal set forth in *Pi Yen-Lu* (*Heikiganroku* in Japanese), a Song treatise on the Zen ethic that was held in great esteem by those affiliated with the Rinzai branch. This quest for a symbolic landscape of great complexity seemed to haunt Musō Kokushi, who laid out not only the Saihōji gardens but those of Tenryūji and Rinsenji.

To adjust the design so that it is in complete harmony with the natural setting; to make studied, but understated use of rock arrangements (*ishigumi*); to eschew anything too conspicuous or contrived—these were the guiding principles of garden design at the time. At Saihōji, the artist worked solely with the hundred or so varieties of mosses that flourish in Kyoto's climate. People began to speak of Saihōji as the Kokedera, or Moss Temple, a name still used today. Musō Kukoshi's genius turned a simple form of vegetation having a rustic vitality into a miniature reconstitution of the entire world: mountains, forests, deserts, waterways, and seas (chapels and pavilions once stood at the edge of the lake, which is in the shape of the Japanese character for "heart"). Everything is envisaged in a specific symbolic meaning; the narrow, winding paths throughout the garden are difficult and unpredictable, suggesting man's tortuous path toward Enlightenment.

720 SAIHŌJI. MOSS-CARPETED SHORE OF THE POND

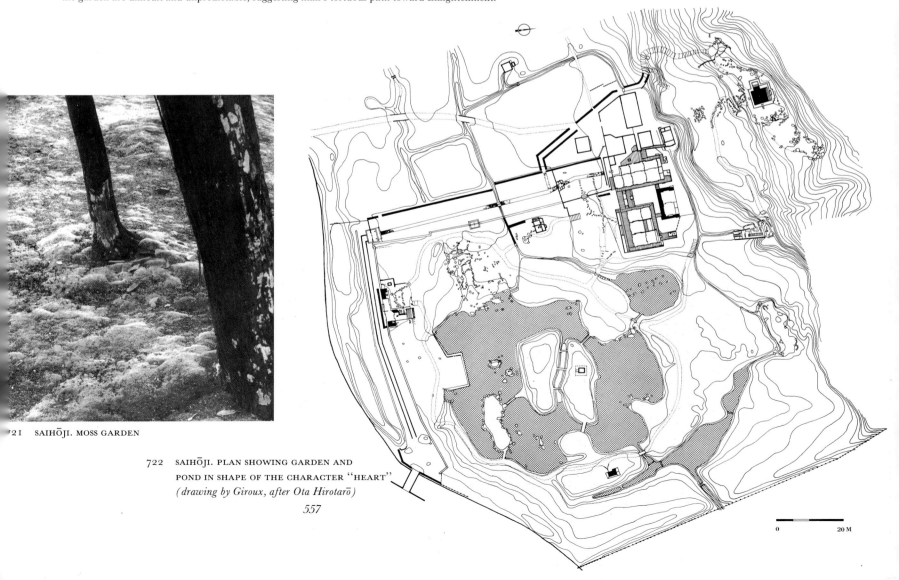

721 SAIHŌJI. MOSS GARDEN

722 SAIHŌJI. PLAN SHOWING GARDEN AND POND IN SHAPE OF THE CHARACTER "HEART" (*drawing by Giroux, after Ota Hirotarō*)

557

0 20 M

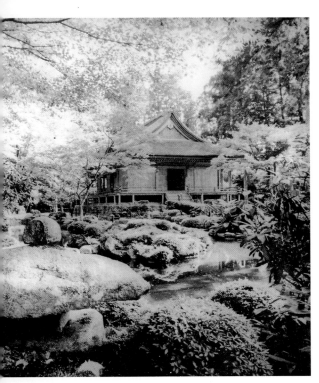

723 SANZENIN. GARDEN

SANZENIN 三千院

Sanzenin was founded by Saichō (posthumous name, Dengyo-daishi: 767–822), who brought the tenets of Tendai to Japan in 805 and founded Enryakuji on Mt. Hiei (see p. 546). Tendai is also the doctrine taught at Sanzenin.

In 860, Emperor Seiwa (r. 859–876)—or those who governed for the child-ruler—launched the reconstruction of the temple complex and placed the project under the supervision of a priest named Jōun. For its principal image, the temple was given a statue of Yakushi Nyorai, the healing Buddha of the Future.

The monastery reached its zenith a century later under Eshin (942–1017), the scholar, painter, sculptor, and priest whose concept of compassionate Buddhism prepared for the later introduction of the Pure Land sect in Japan (Jōdo, 1224).

In 985, acting on the wishes of Emperor Kazan—his reign lasted only three months—Eshin built what is still the main edifice of Sanzenin: the Hall of Paradise in Rebirth (*Ojō-Goku-Raku-in*), a rare example of authentic Heian architecture. Bodhisattvas are depicted in the coffered ceiling, whose shape suggests the hull of a ship. The walls are decorated with symbolic representations (mandalas) of the spiritual world (*Kongō-kai*) and the material world (*Taizō-kai*), all said to be the work of Eshin himself.

Except for the *shinden*, which was built in the Keicho era (1596–1615) with materials from the Shishinden or ceremonial hall of the Imperial Palace at Kyoto, the rest of Sanzenin was reconstructed in 1926 or later.

SHŪGAKUIN RIKYŪ 修學院離宮

The Tokugawa had the Shūgakuin imperial villa built in the 17th century in response to the retirement of Emperor Go-Mino-o (r. 1612–1629); abdicating in favor of his daughter, who was still a child at the time, he became a "retired emperor" (*insei*), and renounced the excessive independence he had shown earlier in his reign.

The village of Shūgakuin, at the foot of Mt. Hiei, northeast of Kyoto, dates back to the Heian period. It developed around a small temple dedicated to Fudō Myōō which was destroyed during the Ōnin civil war (1467–1477).

It is not known exactly when work on the imperial residence began, but the emperor is reported to have stayed there for the first time in 1655, at the age of sixty. Over the next twenty-five years, he never tired of making daily excursions to marvel at the gardens surrounding the villa.

The *rikyū* was more or less abandoned after Go-Mino-o's death, but abdicated Emperor Reigen (r. 1663–1686) ordered the residence rehabilitated in 1721. The cycle repeated itself when Reigen died in 1732; Shūgakuin fell again into disrepair, then was restored when Emperor Kōkaku retired in 1816. Kōkaku died in 1841, and once again the villa decayed until 1883, when it passed to the Department of the Imperial Household (*Kunaisho*) and became its Kyoto office.

Shūgakuin consists of three summer houses (*Ochaya*)—upper (Kami-no-rikyū), middle (Naka-no-rikyū), and lower (Shimo-no-rikyū)—and an enchanting park with verdant slopes, forests, rice fields, and lakes. The surrounding mountains (Hiei, Yokoyama, Eihō) form a sumptuous natural backdrop that is skillfully integrated with the design of the palace.

Perhaps the most interesting building is the middle villa (Naka-no-rikyū), which contains the dressing room of Tōfuku Mon-in (1607–1678), daugther of Emperor Go-Mino-o. The screens and paintings are by Sumiyoshi Gukei (1631–1705), a member of the Tosa-derived Sumiyoshi school. They were restored in the 18th century by Maruyama Ōkyo (1733–1795), a master of close, accurate landscape painting (*megane-e*).

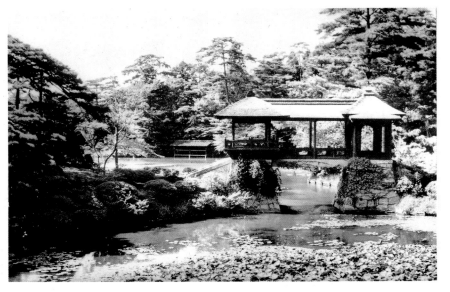

724 SHŪGAKUIN RIKYŪ.
PAVILION OVERLOOKING THE POND

NARA 奈良

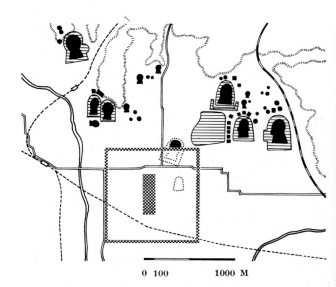

HEIJŌKYŌ 平城京

In the first year of the Wado era (708 A.D.), Empress Gemmei (r. 707–714) issued an edict ordering the construction of a vast, permanent capital. Patterned after Changan, capital of the Sui and Tang dynasties in China, and based on a grid plan which would later be adopted also at Kyoto (see p. 537), it was destined to add a glorious chapter to the history of the Japanese empire. Her son, Emperor Mommu (r. 697–707)—whose death at age twenty-five ushered in her own reign—had already turned his back on the venerable religious custom which compelled the court to change location with the accession of each new ruler. Although the area within which the imperial residence and government buildings had moved about was limited to Asuka and vicinity, there was confusion and expense in having constantly to shift locations. To remedy this circumstance—and perhaps Buddhism was to some extent already eroding the old Shinto taboos—Empress Gemmei continued to occupy her deceased son's residence, Fujiwara-no-Miya (Wisteria-yard Capital), when she ascended the throne. However, this palace soon proved too small and its atmosphere too heavy with court intrigue, and it was decided to establish another capital far away from the old seat of government at Asuka. On the Nara plain, in the Suzuka piedmont overlooking what is now Ōsaka Bay, rose Heijōkyō, the "Capital of Peace and Tranquillity."

By the third year of the Wado era (710), when most of the new city was in place, Heijōkyō was officially declared the capital of Japan. One after another, the leading temples around Asuka and Fujiwara-no-Miya relocated to new, pre-assigned sites in Heijōkyō. It was the dawn of the 8th century, a spectacular period in Japanese history that witnessed the blossoming of a culture steeped in Buddhism and a deepening interdependence of religious and temporal power.

The city was not called Nara until the government abandoned the site in 784 to escape the developing stranglehold of the temples. Emperor Kammu (r. 781–806) initiated the move of the imperial court to Nagaoka (Yamashiro Province), west of present-day Kyoto, but the gods were to decide otherwise. Ten years later assassination and several fatal illnesses induced the emperor to move again, this time to the site of what was to become Heiankyō (literally, "the peaceful capital"), later named Kyoto.

Nara still ranked supreme as a religious center, but this status was soon challenged by Saichō (767–822) and his Tendai temple on Mt. Hiei (see p. 546). In 833, Enryakuji was granted permission to ordain its own priests, thereby breaking the accepted monopoly which the Ritsu (literally, "law") sect had enjoyed until then. (The Chinese monk Ganjin, founder of Tōshōdaiji, had brought Ritsu to Nara in 753.) This dispute led to centuries of armed conflict between the soldier-monks of Enryakuji and mercenaries fighting on behalf of the great temples of Nara. The Ashikaga shōguns tried to quell the unrest by appointing a governor (nanto-bygyō) to rule at Nara, but the dictators of the late 16th century embarked on a more radical and effective course of action, stripping the temples of their lands and thus of their ability to pay or maintain troops.

From that time on, Nara confined itself to religious matters. The years flowed by peacefully, the days punctuated by the low-pitched gongs which still seem to reverberate in time with the rhythm of the cosmos. In their sounds one can sense the real spirit of the old imperial capital. As for Nara's buildings, extensive damage in the late 13th and 15th centuries led to some renovations during the Edo period. The Tokugawa regime was more concerned with seeing to the immediate needs of monks and worshipers—and adding to its own prestige—than with esthetic considerations. Moreover, Buddhism had since become subordinate to the government, and religious institutions were allotted no more than was considered absolutely necessary. Therefore, one must not confuse the restorations of the Kamakura period (13th century), carried out in a spirit of respect for the past and amid a climate of religious fervor, with the hastier repairs of the Edo period (17th–18th centuries), when expediency and practicality were the order of the day.

0 100 1000 M

725 HEIJŌKYŌ. LOCATION OF 8TH-CENTURY CAPITAL WITH RESPECT TO SURROUNDING TUMULI (KOFUN) *(drawing by Giroux, after Hayashi)*

726 HEIJŌKYŌ. PLAN OF THE PALACE *(drawing by Giroux, after K. Kasawara)*

HŌRYŪJI 法隆寺

Hōryūji, the oldest temple in Japan and the most splendid of Nara's temples, consists of two dense clusters of buildings: the West Enclosure (Saiin), with the Kondō (main building) and five-story pagoda, and the East Enclosure (Tōin). The Yumedono, or Hall of Dreams, an octagonal structure at the heart of the East Enclosure, is famous for both its architectural beauty and its works of art, now displayed in smaller museums built expressly for these nearby (figs. 41, 203–5, 207–9, 213–18).

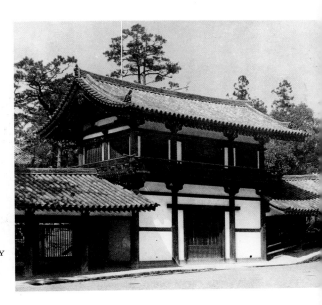

559 727 HŌRYŪJI. SAIIN: SUTRA LIBRARY

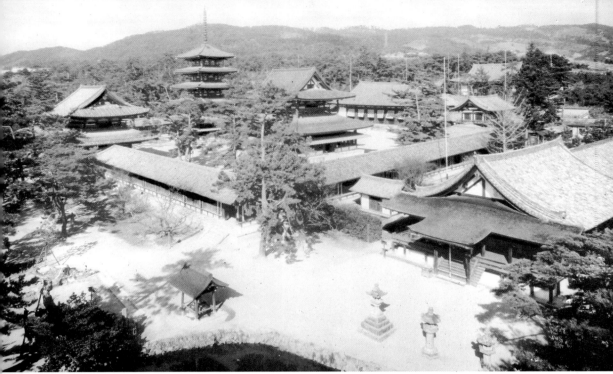

728 HŌRYŪJI. SAIIN: GENERAL VIEW

The Saiin is the more important of the two enclosures; the buildings in it are not only the oldest in Hōryū-ji, but the most important for ceremonial performances. The Tōin is believed to have risen somewhat later on the site of the palace of Crown Prince Shōtoku-Taishi (574–622).

The Kondō (main sanctuary) of Hōryūji, in the West Enclosure, is generally regarded as the oldest surviving wooden building in the world. Inside, the statues of greatest religious and esthetic significance include the gilt-bronze Shaka Triad, attributed to the Tori school, and a bronze effigy of Yakushi.

The inscription on Yakushi's halo reminds us that the order to build Hōryūji was issued in 607 by Empress Suiko (r. 592–628) and Crown Prince Shōtoku-Taishi. The founding of the temple was duly recorded, among other documents, in the texts later known collectively as *Nihon Shoki*, but they also tell us that the entire complex burned down on April 30 in the ninth year of the Tenchi era (that is, 670); reference is also made in other texts to a catastrophic fire. But curious discrepancies arise concerning the date of the fire and even

729 HŌRYŪJI. TŌIN: ELEVATION
(drawing by Giroux, after Ota Hirotarō)

which buildings were damaged. The latter texts mention the Ikarugadera, which is the name of Shōtoku-Taishi's residence a short distance from Hōryūji as well as another name for Hōryūji itself. It is possible that the texts were unwittingly altered from copy to copy, and that these conflicting places and dates may refer to the same establishment and conflagration.

This has raised one of those turbulent, but ultimately fruitful, debates which occasionally engage scholars in their efforts to understand and appreciate Japanese art. Scholarly opinions aside, the final issue concerns whether or not Hōryūji is a genuine example of Asuka architecture. If the monastery did not require rebuilding, the answer is yes; if it was rebuilt, no. Since not a single edifice from this comparatively remote period (552–644) has come down to us unchanged, much remains in the balance.

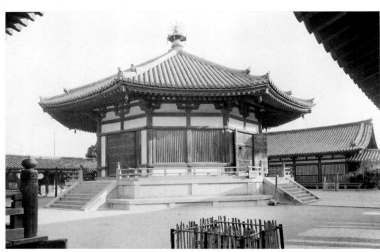

730 HŌRYŪJI. TŌIN: YUMEDONO

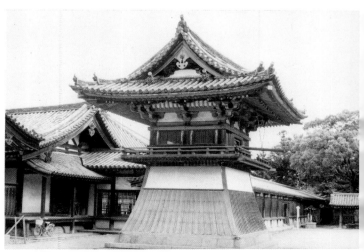

731 HŌRYŪJI. SAIIN: BELL TOWER

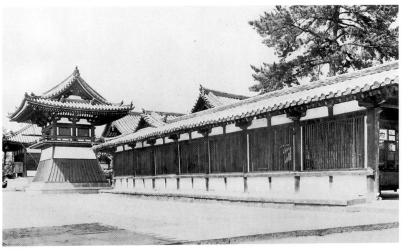

732 HŌRYŪJI. SAIIN: KAIRŌ (CLOISTER) AND BELL TOWER

733 HŌRYŪJI. SAIIN: KONDŌ (MAIN HALL)

Written accounts having proved unreliable, the controversy has focused more recently on the temple's two most important images: the Yakushi of 607 (fig. 199) and the Shaka Triad of 623 (fig. 200), the thirty-first year of Empress Suiko's reign. Incidentally, this circumstance sheds light on the role of religious sculpture in Japanese art, for in this instance the building took shape around the statue, architecture providing a setting for the principal image. Such pains were not taken, however, with effigies of lesser importance.

Excavations carried out during World War II led to the discovery in 1945 of sketches and caricatures in the pagoda of Hōryūji (figs. 145–46). Their highly fluid, "calligraphic" style was common during the reign of Emperor Temmu (r. 673–686), which lends support to the "reconstruction" or "post-Asuka" theory. But a new question now arose: what is the date of the present buildings of Hōryūji?

To complicate the issue further, not all of the buildings and objects believed to date from the Asuka period are still extant. The Hokkiji and Hōrinji pagodas were struck by lightning and burned down in 1944, and scholars now doubt that the famous lacquer Tamamushi-zushi shrine dates before the latter part of the 7th century (fig. 290). They also believe—though the point is still arguable—that the east pagoda at Yakushiji (see p. 569), until recently thought to be a masterpiece of the Hakuhō era (672–685), was not built until 731, or about the same time as the one at Kairyūōji, also from the mid-8th century. In a word, the dates of buildings once considered to belong in the Asuka period have now been pushed forward.

Consequently, we are left with no valid framework for Japan's ancient architecture, and the establishing of a chronological sequence is now more problematical than ever. No building has survived to provide us with verifiable criteria, either from the Asuka period (552–644) or the Hakuhō era (672–685) save those inside the present West Enclosure of Hōryūji, and to what date should they be ascribed? Scholars sometimes find no alternative but to "adjust" their historical appraisals in ways often colored by emotion or rooted in legend, or by the desire to invent a history as old as that of the world's ancient civilizations. Perhaps we are on the verge of making such an adjustment.

734 HŌRYŪJI. GENERAL PLAN
(SHADED AREAS ARE LOCATIONS
OF ANCIENT BUILDINGS)
(after Mizuno Seuchi)

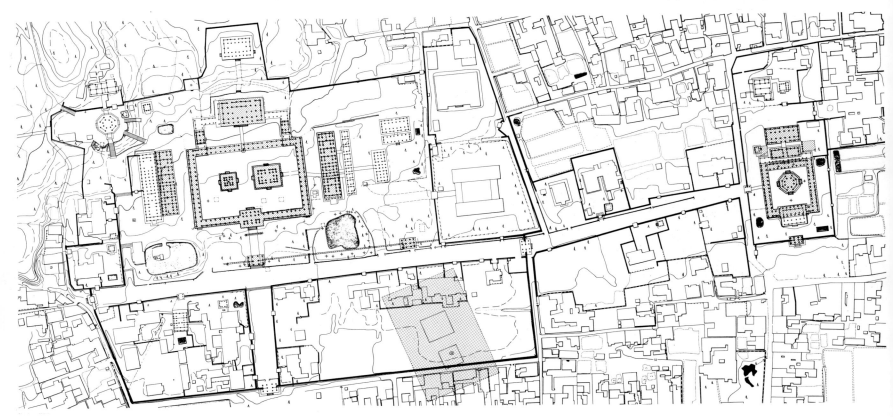

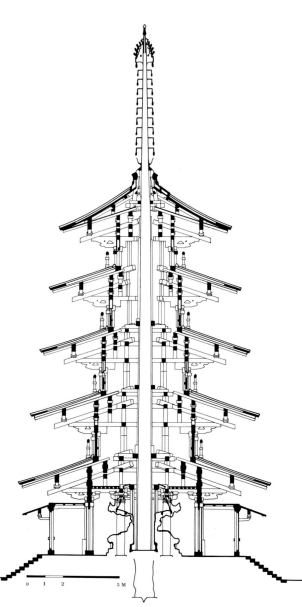

736 HŌRYŪJI. CROSS SECTION OF FIVE-STORY PAGODA
(drawing by Giroux, after Ota Hirotarō)

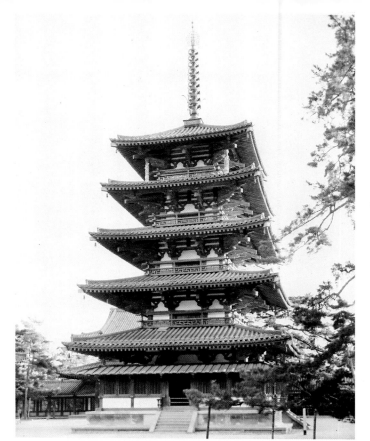

735 HŌRYŪJI.
FIVE-STORY PAGODA

At present, despite the appealing hypotheses that have been advanced, no one can say for certain when the reconstruction began after the fire, or what setbacks were encountered along the way. Apparently the central pillar of the pagoda was left with no walls or roofs for some months, exposed to the elements, and its relics vanished.

There is general agreement that the Kondō was probably the first building to be completed, in the seventh or eighth year of the reign of Temmu's wife, Empress Jitō (r. 686–697), and thus in 693 or 694. The five-story pagoda, usually acknowledged to be the masterpiece of Hōryūji, was supposedly rebuilt in 712, according to a text from the Tempyō era (729–748) entitled *Hōryūji Garan Engi Narabi ni Ruki Zairyō Chō*, or "Documents Pertaining to the History of the Hōryūji Monastery." In any event, the pagoda is the oldest surviving specimen of its kind, and more straightforward in its design than any in Japan.

Though undeniably ancient, Hōryūji underwent its share of changes over the years. The ground, originally of pounded earth, was covered with bricks during the Hōshō era (1460–1465), and there were a number of restorations, particularly during the Genroku era (1687–1703).

Renewed efforts to restore the Kondō at the end of World War II ended in disaster. In 1949, the frescoes decorating the walls were irreparably damaged in a fire accidentally set by a workman, some from the flames, others from water. But all the buildings were saved, as were the statues of the tutelary gods of the monastery: the Shaka Triad, with its statue of Sakyamuni dedicated to the memory of Crown Prince Shōtoku-Taishi; Yakushi, celestial guardian of the prince's father, Emperor Yōmei (r. 585–587); and Amida Nyorai, protector of his mother, Dowager Empress Hashihito.

KASUGAJINJA 春日大社

Renowned for its picturesque setting at the foot of Mt. Mikasa and for its captivating lanterns, the Kasuga shrine played an important role in Japanese history. Here were venerated the tutelary deities of the Fujiwara clan as well as the gods of Kōfukuji, a nearby Buddhist temple affiliated with the same family. This is a good example of the unified and parallel development of Buddhism and Shintoism during the Heian period.

Most of the buildings we see at the site today are 9th-century reconstructions, the most recent of many, and no building dates before the 15th century. Nonetheless, the complex as a whole still conveys something of the spirit of that remote period when Nara and Heian were successive capitals of the empire.

The four main buildings, all painted vermilion, illustrate one of the principal Shinto shrine-types, to which it has given its name, the Kasuga style: a structure one bay square, set on a high platform, a roofed stairway leading up to the door. The spectacularly massive thatch roof is crowned with a ridge beam (*katsuo*) and scissors-shaped finials (*chigi*).

To this day, visitors to Kasugajinja still recall the quasilegendary founding of the shrine, some say in 768, others in 709 (if the latter, Kasuga and Kōfukuji would share the distinction of being the oldest centers of religious activity in Nara). Those acknowledging the earlier date believe that Kasugajinja was created by

737 KASUGAJINJA. LANTERNS IN FRONT OF
THE MAIN SHRINE

562

Fujiwara-no-Fuhito (659–720), son of Fujiwara-no-Kamatari (614–669), founder of the clan and active participant in the Taika reform launched by Emperor Kōtoku (r. 645–654). Certainly the shrine prospered under the patronage of the Fujiwara, the family which traditionally provided Japan with Empresses, and by the Heian period Kasugajinja had become one of the three places where tutelary gods of the imperial family were worshiped—the other two being the Ise shrine (5th–6th centuries?) and Iwashimizu Hachimangū (Ōsaka, founded in 859).

The four "resident" deities of Kasuga found refuge at the shrine after years of wandering, just as the imperial court had roamed from site to site before moving to Nara. The god Take-mikazuchi-no-mikoto was transferred from Kashimajingū in Hitachi Province (now Ibaraki Prefecture) to Yamato, where his shrine had two temporary homes before the final move to Kasuga: Take-mikazuchi-no-mikoto was sent to earth, the legend goes, to vanquish Okuninushi, a descendant of the tempestuous Susano-o, and to pave the way for Ninigi, son of the sun goddess Amaterasu. The Kasuga shrine also became the permanent home, first of Futsunushi-no-mikoto, the god of Katorijingū in Shimōsa Province (present-day Chiba and Ibaraki prefectures), then Ameno-koyane-no-mikoto and Hime-okami from Hiraoka in Kawachi Province (now outside Ōsaka). According to Fujiwara mythology, Ameno-koyane-no-mikoto, a retainer of Amaterasu, was the family's first ancestor. Historically, Kasugajinja evokes the glorification of imperial conquest through its mythic heroes; geographically, it symbolizes the uniting of deities from eastern Japan with those from the Yamato region. Little wonder that for centuries this shrine has been one of the most beloved in all Japan, an enduring reminder of a noble past.

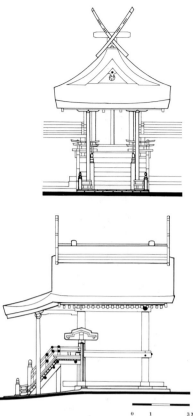

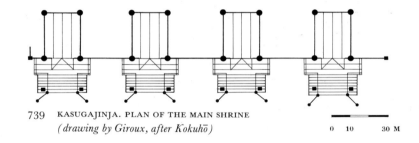

738 KASUGAJINJA. ONE OF THE BUILDINGS
IN THE MAIN SHRINE: FRONT AND SIDE VIEWS
(drawing by Giroux, after Ota Hirotarō)

740 KASUGAJINJA. MAIN SHRINE

739 KASUGAJINJA. PLAN OF THE MAIN SHRINE
(drawing by Giroux, after Kokuhō)
0 10 30 M

KŌFUKUJI 興福寺

Symbolically the Fujiwara family temple of Kōfukuji looms large in the history of Nara, for it was one of the first Buddhist institutions to rise when the emperor—actually, the empress—and the imperial court settled at the new capital in 710.

Eleven years later, in 721, a small octagonal hall, the Hokuendō, was added north of the main building; in 730, a five-story pagoda; much later, in 1143, abdicated Emperor Sutoku (r. 1124–1141; d. 1164) had a three-story pagoda transported from Kyoto's imperial palace to Kōfukuji.

Like all Nara temples, however, Kōfukuji burned down a number of times—its damage in 1180 coincided with the burning of Tōdaiji, both victims of the strife which scarred the end of the Heian period—and the buildings we see today all date from the Kamakura and Muromachi period. But the Fujiwara and the imperial court were partial to this monastery, and rebuilding was quickly begun. By 1195, the new Kōfukuji was more than half finished.

Kōfukuji was restored in the wayo or native style, whereas the rebuilding of Tōdaiji was influenced by contemporary Song architecture in China, which symbolized the "old" Japanese tradition (albeit once Chinese-inspired itself) as opposed to the "new" Chinese manner. From the standpoint of form and proportions, Kōfukuji's rebuilt Hokuendō is a throwback to the Nara period.

The rebuilt three-story pagoda reflects architectural improvements of the Kamakura period. Especially characteristic of this style are its comparatively well-lighted interior with openwork windows. But the design of the structural framework was remarkable in its own right: the central pillar starts in the lowest floor, sur-

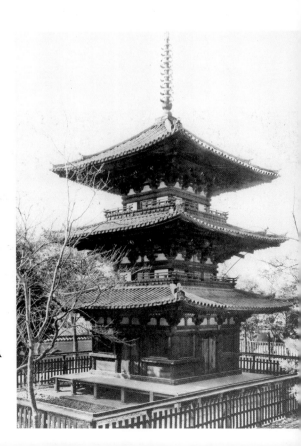

563 741 KŌFUKUJI. THREE-STORY PAGODA

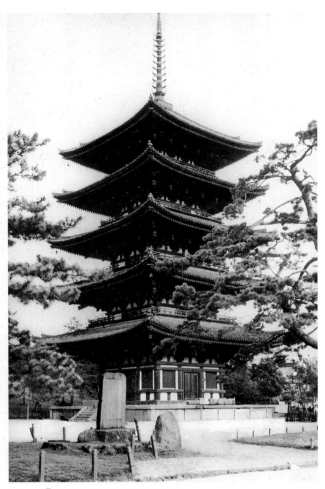

742 KŌFUKUJI. FIVE-STORY PAGODA

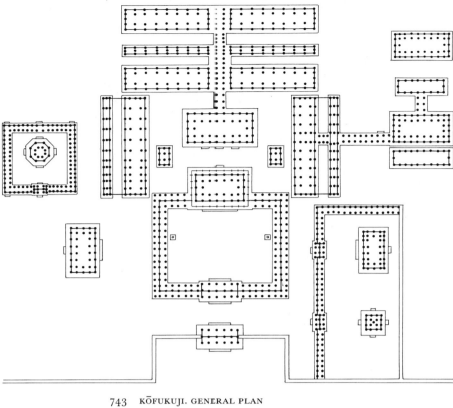

743 KŌFUKUJI. GENERAL PLAN
(after Sekaikōkozaku Taikei)

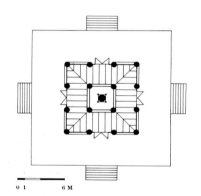

744 KŌFUKUJI. FIVE-STORY
PAGODA: FLOOR PLAN
(after Sekaikōkogaku Taikei)

rounded by twelve columns; at the second floor it is replaced by a more slender pillar that rises through four floors, each supported by four corner columns. The central pillar and the columns are decorated with a thousand painted Buddhas. Structurally, this pagoda is unique of its kind.

The Tōkondō (Golden Hall of the East) was erected in 726 at the request of Emperor Shōmu (r. 724–749) in hopes that ex-Empress Genshō-tennō (r. 715–724) might recover from an illness. It burned down in 1017, was rebuilt ten years later (1027), and burned again in 1046. Though rebuilt in three years, the Tōkondō seemed ill-fated: next the Taira set fire to it in 1180, and the rebuilding launched by the Kamakura regime in 1185 did not mark the end of its tumultuous history the Tōkondō burned in 1356 and in 1411, and each time, as in previous disasters, a new building rose, in 1370 and 1414–15, respectively.

The wife of Emperor Shōmu, Empress Komyō (701–760) ordered a five-story pagoda to be built, and it was completed in 730, more or less contemporary with the Tōkondō. Struck by lightning and destroyed in 1017, it was rebuilt in 1031, only to burn down again some thirty years later. The cycle of ruin and rebirth seemed endless: in 1078, rebuilding; in 1180, fire during the wars of the Late Heian period; in 1205, rebuilding; in 1356, lightning and fire; in 1388, rebuilding; in 1411, again lightning and fire; in 1426, rebuilding. Miraculously, this last pagoda from the 15th century (height: 50.25 meters) has survived to this day. Though built in the same "native" (*wayo*) style as the Tōkondō, it has a greater delicacy that is much in keeping with the tastes of the Muromachi period.

MURŌJI 室生寺

Tucked away in a shady valley in southeast Nara, Murōji is one of the most impressive temples in Japan. Perhaps more than anywhere else, this place conveys the spirit of the "back-to-nature" movement which developed within Buddhism in the early Heian period, when religious life in Nara had become so involved in the political strife of the era.

Apparently, its mysterious setting beneath gigantic cryptomeria trees had been considered sacred since ancient times, and legends said that the rain god Ryūketsuin made his home in this valley. In 777–78, during the reign of Emperor Kōnin (r. 770–781), the heir apparent fell gravely ill, and his condition deteriorated despite prayers offered on his behalf by Japanese everywhere. But monks went to pray and meditate at the site of what is now Murōji, and he recovered. When the miraculously cured prince ascended the throne as Emperor Kammu (r. 782–805), he ordered Murōji built as a thank-offering and placed it under the supervision of Kenkei, a priest from Kōfukuji.

745 MURŌJI. FIVE-STORY PAGODA: ELEVATION
(drawing by Giroux, after Louis Frédéric)

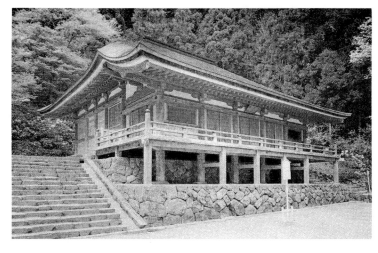

746 MURŌJI. KONDŌ
(LOWER GALLERY ADDED
IN 17TH CENTURY)

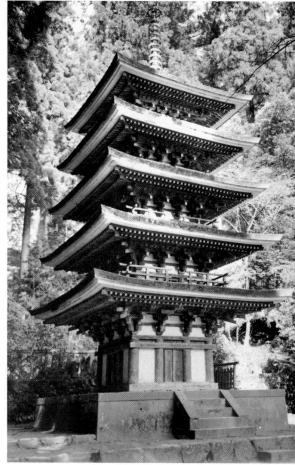

Only two buildings have survived from the time of the temple's founding, both outstanding architecturally: the Kondō (Golden Hall) and the pagoda. Extensively restored and altered in 1672, the main temple is remarkable for its graceful proportions and the fine sculpture displayed inside (figs. 55, 82, 256, 258–60). Most impressive is the pagoda: five stories high, it is nevertheless one of the smallest pagodas in Japan (height 16.18 meters). Its construction of cypress wood; its location on a mountainside, providing an admirable view from below; the slight entasis of its columns, which gives to the roofs the look of birds' outspread wings—all of these features together make a paragon of elegance. The "bird's-wing" effect was utilized during the Asuka period at Hōryūji and elsewhere, and though later discarded, it is still in evidence here.

Owing to the early ties between Murōji and Kōfukuji, the sacred images in the Kondō were seen as incarnations of the tutelary Fujiwara deities worshiped at the Kasuga shrine. Moreover, both Kenkei, the first abbot of Murōji, and his successor and disciple, Shūen, were conversant with the doctrines of esoteric Buddhism that were widely popular during the Heian period. Their teachings became so entrenched over the centuries that in 1701 the temple was officially proclaimed an affiliate of the Shingon sect. This offers yet another example of the numerous, complex ways in which this religion slowly sank its roots into Japanese soil.

747 MURŌJI. FIVE-STORY PAGODA

SHŌSŌIN, TŌDAIJI 正倉院

The Shōsōin of Tōdaiji may be thought of as an enormous treasure house of the objects used during the dedication ceremonies in 752 for the bronze Great Buddha (Roshana Butsu; fig. 49), begun during the reign of Emperor Shōmu (r. 724–729, abdicated). A month and a half after Shōmu's death on May 2, 756, Dowager Empress Kōmyō and her daughter, Empress Kōken (r. 749–764), had a catalogue of the deceased emperor's most cherished items placed inside that colossal statue. The *Tōdaiji Kemmotsu Cho* is a priceless document, our guide to the tastes and passions of an 8th-century Japanese art lover; and this was no ordinary art lover, but an emperor who took an active interest in matters of art and religion. The document might well have been only a soulless enumeration of styles and forms which could no longer be seen, much less appreciated, but such is not the case; an entire building, the Shōsōin, was erected for the express purpose of preserving the riches listed in the imperial catalogue.

Originally the term *shōsō* was used for the repositories maintained at all government, provincial, and departmental temples to safeguard valuable objects from the onslaughts of man and nature. Today these "storehouses" have all vanished save for the *shōsō* of Tōdaiji, considered so venerable that to its title was eventually added the suffix *-in*, usually reserved for a religious structure or institution. Thus, the Shōsōin was not an unusual feature in the history of Japanese temples, for all leading monasteries preserved their archives and precious ob-

748 SHŌSŌIN. PLAN OF LOWER STORY (ABOVE) AND
UPPER STORY (BELOW) *(after K. Kasawara)*

749 SHŌSŌIN.
GENERAL VIEW

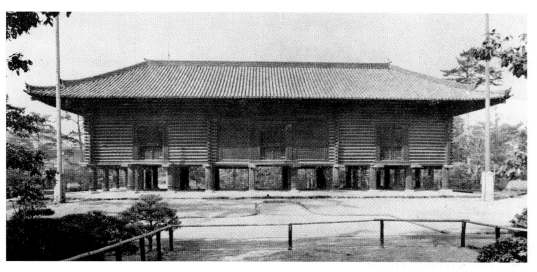

jects in similar structures. But these in no case matched the splendor of Tōdaiji's, nor housed so extensive a collection from one period, and all the others became victims of Japan's strife-ridden history, particularly when the Tokugawa subjugated the monasteries which had been resistant during the civil wars.

The Shōsōin, built of logs and capped with a tile roof, measures 33 meters long, 9.97 meters wide, and 14 meters high. The structure rests on a partially sunken flagstone terrace (approximately 60 meters long and 2.4 meters thick) into which forty round holes were cut to permit the piles of the building to be driven directly through the terrace and into the ground.

The interior layout consisted of three rooms, modified in 1913 to display the objects on two levels in small "storage cells."

In 1875, the Shōsōin treasures passed from Tōdaiji to the Department of the Interior and then to the imperial court. But objects in the north and middle rooms, used during the dedication ceremony, continue to be distinguished from those in the south room, which include temple property from its founding as well as other 8th-century donations unconnected with the dedication ceremony. To allow air to circulate and to check the condition of the treasures, the Shōsōin is opened every year in mid-October and closed in early November with a solemn ceremony performed in the presence of an imperial representative.

Even though most of these objects come from the major cultural centers of Asia (including Byzantium) rather than from Japan, Japanese artists have always held them in such high esteem that they are rightly considered to be part of their own cultural heritage. Pondered, copied, and interpreted over the centuries, they have shone like a beacon for a people whose art springs from civilizations the world over (see figs. 289, 494, 495, 500–506, 534–36.)

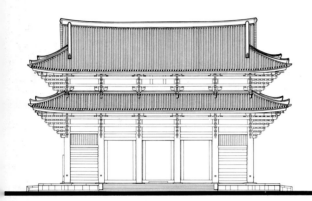

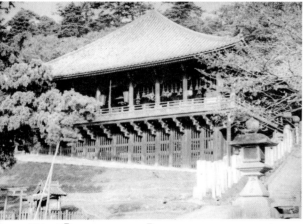

750 TŌDAIJI. SIDE ELEVATION OF DAIBUTSUDEN (GREAT BUDDHA HALL) *(drawing by Giroux, after Ota Hirotarō)*

751 TŌDAIJI. NIGATSUDŌ

TŌDAIJI 東大寺

In 743, Emperor Shōmu ordered the construction of a building to house what is still the largest bronze statue in the world, the Great Buddha (Roshana Butsu) of Nara (fig. 212). This colossal undertaking required several decades, for although the Buddha Hall was completed in 751, the temple enclosure (*garan*) was not finished until about 780.

The imperial edict which founded Tōdaiji specified that the complex be built "to safeguard the country and promote the welfare of the nation." A priest and adviser by the name of Rōben seems to have fostered steadily the emperor's political and religious ardor (fig. 83). The founding of the temple was more than the fulfillment of an imperial fiat, however; it also served the broader policy of bringing the Buddhist faith under closer government scrutiny. Two years earlier, in 741, Shōmu had ordered that two "official" temple-monasteries—for monks (*kokubunji*) and for nuns (*kokubuniji*)—be created in every district in Japan then under imperial jurisdiction, and that the *Konkōmyō Saishōō Kyō* was to be read in every monastery to assure the gods' protection of Japan. In state convents, nuns recited the *Hokkekyō* (*Lotus Sutra*) to exorcise evil and sinfulness. Thus the establishment of Tōdaiji, far from being an isolated phenomenon, provided a whole network of official abbeys with a central or "mother" house, but Tōdaiji has always played the most prominent role, perhaps not so much in Japanese art as in the country's religious and socio-economic history.

Tōdaiji was affiliated with Kegon, a "new" sect introduced into Japan in 735 by Dōzen, a Chinese monk. It taught that the historical Buddha was but one manifestation of the universal Buddha (Vairocana in Sanskrit, Roshana in Japanese). Because all the leading temples of Nara traced their doctrines to China, they—in particular, Tōdaiji—always lavished special attention on objects and ideas from the mainland.

The second greatest moment in the temple's history, following the dedication of the colossal statue of Roshana Butsu in 752, was the solemn initiation or "baptism" of the abdicated emperor in 754, presided over by the Chinese priest Chien-Chen (Ganjin), renowned founder of Tōshōdaiji. The occasion was fraught with symbolic overtones: the sacred dais on which the "catechists" and candidates for the priesthood took their places was the first ever built in Japan in strict accordance with the Buddhist rule as established on the mainland, thus resolving the dilemma faced by all expanding ritual-oriented religions, of how to make legitimate the ordaining of adherents in newly converted lands.

It is perhaps this venerable history that caused all Japanese emperors to hold Tōdaiji in the highest esteem, even after the capital was transferred away from Nara to Kyoto.

Excavations carried out at Tōdaiji in 1951 and 1958 shed considerable light on the ancient history of the temple. The original nucleus included twin seven-story "East" and "West" pagodas. This complex burned in 1180 when the forces of Taira Shigehira (1157–1185) put Tōdaiji to the torch. The Minamoto rebuilt it in 1195 in accordance with the original layout, supervised by a monk named Chōgen (1137–1206), who perfected at Tōdaiji the *Daibutsuyō* (literally, "Great Buddha manner"), an energetic style inspired by recent architecture in southern China, where he had traveled. But Chōgen's work burned in 1567, save for the Great South Gate (Nandai-mon) and the Hokkedō (Sangatsudō; founded c. 733, renovated in 1199). The buildings we see today date from a still later reconstruction in 1708, whose architects reduced the original proportions of the Great Buddha Hall by one third. The length of the present Daibutsuden is thirty percent too short for its height, which was retained since the size of the statue within it made vertical adjustments impossible.

On a hill to the east of the Great Buddha Hall stands the Sangatsudō, or Third Month Temple. Dedicated to Fukukenjaku Kannon, its original name was Kenjakudō, but this must have been too great a strain on

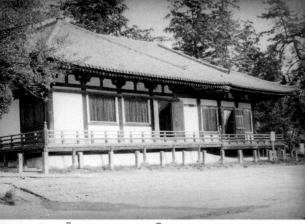

752 TŌDAIJI. SANGATSUDŌ

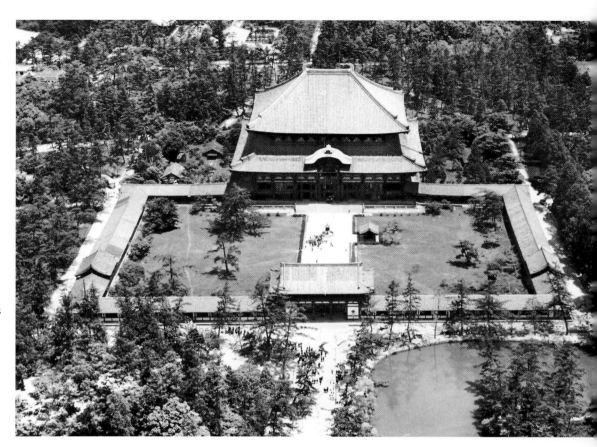

753 TŌDAIJI.
AERIAL VIEW OF THE TEMPLE

the average worshiper's memory. Since the temple's illustrated copy of the *Lotus Sutra* (*Hokkekyō*) was put on display here every March, people began referring to the sanctuary as the Hokkedō (Lotus Hall) or, even more simply, the Sangatsudō (Temple of the Third Lunar Month). Its date is contested—some saying 733, others 746—and it is not mentioned in the Shōsōin archives until 749; the present buildings were almost entirely renovated during the Kamakura period.

The most unusual feature of the Sangatsudō is the division of its main sanctuary into two sections: the sanctuary proper, with the altar positioned to allow for circumambulation of the great sculptures there (figs. 44, 235–38, 284–85); and in front a kind of narthex where worshipers may gather.

Opposite to the Sangatsudō on the east is the Nigatsudō, or Second Month Hall, an allusion to the ceremonies held there every year during the second lunar month, between February 20 and March 15. Monks present the principal effigy, the Eleven-headed Kannon, with water endowed with the "eight spiritual virtues," which became popularized into everyday medicinal properties. Jutting out over a ravine (*kengaizukuri*), the present Nigatsudō (1667) remains a picturesque building; twice risen from the ashes, in 1180 and 1567, the original building of 752 was reputed to have been even more captivating.

TŌSHŌDAIJI 唐招提寺

In 753, after many shipwrecks, the Chinese monk Chien-Chen (Ganjin: 688–763; figs. 277, 349) reached Japan, and six years later he founded Tōshōdaiji. Despite numerous repairs over the centuries, it remains the most impressive, as well as the most authentic, repository of late Nara art.

The large main building (Kondō) is dedicated to the three deities whose colossal statues it contains: a dry-lacquer seated statue (*dakkanshitsu*) of Roshana Buddha (height, including halo and base, 7.21 meters; fig. 49); an effigy (*mokushin-kanshitsu*) of Yakushi, lacquer over wood, which stands 6.15 meters high; and a statue of the Thousand-armed Kannon (height 5.5 meters; fig. 50), also lacquer over wood. These statues, with smaller attendant figures, fairly soar up to the ceiling; all occupy a dais-like altar around which worshipers may perform circumambulation, as is customary in Buddhist temples honoring several deities. At the other end of the hall is a painted wood image of the seated Dainichi Nyorai (fig. 253). These are splendid examples of the school of sculpture then flourishing at Tōshōdaiji, which had far-reaching effects on art throughout medieval Japan.

In keeping with the traditional plan of Buddhist monasteries, the temple includes a lecture hall (*kōdō*) where priests read texts aloud to instruct monks and worshipers; a five-story pagoda-reliquary; and two reposi-

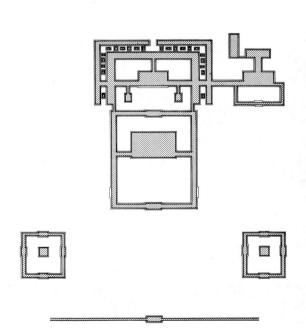

754 TŌDAIJI. ORIGINAL PLAN
(*after "Pageant of Japanese Art"*)

567

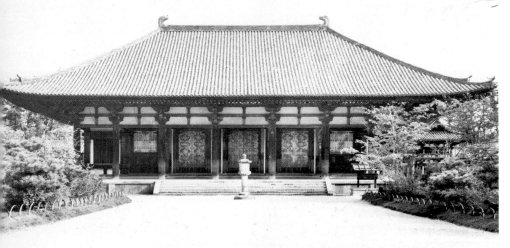

755 TŌSHŌDAIJI. KONDŌ

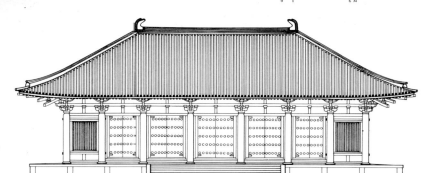

756 TŌSHŌDAIJI. KONDŌ: SECTION

757 TŌSHŌDAIJI. KONDŌ: ELEVATION *(drawings by Giroux, after Ota Hirotarō)*

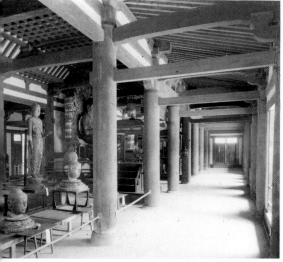

758 TŌSHŌDAIJI. INTERIOR OF THE KONDŌ

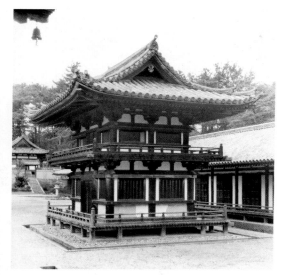

759 TŌSHŌDAIJI. PAVILION OF THE DRUM (FORMER RAIDŌ)

tories—a *hōzō* for precious objects and a *kyōzō* for sutras—to guard their contents against inclement weather and looters. These two little buildings—windowless structures reminiscent of Yayoi huts except roofed with tile, not thatch—are conspicuously different from the purer Chinese manner of the other monastery buildings, which had the good fortune to escape burning and thus retain the graceful proportions their architects intended, rarely the case in Nara architecture.

At the time of Tōshōdaiji's founding, the relics which Ganjin had brought from China were placed in a specially built hall between the Kondō and the Kōdō. It was rebuilt in 1240, and an ink inscription inside the building contains the word *raidō*, meaning "hall of worship." During the Genroku era (1688–1703), however, another hall was erected for venerating relics, and the drum giving the rhythm during ceremonies was placed in the former *raidō*. At the time that the Obaku branch of Zen Buddhism was introduced, in 1655, it came to be known as the "Hall of the Drum of the Sutra Clock," a religious title with no implication that a drum was actually inside. This is why the former *raidō*, which has since become a place of worship again, is still known as the *Korō*, or Pavilion of the Drum.

YAKUSHIJI 藥師寺

Dedicated to Yakushi, the healing Buddha that cures all ills physical and spiritual, Yakushiji is not only the head temple of the Hossō sect, but one of the oldest and most revered religious institutions in Nara.

In 680, even before Nara had been chosen as the site of the imperial capital, Emperor Temmu (r. 673–686) ordered a sanctuary built there and a number of statues cast so that his wife might recover from a serious illness. Most of the buildings completed in 698 stood outside of what is now Nara, but gradually they were removed to the new capital when the imperial court moved into Heijō palace. Before abdicating in 718, Empress Gemmei (r. 707–714) ordered all the wooden structures carefully dismantled and—a subject still subject to controversy—reassembled at their present site. The original site did not remain empty, however: perhaps the old buildings were left as they were; perhaps new ones rose in their stead. In any event, the complex on the old site was called "Old Yakushiji" (Moto-Yakushiji) to distinguish it from the new temple which the imperial court took under its wing during the Nara and Heian periods. Furthermore, the Yakushiji at Nara must not be confused with what is known as "New Yakushiji" (Shin-Yakushiji), a small temple that Empress Kōken founded at Nara in 750 for the recovery of her husband, Emperor Shōmu (r. 749–758). The splendid buildings which now comprise Shin-Yakushiji, southwest of Kasugajinja, are from various periods and places; except for the main hall, there seems little connection between the buildings and the burned structures they replaced, which doubtless had other locations.

The plan of Yakushiji generally coincides with that of Buddhist temples from the Nara period, except that its east and west pagodas rise inside, not outside the galleries forming the enclosure (*garan*). It was logical

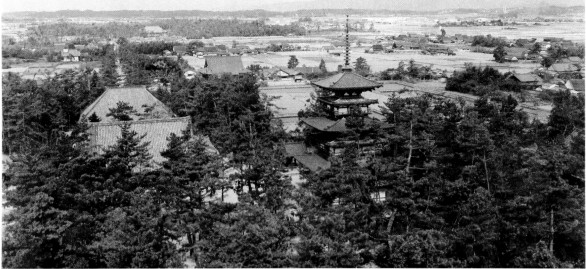

760 YAKUSHIJI. GENERAL VIEW

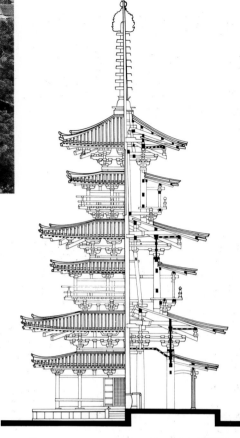

761 YAKUSHIJI. ELEVATION AND SECTION
OF THE EAST PAGODA (TŌTŌ)
(drawing by Giroux, after Louis Frédéric)

that the one pagoda in the temple of Asuka, for example, should stand inside the *garan* as the focal point of the complex (see fig. 576); but complexes with two pagodas, such as those at Nara, were usually not suited to this arrangement. The "interior pagoda" layout at Yakushiji appears to have been a holdover from the Asuka period.

The East Pagoda (Tōtō) is a most captivating structure of its kind, and one of Yakushiji's crowning glories. It has fewer roofs than would appear, for above each of the pagoda's three stories was added a tiled eave (total height 33.6 meters). The resulting six registers create striking effects of light and shadow throughout the year.

Inside the pagoda square stones cover the floor, and the stone foundations of the round pillars are also square. The central mast soars majestically through the entire pagoda with none of the intricate framework that is needed to strengthen a pieced central pillar, and the pagoda is capped by a steeple of nine rings (*sorin*) and an elaborate flame-shaped finial (*sui-en*). With its elegant arabesques of gilt bronze, the *sui-en* of Yakushiji must be counted a masterpiece of its kind. (The original, in the Nara Museum, is replaced by a copy atop the pagoda.)

Yakushiji is renowned for its wealth of painting and sculpture (figs. 46, 48, 81, 210–11, 223–34, 276). Except for the "six"-story Tōtō, however, the present buildings were reconstructed during the Kamakura period or later: the Toindō in 1285, the Kondō in 1635, and the Kōdō in 1852, their originals falling victim to devastating fires.

Pilgrims are still drawn to Yakushiji to worship Bussokuseki, or "Buddha's Footprint," a rock (1.66 by 1.15 m.) bearing an incised outline of a gigantic foot (approximately 50 cm. long). The inscription on it reads: "During the Tang dynasty, Xuan-Chuang, a messenger of the imperial court, traveled to Magadha in India, where he himself took the imprint of Buddha's foot. Kifumi-no-Motomi, a Japanese emissary at the Tang court, made a copy and brought it back with him to Japan. This work, which Fumiya-no-Mahito requested in the fiftieth year of Tempyō-shōhō [753] so that his wife's soul might rest in peace, was based on his copy."

Originally placed in Tōshōdaiji, this stone attests not only to the worship of relics—a powerful force in China and Japan at the time—but to early Buddhist iconography, which in ancient times forbade representation of the Buddha and resorted to symbols such as this footprint.

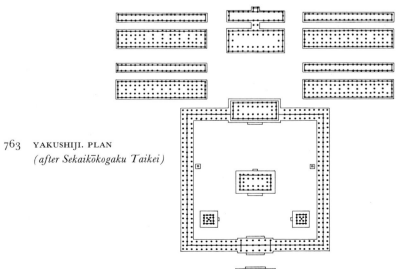

763 YAKUSHIJI. PLAN
(after Sekaikōkogaku Taikei)

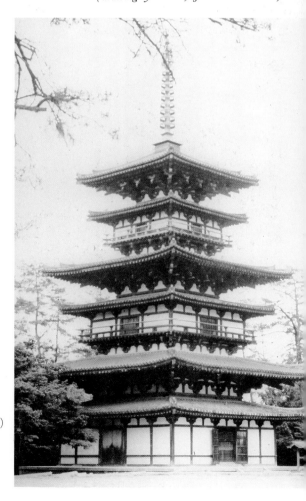

762 YAKUSHIJI.
EAST PAGODA (TŌTŌ)

Gardens

764 GARDEN OF THE DAISEN-IN, DAITOKUJI, KYOTO
Garden designed in 1509 by the priest Daishō.
Muromachi Period (photo Mireille Vautier-Decool)

765 GARDEN OF THE SHISENDŌ, THE RETREAT OF ISHIKAWA JŌZAN (1583–1672), KYOTO
Edo Period (photo Dusan Ogrin)

766 GARDEN OF THE RITSURIN, TAKAMATSU, KAGAWA PREFECTURE
Garden established on the site of the one-time residence of the Matsudaira family.
Edo Period, 18th century (photo John Hymas)

767 GARDEN OF NIJŌ PALACE, KYOTO
Edo Period; large trees planted recently (photo Jean-Paul Nacivet)

768 SAND, ROCK, AND PLANT GARDEN, KYOTO
(photo Dusan Ogrin)

769 SAND AND ROCK GARDEN, HŌFU, YAMAGUCHI PREFECTURE
(photo John Hymas)

770 SAND AND ROCK GARDEN, RAIKYŪJI, TAKAHASHI, OKAYAMA PREFECTURE
(photo John Hymas)

771 SAND GARDEN, KONCHIN OF NANZENJI, KYOTO
Edo Period (photo John Hymas)

772 SAND GARDEN, RYŌGEN-IN, KYOTO
(photo Dusan Ogrin)

773 SAND AND MOSS GARDEN, TŌFUKUJI, KYOTO
1938 (photo John Hymas)

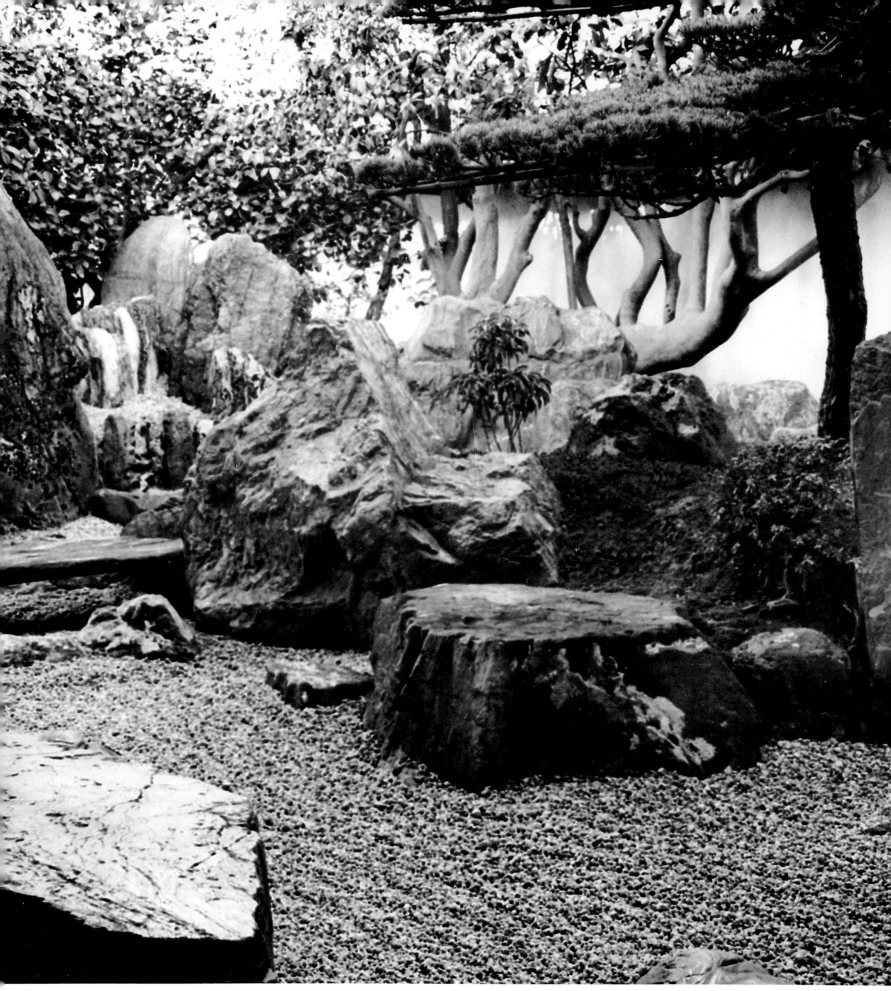

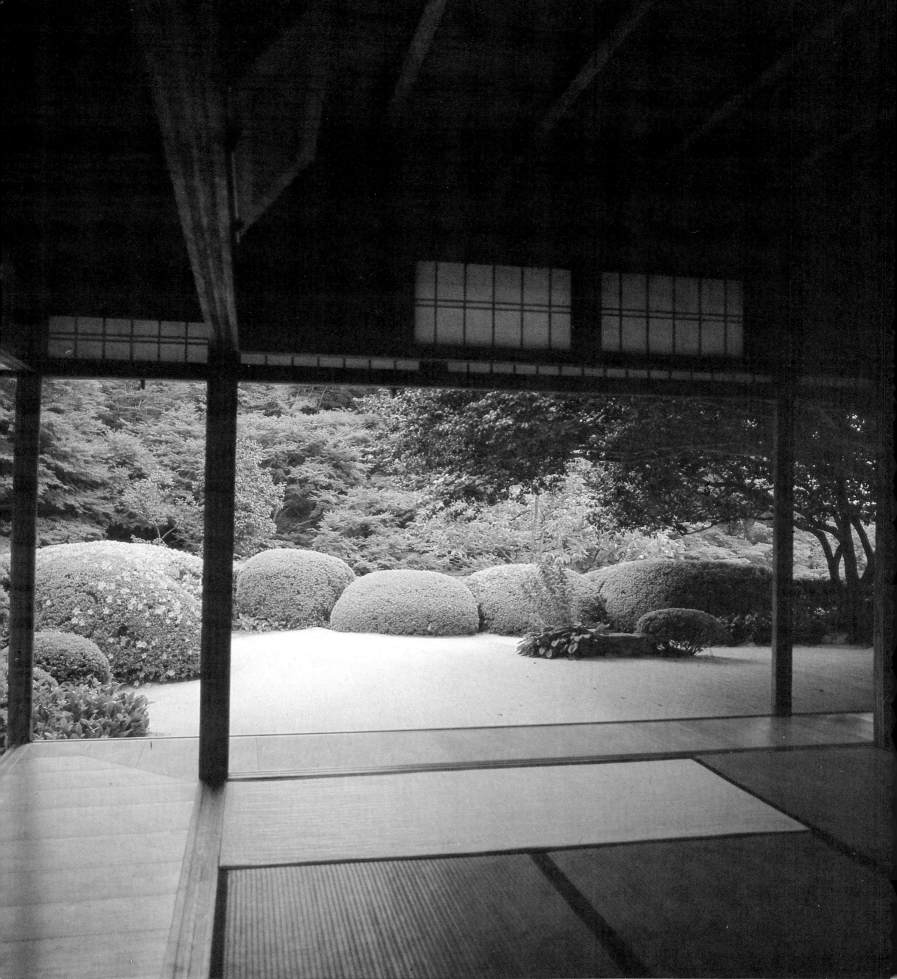

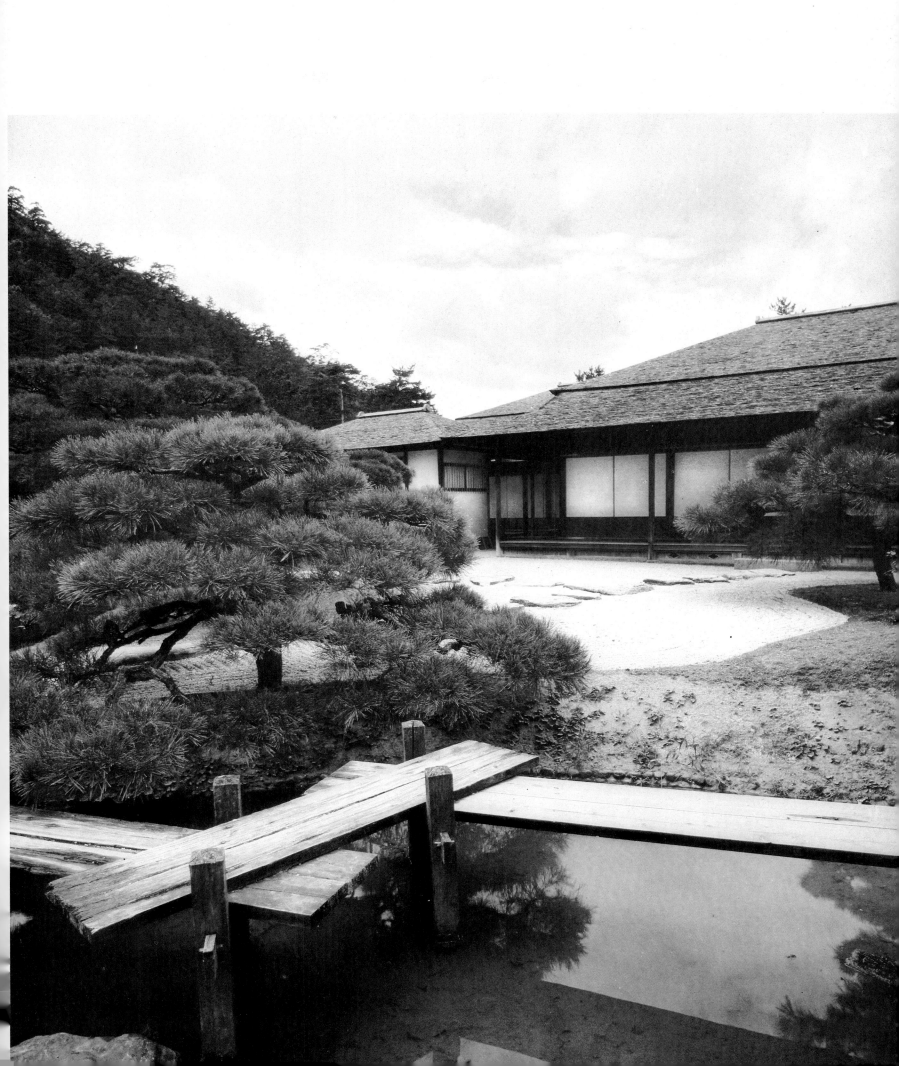

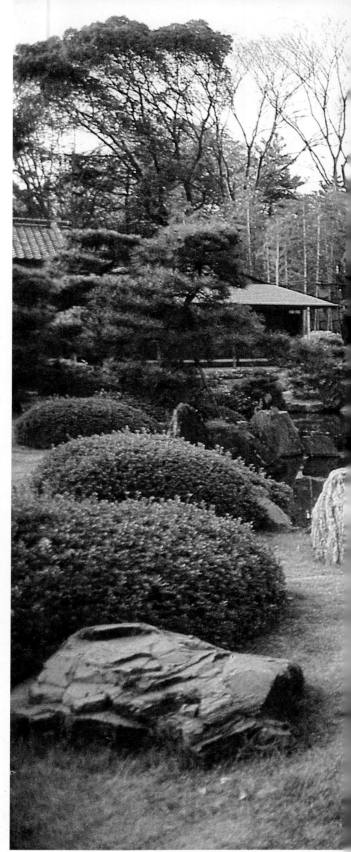

767

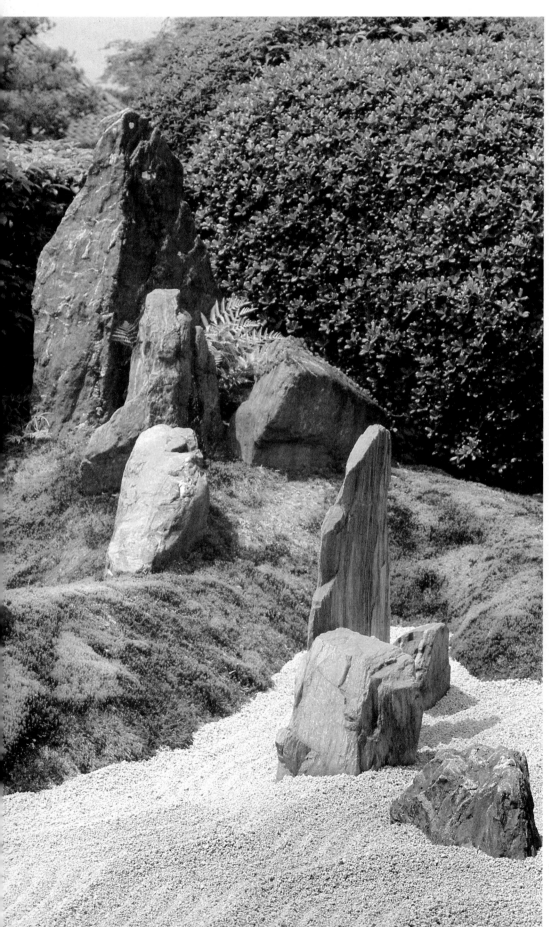

768

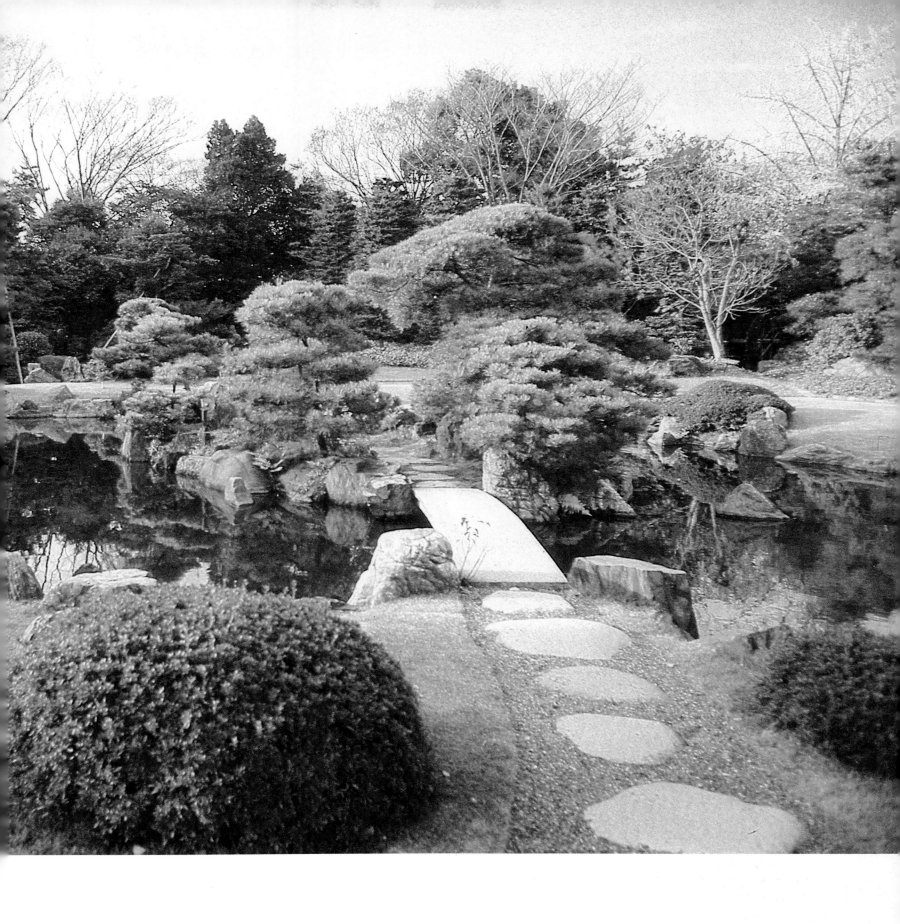

769

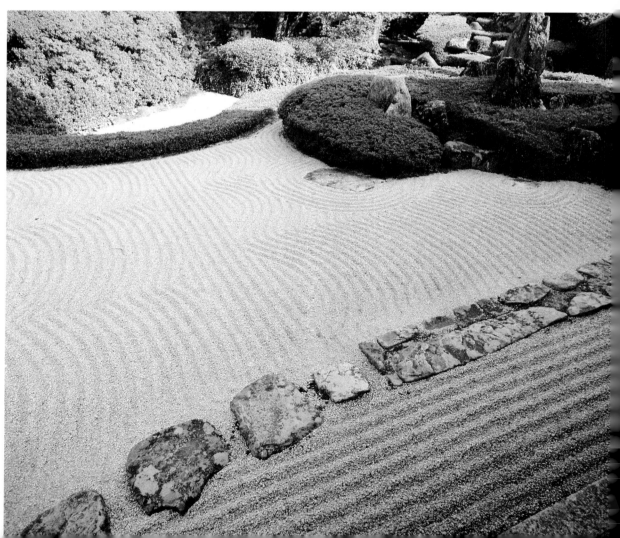

770

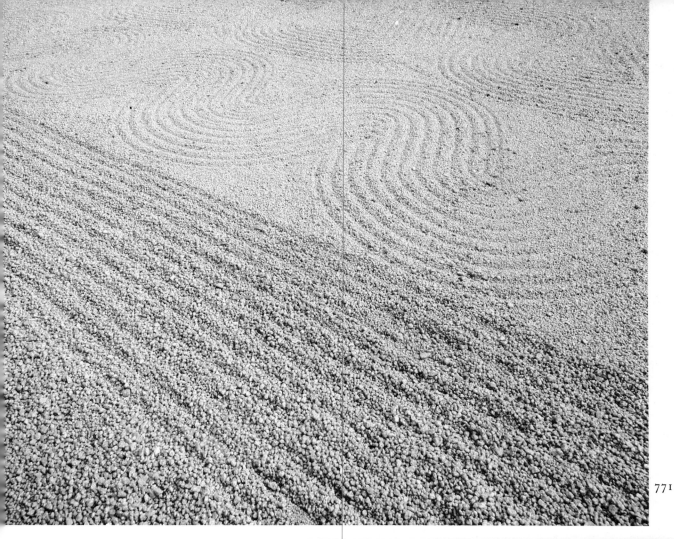

771

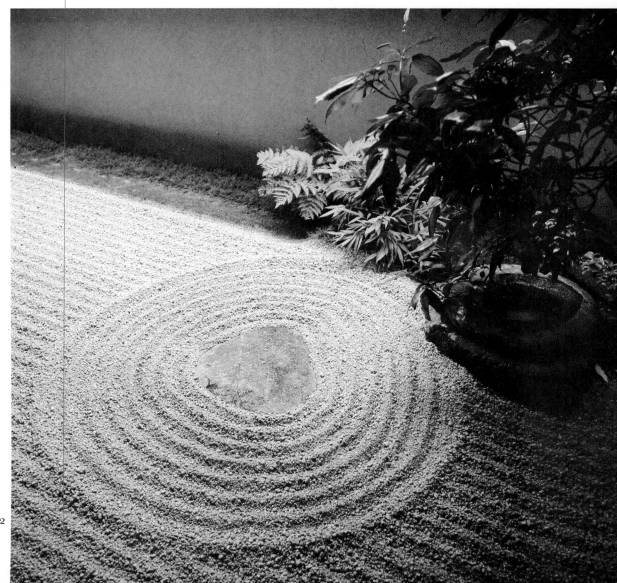

772

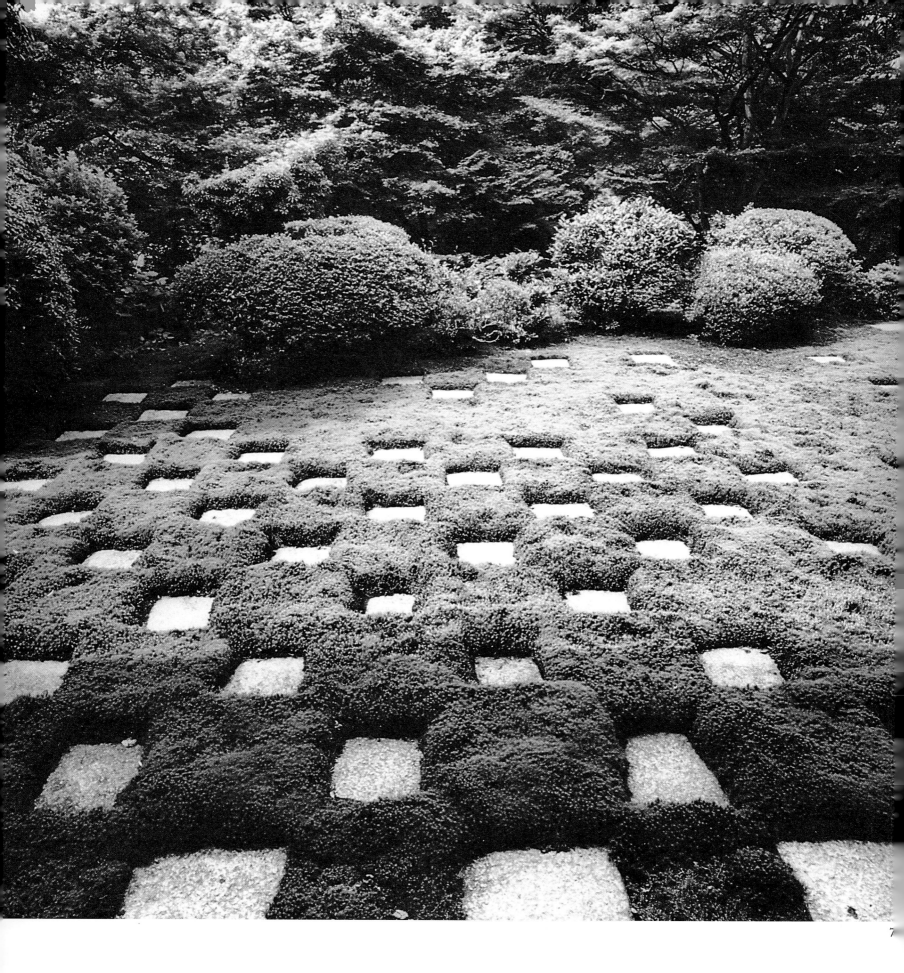

Calligraphy and Handwritten Documents

774 KŪKAI (KŌBŌ DAISHI, 774–835)
Detail of handwritten letter. Ink on paper, entire scroll 28.8 × 158 cm.
Heian Period, 812.
Kyōōgokokuji (Tō-ji Treasure House), Kyoto (photo Benrido)

775 ICHIJI ICHIBUTSU HOKKEKYŌ (LOTUS SŪTRA: "AS MANY BUDDHAS AS THERE ARE CHARACTERS")
Detail of handscroll, with stamps and calligraphy. Ink and color on paper, entire scroll 28.1 × 212.4 cm.
Heian Period, 11th century.
Zentsuji Treasure House, Kagawa Prefecture (photo Benrido)

776 SŪTRA RISHUKYŌ (SUTRA OF THE PRINCIPLES OF DESTINY)
Detail of handscroll. Ink on decorated paper (gold flecks and sketches), entire scroll 25.3 × 456 cm.
Kamakura Period, 1192.
Daitōkyū Kinen Bunkō, Tokyo (photo Sakamoto Manshichi)

777 EMPEROR TAKAKURA (r. 1168–1180)
Detail of handwritten document. Ink on paper, entire height 29.7 cm.
Heian Period, 1178.
Ninnaji Treasure House, Kyoto (photo Tokyo National Museum)

778 FAN-SHAPED LOTUS SŪTRA
One of ninety-eight leaves. Ink and color on paper, 25.5 × 41.2 cm. (upper) × 19.4 cm. (lower).
Kamakura Period, late 12th century.
Shitennōji, Ōsaka (photo Sakamoto-Ziolo)

779 NICHIREN (1222–1282)
Handwritten document. Ink on paper.
Kamakura Period, 1280.
Honnōji, Kyoto (Temple photo)

780 TEXT ACCOMPANYING PORTRAIT OF TAIRA-NO-KANEMORI
From Thirty-six Poets (Sajūrokkasen).
Satake version. Attributed to Fujiwara-no-Nobuzane (1176–1266).
Ink on paper, 37.8 × 59.1 cm.
Kamakura Period.
Kyūsei Atami Art Museum, Atami (Museum photo)

781 SHITENNŌJI ENGI (LEGENDS OF THE SHITENNŌ TEMPLE)
Detail of handscroll with calligraphy. Ink on paper, entire height about 30 cm.
Kamakura Period, 13th–14th century.
Shitennōji, Ōsaka (photo Mainichi)

782 EMPEROR GO-UDA (r. 1275–1287)
Detail of handwritten last will and testament. Ink on paper, entire height about 25 cm.
Late Kamakura Period, 1333.
Daikakuji, Kyoto (photo Kodansha)

783 SESSHŪ (1420–1506)
Signature from handscroll THE FOUR SEASONS *(see figs. 374–76).*
Ink on paper, entire height 39.7 cm.
Muromachi Period, c. 1486.
Mōri Museum, Hōfu (Museum photo)

咸詣咸聽彼獲一切寂樂愉畳大樂金剛不

空三昧究竟志地現受獲得一切自在愉

繋以十六大菩薩盡得故如来執金剛位

介勝一切如来及持金剛菩薩摩訶薩等以

棗集會敬令此法速成就故咸興

獨讚金剛手言

善哉善哉大隆壇　善哉善哉大安樂

大法立事始於五
晚旦于今處事以法
可放之海存旦始
慎之於先於二惺
宿放瞿其江所重驗對
晴之正今又以此並所對
仁法事期而
二月十三日

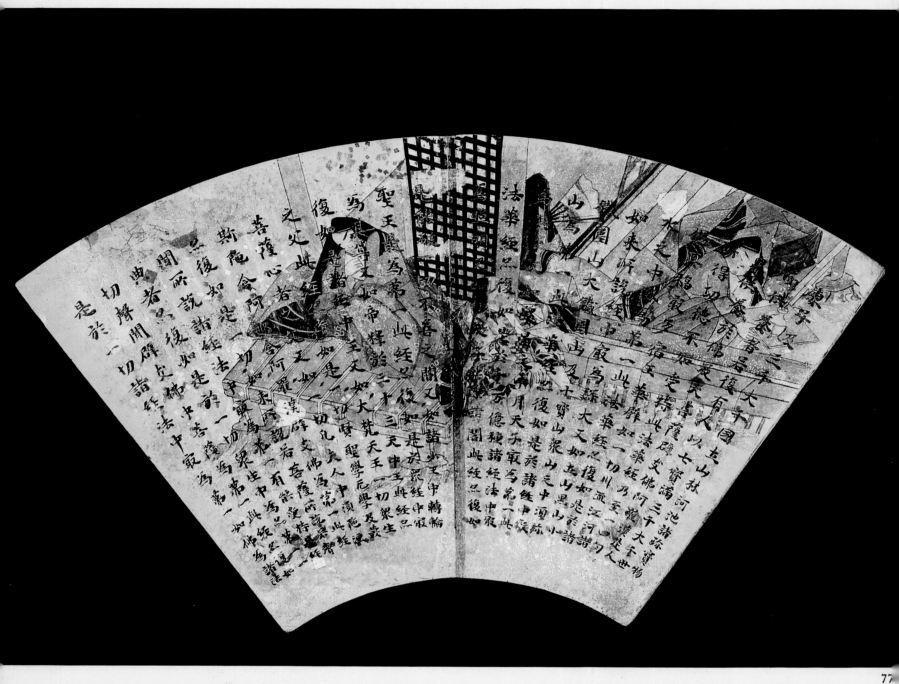

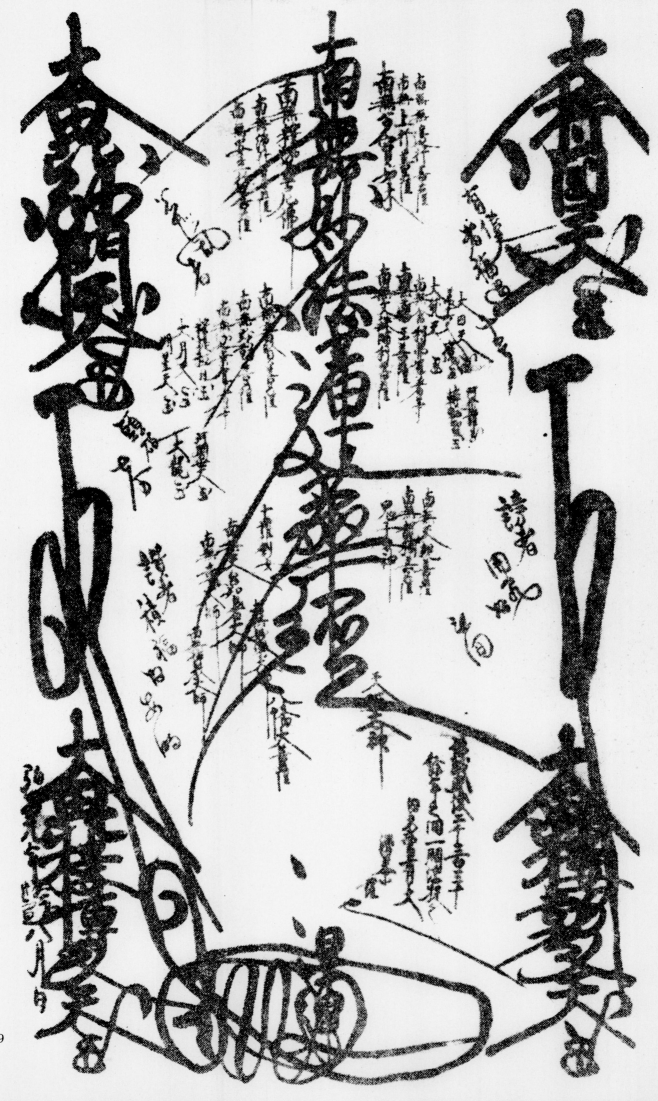

779

従五位上行讃岐守平朝臣盛國

亮孝天皇恒一品或評七老親王曾孫

従五位上興我王孫隱云位上筑紫守篤以

二男母宮道民朱雀村上参氣圓縣華山

一源方代人

うれいり可小門りうこ

たくりもふくまりい至

一座雪卌雙玉揚六十九年葉漢

CONCISE BIOGRAPHIES

Rulers and Statesmen
Monks, Priests, Philosophers
Writers, Poets, Dramatists
Painters
Sculptors
Potters
Tea Masters

RULERS AND STATESMEN

EMPERORS

NINTOKU (4th century, traditional dates: 313–399)
Nothing is known about the sixteenth emperor of Japan, except that his "keyhole" tomb (*zempō-kōen*), located on the plain of Ōsaka, is one of the largest and most beautiful of all Iron Age burial mounds (Kofun Jidai, 4th–6th centuries; see figs. 610, 611).

KŌTOKU (r. 645–654)
Thirty-sixth emperor of Japan. He succeeded his sister Kōgyoku (r. 642–645), who reascended the throne after him as Saimei (r. 655–661). The Chinese-style government established during his reign was part of the Taika reform (646). The use of eras (*nengō*) for chronological purposes—the Taika era was the first *nengō*—was also borrowed from China.

TENCHI (r. 661–671)
Thirty-eighth emperor of Japan. He succeeded his mother, Empress Saimei (r. 655–661), who had already ruled as Kōgyoku (r. 642–645). An able administrator, he published the *Ōmiryō*, a twenty-two-volume code of laws which was completed in 668 under the supervision of Nakatomi-no-Kamatari (614–669). (Kamatari was given the family name of Fujiwara for his efforts; see fig. 328.) Tenchi acknowledged the failure of the Japanese colony in Korea and had an administrative outpost built at Dazaifu, on Kyūshū (figs. 633, 634).

SHŌMU (701–756, r. 724–749)
Forty-fifth emperor of Japan. In addition to furthering Buddhism—the Great Buddha of Tōdaiji (fig. 212) rose during his reign—he saw to the administrative and personal needs of his people. The *shiyaku-in* (public drugstore) was established on his orders.

KAMMU (736–806, r. 781–806)
Fiftieth emperor of Japan. During his reign the imperial court moved to Heian, and Sakanoe-no-Tamuramaro (758–811), the first to receive the title of *sei-i-tai-shōgun*, launched the campaign to "pacify" the northern barbarians of Tōhoku.

SAGA (r. 809–823)
Fifty-second emperor of Japan. Succeeded his brother Heijō (r. 806–809); his father, Emperor Kammu (r. 781–806), founded Heian (Kyoto). Emperor Saga is remembered for his accomplishments in administration: the Taihō Code (*Taihō-ryō*), completed in 701, was greatly amplified during his reign, and he created the administrative office of *kurōdo*, and of *kebiishi* (police).

DAIGO (885–930, r. 897–930)
Sixtieth emperor of Japan. The surge in literary output during his reign included such brilliant figures as Ki-no-Tsurayaki (883–946). He was buried in Daigoji, the temple he had caused to be built (figs. 674–77).

SHIRAKAWA (1053–1129, r. 1072–1086)
Seventy-second emperor of Japan. Events during his reign led to the collapse of the Heian regime: the wars against the soldier-monks of Enryakuji on Mt. Hiei; the emergence of a provincial aristocracy whose tax-free domains, originally lifetime holdings granted by the government in exchange for money, became hereditary. In 1096, Shirakawa became a monk and took the title of *hoō* that was bestowed on such former emperors.

GO-TOBA (1180–1239, r. 1183–1198)
Eighty-second emperor of Japan. Bestowed the celebrated title of *sei-i-tai-shōgun* on his general Minamoto-no-Yoritomo (1147–1199) in 1192. Despite an attempt to regain power in 1221, Go-Toba's reign marked the irreversible decline of imperial authority in political matters.

GO-DAIGO (1288–1339, r. 1318–1338)
Ninety-sixth emperor of Japan. Possibly the boldest, certainly the most controversial individual to ascend the Japanese throne. Determined to regain control over affairs of state, he broke away from the purely religious or symbolic role to which emperors had been relegated. The ensuing civil war led to the fall of the Kamakura shogunate and the subsequent ascendancy of the Ashikaga shōguns, headquartered in the Muromachi district of Kyoto. A dispute over shogunal succession complicated an already chaotic situation: the nobility split into two factions, one supporting the "Northern Dynasty," the other supporting Go-Daigo's "Southern Dynasty." The conflict further weakened imperial authority.

EMPRESSES

SUIKO (554–628, r. 592–628)
Thirty-third empress of Japan, succeeding her brother Sushun (r. 587–592). As first real empress, not merely the regent for a son, Suiko governed with the help of her famous nephew, Crown Prince Shōtoku-Taishi (572–622).

JITŌ (r. 686–697)
Forty-first empress of Japan. A daughter of Emperor Tenchi (r. 661–671), she succeeded her husband, Emperor Temmu (673–686). She is believed to have promoted the development of agriculture, fostered sound administrative practices, and struck the first silver coins. It was she who ordered the building of Horyūji near Nara. Abdicated in favor of her nephew Mommu (r. 697–707) and received the title of abdication *dajō-tennō*.

GEMMEI (661–721, r. 707–715)
Forty-third empress of Japan. A daughter of Emperor Tenchi (r. 661–671), she succeeded her own son, Emperor Mommu (r. 697–707), at the age of forty-six. Transferred the imperial court to the permanent capital of Nara (figs. 725, 726). She is credited with a number of accomplishments, including the publication of the *Kojiki* (chronicles of history and tradition) and the *fudoki* (local chronicles) as well as the striking of the first copper money. Abdicated in favor of her daughter Genshō.

EMINENT STATESMEN

SHŌTOKU-TAISHI (572–622)

This near-legendary figure played a decisive role in government and religion (figs. 279, 339–42). Second son of Emperor Yōmei (r. 585–587), he followed the Chinese model of administrative structure and staunchly supported Buddhism. His birth was so sudden, the legend goes, that his mother could not reach her chambers in time and brought him into the world in the stables (*umaya*): thus, young Shōtoku is often referred to as Umayado.

He came of age, politically speaking, when his aunt, Empress Suiko (r. 592–628), succeeded her brother Sushun (r. 587–592) as well as her other brother (and husband) Bidatsu (r. 572–585). In those times, brothers apparently took precedence in the imperial succession, and Suiko became empress only after male siblings had been exhausted. She named her nephew Shōtoku *Kōtaishi*, or heir to the throne, and relied heavily on his advice in all matters. Although Shōtoku predeceased his aunt and never officially held the reins of government, his legacy to Japan's political development is impressive: he established the twelve ranks of the imperial court in 603; issued a code of laws in 604 that provided Japan with a Chinese-style constitution having seventeen articles; adopted the Chinese calendar; and sent the first Japanese mission (607–608), headed by Ono-no-Imoko, to the Sui imperial court.

THE FUJIWARA

In 669, Emperor Kōtoku (r. 645–654) bestowed on his faithful minister Nakatomi Kamatari (614–669; fig. 328) the family name of Fujiwara—actually the name of their Yamato residence, meaning "wisteria yard." The Nakatomi claimed a very ancient, quasi-legendary lineage believed to go back to a retainer of the Shinto sun goddess Amaterasu and Ninigi-no-mikoto. Of all the ministers and high officials produced over the centuries in each generation of the family, none left so indelible a mark on his time, or added such luster to the family name, as Fujiwara-no-Michinaga (see below).

FUJIWARA-NO-MICHINAGA (966–1027)

In 995 Michinaga was appointed *kampaku*, the highest post at the imperial court, serving as intermediary between the emperor and his officials. His star rose higher still when in 999 he gave his daughter in marriage to Emperor Ichijō (r. 986–1011), for this launched the long-standing policy of matrimonial alliances between daughters of the Fujiwara family and reigning emperors, which gave them the enviable position of being the fathers-in-law and later the grandfathers of Japanese rulers. The Fujiwara held this privileged status for nearly two centuries; should an emperor show too much initiative, they always arranged for his abdication and found a suitable replacement among the imperial grandchildren. In 1017 Michinaga secured the office of *dajōdaijin* (Prime Minister and President of the Supreme Council) for his eldest son Yorimichi (992–1074) and officially retired two years later, becoming a monk at Tōdaiji. In 1020 he launched the construction of Hōjōji on the west bank of the Kamo River, located on his Kyoto fief, compelling the provinces to make sizable "contributions" to this project. The

recipient of countless honors, Michinaga died in 1027.

FUJIWARA-NO-YORIMICHI (992–1074)

Michinaga's eldest son, Yorimichi, succeeded his father as *kampaku* in 1027 and remained in office until 1068, resigning in favor of his brother Norimichi (996–1075). Following the model set by his resourceful ancestors, he continued their policy by marrying his daughter into the imperial family—which brought Michinaga to the acme of his power. But the Taira, the Minamoto, and other aristocratic families from the provinces were beginning to forge their reputations as unsurpassed men of action, and Yorimichi's long mandate actually marked the end of Fujiwara ascendancy. The imperial court and its surrounding region were at first unaware of these developments, and at Uji, Yorimichi built the famous Byōdōin, a jewel of Heian architecture that served as a setting for extravagant revels (figs. 671–73).

THE TAIRA

The Taira, like the Minamoto (see below), traced their ancestry to the imperial line: the family was founded by Prince Katsubara-shinnō (786–853), son of Emperor Kammu (r. 781–806). The final years of the Heian period were scarred by a fierce power struggle between the Taira and the rival Minamoto clan.

TAIRA-NO-KIYOMORI (1118–1181)

Appointed governor of Aki Province (modern Hiroshima Prefecture) in 1146, Kiyomori took an active part in the Hōgen and Heiji civil wars (1156 and 1159, respectively). He rescued Emperor Go-Shirakawa (r. 1155–1158), who had been captured by the Minamoto, and he exiled Minamoto-no-Yoritomo, whose father, Yoshitomo, was murdered (see below). Kiyomori was now the undisputed ruler of Japan. A marriage on the female side with the imperial family enabled him to rise to the ranks of *naidaijin* (Minister of Internal Affairs) and *dajōdaijin* (Prime Minister and President of the Supreme Council). In 1168, however, he fell ill and decided to become a monk. He continued to rule the country from his retreat, Fukuhara Palace (near Kōbe, Hyōgo Province) and members of his family filled all key offices. In 1171, he even managed to marry his daughter Tokuko to Emperor Takakura (r. 1168–1180), then eleven years old. When the Minamoto plotted against Kiyomori and when Shigemori, his son and trusted adviser, died in 1179, Kiyomori gave full vent to his unbridled lust for power. He forced his emperor son-in-law to abdicate, replacing him with his own two-year-old grandson Antoku. Prominent aristocrats as well as other members of the imperial family chafed at this dictatorial handling of the government. By the time of Kiyomori's death in 1181, the entire Kantō region had joined the rebellion led by Minamoto no Yoritomo.

THE MINAMOTO

The Minamoto (or Genji) family came into being in 814, when the court, faced with the number of imperial princes, was unable to meet its expenses; Emperor Saga's (r. 809–823) seventh son was given the name Minamoto and transferred to a residence outside the imperial compound. Other young princes followed: the four main branches of the Minamoto (or Genji) clan—the Saga-Genji, Seiwa-Genji, Uda-Genji, and Murakami-Genji—are distinguished from one another by the name of the emperor to whom they traced their roots.

MINAMOTO-NO-YOSHITOMO (1123–1160)

Minamoto-no-Yoshitomo was a member of the Murakami-Genji, the branch descended from the sixty-second emperor of Japan, Murakami (r. 946–967). His strife-torn life included a temporary alliance with the Taira, which then became a fierce war against the same family. Yoshitomo was assassinated by one of his own vassals (*kerai*), Osada Tadamune.

MINAMOTO-NO-YORITOMO (1147–1199)

Third son of Minamoto-no-Yoshitomo. When the latter was murdered in 1160, Taira-no-Kiyomori (1118–1181) exiled thirteen-year-old Yoritomo to the Izu Peninsula. Twenty years later Yoritomo answered the call sent out by the imperial family and took up arms against the Taira. Resourcefully manipulating family intrigues in both camps, he won decisive victories over his adversaries at Ichino-Tani (1184) and Dan-no-Ura (1185); five years later he consolidated his authority over the whole of Japan and was named *sōtsuihoshi* (superintendant) of all the provinces (fig. 87). In 1192 Emperor Go-Toba (r. 1184–1198) dubbed him *sei-i-tai-shōgun* (commander-in-chief), the prestigious title created for Sakanoe-no-Tamuramaro in 801. From his headquarters at Kamakura (fig. 550), in his native Izu Province, Yoritomo launched the shogunate, the power structure which implemented the government of Japan until 1868.

THE ASHIKAGA

As the ranks of the Minamoto swelled, certain groups slowly detached themselves from the main family. The Ashikaga formed one such branch. Although they retained the uji *(family name) of Minamoto, it was common for them to add a special name (myōji), usually taken from the locality where one of their ancestors had resided. The Ashikaga, Tokugawa, Matsudaira, Nitta, Takeda, Sasaki, Akamatsu, and Kitabatake—to name only the most celebrated families of medieval Japan—were all descended from the first Minamoto, and thus scions of the imperial line. The Ashikaga became an independent offshoot of the Minamoto family tree in 1150, when Yoshikuni settled in the village of Ashikaga, in Shimotsuke Province (modern Tochigi Prefecture). His son, Yoshiyasu (1126–1157), was the first actually to bear the name of Ashikaga. The family left a real mark on history with Takauji (1305–1358), after 1338 the first so-called Ashikaga shōgun.*

ASHIKAGA TAKAUJI (1305–1358)

Lived during the troubled time when Emperor Go-Daigo (r. 1319–1338) attempted to regain political supremacy. As their self-interest dictated, some of the leading aristocrats sided with Go-Daigo, others joined the rival faction. The dispute was complicated by the success of the feudal lords in stripping the weakened Taira Hōjō of their ministerial office of *shikken*. Through it all ran the fierce struggle to turn the office of shōgun into the focal point of political power, and Takauji was at the heart of that struggle. He took the title of shōgun and, in 1336, entered Kyoto. He deposed Emperor Go-Daigo, who fled the capital, and he placed on the throne Kōmyō (r. 1336–1348), son of the abdicated Emperor Go-Fushimi (r. 1299–1301).

Thus began the dynastic schism which divided Japan into Go-Daigo's Southern Court in the Yoshino mountains southeast of Kyoto—eventually recognized as the legitimate imperial court—and the Northern Court supported by the Ashikaga. Takauji, first of the Ashikaga shōguns, did not live to see the issue satisfactorily resolved, and was forced in 1350 to take up arms against members of his own family, for his brother Tadayoshi and his illegitimate son Tadafuyu sided with the southern faction founded by Go-Daigo.

ASHIKAGA YOSHIMITSU (1358–1408)
The third Ashikaga shōgun (sh. 1367–1395) was the son of Yoshiakira (1330–1368), the second Ashikaga shōgun (sh. 1358–1367), and the grandson of Takauji. It was a troubled age of dynastic schism, and Yoshimitsu's first great accomplishment was the pacification of Kyūshū (1374). After returning to Kyoto, he moved into a new palace in the Muromachi district; the brilliant period of the Ashikaga rule is commonly known as the Muromachi period.

Yoshimitsu finally resolved the dynastic schism that had for so long ravaged the country by securing the abdication of the Southern Emperor, Go-Kameyama (r. 1383–1392). He also maintained relations with the Ming dynasty, which had just driven the Mongol Khans out of China (1368)—an indication of the broad national scope of his political authority. But he is remembered above all as a patron of the arts and religion (fig. 325). In 1395, two years after the reunification of the empire, he resigned and even withdrew from the office of *dajōdaijin* which Emperor Go-Komatsu had bestowed on him. So great was his prestige that after officially retiring to Kinkakuji, the Golden Pavilion (built 1397; figs. 717, 718), he continued to oversee affairs of state.

ASHIKAGA YOSHIMASA (1435–1490)
Yoshimasa became the eighth Ashikaga shōgun (sh. 1449–1474) when he was fourteen years old. The Ashikaga were having difficulty controlling the aristocracy, and this, coupled with Yoshimasa's youth, permitted revolt to spread in both the Kyoto and Kantō regions. By 1464, Japan was locked in a fierce dispute over shogunal succession. Lacking an heir, Yoshimasa designated as the next ruler his brother Gijin, a monk who had re-entered secular life. But an heir was born the following year and Yoshimasa intended to revoke the promise made to Gijin the year before. One faction of prominent nobles sided with Yoshimasa, another with Gijin; the stage was set for what proved to be the most devastating of the conflicts in Japan in the 15th century, the Ōnin civil war (1467–1477). Yoshimasa, however, indifferent to the horrors and wretchedness around him, ordered the Silver Pavilion built at the foot of Mt. Higashiyama (figs. 687–90). Although people readily acknowledge Yoshimasa's pivotal role in the development of the arts (fig. 326), posterity apparently has not forgiven the shōgun his unconcern and disinterest for humanity.

DICTATORS

ODA NOBUNAGA (1534–1582)
The Oda family of Owari province (modern Aichi Prefecture) was descended from Taira Sukemori,

son of Shigemori (1138–1179), and thus had a prestigious link with the imperial line. When Nobunaga's father died and feudal lords saw in the lad's youth—he was fifteen—an opportunity to usurp his domains, Nobunaga reacted with bravery and military acumen. His reputation spread far and wide, even to Kyoto: Emperor Ōgimachi (r. 1557–1586) asked him in secret (1562) to terminate the civil strife which had been devastating the capital for almost a century. Nobunaga consolidated his military victories by skillfully arranging marriages, and in 1568 his intervention placed the reins of government in the hands of Ashikaga Yoshiaki (sh. 1568–1573), whose brother Yoshiteru (sh. 1545–1565), the thirteenth Ashikaga shōgun, had committed suicide in 1565. Nobunaga's power steadily grew over the years. He launched a number of "police" operations throughout Japan, including one against the soldier-monks of Mt. Hiei (1571). Shortly thereafter, the shōgun began to fear his powerful protector and to plot against him. Informed of the conspiracy, Nobunaga deposed Yoshiaki (1573) and thus brought to an end the Ashikaga shogunate. The following year, the emperor bestowed on Nobunaga the title of Gon-Dainagon. Nobunaga built his superb castle at Azuchi (fig. 577), and continued his campaigns of "pacification" with the help of Tokugawa Ieyasu (1542–1616), but the betrayal of Akechi Mitsuhide (1526–1582)—a former lieutenant intent on killing the person unwittingly responsible for his mother's death—led to Nobunaga's mortal wounding in the Honnōji temple in Kyoto on June 22, 1582.

TOYOTOMI HIDEYOSHI (1536–1598)
Unlike Oda Nobunaga or Tokugawa Ieyasu, Hideyoshi had no claim to imperial ancestors. He was born in Owari Province (modern Aichi Prefecture), and was placed in a monastery at an early age; he escaped at age fifteen and, after lively exploits, entered the service of Oda Nobunaga (see above). Hideyoshi's gifts caught the attention of his master, and in 1559 his marriage was arranged to a daughter of Sugihara Yoshifusa, of an ancient and noble family. In 1562, he took the name of Hideyoshi; in 1574, he was given Nagahama Castle on the eastern shore of Lake Biwa and granted the title *Chikuzen-no-kami*: shortly he traded the citadel at Nagahama for Himeji Castle (figs. 40, 580–85); from then on the fortunes of Hideyoshi, who seemed destined for greatness, steadily rose. When Nobunaga was all but assassinated in 1582, Hideyoshi hunted down and killed the assailant, then assumed the affairs of state for Nobunaga's youthful heirs, hoping to turn the power of his former master to his own advantage. The Oda, however, rallied their allies, including Tokugawa Ieyasu, to their cause. Hideyoshi found no alternative but to sue for peace; he even offered to Ieyasu his daughter's hand in marriage, and Ieyasu in turn left his son Hideyasu with Hideyoshi as hostage (1584). A year later (1585), Hideyoshi was the undisputed master of all Japan. Not being of Minamoto descent, he could not claim the title of shōgun, but the imperial court appointed him *kampaku* and bestowed on him the family name of Toyotomi (1586). With the Japanese archipelago under his command, Hideyoshi launched an invasion of Korea in 1592 and again in 1597, when he deemed the proposals of the Chinese envoy to be offensive to Japanese honor. Although this undertaking ended in disaster, Hideyoshi is still credited with having established order within a Japan

which, thanks to his flair for pacification and organization, managed then to rise in prosperity. His efforts brought to fruition the work begun by his former master, Oda Nobunaga. Hideyoshi died on September 15, 1598, in his splendid palace at Fushimi.

THE TOKUGAWA

Early in the 13th century, Yoshisue, the fourth son of Nitta Yoshishige (d. 1202), settled in the village of Tokugawa in Kozuke Province (modern Gumma Prefecture) and took on the name of that town. Nitta being a grandson of Minamoto-no-Yoshiie (1041–1108), the Tokugawa were scions of the Seiwa-Genji, the branch of the Minamoto descended from Emperor Seiwa (r. 859–876).

TOKUGAWA IEYASU (1542–1616)
Born Takechiyo, Ieyasu spent his youth forging a reputation as a warrior and an able leader and organizer. Becoming Oda Nobunaga's right-hand man after 1570, he was at first on unfriendly terms with Hideyoshi, but the two became reconciled and, in token of their bond, Ieyasu married Hideyoshi's daughter in 1584. He was awarded sizable fiefs in the Kantō region for his victorious campaign (1590) against the Hōjō of Odawara. He decided to settle in the little port of Edo and ordered a huge castle built on the ruins of the citadel which Ōta Dōkan had constructed in the 15th century (figs. 540–46). When Hideyoshi felt death was near, he placed his son Hideyori in Ieyasu's care. Difficulties soon arose, for Hideyoshi's old retainers accused Ieyasu—not without justification—of wanting to usurp the power of his ward. Japan became split into two rival factions, Ieyasu's adherents and those faithful to Hideyoshi. Hostilities commenced in August 1600, and ended on October 21, with Ieyasu victorious at the memorable battle of Sekigahara (fig. 564). He quickly took advantage of the situation, offering generous rewards to those who joined his side and thereby forestalling fresh rebellions. But Ieyasu cared for more than the spoils of war; he seems to have genuinely enjoyed managing the affairs of a Japan that had been reunified through dictatorship. In 1603, Emperor Go-Yōzei (r. 1586–1611) awarded him the title of shōgun, but Ieyasu resigned two years later in favor of his son Hidetada, thereby making this august rank seem a hereditary title for the Tokugawa family. By officially withdrawing from government, Ieyasu was now free to crush Hideyori, Hideyoshi's son and his own former protégé—as well as the deceased dictator's remaining supporters in 1615 at Ōsaka Castle (figs. 615, 616, 619). His policies of administration followed the Confucian model—disapproval of Christianity (1614), and distrust of foreigners—and set the tone for his successors. Ieyasu's magnificent tomb is in Nikkō (fig. 38).

TOKUGAWA HIDETADA (1579–1632)
Ieyasu's third son, Hidetada, was the second Tokugawa shōgun from 1605 to 1622, at which time he abdicated in favor of his son, Iemitsu (1603–1651). Hidetada implemented all his father's policies, taking even harder measures against foreigners. In a maneuver recalling those of the Fujiwara family, he married his daughter to Emperor Go-Mino-o (r. 1612–1629), thereby defusing any of the emperor's potential hostility and assuring the legitimacy of his shogunate.

TOKUGAWA IEMITSU (1603–1651)
Eldest son of Hidetada and third Tokugawa shō-gun, Iemitsu forged the government of his father and grandfather into a system virtually unassailable. The *sankin-kōdai* law issued in 1634 required *daimyō* to reside alternately in Edo and in their provincial domains. Iemitsu forbade the building of ships capable of long voyages (1636) and, in 1638, ruthlessly crushed the Shimabara insurrection. The following year the country was cut off from all foreigners except for the Dutch, confined to the island of Deshima in Nagasaki harbor (figs. 635, 636). His ties with the imperial family—he was brother-in-law to Emperor Go-Mino-o—not only added to the Tokugawa's prestige at Kyoto and Edo, but helped to strengthen Japan's political structure.

MONKS, PRIESTS, PHILOSOPHERS

DŌSHŌ (d. 700)
A monk from Genkōji, Dōshō was part of the mission sent to China by the Japanese government in 653. He returned the following year a disciple of Hossō (or Yuishiki), a sect he had learned about through the famous Buddhist pilgrim Xuan-Zang, which taught that the only reality lies in human consciousness. In addition to his preaching activity, Dōshō was a tireless builder and spent the rest of his life on projects designed to improve the lot of all Japanese: bridges, wells, and systems to irrigate fields and make rivers navigable.

GANJIN (688–763) (Chinese: CHIEN-CHEN)
A Chinese monk who brought the Ritsu sect of Buddhism to Japan and settled certain questions concerning ritual (fig. 277). The Japanese government had sent a mission to China in search of a priest who could serve as an authority on proper ordination procedures and rules concerning monastic life. Chien-Chen, a native of Ta-Ming-Su in Yangchow, was moved by their request and set sail for Japan. Shipwrecked several times—he lost his sight during one wreck—Ganjin finally reached the archipelago in 754. After a rapturous reception, he inaugurated a solemn initiation ceremony in front of the Daibutsuden of Tōdaiji (fig. 250), with Emperor Shōmu and Empress Kōken in attendance. In 759 the imperial court granted Ganjin a domain on which he built Tōshōdaiji (figs. 255–59). He died there in 763.

ABE-NO-NAKAMARO (701–770)
The quasi-legendary life of this poet attests to the fascination which China held for the upper classes of Japan during the Nara period. At the age of fifteen (716), Nakamaro was sent to China to complete his studies but remained there for thirty years. Fujiwara-no-Kiyokawa, appointed Japan's ambassador to China in 749, finally persuaded him to come home, but they were shipwrecked and somehow reached the coast of Vietnam. The two returned to China, never to see their homeland again, and settled in Changan, the Chinese capital which would reach its zenith during the brilliant rule of the 9th-century Tang emperors.

KIBI-NO-MAKIBI or MABI (693–775)
Shimotsumichi Asomi was born in Kibi (southwest of modern Kyoto), the province after which this legendary scholar was named. He accompanied Abe-no-Nakamaro to China in 716, came home in 735, and returned to China in 752. He was then given an important post in the Japanese government, but resigned in 769 in protest against the nomination of a new emperor. He is traditionally credited with inventing the *katakana* (a Japanese alphabet of forty-seven syllables) and bringing back from China the game of *go*, the art of embroidery, and the *biwa*, a four-stringed instrument.

SAICHŌ (767–822). Posthumous name: Dengyō Daishi
Born in Omi Province (modern Shiga Prefecture), Saichō became a monk when he was twelve and was a disciple of Gyōhyō. In 802, he and Kūkai (see below) were sent to China by order of the emperor. His travels brought him to Zhejiang Province, where he became acquainted with the 6th-century doctrine of T'ien-t'ai. He brought T'ien-t'ai to Japan and made it, called Tendai in Japanese, the official religion of Enryakuji, the temple he founded on Mt. Hiei in 788. Saichō also introduced the ceremony of Buddhist baptism.

KŪKAI (774–835). Posthumous name: Kōbō Daishi
Born in Sanuki Province (modern Kagawa Prefecture on Shikoku), Kūkai became a monk while still quite young and took the name of Kūkai when he was nineteen. In 804, Saichō (see above) and he traveled to China. He returned two years later a disciple of Chen-yen (Japanese: Shingon) or esoteric Buddhism (fig. 774). In 817 he retired to Mt. Kōya and there founded Kongōbuji, which remains to this day the principal temple of the Shingon sect. Kūkai died at his mountain retreat, and it is believed that all those buried near him will enter Paradise.

ENNIN (794–864). Posthumous name: Jikaku Daishi
Born in Shimotsuke Province (modern Tochigi Prefecture), Ennin entered the Mt. Hiei monastery and was a pupil of Saichō (767–822), the priest who introduced Tendai precepts into Japan. In 838 he accompanied Fujiwara-no-Tsunetsugu to China, where he remained for nine years and wrote a travel diary that won him lasting fame. His extensive writings on religious matters include more than twenty-one works on doctrine. In 854 he was appointed head of the Tendai sect (*Tendai-zasu*).

KŪYA (903–972)
Kōshō—also known as Kūya, the name he took on becoming a monk—is one of the most popular religious figures in Japanese Buddhism. In addition to preaching, he took an active interest in the building of bridges and roads, digging wells, and other projects for the public good. He is also said to have performed miracles. In 951 he saved Kyoto from an epidemic by having carried about the city a large statue of the Eleven-headed Kannon he himself had carved. The Rokuhara-no-Kannon-dō was built in Kyoto to house this miraculous effigy. After preaching in remote regions of Tōhoku in northeast Japan, Kūya died at Saikōji. He is traditionally shown walking with a pilgrim's staff in his hand, while tiny bodhisattvas coming out of his mouth symbolize his venerable teachings.

GENSHIN (942–1017)
A priest affiliated with the Tendai sect, Genshin studied with Ryōgen (912–985), who was named head of the Mt. Hiei temples in 966. He wrote a number of works on the efficacy of prayer.

HŌNEN or GENKŪ (1133–1212). Posthumous name: Enkō Daishi
A native of Mimasaka Province (modern Okayama Prefecture), Genkū—later popularly known as Hōnen-shōnin—entered the Mt. Hiei monastery at age fifteen, then became a pupil of Ajari Eikū. After studying Genshin's works on the efficacy of prayer (see above), he embraced the Pure Land (Jōdo) doctrine which had been brought to Japan from China in the 9th century. He spurned Tendai ritual, proclaiming that salvation could be obtained simply through prayer and constant repetition of the name of Amida. Incensed, the redoubtable monks of Mt. Hiei had Hōnen exiled in 1206 to Sanuki on the island of Shikoku for four years. He was allowed to return to Kyoto, and in 1211 founded the Chion-in Temple.

EISAI (1141–1215). Posthumous name: Zenkō Kokushi
Born in Bitchū Province (modern Okayama Prefecture), Eisai was fourteen when he entered the Mt. Hiei monastery. At twenty-seven he traveled to China and visited a number of T'ien-t'ai (Tendai) temples. He also became acquainted with the Ch'an sect, but he had no time for a deep study of its teachings before returning to Japan. Eisai went back to China twenty years later, in 1187, in hopes of journeying to India, but unfavorable winds thwarted his plans and he remained on Mt. T'ien-t'ai in Zhejiang Province. He finally went home in 1191 after studying the doctrines of Zen Buddhism. Soon after his arrival in Hakata (modern Fukuoka), he founded Shōfukuji (1192) and began the cultivation of tea, a beverage which helped keep the monks alert during their long hours of meditation. In 1202, shōgun Minamoto-no-Yoriie (sh. 1182–1204) founded the temple of Kenninji in Kyoto, and named Eisai as its abbot. He is buried there. The popularity of Eisai's Zen teachings carried him to the pinnacle of the Buddhist hierarchy; he was given the title of *Dai-sōjo* in 1203. He was then summoned to Kamakura, where he founded Jufukuji. It is said that the cultivation of tea did not begin to spread until after Eisai used it to cure the shōgun Minamoto-no-Sanetomo (sh. 1192–1219) of an illness.

MYŌE or KŌBEN (1173–1232)
A fervent exponent and champion of Ryōbu-shintō, combining Buddhist and Shinto beliefs, this priest grew up in Kōzanji (Takao, near Kyoto), lived for a while at Tōdaiji in Nara, then returned to spend his last years in his native Takao. In addition to being the subject of a famous portrait in the Chinese style (fig. 86), he is said to have helped plant the tea which Eisai (1141–1215) brought from the continent.

DŌGEN (1200–1253). Posthumous name: Shōyō Daishi
Son of Kuga Michichika, a high-ranking official in the imperial court, Dōgen entered the Mt. Hiei monastery at the age of eight and studied the doctrines of Tendai Buddhism under Eisai. In 1223 he journeyed to China for five years. Instead of returning to Mt. Hiei, however, he settled at Kenninji (Kyoto), where he preached the Ch'an doctrine he had brought back with him from Song China. (The Japanese called it the "Sōtō" sect, from the characters for two places frequented by eminent priests.) Dōgen founded a small Zen temple of his own in Yamashiro in 1242, which eventually came under the patronage of Emperor Shijō (r. 1233–1242). Two years later (1244), Hatano Yoshishige invited him to settle in Echizen (modern Fukui Prefecture), and there Dōgen founded Eiheiji, the principal temple of the Sōtō sect.

SHINRAN (1174–1263)
Founded the new Amidist sect known as Jōdoshinshū. Born in Kyoto to imperial nobility (kuge), he became a monk at the age of nine. Jichin taught him Tendai, and Genkū—or Hōnen, founder of the Jōdo sect in Japan—gave him instruction in Jōdo. Finding neither of these philosophies satisfactory, Shinran founded his own school of Jōdo-shinshu in 1224, also known as Montoshu and Ikkōshū. Jōdo-shinshu differed from Jōdo in that Shinran taught that a person who only repents at point of death may yet enter Paradise, and that priests were allowed to marry. Shinran's life was far from uneventful. His unrelenting attacks against other sects led to his banishment for five years to Echigo (modern Niigata Prefecture). After his death, his daughter and grandson founded in Kyoto in 1272 the main temple of his sect; only then was Jōdo-shinshu granted official recognition and given the name Higashi Honganji. It was a major spiritual and political force in Japan during the Muromachi and Momoyama periods, but its influence waned when the government divided the sect into two branches in 1602.

NICHIREN (1222–1282)
A remote descendant of Fujiwara Fuyutsugu (775–826), Nichiren (born Zennichi-maru) was the son of an ordinary fisherman. A zealot even as a youth, he became a priest of the Shingon sect and took the name of Nichiren (literally, "Lotus of the Sun"). He immersed himself in the *Myōhorenge-kyō* (Book of the Lotus of the Good Law), a sutra said to contain the Buddha's last teachings. This became the basis of a doctrine which Nichiren began to preach in 1253, and the title of the sutra was turned into a prayer that worshipers repeat to this day. The number of his disciples quickly grew, and in 1260 a heartened Nichiren translated his spiritual vision into action. In his *Ankoku-ron,* he proposed a program which he believed would set Japan on the course of peace and prosperity, but the pamphlet also violently attacked other sects. When Nichiren dared to bring it to the attention of Hōjō Tokiyori (1226–1263), whom he knew to be a fervent advocate of Zen, the *shikken* replied by having him deported to Itō, in Izu Peninsula. When pardoned three years later, Nichiren only renewed his attacks on other religious beliefs as soon as he arrived in Kamakura. He was condemned to death, but his sentence was commuted in 1271 to exile on the island of Sado; after two years there, he went to live in Kai Province (modern Yamanashi Prefecture), and in 1281 he founded Kuonji at Minobu, which became the headquarters of his sect. Nichiren died the following year and his ashes were buried there.

IPPEN or OCHI MICHIHIDE (1239–1289). Posthumous name: Enshō Daishi
Ippen began his study of Tendai, Jōdo (Pure Land), and Nembutsu (repetition of the name of Amida) at an early age. After 1275 he devoted himself exclusively to traveling throughout Japan and preaching his own beliefs, known as the Ji sect (fig. 159).

SOSEKI (1271–1346). Posthumous name: Musō Kokushi
Born in Ise Province (modern Mie Prefecture), Soseki was a descendant of Emperor Uda (r. 887–897) and had a political importance that his reputation as a poet has often overshadowed (fig. 13). Orphaned at an early age and placed in a temple in Kai Province (modern Yamanashi Prefecture), he was transferred to a Shingon temple and, at age eighteen, became a priest in a Zen monastery. He took the name Soseki from the names of two temples in China, Sozan and Sekitō. Emperor Go-Daigo (r. 1319–1338) received him at court in 1325. The following year Soseki founded Zen-ō-ji in Ise Province, and in 1339 the renowned Tenryūji temple and its garden, not far from Kyoto (Yamashiro Province): this became the headquarters of a branch of the Rinzai sect and served as an important cultural and economic intermediary between China and Japan. The moss gardens of Saihōji in Kyoto are also of his design (figs. 720–22).

NAKAE TŌJŪ (1608–1648)
Born in Omi Province (modern Shiga Prefecture), Nakae Tōjū was brought up to hold the Confucian classics and education in high regard. This preparation in Chinese language and philosophy enabled him to make a study of the philosophy of Wang Yang-ming, a Chinese quietist, which he taught in Japan as Ōyōmei.

HAYASHI RAZAN or DŌSHUN (1583-1657)
Born in Kaga Province (modern Ishikawa Prefecture), Razan was fourteen years old when he began his studies at Kenninji in Kyoto. He then became a pupil of Fujiwara Seika (1561–1619), who taught him the Neoconfucianist philosophy of Song China, and the young scholar thereby entered into the good graces of shōgun Tokugawa Ieyasu (1542–1616), a votary of Chinese culture. In 1606, Razan was given the title of *hakase* ("doctor") and named first secretary of the *bakufu.* As such he recorded all the official acts of the era. His expertise in Chinese literature and philosophy and his avowed distrust of Buddhist priests won him Ieyasu's respect and admiration: Razan's influence amounted to censorship over all intellectual activity in Japan.

YAMAZAKI ANSAI (1618–1682)
This young scholar-monk from Kyoto kindled widespread interest in Chinese and Japanese antiquities as well as in Chinese science. He opened a school for young *samurai* in Edo, returning to Kyoto in 1672 after the death of the *daimyō* he had been serving. In his philosophical treatises he applied the doctrines of the Chinese philosophers of the Song dynasty (960–1279) to Shintoism, resulting in a new sect called Suiga-Shintō.

YAMAGA SOKŌ (1622–1685)
A *samurai* of the Aizu clan of Iwashiro Province (modern Fukushima Prefecture), Sokō was a pupil of Hayashi Razan (1583–1657) and Hōjō Ujinaga, receiving a solid grounding in Chinese philosophy. At age forty he reacted violently against Neoconfucianism, however, burning everything he had written and coming out with a kind of manifesto of his new philosophy (Seikyō-yōroku). This displeased the shogunate, and he was imprisoned in 1666. Pardoned ten years later, he founded the Yamaga-ryū, a military school at Edo, and is said to have codified the rules of the *Bushidō.* Ōishi Yoshio (1659–1703), leader of the famous forty-seven *rōnin,* was his disciple.

KUMAZAWA BANZAN or RYŌKAI (1619–1691)
Born Nojiri Jirōhachi, this philosopher is known by the family name of his maternal grandfather, who brought him up. Banzan was a pupil of Nakae Tōjū (1608–1648), teacher of the Chinese philosophy of Wang Yang-ming (Ōyōmei in Japanese), whose quietism became popular among the Japanese middle class. In 1645 Kumazawa Banzan served as an adviser to a *daimyō* of Okayama, then in 1656 moved to Kyoto and opened a school for sons of the *kuge* (imperial nobility). Its success aroused the suspicions of the *bakafu,* and in 1666 Ryōkai sought refuge on Mt. Yoshino. A *daimyō* of Harima Province (modern Hyōgo Prefecture) took him into his service. In 1687, Banzan wrote a pamphlet outlining urgent reforms in the government and brought it to the attention of shōgun Tokugawa Tsunayoshi (1646–1709); the shōgun's reply was a prison sentence. Banzan continued to write after his release, but never again criticized the regime.

KEICHŪ or SHIMOKAWA KŪSHIN (1604–1701)
His father was a vassal (*kerai*) of a *daimyō* of Settsu Province (modern Ōsaka and Hyōgo prefectures). Kūshin entered Myōhōji (near Edo) at age eleven; two years later he went to Mt. Kōya and took the name of Keichū. He was a great admirer of Japanese history and literature, and could not be induced to leave his retreat. Keichū was the first to revive an appreciation for his country's cultural heritage in the 17th century, when Chinese studies were so fashionable.

KAIBARA EKKEN or EKIKEN (1630–1714)
Born in Fukuoka, Ekken went to Kyoto in 1657 to study with Yamazaki Ansai (see above) and Kinoshita Jun-an (1621–1698). There he familiarized himself with the Neoconfucianism out of which the Tokugawa shōguns were trying to formulate the standard philosophy of Japan. But doubts began to rise in the mind of this writer, whose flowing and very readable works remained in vogue until 1868. Ekken's output includes such blandly conformist tracts as *Onna daigaku* (Teach-

ings on Women's Duties) and others, such as *Taigiroku* (Great Doubt), that attest to his growing moralism.

AOKI KON-YŌ (1698–1769)
Brought up to have the highest regard for the Chinese tradition, this scholar played an important, though relatively obscure role in the development of ideas in 18th-century Japan. He was as inquisitive about foreign culture—he even learned Dutch—as he was about economy, natural history, and the type of philological research developed by Ming scholars in China. In 1739 the government commissioned him to visit all the provinces of Japan and collect ancient manuscripts. On his return he was appointed *Shomotsu-bugyō*, a title equivalent to director of archives. It is said that he introduced sweet potatos (*satsuma-imo*) into Japanese agriculture.

WRITERS, POETS, DRAMATISTS

ŌNO YASUMARO (d. 723)
This quasi-legendary figure was an official historian, commissioned to transcribe the old traditions of the country into the *Kojiki,* published in 712.

OTOMO-NO-YAKAMOCHI (718?–785)
In addition to what seems to have been a somewhat tumultuous political career, Yakamochi's name is attached, as is that of Tachibana-no-Moroe, with the compilation of the *Man-yōshū,* the first large anthology of Japanese poetry, containing close to 4,500 pieces (mid-8th century).

ARIWARA-NO-NARIHIRA (825–880)
A descendant of ex-Emperor Heijō (r. 806–809), Ariwara-no-Narihira not only held a number of key administrative offices, but distinguished himself as a poet and painter. Apparently he was also partial to women; the *Ise Monogatari,* not written until about 950, was supposedly based on his love intrigues.

KI-NO-TSURAYUKI (883–946)
In 905 this learned poet and calligrapher, together with his nephew Tomonori and a number of court officials known for their poetic ability, was commissioned to compile the *Kokin Wakashū,* or "Collection of Japanese Poems Both Ancient and New," published in 922. Tsurayuki's relatively short preface reads like a manifesto of Japanese-language poetry (as opposed to poetry in the "Chinese manner"). About 925, he was appointed governor of Tosa Province (modern Kōchi Prefecture), and while in office he wrote the *Tosa Nikki,* an ingenious classic among travel diaries.

SEI SHŌNAGON (c. 1000)
Lady-in-waiting to the empress and a writer of penetrating essays. Her *Makura-no-Sōshi* (*Pillow Book*), a masterpiece of psychological observation, was the model for a current of writing in random style known as *zuihitsu* (literally, "off the edge of the brush").

MURASAKI SHIKIBU (978–1016)
Daughter of Fujiwara-no-Tametoki and wife of Fujiwara-no-Nobutaka, she was a lady-in-waiting to Empress Jōtōmon-in, wife of Emperor Ichijō (r. 987–1011). Her lasting fame comes from having given aristocratic literary form to the purely Japanese language in writing her diary (*Murasaki Shikibu Nikki;* see fig. 127) and especially her *Genji Monogatari,* an epic novel known world wide today, which would play a pivotal role in the development of painting in Japan (see fig. 125).

FUJIWARA TOSHINARI or SHUNZEI (1114–1204)
In 1138, he became a pupil of Fujiwara-no-Mototoshi, from whom he learned all the refinements of the art of Japanese poetry. After a serious illness, he decided to withdraw from court service (1176) and become a monk. He did not abandon literary pursuits, however. In 1178 he was ordered to compile the *Chōshū Eisō,* an anthology of poems. Six years later, Emperor Go-Shirakawa (r. 1156–1158, d. 1192) commissioned the first anthology to appear during the Kamakura period, the *Senzai waka-shū,* which Shunzei edited and presented to the emperor in 1187.

KAMO-NO-NAGAAKIRA or CHŌMEI (1155–1216)
This poet and essayist lived in a monastic hut and there in 1212 wrote the *Hōjōki,* or "History of a Room Ten Feet Square," a masterpiece of the introspective style of writing which became popular during the latter part of the Heian period.

FUJIWARA-NO-SADAIE or TEIKA (1162–1241)
This poet contributed to a number of well-known collections of poetry, including the *Shinkokin waka-shū* ("New Anthology of Japanese Poems, Ancient and Modern," 1205). The *Hyakunin Isshū* ("Poems of a Hundred Poets"), another collection in which Fujiwara-no-Sadaie's work appears, inspired an entire series of scroll paintings.

YOSHIDA KENKŌ or KANEYOSHI or URABE KENKŌ (1283–1350)
When Emperor Go-Uda (r. 1274–1287) died in 1324, this renowned essayist became a monk and withdrew from secular life. At some time thereafter he wrote the famous *Tsuredzure-gusa,* or "Essays in Idleness."

KITABATAKE CHIKAFUSA (1293–1354)
A prominent political figure who wrote several interesting treatises on history and administration.

KAN-AMI KIYOTSUGU (1333–1384)
Together with his son, Se-ami Motokiyo (see below), this actor and dramatist created the acting styles and repertory of the Nō drama, perhaps one thousand plays, of which about eight hundred have survived.

SE-AMI MOTOKIYO (1364–1443)
A dramatist who, with his father Kan-ami (see above), formulated the basic rules of Nō, a symbolic theatrical presentation of poetic dialogues, combined with song, dance, and subtle gestures.

MATSUNAGA TEITOKU (1571–1653)
This poet excelled at *Haikai-no-Renga,* the amusing "linked-verse" poems that were exchanged among friends at the time, as in a serious game. Nishiyama Sōin was one of his pupils (see below).

NISHIYAMA SŌIN (1605–1682)
Poet and founder of the so-called Danrin school introducing new ideas, Nishiyama Sōin is remembered for his *haiku,* jewel-like poems of seventeen syllables in three verses (grouped 5, 7, and 5), whose apparent simplicity belies a message of depth and complexity.

IHARA SAIKAKU (1642–1693)
Novelist and a keen observer of the urban society which flourished during the Edo period. Saikaku set the fashion for *ukiyō-zōshi* ("notebooks of the floating world") in literature as well as in woodblock illustrations for novels.

MATSUO BASHŌ (1644–1694)
Born a *samurai,* Matsuo Bashō became a serious writer, the greatest poet of the Edo period. He lived as a recluse in his "Banana-tree Retreat" (*Bashō-an*), from which he took his pen name), and also journeyed throughout Japan. Influenced by Zen, he wrote *haiku* (17-syllable poems) of unsurpassed beauty and independence of outlook.

CHIKAMATSU MONZAEMON (1653–1724)
Born Sugimori Nobumori, Chikamatsu Monzaemon came from Hagi in Nagato Province (modern Yamaguchi Prefecture). The dramatic intensity and penetrating insight of his ninety-seven *jōruri* dramas brought new esteem to the puppet plays that were much in vogue in 18th-century Ōsaka. He is also considered a great Japanese dramatist, and his plays dealing with universal themes, reminiscent of those by Shakespeare, were adapted for *kabuki,* a form of theater which became increasingly popular during the Edo period.

KAMO MABUCHI (1697–1769)
His father was a *kannushi* (superior of a Shinto shrine) in Tōtōmi Province (modern Shizuoka Prefecture). Heedless of pressing material needs, Kamo Mabuchi became a devoted student of ancient Japanese literature before Chinese influences, and was instrumental in rekindling interest in ancient poems known as *naga-uta.* He studied with Kada Azumamaro (1668–1736) in Kyoto, then went to Edo to teach. He enjoyed great success there and entered the service of shōgun Tokugawa Yoshimune (1684–1751).

PAINTERS

KANAOKA (Kose-no-Kanaoka, fl. late 9th to early 10th century)
Little is known about this court painter, whose family took its name from Kose Province. None of his works is extant, but we do know that in 880 he painted for Emperor Yōzei portraits of Confucius and his principal disciples. He is said to have been the founder of the *Yamato-e* school and probably was the first to paint Buddhist themes from China and Korea in purely Japanese style.

ASUKABE-NO-TSUNENORI (fl. mid–10th century)
A master of *Yamato-e*, a school of secular painting much esteemed at the time, this court painter received a number of commissions from Emperor Murakami (r. 946–967). He is credited in the *Genji Monogatari* with the illustrations in the *Utsubo Monogatari Emaki* ("Illustrated Tale of the Lair"), but nothing can be definitely attributed to him.

MITSUNAGA (Tokiwa or Fujiwara-no-Mitsunaga, fl. 1158–1179)
Yamato-e painter, believed to have been the eldest son of Takachika (Fujiwara-no-Takanari, fl. c. 1150). He is traditionally regarded as one of the most inspired of the Tosa masters, but works can only be tentatively ascribed to him (see fig. 124)

TAKANOBU (Fujiwara-no-Takanobu, 1142–1205)
Son of a courtier (Fujiwara-no-Tametaka) and pupil of Kasuga Takachika (Fujiwara-no-Takanari, mid-12th century), Takanobu won enduring fame as a poet and portrait painter. To him are attributed the celebrated portraits of Minamoto-no-Yoritomo (1147–1199; fig. 87), Fujiwara-no-Mitsuyoshi (mid-12th century), and Taira-no-Shigemori (1138–1179), all in the Jingoji, Kyoto.

NOBUZANE (Fujiwara-no-Nobuzane, 1176/77–c. 1265)
Like his father, Fujiwara-no-Takanobu (see above), he was a *Yamato-e* painter who specialized in portraiture, becoming the most eminent court painter of his time. No works can definitely be attributed to him, but he is said to have illustrated the *Sanjūroku Kakuin Kashū* ("The Thirty-six Poets"), the *Murasaki Shikibu Nikki Emaki* ("Diary of Murasaki Shikibu"; fig. 127), in 1247 the *Zuishin Teiki Emaki* ("Revels of the Mounted Guard"; fig. 132), and in 1221 a portrait of retired Emperor Go-Toba (r. 1184–1198) in Minase-jingū, south of Kyoto.

EN'I (fl. late 13th century)
Yamato-e painter. En'i's name and religious title (*hōgen*) are mentioned on the back of one of the twelve scrolls recounting the life of Ippen (1239–1289), the celebrated founder of the Ji sect, and it is thought that he was a friend and traveling companion of the itinerant priest toward the end of Ippen's ministry. He probably supervised, and even had a hand in the painting of the elegant *Ippen Shōnin Eden* series (Kankikōji) in 1299 (fig. 159), ten years after his master's death.

TAKAKANE (Takashina Takakane, fl. first half of 14th century)

This *Yamato-e* painter may have been the son of Tosa Kunituka (fl. late 13th century). His unremarkable, though elegant manner can be seen in the first three scrolls of the *Ishiyamadera Engi* (figs. 378–81) as well as in the *Kasuga Gongen reigen ki* of 1309.

YUKIMITSU (Fujiwara-no-Yukimitsu, fl. 1352–1389)
This painter, the progenitor of the Tosa School, was said to have been one of the most illustrious masters of his time. Many works have been attributed, but none is definitely ascribed to him.

YUKIHIRO (Tosa Yukihiro, born Fujiwara-no-Yukihiro, fl. 1406–1434)
This Tosa painter was the son of Yukimitsu and the first to use Tosa, the name of the province of which he was governor, as his own name. A Tosa genealogy was fabricated later for periods preceding him, but Yukihiro was the first verifiable member of the Tosa "family" to use the name for the lineage of an artistic school, not a bloodline. He and five other artists painted the *Yūzū Nembutsu Engi* (1414) in Seiryōji, Kyoto.

MINCHŌ (1352–1431)
Born on Awaji Island at the eastern entrance to the Inland Sea, Minchō was a Zen priest at Tōfukuji in Kyoto. He became a *suiboku* (literally, "water and ink") painter and was especially fond of copying Southern Song masters. His work is technically superior to that of other Zen priests at the time who considered spontaneity of paramount importance.

JOSETSU (fl. first quarter of 15th century)
Little is known about the life of this Zen priest except that he resided at Shōkokuji (Kyoto). He is traditionally thought to have been the teacher of Shūbun (see below). He was one of the earliest exponents of monochrome ink painting (*suiboku-ga*) in Japan, based on the Southern Song style in China.

SHŪBUN or EKKEI (fl. 1414–1463)
In addition to serving as abbot of Shōkokuji (Kyoto), Shūbun was a painter—Sesshū is said to have been his best pupil—and a sculptor, and he supervised the rebuilding of his temple (1430–1440). Although no painting or sculpture can be positively ascribed to him there are attributed works (fig. 106), and he and Sesshū (see below) are regarded as the preeminent painters of the Muromachi period (14th–16th centuries).

NŌAMI (Nakao Shinnō, 1397–1471)
Few, if any, authentic works by this master survive, but certainly his flair for poetry, interior and garden design, and the tea ceremony matched his fame as a landscape painter, based on the Southern Song style. Geiami (see below; Nōami's son), Sōami (1485?–1525; Nōami's grandson), and Nōami were the three "-ami" artists who imbued painting with a full-fledged philosophical discipline. He served as *dōbōshū* (cultural adviser) to shōgun Ashikaga Yoshimasa (1435–1490).

GEIAMI (Nakao Shingei, 1431–1485)
Cultural adviser (*dōbōshū*) to the Ashikaga shōguns and one of the early masters of monochrome ink painting in the Song manner. Nōami (see above) and Sōami (1485?–1525), who also served as cultural advisers to the Ashikaga, shared Geiami's passion for the Southern Song tradition; and the three of them had so profound an impact on Muromachi art that posterity has ascribed to them blood ties which may have no basis in fact.

SESSHŪ (1420–1506). Posthumous name: Tōyō
Eleven-year-old Sesshū entered a monastery in his native Bitchū Province (modern Okayama Prefecture) and was ordained a priest at an early age. He then moved to the capital and is thought to have lived in Shōkokuji, where he was a pupil of Shūbun (fl. 1414–1463). At some point between 1462 and 1465, he made his teacher's name the basis for the *gō* (pseudonym) by which he is known the world over: Sesshū (figs. 329, 783). The patronage of the Ouchi, a *daimyō* family of the Yamaguchi region, made it possible for him to spend three years in China (c. 1467–1470). An ardent admirer of Song and Yuan painting, Sesshū was received in Beijing with full honors. To avoid the Ōnin civil war (1467–1477), he did not visit the capital on his return to Japan, and from 1481 to 1484 he traveled extensively throughout the archipelago. Except for a stint in Kyūshū in the service of the Ōtomo family (Ōita region), he spent the rest of his life at the Unkoku-an, his retreat in Suō Province (Yamaguchi). In addition to being the most accomplished of all monochrome ink painters (figs. 108–10, 374–76, 411–13), Sesshū was an avid student and designer of gardens.

SŌEN (fl. 1489–1500)
Zen priest, lived for a while in Engakuji (Kamakura). Partial to painting in monochrome ink washes, Sōen joined Sesshū at the Unkoku-an (see above), and remained with him until 1495, when he returned to Engakuji to teach his master's style.

MITSUNOBU (Tosa Mitsunobu, 1434–1525)
Perhaps the son of Tosa Mitsuhiro (fl. c. 1430–1445), this Tosa painter is traditionally considered one of the leading exponents of the Tosa school. Mitsunobu is credited with rekindling interest in the colorful *Yamato-e* at a time when *suiboku* or ink painting was much in vogue.

SŌAMI (Nakao Shinsō, 1485?–1525)
Painter, poet, garden designer, and art critic, Sōami was instrumental in popularizing Song-style monochrome ink painting in Japan (fig. 400), especially the misty effects of Mu-Qi (13th century). Nōami (1397–1471), Geiami (1431–1485), and Sōami, the three "-ami" painters, are thought to have been the arbiters of taste during the Muromachi period, and Nōami also served as cultural adviser (*dōbōshū*) to the Ashikaga shōguns.

KANŌ MASANOBU (Hakushin, 1434–1530)
A descendant of the Fujiwara, this painter founded the Kanō school, named for the village on the Izu peninsula where his family lived. After taking lessons with his father, Kagenobu, he entered the service of shōgun Ashikaga Yoshimasa (1435–

1490) as an assistant to Shūbun (fl. 1414–1463) and Sōtan (1413–1481), then succeeded them as the shōgun's official painter. An avid student of such Southern Song masters as Ma Yuan and Xia Gui (fig. 399), he received the honorary religious title of *hōgen*.

KANŌ MOTONOBU (Motonobu, 1476–1559)
Eldest son of Kanō Masanobu (see above), this painter married Chiyo, daughter of Tosa Mitsunobu (1434–1525) and herself a painter. On the death of his father-in-law, Kanō took over as head of the Tosa family workshop, and he is often considered the true founder of the Kanō school (fig. 402). He was official painter both to the imperial court (*goyō eshi*) and the Ashikaga shōguns, and he received the honorary religious title of *hōgen*. Unfortunately, works can only be attributed to him.

SESSON (Satake Shūkei, c. 1504–1589)
A self-taught student of Song and Yuan painting in China and an admirer of Sesshū's work, Sesson spent his final years (after 1573) as a Zen monk (fig. 100) in Tamura in Iwashiro Province (modern Fukushima Prefecture). He is said to have written a treatise on painting (1542), and in 1546 supposedly served as cultural adviser to the *daimyō* of Aizu in Iwashiro Province.

EITOKU (Kuninobu, 1543–1590)
Son and pupil of Kanō Shōei (1519–1592), this painter became the fifth-generation head of the Kanō line in Kyoto. He is considered the first great master of the Momoyama period. Inspired primarily by Southern Song artists and the Che school of the Ming dynasty, his work, albeit occasionally lacking in originality, had a profound effect on his contemporaries. His genius lay in an ability to combine in one and the same painting the traditionally Chinese style of his workshop with certain aspects of the *Yamato-e* manner as practiced by the Tosa (figs. 141, 422). Official painter (*goyō eshi*) to both Oda Nobunaga (1534–1582) and Toyotomi Hideyoshi (1536–1598), Eitoku decorated Azuchi Castle (1576–79) and the Jurakudai palace (1587) in Kyoto, both of which were destroyed. The most beautiful collection of his work is in Nanzenji (Kyoto). He received the honorary religious titles of *hōgen* and *hōin*.

MITSUNOBU (Kanō Mitsunobu, 1565–1608)
Son and pupil of Eitoku, Mitsunobu became the sixth-generation head of the Kanō school. Little of his work remains. He worked with his father on the decoration of Azuchi Castle and at other residences of the dictators, but only a few screen- and *fusuma*-paintings escaped the flames. He moved to Edo at the behest of Tokugawa Ieyasu, and as founder of the Kanō school there, Mitsunobu played a pivotal role in the artistic history of his family.

TŌHAKU (Hasegawa Kyūroku, 1539–1610)
Son of a dyer in Noto province (Ishikawa Prefecture), young Tōhaku had the good fortune to be adopted by the Hatakeyama family, overlords of the locality where his father worked. In 1570 he was sent to Kyoto to study Kanō painting, and he is said to have been a pupil of Eitoku (see above). But he was especially partial to Sesshū (1420–

1506) as well as to Song and Yuan painters. It was not long before this admirer of the 15th-century master found himself at odds with Unkoku Tōgan (1547–1618), Sesshū's self-proclaimed spiritual heir. Tōhaku rebelled against existing groups and founded a school of his own, the Hasegawa. He moved to Hompōji (Kyoto) and with his son, Kyūzō, accepted commissions to decorate the sumptuous secular and religious buildings of the time. Although he occasionally painted gold screens, subtly shaded black-and-white paintings remained Tōhaku's area of expertise (fig. 111).

TAKANOBU (Kanō Takanobu, 1571–1618)
Second son and pupil of Eitoku (1543–1590), Takanobu's claim to fame is that he was the father of the renowned painters Tan'yū, Naonobu, and Yasunobu. He spent much time decorating the gorgeous castles of the Momoyama period, but little has survived; his work combined Kanō figure style with strong color (figs. 161, 395–98). He was given the honorary religious title of *hōgen*.

SANRAKU (Kanō or Kimura Mitsuyori, 1559–1635)
Son of Kimura Nagamitsu (fl. c. 1570), who was a pupil of Kanō Motonobu. After Toyotomi Hideyoshi (1536–1598) sent him to Eitoku (1543–1590) for lessons, young Kimura Mitsuyori married Eitoku's daughter, became his adopted son, and thus acquired the Kanō family name. Difficulties arose, however, when he decided to remain loyal to Hideyoshi's faction after the fall of Ōsaka Castle in 1615. Tokugawa Ieyasu (1542–1616) pardoned him, and Mitsuyori became a monk and took the name of Sanraku. Although his themes and styles are frequently Chinese, he also worked in the *Yamato-e* manner and in genre painting, especially *namban* (fig. 140). This versatility makes it difficult to identify his authentic works, few of which are signed.

KŌETSU (Hon'ami Kōetsu, 1558–1637)
Kōetsu was one of the most versatile artists of his day, accomplished in painting and calligraphy (fig. 415), in lacquerwork (fig. 168), pottery, and garden design. He established an artistic community—Takagamine, near Kyoto—on land which shōgun Tokugawa Ieyasu (1542–1616) granted him in 1615. Through Takagamine he had a decisive influence on many branches of art at the time. With Sōtatsu (see below), he founded the decorative style known as the Rimpa school.

SŌTATSU (Tawaraya, then Nonomura Ietsu, 17th century; d. 1643?)
A native of Noto Province (Ishikawa Prefecture); his father sold fans and pictures to be placed on folding screens. Sōtatsu went to Kyoto to work with Kōetsu (see above), then entered the service of the Maeda, a *daimyō* family of Kaga Province. With Kōetsu, he founded the charming decorative style of the Rimpa school (figs. 116, 408, 434). He also focused on the principal themes of *Yamato-e* (fig. 101). In a style allied to the Rimpa school, he illustrated the *Genji Monogatari*, the *Heiji Monogatari*, and the *Ise Monogatari*. In 1630, he received the honorary religious title of *hokkyō*.

MATABEI (Iwasa Matabei, 1578–1650)
Illustrator and painter of historical events, Iwasa Matabei was also one of the earliest genre painters (in the modern sense of the term), illustrating classic tales and scenes of historic events. His figures, taken from everyday life, were remarkable for their unusually large heads and crisply defined features. Matabei was the illegitimate son of a *daimyō* of Itami whom Oda Nobunaga (1534–1582) later forced to commit suicide. His mother brought him up in Kyoto, and young Matabei probably received his training both with Kano Shōei (1519–1592) and the Tosa painters. In 1616 he was in Fukui, painting for the Matsudaira, and in 1637 he was working on a project for Tokugawa Iemitsu (sh. 1623–1651) in Edo.

NAGANOBU (Kanō Naganobu, 1577–1654)
Fourth son of Kanō Shōei (1519–1592) and youngest brother of Eitoku (1543–1590), he was the official painter of Tokugawa Ieyasu (1542–1616), following him to Edo, where he founded the Okachimachi branch of the Kanō family. He is best known for a pair of screens entitled *Merrymaking Under the Cherry Blossoms* (National Museum, Tokyo), one of the loveliest of all genre paintings and marking a new direction from the pro-Chinese style of the earliest Kanō painters.

TAN'YŪ (Kanō Morinobu, 1602–1674)
Son of Takanobu and grandson of Eitoku, Morinobu moved to Edo in 1617 and there founded the Kajibashi branch of the Kanō family (named after the district in which they lived); he entered the service of Tokugawa Hidetada (1579–1632) and became head of the shōgun's "department of painting." In 1636 he became a priest at the behest of the shōgun and later received the honorary titles of *hōgen* (1638) and *hōin* (1665). Tan'yū is considered the preeminent Kanō painter of the Edo period (figs. 423, 426), but his renowned scroll recounting the life of Ieyasu (*Tōshōgū Engi*) is painted, curiously, in the Tosa manner.

NOBUKATA (late 16th–early 17th century)
Worked in the *yōga* (European) style from engravings and paintings which Jesuit missionaries brought to Japan in the second half of the 16th century (fig. 457). Nothing more is known about his life, except that his is the only name to appear on a few of the first Japanese paintings to be influenced by European art. It has been suggested that he was enrolled in a painting school run by Jesuits, but this is pure conjecture.

KŌRIN (Ogata Koretomi, 1658–1716)
Kōrin and his brother Kenzan (1663–1743) were sons of a prosperous Kyoto cloth merchant, Ogata Sōken (1621–1687), and both were gifted potters, lacquerers, textile designers, and painters in the Rimpa manner created by Kōetsu and Sōtatsu (see above). Kōrin added to their style the splendid coloring of *Yamato-e* and the crisp, lively draftsmanship of the black-and-white tradition. His forceful works combine keen observation of nature and a decided tendency to abstraction. In 1701 he was awarded the honorary religious title of *hokkyō* (figs. 117, 119–20, 409, 417, 424, 433, 510, 514, 515). The brothers' collaborative work is illustrated in figs. 512, 513, and 519–22.

SCULPTORS

Over the centuries, Japan has produced a number of gifted sculptors. Information about their lives is often scanty, however, and may read like legend rather than biography. Below are briefly sketched a few eminent Heian and Kamakura masters whose originality had a profound effect on Japanese art.

JŌCHŌ (d. 1057)
Creator of the renowned bronze Amida Nyorai (1053) in the Byōdōin at Uji (figs. 51, 264). Jōchō is thought to be the foremost sculptor of his day. His concept of Amida is decidedly un-Chinese, and both artistically and technically his work exemplifies *yōsegi zukuri*, the "joined-wood" approach which, though long in use, was still less esteemed at that time than the "single-block" method (*ichiboku zukuri*). He was trained by his father Kōshō (fl. 990–1020) in carving figures for Fujiwara-no-Michinaga (966–1027) and received

the Buddhist titles of *hokkyō* (1022) and *hōgen* (1048), the first sculptor to be so honored.

UNKEI (1151–1223)
This sculptor was the son of Kōkei (fl. late 12th century) and head of the Shichijō *Bussho*. His output was prolific, for the Kamakura *bakufu* put him in charge of restoring the massive Tōdaiji (figs. 76, 284, 285) and Kōfukuji complexes at Nara (fig. 332). He also worked at Tōji and Hōshōji, both in Kyoto. Assisted by his six sons, all sculptors, Unkei was the chief exponent of the Kamakura style, which may be characterized as a revival of classic Nara technique combined with a new spiritual intensity.

TANKEI (1173–1256)
Eldest son and pupil of Unkei (see above), whom he succeeded as head of the Shichijō *Bussho*, Tan-

kei carried his father's style further in the direction of realism and incorporated into his own manner many elements of Chinese Song sculpture (10th–13th centuries). He was in charge of restoring the thousand statues of the Thousand-armed Kannon in the Rengeōin, Kyoto (fig. 715). He received the honorary titles of *hokkyō* in 1194, *hōgen* in 1203, and *hōin* in 1213.

KŌBEN (early 13th century)
Little is known of this sculptor, except that he created the statue of Tentōki (1215) in Kōfukuji, Nara. His work exemplifies the baroque, almost grotesque style of Japanese art during the Kamakura period. Kōben is thought to have been the third son of Unkei (1151–1223) and a member of the Shichijō *Bussho*. He was awarded the tittle of *hokkyō* (1215) and later that of *hōgen*, high ranks in the honorary Buddhist hierarchy.

POTTERS

NINSEI (Nonomura Seiemon, 17th century)
Born in Tamba Province (Kyoto region), Ninsei lived and worked in the capital, where he made wares for the tea ceremony. His workshop was located in front of Ninnaji, and it was that temple's abbot—Ninsei's patron—who allowed the potter and painter to use the character "nin" in his *gō* (artist's pseudonym). The art of porcelain came of age in Japan during Ninsei's lifetime, and his contribution was in applying lustrous enamels to the earthenware then in vogue among tea enthusiasts (figs. 175, 530, 532). In addition to pieces of remarkable simplicity, his output includes splendid vessels that fairly shimmer with the bright colors of *Yamato-e* and the gorgeous gold effects with

which Momoyama artists worked such wonders (figs. 521, 528).

KAKIEMON (Sakaida Kakeimon, 1596–1666)
A Karatsu potter like his father, Kakiemon went on to found a veritable dynasty of potters that are traditionally credited with creating porcelain in Japan. Combining enamels with the kaolin and blue underglaze decoration that Arita craftsmen were discovering at the time, Kakiemon was the first Japanese potter to produce *iro-e*, or porcelain with multicolored painting (figs. 531, 533).

KENZAN (Ogata Koremasa, 1663–1743)
Though as gifted as his older brother Kōrin

(1658–1716) in painting and calligraphy, Kenzan specialized in producing the pottery which Kōrin then decorated (figs. 512, 513, 519–22). He studied with Ninsei and later became a pupil of Kōetsu's grandson, Kūchū (1601–1682), after which he set up a kiln near Ninnaji. In 1699 he moved his workshop to Narutaki, north of Kyoto, where he worked with his brother Kōrin until 1712. In 1731 he left Kyoto for Edo and then moved on to Sano in Shimotsuke Province (modern Tochigi Prefecture). Kenzan's own work, mostly blackish brown with occasional spots of bright color, was strongly influenced by Zen and the tea ceremony.

TEA MASTERS

MURATA JUKŌ (1423–1502)
A priest affiliated with the Shōmyōji temple in Kawachi Province, Murata Jukō was instrumental in developing Ashikaga Yoshimasa's taste for tea. He taught the tea ceremony in a house that Yoshimasa (1435–1490) had given him in the Sanjō district of Kyoto, and there Jukō forged his reputation as one of the pioneers of the tea aesthetic.

TAKENŌ JŌŌ (1504–1555)
An accomplished flower arranger as well as a tea master, Takenō Jōō was the teacher of Sen-no-Rikyū (see below). He first resided in Sakai, then moved to Kyoto, not far from the Shijō district. His celebrated poems probe the relationship between flower arrangements and human feelings.

SEN-NO-RIKYŪ (Nakada Yoshirō or Sen Sōeki, 1522–1591)
A native of Sakai in Izumi Province, Sen-no-Rikyū entered the service, first of Oda Nobunaga (1534–1582), then of Toyotomi Hideyoshi (1536–1598). Renowned for his flower arrangements and for the unprecedented solemnity and refinement he brought to the tea ceremony, his ideas proved so popular that in 1588 he was allowed to appear before Emperor Go-Yozei (r. 1586–1611). However, Sen-no-Rikyū was denounced and forced to commit suicide for refusing to offer his daughter in marriage to Hideyoshi.

KOBORI ENSHŪ or MASAKAZU (1579–1647)

Descended from a *daimyō* family of Ōmi Province (modern Shiga Prefecture), Masakazu had an outstanding government career in the service of Tokugawa Ieyasu (1542–1616), first as governor of Tōtōmi Province (modern Shizuoka Prefecture), then (1623) as *Fushimi-Bugyō*, or superintendent of Fushimi Castle on Momoyama Hill. He was famous above all for his expertise in the preparation of tea; he instructed shōgun Tokugawa Iemitsu (1603–1651) in this complex discipline. Since "Enshū" is the Chinese equivalent of "Tōtōmi," the name of the province he governed, Masakazu is commonly known as Kobori Enshū and his teachings collectively referred to as *Enshū-ryū*, or the "Enshū style."

CHRONOLOGICAL TABLE

The chronology for the earliest phases of Japanese civilization remains problematic. Archaeological areas have undergone frequent disruptions; the importation of material from outside the archipelago was intermittent; these circumstances have affected the usual evidence of the evolution of primitive societies. The dates given below for the Jōmon period, based on carbon-14 analysis and subject to revision, are therefore only approximate.

7000	PRE-POTTERY MICROLITHIC PERIOD
	PROTO-JŌMON PERIOD (earliest corded pottery)
5000	
	EARLY JŌMON PERIOD (corded pottery)
2200	
2000	MIDDLE JŌMON PERIOD
1000	
600	LAST JŌMON PERIOD
300	
0	YAYOI PERIOD
	Bronze Age
300	

c. 350: Unification of *Yamato Chōtei* (literally, the "Yamato Court")

538: Traditional date for the introduction of Buddhism

593–622: Regency of Shōtoku-Taishi, under Empress Suiko (r. 592–628)

607: First Japanese mission leaves for China

600

	PERIOD	REIGN		ERA			
650	ASUKA	Kōtuku:	645-654	646-659:	Taika		
660		Saimei:	655-661	650-654:	Hakuchi		
670		Tenchi:	661-671				
680		Kōbun: Temmu:	671-672 673-686	672-685:	**Hakuhō**		
690		Jitō:	686-697	686:	Shuchō		
700		Mommu:	697-707				
710		Gemmei:	707-715	701-703: 708-714:	Taihō Wadō	704-707: Keiun	
720	NARA	Genshō:	715-724	715-716:	Reiki	717-723: Yōrō	
730		Shōmu:	724-749	724-728: 729-748:	Shinki **Tempyō**		
740							
750		Kōken:	749-758	749:	**Tempyō**-Kampō	749-756: **Tempyō**-Shōhō	
760		Junnin:	758-764	757-764:	**Tempyō**-Hōji		
770		Shōtoku:	764-770	765-766:	**Tempyō**-Jingo	767-769: Jingo-Keiun	
780		Kōnin:	770-781	770-780:	Hōki		
790		Kammu:	781-806	781:	Ten.ō	782-805: Enryaku	
800	HEIAN						
810		Heijō:	806-809	806-809:	Daidō		
820		Saga:	809-823	810-823:	**Kōnin**		
830		Junwa:	823-833	824-833:	Tenchō		
840		Nimmyō:	833-850	834-847:	Jōwa		
850				848-850:	Kashō		
860		Montoku: Seiwa:	850-858 859-876	851-853: 857-858:	Ninju Ten.an	854-856: Saikō 859-876: **Jōgan**	
870							
880		Yōzei:	877-884	877-884:	Gangyō		
890		Kōkō: Uda:	884-887 887-897	885-888:	Ninna	889-897: Kampei	
900		Daigo:	897-930	898-900:	Shōtai		
910				901-922:	Engi		
920	Spread of "Fujiwara" culture						
930				923-930:	Enchō		

	PERIOD	REIGN		ERA					
940		Shujaku:	930-946	931-937:	Shōhei				
				938-946:	Tengyō				
950		Murakami:	946-967	947-956:	Tenryaku				
960				957-960:	Tentoku				
970		Reizei:	967-969	961-963:	Ōwa	964-967:	Kōhō		
		En.yu:		968-984:	Anna				
980				970-972:	Tenroku	973-975:	Ten.en		
				976-977:	Jōgen	978-982:	Tengen		
990	Spread of "Fujiwara" culture	Kazan:	984-996	983-984:	Eikan				
		Ichijō:	987-1011	985-986:	Kanwa	987-988:	Eien	989:	Eiso
1000				990-994:	Shōryaku				
				995-998:	Chotoku	999-1003:	Chōhō		
1010				1004-1011:	Kankō				
1020		Sanijō:	1011-1016	1012-1016:	Chōwa				
		Go-Ichijō:	1016-1036	1017-1020:	Kannin				
1030				1021-1023:	Jian	1024-1027:	Manju		
				1028-1036:	Chōgen				
1040	HEIAN	Go-Shujaku:	1036-1045	1037-1039:	Chōryaku				
1050		Go-Reizei:	1045-1068	1040-1043:	Chōkyū	1044-1045:	Kantoku		
				1046-1052:	Eishō				
1060				1053-1057:	Tenki				
				1058-1064:	Kōhei				
1070		Go-Sanjō:	1068-1072	1065-1068:	Jiryaku	1069-1073:	Enkyū		
1080		Shirakawa:	1072-1086	1074-1076:	Shūhō				
				1077-1080:	Shōryaku				
1090		Horikawa:	1086-1107	1081-1083:	Eihō	1084-1086:	Ōtoku		
				1087-1093:	Kanji				
1100				1094-1095:	Kahō				
				1096:	Eicho	1097-1098:	Shōtoku	1099-1103:	Kōwa
1110		Toba:	1107-1123	1104-1105:	Chōji				
				1106-1107:	Kashō	1108-1109:	Tennin		
1120				1110-1112:	Ten.ei	1113-1117:	Eikyū		
				1118-1119:	Gen.ei				
1130		Sutoku:	1123-1141	1120-1123:	Hōan	1124-1125:	Tenji		
				1126-1130:	Taiji				
1140				1131:	Tenshō	1132-1134:	Chōjō		
				1135-1140:	Hōen				
1150		Konoe:	1142-1155	1141:	Eiji	1142-1143:	Kōji	1144:	Ten.yō
				1145-1150:	Kyūan				
1160		Go-Shirakawa:	1156-1158	1151-1153:	Ninhei	1154-1155:	Kyūju		
		Nijō:	1158-1165	1156-1158:	Hōgen	1159:	Heiji		
1170		Rokujō:	1165-1168	1160:	Eiryaku	1161-1162:	Ōhō	1163-1164:	Chōkan
		Takakura:	1168-1180	1165:	Eiman	1166-1168:	Nin.an	1169-1170:	Kaō
1180				1171-1174:	Shōan				
				1175-1176:	Angen	1177-1180:	Jishō		
1190		Antoku:	1180-1185	1181:	Yōwa	1182-1184:	Jūei	1184:	Genryaku
		Go-Toba:	1184-1198	1185-1189:	Bunji				
1200	KAMA-KURA	Tsuchimikado:	1198-1210	1190-1198:	Kenkyū	1199-1200:	Shōji		
1210				1201-1203:	Kennin	1204-1205:	Genkyū		
				1206:	Ken.ei	1207-1210:	Shōgen		
1220		Juntoku:	1210-1221	1211-1212:	Kenryaku	1213-1218:	Kempō		
				1219-1221:	Jōkyō				

	PERIOD	REIGN		ERA					
1230	KAMAKURA	Chūkyō:	1221	1222-1223: Jōō		1224: Gennin			
		Go-Horikawa:	1222-1232	1225-1226: Karoku		1227-1228: Antei		1229-1231: Kanki	
1240		Shijō:	1233-1242	1232: Jōei		1233: Tempuku		1234: Bunryaku	
				1235-1237: Katei		1238: Ryakunin		1239: En.ō	
1250		Go-Saga:	1242-1246	1240-1242: Ninji		1243-1246: Kangen			
		Go-Fukakusa:	1246-1259	1247-1248: Hōji		1249-1255: Kenchō			
1260		Kameyama:	1259-1274	1256: Kōgen		1257-1258: Shōka		1259: Shōgen	
1270				1260: Bun.ō		1261-1263: Kōchō		1264-1274: Bun.ei	
1280		Go-Uda:	1274-1287	1275-1277: Kenji		1278-1287: Kōan			
1290		Fushimi:	1288-1298	1288-1292: Shōō					
1300		Go-Fushimi:	1299-1301	1293-1298: Einin					
				1299-1301: Shōan					
1310		Gonijō:	1301-1308	1302: Kengen		1303-1305: Kagen			
		Hanazono:	1309-1318	1306-1307: Tokuji		1308-1310: Enkyō			
1320		Go-Daigo:	1319-1338	1311: Ōchō		1312-1316: Shōwa			
				1317-1318: Bumpō		1319-1320: Gen.ō			
1330				1321-1323: Genkōl		1324-1325: Shōchū			
				1326-1328: Karyaku		1329-1330: Gentoku		*1329-1331: Gentoku*	
1340	NORTHERN DYNASTY (SCHISMATIC) SOUTHERN DYNASTY (NAMBOKU-CHŌ)	Kōgon:	1331-1333	1331-1333: Genkō		1334-1335: Kemmu		*1332-1333: Shōkyō*	
		Go-Murakami:	1339-1368	1336-1339: Engen		*1334-1337: Kemmu*		*1338-1341: Ryakuō*	
1350		Kōmyō:	1336-1348	1340-1345: Kōkoku		*1342-1344: Kōei*			
		Sukō:	1348-1351	1346-1369: Shōhei		*1345-1349: Jōwa*			
1360		Go-Kogon:	1352-1371	*1350-1351: Kan.ō*		*1352-1355: Bunwa*			
				1356-1360: Embun					
1370		Chokei:	1368-1383	*1361: Koan*		*1362-1267: Jōji*			
				1368-1374: Oan					
1380		Go-Enyu:	1371-1382	1370-1371: Kentoku		1372-1374: Bunchu			
				1375-1380: Tenju		1375-1378: Eiwa		*1379-1380: Kōryaku*	
1390		Go-Kameyama:	1383-1392	1381-1383: Kowa		1384-1392: Genchū		*1381-1383: Eitoku*	
		Go-Komatsu:	1382-1392	*1384-1386: Shitoku*		*1387-1388: Kakei*		*1389: Kōō*	
1400	MUROMACHI	Go-Komatsu:	1392-1412	1394-1427: Ōei					
				1390-1393: Meitoku					
1410									
1420		Shōkō:	1412-1428						
1430		Go-Hanazono:	1428-1464	1428: Shōchō		1429-1440: Eikyō			
1440									
1450				1441-1443: Kakitsu		1444-1448: Bun.an			
				1449-1451: Hōtoku					
1460				1452-1454: Kyōtoku					
				1455-1456: Kōsho		1457-1459: Chōroku			
1470		Go-Suchimikado:	1466-1500	1460-1465: Kanshō					
				1466: Bunshō		1467-1468: Ōnin		1469-1486: Bunmei	
1480									
1490				1487-1488: Chōkyō		1489-1491: Entoku			
1500				1492-1500: Meiō					
1510		Go-Kashiwabara:	1500-1525	1501-1503: Bunki		1504-1520: Eishō			

PERIOD	REIGN	ERA		
MUROMACHI (1520–1573)	Go-Nara: 1526-1557	1521-1527: Taiei		
		1528-1531: Kyōroku		
		1532-1554: Temmon		
	Ogimachi: 1557-1586	1555-1557: Kōji	1558-1569: Eiroku	
		1570-1572: Genki	1573-1591: Tenshō	
AZUCHI-MOMOYA-MA	Go-Yōzei: 1586-1611	1592-1595: Bunroku		
		1596-1614: Keichō		
EDO	Go-Mino-o: 1612-1629	1615-1623: Genna		
		1624-1643: Kan.ei		
	Myōshō: 1630-1643			
	Go-Kōmyō: 1643-1654	1644-1647: Shōhō		
		1648-1651: Keian		
	Go-Saiin: 1654-1663	1652-1654: Shōō		
		1655-1657: Meireki	1658-1660: Manji	
	Reigen: 1663-1687	1661-1672: Kambun		
		1673-1680: Empō		
	Higashiyama: 1687-1709	1681-1683: Tenna	1684-1687: Jōkyō	
		1688-1703: **Genroku**		
	Nakamikado: 1709-1735	1704-1710: Hōei		
		1711-1715: Shōtoku		
		1716-1735: Kyōhō		
	Sakuramachi: 1735-1747	1736-1740: Gembun		
	Momozono: 1747-1762	1741-1743: Kampō	1744-1747: Enkyō	1748-1750: Kan.en
		1751-1763: Hōreki		
	Go-Sakuramachi: 1762-1770	1764-1771: Meiwa		
	Go-Momozono: 1771-1779	1772-1780: An.ei		
	Kōkaku: 1780-1817	1781-1788: Temmei		
		1789-1800: Kansei		

"Genroku" Culture

	PERIOD	REIGN	ERA			
1810	EDO		1801-1803: Kyōwa	1804-1817: Bunka		
1820		Ninko: 1817-1846	1818-1829: Bunsei			
1830						
1840			1830-1843: Tempō			
1850		Kōmei: 1847-1866	1844-1847: Kōka / 1848-1853: Kaei			
1860			1854-1859: Ansei			
1870		Meiji: 1868-1912	1860: Man.ei / 1865-1867: Keiō	1861-1863: Bunkyu / 1868-1912: Meiji	1864: Genji	
1880	MEIJI					
1910		Taishō: 1915-1926	1912-1926: Taishō			
1920	TAISHŌ		1926: Shōwa			
1930	SHOWĀ	1926 Reigning emperor				
1940						
1950						
1960						
1970						
1980						

BIBLIOGRAPHY

INDEX

BIBLIOGRAPHY

The literature on Japanese culture is vast, and the following bibliography is a selected one, based on the original list in the French edition of this book, but with many changes. Where possible, English editions have been substituted for those in French and Japanese, and other important books and articles in English have been added.

Two works in this bibliography are of particular use in locating other sources of information. The Bibliography of Asian Studies, *initiated in 1936, is a yearly compendium of articles and books published on Asian studies. The Japan Society's* Japanese Art Exhibitions with Catalogue in the United States of America *is invaluable for finding records of this useful type of literature.*

ABE, Y. "Development of Neo-Confucianism in Japan, Korea and China: a Comparative Study." *Acta Asiatica*, XIX, 1970, pp. 16–39

————. La Culture japonaise à la recherche de son identité. *Esprit*, n.s. XLI², Févr. 1973, pp. 295–314

ABRAMS, L. E. *Japanese prints: A bibliography of monographs in English.* Chapel Hill, University of North Carolina Press, 1977

ADDISS, S. *Uragami Gyokudo: the complete literati artists.* Vols. 1 and 2. Ann Arbor, University of Michigan Press, 1977

AKIYAMA, T. *Japanese painting.* Trans. by J. Emmons. Geneva, Skira, 1961. Reprint. London, Macmillan, 1977

————. "Genji-e (Representations of Genji)." *Nihon no Bijutsu*, 4, no. 119, 1976

————. "New Buddhist sects and emakimono in the Kamakura Period." *Acta Asiatica*, XX, 1971, pp. 58–76.

————. *Secular painting in early mediaeval Japan.* Tokyo, Yoshikawa Kōbunkan, 1964

ALEX, W. *Japanese architecture.* New York, G. Braziller, 1963 (Great ages of world architecture)

ANESAKI, M. *Art, life and nature in Japan.* With intro. to the new edition by T. Barrow. Rutland, C. E. Tuttle Co., 1973

————. *Buddhist art in its relation to Buddhist ideals, with special reference to Buddhism in Japan.* Re-print, 1923 ed. New York, Hacker Art Books, 1978

————. *History of Japanese religion, with special reference to the social and moral life of the nation.* Rutland, C. E. Tuttle Co., 1963

————. "Psychological observations on the persecution of the Catholics in Japan in the seventeenth century." *Harvard Journal of Asiatic Studies*, I, 1936, pp. 13–27

————. *Quelques pages de l'histoire religieuse du Japon.* Paris, E. Bernard, 1921 (Annales du Musée Guimet. Bibliothèque de vulgarisation, 43)

ARAKAWA, K. *Zen painting.* Trans. by J. Bester. Tokyo, Kodansha, 1970

Architecture in the Shoin Style: Japanese feudal residences. Edited by F. Hashimoto. Trans. and adapted by H. M. Horton. 1st ed. Tokyo, New York, Kodansha International, 1981

Art Guide of Nippon, I, Nara, Mie and Wakayama Prefectures. Tokyo, Society of Friends of Eastern Art, 1943

Art Treasures from the Imperial Collections: in commemoration of the visit of their Imperial Majesties the Emperor and Empress of Japan to the United States. The Japan Foundation, 1975

Art Treasures from the Imperial Collections/Japanische Kunstschätze aus der kaiserlichen Sammlung. Catalogue of exhibition held at the British Museum, London; Studio 44, Brussels; Japanisches Kul-turinstitut, Cologne. Tokyo, Ministry of Foreign Affairs, 1971

BEARDSLEY, R. K., J. W. HALL, and R. E. WARD. *Village Japan.* 3d ed. Chicago, University of Chicago Press, 1959

BERNARD, H., P. HUMBERTCLAUDE, and M. PRUNIER, "Infiltrations occidentales au Japon avant la réouverture du XIXᵉ siècle." *Bulletin de la Maison Franco-Japonaise*, XI, 1939

BERNARD-MAÎTRE, H. (see also BERNARD, H.). "L'Orientaliste Guillaume Postel et la découverte spirituelle du Japon en 1552." *Monumenta Nipponica*, IX, Avr. 1953, pp. 82–108

"Bibliographie des principales publications éditées dans l'empire japonais." *Bulletin de la Maison Franco-Japonaise*, série française, III³⁻⁴, 1931

"Bibliographie sommaire des ouvrages d'orientalisme en langue japonaise parus entre 1938 et 1950." Préface de Vadime Elisseeff. *Bulletin de la Maison Franco-Japonaise*, n.s., I, 1951

Bibliography of Asian Studies. Feb. 1936–date. Ann Arbor, Association for Asian Studies, 1936–date. Title varies: vol. 1–5, *Bulletin of Far Eastern Bibliography;* 1941–55, *Far Eastern Bibliography*

BINYON, L., and J. J. O'B. SEXTON. *Japanese colour prints.* Edited by B. Gray. 2d ed. London, Faber & Faber, 1960

Biographical Dictionary of Japanese Art. Supervising editor, Y. Tazawa. 1st ed. Tokyo, New York,

San Francisco, Kodansha International, in collaboration with the International Society for Educational Information, 1981

BLAKEMORE, F. *Japanese design through textile patterns.* New York, Weatherhill, 1978.

BORTON, H., et al. *A selected list of books and articles on Japan in English, French and German.* Rev. and enl. ed. Cambridge, Harvard-Yenching Institute, 1954

Boston. Museum of Fine Arts. *Catalogue of the Morse Collection of Japanese pottery.* Cambridge, Riverside Press, 1901

BOYER, M. H. *Japanese export lacquers from the seventeenth century in the National Museum of Denmark.* Copenhagen, 1959 (*Nationalmuseets Skrifter. Større beretninger.* 5)

BUHOT, J. "Les paravents des Portugais." *Revue des Arts Asiatiques,* XII²⁻³, Juin–Sept. 1938, pp. 112–24, Pls. XLIII–XLVIII

BUSHELL, R. *The inrō handbook: studies of netsuke, inrō and lacquer.* 1st ed. New York, Weatherhill, 1979

CAHILL, J. *Scholar painters of Japan: the Nanga School.* Exhibition catalogue, Asia House Gallery. New York, Asia Society, 1972. Reprint. New York, Arno Publishers, 1976

CASAL, U. A. *Japanese art lacquers.* Tokyo, Sophia University, 1961 (Monumenta Nipponica Monographs, no. 18)

Cologne. Museum für Ostasiatische Kunst. *Der wandelbare Raum, japanische Wandschirme und Schiebetüren.* Exhibition catalogue. Cologne, Museum für Ostasiatische Kunst, 1972

COMPTON, W. A., et al. *Nippon-to: art swords of Japan.* Exhibition catalogue, Japan House Gallery. New York, Japan Society, 1976

COOPER, M., et al. *The southern barbarians: the first Europeans in Japan.* Tokyo, Palo Alto, Kodansha, 1971

COVELL, J. E. H. C. *Masterpieces of Japanese screen-painting, the Momoyama period (late sixteenth century).* New York, Crown Publishers, 1962

———. *Under the seal of Sesshū.* New York, De Pamphilis Press, 1941

———. *Zen at Daitoku-ji.* 1st ed. Tokyo, New York, Kodansha International, 1974

DEMIEVILLE, P. *Le Concile de Lhassa: une controverse sur le quiétisme entre bouddhistes de l'Inde et de la Chine au VIIIᵉ siècle de l'ère chrétienne.* Paris, Imprimerie Nationale, 1952 (Bibliothèque de l'Institut des hautes études chinoises, VII)

Dialogue in art: Japan and the West. C. F. Yamada, General Editor. 1st ed. Tokyo, New York, Kodansha International, 1976

DOI, T. *Momoyama decorative painting.* Trans. by E. B. Crawford. 1st English ed. New York, Weatherhill, 1977 (Heibonsha Survey of Japanese Art, 14)

DOTZENKO, G. F. *Enku: master carver.* Tokyo, New York, Kodansha, 1976

EGAMI, N. *The beginnings of Japanese art.* With supplementary chapters by T. Esaka and K. Amakasu. Trans. by J. Bester. 1st English ed. New York, Weatherhill, 1973 (Heibonsha Survey of Japanese Art, 2)

ELISSEEFF, D., and V. ELISSEEFF. *La civilisation japonaise.* Paris, Arthaud, 1974 (Collection Les Grandes Civilisations, 13)

ELISSEEFF, S. "The Bommōkyō and the Great Buddha of the Tōdaiji." *Harvard Journal of Asiatic Studies,* I, 1936, pp. 84–95

———. "Littérature japonaise." *Histoire générale des littératures,* Paris, Quillet, 1961. t. I, pp. 477–94, 819–36; t. II, pp. 545–60; t. III, pp. 667–81, 833–36

———. "Mythologie du Japon." *Mythologie asiatique illustrée,* Paris, Librairie de France, 1928

———. "Notes sur le portrait en Extrême-Orient." *Études d'Orientalisme publiées par le Musée Guimet à la mémoire de Raymonde Linossier.* t. I. Paris, E. Leroux, 1932

ELISSEEFF, V. *Japan.* Trans. by J. Hogarth. London, Barrie & Jenkins, 1974 (Ancient Civilizations series)

———. "Notes sur l'histoire des laques." *Études d'Outre-Mer,* Déc. 1952, pp. 393–400

———. "La vie religieuse dans le Japon d'aujourd'hui." *Encyclopédie française,* t. XIX: Philosophie, religion. Paris, Larousse, 1957

ERNST, E. *The Kabuki theatre.* New York, Oxford University Press, and Grove Press (Evergreen Encyclopedia series, no. 3); Honolulu, University Press of Hawaii; London, Secker & Warburg, 1956

Expo Museum of Fine Arts, Osaka. *Comprehensive catalogue: Catalogue Général II: The contact between East and West/Contacts entre l'Orient et l'Occident.* Osaka, 1970

FOARD, J. F. *Ippen Shonin and popular Buddhism in Kamakura Japan.* Ann Arbor, University of Michigan Press, 1977

FONTEIN, J. *Zen painting and calligraphy: an exhibition of works of art lent by temples, private collectors and public and private museums in Japan,* organized by J. F. and M. L. Hickman in collaboration with the Agency for Cultural Affairs of the Japanese Government. Boston, Museum of Fine Arts/ New York Graphic Society, 1971

———, and R. HEMPEL. *China, Korea, Japan.* Berlin, Propyläen Verlag (Propyläen Kunstgeschichte, Bd. 9) 1968

FRANK, B. "Kata-ima et kata-tagae. Étude sur les interdits de direction à l'époque Heian." *Bulletin de la Maison Franco-Japonaise,* n.s. V²⁻⁴, 1958, 246 p.

FRÉDÉRIC, L. *Japan, art and civilization,* New York, Harry N. Abrams, 1971 [c. 1969]

———. *Le Shintō, esprit et religion du Japon.* Paris, Bordas, 1972 (Collection Bordas-connaissance, 107. Série information)

The Freer Gallery of Art, Washington, D.C. Vol. II, *Japan.* Preface by H. P. Stern. Tokyo, Kodansha, 1973

Freer Gallery of Art, Washington, D.C. *Masterpieces of Chinese and Japanese art: handbook.* Washington, D.C., 1976

FRENCH, C. L. *The poet-painters: Buson and his followers.* Ann Arbor, University of Michigan Museum of Art, 1974

———. *Shiba Kokan: artist, innovator and pioneer in the westernization of Japan.* New York, Weatherhill, 1974

———. *Through closed doors: western influence on Japanese art 1639–1853.* Rochester, Mich., 1977

FUJIOKA, R., et al. *Tea ceremony utensils.* Trans. and adapted with an introduction by L. A. Cort. 1st ed. New York, Weatherhill, 1973 (Arts of Japan, 3)

FUKUYAMA, T. *Heian temples: Byodo-in and Chuson-ji.* Trans. by R. K. Jones. 1st English ed. New York, Weatherhill, 1976 (Heibonsha Survey of Japanese Art, 9)

FUTAGAWA, Y. *The roots of Japanese architecture; a photographic quest.* With text and commentaries by T. Itoh. 1st ed. New York, Harper & Row, 1963

GARNER, H. M. "The Export of Chinese Lacquer to Japan in the Yuan and Early Ming Dynasties." *Archives of Asian Art,* XXV, 1971–72, pp. 6–28

GASPARDONE, E. "Les Bibliographies japonaises." *Bulletin de la Maison Franco-Japonaise,* IV¹⁻⁴, 1933, pp. 29–115

———. "Histoire de l'Extrême-Orient. (années 1938–1948) [bibliographie]." *Revue Historique,* no. 202³. Oct.–Déc. 1949, pp. 238–68; no. 203¹, Janv.–Mars 1950, pp. 70–89; no. 203², Avr.–Juin, 1950, pp. 234–72

GENTLES, M. *Masters of the Japanese print: Moronobu to Utamara.* Exhibition catalogue, Asia House Gallery. Foreword by G. Washburn. New York, Asia Society, 1964

GRAY, B. *Japanese screen painting.* London, Faber & Faber, 1953 (Faber Gallery of Oriental Art)

The Great Japan Exhibition: art of the Edo Period, 1600–1818. Edited by W. Watson. London, Royal Academy of Arts in association with Weidenfeld & Nicolson, 1981

GRILLI, E. *The art of the Japanese screen.* Tokyo, New York, Walker/Weatherhill, 1970

———. *Japanese picture scrolls.* New York, Crown, 1958

———. *Tawaraya Sotatsu (active early 17th century).* Edited by I. Tanaka. 1st English ed. Tokyo, Rutland, C. E. Tuttle Co., 1956 (Kodansha Library of Japanese Art, 6)

GROOT, G. *The pre-history of Japan.* Edited by B. S. Kraus. New York, Columbia University Press, 1951

GROUSSET, R. *The civilizations of the East.* Vol. 4, *Japan.* Trans. by C. A. Phillips. New York, London, A. Knopf, 1931–34

A Guide to Japanese architecture. With an appendix on important traditional buildings. 1st ed. Tokyo, Shinkenchiku-sha, 1971

GUILLAIN, F. "Châteaux forts japonais." *Bulletin de la Maison Franco-Japonaise,* XIII¹, 1942, 216 p.

———. *The Japanese challenge.* Trans. by P. O'Brian. 1st ed. in English. Philadelphia, Lippincott, 1970

GUILLAIN, R. *Japon, troisième grand.* Ed. revue. Paris, Seuil, 1972

GUNSAULUS, H. C. *The Clarence Buckingham Collection of Japanese prints: the primitives.* Chicago, Art Institute of Chicago, 1955

———. *Japanese textiles.* New York, Japan Society, 1941

HALL, J. W. *Japan from prehistory to modern times.* New York, Delacorte, 1970

———. *Japanese history: a guide to Japanese reference and research materials.* Ann Arbor, University of Michigan Press, 1954

HARADA, J. *A glimpse of Japanese ideals.* Tokyo, Kokusai Bunka Shinkokai (Society for International Cultural Relations), 1937

HARADA, M. *Meiji Western Painting.* Trans. by A. Murakata. Adapted by B. F. Abiko. New York, Weatherhill, 1974 (Arts of Japan, 6)

HARAT, K. *Feudal architecture of Japan.* Trans. by H. Sato and J. Ciliotta. 1st English ed. New York, Weatherhill, 1973 (Heibonsha Survey of Japanese Art, 13)

HASHIMOTO, F. *Architecture in the Shoin Style.* Trans. and adapted by J. M. Horton. 1st ed. Tokyo, New York, Kodansha International, 1981

HASUMI, T. *Zen in Japanese art, a way of spiritual experience.* Trans. from the German by J. Petrie. New York, Philosophical Library, 1962

HATTORI, S. "The affinity of Japanese." *Acta Asiatica,* II, 1961, pp. 1–29

HAUGE, V., and T. HAUGE. *Folk traditions in Japanese art.* Exhibition catalogue. Washington, D.C., International Exhibitions Foundation, 1978

HAYAKAWA, M. *The garden art of Japan.* Trans. by R. L. Gage. 1st ed. New York, Weatherhill, 1973 (Heibonsha Survey of Japanese Art, 28)

HAYASHI, R. *The Silk Road and the Shoso-in.* Trans. by R. Ricketts. 1st English ed. New York, Weatherhill, 1975 (Heibonsha Survey of Japanese Art, 6)

HAYASHIYA, S. *Chano-yu–Japanese tea ceremony.* Exhibition catalogue adapted and trans. by E. J. Sano. Essays by H. P. Varley et al. New York, Japan Society, 1979

HAYASHIYA, T., M. NAKAMURA, and S. HAYASHIYA. *Japanese art and the tea ceremony.* Trans. and adapted by J. P. Macadam. 1st English ed. New York, Weatherhill, 1974 (Heibonsha Survey of Japanese Art, 15)

Heibonsha Survey of Japanese Art. General Index, by R. Bird. 1st ed. New York, Weatherhill, 1980 (Heibonsha Survey of Japanese Art, 31)

HEMPEL, R. *The golden age of Japan, 794–1192.* Trans. by K. Watson, New York, Rizzoli, 1983

HENDERSON, G., and L. HURVITZ, "The Buddha of Seiryōji: New Finds and New Theory." *Artibus Asiae,* XIX[1], 1956, pp. 5–55

HERBERTS, K. *Oriental lacquer: art and technique.* Trans. by B. Morgan. New York, Harry N. Abrams, 1962

The heritage of Japanese art, by M. Ishizawa et al. 1st ed. Tokyo, New York, Kodansha International, 1982 [1981]

HIBBETT, H. "The Portrait of the artist in Japanese fiction." *Far Eastern Quarterly,* XIV[3], May 1955, pp. 347–54

———. "Saikaku and burlesque fiction." *Harvard Journal of Asiatic Studies,* XX[1–2], Studies presented to Serge Elisseeff, June 1975, pp. 53–73

———. "The role of the Ukiyo-zōshi illustrator." *Monumenta Nipponica,* XIII[1–2], 1957, pp. 67–82

HILLIER, J. R. *The art of Hokusai in book illustration.* London, Sotheby Parke Bernet; Berkeley, University of California Press, 1980

———. *The uninhibited brush: Japanese art in the Shijō style.* London, Hugh M. Moss Publishing Ltd., 1974

HIRAI, K. *Feudal architecture of Japan.* Trans. by H. Sato and J. Ciliotta. New York, Tokyo, Weatherhill/Heibonsha, 1973

Hiroshige, Tōkaidō. Introduction et commentaires par Serge Elisseeff. Paris, Éditions du Crédit Lyonnais, 1960

HISAMATSU, S. *The vocabulary of Japanese literary aesthetics.* Tokyo, Centre for East Asian Studies, 1963

Histoire du développement culturel et scientifique de l'humanité. t. III, "Les grandes civilisations du Moyen Age," by V. Elisseeff, J. Naudou, G. Wiet, and P. Wolff. Paris, Laffont, 1969

Hōbōgirin, Dictionnaire encyclopédique du bouddhisme d'après les sources chinoises et japonaises. Tokyo, Maison Franco-Japonaise, 1929–67. 4 vols. in 2

"Hōnen shōnin eden (The illustrated history of the priest Hōnen)." *Nihon no Bijutsu,* 4, no. 95, 1974

HONEY, W. B. *The ceramic art of China and other countries of the Far East.* New York, Beechhurst Press, 1954

HORIGUCHI, S. *The Katsura Imperial Villa.* Photographs by T. Sato. English resumé by J. Harada. Tokyo, Mainichi Newspapers, 1953

HOSONO, M. *Nagasaki prints and early copperplates.* Trans. by L. Craighill. Tokyo, Kodansha, 1978

ICHIKO, I. " 'Otogi' and literature." *Acta Asiatica,* IV, 1963, pp. 32–42

IENAGA, S. *Japanese art: a cultural appreciation.* Trans. by R. L. Gage. 1st English ed. New York, Weatherhill, 1979 (Heibonsha Survey of Japanese Art, 30)

———. *Painting in the Yamato style.* Trans. by J. M. Shields. 1st English ed. New York, Weatherhill, 1973 (Heibonsha Survey of Japanese Art, 10)

ISHIDA, M. *Japanese Buddhist prints.* English adaptation by C. S. Terry. New York, Harry N. Abrams, 1964

ITOH, T. *The elegant Japanese house: traditional Sukiya architecture.* 1st ed. New York, Walker/Weatherhill, 1969

———. *Kura, design and tradition of the Japanese storehouse.* 1st ed. Tokyo, New York, Kodansha International, 1973

———. *Traditional domestic architecture of Japan.* Trans. by R. L. Gage. 1st ed. New York, Weatherhill, 1972 (Heibonsha Survey of Japanese Art, 21)

Itsuo Bijutsukan. *Chawan. Tea bowls in the collection of Ichiaō Kobayashi.* Catalogue by G. Kato. Osaka, Itsuo Bijutsukan, 1968

IZUMI, SHIKIBU. *The Izumi Shikibu diary: a romance of the Heian court.* Trans. by E. A. Cranston. Cambridge, Harvard University Press, 1969

JAHSS, M., and B. JAHSS. *Inro and other miniature forms of Japanese lacquer art.* Rutland, C. E. Tuttle Co., 1971

Japan. Bunkazai Hogo Inkai (Commission for the Protection of Cultural Properties). *Catalogue of art objects registered as national treasures.* Tokyo, Benrido, 1951–date

———. *Kokuhō* (The national treasures). Tokyo, Mainichi Shimbunsha, 1963–67. 12 vols.

———. *Nippon no bunkazai* (Cultural properties of Japan). 2 vols. Tokyo, 1961

Japan Society. *Japanese art exhibitions with catalogue in the United States of America.* New York, Japan Society, 1981

JENYNS, R. S. *Japanese porcelain.* London, 1965

———. *Japanese pottery.* New York, Praeger, 1965

———. "The Wares of Kutani." *Transactions of the Oriental Ceramic Society,* 21, 1954–56

JOLY, H. L. *Legend in Japanese art, a description of historical episodes, legendary characters, folk-lore myths, religious symbolism, illustrated in the arts of old Japan.* Reprint of 1908 ed. Rutland, C. E. Tuttle Co., 1967

———, and K. TOMITO. *Japanese art and handicraft.* Reprint of 1916 ed. Rutland, C. E. Tuttle Co., 1976

JOÜAN DES LONGRAIS, F. *L'Est et l'Ouest. Institutions du Japon et de l'Occident comparées (Six études de sociologie juridique).* Paris, Institut de recherches d'histoire étrangère; Tokyo, Maison Franco-Japonaise, 1958

KAGEYAMA, H. *The arts of Shinto.* Trans. by C. Guth. New York and Tokyo, Weatherhill/Shibundo, 1973

———, and C. G. KANDA. *Shinto arts: nature, gods and man in Japan.* New York, Japan Society, 1976

KASAWARA, K. *Nihonshi chizu chō* (Little historic atlas of Japan). 3d ed. Tokyo, Yamakawa Shuppansha, 1966

KATŌ, S. *Form, style, tradition; reflections on Japanese art and society.* Trans. by J. Bester. Berkeley, University of California Press, 1971

KAWAKATSU, K. *Kimono.* Tokyo, Japan Travel Bureau, 1947 (Tourist Library, n.s. 3)

KAWAKITA, M. *Modern currents in Japanese art.* Trans. and adapted by C. S. Terry. 1st English ed. New York, Weatherhill, 1974 (Heibonsha Survey of Japanese Art, 24)

KEENE, D. *Anthology of Japanese literature from the earliest era to the mid-nineteenth century.* New York, Grove Press, 1960 (UNESCO Collection of Representative Works: Japanese series)

———. *Bunraku; the art of the Japanese puppet theatre.* 1st ed. Tokyo, Kodansha International, 1965 (includes phonodisc)

———. *Nō; the classical theatre of Japan.* 1st. ed. Tokyo, Palo Alto, Kodansha International, 1966 (includes phonodisc)

———. "The portrait of Ikkyū." *Archives of Asian Art,* XX, 1966–67, pp. 54–65

KEIKAI. *Miraculous stories from the Japanese Buddhist tradition: the Nihon Ryoiki of the monk Kyokai.* Trans. by K. M. Nakamura. Cambridge, Harvard University Press, 1973

KEYES, R., and J. B. AUSTIN. *Eight hundred years of Japanese printmaking from the Collection of Dr. and Mrs. James B. Austin.* Exhibition catalogue. Pittsburgh, Museum of Art, Carnegie Institution, 1976

KIDDER, J. E. *The birth of Japanese art.* New York, Praeger, 1965

———. *Early Buddhist Japan.* New York, Praeger, 1972 (Ancient peoples and places)

———. *Early Japanese art: the great tombs and treasures.* Princeton, Van Nostrand, 1964

———. *Japan before Buddhism.* Rev. ed. New York, Praeger, 1966 (Ancient peoples and places)

———. *Japanese temples: sculpture, paintings, gardens, and architecture.* New York, Harry N. Abrams, 1964

———. *Masterpieces of Japanese sculpture.* Tokyo, Bijutsu Shuppan-sha; Rutland, C. E. Tuttle Co., 1961

———. *Prehistoric Japanese art: Jomon pottery.* With contribution by T. Esaka. 1st ed. Tokyo, Palo Alto, Kodansha International, 1968

KIEJ'E, N. *Japanese grotesqueries.* With introductory essay by T. Barrow. Rutland, C. E. Tuttle Co., 1973

KIMURA, K. *Japanese literature: manners and customs in the Meiji-Taishō Era.* Trans. by P. Yampolsky. Tokyo, Obunsha, 1957 (Centenary Cultural Council Series)

KINOSHITA, M. *Japanese architecture: Sukiya.* Tokyo, Shokokūsha Publishing Co., 1964

———. "Sanjuroky nin kaskū." *Nihon no Bijutsu,* 5, no. 168, 1980, 98 p.

KIRBY, J. B. *From castle to teahouse: Japanese architecture of the Momoyama period.* 1st ed. Tokyo, Rutland, C. E. Tuttle Co., 1962

KISHIDA, H. *Japanese architecture.* Rev. ed. Tokyo, Japan Travel Bureau, 1954 (Tourist Library, 6)

KITAGAWA, H., and B. T. TSUCHIDA. *The tale of the Heike.* Tokyo, University of Tokyo Press, 1975

KITAGAWA, M. *The Muro-ji, an eighth-century Japanese temple, its art and history.* English text by R. A. Miller. Tokyo, Bijutsu Shuppan-sha, 1954

KITAO, H. *Shoin architecture in detailed illustrations.* Tokyo, Shokokusha Publishing Co., 1956

KOBAYASHI, T. *Nara Buddhist art, Todai-ji.* Trans. and adapted by R. L. Gage. 1st English ed. New York, Weatherhill, 1975 (Heibonsha Survey of Japanese Art, 5)

———. *Study on the life and works of Unkei.* Okajima, 1954

KODAMA, K. *Nihonshi chizū* (Historical atlas of Japan). New ed. Tokyo, Yoshikawa Kōbunkan, 1971

Kodansha encyclopedia of Japan. 1st ed. Tokyo, Kodansha, 1983. 9 vols.

Kokusai Bunka Shinkōkai. *Introduction to classic Japanese literature.* Tokyo, Kokusai Bunka Shinkōkai, 1948

KONDO, I. *Japanese genre painting: the lively art of Renaissance Japan.* Trans. by R. A. Miller. Tokyo, Rutland, C. E. Tuttle Co., 1961

———. *Kitagawa Utamaro.* Trans. by C. S. Terry. Tokyo, Rutland, C. E. Tuttle Co., 1956

———. *Suzuki Harunobu, 1725?–1770.* Trans. by K. Ogimi. 1st English ed. Tokyo, Rutland, C. E. Tuttle Co., 1956 (Kodansha Library of Japanese Art, 7)

"Ko Seto (Old Seto)." *Nihon no Bijutsu*, 6, no. 133, 1977, 86 p.

KOYAMA, F. *The heritage of Japanese ceramics.* Trans. and adapted by J. Figgess. 1st ed. New York, Weatherhill, 1973

———, and J. FIGGESS. *Two thousand years of Oriental ceramics.* New York, Harry N. Abrams, 1961

KUNO, T. *A guide to Japanese sculpture.* Tokyo, Mayuyama, 1963

———, and T. INOUE. "Study of the Yakushi Triad in the Kondō Yakushi-ji." *Acta Asiatica*, I, 1960, pp. 89–108

KYŌTARŌ, N., and E. J. SANO. *The great age of Japanese Buddhist sculpture, A.D. 600–1300.* Exhibition catalogue. Fort Worth, Kimbell Art Museum; New York, Japan Society, 1982

LANE, R. D. *Images from the floating world: the Japanese print, including an illustrated dictionary of Ukiyo-e.* New York, Putnam, 1978

LAZARNICK, G. *The signature book of netsuke, inro and ojime artists in photographs.* Honolulu, Reed Publishers, 1976

LEE, SHERMAN E. *The genius of Japanese design.* 1st ed. Tokyo, New York, Kodansha International, 1981

———. *A history of Far Eastern art.* 4th ed. New York, Harry N. Abrams, 1982

———. *Japanese decorative style.* Cleveland, Cleveland Museum of Art; New York, Harry N. Abrams, 1961; Icon ed., New York, Harper & Row, 1972

———. *Reflections of reality in Japanese art.* Catalogue by M. R. Cunningham with J. T. Ulak. Cleveland Museum of Art in cooperation with the Indiana University Press, 1983

———. *Tea taste in Japanese art.* Exhibition catalogue. Asia House Gallery. New York, Asia Society, 1965

LEE, Y. *Oriental lacquer art.* 1st ed. Oriental House Ltd., Tokyo; New York, Weatherhill, 1972 [c. 1971]

LEQUILLER, J. "Bibliographie des ouvrages de sciences humaines consacrés au Japon et publiés entre 1945 et 1958 en français, anglais et allemand." *Bulletin de la Maison Franco-Japonaise*, n.s., V¹, 1958

LINK, H. A. *Exquisite visions: Rimpa paintings from Japan.* Exhibition catalogue. Honolulu, Honolulu Academy of Arts, 1980

———. *The theatrical prints of the Torii masters: a selection of seventeenth and eighteenth century Ukiyo-e.* Honolulu, Honolulu Academy of Arts; Tokyo, Riccar Art Museum, 1977

Los Angeles County Museum of Art. *Art treasures from Japan.* Exhibition catalogue. Tokyo, Kodansha International, 1965

LUBAC, H. DE. *La Rencontre du bouddhisme et de l'Occident.* Paris, Editions Montaigne, 1952 (Collection Théologie, 24)

MABIRE, J., and Y. BRÉHERET. *Les Samouraï.* Paris, Balland, 1971

MACHIDA, K. "A historical survey of the controversy as to whether the Hōryū-ji was rebuilt or not." *Acta Asiatica*, XV, 1968, pp. 87–115

MATSUSHITA, T. *Ink painting.* Trans. and adapted with an introduction by M. Collcutt. 1st ed. New York, Weatherhill, 1974 (Arts of Japan, 7)

———, T. INOUE, G. NAKANO, and T. TAKEDA. *Problems of portrait art: concerning portrait sculpture and paintings of high priests,* 25 Oct., 1977. Kyoto, National Museum. Committee on Research, The Ueno Memorial Foundation for Study of Buddhist Art, Report V, March 1978

MAYBON, A. *Le théâtre japonais.* Paris, H. Laurens, 1925

McCALLUM, D. "The Ninnaji Amida Triad and the Orthodox Style." *Artibus Asiae*, XXXVI³, 1974, pp. 219–41

McCULLOUGH, H. C. *Okagami: the Great Mirror, Fujiwara Michinaga (966–1027) and his times.* Princeton, Princeton University Press, 1980

———, ed. *Tales of Ise: lyrical episodes from tenth-century Japan.* Stanford, Stanford University Press, 1968

———, trans. *Yoshitsune: a fifteenth-century Japanese chronicle.* Stanford, Stanford University Press, 1966

MICHENER, J. A. *Japanese prints, from the early masters to the modern.* Tokyo, Rutland, C. E. Tuttle Co., 1959

MIKAMI, T. *The art of Japanese ceramics.* Trans. by A. Herring. 1st English ed. New York, Weatherhill, 1972 (Heibonsha Survey of Japanese Art, 29)

MILLER, R. A. *Japanese Ceramics.* Japanese text by S. OKUDA, F. KOYAMA, and S. HAYASHIYA. Rutland, C. E. Tuttle Co.; Tokyo, Toto Shuppan, 1960

MIYA, T. "Ippenshōnin eden (Illustrated history of the Priest Ippen)." *Nihon no Bijutsu*, I, no. 56, 1971, 106 p.

MIZUNO, S. *Asuka Buddhist art: Hōryū-ji.* Trans. by R. L. Gage. 1st English ed. New York, Weatherhill, 1974 (Heibonsha Survey of Japanese Art, 4)

MIZUO, H. *Edo painting: Sotatsu and Korin.* Trans. by J. M. Shields. 1st English ed. New York, Weatherhill, 1972 (Heibonsha Survey of Japanese Art, 18)

MORAN, S. F. "Ashura, a dry-lacquer statue of the Nara Period." *Artibus Asiae*, XXVII¹⁻², 1964, pp. 99–133

———. "Early Heian sculpture at its best: three outstanding examples." *Artibus Asiae*, XXXIV²/³, 1972, pp. 119–61

———. "The gilding of ancient bronze statues in Japan." *Artibus Asiae*, XXXI, 1969, pp. 55–65

———. "Kichijōten, a painting of the Nara Period." *Artibus Asiae*, XXV⁴, 1962, pp. 237–79

———. "The statue of Miroku Bosatsu of Chūgū-ji." *Artibus Asiae*, XXI³/⁴, 1958, pp. 179–203

———. "The Yumedono Kannon of Hōryūji." *Archives of the Chinese Art Society of America*, XI, 1957, pp. 59–68

MORAOKA, K., and K. OKAMURA. *Folk arts and crafts of Japan.* Trans. by D.D. Stegmaier. 1st English ed. New York, Weatherhill, 1973 (Heibonsha Survey of Japanese Art, 26)

MORI, H. *Sculpture of the Kamakura Period.* Trans. by K. Eickmann. 1st English ed. New York, Weatherhill, 1974 (Heibonsha Survey of Japanese Art, 11)

MORI, K. "International relations between the 10th and the 16th Century and the development of the Japanese international consciousness." *Acta Asiatica*, II, 1961, pp. 69–93

MORRISON, A. *The painters of Japan.* London, Edinburgh, T. C. & E. C. Jack, 1911. 2 vols.

MUNSTERBERG, H. *The arts of Japan, an illustrated history.* 1st ed. Tokyo, Rutland, C. E. Tuttle Co. 1957

MURASAKI SHIKIBU. *Genji monogatari.* Trans. by K. Suematsu. Rutland, C. E. Tuttle Co. 1974

MURASAWA, F. *Treasures of Japanese architecture: castles.* English text by D. L. Philippi. Edited by Shokoku-sha under the supervision of the National Commission for Protection of Cultural Properties. Tokyo, Shokoku-sha, 1962

MURASE, M. *Byōbu: Japanese screens from New York collections.* New York, Asia Society, by New York Graphic Society, 1971

———. *Emaki: narrative scrolls from Japan.* New York, Asia Society, 1983

———. "Farewell paintings of China: Chinese gifts to Japanese visitors." *Artibus Asiae*, XXXII²/³, 1970, pp. 211–36

———. *Iconography of the Tale of Genji.* 1st ed. New York, Weatherhill, 1984

———. *Japanese art: selections from the Mary and Jackson Burke Collection.* New York, Metropolitan Museum of Art, 1975

MURDOCH, J. *A history of Japan.* Reprint, 1925 ed. New York, F. Ungar, 1964. 3 vols. in 6

NAGAOKA, H. *Histoire des relations du Japon avec l'Europe aux XVIᵉ et XVIIᵉ siècles.* Paris, H. Jouve, 1905

NAKAGAWA, S. *Kutani ware.* Trans. and adapted by J. Bester. 1st ed. Tokyo, New York, Kodansha International, 1979

NAKAMURA, H. "A critical survey of Mahāyāna and esoteric Buddhism chiefly based upon Japanese studies." *Acta Asiatica*, VI, 1964, pp. 57–88; VII, pp. 36–94

———. *Ways of thinking of Eastern peoples: India, China, Tibet, Japan.* Rev. English trans. edited by P. P. Wiener. Honolulu, East-West Center Press, 1964

NAKAMURA, T. *Sesshu Toyo, 1420–1506.* English text by E. Grilli. 1st English ed. Tokyo, Rutland, C. E. Tuttle Co., 1957 (Kodansha Library of Japanese Art, 10)

NAKAMURA, Y. *Noh: the classical theater.* Trans. by D. Kenny. New York, Walker/Weatherhill, 1971

NAKATA, Y. *The art of Japanese calligraphy.* Trans. by A. Woodhull and A. Nikovskis. 1st English ed. New York, Weatherhill, 1973 (Heibonsha Survey of Japanese Art, 27)

NARAZAKI, M. *The Japanese print: its evolution and essence.* Trans. by C. H. Mitchell. Tokyo, Kodansha, 1966

———. *Masterworks of Ukiyo-e.* Vol. 1: *Early paintings.* Trans. by C. A. Pomeroy. Tokyo, Palo Alto, Kodansha, 1968

———. *Masterworks of Ukiyo-e.* Vol. 5: *Hiroshige: Famous Views.* Trans. by R. L. Gage. Tokyo, Palo Alto, Kodansha, 1968

———. *Masterworks of Ukiyo-e.* Vol. 10: *Hiroshige: The Fifty-three Stations of the Tokaido.* Tokyo, Kodansha, 1974

———. *Masterworks of Ukiyo-e.* Vol. 7: *Hokusai: sketches and paintings.* Trans. by J. Bester. Tokyo, Palo Alto, Kodansha, 1969

———. *Masterworks of Ukiyo-e.* Vol 3: *Hokusai: The Thirty-six Views of Mount Fuji.* Trans. by J. Bester. Tokyo, Palo Alto, Kodansha, 1972

———. *Masterworks of Ukiyo-e.* Vol. 9: *Kiyonaga.* Trans. by J. Bester. Tokyo, Kodansha, 1970

———. *Masterworks of Ukiyo-e.* Vol. 11: *Studies in nature: birds and flowers by Hokusai and Hiroshige.* Trans. by J. Bester. Tokyo, Kodansha, 1974

———, S. TAKAHASHI, S. KIKUCHI et al. *Kinsei Fu-*

zoku Zukan (Collection of genre painting scrolls of the Edo Period). Tokyo, 1973–74

New York. Metropolitan Museum of Art. *Momoyama, Japanese art in the age of grandeur*. Organized in collaboration with the Agency for Cultural Affairs of the Japanese Government. New York, Metropolitan Museum of Art, 1975

NISHIKAWA, I. *Floral art of Japan*. Tokyo, Board of Tourist Industry, Japanese Government Railways, 1936 (Tourist Library, 11)

NISHIMURA, H., J. MAILEY, and J. S. HUGHES, JR. *Tagasode—Whose Sleeves... Kimonos from the Kanebo Collection*. Exhibition catalogue. New York, Japan Society, 1976

NITSCHKE, G. "The Universe and Kyoto." *The East*, XI⁶, 1966, pp. 42–46

NOGUCHI, Y. *Hiroshige and Japanese landscapes*. 4th ed. Tokyo, Japan Travel Bureau, 1946 (Tourist Library, n.s. 2)

NOMA, S. *The arts of Japan*. Trans. and adapted by J. Rosenfield and G. T. Webb. 1st ed. Tokyo, Kodansha International, 1966–67. 2 vols.

——. *Japanese costume and textile arts*. Trans. by A. Nikovskis. 1st English ed. New York, Weatherhill, 1974 (Heibonsha Survey of Japanese Art, 16)

——. *Masks*. English adaptation by M. Weatherby. 1st English ed. Tokyo, Rutland, C. E. Tuttle Co., 1957 (Arts and Crafts of Japan, 1)

——, and N. TANI. *Nihon bijutsu jiten (Dictionary of Japanese art)*. 16th ed. Tokyo, Tokyōdō, 1964

NUMATA, J. "Historical aspects of the acceptance of western culture in Japan (Pre-Meiji period)." *East Asian Cultural Studies*, VI ¹⁻⁴, March 1967, pp. 110–23

NUMAZAWA, K. "The fertility festival of Tegata Shintō Shrine, Aichi Prefecture, Japan." *Acta Tropica: Zeitschrift für Tropenwissenschaften und Tropenmedizin, XVI³*, 1959, pp. 193–217

OBAYASHI, T. "The origins of Japanese mythology." *Acta Asiatica*, XXXI, 1977, pp. 1–23

OKADA, J. *Genre screens from the Suntory Museum of Art*. Exhibition catalogue. Trans. by E. J. Sano. New York, Japan Society, 1978

OKAKURA, K. *The book of tea*. 12th ed. New York, Fox, Duffield & Co., 1929. Reprinted New York, Dover Publications, 1963

OKAMOTO, Y. *The Namban art of Japan*. Trans. by R. K. Jones, 1st English ed. New York, Weatherhill, 1972 (Heibonsha Survey of Japanese Art, 19)

OKAWA, N. *Edo architecture, Katsura and Nikko*. Trans. by A. Woodhull and A. Miyamoto. 1st English ed. New York, Weatherhill, 1975 (Heibonsha Survey of Japanese Art, 20)

OKAZAKI, J. "Jōdokyoga (Painting of the Jodo)." *Nihon no Bijutsu*, 12, no. 43, 1969

——. *Pure land Buddhist painting*. Trans. and adapted by E. ten Grotenhuis. 1st ed. Tokyo, New York, Kodansha International, 1977 (Japanese Arts Library, 4)

OKUDA, S., et al. *Japanese ceramics*. Adapted by R. A. Miller. Tokyo, Tōtō Shuppan Co., distributed by C.E. Tuttle Co., 1960

OKUDAIRA, H. *Emaki: Japanese picture scrolls*. 1st English ed. Rutland, C.E. Tuttle Co., 1962

——. *Narrative picture scrolls*. Trans. by E. ten Grotenhuis. New York, Weatherhill, 1973 (Arts of Japan, 5)

OMURA, S. *Kakko zuroku (Archaeological objects in photographic illustrations)*. Selected by I. K. Gakujin (pseud.). Osaka, Darum-ya shōten, 1923. 2 vols.

OOKA, M. *Temples of Nara and their art*. Trans. by D. Lishka. 1st English ed. New York, Weatherhill, 1973 (Heibonsha Survey of Japanese Art, 7)

OSUMI, S. *Histoire des idées religieuses et philosophiques du Japon*. Kyōto, Jigyokudō, 1929

OTA, H., ed. *Japanese architecture and gardens*. Tokyo, Kokusai Bunka Shinkokai, 1966

OTANI, C. "Pages de Shinran." *Bulletin de la Maison Franco-Japonaise*, n.s. IX¹, 1969

Pacific Science Congress, 10th, Honolulu, 1961. *Japanese culture: its development and characteristics*. Ed. by R. J. Smith and R. K. Beardsley. Chicago, Aldine Publishing Co., 1966 [c. 1962] (Viking Fund Publications in Anthropology, 34)

Pageant of Japanese art. Edited by Staff Members of the Tokyo National Museum. Tokyo, Tōtō Bunka, 1952–54. Popular edition, 1957

PAINE, R. T. "Japanese porcelains: the gift of Miss Lucy T. Aldrich." Boston. Museum of Fine Arts. *Bulletin*, XLV, June 1947, pp. 26–35

——, and A. SOPER. *The art and architecture of Japan*. 2d ed. Pt. 1 brought up to date by D. B. Waterhouse; Pt. 2 brought up to date by B. Kobayashi. Harmondsworth, Baltimore, Penguin Books, 1974 (Pelican History of Art)

PAPINOT, E. *Historical and geographical dictionary of Japan*. Intro. by Terence Barrow. Reprint of 1910 ed. Tokyo; Rutland, C.E. Tuttle Co., 1972

Paris. Galerie Janette Ostier. *Les objets tranquilles: natures mortes japonaises XVIIIᵉ–XIXᵉ siècles*. Catalogue par E. Kondo et al. Paris, 1978

Paris. Musée Cernuschi. *Kimonos d'hier et d'aujourd'hui*. Catalogue par M. Paul-David. Exposition, Fév.–Mars 1957. Paris, 1957

——. *Namban, ou, De l'Européisme japonais, XVIᵉ–XVIIᵉ siècles*. Exposition, 18 Oct.–14 Déc. 1980. Paris, 1980

Paris. Musée des Arts Décoratifs. *Images du temps qui passe: peintures et estampes d'Ukiyo-e*. Exposition, Juin–Oct. 1966. Paris, 1966

Paris. Petit Palais. *L'Au-delà dans l'art japonais*. Catalogue de l'exposition. Préface par S. Noma et V. Elisseeff. Paris, 1963

PENKALA, M. *Far Eastern ceramics: marks and decoration*. The Hague, Mouton, 1963

PERI, N. *Le nō*. Tokyo, Maison Franco-Japonaise, 1944

PEZEU-MASSABUAU, J. "La Maison japonaise et la neige." *Bulletin de la Maison Franco-Japonaise*, n.s. VIII¹, 1966

Philadelphia Museum of Art. *Foreigners in Japan. Yokohama and related woodcuts in the Philadelphia Museum of Art*. Philadelphia, 1972

Philosophical studies of Japan. Tokyo, Japanese National Commission for UNESCO by the Japan Society for the Promotion of Science, 1959–75. 11 vols.

PIGEOT, J. "Histoire de Yokobue ('Yokobue no sōshi'). Étude sur les récits de l'époque Muromachi." *Bulletin de la Maison Franco-Japonaise*, n.s. IX², 1972

RAGUÉ, B. VON. *A history of Japanese lacquerwork*. Trans. by A. R. de Wasserman. Buffalo, Toronto, University of Toronto Press, 1976

RATHBUN, W. J. *Yōnobi: the beauty of Japanese folk art*. With contributions by M. Knight. Seattle, Seattle Art Museum and the University of Washington Press, 1983

REISCHAUER, E. O. *Japan, past and present*. Rev. (4th) ed. New York, A. Knopf, 1974

——, and J. K. FAIRBANK, *A history of East Asian civilization*. Vol. I, "East Asia, the great tradition." Boston, Houghton Mifflin, 1960

——, and J. F. YAMAGIWA. *Translations from early Japanese literature*. Cambridge, Harvard University Press, 1951. 2d ed., abridged, 1972. (Harvard-Yenching Institute Series, 29)

RENONDEAU, G. *Le Bouddhisme dans les nō*. Tokyo, 1950 (Publications de la Maison Franco-Japonaise, Série B, t. II)

——. "L'Influence bouddhique sur les nō. La dévotion à Kwannon (Nō de Tomonaga)." *Les Théâtres d'Asie*. Paris, Editions du Centre National de la Recherche Scientifique, 1961.

RHODES, D. *Tamba pottery*. Tokyo, Palo Alto, Kodansha International, 1970

ROBERTS, L. P. *A dictionary of Japanese artists*. Tokyo, New York, Weatherhill, 1976

——. *Roberts's guide to Japanese museums*. Tokyo, New York, and San Francisco, Kodansha, 1978

ROSENFIELD, J. M. *The courtly tradition in Japanese art and literature*. Selections from the Hofer and Hyde Collections by J. M. Rosenfield and F. E. and E. A. Cranston. Cambridge, Fogg Art Museum, Harvard University, 1973

——. *Japanese art of the Heian period, 794–1185*. Exhibition, Asia House and the Fogg Art Museum, Harvard University, 1967–68. New York, Asia Society, 1967

——. "The Sedgwick Statue of the Infant Shōtoku Taishi." *Archives of Asian Art,* XXII, 1968–69, pp. 56–79

——, and S. SHIMADA. *Traditions of Japanese art*. Cambridge, Fogg Art Museum, Harvard University, 1970

——, and E. TEN GROTENHUIS. *Journey of the three jewels: Japanese Buddhist paintings from western collections*. New York, Asia Society, 1979

ROWAN, D. P. "The Yakushi Image and Shaka Trinity of the Kondō, Hōryūji: a study of drapery problems." *Artibus Asiae*, XXXI⁴, 1969, pp. 241–75

SAIKAKU, I. *The Japanese family storehouse*. Trans. by G. W. Sargent. Cambridge, 1959

SANSOM, G. B. *Japan, a short cultural history*. Rev. ed. New York, Appleton, Century, Crofts, 1962

——. *A history of Japan*. Stanford. Stanford University Press, 1958–63. 3 vols.

——. *The western world and Japan*. 1st ed. New York, A. Knopf, 1950 [c. 1949]

SATO, M. *Kyoto ceramics*. Trans. and adapted by A. O. Towle & U. P. Coolidge. New York, Weatherhill, 1973 (Arts of Japan, 2)

SAUNDERS, E. D. *Mudrā; a study of symbolic gestures in Japanese Buddhist sculpture*. New York, Pantheon Books, 1960 (Bollingen series, 58)

SAWA, R. *Art in Japanese esoteric Buddhism*. Trans. by R. L. Gage. 1st English ed. Tokyo, New York, Weatherhill/Heibonsha, 1972 [c. 1971] (Heibonsha Survey of Japanese Art, 8)

SCHAARSCHMIDT-RICHTER, I., and O. MORI. *Japanese gardens*. Trans. by J. Seligman. New York, Morrow, 1979

SCHMORLEITZ, M. S. *Castles in Japan*. Rutland, C. E. Tuttle Co., 1974

SEAMI, 1363–1443. *La tradition secrète de Nō; suivi de Une journée de Nō*. Traduction et commentaires de R. Sieffert. Paris, Gallimard, 1960. (Connaissance de l'Orient: Collection UNESCO d'Oeuvres Représentatives. Série Japonaise, 11)

Seattle Art Museum. *Song of the brush: Japanese paintings from the Sansō Collection*. Edited by J. M. Rosenfield. Essays by Peter Drucker et al. Seattle, 1979

SECKEL, D., and A. HASE. *Emakimono: the art of the Japanese painted hand-scroll*. Trans. by J. Max-

well-Brownjohn. New York, Pantheon, 1959

SEN, S., ed. *Chashitsu (The original drawings and photographic illustrations of the typical Japanese tea architectures and gardens)*. Kyoto, Tankōshinsha, 1959

————. *Tea life, tea mind. Soshitsu sen XV*. Trans. and edited in the Foreign Affairs Section, Urasenke Foundation. 1st ed. New York, published for the Urasenke Foundation, Kyoto, by Weatherhill, 1979

SERA, Y. *Ko Imari sometsuke zufu (Old Imari blue and white porcelain)*. Kyoto, Heiandō, 1959

SHIBATA, M. *Dans les monastères zen au Japon*. Paris, Hachette, 1972

————. *Les maîtres du zen au Japon*. Paris, Gustave-Paul Maisonneuve et Larose, 1969

SHIMIZU, Y., and C. WHEELWRIGHT, eds. *Japanese ink paintings from American collections: the Muromachi Period*. Princeton, Princeton University Art Museum, 1976

SHIMODE, S. "Shozoga (portrait painting)." *Nihon no Bijutsu*, 8,#12, 1966. 130 p.

Shosoin, Nara, Japan. *The treasures of the Shosoin*. Trans. by S. Kaneko. Tokyo, Asahi Shimbun Publishing Co., 1965

SHOTEN, K., ed. *A pictorial encyclopedia of the Oriental arts: Japan*. New York, Crown, 1969. 4 vols.

SHUNJŌ, Japanese Priest. *Honen, the Buddhist saint: his life and teaching*. Trans., historical introduction, explanatory and critical notes by H. H. Coates and R. Ishizuka. Kyoto, Society for the Publication of Sacred Books of the World, 1949. 5 vols.

SIEFFERT, R., ed. *Le Japon et la France: images d'une découverte*. Paris, Publications orientalistes de France, L'Association des langues et civilisations, 1974 (Collection Les Sept Climats)

————. *La littérature japonaise*. Paris, A. Colin, 1961

————. "La Lune au Japon," in *La Lune, mythes et rites*. Paris, Seuil, 1962 (Sources Orientales, V)

SOPER, A. C. *The evolution of Buddhist architecture in Japan*. Princeton, Princeton University Press; London, H. Milford, Oxford University Press, 1942 (Princeton Monographs in Art and Archaeology, XXII)

————. "Illustrative method of the Tokugawa Genji pictures." *Art Bulletin*, 37 (March 1955)

————. "A ninth century landscape painting in the Japanese Imperial Palace and some Chinese parallels." *Artibus Asiae*, XXIX⁴, 1967, pp. 335–50

————. "The rise of Yamato-e." *Art Bulletin*, 24 (Dec. 1942)

SPAE, J. J. "Japan's three million self-styled Christians." *The East*, II⁶, 1966, pp. 11–14

STEIN, R. "Jardins en miniature d'Extrême-Orient." *Bulletin de l'Ecole Française d'Extrême-Orient*, XIII, 1942, pp. 1–104

STERN, H. P. *Birds, beasts, blossoms, and bugs: the nature of Japan*. New York, Harry N. Abrams, 1976

————. *The magnificent three: lacquer, netsuke and tsuba, selections from the collection of Charles A. Greenfield*. New York, Japan Society, 1972

————. *Master prints of Japan: Ukiyo-e hanga*. New York, Harry N. Abrams, 1969

————. *Rimpa, masterworks of the Japanese decorative school*. Catalogue of the opening exhibition of Japan House Gallery. New York, Japan Society, 1971

————. *Ukiyo-e painting*. Exhibition catalogue. Freer Gallery of Art. Washington, D.C., Smithsonian Institution, 1973 (Smithsonian Institution. Fiftieth Anniversary Exhibition, vol. I)

STREETER, T. *The art of the Japanese kite*. New York, Weatherhill, 1974

SUGAHARA, H. *Japanese ink painting and calligraphy from the collection of the Tokiwayama Bunko, Kamakura, Japan*. With an introductory essay by T. Matsushita. Trans. by M. Murase et al. Brooklyn, Brooklyn Museum, 1967

SUGIMOTO, M., and D. L. SWAIN. *Science and culture in traditional Japan, A.D. 600–1854*. Cambridge, Massachusetts Institute of Technology Press, 1978

SUZUKI, K. *Early Buddhist architecture in Japan*. Trans. and adapted by M. N. Parent and N. S. Steinhardt. 1st ed. Tokyo, Kodansha International, 1980 (Japanese Arts Library)

————. "Jodai no jiin kenchiku (Ancient Buddhist architecture)." *Nihon no Bijutsu*, 10, no. 65, 1971, 114 p.

SWANN, P. C. *The art of Japan, from the Jōmon to the Tokugawa period*. New York, Crown, 1966 (Art of the World, non-European cultures; the historical and religious backgrounds.)

————. *A concise history of Japanese art*. Rev. ed. of *An introduction to the arts of Japan* (New York, Praeger, 1958). Tokyo, Kodansha International, 1979

TAHARA, M. M., trans. *Tales of Yamato: a tenth-century poem-tale*. Honolulu, University of Hawaii Press, 1980

TAJIMA, R. "Les deux grands mandalas et la doctrine de l'ésotérisme shingon." *Bulletin de la Maison Franco-Japonaise*, n.s. VI, 1959

TAKAHASHI, S. *Traditional woodblock prints of Japan*. Trans. by R. Stanley-Baker. 1st ed. New York, Weatherhill, 1972 (Heibonsha Survey of Japanese Art, 22)

TAKAZAKI, F. "Ōtogi zōshi (Stories through the ages)." *Nihon no Bijutsu*, 9, no. 52, 1970. 104 p.

TAKEDA, T. *Kanō Eitoku*. Trans. and adapted by H. M. Horton and C. Kaputa. Tokyo, New York, Kodansha International, 1977 (Japanese Arts Library)

The Tale of Genji Scroll. Trans. by I. Morris. Facsimile. Tokyo, Palo Alto, Kodansha International, 1971

TANAKA, I. *Japanese ink painting: Shubun to Sesshu*. Trans. by B. Darling. 1st English ed. New York, Weatherhill, 1972 (Heibonsha Survey of Japanese Art, 12)

TANGE, K., and W. GROPIUS. *Katsura: tradition and creation in Japanese architecture*. New Haven, Yale University Press, 1960

TERADA, T. *Japanese art in world perspective*. Trans. by T. Guerin. 1st English ed. New York, Weatherhill, 1976 (Heibonsha Survey of Japanese Art, 25)

TODA, K. "Japanese screen paintings of the ninth and tenth centuries." *Ars Orientalis*, 3 (1959)

Todaiji ran (Exhibition of Todaiji Treasures). Catalogue of traveling exhibition, April–October 1980. Tokyo, Asahi Shimbun, 1980

TOGANO, S. M. *Symbol system of Shingon Buddhism*. Ann Arbor, 1980

Toronto. Royal Ontario Museum. *Catalogue of the exhibition of Japanese country textiles*. Toronto, University of Toronto Press, 1965

TSUDA, N. *Handbook of Japanese art*. Rutland, C. E. Tuttle Co., 1976 (Tut Books: A)

TSUJI, N. "Rakuchū rakugai zu." *Nihon no Bijutsu*, 6, no. 121, 1976. 114 p.

TSUNODA, R., T. DEBARY, and D. KEENE, *Sources of the Japanese tradition*. New York, Columbia University Press, 1958. Text ed., 1965, 2 vols.

UENO, N. *Emaki-mono kenkyu (Study of scroll paintings)*. Tokyo, Iwanami Shoten, 1950

UMEZU, J. *Emakimono soko (Corpus of scroll paintings)*. Tokyo, Chūōkoron Bijutsu shuppan, 1968

UNESCO. *Japan: ancient Buddhist paintings*. Intro. by T. Matsushita. Greenwich, Conn., New York Graphic Society, 1959

USHIOMI, T. "La Communauté rurale au Japon." *Bulletin de la Maison Franco-Japonaise*, n.s., VII²⁻³, 1962

UYENO, N. *Japanese arts and crafts in the Meiji era*. English adaptation by R. Lane. Tokyo, Pan-Pacific Press, 1958 (Centenary Cultural Council series [A cultural history of the Meiji era] 8)

VARLEY, H. P. *Japanese culture: a short history*. New York, Praeger, 1973

VIE, M. *Histoire du Japon des origines à Meiji*. Paris, Presses Universitaires de France, 1969 *(Que sais-je?*, no. 1328)

VLAM, G. A. H. "Kings and heroes: western-style painting in Momoyama Japan." *Artibus Asiae*, XXXIX³/⁴, 1977, pp. 220–50

WANG, I-TUNG. "Official relations between China and Japan, 1368–1549." *Harvard-Yenching Institute Studies*, IX, 1953

WARNER, L. *The craft of the Japanese sculptor*. New York, McFarlane, Warde, McFarlane/Japan Society, 1936

————. *The enduring art of Japan*. Cambridge, Harvard University Press, 1952

————. *Japanese sculpture of the Tempyo period; masterpieces of the 8th century*. Edited and arranged by J. M. Plumer. 1 vol. ed. Cambridge, Harvard University Press, 1964

WATANABE, Y. *Shinto art: Ise and Izumo shrines*. Trans. by R. Ricketts. 1st English ed. New York, Weatherhill/Heibonsha, 1974 (Heibonsha Survey of Japanese Art, 3)

WEBER, V. F. *Ko-ji Hō-ten. Dictionnaire à l'usage des amateurs et collectionneurs d'objets d'art japonais et chinois*. Paris, 1932. New ed., New York, Hacker Art Books, 1965. 2 vols.

YAKU, M. *The "Kojiki" in the life of Japan*. Tokyo, Centre for East Asian Cultural Studies, 1968 (East Asian Cultural Studies, 13)

YAMANE, Y. *Momoyama genre painting*. Trans. by J. M. Shields. New York, Tokyo, Weatherhill/Heibonsha, 1973 (Heibonsha Survey of Japanese Art, 17)

————. "Ogata Kōrin and the art of the Genroku era." *Acta Asiatica*, XV, 1968, pp. 69–86

Yamato Bunkakan meihin zuroku (Selected catalogue of the Museum Yamato Bunkakan, Nara). List of plates and descriptive notes in Japanese and English. Nara, 1960

YASHIRO, Y. *Art treasures of Japan*. Tokyo, Kokusai Bunka Shinkokai, 1960. 2 vols.

————. *Two thousand years of Japanese art*. Edited by P. C. Swann. New York, Harry N. Abrams, 1958

YONEZAWA, Y. "The style of 'Musicians Riding an Elephant' and the transition in landscape painting." *Acta Asiatica*, XV, 1968, pp. 1–25

————, and C. YOSHIZAWA. *Japanese painting in the literati style*. Trans. and adapted by B. I. Monroe. 1st English ed. New York, Weatherhill/Heibonsha, 1974 (Heibonsha Survey of Japanese Art, 23)

YOSHIKAWA, I. *Major themes in Japanese art*. Trans. by A. Nikovskis. 1st English ed. New York, Weatherhill, 1976 (Heibonsha Survey of Japanese Art, 1)

YOSHINO, T. *Japanese lacquer ware*. 2nd ed. Tokyo, Japan Travel Bureau, 1963

YOSHINOBU, T., and O. SADAO. *The Tokugawa collection: Nō robes and masks*. Exhibition catalogue. Trans. and adapted by L. A. Cort and M. Bethe. New York, Japan Society, 1976

Yunesuko Higashi Ajia Bunka Kenkyu Senta, Tokyo. *Bibliography of bibliographies of East Asian Studies in Japan*. Editor, K. Goto. Tokyo, Centre for East Asian Cultural Studies, 1964

———. *Research Institutes for East Asian Studies in Japan*. Rev. and enl. ed. Edited by K. Enoki. Tokyo, Centre for East Asian Cultural Studies, 1967

———. *A survey of bibliographies in Western languages concerning East and Southeast Asian studies*. Tokyo, Centre for East Asian Cultural Studies, 1966–date

———. *A survey of Japanese bibliographies concerning Asian studies*. Tokyo, Centre for East Asian Cultural Studies, 1963

ZAINIE, C. M. "Ryōzen: from Ebusshi to ink painter." *Artibus Asiae*, XL$^{2/3}$, 1978, pp. 93–123

———. "Sources for some early Japanese ink paintings." Cleveland Museum of Art. *Bulletin*, LXV7, Sept. 1978, pp. 232–46

ZOLBROD, L. M. *Haiku painting*. 1st ed. Tokyo, New York, Kodansha International, 1982

INDEX